MW01074949

Jesuit Art and Czech Lands, 1556–1729

Jesuit Art and Czech Lands, 1556–1729

Missionizing through the Arts

Edited by
Kateřina Horníčková and Michal Šroněk

LEXINGTON BOOKS
Lanham • Boulder • New York • London

Published by Lexington Books
An imprint of The Rowman & Littlefield Publishing Group, Inc.
4501 Forbes Boulevard, Suite 200, Lanham, Maryland 20706
www.rowman.com

86-90 Paul Street, London EC2A 4NE

The book is result of research project financed by the Czech Science Foundation grant no. 17-11912S, The Idea and its Implementation: The Art Culture of the Society of Jesus in the Czech Lands

Translations: Markéta Hanelová, Hana Logan, David Livingstone

Copyright: Martin Deutsch, Kateřina Horníčková, Ondřej Jakubec, Martin Mádl, Kathrin Sterba, Michal Šroněk, Štěpán Vácha.

English copy editing: Judith Rasson

British Library Cataloguing in Publication Information Available

Library of Congress Cataloging-in-Publication Data

Names: Horníčková, Kateřina, editor. | Šroněk, Michal, editor.
Title: Jesuit art and Czech lands, 1556-1729 : missionizing through the arts / edited by Kateřina Horníčková and Michal Šroněk.
Description: Lanham : Lexington Books, [2023] | Includes bibliographical references and index.
Identifiers: LCCN 2022042996 (print) | LCCN 2022042997 (ebook) |
 ISBN 9781666905861 (cloth) | ISBN 9781666905878 (ebook)
Subjects: LCSH: Jesuit art—Czech Republic—Bohemia. | Jesuit architecture—Czech Republic—Bohemia. | Jesuits—Missions—Czech Republic—Bohemia. | Christianity and art—Czech Republic—Bohemia.
Classification: LCC N7971.C9 J47 2023 (print) | LCC N7971.C9 (ebook) |
 DDC 261.5/7094371—dc23/eng/20221011
LC record available at https://lccn.loc.gov/2022042996
LC ebook record available at https://lccn.loc.gov/2022042997

∞™ The paper used in this publication meets the minimum requirements of American National Standard for Information Sciences—Permanence of Paper for Printed Library Materials, ANSI/NISO Z39.48-1992.

Contents

List of Plates

CHAPTER 2: M. ŠRONĚK, MARIAN COLUMNS FROM ROME TO CENTRAL EUROPE

CHAPTER 4: K. HORNÍČKOVÁ, A UNIQUE SIGN OF TRUE FAITH

CHAPTER 5: M. DEUTSCH, *SALUS POPULI ROMANI*

CHAPTER 6: Š. VÁCHA, JESUIT SAINTS IN THE CZECH LANDS

CHAPTER 7: K. ŠTĚRBA, FROM VISIBLE TO INVISIBLE

CHAPTER 8: M. MÁDL, RIVALRY AND INSPIRATION

Introduction

The Jesuits and the Visual Arts in the Czech Lands

Michal Šroněk[1]

Research on the Jesuit order in Europe and its mission on other continents has long shaped the discourse on early modern religious history, also profoundly affecting the fields of art history, architecture, and visual culture. Indeed, in addition to the spoken word (preaching, catechesis, and teaching), the Jesuits made extensive use of a variety of visual, performative, musical, and print media in their missionary work, which cocreated a local missionary culture in which diverse means were subordinated to a unified effort to convert the population.[2] This missionary culture had two levels, the universal, related to the centralized organization of the order and the interconnection of colleges, and the regional, derived from knowledge of local conditions, historical and cultural traditions, and the use of local artistic forces.

Researchers' interest has mainly focused on Italy, Western Europe, North, Central, and South America, and the countries of South and East Asia.[3] Today, the concept of a universal Jesuit style in architecture that would be binding for all the order's building activities regardless of the region is recognized as a myth, shattered by a number of scholars from Joseph Braun and Rudolf Wittkower to Evonne Levy. They have documented that the order's architecture shows no tendency toward stylistic conformity, but rather a variety of local tendencies.[4] The research on the Societas Jesu's artistic activities now focuses on the high degree of local adaptability, in the sense of adapting to and using local artistic resources. This is related to the view of the Society of Jesus as an order that focuses on disseminating the universally valid principles of the Christian faith in local contexts, the idea of the interconnectedness of the supernatural and the earthly world, which is governed by the same laws that can be learned through the senses, reason, and faith.[5]

There is no doubt that the Jesuits had an extraordinary impact on the religious, cultural, and political life of Central Europe between the mid-sixteenth

and mid-eighteenth centuries. They entered an area affected to varying degrees by the non-Catholic (Lutheran, and in Bohemia, Utraquist, Unity of the Brethren, Calvinist, Anabaptist) confessions, where they established themselves with strong support from the Catholic rulers, the Habsburgs and Wittelsbachs, and the Catholic nobility, who supported the establishment of a number of religious houses. The Jesuits managed a significant part of education, especially secondary and higher education, which is evidenced by the fact that in the territory of Bohemia, Moravia, and Silesia they controlled all three universities—in Prague, Olomouc, and Wrocław. In Central Europe, their focus was on the conversion of the well-established Protestant population, that is, Christians who knew Christian doctrine well. In the confessional conflict, the differences and nuances of the Christian faith were important and needed to be consistently and clearly presented and interpreted. The Jesuits were quite inventive in their strategies for reaching out to non-Catholic communities, and their influence on catechesis and conversion cannot be overstated. This book will examine the various types of artistic and visual culture and imagery used in the Jesuit missionary strategies that played an important role in converting the country.

Research on Jesuit art and culture in Central Europe has recently resulted in several publications that present the results of research for individual regions in Bavaria, Silesia, Slovakia, and the eastern part of the former Habsburg monarchy, the Czech lands, and important centers of the Jesuit order's activity: Vienna, Brno, and other cities. In this research, two publications from the Central European region helped to frame the focus of our book, first and foremost an exhibition and large-scale catalog, *Rom in Bayern. Kunst und Spiritualität der ersten Jesuiten*, dedicated to the Munich Jesuit college and its church of St. Michael. The work testifies to the dominant influence that the commissioner and patron had on the selection of artists, the building process, and decoration, which is truly remarkable in terms of its artistic exclusivity and how it presents Catholic triumphalism.[6] Both the college and church clearly demonstrate the extent to which the Munich Jesuits made use of the interests of their patron and lead to the question of whether similar situations arose elsewhere and how the Jesuits came to terms with interventions by their patrons. No less inspiring is the reference to the role of strong individuals, whether they were patrons, like the Wittelsbachs or the early generation of the Jesuits, such as Peter Canisius.[7] In addition, there are a number of monographs on important personalities, artists, and various activities of the order, which to a greater or lesser extent are based on the premise that all visual media, including architecture, were primarily tools for the Jesuits to promote the Catholic Counter-Reformation.[8]

The second is the proceedings of a symposium dedicated to the art and culture of the Austrian province of the Society of Jesus, which were published

in 2003. The authors' focus is Viennese Jesuit architecture and its decoration, which are analyzed in particular from the architectural-historical and typological perspectives, with the decoration being examined from an iconographic perspective. Only the studies by Telesko on the iconography program of the Viennese university church in the context of Jesuit spirituality, the treatment by Levy on "the Jesuitness" of architecture of the SJ, and a text by Appuhn-Radtke about the medieval motifs in Jesuit iconography are focused on a broader interpretation of the phenomena. This publication also does not address either the question of patronage or any form of interaction between the *patres* and their Viennese surroundings, whether that involved the representation of other ecclesiastical orders, the aristocracy, or the Habsburg court.

There is no monograph in Czech art history that deals comprehensively with the art and culture of the Jesuit order in the Czech lands or the full extent of the former Lands of the Bohemian Crown, although there are a number of works that form a solid base for such a synthesis to some extent. These works deal with the individual topics, such as artists working for the Society of Jesus, important architectural, sculptural and pictorial creations, university theses, emblematics, and the decoration programs of the order's churches. On a general historical level, only the *Bohemia Jesuitica* collection of studies attempts to provide a more comprehensive view on the Jesuit mission in the region. It offers several art history studies limited in scope and focusing on narrow topics, plus a valuable general introduction to the art historical issues facing researchers of Jesuit visual culture in the Bohemian crown lands.[9]

The coverage is better in the case of the minor lands of the Bohemian Crown. The conference proceedings covering Jesuit art and culture in Silesia and Kłodzko have a wider territorial base and take similar approaches to the studies of Bavaria and Vienna. The activities of the Society of Jesus in a wider social and religious context are not addressed, however, with the exception of the figure of the Wrocław bishop, Franz Ludwig von Pfalz-Neuburg, even though Silesia was a region with a strong Lutheran tradition and the question of how the Jesuits defined themselves in relation to this heritage is certainly relevant.[10]

Our book explores the artistic strategies the Jesuits used to promote and reintroduce the cults of miraculous images and saints and local Catholic customs in a region where the tradition of religious dissent went back to the legendary Hussites and seeks to present Jesuit art as means of religious persuasion and representation of the order. It also demonstrates the degree of control the order had over the various uses of images in Jesuit churches, ensuring not only correct Catholic and theological content but using architectural and pictorial constructions as sophisticated ways of promoting the order. The timeframe starts at the moment when the first Jesuit college was founded in Prague in 1556 and ends in the first half of the eighteenth century, when

the artistic activities of the order peaked and coincided with the epoch of high Baroque art in the region.

One of the keys to the success of the society was reinterpreting the domestic past, which enabled the active use of a pool of older works of art, which were adapted and appropriated into new cultic contexts (Horníčková). Furthermore, with the support of mostly aristocratic patrons, the order had the ability to establish itself in important places in the urban environment, sometimes by brutal intervention in existing urban contexts, sometimes by taking over and gradually adapting older buildings and building necessary new facilities (Jakubec). The Jesuits were also able to adopt models of piety, cults of saints, and iconographic types created earlier, especially in Italy, and adapt them to local environments so that they became functional instruments of the representation of the order and at the same time addressed the local audience (Deutsch, Šroněk, Štěrba, Vácha). They adopted successful forms of presentation and piety created by other orders, even when they had participated in the creation but partially lost their influence on them due to external circumstances (Šroněk).

The book also deals with other cultural and artistic aspects of the Jesuit mission in the Czech lands, such as how the Jesuits adopted local cultic traditions, how they were inspired by other religious orders, and how they coped with the problems posed by their patrons, local Protestants, and other religious orders (Horníčková, Mádl, Šroněk). It examines art in Jesuit churches in the context of the cultural transmission of ideas (e.g., the theology of the image, the construction of the religious past, and concepts of the global mission) and their local application. This transfer functioned not only between the Roman center of the order and the Czech lands but also among various other Central European centers. The individual chapters focus on the unidirectional adoption of universal models, their local adaptation, transformation, and transfer to other media, as well as their eventual re-export back to Rome (Šroněk-Horníčková). The authors of the various studies in this book come to a common conclusion: Jesuit artistic transfer was an early and, for nearly two centuries, successful test of the adaptability and creative extension of Tridentine artistic strategies in Central Europe and it contributed considerably to the order's success in the region.

BETWEEN REFORMATION, COUNTER-REFORMATION, AND THE CATHOLIC REFORM

Although the basic principles of the Jesuit Order's activities were universal, the Jesuits had to deal with a number of local specific situations in their missionary work, and, in many European countries, it had to face the various Reformation movements spreading through Europe in the sixteenth century.

The situation in the Czech lands, however, was markedly different from other areas of the continent affected by Lutheranism, Calvinism, or other non-Catholic denominations. By the time Martin Luther appeared, the Bohemian lands had already had a century of experience with radical church reform, including openly anti-papal protests triggered in Bohemia by the burning of John Hus in 1415 and the subsequent Hussite Wars (1420–1434). In the Catholic view, this made parts of the Bohemian population the oldest surviving and politically best-established heretical peoples. In addition to a number of political and property changes, with monastic houses incurring the major losses, this war also brought about the emergence of a relatively independent Utraquist church. This differed from the universal Catholic Church in particular by administering the sacrament of the body and blood of Christ to all believers, including children (under both species—*sub utraque*).

The existence and coexistence of the Catholic and Utraquist confessions in the Bohemian lands was guaranteed by the laws of the land, but the Jagiellonian (on the Bohemian throne from 1471 to 1526) and Habsburg (from 1526 onward) rulers traditionally adhering to the Catholic Church were reluctant to respect this fact. The situation became even more complicated in the middle of the fifteenth century after another reformist church denomination was established in Bohemia—the Unity of the Brethren—which was much more radical and independent of Rome than the Utraquist Church. Although not legally recognized, it functioned thanks to the weak central power of the monarch and protection by sympathetic aristocrats who allowed it to operate on their own estates. At the end of the second decade of the sixteenth century, the first movement of the European Reformation—Lutheranism—emerged in Germany and spread quickly through Europe, including Bohemia, where it affected mainly the areas bordering Germany and Austria, some larger towns in Moravia, and most of Silesia. Another Reformation denomination, the Calvinists, had weaker influence, attracting only a small group whose members were recruited mainly from among German and Dutch merchants working in Prague. All the radical Reformation movements—the Unity of the Brethren, Lutherans, Calvinists, and Anabaptists (settled in Moravia)—were *de jure* outside the laws of the lands of the Bohemian Crown.

The first attempt at legalization was made by the Unity of the Brethren, Lutherans, and Lutheran-oriented Utraquists in 1575, when they asked Emperor Maximilian II of Habsburg to recognize the so-called Bohemian Confession, which the monarch approved verbally, but ultimately did not confirm. The following period was a time of increasing instability and more or less enforced religious tolerance based on the coexistence and competition of non-Catholic confessions and the opposing minority Catholic Church, programmatically supported by the Habsburg rulers and the Catholic nobility. As in other European countries, religious fundamentalism and antagonism

between Protestants and Catholics gradually prevailed during the second half of the sixteenth and the early decades of the seventeenth century.[11]

In 1555–1556 the Jesuits made a radical entrance into this complicated confessional situation, which had over a century-long tradition of interdenominational communication. They already had experience with the denominational situation in the German and Austrian countries, where Jesuit colleges had already been founded in Munich and Ingolstadt in the early 1550s, and they had been operating their own gymnasium in Vienna since 1553. Although Central European houses of the Society of Jesus were founded in a multi-confessional environment, the Jesuits did not initially have a theologically founded strategy for such a mission; with earlier attempts made by Peter Canisius, Roberto Bellarmino was the first to lay a solid foundation in his works on controversial theology in the late 1580s to 1590s. The first generation of the Jesuits in Bohemia had to build on practical experience from Germany, where the denominational conflict was clearly defined along the lines of Lutheranism and Catholicism. With foresight, they sent Peter Canisius (Petrus Canisius) to Bohemia, a man with a long-term vision of the Society's needs and a sound understanding of the local denominational situation, which he judged as more favorable than in Germany. The circumstances of the founding of the oldest Czech Jesuit college in Prague are an excellent example of how significantly they intervened in the life and topography of a multi-confessional city, and how shrewdly they were able to work with symbolic potential and mediation in the fields of architecture, art, and visual culture.

The Prague foundation also shows the joint strong support for the order by the monarch, Catholic nobility, and high clergy. Ferdinand I of Habsburg approached Ignatius of Loyola directly to request the establishment of a college of the society in Prague. Ignatius sent his emissary Canisius to Prague in 1555 to investigate the local situation and decide immediately where to establish the order's first house in Prague. Canisius reported directly to Ignatius on the situation in Prague in a lengthy letter, the contents of which attest to his excellent knowledge of the local religious situation. Canisius at first refused the offer to take over two monasteries in the Lesser Town: the former convent of the sisters of St. Mary Magdalene in Újezd and the St. Thomas Augustinian monastery; instead he chose the Dominican monastery at St. Clement's in the Old Town, the future Clementinum. Although the original medieval complex, damaged during the Hussite wars and inhabited in the mid-sixteenth century by only two Dominican friars, was not in the best condition, Canisius astutely perceived the practical advantages and the enormous potential of the site, situated on the bridgehead of the only bridge over the Vltava River at the time connecting the conglomerate of Prague towns spread along both sides of the river.

We liked this place (St. Clement's) because it's in the center of town and convenient for young people and has plenty of room for schools and classes, for rooms, stables, and part of the garden. And it could be restored and adapted to good living for this first year at low cost.[12]

Here, as elsewhere, the Jesuit order tried to take advantage of the local situation, including the historical context, topography, local artists, and inspirations, which were later applied to building the monumental complex of the Clementinum College. In Bohemia and Moravia the Jesuits used a central location, social interaction, and personal ties in their building and artistic enterprises (Jakubec, Šroněk). Thanks to their personal ties with patrons, the Jesuits were able to take advantage of other orders' sites, adapt to local conditions, and even adapt where they were only partially successful (Šroněk).

The Letter of Majesty on Religious Freedom was an attempt to settle the religious situation by legalizing all the religious denominations in the country. It was issued by Emperor Rudolf of Habsburg in 1609 under pressure from the Czech Estates, but it did not last long. Political and religious development in the Czech lands was heading toward open conflict and eventually resulted in a revolt of the Protestant Estates against Emperor Ferdinand II of Habsburg and his Catholic supporters. It began in 1618 and ended with the crushing defeat of the uprising at the Battle of White Mountain (Bílá Hora) on November 8, 1620. The Battle of White Mountain was an episodic skirmish from a military point of view, one of a multitude during the Thirty Years' War, but it opened the door to a radical political, social, cultural, and religious recatholization of the Czech lands that influenced local events for several centuries.

The goal of the Habsburg monarchs and the Catholic Church authorities became the elimination of non-Catholic denominations, the renewal of Christian faith in the country, and the restoration of Catholic Church institutions, including the disintegrated system of parish administration that remained in a dismal state long after the protracted war. The state had these goals in common with the Catholic Church, which enjoyed a significant rise in power and financial resources at the time as a result of the new situation. There was more or less covert competition between the state power and the church hierarchy for the dominant position in the country in which both sides often pursued their own, partly divergent, goals in the process of recatholization. At the same time, the state remained the main initiator of recatholization, creating the legal framework for it and using its power to put legislative measures into practice with the idea that a subject devoted to the Catholic faith would be equally loyal to his sovereign. In contrast, the task of the church was mainly to recatholicize the country on a religious level.

Based on a patent issued in 1621 by the royal governor, Prince Charles I of Liechtenstein (1569–1627), the Utraquist clergy were expelled from

Prague and other royal towns. A year later, the Lutheran clergy had to leave the country and the congregations of the Unity of the Brethren were closed. In the following years, further rulings outlawed non-Catholic denominations. The fundamental change in the political and religious situation in the country in the post-1620 period was confirmed by the Renewed Land Ordinance, a constitution instituted by Emperor Ferdinand II for Bohemia in 1627 and for Moravia the following year. The earlier system of estates was abolished and replaced by an absolutist government, with the Bohemian crown becoming subject to the hereditary right of the Habsburg family. The clergy, whose importance in state politics had been severely limited in the previous period, gained its first seat in the provincial assembly, thus assuring the high clergy of active participation in the political life of the country. The Catholic religion was declared the only permitted religion in Bohemia and Moravia. Free inhabitants—nobility and bourgeoisie—who did not want to follow the religion of their ruler had to leave the country and non-Catholic subjects were forced to convert to Catholicism. Further recatholization measures followed after the end of the Thirty Years' War.[13]

The Catholic Church in Bohemia and Moravia underwent a rather complex organizational transformation in the post-Hussite period (1420–1620). The parish network, established during the fourteenth century, had thinned out considerably during the Hussite period and most parishes in Bohemia came under the administration of the Utraquist Church. The University of Prague was also subject to the Utraquist Church; graduates often took teaching positions in municipal schools and municipal authorities of Utraquist towns. In the years following the Battle of White Mountain, the Catholic Church, which now held a religious monopoly, struggled with both a broken parish network and a shortage of clergy capable of pastoring the countryside. One of the significant developments that helped to improve the unfavorable situation in the field of clerical administration was the establishment of an archiepiscopal seminary for the education and training of priests in 1631. Later, the establishment of two new dioceses—Litoměřice (1655) and Hradec Králové (1664)—also contributed to greater efficiency of church administration in Bohemia.

In Moravia, the parish administration was less weakened. Bishop Charles II of Liechtenstein-Castelcorno (bishop 1664–1695) paid particular attention to improving it.[14] Important symbolic moments of the recatholization of the country were the transfer of the relics of St. Norbert, the founder of the Premonstratensian Order, from Magdeburg to Prague, where they were deposited in the Premonstratensian monastery church of St. Mary at Strahov in 1627.[15] Much more significant was the canonization in 1727 of the priest and archbishop's vicar John of Nepomuk, a martyr who died in 1393 allegedly for not revealing secrets of the confessional. He was accepted by

the already fully recatholized society as the next patron saint of the country; Jesuit missionaries spread his cult in the countries of Central and Southern Europe and even extended it overseas.[16]

The Jesuits were part of a wider stream of recatholization in the Bohemian Lands, in which religious orders played an important role. Their expansion materialized in the construction of monastery churches and complexes, which had a significant impact on the Czech landscape. First and foremost, this affected the traditional monastic institutions that had been active there since the Middle Ages, including the contemplative monastic orders of the Benedictines and Cistercians, mendicant orders such as the Dominicans and Franciscans, Minorites, Capuchins, and Augustinians, orders of religious canons, the most important of which were the Premonstratensians, and religious knights' orders, which included the original Bohemian Order of the Crusaders with the Red Star. Their monasteries, in many cases disrupted and damaged during the Hussite Wars and stagnating during the Reformation, gradually regained their lost landed property, which opened the way for them to regain economic and political power. Toward the end of the seventeenth century and later, they engaged in large-scale building and artistic activities.

Several orders were newly introduced to the Bohemian lands in connection with the recatholization and also made their presence known by constructing magnificent complexes. In addition to the Jesuits (in Prague 1556, Olomouc 1569, and Brno 1578),[17] these included, among others, the stricter orders of the Capuchins, the Brothers of Mercy, and the barefoot Augustinians and Carmelites, who had not been seen there since the Hussite Wars. By their example, they called for spiritual transformation toward individual repentance and inner conversion. In 1599, the first Capuchin house was founded in Hradčany. In 1605, the first convent of the Brothers of Mercy was established in Valtice in Moravia, and they were active in Bohemia from 1620. The Barefoot Augustinians founded their first Prague monastery in 1623, the Barefoot Carmelites a year later, the Barnabites settled in Prague at Hradčany in 1625, the Servites in 1626, and the Cyriacs in 1628. The Paulines came to Bohemia in 1626, the Piarists in 1631, the Ursulines in 1655, the Carmelites in 1656, the Theatines in 1666, and the Trinitarians at the beginning of the eighteenth century. During the seventeenth and eighteenth centuries, several dozen new monasteries were founded in various parts of the country. The religious orders made a significant contribution to the recatholization of the population through missionary work, the administration of parishes and places of pilgrimage, the education of the clergy and the population, and various other related spiritual, educational, and cultural activities. At the same time, thanks to their international organization, the individual orders and religious houses were often freed from the centralized control of the state and ecclesiastical authorities.

In the second half of the eighteenth century, the interest of the traditional supporters of the order—the monarch and the aristocracy—faded and the state reformist Enlightenment efforts began to affect Jesuit education. The order was abolished in 1773. In a global context, this was more for political than religious reasons, although the Habsburg monarchy felt the influence of the Enlightenment, which had gained ground under the reign of Emperor Joseph II. The other orders retained their importance until the last decades of the eighteenth century, when the development of many ecclesiastical institutions was severely restricted or completely halted during the Enlightenment absolutist regime of Joseph II.[18]

THE SOCIETY OF JESUS, THE BOHEMIAN REFORMATION, AND THE RELIGIOUS IMAGE

Recent publications have pointed to the key position of the image in Jesuit missionary culture, where the image functioned as a didactic aid to help the convert fix biblical and other narratives in his memory, as an object of mystical meditation, as a miraculous agent of divine will, and as a means of adorning the church as God's house.[19] Inherent in all Jesuit projects was an extraordinary desire for complex and multilayered visual communication based on an elaborate central concept of the image in order to address the widest possible—or, conversely, most clearly defined—range of recipients. The Jesuits did not work in isolation, but were in constant interaction with a wide variety of actors, often religious institutions, to find stimulus or participate in their undertakings, while at the same time being inspired themselves. Efforts to reach audiences as powerfully as possible led Jesuit thinkers to adopt and transform successful motifs or iconographic patterns and transfer them from one medium to another, again with the aim of reaching recipients from as broad and widely stratified social groups as possible. Local tradition was applied in a program to reach out, engage, and persuade, used with imported motifs, particularly the veneration of Jesuit religious saints, all in conjunction with the cult of the Virgin Mary. Since the basic tenets of the Jesuit mentality were belief in the universally valid principles of Christianity—Catholic, of course—and the notion of general laws universally valid in both the earthly and divine worlds, they could not and would not achieve anything in the Czech lands that were outside this framework, which formed the basis for all their missionary activities. Instead, they used local tradition and currently available artistic forces to make the image an instrument that appealed to the maximum extent possible to the local population of all groups, who viewed its activities and efforts with considerable disdain in the early decades of the Jesuit mission in the Czech lands. This effort, still visible in many pieces of

art and architectural structures in the Czech lands today, was very effective, at least for the period of time until the Jesuit order was banned in 1773.

In the Bohemian environment, the image in the Jesuit context did not become the subject of deeper theological reflection, but nevertheless great attention was paid to its content and use in religious practice. The more sophisticated forms of reception of images, such as meditation, were only rarely applied in a lay context but were part of Jesuit religious formation. Jesuit image culture focused on maximizing the potential of the dichotomy between didactic and miraculous intercessory images in church interiors, which can be seen as a continuation of medieval religious practice. The emphasis on the practical use of the image in the religious practice of the new Catholicism, however, had its own dimension in Bohemia, owing to the long existence of the Bohemian Reformation. Ostentatious reverence for images was openly promoted by the Catholic Church in Bohemia, as a result from the unique historical context of the Bohemian Reformation, which had made versatile use of images in practice even while conducting a nearly two-century-long debate about their legitimacy.

The debate about religious images, their legitimacy, and the way they should be used in religious practice has a long tradition in the church going back to the first millennium of its existence. In the Czech lands it has been a major topic of interdenominational polemics and an instrument of internal discipline for individual churches since the fifteenth century. At the same time, the image became a powerful tool of confessional representation for groups and individuals. Although Baroque Catholic historians wrote of the Hussites and their followers exclusively as iconoclasts, in fact the views of pre-Hussite Reformation thinkers and Hussite theologians on religious images were wide-ranging; there were radical rejecters and authors seeking to compromise on their use in church interiors and religious practice. The Hussite field troops during the Hussite wars (1420–1436) also made a clear "statement" on the issue of images with their attacks on church property, and they were—rightly—the main contributors to the Hussites' reputation as iconoclasts. In the practical religious life of the Utraquist Church in the second half of the fifteenth and throughout the sixteenth century, however, the use of religious imagery became commonplace. Sacred spaces became the place where altars, epitaphs, pulpits, and, well into the sixteenth century, richly illuminated manuscripts of hymnals of religious songs, often executed to high artistic standards, were created by the donations of the nobility and burghers.

A large group of texts on images was written in the early and then late sixteenth century in the environment of the Unity of the Brethren. They belonged to the radical strand of the Reformation, close to Calvinism and

its implacably critical rhetoric, which corresponded to their rejection of any use of images in religious practice. The Brethren based their argument on the Old Testament prohibition against images, arguing that the creation of images was an open path to idolatry, which was a profound affront to God. Despite radical verbal declarations against images by a number of Brethren theologians, however, overt acts of iconoclasm rarely occurred in the history of the Unity during the sixteenth century. Operating outside the law, apparently the Unity tried not to draw too much attention to itself.

Despite occasional iconophobia and verbal attacks, the Czech non-Catholic denominations, above all Utraquists, were tolerant of the use of images. This did not fit into the image that Tridentine theologians constructed for them, which the Jesuits tried to apply in Bohemia (and Germany) as part of their controversial theology. The Jesuits used Bellarmino's idea, created in Rome, that there is a clear dividing line between Protestants and Catholics in which the heretic is always an iconoclast. Bellarmino's thesis, however, that a non-Catholic, that is, a heretic, is automatically an iconoclast did not apply in the Czech lands. Since the Jesuits made the demonstrative use of images and other visual media an important tool in their educational and evangelizing activities, in Bohemia they had to look for a way to distinguish the Catholic use of the image and adapt it to the local conditions. They found a solution in exalted forms of the cult of miraculous images and relics, which was regarded as purely a Catholic practice. This situation lasted until the escalation of open conflict between Catholics and Protestants from the Majesty period (1609) and the Uprising of the Estates (1618–1620).

The Catholic Party's radicalization on the point of image use was not only due to developments in the Czech lands during the first two decades of the seventeenth century but also reflected the turn that took place in the Roman Church during and after the Council of Trent (1545–1563). The council's decree on religious images and relics was sharply defined against the Reformation critique of the Catholic Church's practice initiated by Martin Luther and developed further by many of his followers.[20]

The formulations of the decree *De invocatione, veneratione reliquiis Sanctorum et sacris imaginibus*, to which the XXVth Assembly was dedicated in December 1563, are quite general and in no way contain specific recommendations regarding the choice of themes or specific details of artworks. No new arguments justified the use of images in religious practice. The Tridentine Council, on the contrary, subscribes to the church's tradition and authorities, which formulated positive views on religious images in the first centuries of the church's existence and defended them at the time of their first great threat, Byzantine iconoclasm. The veneration of relics and holy images is thus based on an ancient tradition of the church, supported by the views of the holy Church Fathers and the authority of the councils.[21]

Images themselves are entitled to compulsory respect and veneration, which, however, is not based on the divine character or the power and strength of the images themselves because the veneration is not addressed directly to them, but to their prototypes, that is, to the divine persons depicted in the images. According to this interpretation, images are mediators for believers, mediators between the earthly and the heavenly world. Further, the council recommended that images which lead the uninformed faithful into error or are openly heretical should be removed from churches.

The views on images expressed at the Council of Trent were elaborated on by Catholic theologians such as the archbishop of Bologna, Gabriele Paleotti, in his 1582 work *Discorso intorno alle imagini sacre e profane*, published in Latin translation in Ingolstadt under the title *De imaginibus sacris et profanis*. Johannes Molanus also drew on the council's decrees in his writings *De historia SS Imaginum et Picturarum* (1571) and *De picturis et imaginibus* (1570 and 1574). Practical recommendations on sacred architecture were then given by the archbishop of Milan, St. Charles of Boromeo, in his work *Instructiones fabricae et supellectilis ecclesiasticae* (1577). In particular, Paleotti's idea that a painting should captivate the viewer and be comprehensible to him and at the same time evoke emotions that convince and direct him toward the true Christian, that is, Catholic, faith, resonates with the character of the visual language of Baroque art.

In the Archdiocese of Prague, the official declaration of the conclusions of the Council of Trent came relatively late, only at the so-called Synod of Prague in 1605. Its provisions include a chapter, *De sacris imaginibus*, that provides the first regulation on the use of images in the archdiocese. The introductory formulation was clearly based on Paleotti's views: images of saints—when "painted or sculpted in a proper and pious manner"—have an extraordinary potential on the plane of emotion, for they "wonderfully stir and inflame the souls of the faithful to Christian piety."[22] The regulation thus touches on the very ability of the painting to stimulate the imagination of the faithful, conditioned, of course, by the "correct" approach of the artist, and fully in line with Paleotti's idea that the task of paintings "is to persuade persons to piety and order them toward God." But this goal can only be achieved by an artist who is not only a good artist but someone whose disposition to create is shaped above all by his Christian mind and feelings.[23] The Tridentine theory of artistic creation was used to frame the Catholic religious practice in Bohemia.

The chapter on images in the text of the Synod, in line with the Tridentine decree, commanded that images "painted or carved in such a way as to contradict in any way the Holy Scriptures or the ritual of the Church or Christian piety" be removed and destroyed. The chapter further prohibits the creation of images that "may contain some erroneous dogma or provide an

opportunity for dangerous error, nor those [images] that would not conform to the Scriptures or to the rite or traditions of the Church [should be kept in churches]." In Bohemia, this was directed at some of the subjects of images in non-Catholic settings. As we know from written sources and surviving monuments, there were numerous images of John Hus,[24] venerated as a saint by the Utraquists. The enforceability of such a norm was, of course, very low in the pre-1620 era, when Catholics were only a minority in society, but it provided an instruction that was put to full use in the post-1620 era, when all non-Catholic denominations were banned. The wording of the resolutions of the Prague Synod gives no further guidelines on iconography and are so vague that, like the later patents of the governor, Charles I of Liechtenstein, they gave wide scope for interpretation and application in practice.

The situation changed radically during the short reign of Frederick V. of the Palatinate (1619–1220), who was elected king of Bohemia during the Estates' uprising. Frederick espoused Calvinism, which was closest to the Unity's radical views among the domestic non-Catholic churches, but still represented an insignificant minority of the population. At the same time, a number of aristocratic members of the Unity moved into the political limelight in Frederick's royal court. Shortly after Frederick was crowned king of Bohemia, events occurred that fundamentally changed the content and tone of writings on religious images in Bohemia. Between December 21 and 23, 1619, all pictures and sculpted works were removed from the St. Vitus Cathedral at Prague Castle, the main church of the country. This was initiated by Abraham Scultet, a Calvinist preacher at the court of King Frederick, supported in word and deed by members of the domestic aristocracy who held high positions at the court. Scultet delivered a solemn sermon after the completion of the "cleansing" of the church, basing his sermon on the text of Exodus (20: 4–6), that is, the second of the Ten Commandments, "Thou shalt not make unto thee graven images . . .," which he immediately published in book form, in both German and Czech translation.[25] Not surprisingly, this act met with a negative response from the Catholic side, who were shocked not only by the loss of the paintings but especially by the devastation of the relics housed in the church. There were even voices of rejection from the ranks of non-Catholics in the Czech lands, who were taken aback by the vigor with which the iconoclastic "reformation" of the first church of the kingdom was carried out. At the same time, there were fears that this would not end with the cathedral alone, but that similar iconoclastic purges would take place elsewhere. The iconoclasm was carried out—as the defenders of the church-cleansing emphasized particularly—on the orders of the ruler (which was unusual in the Czech lands). He, however, did not seek the complete destruction of the church furnishings, but only the removal of too-conspicuous objects of the Catholic cult.[26]

On the Catholic side, two authors, both members of the St. Vitus chapter and graduates of Prague Jesuit schools, Josef Makarius of Merfelice[27] and Kašpar Arsenius of Radbuza,[28] responded to the St. Vitus' iconoclasm. Makarius of Merfelice published his book *Rozmlouvání o kostelních obrazích* (Talking about church paintings) in Prague as early as 1621. He conceived the book as a dialogue between a son, father, and grandfather, in which the son defends Scultet, but the father and grandfather, both Catholics, gradually convince him. The son's arguments are based mainly on Scultet's 1619 sermon, *Krátká, avšak na mocném gruntu a základu Svatých Písem založená Správa o modlářských obrazích* (A Short but Powerful Report on Idolatrous Images), based the Holy Scriptures and on his claim that the worship of images is idolatry. The father and grandfather argue for an ancient tradition going back to the origins of Christianity, early images of Christ who himself gave his own likeness to King Abgar, and images of the Virgin Mary revealed to St. Luke. Images of divine persons are true, because they are parables of the divine essence, which the believer recognizes and worships through them.[29]

The second Prague Catholic print is the work of the dean of the Metropolitan Chapter of St. Vitus, Kašpar Arsenius of Radbuza, a graduate and holder of a doctorate from the Jesuit *Collegium Germanicum* in Rome, who, first in 1603 and again in 1629, published *Pobožné knížky o Blahoslavené Panně Marii* (Pious Books on the Blessed Virgin Mary).[30] The text of the second edition was considerably updated from the earlier, with the inclusion of a section advocating religious images instead of a chapter on the veneration of the Virgin Mary.[31] Arsenius describes the sacking of the cathedral as a crime that brought divine vengeance on its perpetrators; the capital punishments that were meted out to the leaders of the Estates' revolt and the perpetrators of the iconoclasm in St. Vitus's, and warns that "it has always been harmful to men, very dangerous, yes, deadly, to make war with God and the Saints, and to change ancient religion and to disturb and corrupt sacred things."[32]

It is evident from Merfelius's text in particular that its author was familiar with the arguments of Bellarmino's controversial theology, which he skillfully applied to the local situation and disseminated to a wide readership in a book written in Czech. It is clear that the iconoclastic sacking of the cathedral radicalized the Czech Catholic party in its attitude to the opponents of the images—Arsenius of Radbuza calls iconoclasm a capital crime punishable by the wrath of God and a death sentence by the secular court. This opinion endured for posterity in a rather simplified form of theological argumentation.

In addition to the theologians, political power and legal norms also came into play. In 1624, the imperial governor of Bohemia, Charles I of Liechtenstein, issued a patent, which, in the penultimate paragraph, ordered that works on city gates, facades, and inside houses that mocked or spoke

against the Catholic religion should be removed or replaced with more appropriate themes. We know that the Jesuit order targeted images of John Hus and other representatives of Hussitism and Utraquism. The governor's patent also recommended that defective works be replaced by paintings of "the Passion of God" or "other ancient devotional paintings." Here, "ancient" means untouched by Hussitism and the Reformation.[33] The aim of these instructions was *damnatio memoriae*[34]—to erase the memory of Hussitism and the Reformation.[35]

In the Bohemian Jesuit province, original texts dealing with religious images like the books of Paleotti and Molanus did not appear, probably because local authors did not feel the need to comment on the opinions of Italian authorities or even add anything to them. The only author who repeatedly commented on the subject of a painting was the Jesuit historian Bohuslav Balbín (1621–1668). In his writings he returned repeatedly to the topic of religious images devoted to the venerated Marian statues and paintings in Tuřany and Wartha and on Svatá Hora.[36] He devotes an extraordinary amount of detail to their history, emphasizing their antiquity and miraculous preservation in the hostile times of the Reformation (Horníčková elaborates on this). According to Balbín, these attributes are the basis for the reverence shown to them by contemporary worshippers, whose faith is furthermore strengthened by numerous miracles. In this concept, the image or statue becomes evidence of divine intervention in earthly affairs and at the same time, in the spirit of the Tridentine concept, acts as a mediator between the faithful and the world of heaven.

Balbín also authored didactic writings on humanistic education, Latin stylistics and grammar, and individual literary genres such as historical texts, poems, and oratory. He devoted himself to emblematics, and in the passages devoted to so-called poetic portraits he also included instructions for viewing works of art. Balbín writes how he "imagines with closed eyes the painted individuals and stores them in the womb of his memory for when he needs" a work that has captured his attention by attributes, gestures, or emotion.[37] This method is very close to the practice of imaginative meditation recommended by St. Ignatius in the *Spiritual Exercises*, where he repeatedly calls for the person contemplating Christ to imagine with inner vision the scene of the event, which will lead to the illumination of the heart and the imitation of Christ that makes the way to salvation possible.[38] For Balbín and other indigenous authors, then, the image is not a topic of theological reflection or debate about the mode of perception and its effect on the human mind. The image is always only a tool to serve one purpose, to engage, instruct, and confirm the Catholic Christian in the faith or to help the apostate to return to the true church. It is therefore a utilitarian instrument to aid the believer on the way to salvation.

Bohuslav Balbín's texts serve as an example of the shift from the pluralistic Reformation-era debate on images in churches, even from the Italian Tridentine concepts of the truthful image, toward the "practical" notion of the image as an earthly manifestation of the sacred that serves to confirm the universal truth of the Catholic faith. There was a wide range of attitudes toward religious images in the texts of Reformation authors from the fourteenth to the sixteenth century, but for the Catholic authors of the post-1620 period this plurality of opinion and argumentation ceased to exist. The polemical dialogue or exchange of views turned into a monologue full of the topoi of the Catholic side. Even the fact that non-Catholic churches in Bohemia (with the exception of the Unity of the Brethren congregation houses) were literally full of images ceased to have any weight. The non-Catholic became an iconoclast indiscriminately and in contradiction to reality, and Catholic authors, of course, had no need to question or dilute the image of the enemy thus cultivated.

NOTES

1. With contributions from Kateřina Horníčková and Martin Mádl.

2. Levy, *Propaganda*.

3. O'Malley et al., eds., *The Jesuits*; Bailey, *Between Renaissance and Baroque*; Bösel and Karner, *Jesuitenarchitektur in Italien (1540–1773), vol. 2, Die Baudenkmäler der mailändischen Ordensprovinz.*

4. Wittkower and Jafé, eds., *Baroque Art. The Jesuit Contribution*; Bailey, "Le style jésuite n'existe pas"; O'Malley et al., eds., 38–89; Oy-Mara and Remmert, eds., *Le monde est une peinture.*

5. Roberto Bellarmino's writing, for example, embodies such a concept. The title of his text *De Ascensione Mentis in Deum per Scalas Rerum Creatarum* [in Czech *Nebeský žebřík*] refers to his belief in the permeability of the earthly and the natural. It was published in Rome in 1615 and a Czech translation appeared in Prague as early as 1630.

6. The influence of the duke of Bavaria on the appearance of the Church of St. Michael has been analyzed recently by Leuschner, who interprets the decoration of the church facade as a pure secular representation of the commissioner. Leuschner, "Propagating St. Michael in Munich," 177–202.

7. The role of influential patrons and initiators from the Jesuit order and their supporters has been little studied in Czech art history, in contrast to the Cistercians or the Benedictines, where the initiatory role played by certain abbots such as V. Vejmluva from Žďár nad Sázavou and M. Finzgut from Kladruby was greatly respected in the literature. Kalista, *Česká barokní gotika a její žďárské ohnisko*, Kotrba, *Česká barokní gotika: dílo Jana Santiniho-Aichla.*

8. Baumstark, ed., *Rom in Bayern*; Ohlidal and Samersky, eds., *Jesuitische Frömmigskeitskultur*; Cemus and Cemus, eds., *Bohemia Jesuitica 1556–2006*, vol. 2;

Karner and Telesko, eds., *Die Jesuiten in Wien*; Kačic and Zavarský, *Aurora Musas nutrit. Die Jesuiten und die Kultur*; Galewski and Jezierska, eds., *Silesia Jesuitica. Kultura*; Jordánková and Maňas, eds., *Jezuité a Brno*.

9. Cemus and Cemus, eds., *Bohemia Jesuitica 1556–2006*.

10. Baumstark, ed., *Rom in Bayern*; Ohlidal and Samerski, eds., *Jesuitische Frömmigskeitskultur*; Cemus and Cemus, eds., *Bohemia Jesuitica 1556–2006*, vol. 2, Karner and Telesko, eds., *Die Jesuiten in Wien*; Kačić and Zavarský, eds., *Aurora Musas nutrit die Jesuiten*; Galewski and Jezierska, eds., *Silesia Jesuitica*; Jordánková and Maňas, eds., *Jezuité a Brno*.

11. On the religious situation in the Czech lands before 1620, see Winter, *Život církevní*; Hrubý, *Luterství a novoutrakvismus*, 31–44; Hrejsa, *Dějiny křesťanství*, vol. 5; Říčan, *Dějiny Jednoty bratrské*; Eberhard, "Ständepolitik und Konfession," 222–235; idem, *Konfessionsbildung und Stände in Böhmen 1478–1530*; Bahlcke and Strohmeyer, eds., *Konfessionalisierung in Ostmitteleuropa*; Macek, *Víra a zbožnost*; David, *Finding the Middle Way*; Vorel, *Velké dějiny*, vol. 7: (1526–1618), 149–156, 255–272, 285–302, 381–410, 436–445; Čornejová, Kaše, Mikulec, and Vlnas, *Velké dějiny*, vol. 8 (1618–1683), 9–114; Mikulec, ed., *Církev a společnost raného novověku*. From the point of view of art and visual culture produced by these denominations, Horníčková, and Šroněk, eds., *Umění české reformace (1380–1620)*, idem, eds., *From Hus to Luther*.

12. *Petrus Canisius SJ*, 544–552, quote on 548–549. "Clemente questo luogo ci ha piacuto, perche e nel centro della cita et piu comodo alla gioventu, et tiene luogi sofficienti per le schole et classi per stancie et camere noc una buona parte del horto. Et se potre noc poche spese restaurare tutto, et adaptare a una buona habilitatione per questo primo anno." See Sievernich SJ, "Die urbane Option," 173–192; Šroněk, "The Jesuits and their Urban Visual Presence"; Lucas, *Saint, Site and Sacred Strategy*; Lucas, *Landmarking. City, Church and Jesuit Urban Strategy*.

13. Jireček, *Obnovené právo a zřízení zemské dědičného*; Gindely, "Vznik obnoveného zřízení zemského," 1–9; Kadlec, *Přehled českých církevních dějin*, vol. 2, 73–97; Čornejová, "Pobělohorská rekatolizace," 14–34; Mikulec, *31. 7. 1627 – Rekatolizace šlechty v Čechách*; Čornejová, Kaše, Mikulec, and Vlnas, *Velké dějiny*, vol. 8: 1618–1683, 107–115, 288–327; Kůrka, Mikulec, Ondo-Grečenková, "Církve a stát," 72–77. In English and from a broader perspective see Louthan, *Converting Bohemia*.

14. Štědrý, "Počet far v době předhusitské," 10–30; idem, "Znovuzřízení katolické duchovní," 33–47; Čáňová, "Vývoj správy pražské arcidiecéze," 486–560; Zuber, *Osudy moravské církve v 18. století*, vol. 1; Vichra, "Pražský arcibiskupský seminář," 123–134; Maur, "Problémy farní organizace pobělohorských Čech," 163–176; Zuber, *Osudy moravské církve v 18. století*, vol. 2; Pumpr, *Beneficia, záduší a patronát*; Mikulec. Ondo-Grečenková, and Sterneck, "Církevní správa a náboženská praxe," 109–162; Jakubec, ed., *Karl von Lichtenstein-Castelcorno (1624–1695)*; Švácha, Potůčková, and Kroupa, eds., *Karl von Lichtenstein-Castelcorno (1624–1695)*, vol. 2.

15. Straka. *Přenešení ostatků sv. Norberta z Magdeburku*.

16. Baumstark, *Johannes von Nepomuk*.

17. Bílek, *Dějiny řádu Tovaryšstva Ježíšova*; Oliva, *Tovaryšstvo Ježíšovo*; Podlaha, "Dějiny kollejí jesuitských v Čechách"; Čornejová, "Tovaryšstvo Ježíšovo" (with further literature).

18. On the monastic orders in the Czech lands selectively, see Vlček, Sommer, and Foltýn, *Encyklopedie českých klášterů*; Čornejová, "Úloha církevních řádů"; Foltýn, ed., *Encyklopedie moravských a slezských klášterů*; Čornejová, Kaše, and Vlnas, *Velké dějiny*, 293–301; Čornejová, "Horlivost jejich v kázání slova Božího. . . ." 265–273; Mikulec, "Klášter a barokní společnost," in *Locus pietatis et vitae*, 281–300, Buben, *Encyklopedie řádů*, vol. 1–4.

19. Oy-Mara and Remmert, *Le Monde est une peinture*.

20. The literature on the influence of the Council of Trent on artistic culture is now very extensive, so I only mention the basic works: Mâle, *L'Art religieux après le Concile de Trente*; Jedin, "Entstehung und Tragweite des Trienter Dekrets über die Bildverehrung," 143–188, 404–429; Knipping, *De Iconographie van de Contra-Reformatie in de Nederlanden*, 2 vols; and idem, *Iconography of the Counter Reformation in the Nederlands*; Hecht, *Katholische Bildertheologie im Zeitalter von Gegenreformation und Barock*. In the Czech literature, no one has yet dealt with this topic in detail; it was briefly mentioned by Royt, *Obraz a kult*, 10–17.

21. This view, defended in polemics with the Byzantine iconoclasts at the Council of Nicaea, is based on the teaching of the defender of images, St. John of Damascus (700–749). Another passage of the decree that discusses the didactic role of images, through which people are educated and confirmed in the faith, echoes another of the Church Fathers, namely, St. Gregory, who formulated the opinion that images are the writing of the illiterate. Hecht, *Katholische Bildertheologie*, 263–74.

22. *Synodvs Archidioecesana Pragensis* (chapter: *De sacris imaginibus*), 26–28.

23. Paleotti, *Discourse on Sacred and Profane Images*, 111 and 60: "The other is that it is not enough just to be a good artist: since he is a Christian by name and profession, the images he makes will require of him not only artistic excellence but a Christian mind and Christian sentiments, this quality being inseparable from his person, and such that he is under obligation to demonstrate it wherever necessary."

24. Vacek, *Diecesní synoda pražská*, 25–45.

25. Scultet, *Kurtzer, aber schrifftmessiger Bericht von den Götzenbildern*.

26. Kramář, *Zpustošení chrámu svatého Víta v roce 1619*.

27. Podlaha, *Series praepositorum*, no. 757, 157–159.

28. Podlaha, *Series praepositorum*, no. 757, 152–154.

29. Makarius z Merfelic, *Rozmlouvání o kostelních obrazích*.

30. Arsenius z Radbuzy, *Pobožné knížky o Blahoslavené Panně Marii*.

31. Ryneš, *Paladium země České*.

32. Arsenius z Radbuzy, *Pobožná knížka o Blahoslavené Panně Marii*, unpag.

33. Patent against non-Catholics, 1624; Beckovský, *Poselkyně starých příběhův českých*, 402–403.

34. Louthan, *Converting Bohemia*.

35. On the beginnings of the Catholic Counter-Reformation in the field of visual culture in the Czech lands, see Šroněk, *De sacris imaginibus*.

36. Balbín, *Diva Turzanensis*; *Diwa Wartensis*; and *Diva Montis Sancti*.

37. Balbín, *Verisimilia hvmaniorvm disciplinarvm . . .,*109.
38. St. Ignatius of Loyola, *Spiritual Exercises*, First Week, First Exercise, paragraph 047.

BIBLIOGRAPHY

Primary Sources

Arsenius z Radbuzy, Kašpar. *O Blahoslawené Panně Marygi přečisté Rodičce Syna Božjho | a o Diwjch | kteřjž se děgj před gegjm Obrazem w Staré Boleslawi. Knižka nábožným Pautnijkům | y giným Křestianům welmi vžitečná . . . w nowě sepsaná.* Prague: Kašpar Kargesius, 1613.

Arsenius z Radbuzy, Kašpar. *Pobožná Knjžka O Blahoslawené Panně Marygi | a přečisté Rodičce Syna Božjho: a o Diwjch | kteřjž se děgj před gegjm Obrazem w staré Boleslawi: nábožným Pautnjkům | y giným Křestianům welmi vžitečná . . . w nowě sepsaná.* Prague: Pavel Sessius, 1629.

Balbín, Bohuslav. *Diva Montis Sancti: seu Origines & Miracula Magnae Dei Hominumque Matris Mariae, Quae In Sancto Monte Regni Bohemiae, ad Argentifodinas Przibramenses . . . in Statua sua mirubili, aditur, & colitur: V. Libris comprehensa. Adjecta sunt . . . alia digna lectu plurima, totaque illa vicina S. Monti Regio, tum etiam . . . Stirpis, Maloveciorum Equitum . . . origines separatim descriptae . . .* Pragae: Typis Vniversitatis Carolo-Ferdinandeae, in Collegio Soc: Jesu ad S. Clementem, per Georgium Czernoch, 1665.

Balbín, Bohuslav. *Diva Turzanensis: Sev Historia Originis & Miraculorum . . . Dei . . . Matris Mariae: Cujus . . . Statua, prope Brvnam . . . in rvbis inventa . . .* Olomutii: Typis Viti Henrici Etteli, 1658.

Balbín, Bohuslav. *Diwa Wartensis, seu Origines, et Miracvla Magnae Dei . . . Matris Mariae, quae a tot retro saeculis Wartae, in limitibus Silesiae . . . colitur, . . .* Pragae: Formis Caesareo-Academicis, 1655.

Balbín, Bohuslav. *Verisimilia hvmaniorvm disciplinarvm . . .* Augsburg [Avgvstae Vindelicor]: Paul Kuehtze, 1710.

Beckovský, Jan František. *Poselkyně starých příběhův českých, vol. 2: 1526–1715.* Edited by Antonín Rezek, vol. 2, 1608–1624. Prague: Nákladem Dědictví sv. Prokopa, 1879.

Bellarmino, Roberto. *Nebeský Řžebřjk / To gest: Wstupowánij Mysli Lidské od Země do Nebe k Bohu Stwořiteli / po Stupnijch rozdjlných wsselikého na Swětě Stwořenij. Od Roberta Belľarmjna . . . wystawen.* Prague: Jan Bilina mladší, 1630.

Ignatius of Loyola. *Spiritual Exercises. St. Ignatius of Loyola.* Translated by Louis J. Puhl S. J., based on 1951 edition, found at http://spex.ignatianspirituality.com/SpiritualExercises/Puhl.

Macarius z Merfelic, Josef. *Rozmlauwánj o Kostelnjch Obrazých Aneb: Správa a odpowěd Na prawém a starožitném gruntu a základu Pjsma Swatého založená Na rauhawé a hánliwé Kázánj, proti Obrazům Kostelnjm a starožitným Ceremonjm w Kostele Hradu Pražského Léta Páně 1619 . . .* Prague: Thobiáss Leopolt, 1621.

Paleotti, Gabriele. *Discourse on Sacred and Profane Images*. Introduction Paolo Prodi, translation William McCuaig. Los Angeles: Getty Research Institute, 2012.

Petrus Canisius SJ, Epistulae et acta I, (1541–1556). Edited by Otto Braunsberger. Freiburg im Breisgau: Herder, 1896.

Scultet, Abraham. *Krátká, avšak na mocném gruntu a základu Svatých Písem založená Správa o modlářských obrazích. Učiněna shromáždění křesťanskému v kostele slavném Hradu Pražského, toho času, když z milostivého jeho Milosti Královské poručení kostel slavný zámecký ode všech modl a modlářství vyčišťován byl v neděli čtvrtou adventní, to jest 22. 12. dne prosince Léta Páně 1619 od Abrahama Sculteta*. Prague: Daniel Karolides z Karlsberka, 1620.

Scultet, Abraham. *Kurtzer, aber schrifftmessiger Bericht von den Götzenbildern, an die Christliche Gemein zu Prag, als aus Königlicher Majestät gnädigstem Befehlich die Schlosskirch von allem Götzenwerck gesäubert worden gethan, Sontags den 12. (22.) Decembris des 1619 Jahrs. Durch Abrahamum Scultetum . . .* Prague: Daniel Karolides z Karlsberka, 1620.

Synodvs Archidioecesana Pragensis, Habita ab Illvstriss. Et Reverendiss. Domino, D. Sbigneo Berka, Dei & Apostolicae Sedis Gratia Archi-Episcopo Pragen. & Principe, Legato Nato, &c. Anno a Chr. Natiu. M. D. C. V. In Festo S. Wenceslai Principis Martyris, ac Patroni Synodus Archi-Diocesana Pragensis. Prague: Jiří Černý z Černého Mostu, 1605.

Secondary Sources

Bahlcke, Joachim, and Arno Strohmeyer, eds. *Konfessionalisierung in Ostmitteleuropa. Wirkung des religiösen Wandels im 16. und 17. Jahrhundert in Staat, Gesellschaft und Kultur*. Stuttgart: Steiner, 1999.

Bailey, Gauvin A. *Between Renaissance and Baroque, Jesuit art in Rome 1565–1610*. Toronto: University of Toronto Press, 2003.

Bailey, Gauvin A. "'Le style jésuite n'existe pas': Jesuit Corporate Culture and the Visual Arts." In *The Jesuits, Cultures, Sciences, and their Arts 1540–1773*, edited by John W. O'Malley et al., 38–89. Toronto: University of Toronto Press, 1999.

Bartlová, Milena, and Michal Šroněk, eds. *Public Communication in European Reformation*. Prague: Artefactum 2007.

Baumstark, Reinhold. *Johannes von Nepomuk (1393–1993)*. Munich: Bayerisches Nationalmuseum, 1993.

Baumstark, Reinhold, ed. *Rom in Bayern. Kunst und Spiritualität der ersten Jesuiten*. Munich: Hirmer, 1997.

Bílek, Tomáš V. *Dějiny řádu Tovaryšstva Ježíšova a působení jeho vůbec a v zemích království Českého zvláště*. Prague: Dr. Frant. Bačkovský, 1896.

Bösel. Richard, and Herbert Karner. *Jesuitenarchitektur in Italien (1540–1773), Vol. 2, Die Baudenkmäler der mailändischen Ordensprovinz*. Vienna: Verlag der österreichischen Akademie der Wissenschaften, 2007.

Buben, Milan. *Encyklopedie řádů a kongregací v českých zemích*, 4 vols. Prague: Libri, 2002–2018.

Čáňová, Eliška. "Vývoj správy pražské arcidiecéze v době násilné rekatolizace Čech (1620–1671)." *Sborník archivních prací* 35 (1985): 486–560.

Cemus Petronilla, Cemus Richard, S. J., eds. *Bohemia Jesuitica 1556–2006*, vol. 2. Prague: Karolinum, 2010.

Čornejová, Ivana. "Horlivost jejich v kázání slova Božího . . ." *Theatrum historiae* 3 (2008): 265–273. [=thematic issue under the title *Církevní řády a rekatolizace*]

Čornejová, Ivana. "Pobělohorská rekatolizace v českých zemích. Pokus o zasazení fenoménu do středoveropských souvislostí." In *Úloha církevních řádů při pobělohorské rekatolizaci*, edited by Ivana Čornejová. *Sborník příspěvků z pracovního semináře konaného ve Vranově u Brna ve dnech 4.–5. 6. 2003)*. Prague: Univerzita Karlova: Ústav dějin Univerzity Karlovy – Archiv Univerzity Karlovy; Dolní Břežany: Scriptorium, 2003.

Čornejová, Ivana. *Tovaryšstvo Ježíšovo. Jezuité v Čechách*. Prague: Nakladatelství Mladá fronta, 1995.

Čornejová, Ivana, Jiří Kaše, Jiří Mikulec, and Vít Vlnas. *Velké dějiny zemí Koruny české, vol. 8, 1618–1683*. Prague: Litomyšl: Paseka, 2008.

David, Zdeněk V. *Finding the Middle Way. The Utraquists' Liberal Challenge to Rome and Luther*. Washington, DC: Woodrow Wilson Center Press, 2003.

Eberhard, Winfried. "Ständepolitik und Konfession." In *Bohemia sacra. Das Christentum in Böhmen 973–1973*, edited by Ferdinand Seibt, 222–235. Düsseldorf: Schwann, 1974.

Eberhard, Winfried. *Konfessionsbildung und Stände in Böhmen 1478–1530*. Munich: Oldenbourg, 1981.

Foltýn, Dušan, ed. *Encyklopedie moravských a slezských klášterů*. Prague: Libri, 2005.

Galewski, Dariusz, and Anna Jezierska, eds. *Silesia Jesuitica. Kultura i sztuka zakonu jezuitów na Śląsku i w hrabstwie kłodzkim 1580–1776. Materiały konferencji naukowej zorganizowanej przez Oddział Wrocławski Stowarzyszenia Historików Sztuki (Wrocław, 6.–8. 10. 2011) dedykowane pamięci Profesora Henryka Dziurli*. Wrocław: Instytut Historii Sztuki Uniwersytetu Warszawskiego, 2012.

Gindely, Antonín. "Vznik obnoveného zřízení zemského." *Právník* 33 (1894): 1–9.

Horníčková, Kateřina, and Michal Šroněk, eds. *Umění české reformace (1380–1620)*. Prague: Academia, 2010.

Horníčková, Kateřina, and Michal Šroněk, eds. *From Hus to Luther. Visual Culture in the Bohemian Reformation (1380–1620)*. Turnhout: Brepols 2016.

Hrejsa, Ferdinand. *Dějiny křesťanství v Československu*, vol. 5. Prague: Husova československá evangelická fakulta bohoslovecká, 1948.

Hrubý, František. "Luterství a novoutrakvismus v českých zemích v 16. a 17. století." *Český časopis historický* 45 (1939): 31–44.

Jakubec, Ondřej, (ed.), *Karl von Lichtenstein-Castelcorno (1624–1695). Bishop of Olomouc and Central European Prince*. Olomouc: Muzeum umění Olomouc, 2019.

Jireček, Hermenegild. *Obnovené právo a zřízení zemské dědičného království Českého*. Prague: Nákladem F. Tempského, 1888.

Jordánková, Hana, and Vladimír Maňas, eds. *Jezuité a Brno. Sociální a kulturní interakce koleje a města (1578–1773).* Brno: Statutární město Brno: Archiv města Brna, 2013.

Kačic, Ladislav and Svorad Zavarský, eds. *Aurora Musas nutrit. Die Jesuiten und die Kultur Mitteleuropas im 16.-18. Jahrhundert. Acta conventus.* Bratislava: Slavistický ústav Jána Stanislava SAV, 2007.

Kadlec, Jaroslav. *Přehled českých církevních dějin,* vol. 2. Rome: Křesťanská akademie, 1987.

Kalista, Zdeněk. *Česká barokní gotika a její žďárské ohnisko.* Brno: Blok, 1970.

Karner, Herbert, and Werner Telesko, eds. *Die Jesuiten in Wien. Zur Kunst- und Kulturgeschichte der österreichischen Ordensprovinz der "Gesellschaft Jesu" im 17. und 18. Jahrhundert.* Vienna: Verlag der österreichischen Akademie der Wissenschaften, 2003.

Kotrba, Viktor. *Česká barokní gotika: dílo Jana Santiniho-Aichla.* Praha: Academia 1976.

Kramář, Vincenc. *Zpustošení chrámu svatého Víta v roce 1619.* Prague: Artefactum, 1998.

Kůrka, Pavel, Jiří Mikulec, and Martina Ondo Grečenková. "Církve a stát." In *Církev a společnost raného novověku v Čechách a na Moravě,* edited by Jiří Mikulec, 53–107. Prague: Historický ústav, 2013.

Leuschner, Eckhard. "Propagating St. Michael in Munich: The New Jesuit Church and its Early Representations in the Light of International Visual Communications." In *Le monde est une peinture. Jesuitische Identität und die Rolle der Bilder,* edited by Elisabeth Oy-Marra und Volker R. Remmert, 177–202. Berlin: Akademie, 2011.

Levy, Evonne. *Propaganda and the Jesuit Baroque.* Berkeley: University of California Press, 2004.

Louthan, Howard. *Converting Bohemia: Force and Persuasion in the Catholic Reformation.* Cambridge: Cambridge University Press, 2011.

Lucas, Thomas M. *Saint, Site and Sacred Strategy. Ignatius, Rome and Jesuit Urbanism.* Rome: Biblioteca Apostolica Vaticana, 1990.

Macek, Josef. *Víra a zbožnost jagellonského věku.* Prague: Argo, 2001.

Maur, Eduard. "Problémy farní organizace pobělohorských Čech." In *Traditio et cultus. Miscellanea historica bohemica Miloslao Vlk archiepiscopo Pragensi,* edited by Zdeňka Hledíková, 163–176. Prague: Univerzita Karlova, 1993.

Mikulec, Jiří. "Klášter a barokní společnost. K vlivu řeholního prostředí na spiritualitu laiků." In: *Locus pietatis et vitae. Sborník příspěvků z konference konané v Hejnicích ve dnech 13.–15. září 2007,* edited by Ivana Čornejová, Hedvika Kuchařová, and Kateřina Valentová, 281–300. Prague: Univerzita Karlova v Praze: Scriptorium, 2008.

Mikulec, Jiří, ed., *Církev a společnost raného novověku v Čechách a na Moravě.* Prague: Historický ústav, 2013.

Mikulec, Jiří. *31. 7. 1627 – Rekatolizace šlechty v Čechách. Čí je to země, toho je i náboženství.* Prague: Havran, 2005.

Mikulec, Jiří, Martina Ondo Grečenková, and Tomáš Sterneck. "Církevní správa a náboženská praxe." In *Církev a společnost raného novověku v Čechách a na Moravě*, edited by Jiří Mikulec, 109–162. Prague: Historický ústav, 2013.

Ohlidal, Anna, and Stefan Samerski, eds. *Jesuitische Frömmigskeitskultur. Konfessionelle Interaktion in Ostmitteleuropa 1570–1700.* Stuttgart: Steiner, 2006.

Oliva, Václav. *Tovaryšstvo Ježíšovo. Několik kapitol z dějin církevních.* Brno: Dědictvím sv. Cyrilla a Metoděje, 1910.

O'Malley John W. et al., eds. *The Jesuits, Cultures, Sciences, and their Arts 1540–1773.* Toronto: University of Toronto Press, 1999.

Oy-Mara, Elisabeth, and Volker R. Remmert, eds. *Le monde est une peinture. Jesuitische Identität und die Rolle der Bilder.* Berlin: Akademie Verlag, 2011.

Podlaha, Antonín. *Dějiny kollejí jesuitských v Čechách a na Moravě od r. 1654 až do jejich zrušení.* Prague: nákladem vlastním, 1914.

Podlaha, Antonín. *Series praepositorum, decanorum, archidiaconorum aliorumque praelatorum et canonicorum S. metropolitanae ecclesiae Pragensis a primordiis usque ad praesentia tempora.* Prague: Sumptibus s. f. metropolitani capituli Pragensis, 1912.

Pumpr, Pavel. *Beneficia, záduší a patronát v barokních Čechách na příkladu třeboňského panství na přelomu 17. a 18. století.* Brno: Matice moravská, 2010.

Říčan, Rudolf. *Dějiny Jednoty bratrské.* Prague: Kalich, 1957.

Ryneš, Václav. *Paladium země České: Kapitola z českých dějin náboženských.* Prague: Universum, 1948.

Sievernich, Michael, S. J. "Die urbane Option sed Ignatius von Loyla am Beispiel der Metropole Prag." In *Bohemia Jesuitica 1556–2006*, vol. 1, edited by Petronilla Cemus in cooperation with Richard Cemus SJ, 173–192. Prague: Karolinum, 2010.

Šroněk, Michal. *De sacris imaginibus: patroni, malíři a obrazy předbělohorské Prahy.* Prague: Artefactum, 2013.

Šroněk, Michal. "The Jesuits and Their Urban Visual Presence in the Bohemian Lands." In *Faces of Community in Central European Towns: Images, Symbols, and Performances, 1400–1700*, edited by Kateřina Horníčková, 279–310. Lanham, MA: Lexington Books, 2018.

Šroněk, Michal. "Visual Culture and the Unity of Brethern: 'Do Not Make unto Yourself Graven Images . . .'." In *Public Communication in European Reformation*, edited by Milena Bartlová, and Michal Šroněk. Prague: Artefactum, 2007.

Štědrý, František. "Počet far v době předhusitské a po Bílé hoře." *Sborník historického kroužku* 21 (1920): 10–30.

Štědrý, František. "Znovuzřízení katolické duchovní správy po roce 1620." *Sborník historického kroužku* 25 (1925): 33–47.

Straka, Cyril. *Přenešení ostatků sv. Norberta z Magdeburku na Strahov, (1626–1628).* Prague: Ladislav Kuncíř, 1927.

Švácha, Rostislav, Martina Potůčková, and Jiří Kroupa, eds. *Karel z Lichtensteinu-Castelcorna (1624–1695). Místa biskupovy paměti.* Olomouc: Muzeum umění Olomouc, 2019.

Švácha, Rostislav, Martina Potůčková, and Jiří Kroupa, eds. *Karl von Lichtenstein-Castelcorno (1624–1695). Places of the Bishop's Memory*. Olomouc: Muzeum umění Olomouc, 2019.

Vacek, František. "Diecesní synoda pražská z r. 1605." *Sborník historického kroužku* 5 (1896): 25–45.

Vichra, Jan. "Pražský arcibiskupský seminář a jeho studenti v 17.–18. století." *Documenta Pragensia* 11 (1993): 123–134.

Vlček, Pavel, Petr Sommer, and Dušan Foltýn. *Encyklopedie českých klášterů*. Prague: Libri, 1997.

Vorel, Petr. *Velké dějiny zemí Koruny české, vol. 7, 1526–1618*. Prague: Litomyšl: Paseka, 2005.

Winter, Zikmund. *Život církevní v Čechách. Kulturně-historický obraz z XV. a XVI. století*, vols. I–II. Prague: Česká akademie císaře Františka Josefa pro vědy, slovesnost a umění, 1895.

Wittkower, Rudolf and Jafé, Irma B. eds. *Baroque Art. The Jesuit Contribution*, New York: Fordham University Press, 1972.

Zuber, Rudolf. *Osudy moravské církve v 18. století*, vol. 1–2. Prague: Ústřední církevní nakladatelství; Olomouc: Matice cyrilometodějská, 1987 and 2003.

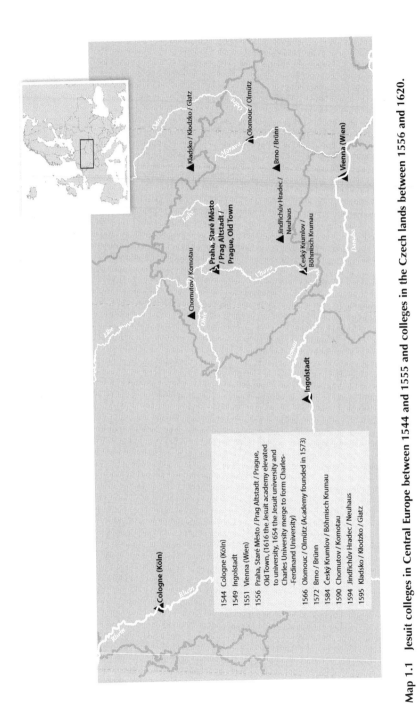

Map 1.1 Jesuit colleges in Central Europe between 1544 and 1555 and colleges in the Czech lands between 1556 and 1620.

1544 Cologne (Köln)
1549 Ingolstadt
1551 Vienna (Wien)
1556 Praha, Staré Město / Prag Altstadt / Prague,
Old Town, (1616 the Jesuit academy elevated
to university, 1654 the Jesuit university and
Charles University merge to form Charles-
-Ferdinand University)
1566 Olomouc / Olmütz (Academy founded in 1573)
1572 Brno / Brünn
1584 Český Krumlov / Böhmisch Krumau
1590 Chomutov / Komotau
1594 Jindřichův Hradec / Neuhaus
1595 Kladsko / Kłodzko / Glatz

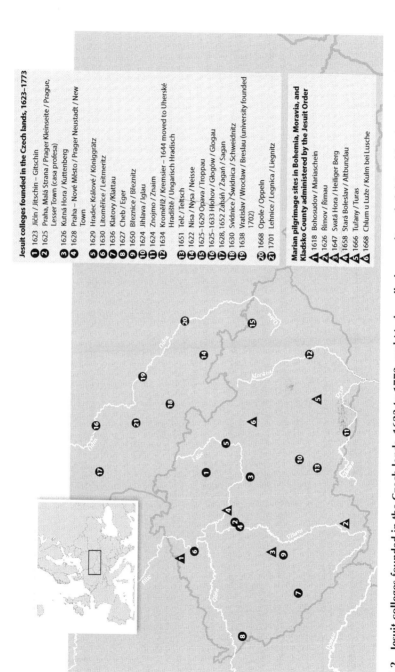

Jesuit colleges founded in the Czech lands, 1623–1773

1 1623 Jičín / Jitschin – Gitschin
2 1625 Praha, Malá Strana / Prager Kleinseite / Prague, Lesser Town (casa profesa)
3 1626 Kutná Hora / Kuttenberg
4 1628 Praha – Nové Město / Prager Neustadt / New Town
5 1629 Hradec Králové / Königgrätz
6 1630 Litoměřice / Leitmeritz
7 1636 Klatovy / Klattau
8 1627 Cheb / Eger
9 1650 Březnice / Březnitz
10 1624 Jihlava / Iglau
11 1624 Znojmo / Znaim
12 1634 Kroměříž / Kremsier – 1644 moved to Uherské Hradiště / Ungarisch Hradisch
13 1651 Telč / Teltsch
14 1622 Nisa / Nysa / Neisse
15 1625–1629 Opava / Troppau
16 1625–1633 Hłohov / Głogów / Glogau
17 1628, 1652 Zaháň / Żagań / Sagan
18 1630 Svídnice / Świdnica / Schweidnitz
19 1638 Vratislav / Wrocław / Breslau (university founded 1702)
20 1668 Opole / Oppeln
21 1701 Lehnice / Legnica / Liegnitz

Marian pilgrimage sites in Bohemia, Moravia, and Kladsko County administered by the Jesuit Order

1 1618 Bohosudov / Mariaschein
2 1626 Římov / Rimau
3 1647 Svatá Hora / Heiliger Berg
4 1658 Stará Boleslav / Altbunzlau
5 1666 Tuřany / Turas
6 1668 Chlum u Luže / Kulm bei Lusche

Map 1.2 Jesuit colleges founded in the Czech lands, 1623 to 1773, and Marian pilgrimage sites administered by the Jesuit Order.

Timeline

Michal Šroněk

1415—John Hus (b. circa 1370) condemned as a heretic by the Council of Constance and burnt on 6 July

1420–1434—Hussite Wars between the followers of John Hus against the armies of the King Sigismund of Luxembourg, several crusaders and the army of Czech Catholic league, then radicals against moderate Hussites

1434—The defeat of the radical Hussites at the Battle of Lipany, the victory of the moderate Hussite party opening the way to an agreement with the Roman Church, and the legalization of the property changes that took place during the Hussite Wars

1436—The Basel Compacts are promulgated, allowing members of the Utraquist Church to receive communion under both species

1454—The Unity of the Brethren church is formed

1491—Ignatius of Loyola is born (d. 1556)

1517—Martin Luther (1483–1546) promulgates the 95 Theses in Wittenberg; the European Reformation begins and Lutheranism spreads into Bohemia

1526—Ferdinand I of Habsburg (d. 1564) becomes king of Bohemia and the lands of the Bohemian Crown become part of the Habsburg Monarchy until 1918

1540—The Society of Jesus is founded

1545–1563—The Council of Trent meets

1551—The Jesuit college *Collegium Romanum* is founded in Rome

1555—Peter Canisius SJ arrives to Prague choosing a place for the future Jesuit college and refers to religious matters in Bohemia

1556—The first Jesuits arrive in Prague, founding the first Jesuit college, the Clementinum

1431–1561—The archbishop's seat in Prague is vacant (archbishop's sedisvacancy)

1561—Antonín Brus of Mohelnice becomes archbishop of Prague

1562—The Jesuit Academy established in Prague

1566—Bishop Wilhelm Prusinovský founds a Jesuit college in Olomouc

1575—Lutherans, some Utraquists, and the Unity of the Brethren unsuccessfully petition Maximilian II of Habsburg to recognize the so-called Czech Confession (an attempt to legalize non-Catholic churches that were operating in the Czech lands despite being banned)

1577—The first part of the Clementinum College is completed

1578—The Church of St. Savior is founded at Clementinum College

1583—Rudolf II's (1552–1612) imperial residence is transferred to Prague from Vienna

1584—Wilhelm of Rosenberg founds a Jesuit college in Český Krumlov

1589—Jiří Popel of Lobkowicz founds a Jesuit college in Chomutov

1598–1599—The Catholic party takes over important provincial offices: Zdeněk Vojtěch Popel of Lobkovice becomes Czech Chancellor, Jáchym Haugvic of Biskupice becomes Moravian Governor

1578, 1592, and 1594—Jesuit colleges are established in Brno, Kładsko, and Jindřichův Hradec

1605—The Prague Synod meets and issues *De sacris imaginibus* which declares that "images of saints usually wonderfully stimulate and inflame the souls of the faithful to Christian piety," hence their emotional value. The text was clearly targeted at images of non-Catholic origin

1609—Non-Catholic states force Rudolf II to issue a Majesty of Religious Freedom permitting the practice of all non-Catholic denominations

1611—Rudolf II attempts to reverse the situation: the so-called Passau army fails to conquer the Old Town of Prague, but occupies Lesser Town, Hradčany, and Prague Castle; the Franciscan monastery of Our Lady of the Snow is plundered and eleven friars die there

1611—Rudolf is forced to abdicate, his brother Matthias becomes king of Bohemia (d. 1619)

1616—The Jesuit academy is upgraded to a university

1617—Ferdinand II Habsburg is crowned king of Bohemia

May 23, 1618—Prague Defenestration: the rebellious Estates throw the imperial governors out of the windows of Prague Castle. The beginning of the Estates Revolt and the Thirty Years' War

June 1, 1618—The Society of Jesus is expelled from Bohemia

August 26, 1619—Frederick V of the Palatine (Calvinist) is elected king of Bohemia, crowned on November 4, 1619, in St. Vitus Cathedral at Prague Castle

December 21–23, 1619—Iconoclastic devastation of the furnishings of St. Vitus Cathedral

November 8, 1620—The Battle of White Mountain (Bílá Hora), the Catholic League army defeats the Estates, Frederick V of the Palatine escapes from the country, and the Society of Jesus returns

June 21, 1621—The Old Town Execution: twenty-seven leaders of the Estates Revolt are executed (three lords, seven knights, seventeen townsmen)

1622—The beginning of the Catholic Counter-Reformation: non-Catholic clergy are expelled from the country, celebrating the feast of John Hus is banned, and the canonizations of Ignatius of Loyola and Francis Xavier are celebrated in Prague and Olomouc

1622—The Society of Jesus attempts to take over Charles University; coming into conflict with Archbishop Ernst von Harrach, the chancellor of the university

1623—A separate Czech Jesuit province is established that includes Bohemia, Moravia, and Silesia

1624—The imperial governor of Bohemia, Charles I of Liechtenstein issues a patent, the penultimate paragraph of which orders the removal of non-Catholic monuments and works of art that contradict or mock the Catholic religion or their replacement with more appropriate subjects.

1627 in Bohemia and 1628 in Moravia—A new Land Code is published, the so-called Renewed Land Ordinance, which prohibits all non-Catholic denominations

1627—The relics of St. Norbert are transferred from Magdeburg to Prague

1634—Albrecht of Wallenstein, supreme commander of the Habsburg army, is murdered in Cheb (Eger)

1623–1685—New Jesuit colleges established: In Bohemia: Jičín 1623, Prague—Lesser Town 1625, Kutná Hora 1626, Prague—New Town 1628 as a professed house, Hradec Králové 1629, Litoměřice 1630, Klatovy 1630, Cheb (Eger) 1650, Březnice 1650, Moravia: Jihlava 1624, Znojmo 1624, Kroměříž 1636, 1644 transferred to Uherské Hradiště, Telč 1651, Silesia: Nisa 1622, Opava 1625, Żagań 1628, Świdnica 1630, Wrocław 1638, university founded here 1702, Opole 1673, Breg 1685, more than twenty residences also established, often at important pilgrimage sites.

1631 and 1640—Piarist schools are founded in Mikulov and Litomyšl

1648—The Swedish army occupies Prague Lesser Town, Hradčany, and Prague Castle; the Old and New Towns of Prague are besieged, and university students and professors join the defense of the city. The Peace of Westphalia is concluded between the Holy Roman Empire headed by Emperor Ferdinand III, other German princes, Spain, France represented by Louis XIV and Cardinal Jules Mazarin, the Republic of the United Provinces of the Netherlands, and Sweden

1652—A Marian Column by Johann G. Bendl is consecrated in Prague's Old Town Square to commemorate the end of the Thirty Years' War and as a symbol of the victory of the Catholic Counter-Reformation

1653–1724—The Clementinum is constructed—the largest Jesuit college in the Czech lands (architects Carlo Lurago, Domenico Orsi and František Maxmilián Kaňka, sculptors Johann Georg Bendl and Mathias Bernard Braun, and painters Johann Hiebel and Wenceslas Lorenz Reiner participate in the decoration)

1654—On the initiative of Ferdinand III of Habsburg, the conditions at the University of Prague are modified: the university is united under the name Charles-Ferdinand University; the Faculty of Philosophy and the Faculty of Theology are administered by the Jesuit Order; students must swear an oath to the Immaculate Conception of the Virgin Mary

1659—Bedřich Bridel authors the poem "What God? Man?", a masterpiece of Czech Baroque poetry

1664—General of the Society of Jesus announces that members of the order from the countries of the Habsburg Monarchy may serve as missionaries in the Spanish colonies

1673–1751—A Jesuit professed house and the Church of St. Nicholas are constructed in Prague's Lesser Town; they are among the most architecturally impressive buildings of the Czech Baroque (the architects are Christoph and Kilian Ignaz Dientzenhofer)

1675—Matthias Tanner SJ, historian, professor at the University of Prague and religious dignitary, publishes a book on the prominent members of the Jesuit Order active throughout the world, *Societas Jesu usque ad sanguinis et vitæ profusionem militans, in Europa, Africa, Asia, et America . . .* Prague 1675, with rich illustrations by the artist Karel Škréta

1680—Plague epidemic in Central Europe

1680—Bohuslav Balbín SJ, the most important Czech historian of the early modern period, begins publishing his main work, *Miscellanea historica regni Bohemiae*; ten volumes are published by the time of his death in 1688

1683—Ottoman Turks besiege Vienna

1683—A statue of Jan Nepomucký is erected on the Charles Bridge in Prague

1710–1711—Statues of the Jesuit saints Sts. Ignatius of Loyola, Francis Xavier, and Francis Borgia by Ferdinand Maximilian Brokoff are erected on the Charles Bridge in Prague

1729—St. John of Nepomuk is canonized

1740–1748—The War of Austrian Succession, Silesia and Kłodzko are lost to Prussia

1755—Prussia occupies Silesia; the local religious colleges, including the University of Wrocław, are separated from the Czech Jesuit province

1773—The Society of Jesus is dissolved. The Clementinum becomes the seat of the university and the public university library

1781—Joseph II issues the Patent of Toleration, abolishing the monopoly of the Catholic Church, allowing Lutheranism, Calvinism, and Orthodoxy

Chapter 1

The Church that Žižka Destroyed

The First Jesuit Churches in the Czech Lands

Ondřej Jakubec

"These early Jesuit activities do not constitute a major achievement in architecture."[1] This is how Dobroslav Líbal, a prominent Czech architectural historian, evaluated the early adaptation of the first Jesuit church of St. Clement (later the St. Savior) in Prague's Old Town, begun in 1578. Líbal's statement is consistent with the traditional perspective of formalist art history, focusing on morphological aspects, architectural typology, and the evolution of styles. The same approach is evident in Líbal's evaluation, this time positive, of the so-called Italian Chapel built nineteen years later for the Italian religious congregation associated with the St. Clement Church [figure 1.1]. Here, contrary to his first judgment, Líbal describes the chapel with admiration as "a work erected in the Prague milieu without even a touch of stylistic delay."[2] If we choose to perceive the history of architecture as a series of style innovations, the two judgments epitomize the formal diversity of the first Czech Jesuit commissions, but taking such a perspective means that some significant aspects of Jesuit church construction will go unnoticed. The Jesuits were not "competing" for architectural or stylistic primacy, but aiming to establish themselves in their new locations in a solid and simultaneously impressive manner. At the same time, their efforts were shaped by specific local conditions, finances, and the availability and creativity of their architects and their patrons' intentions.

While numerous factors limited the Jesuits' construction activities and sometimes even forced them into a passive position, one condition uncompromisingly defined their strategy for their churches' appearance and location. This strategy involved a number of functions and activities that made Jesuit churches active "players" in local social and religious interaction. For Jesuits, settling in the Czech lands before 1620 meant operating in a denominationally mixed and often outright hostile environment in which

1

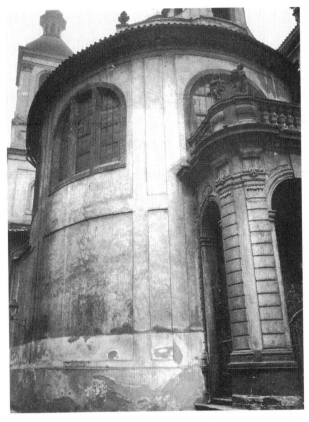

Figure 1.1 Italian Chapel (Assumption of the Virgin Mary), Prague, Old Town, 1590.

their buildings and activities were designed and resonated in a specific manner entirely different from the Catholic hegemony that followed the Battle of White Mountain (1620). Here I analyze the first Jesuit churches in the Czech lands built before 1600 in Prague, Olomouc, Brno, Jindřichův Hradec, Český Krumlov, Chomutov, and Kłodzko, focusing on Jesuit architectural interventions in the urban environment.

Jesuit church architecture has been the subject of many studies, which over the past few decades have correctly observed that, in the global context, Jesuit architectural output was extraordinarily diverse, oscillating between ostentatiously modern forms on the one hand and various adaptive strategies (e.g., the use of historicizing forms) on the other.[3] The final appearance of Jesuit churches and colleges was also a result of negotiations with local patrons—the buildings had to meet the requirements of patrons while also fulfilling instructions from the Jesuit headquarters in Rome, where the officials tended to focus on functionality rather than style. Although in the 1570s Jesuits

strove to find an ideal or typologically standardized church, they soon abandoned the effort.[4] Specifications of the church *al modo che usa la Compania* (Diego Laínez, 1562) mostly concerned the function of an "urban church" as a space where Jesuits could effectively reach out to worshippers through liturgy, sermons, and other religious and social activities.[5] Although various Jesuit authorities, such as the purist-inclined General Giovanni Paolo Oliva,[6] demonstrated their interest and aesthetic preferences, this never led to the prescription of actual norms for Jesuit architecture. The message that General Claudio Aquaviva (1543–1615) sent to his fellow Jesuits in Verona characterizes Jesuit building practices: "Explain to the most reverend fathers that it is not necessary that our churches all be done using the same model; according to convenience and circumstances that arise, things can be done in one manner or another, whatever turns out best."[7] The main requirement was that a newly founded complex contains everything necessary for its educational, social, and economic functioning (school buildings, auditorium, theater, seminary, as well as stables, administrator's rooms, breweries, and so on). It was precisely this "functional architecture" and its economical construction that best met the order's internal and external needs in any given place.[8] A similar approach can be found in *Disputationes* by Cardinal Roberto Bellarmino, who discussed the appearance of sacred buildings without defining their artistic or stylistic character. Rather, Bellarmino emphasized that their character must correspond with the church's status as a space for both public liturgy and sermons and private prayer and meditation. In all its aspects, the church space was meant to participate in shaping righteous (Catholic) Christians.[9] Similar general guidance appears in Charles Borromeo's famous manual, *Instructiones fabricae et supellectilis ecclesiasticae* (1577), which, in addition to a number of practical instructions, demands that the church be made suitable for religious services so that nothing disturbs its role as a sacred place.[10] It is precisely this perception of churches in their sacred functionality that is largely missed when looking through the prism of formalist art history.

Each Jesuit church necessarily presented a site-specific solution to the unique circumstances of its construction. In Central Europe, and particularly in the multi-denominational milieu of Bohemian and Moravian cities, Jesuit colleges created their own "denominational islands."[11] For this reason, it is useful to examine these structures from the perspective of social and religious activities that generated them and determined their interfaces.[12] These activities were not limited to urban space but extended outside of towns to their surroundings. Jesuits organized pilgrimages to local sites and managed pilgrimage sites such as Stará Voda near Olomouc, Svatá Hora at Příbram, Stará Boleslav, Tuřany, Bohosudov (Mariaschein), and Bardo (Wartha). Jesuit buildings were also associated with ritualized forms of religious behavior like processions, theatrical plays, and thus becoming denominationally

constitutive, demonstrative, and manipulative factors in both urban and village environments. To address these issues, the most recent research into Early Modern era architecture focuses on the context of social interactions associated with sacred buildings:[13] "the central issue is not space, but the behavior and the communal beliefs that spaces prompt or witness."[14]

THE FIRST JESUIT BUILDINGS IN THE CZECH LANDS AND THEIR PATRONS

The gradual arrival of Jesuits in the Czech lands over the course of the second half of the sixteenth century was facilitated by important figures in political and religious life. The Society of Jesus settled in Prague in 1556, when the Emperor and King of Bohemia Ferdinand I intervened after requests by the future Prague archbishop, Antonín Brus of Mohelnice, prominent representatives of the local church (e.g., the provost of the St. Vitus chapter), and important Catholic aristocrats. In 1566, Bishop Wilhelm Prusinovský of Víckov invited the Jesuits to Olomouc, the metropolis of the Moravian margraviate. Further Jesuit buildings were erected in residential centers of aristocratic domains. In 1566, Wilhelm of Rosenberg, the future Prague burgrave and highest representative of the aristocratic community, initiated negotiations with the Prague Jesuits about founding a new college in Třeboň. In 1572, the Jesuits settled in Brno, "the second Moravian capital," on the initiative of the chapter provost, Jan Grodecký of Brod, and his brother, Václav Grodecký, the future bishop of Olomouc. Other prominent Catholic aristocrats soon followed Wilhelm of Rosenberg's example and invited Jesuits to their domains; Jiří Popel of Lobkowicz, the High Steward (Hofmeister) of the Kingdom of Bohemia, helped Jesuits settle in Mariaschein and two years later founded a permanent Jesuit college in his residential town of Chomutov. Adam II of Hradec founded the Jesuit college in Jindřichův Hradec between 1594 and 1595.[15] The last Jesuit college before 1620 was established in Kłodzko (1597, renewed in 1624) with the support of prominent church authorities: Grand Prior of the Knights Hospitaller Mathew Theobald Popel of Lobkowicz (who held patronage over the local parish), and the highest members of the Habsburg dynasty such as Archduke Charles of Austria (archbishop of Wrocław from 1608 onward). All of these towns and cities had a common feature: they were important urban centers with significant or even dominant non-Catholic populations and the founders were hoping that the Jesuits would help them convert the local communities to Catholicism. This was in fact a typical situation for Jesuits, who often found themselves in environments that generated conflict and created plentiful opportunities to interact with believers.

When evaluating the character of Jesuit sacred architecture, these local conditions need to be taken into account. The above recapitulation shows that patrons' interests defined the circumstances around the founding of Jesuit colleges to a significant degree. In addition to an openly manifest politico-religious strategy (enhancement of the Catholic religion and spiritual care for their subjects), patrons often aimed to establish their personal or family necropolis (Olomouc, Český Krumlov, Chomutov, Jindřichův Hradec, Brno). These "diverse interests on the part of actors in the emerging Catholic reformation"[16] were already evident in the case of Il Gesù, the first Jesuit church in Rome. While the Jesuits envisioned a simple functional building, Cardinal Alessandro Farnese, who financed the construction, pushed for an opulent structure with a dome above his grave. In Central Europe, the Jesuit church in Munich was conceived by the Bavarian Duke Wilhelm V as a Wittelsbach necropolis. In other churches and colleges (e.g., the Jesuit college in Landsberg), Wilhelm V also intervened to restyle austere buildings into opulent structures with lavish adornments, reflecting his self-representation and Counter-Reformation ideas.[17]

Research into early Jesuit architecture in the Czech lands must take these circumstances into account while also reflecting the ongoing discussion about the general character of Czech Jesuit architecture and its local specifics. In many cases, the Jesuits were far from being determined initiators. On the contrary, they often had to accept and then decline aristocratic offers, a situation that caused considerable embarrassment.[18] When building their colleges, the Jesuits always balanced their own requirements with the ideas and expectations of their aristocratic supporters, who could exercise their wills strongly.[19] Jesuits were often forced to accept these interventions even when they did not suit their purposes, although in their written reflections they mostly expressed respect and gratitude. For example, the first report to Rome, from January 1591, written by Martin Bast, the rector of the Chomutov college, describes the founding ceremony: "after the sung holy service, the Magnificus Himself [Jiří Popel of Lobkowicz] laid the foundation stone with the founder's coat of arms and dedication engraved into it."[20] Aristocratic patrons, in contrast, treated the *patres* with little respect, as was the case with the bishop of Olomouc, Francis of Dietrichstein, whose relationship with the Brno Jesuits is discussed below. His intervention in the construction of the Capuchin monastery in his dynastic residence, the town of Mikulov, is an example of blatant domination. When the Capuchins opposed his intention to install a costly altarpiece in the church, he responded curtly: "the place is mine, the monastery is mine."[21] Dietrichstein's attitude toward the Jesuits was similar. Catholic patrons saw the Jesuits as a guarantee of the Counter-Reformation in their domains, but also expected them—quite pragmatically—to provide spiritual guidance to their subjects "for the protection and maintenance of

religion," as Jiří Popel of Lobkowicz stated.[22] From the time his activity in the Lobkowicz domain began, the Chomutov rector administered the patronage of thirty-nine parishes. This was fully in line with Georg Popel's plan for the Jesuits to convert his subjects from Lutheranism to Catholicism.[23] Popel expressed his intention clearly in the Jesuit college's founding document, emphasizing that he wanted to "provide adequate support for the Catholic religion, particularly in my dominion, unsettled in this disastrous time, especially when I observed, with immeasurable pain, the general state of our rightful religion ravaged by endless attacks of heretics."[24] This practice continued into the era after the Battle of White Mountain, when in some places, Jesuits administered the patronage of parishes and churches not only in their own primary locations but also in other domains (e.g., the Slavata and Lobkowicz domains) and territories administered by the royal chamber. In the pre-White-Mountain era, these expectations on the part of the Catholic nobility were based on the fact that the state of religious administration was far from optimal in these places. For example, Wilhelm of Rosenberg, the most powerful Czech aristocrat, strove to establish Jesuits in all the places in his domain where earlier monastic institutions had either perished or stagnated (e.g., the Augustinian canonries in T ebo and Borovany) and where Jesuits could effectively serve his politico-religious goals. Naturally, for the Jesuits, this subservient role was somewhat problematic.

The first group of Jesuits, headed by Peter Canisius, arrived in Prague in April 1556 and decided to settle in a highly exposed location at the Dominican Monastery of St. Clement.[25] This location, near the Charles Bridge, which provided communication between the Old and New Towns and the Lesser Town, was ideal for the Jesuits and their missionary activity, perfectly embodying Ignatius's *edificatione et frutto spirituale della città*.[26] The Jesuits soon drew the public's attention to their activities, offering not only education but also theater plays, Holy Sepulchre displays, Christmas creches, and processions. These events typically emphasized the primacy of the Catholic Church (e.g., *Comoedia de ecclesia eiusque in populos auctoritate*) or were related to a local tradition (a Czech-language play about St. Wenceslas).[27] Beginning in 1581, the Jesuits delivered sermons in Czech in the renewed church of St. Savior.[28] These public performances were meant to attract believers in a competitive, multi-denominational environment.

The early efforts included also the Jesuits' plan to renovate the dilapidated monastery and replace it with an impressive building that included a refurbished central church. The debates about the appearance of the future college were intense; a number of variations and changes attest to the pragmatic thinking of the Jesuits, who were primarily interested in the appearance and location of school buildings and well-lit interiors.[29] The remodeling of the old monastery was clearly perceived as important because, at the beginning of the

1560s, the royal architect, Boniface Wohlmut, took part in the planning and Giovanni Delfino, the papal nuncio, personally supervised the whole process.[30]

The first plans for the renovation of the Prague college church appeared after the mid-1570s. In 1578, the Jesuits, under the leadership of the architect Marco Fontana di Brusata (perhaps based on a project by the Jesuit auditor Nicholas Lanoy and the Rector Jan Campanus),[31] began to renovate the eastern part of the crumbling church of St. Clement. The first phase included the vaulted chancel with two chapels and a tower, as well as a transept with galleries for singers and the faithful. The next phase did not begin until 1600, when Emperor Rudolf II made a considerable financial contribution; his court architect, Giovanni Maria Filippi, later designed several adaptations in the church. Finished in 1601, the western part of the church, featuring a representative facade, doubled the existing interior space. Inspired by Italian architecture, the facade presented a new type of backdrop, monumental pilasters and a two-story gable flanked by volutes and three Mannerist portals added to the overall visual impressiveness. The papal nuncio consecrated the building in August 1602. The change in the titular dedication—the church was now dedicated to the St. Savior—was a symbolic reflection of the church's transformation from a ruin to the majestic center of the college, whose artistic and monumental form marked the Jesuits' presence in the city. By the beginning of the seventeenth century, the Prague Old Town college was a large compound with two churches, two chapels, and five courtyards, adding six towers to the city's panorama.

This Jesuit "prominence" was not always received positively, as is evident from chronicle records describing how non-Catholics attacked what they saw as a provocative institution and its operation. According to the Jesuits' complaints, they threw rocks at the college and church, threatening the worshippers praying inside while also disturbing the liturgy and prayers by shouting and talking loudly.[32] In the center of pre-1620 Prague, the Jesuit church was not only a space where Jesuit activities took place against the backdrop of the newly erected architecture, but it was also a space that generated conflict and controversy. Here, the sacred building became the site of religious competition and rivalry.

The Jesuits were clearly interested in visually attractive architecture; in 1631, the Clementinum *patres* criticized one of the designs for its insufficiently decorative (*indecora*) character [figure 1.2].[33] The Late Renaissance church facade, with its impressive marble portals, suggests that the Jesuits (and their patrons, who had their tombs in the church) wanted the church to look imposing; there is also a record of a costly high altar and other altar paintings by prominent Rudolfine artists. This is consistent with the Post-Tridentine requirement that sacred buildings have a dignified appearance and it also suited the donors' political strategies.[34]

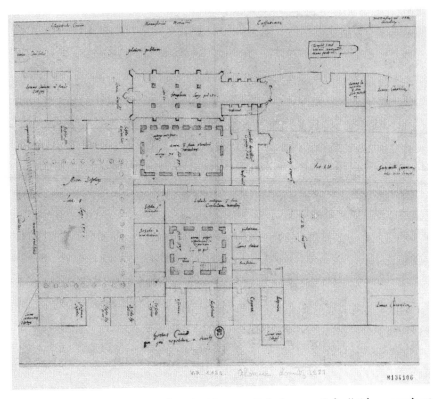

Figure 1.2 Plan of the Jesuit college in Olomouc (*Inferior pars Colegii Olomucensis ut iam est ab 1587*), pen and ink drawing on paper, last third of the 16th century.

Other attributes contributed to the majestic character of Prague's first Jesuit church, particularly the striking statue of Christ inside the church's gable (the space now houses a sculpture by Johann Georg Bendl). This statue had the same triumphalist connotations as the Jesuits' traditional "trademark," the IHS monogram, which was likely also featured on the original facade. The Savior-Pantocrator, with his victorious imperial gesture, may have been an allusion to the victory over the dark Hussite past of the monastery "destroyed by Žižka."[35] The facade's iconography may have followed similar principles as the Jesuit church of St. Michael in Munich, where analogical elements – the cross motif and the triumphant Archangel Michael – expressed the building's *repräsentatives Heiltum*.[36] This visual intensity and stylistic modernity were balanced by traditional elements such as the long tall chancel with a polygonal apse and the pointed arch window with Gothic tracery in the southern tower. Stylistic syncretism is also evident in the church's combination of the traditional basilica form with a pair of archaic towers adjoining the chancel and a modern, Rome-inspired, "false" dome above the crossing.

The second place where Jesuits settled as part of their mission in the Czech lands was Olomouc, the capital of the Moravian margraviate and the seat of the Moravian bishop. In 1558, Bishop Mark Kuen invited the Jesuit Jan de Victorius to Olomouc.[37] In 1565, Bishop Wilhelm Prusinovský of Víckov renewed negotiations with the Jesuits, aiming to establish a four-year college that would serve as a university. In the spring of 1566 (i.e., in the same year when the Jesuits unsuccessfully planned their college in South Bohemian Třeboň), the first Jesuits came to Olomouc from Vienna and began gradually to build the college, for which Prusinovský reserved a yearly endowment of 2000 guldens. In October 1569, following a period of temporary arrangements, the Jesuits finally settled in the site of the former Friars Minor friary from the thirteenth century.[38] The next Olomouc bishop, Stanislav Pavlovský of Pavlovice, continued to support the Jesuits; he raised the endowment and, in 1590, founded a seminary for poor students. In 1581, Pope Gregory XIII founded the so-called Collegium Nordicum in Olomouc as a training center for future clerics from Scandinavia and Eastern Europe. These interconnected institutions (college, seminary, and dormitory) were housed in a generously designed compound that continued to grow. As in Prague, the Olomouc college was situated in a high-traffic area in the city center near the main road. Similar to Prague's Clementinum, by the beginning of the eighteenth century the Olomouc college was the largest and most prominent structure in the city, but all the structures built at the turn of the seventeenth century gave way to newer buildings that still stand today.

The Jesuits started renovating the old Friars Minor monastery in 1567, soon after their arrival. They enjoyed great support from Bishop Wilhelm Prusinovský, who provided building material supplies and workmen, and also coordinated the entire construction. Remarkably, he personally supervised detailed technical procedures such as digging foundations, renovating vaults, and carpentry, consistently referring to the Jesuit college as "our building."[39] Bishop Pavlovský, too, regarded the college as his personal responsibility. When the college's privileges were not taken seriously, he reacted irritably: "we, as *protectoris fundatori*, are being ridiculed here."[40] This did not mean that the bishops would not respect the Jesuits' wishes; however, as evidenced by Prusinovský's instructions to the hetman: "first, you must talk to the rector and the Jesuits about how they want the vaults done."[41] But the bishop still kept his right to the final decision and he also determined the workmens' wages based on the quality of their work.[42] Prusinovský saw himself as the founder; in his letter to the Olomouc city council, he referred to the building as an embellishment of the city and the country: "we will have this building erected at our considerable and magnificent expense in honor of our country and our city . . . so you should be truly grateful to me."[43] In accordance with his role as founder, the bishop

was buried in the Jesuit church in front of the high altar with an elaborate sculptural tomb above his grave (this was also the case with Wilhelm of Rosenberg, who had a large tomb in the Jesuit-administered church of St. Vitus in Český Krumlov).[44]

Bishop Stanislav Pavlovský, another prominent Counter-Reformation figure, continued to support the construction of the Jesuit compound.[45] Appreciating the Jesuits for their service *ad religionem ortodoxam augendam et conservandam*, the bishop provided funding and materials for the construction. He also used his authority to gain further space for the college's expansion, taking a high hand against Olomouc's non-Catholic city council.

Construction work included not only new structures but also refurbishing earlier buildings. At the beginning of the 1590s, the architects (John the Spanish-Hispanus and Jerome the Italian from Venice) built a new school on the site of the former monastery; the college (completed in 1582) was erected south of the church. The earliest seminary building and dormitory were built in the 1580s and 1590. The earlier church of Corpus Christi adjoining the dormitory was heavily damaged during the short period of the Protestant administration in the 1620s, perhaps due to its titular dedication.[46] Both the college and school buildings, all with two storeys, were erected on a regular site layout around arcade courtyards. During Pavlovský's episcopate, the college church of Our Lady was also modified or rebuilt, afterward, it underwent numerous modifications and extensions until eventually the old church was torn down before 1720, giving way to the new church of Our Lady of the Snows. This new structure was situated perpendicularly to the original church and its monumental facade dominates the space of the adjoining piazetta. The new church also received the new titular dedication to Our Lady of the Snows, associated with the Roman basilica of St. Maria Maggiore and the miraculous (anti-plague) icon. The cult of this image, discussed in the study by M. Deutsch in this volume, began to develop here at about the same time as in Brno, that is, at the end of the sixteenth century.[47]

Between 1584 and 1591, Jesuits expanded the church's chancel and built a new high altar that featured a painting of the Virgin and sculptures of St. Peter and St. Paul. This iconography, characteristic of Jesuit spirituality, is similar to the iconographic programs in other Jesuit churches.[48] The patron, Bishop Pavlovský, had his coat of arms depicted on the ridge turret of the new chancel.[49] The new modified chancel maintained the Gothic character of the original building consistently with the traditionalist profile of sixteenth-century sacred architecture in Bohemia and Moravia. The college itself, however, was built in the "modern" style and the whole Late-Renaissance compound, with its refined architectural elements and adornments, must have made a spectacular impression. During his 1597 visit to Olomouc, the papal master of ceremonies, Giovanni Pietro Mucante, wrote enthusiastically about

the compound: "the church of the Jesuit Fathers is quite large and beautiful, and it has a splendid college."[50]

In Olomouc, too, the Jesuit college and church introduced a new element into urban society, creating a new place for Catholic self-identification and specific forms of socio-religious interaction [figure 1.3]. The Jesuits' presence in the town brought a wide spectrum of conflicts, from those tied to students' discipline through disputes over municipal land and house purchases all the way to open, denominationally motivated, attacks. The non-Catholic, predominantly Lutheran, city elite was well aware that the Jesuits offered

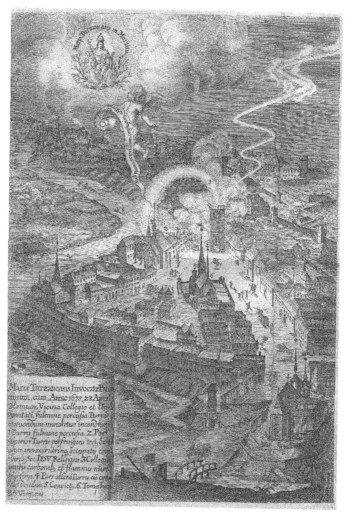

Figure 1.3 View of Olomouc (Předhradí) on the university thesis of Mathias Schmidt, copper engraving on paper, 1676.

a rival denominational model and that they were becoming active political players, for example, Olomouc bishops and the representatives of the college openly discussed the strategy of how to achieve a Catholic majority in the city council.[51] For this reason, the Lutheran city council tried every possible obstruction to prevent the Jesuits from expanding their college.[52] The Jesuits and their new forms of religious life created tension, but also raised interest. While Jesuit processions were still attacked with rocks, against which Bishop Prusinovský had to provide protection,[53] the Jesuits took control of some traditional local cults, such as the locally popular cult of St. Anne. The Olomouc confraternity of St. Anne had its altar in the Jesuit church and Jesuits organized pilgrimages to the nearby pilgrimage site in Stará Voda near Libavá (there were rooms for pilgrims on the college's second floor).[54] In 1623, the Jesuit, Nicholas Lancicius, transported relics of St. Pauline from the Roman catacombs to Olomouc, an event followed by a festive anti-plague procession, after which the saint immediately entered the pantheon of Olomouc's holy protectors. It was no coincidence that the procession, on October 8, 1623, started at the Jesuit church and continued to the city's main parish church of St. Maurice, thus connecting the two key sacred places in the city [figure 1.4]. At the same time, supported by the active role of the Jesuits and their college, this was an attempt to establish a Catholic foundation for the city's identity. Around 1600, this identity was still unstable and confrontational, confirming that, in Olomouc, the arrival of the Jesuits heightened the friction between the minority Catholic enclaves and the largely Protestant urban milieu.[55]

The Jesuit mission in Brno followed a course similar to that in Olomouc and later in other Czech and Moravian cities. Here, too, the Jesuits were entering a hostile environment, clashing with local Protestants, but also, at the beginning, with the sovereign and the Brno collegiate chapter, which refused to help finance the Jesuit foundation. This foundation was created in June 1572 on the initiative of the chapter's provost, Jan Grodecký of Brod, and a Brno canon named Václav, both active promoters of the Counter-Reformation. The Jesuits in Brno did not receive their own space until 1578, when they founded a lyceum on the site of the almost-abandoned convent of Dominican nuns. They first converted the original buildings to create temporary space and later erected an entirely new college building, using funds they received from the Catholic aristocratic elite. By the beginning of the seventeenth century they had also completed the new church of Assumption of the Virgin, today the only remnant of the original extensive compound, as the college was demolished in the nineteenth century.

The Jesuits dedicated their first years in Brno to making the necessary repairs to the old convent church, consecrated in 1582 by Olomouc Bishop Stanislav Pavlovský. It soon became evident, however, that the existing hall church did

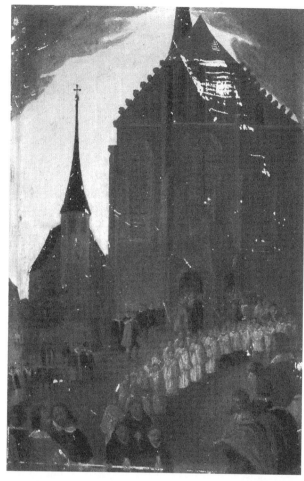

Figure 1.4 **The former Minorite church and the Church of Our Lady at Předhradí from the west in 1623. View of the procession with the relics of St. Pauline in 1623, oil on copper plate, original 1762–1782, copy 1901.**

not meet the needs of the expanding college (the Jesuits referred to it as the "small church" (*tempellum*) and the Jesuit provincial even said it was "a cave rather than a church").[56] The idea of rebuilding the church was also influenced by a significant financial gift from Helena Berková of Tovar and her brother, Ladislav Berka of Dubá, the highest chamberlain of the Moravian margraviate and later provincial hetman. After the death of her husband, Bernard of Tovar, in 1597 and his burial in the chapel of St. Ursula in the Brno Jesuit church, Helena decided to support the construction of a new church incorporating her husband's grave, which would become the necropolis of the whole Tovar

family. Helena of Tovar wished to be buried beside her husband; before the new church was built, she had the chapel enlarged and hung some pieces of her husband's armor in it, despite the Jesuit's protests.

The church's construction history is complicated as the plans changed several times, the whole process suggesting that the patrons intervened in the construction and the Jesuits had to meet their demands.[57] The foundation stone was laid in 1598 and the church was consecrated four years later. Before that, however, the Jesuits had an interesting design for the church's expansion drawn up by the architect Donato Tenedla. His three-naved hall church with a polygonal apse and net vault maintained the Gothic features characteristic of Renaissance ecclesiastic architecture in Bohemia and Moravia. In 1598, a new project was created and sent for approval to the Jesuit chief architect, Giovanni de Rosis, in Rome. Although Rosis had no objections to the design, the design still differed from today's church. Based on the design, the church, with an almost square floor plan, was meant to occupy the entire lot, taking the shape of a basilica with a nave and two aisles. The Jesuits placed great emphasis on confessionals—there were sixteen of them in the niches along the aisles. At this point, however, the patrons, particularly Ladislav Berka of Dubá, again entered the negotiations. Ladislav disagreed strongly with the placement of the tower near the chancel and, with the threat of withdrawing his financial aid, forced the Jesuits to move it in front of the western facade. This atypical facade tower may have been meant to compete with other towers such as those at the church of St. James and the city hall that were being rebuilt and expanded in this period.[58] This, however, was not the last modification to the design, despite the fact that the church's foundations had already been dug by the spring of 1599. Unspecified "esteemed and experienced citizens" and other Moravian "noble, wise and famous men" noticed that the church was too short and suggested that the chancel be extended toward the east. Ladislav Berka enabled the purchase of the area on the eastern side of the church and four houses, and in the spring of 1599, the Jesuit architect, Giovanni Brizio, authorized this new plan. Brizio, who had been working mainly in Poland since the 1570s, supervised the construction until 1602. With his help, the church received the form it still bears today. Because of continuing efforts to change the design, the provincial superior, Alfonso Carilla, prohibited further modifications in October 1600.[59]

The resulting building is a vaulted basilica space featuring a nave and two aisles and an elongated chancel the same width as the nave. Two one-storey structures on the side of the chancel served as a singers' loft and sacristy, above which there was a space for novices. This final design was the simplest solution, avoiding any architecturally complicated elements (side chapels, transept, dome), although these elements were otherwise quite common in Jesuit architecture of this period. The building appears to be the product of a compromise between the architects, patrons, and the funds available to

them. The church's communication with its surroundings was quite different from its present state. It was only open to the public space through its apse and the northern facade, while the entire western facade and the tower faced the courtyard with a block of school buildings that divided it from today's Jakubské Square. This was because the original church, whose position was a template for the new church, stood well back on the lot and because the school buildings separated the church from the street, an unusual situation for Jesuit urban planning. Researchers often point to the normative recommendations by Archbishop Charles Borromeo and others emphasizing a dignified and dominant position for churches in a city,[60] but circumstances in Brno caused these recommendations to be completely ignored.

Immediately before the consecration, the church underwent one more additional modification. After 1600, the chancel was converted to the family necropolis of the Olomouc bishop, Cardinal Francis of Dietrichstein. This prominent supporter of Jesuits notified the Brno Jesuits about his intention in 1600 when construction was still under way. The Jesuit general welcomed Dietrichstein's choice of necropolis as an honor for both the church and the order. The newly extended chancel was designated for the project as the most prestigious place in the church. The cardinal may have been inspired by one of his predecessors, Olomouc Bishop Wilhelm Prusinovský of Víckov, who was buried in front of the high altar in the Jesuit college church in Olomouc. The first members of the family, the cardinal's brother and Moravian Vice-Chamberlain Sigismund of Dietrichstein and his two sons were soon buried in the church. The cardinal envisaged the whole chancel and its decoration as a dignified place of rest for his dynasty.[61] In 1609, he had large windows installed, possibly featuring stained glass, which were praised by contemporaries for their "special grandeur."[62] Another costly Dietrichstein commission for the chancel – the choir pews, an unusual element in the Jesuit milieu – has been preserved to this day. These pews were adorned with cartouches carrying the Dietrichstein coat of arms. The Dietrichstein emblem can also be found on the large marble slab covering the funeral crypt. The inscription lists only three members of the family; the main text field was clearly reserved for the cardinal's dates, but he later changed his mind and started building a new sepulchre for himself in the new chancel of the Olomouc cathedral.

To this day, the college church interior contains interesting artwork that reflects the Jesuit patronage and illustrates elements of Catholic imagination, such as the emphasis on Marian worship and the ideological strategies of Bishop Francis of Dietrichstein, the church's co-founder. At the beginning of the seventeenth century, Dietrichstein, citing the Tridentine recommendations, declared the mandatory worship of *imagines Christi ac Deiparae semperque Virginis nec non aliorum sanctorum.*[63] The aisles feature a set of eight large paintings by Baldassare d'Anna depicting scenes from the life

of the Virgin Mary, purchased in Venice in 1603 by the Jesuits along with sixteen other paintings.[64] These distinctively Catholic visual forms were best expressed in the most important part of the church's furnishings—the copy of the icon of Our Lady of the Snows—originally placed in the Brno novitiate chapel, where it served primarily as an instrument for young Jesuits' spiritual edification and on special occasions was transferred to the high altar of the college church.[65] The Jesuits acquired the painting in the 1570 and treated it as their most important cult object in denominational identification.[66] Together with the second Marian image in Brno, a Byzantine icon in the Augustinian church, it also played the role of the city's palladium and was believed to have diverted the Swedish siege and plague epidemics.

The church also contained two altars commissioned by Ladislav Berka of Dubá, placed in prominent spots at the eastern face of the northern and southern aisles and dedicated to the Holy Cross and All Saints, respectively. In a typical Jesuit manner, the design oscillated between the order's universal and local perspectives. The first altarpiece depicted St. Ignatius's vision in the La Storta chapel and the second featured Moravian patron saints (St. Vitus, St. Ludmila, St. Wenceslas, Sts. Cyril and Methodius). Both altars were founded as ex votos by Ladislav's second wife, Eliška of Žerotín, who survived a difficult labor praying to Ignatius of Loyola, which was reflected in the altarpieces' predellas depicting the aristocratic couple. Belief in the miraculous power of the Holy Cross altar persisted well into the Baroque period, when believers affixed diverse ex-votos to it as an expression of expectation or thanks for recovery from illness.[67] These altars and the Dietrichstein and Tovar family mausolea illustrate the patrons' strong influence on the appearance and symbolic content of this Jesuit church.

Both the church and the college can thus be perceived on three different levels. At first sight, they were remarkable Mannerist structures built in the *all'italiana* style with high-quality decorative elements. At the same time, they served as centers of Jesuit religious practices that were embodied in liturgy, rituals of sodalities, demonstrative conversions, and worship of the Marian icon as the city's palladium. The church was also a space of self-representation for local aristocrats pursuing their own memorial agendas [figure 1.5].

As was typical for Bohemia at the time, the brothers Wilhelm and Peter Vok, the last male members of the important Rosenberg family, did not share the same denomination. While Peter Vok endorsed the Bohemian Brethren, Wilhelm was a Catholic whose systematic support of the Jesuits culminated in his establishment of a Jesuit college in his residential town of Český Krumlov.[68] Wilhelm first attempted to bring Jesuits to his dominion in 1566 (Třeboň), when he turned to the Prague Jesuits for help. This initiative was among the earliest in Bohemia, attesting to Wilhelm's plan to use the Jesuits

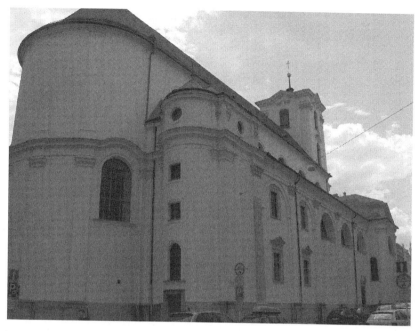

Figure 1.5 Former Jesuit Church of the Assumption of the Virgin Mary in Brno, designed by Jan Křtitel Erna, 1662–1668.

as guarantors of denominational stability in his domain. After 20 years, it became evident to the Jesuits that Český Krumlov, as Wilhelm's residence, was the most suitable place for a new Jesuit foundation. Wilhelm led personal negotiations with the Prague rector, Alexander Voit, and the first friars came to Český Krumlov in 1584. In 1586, the Jesuits began to build the college. Its simple and modest form, free of any distinctive architectural elements, was in line with the Jesuits' pragmatism that required mainly a "simple and healthy" building.[69] The design of the college, dedicated to the Virgin Mary, was created by the Rosenberg court architect Baldassare Maggi of Arogno (a town today in the canton of Ticino), suggesting that this was a project of primary importance for Wilhelm.[70] The choice of a location was also typical—an elevated spot above the river, dominant and busy, fully in keeping with the Jesuit ambition to become the center of the urban organism. This college did not have a new church, however, despite the fact that the Jesuits planned to erect it on the site of a house donated by Wilhelm of Rosenberg and even had a design ready. Instead, they used the nearby church of St. Vitus, which fell under their administration in 1591. This helped them begin their mission immediately among the urban population in Krumlov. They also added a chapel to the college, a structure as high as the building's second floor. In Krumlov, too, the patron decided to be buried in the Jesuit church. The Gothic

church of St. Vitus became Wilhelm's final resting place, although his family's traditional burial site was in the Cistercian monastery church in Vyšší Brod. Between 1593 and 1597, Wilhelm's tomb was built in the chancel as a spectacular combination of tomb and altar, topped by an alabaster sculpture of the family's emblematic figure, the "Rosenberg rider." This sepulchral monument, however, soon began to interfere with liturgical use and, beginning in 1621, the Jesuits gradually disassembled it.[71]

The college building was handed over to the Jesuits in 1588, an event celebrated with a spectacular feast, during which the archbishop of Prague, Antonín Brus of Mohelnice, held mass in the parish church of St. Vitus. Meanwhile, building work continued and the college was still under construction in the 1590s.[72] Supported by Wilhelm of Rosenberg, the Jesuits purchased more lots around the college, citing the need to create a quiet, solitary environment for their students. During Wilhelm's era, the Jesuits enjoyed numerous privileges; his death in 1592 and the ascension of the non-Catholic Peter Vok marked the beginning of religious conflict and disputes over property. The founding of a new Protestant school in particular led to conflicts and physical violence. By then, however, Jesuits and their activities had become an inseparable part of Český Krumlov's cultural life. Their school was active in denominational contestation as it offered strictly Catholic training.[73] In addition to the regular liturgy, the Jesuits organized other religious events that provided an opportunity for the town's inhabitants to participate in elaborate feasts, religious rites, and collective prayers. They offered frequent confession, organized processions during important feasts (especially Corpus Christi), and Jesuit students also prepared theater performances. Further activities included recatholization missions in both the town and neighboring domains. The church of St. Vitus became the clear epicenter of festive rituals and events, soon followed by the church of St. Judoc, formerly used by non-Catholics and acquired by the Jesuits in 1599. In both these places, the Jesuits reached out to the local residents through sermons, instrumental and vocal music, and the liturgy.

While Jesuits arriving in Český Krumlov found support in the Catholic milieu of an aristocratic residential town, in Chomutov they were confronted with a largely Lutheran population and the task of converting it to Catholicism. The Counter-Reformation was the central agenda of Jiří Popel of Lobkowicz, an aristocrat who assumed power over the domain in 1588.[74] In June 1591, two years after the Jesuits' arrival, Chomutov Lutheran burghers organized a rebellion, choosing the nascent Jesuit college as the target of their attack. They systematically damaged the building with the clear aim of rendering it impossible for the Jesuits to return.[75] George Popel gave a number of houses to the Jesuits, so they could build their base there. He also let them use the parish and the castle church, both of which became centers

of Jesuit Counter-Reformation activities. Donating these two churches was a symbolic gesture by Lobkowicz and a significant source of religious conflict in the town, no wonder that, according to the Jesuits' complaints, their services were not well-attended. Political developments kept the Jesuits from building their college church until 1663, despite the fact that Lobkowicz promised from the beginning to help them build their church as part of constructing the college, and later Bohuslav Balbín even suggested that Georg Popel take part in creating the design for the college.[76] In 1594, however, Lobkowicz suffered a major political defeat and his domain was confiscated by the emperor, after which the Lutheran municipal representation regained control of the parish church. The Jesuits then conducted their masses in the large college hall.[77] In 1613, they built a temporary chapel for the members of the college, suggesting that the college and seminary construction continued slowly but steadily even after its Jesuit protector had been politically incapacitated. By the beginning of the seventeenth century, the Jesuits owned an extensive two-storey compound featuring an elongated college building with an arcade courtyard and a bridge tower over the Chomutovka River.

Lobkowicz's donation of patronage rights to churches, his generous support of college building, and his open ambition to build a university in Chomutov gave the Jesuits control of the community's religious life and education, in line with Lobkowicz's fierce Counter-Reformation strategy and his unconcealed zero-tolerance policy against non-Catholics in his domain. In his 1592 report, the college rector, Martin Bast, explains Lobkowicz's motives as: "He had one wish as soon as he assumed power in this domain, namely, to immediately tear all his subjects from Satan's jaws and the grisly monster's delusion."[78] The Jesuits organized an array of activities—masses, sermons, and theater plays—while also supervising education and all rituals including funerals, which, in particular, were a source of conflict. This activity was aimed to indoctrinate and discipline local Lutherans and thus consolidate the situation to benefit the Catholic denomination. These religious policies certainly reflected Lobkowicz's own beliefs but were also part of his career strategy, that is, to ingratiate himself with the Habsburgs. In Chomutov, the Jesuits were once again faced with a strong-willed patron, serving as his allies in his uncompromising politico-religious attitude, but at the same time being used to further his personal ambition.[79] Following Lobkowicz's downfall and the subsequent confiscation of his property, the Chomutov burghers made sure to disgrace his memory, through mocking imitations of the Jesuits. Among other actions, they staged a satirical drama that parodied Jesuit theater plays.[80]

The Jesuits' activity, however, soon left its mark on the town's religious life—individuals converted to Catholicism and Jesuit sodalities were formed. An exclusive Latin congregation dedicated to the Assumption of the Virgin

was founded in 1602 as a branch of the Roman sodality of the Annunciation of the Virgin, whose members included the Prague archbishops. In addition, German burghers founded their own community, renewed in 1635 under the title "Purification of the Virgin."[81] These activities strengthened the Catholic position on the still-predominantly Lutheran territory, allowing burghers to form elite religious communities. As part of these communities, they could institutionalize their devotion, but also build social cohesion through collective mourning for deceased members and increase their social status by belonging to a prestigious group. They aimed to gain public attention by performing unusual religious practices such as the flagellant procession organized by the Jesuit sodality. The town's inhabitants were encouraged to participate in other forms of collective religious life organized by the Jesuits, such as processions to the nearby pilgrimage sites of Květnov and Mariaschein.[82]

In Jindřichův Hradec, too, the Jesuits entered a largely non-Catholic (Lutheran and Utraquist) environment, although the town was held by the Catholic lords of Hradec.[83] At the beginning of 1594, Adam II of Hradec, in this period serving as the supreme burgrave of Bohemia, and his wife, Catherine of Montfort, issued the founding document for the college, citing "the need to renew [Catholic] faith and lead the subjects back to salvation."[84] For the lords of Hradec, supporting the Jesuits was a family tradition; Adam's father, Joachim of Hradec, had been one of the aristocrats who first invited the Jesuits to Prague in 1554, and the local authorities' contact with Jesuits began in the 1560s. The Jesuits were given the space adjoining the parish church of the Assumption of the Virgin, the site of the former Teutonic Knights' monastery with the hospital church of St. Mary Magdalene. By the time the Jesuits arrived, this church was called *tempellum vetus* and the Jesuits themselves liked to refer to it as the oldest church in town.[85] Although rather shabby, this old church offered an opportunity for the Jesuits to build on local tradition and thus become part of the town's identity. The founding document formulates the college's intent thus: "and for this reason I am founding this institution for youth from Hradec and elsewhere, including the house or college and the Lord's temple with its adornments, schools, auditory, courtyards, gardens and a house for the poor." This entire compound was built in the town center on a large lot originally containing thirteen burgher houses, a hospital, a parish residence, and a parish courtyard. Here, the Jesuits created an extensive base, referred to in the founding document as "the island."[86] Perhaps as a safety measure in the non-Catholic environment, a high wall separated the college from the rest of the town. As in Český Krumlov, the college was connected with the town's main parish church, whose patronage rights were handed over to the Jesuits, by a covered corridor which provided comfort, isolation, and safety.

Catholic patrons supported the Jesuit foundation generously. After the foundation stone was laid on July 4, 1595, rapid construction of several college wings followed, assisted by Ticino master builders (Hans Mario Vlach, Beneš Vlach, Antonio da Salla, and others), although construction was halted following the death of Joachim Ulrich of Hradec (1604) and only resumed after a fire in 1615. This was mainly due to the new lord, Wilhelm Slavata, who decided in 1628 to build his mausoleum in the college church.[87] The college was finally completed at the end of the 1620s, resulting in the town's second largest compound (after the local chateau) in the form of an enclosed four-wing building with an arcade courtyard. The college's interiors, such as the refectory lavishly decorated with wall paintings (around 1630), displayed iconography (coats of arms of the college's founders, the cardinal virtues, the IHS monogram, and the Holy Spirit) that referred to the Jesuits' aristocratic patrons or the Jesuits themselves. In 1632, a Jesuit chronicler described the new college as an attractive spot in the town center "a work characterized by artistic moderation, it is tailored to contemporary taste, built primarily of hewn stone. Its charm invites passersby to visit and its diverse vaults please the visitors, welcoming them to stay." This "magnetism" was certainly an intention of the Jesuits and they soon enhanced it by creating a special entrance to the college church of St. Mary Magdalene in the south wall of the church's chancel, inviting local people to visit.[88] The church, renovated with considerable artistic effort between 1628 and 1632, was a remarkable combination of Late Renaissance and Early Baroque elements, but featured also Gothic details as reminders of the town's medieval tradition [figure 1.6].

As in other places, the Jesuits brought a fresh, dynamic, denominational element to Jindřichův Hradec. Catholic indoctrination was based on the successful open educational model that the Jesuits adopted. They also held patronage over religious congregations: in 1602, a student Catholic congregation of the Annunciation of the Virgin was founded as part of the college church. Further Jesuit activities included polemical anti-Protestant sermons in both Czech and German, delivered in the town's various churches, so the Catholic interpretation of the Scriptures fully dominated the town's sacred space. The Jesuits brought new elements to the liturgy conducted in these churches, such as confession, which became mandatory before Holy Communion, including Communion "under both kinds," to which the Czech non-Catholics were officially entitled until 1622. Pilgrimages and processions also played an important role in the public space: Jesuits organized the Corpus Christi processions as well as special processions leading to churches on the town's periphery. The broad spectrum of activities included public teaching, disputations, theater plays,[89] and spectacular shows such as flagellant processions of seminary students to the parish church. In 1637, Jesuits brought a significant addition to the town's religious life by acquiring

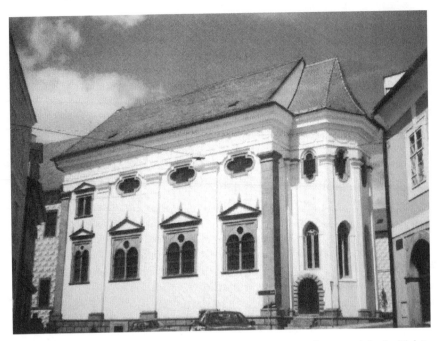

Figure 1.6 Former Jesuit Church of St. Mary Magdalene (14th century) in Jindřichův Hradec, 1628–1632, additions around 1670.

the relics of St. Hippolytus from the Austrian provincial general, Nicholas Lancicius. St. Hippolytus became the town's new patron saint—the arrival of his relics was celebrated with feasts, processions, and public displays in the church of St. Mary Magdalene.

In the period before the Battle of White Mountain, the self-confident Jesuits faced a number of conflicts with Jindřichův Hradec burghers. Particularly intensive collisions sparked after non-Catholics were barred from access to the local cemetery and banned from ringing bells during funerals. As a result, burghers attacked the college in 1610 and the Jesuits were forced to interrupt instruction for some time.[90] Verbal abuse and even physical assaults on Jesuits were a common occurrence in this period.[91] It is therefore not surprising that in June 1618, the Jesuits were expelled from the town as part of the Bohemian Estates' Uprising, but their immediate return in 1620 only confirmed their unshakable position in what was from then on a strictly Catholic town. In Jindřichův Hradec, the Jesuit presence became a key component of local Catholic tradition.[92]

The college in Kłodzko was the last Jesuit foundation in the period before the Battle of White Mountain. Here, too, most of the local population adhered to Protestantism. Between 1584 and 1595, Christopher Kirmeser, a local

luminary and the provost of the Kłodzko Augustinian monastery, strove to organize the Jesuits' settlement in the town. A disciple of German Jesuits, Kirmeser was a typical member of the new Catholic elite, who were deeply bothered by the dominance of "der Lutheraner, Kalviner und Schwenckfelder" in Kłodzko. For years, he attempted, unsuccessfully, to persuade the Prague archbishops to hand over his monastery to the Jesuits. It took complicated diplomatic negotiations and the support of high-profile members of the Catholic nobility, the Knights Hospitallers (the official spiritual patrons of Kłodzko), and members of the Habsburg dynasty to reach an agreement, but in 1595 Pope Clement VIII finally abolished the Augustinian monastery and gave it to the Jesuits. For a long time, the town's administration and non-Catholic estates obstructed the Jesuit adoption of the monastery and the tense situation was only resolved when the emperor intervened. The first three Jesuits came to Kłodzko from Prague in September 1597. A year later, they opened a lyceum as part of their temporary college in the monastery. In 1600, there were fourteen Jesuits in Kłodzko.[93] Their presence in the town was a source of conflict with the non-Catholic majority and, unsurprisingly, the Jesuits were expelled during the Estates' Uprising. Their property was confiscated and the church was closed down, sealed, and guarded. In his commentary on the presence of the Jesuits, the Protestant historian Pavel Stránský describes how "people from the new sect, the Society of Jesus, settled here. And ever since they set foot in these places, this land has not had a moment of relief from confusion."[94] During the estates' revolt, Kłodzko became a base of non-Catholic resistance, which was only broken when the city was conquered in 1622. This military operation, however, destroyed the existing Jesuit college in the former Augustinian monastery. When the Jesuits returned, they first stayed in the provincial estates' house, and later, thanks to the Wrocław bishop, Charles of Austria, they settled in the Knights Hospitallers' monastery with its parish church of the Assumption of the Virgin. In this way, the Jesuits gained control not only over the parish but also over the town's entire education sector. Owning the formerly Augustinian and Knights Hospitallers' property, they were among the wealthiest feudal lords in the country.[95]

Even before the Battle of White Mountain, the Jesuits' presence in Kłodzko was impossible to overlook. In 1601, they organized a showy Corpus Christi procession supported by prominent figures such as the county's future vice-governor, Archduke Charles of Austria, and the new Catholic Kłodzko hetman, Heinrich von Logau (who later become prior of the Knights Hospitaller in the Czech-Austrian province). The procession marched through the town with "flags and crosses, singing ancient songs." Jesuits often used historical references to local pre-Reformation tradition as is evident in their *annuae litterae*. They focused primarily on the tradition associated with the first archbishop of Prague, Ernest of Pardubice (d. 1364), who studied in Kłodzko as a young

man and later became a prominent patron. He founded the local Augustinian monastery and contributed to the new parish church of Assumption of the Virgin, built from the end of the fourteenth century onward. Tradition has it that, as a young boy, he had a vision of the Virgin Mary in this church and he was later buried there. Because of its Marian aspect, this legend was useful to the Jesuits, who gradually acquired both the monastery and the parish church, constantly reviling the Lutherans for "profaning" these sacred spaces. Non-Catholics held the parish church in the second half of the sixteenth century, when they moved Ernest's tomb away from the high altar; in this period, Catholics were only allowed to use the chapel of St. James.

The Jesuit chronicler Johannes Schmidl later saw as "the unfortunate consequences of the "Lutheran plague" afflicting this glorious parish church" and its sacred objects such as the cult statue of the Virgin commissioned by Archbishop Ernest of Pardubice. Schmidl particularly regretted that the Lutherans had "trampled the age-old Catholic cult" that had flourished there thanks to Ernest of Pardubice, whose memory was reportedly very much alive in the city and the whole region. Schmidl lamented that the Lutherans caused the death of the old and "true" liturgy, Marian rituals, and contaminated the church (*Templum Glac. Haeresi contaminatum*), and as a result, the famous Marian pilgrimage site in Wartha, dating to the thirteenth century, lost its popularity.[96] After 1624, the Jesuits systematically supported these cults, pilgrimages to Wartha and Albendorf, and the formation of religious congregations. In 1665, Bohuslav Balbín published his historico-devotional book about Our Lady of Wartha (*Diva Vartensis seu Origines et Miracula magnae Dei hominumque Matris Marie, quae a tot retro saeculis Wartae in limitibus Silesiae comitatusque Glacensis . . . colitur*), in which he recounted the history of this old cult site and its miracles. After 1624, the Jesuits adapted the Knights Hospitallers' monastery and, beginning in the mid-seventeenth century, built their own extensive college and dormitory in the town center near the parish church. They simultaneously "modernized" the parish church, adding new chapels, interior decoration (particularly stuccoes created after 1660), and furnishings, making sure that this new refurbishment accentuated the Gothic sculpture of the Virgin commissioned by Ernest of Pardubice. Later, in 1680, the Jesuits also helped erect a Marian plague column on the central square, inspired by the Prague Marian column of 1650, a visual expression of their dominance over Kłodzko's urban space.[97]

JESUIT ARCHITECTURE: STYLE, PLACE, AND PATRONS

Current research into Jesuit architecture[98] interprets it as a manifestation of specific circumstances driven by diverse actors—patrons, architects with

various talents—taking opportunities and adapting to local limitations, habits, and imported models, which collectively created a distinct tradition and supra-regional network of exchange, from where the inspirations were drawn and through which they were distributed.[99] "Jesuit style" therefore can be understood as a formally diverse approach and reaction to local conditions; as Evonne Levy puts it, "exceptions were the rule" in Jesuit architectural practice.[100] The early Jesuit foundations in the Czech lands discussed above fully reflect this diversity. The process of designing and searching for optimal forms and adornments was not entirely under the Jesuits' control; patrons' interventions and the need to adapt to local conditions did not allow for the development of a coordinated, unified Jesuit style. The chancel was renovated in the Olomouc church and the church in Brno was completed around the same time, but their architecture is quite different. In Olomouc, the resulting architecture reflects the traditional Gothic form, but the Brno church is eloquently Mannerist in style. Moreover, the architectural designs of the Brno church changed several times from the original Gothic form all the way to an entirely modern Late-Renaissance design. This stylistically ambivalent approach is evident in other places as well: Gothic-inspired churches were built in the Lower Rhineland, but elsewhere in Germany, Jesuit architecture showcased the "Roman style" (Munich, Landshut) and similar modern architecture appeared in Poland (Kalisz, Nieśwież, Cracow), Ukraine, and Lithuania (Lviv, Vilnius, Vitebsk).[101] North of the Alps, these often-Italian elements amalgamated with the local regional traditions, and in the seventeenth century, they produced idiosyncratic synthetic forms such as the university church in Vienna (1624–1631) that combined elements of Roman Late Renaissance with local traditions. The church of St. Michael in Munich is an even earlier example of this fusion style. One of the most impressive Jesuit buildings in Central Europe, this church represents the dispositional type referred to as *Wandpfeilerkirche* (wall pilar church), oscillating between Gothic, Renaissance, and Baroque styles. Highly creative visual forms can also be found in other Central European Jesuit complexes. These buildings played an important role in disseminating cultural influences from Italy to regions north of the Alps, where they helped constitute the specific character of Catholic architecture in the Early Modern Era.[102]

The Jesuit foundations in the Czech lands illustrate the complicated circumstances Jesuit patres faced when they arrived in a town or city. They usually acquired older monastic compounds, which they adapted and modernized even though they sometimes saw the older structures as only temporary solutions. For the Jesuits, finding a college and suitable school buildings were priorities, so their first activities upon arrival were aimed at these practical tasks.[103] The Jesuits were traditionalists in the sense that they adopted not only older buildings but also old cults and rituals that sometimes contributed to the adoption of historicizing architectural forms. The Jesuit church of St.

Mary Magdalen in Jindřichův Hradec is an excellent example of "ancient" forms coexisting with contemporary elements, a defining feature of stylistically diverse ecclesiastic architecture in early-seventeenth-century Central Europe.[104] By acquiring what was probably the oldest church in Jindřichův Hradec, the Jesuits appropriated local Catholic tradition, which helped legitimize their efforts. The church respects the original High-Gothic plan with a short chancel and polygonal apse and it even features pointed arches in chancel windows, although the side facades are otherwise Mannerist. This may have been for practical reasons or a conscious effort by the Jesuits to build on the local medieval Catholic tradition.[105] The fact that the Jesuits also maintained the exterior pointed windows in the nearby college chapel of St. Vitus (consecrated in 1642) suggests that the latter is the case.[106] This chapel's monumentalizing architecture combines a proto-Baroque, purist, central space with "Gothic" windows, pointing to the Jesuits' ambition to become part of the local historical identity.

The appropriation of local traditional forms in the liturgy, the cult of saints, the organization of congregations, pilgrimages, and Baroque religious culture in general, was a common Jesuit conversion strategy in Central Europe[107] and other confessions also used appropriation strategies as part of denominational polemics.[108] The traditional forms in Jesuit buildings were also a product of a complicated financial and existential situation that Jesuits faced in the early periods when they could not afford radical new buildings. Old churches (in Český Krumlov, Chomutov, Olomouc, and Kłodzko) presented sufficient space for the immediate needs of pastoral care and education. In these places, new buildings were not erected until the late seventeenth century (Chomutov, Prague) or even at the beginning of the eighteenth century (Olomouc).

The Jesuits and their patrons, however, still aimed to build visually impressive compounds and churches. The urban design of their Late Renaissance colleges bordered on "Baroque" sensibility and the sophistication of these compounds was based not only on adornment but also on the sheer size of these structures. In the sixteenth century, the Jesuits entered the urban arena with architectural ferocity that in many ways foreshadowed the Baroque appearance of these compounds today, as is evident in Prague's Clementinum college. The Olomouc *veduta* (panorama) from the end of the sixteenth century by J. Willenberg (published 1593)[109] shows that the first Jesuit college was as voluminous and dominant as today's building as early as the beginning of the eighteenth century. In Český Krumlov, too, historical panoramas depict the college as a palatial building, a counterpart of sorts to the castle compound standing across from it. Compact and monumental, these Jesuit structures were political and religious statements that corresponded with the equally ostentatious array of religious activities that Jesuits and their patrons undertook in Central European towns and cities.

Jesuit churches were designed with the same ambition. Although the Brno church was the only new Jesuit church in the early phase of the order's settlement in the Czech lands, the local Jesuits did not just passively accept the old structures. In most cases, they adapted these churches for their purposes even before the Battle of White Mountain (1620). In particular, Prague's Clementinum church was gradually rebuilt and expanded until it became practically a new building. From the beginning of the seventeenth century its facade dominated the church's surroundings, prefiguring its current Early Baroque appearance. The church in Jindřichův Hradec also received a visually attractive renovation. In Olomouc, a new and larger chancel was added to the older church and in Kłodzko the Jesuits modernized the church significantly soon after they acquired it. Rather than an abstract stylistic update, this "modernization" was the result of a complex and conscious strategy by both the Jesuits and their patrons. Through targeted modifications, adornments, and new furnishings, the Jesuits accentuated various devotional and cult-related aspects of the sacred space, while the patrons concentrated on their personal and dynastic memorials. These strategies are evident in the complex adornment of the Clementinum church in Prague and in the Venetian series of Marian paintings in the Brno church. Cult objects, such as the "Roman" Marian icon in Brno and the medieval sculpture associated with Ernest of Pardubice in Kłodzko, were also part of this strategy of "cultic renewal."

Patrons made themselves visible in Jesuit churches by donating furnishings and building opulent sepulchral monuments that turned these churches into impressive family mausolea (Wilhelm Prusinovský and others in Olomouc, the Dietrichsteins and Tovars in Brno, Wilhelm of Rosenberg in Český Krumlov, and Wilhelm Slavata in Jindřichův Hradec; in Kłodzko, the Jesuits' patrons had a funeral chapel in their church). In some cases, the patrons' activity significantly influenced the church's architecture. This was the case with Il Gesù in Rome and also with the church of St. Michael in Munich, whose patron, the Wittelsbach Duke Wilhelm V, envisioned a specific Jesuit *Hofkirche* featuring a monumental vault system.[110] In the Czech lands, the Brno church is an example of significant patron interventions. The result is a traditional basilica with an unusually long chancel (with a Dietrichstein mausoleum), which does not particularly reflect the Jesuit requirement of a large space for sermons consistent with the recent Catholic reform of liturgical space.[111] In other places, however, Jesuits strove to create a generous sacred space that could seat a large number of worshippers (Prague, Olomouc, the college church in Jindřichův Hradec). Jesuit architecture and churches in particular can be perceived as an "ideological matrix." It is clear that for both Jesuits and their patrons, function, monumentality, and impressiveness, together with expressive quality of architecture, were of primary importance and no further directives for sacred buildings were needed. These buildings

helped constitute the collective identity of the order in its local context, while also providing a framework for the religious practice that took place inside of them.[112]

JESUIT CHURCHES AS A SPACE FOR SOCIO-RELIGIOUS INTERACTION

After the mid-sixteenth century, an Olomouc protestant chronicler watched the arrival of Jesuits with quite understandable uneasiness: "they suddenly spread around all of the countries like weeds."[113] The Jesuit presence in Early Modern towns and cities was striking; colleges and churches contributed to this visibility as spaces where intensive religious activity took place. Jesuit spiritual life was far from confined within the college. In Czech, Moravian, and Silesian cities, split along denominational lines, they preached and educated, but also worked to convert the non-Catholic population using the church and its immediate surroundings for diverse religious, devotional, and social activities such as processions, disputations, and theater productions. Even without this animated backdrop, the church presented an environment where the sacred content was articulated through artistic and non-artistic means to captivate the visitor's senses.[114] Jesuit sources emphasize that their churches "come alive," particularly during masses, which became increasingly popular with ever-larger numbers of believers gathering for Holy Communion. For this reason, Jesuits made sure that the interiors were equipped with lavishly decorated furnishings, liturgical vessels, and vestments to enhance the sensory experience and add dignity to the religious rituals.[115] The chronicle of the Jesuit confraternity of the Assumption of the Virgin in Olomouc describes how the interplay of many elements (sermons, music, and singing, communal prayers, decoration of the church with paintings and wallpaper) resulted in *magna devotione*, the ultimate religious experience arising from a sacred space filled with believers.[116]

Jesuit colleges and their churches formed architectural and artistic entities that dominated inner urban spaces.[117] They also created an interesting social and religious environment that carried its own specific dynamics in the Early Modern Era. This pertains to sacred space in general.[118] Jesuits, members of the ecclesiastical elite, devout lay Catholics, and Italian communities resident in Prague and Brno formed an enclave of religious life that resonated with the Counter-Reformation interests of Jesuit patrons. Established as offshoots of this religious enclave, the various confraternities first brought together Jesuit students but were soon opened to members of the urban community—burghers and journeymen. Because the Jesuits' entire pedagogical and religious mission was based in Rome, these confraternities followed the

regulations of Roman Jesuit congregations. These religious groups contributed to social and religious cohesion among Catholics across the urban social strata. Their goals included indoctrination and religious education, and they allowed their lay members to participate actively in devotion as part of the specific congregation liturgy.[119] Life in these communities was not confined to a space behind the walls of a Jesuit church or college. Rather, it spilled over into urban public space in the form of religious festivities and members' funerals. This was further supported by other Jesuit activities that brought elements of post-Tridentine devotion to the Central European milieu. In addition to masses and sermons, these elements included dramas, nativity scenes, the Holy Sepulchre, and other alternative devotional activities such as processions and pilgrimages.[120] Jesuits' communication with worshippers followed basic principles described by literary historians studying the so-called *Erbauungsliteratur* (edification literature): a narrative message, well-argued persuasion, and meditative excitement.[121] Jesuit churches provided space for all these methods of interaction and engagement, which defined the sacred environment as much as architecture and style did. All of these elements were meant to "train the senses" as part of Jesuit educational strategies.[122]

In Brno, one example of sensual training was the feast held on the occasion of the laying of the foundation stone of the college church, during which Jesuits staged a play about Constantine the Great and the construction of Christian churches. In the era before the Battle of White Mountain, these religious events often faced animosity from the Protestant population, but Jesuits were able to turn even this to their advantage both religiously and socio-politically. Conversions of non-Catholics were also staged as ostentatious public performances. In the first decades of the seventeenth century, the Brno Jesuit church became the site of many such "festivities."[123] A feast took place on Sunday, September 22, 1602, when the Olomouc bishop, Cardinal Francis of Dietrichstein, consecrated the Brno church despite the fact that it was still unfinished. During this period, the Provincial Diet was held in Brno and the cardinal expected that the presence of provincial estates in the city would bring prominent guests to the celebration.[124] The feast included a large procession from Petrov and a student drama about the return of the ark of the covenant from the land of the Philistines and the destruction of Dagon's idol. This Old Testament story about the defeat of paganism was clearly an allusion to the triumph of the Catholic Church over Protestantism.[125] These activities, however, were not meant simply to provoke. Rather, they manifested the idea of the ultimate Catholic victory using elements of psychological manipulation. Olomouc bishops naturally welcomed these public activities—the first Jesuit theater productions were held in the Olomouc bishop's residence.[126] Popular activities also included Nativity theater plays and building a creche during the Christmas season. Such events targeting the broader public were

first organized in Prague in 1562.[127] In Olomouc, Wilhelm Prusinovský promoted the cult of the Holy Sepulchre during Easter in similar way by organizing a theater performance.

Processions, beginning or ending at Jesuit colleges and churches, were another important element that enlivened these buildings and their surroundings, often spectacularly.[128] They often became a source of conflict; for example, Olomouc bishops had to provide protection for them.[129] Jesuits also organized flagellant processions[130] and other ostentatious manifestations of religious asceticism such as public fasting.[131] Other collective rituals, reflected in the very structure of Jesuit churches, included the funerals of important figures and Jesuit supporters.[132] The promise of a spectacular funeral was one of the main motivations behind the aristocratic support for Jesuits in the Czech lands. Membership in congregations offered boasting social status and a collective religious experience and support, for both students and burghers.[133]

Public conversions of non-Catholics and Jews were another key part of the Jesuits' public activities.[134] They were the most visible achievements of the Jesuit mission and were often emphasized in periodic reports (sometimes the Jesuits complained about their lack of success; in 1590, the Chomutov Jesuits cite a mere eleven converts during the first year of their presence in the town).[135] In Brno, the first conversions are reported in 1584[136] and over time these events became more frequent and ostentatious. The years from 1600 to 1604 and 1616 to 1617 were the most successful in terms of the numbers of converts in Brno.[137] In Olomouc, too, the Jesuits' missionary activity complemented the Counter-Reformation politics of the Olomouc bishops.[138] In 1592, a Lutheran from Saxony, allegedly a student of Philip Melanchton, converted to Catholicism following lengthy training in the Olomouc Jesuit college. His conversion was a spectacular public festivity in the Jesuit church, during which the convert renounced the "Lutheran heresy" (*Demum in Templo nostro coram frequenti populo execratus Lutherum, mox ita se composuit, ut niteretur*) and then joined the others for Holy Communion under one kind *ad Sanctae Ecclesiae gremium.*[139]

All these religious and public activities defined Jesuit churches as extraordinary places in terms of both religion and sensory experience. A Jesuit chronicler in Brno saw the true meaning of the Jesuit church in its role as a place where miracles happened through the miraculous Marian icon producing energy that conquered "heretics and demonic powers."[140] This social animation of architecture was often contentious and Jesuits were well aware of the volatile nature of their mission. St. Ignatius's instructions for the Prague college contain the following recommendation: "do not try to contradict opposing sects . . . avoid arguments that could lead to turmoil. . . ." This advice, however, was often hard to follow.[141] At the beginning, Jesuit

openness went hand in hand with the order's tendency to close itself off so the students' instruction was not disturbed and the college could run without the public intervening.[142] For this reason, Jesuit compounds, such as those in Český Krumlov and Jindřichův Hradec, were often walled in and featured covered corridors. The situation in non-Catholic or multi-denomination towns ruled by Catholic lords (Jindřichův Hradec, Chomutov) showed that the Jesuits were not always ready to make compromises and that they could make full use of the lords' support to assume a privileged position in the urban environment.

NOSTER MODUS IN THE CZECH LANDS: FUNCTIONALITY AND HYBRIDITY AS CONFESSIONAL STRATEGY

When examining the Jesuit Late Renaissance churches in the Czech lands, it becomes evident that their builders worked with several stylistic modes in both an architectural and rhetorical sense. These structures are not much different from the majority of non-Catholic churches in the period before the Battle of White Mountain. Both Catholics and non-Catholics used the two main styles of the period—Late-Renaissance and Mannerist—and combinations of the two, also incorporating older Gothic elements. In the context of Late Renaissance Central Europe, this is fully in line with the "hybrid character" of local art[143] and the syncretic nature of artistic adaptations and transformations that blended together various visual cultures, both Italian and local.[144] In Central Europe, this was also a result of patrons' influence and the builders' opportunities.[145] During his studies of Jesuit and Lutheran sacred architecture in Germany, Jeffrey Chipps Smith concluded that their formal and stylistic characters were practically interchangeable. Both denominations aimed to create a dignified and "interesting" environment in their sacred spaces. The key requirement, which was also reflected in the specific and unique qualities of Jesuit architecture, was that the buildings should present impressive and highly functional places for religious services and backdrops for festivities and conversions. Artistic and architectural means were employed in a similar way for religious and pedagogical purposes which formed "the churches' confessional identities."[146]

Confessional behavior and liturgical content are at the core of sacred architecture's specific character, as attested by the Counter-Reformation reconversions of churches regained by the Jesuits following the defeat of non-Catholic estates in the Battle of White Mountain. In Jesuit historiography, this regaining of control is naturally presented with great satisfaction and as proof of the order's rightfulness and legitimacy. As in other cases, the Jesuits used

a metaphor to express this; at the end of January 1621, the Olomouc provost, Václav Pillar, wrote a sermon inspired by Christ's miraculous calming of the storm on Lake Gennessaret, a metaphor of the invincible and fearless Church, whose temple, like the ship in the Gospel, would withstand all danger.[147]

The situation looked quite different from the point of view of non-Catholic authors and observers. For example, John Amos Comenius described various rituals accompanying the appropriation of sacred spaces by the Jesuits as purges that sometimes involved almost magical practices. Comenius writes that in Prague, Jihlava, and Znojmo, Jesuit friars physically hit ambons and altars "infected" by non-Catholics "lashing them with birches and whips like madmen." In the Prague Jesuit Church of the St. Savior, which was used for some time by the Unity of Brethren, Comenius reports a peculiar ritualistic process of altar re-consecration during which the Jesuits, "in an effort to purify and re-consecrate, sprinkled the altars with gunpowder and, setting them on fire, exorcised the heresy with flame and smoke."[148] Despite a certain bias, these descriptions attest to the ritualism and ostentation with which Jesuits took over their churches and the strong possessive relationship that tied the Catholic Church authorities to their sacred spaces.

In the Early Modern Era confessional split, Jesuit church architecture formed a significant framework for politico-religious life in urban society. Jesuits had a clear idea about what they wanted to build, namely, "funktionaler Architektur" (functional architecture) which would satisfy the order's internal and external needs in any given place.[149] The character of Jesuit churches resulted from various requirements and claims not only made by the Jesuits but also by their patrons. All of this was reflected in a church's appearance and furnishings, along with its functioning as a space for liturgy, remembering the dead, self-representation, public gatherings and feasts, and private prayer and devotion.[150] The Jesuit *noster modus* was a corporate strategy of sorts, "a complex and fluid mixture of experimentation and creativity, combined with a willingness to adapt and learn from the surrounding cultural landscape."[151]

This creative experimentation did not happen in a vacuum. The denominationally mixed environment in Central Europe was unique and fundamentally different from homogeneously Catholic countries such as Italy. As discussed at the beginning of this text, the majority of art historians compare Central European sacred buildings with Italian Renaissance and Baroque churches. These Italian models were indeed great inspiration. Historians often point out the key role of the Il Gesù church, which was meant to become the prototype for other Jesuit churches, but the Jesuits themselves rarely strove to imitate its architecture. For them, the concept of "imitation" had a different meaning than it has for us. In Early Modern discussions about architecture, it implied creative invention rather than the blind copying of models. Many Central

European Jesuit churches show clear Italian roots not only in an architectural sense but also in the way they aesthetically dominate the urban environment. This was an important feature in confessionally divided Central Europe and Jesuits and their patrons were well aware of its symbolism. The visually attractive form of Jesuit compounds and churches was a result of Jesuit efforts to make themselves visible in the places of their mission and it also corresponded with the ambitions of their patrons, who were among the most prominent Catholic aristocrats in the Czech lands, including members of the Habsburg dynasty. For these patrons, the Jesuit presence in towns and cities manifested their religious politics on the state level while also bolstering the individual aristocrats' authority in their domains and fulfilling their personal ambitions.

In the period of confessional struggle, both church authorities and architects discussed sacred architecture as a general theme, seeing it as an active social space that could define or produce a value transcending its material essence.[152] For example, the Jesuit scholar, Antonio Possevino, emphasized that designing a sacred building is the most dignified task for an artist, who must always strive for the perfection that would reflect the mystery of God's wisdom.[153] In the period of the Reformation and Counter-Reformation, the definition of sacred space (and its functions) was the key aspect of religious identity, not only in the general, abstract sense but also in terms of the lives of individuals and communities. The first Jesuit foundations and their churches in the Czech lands were the results of the specific circumstances of their construction, but they also illustrate principles of sacred architecture consisting of formal characteristics as well as the social framework and religious rituals. This architecture can be best understood within the framework of the specific circumstances in which it originated (patrons, builders, advisers, traditions, and the order's control), but it simultaneously needs to be perceived as a "lived space." Rituals and devotion not only fill the space, but they also constitute it.[154] The visual presence of Jesuit foundations is complementary to their religious and social activity in Early Modern towns and cities, thus meeting the order's universalist program. The buildings' forms and the devotion that took place inside them combined modern and traditionalist approaches. Jesuit architecture thus demonstrates the order's ability to harmonize the universal ideological and theological sphere in local applications. Jesuit architectural foundations aimed to root the order firmly in the local environment and create permanent bases for their activities. For this reason, Jesuit architecture is essentially "functional" in its content and visual presentation. Both architectural forms and the activities taking place inside them, supported or complemented by Jesuits' aristocratic patrons, rhetorically expressed the order's politico-religious mission and ambitions.[155]

NOTES

1. Líbal, "Renesance a manýrismus," 28.
2. Ibid., 28.
3. E.g., Bösel, "Grundsatzfragen und Fallstudien zur jesuitischen Bautypologie," 193–209; Lippmann, "Tipologie di chiese in Austria e Germania," 153–172.
4. Levy, *Propaganda and the Jesuit Baroque*, 195.
5. Galewski, "Remarks on the Architecture of Jesuit Colleges," 199–211; Nising, ". . . in keiner Weise prächtig," 47–48; Wittkower, "Problem of the Theme," 2–3.
6. In 1668, Oliva praised the Paderborn college: *"ad religiosos usu nostros accomodata sit fabrica, sed modesta sit ad nostrorum valetudinem et functionum commoditatem peridonea non tamen ulla ex parte superba in substantia vel in modo, denique ut sit ad aedificationem non vero ad pompa sed admirationem."* Quoted from Nising, *". . . in keiner Weise prächtig,"* 49.
7. Quoted from Levy, *Propaganda*, 201.
8. Zierholz, *Räume der Reform*, 314.
9. Ibid., 13–15, 223.
10. DeSilva, *"Piously Made,"* 11–12.
11. Schilling, "Die konfessionelle Stadt–eine Problemskizze," 60–83.
12. Ohlidal, "Präsenz und Präsentation," 207–217; Wenzel, "Transformationen sakraler Räume," 332–354.
13. Wegmann and Wimböck, eds., *Konfessionen im Kirchenraum*; Coster and Spicer, eds., *Sacred Space*; Spicer and Hamilton, eds., *Defining the Holy*; Rau and Schwerhoff, eds., *Topographien des Sakralen*; Harasimowicz, "Der Kirchenbau im konfessionellen Zeitalter," 3–12.
14. DeSilva, *"Piously Made,"* 19.
15. For more about Jesuits in the Czech lands, see Kroess, *Geschichte der böhmischen Provinz*, vol. 1; Cemus and Cemus S. J., eds., *Bohemia Jesuitica 1556–2006*; Čornejová, *Tovaryšstvo Ježíšovo*; Buben, *Encyklopedie řádů*; Schmidl, *Historiae Societatis JESU*, 653–654; Kroess, *Geschichte der böhmischen Provinz*, vol. 1, 677.
16. Hoppe, *Was ist Barock?*, 25–28.
17. Dietrich, "Die erste Jesuitenkirche Bayerns," 158.
18. Buben, *Encyklopedie řádů*, 270–271.
19. Fidler, "Několik poznámek k fenoménu jezuitské architektury," 182–206; Češková, "Jezuité a jejich mecenáši," 21–75.
20. Valeš, *Historie jezuitského areálu*, 18.
21. Jakubec, "Zbožná reprezentace," 40.
22. Valeš, *Historie jezuitského areálu*, 15.
23. Hrdlička, "Konfesionelle Konflikte," 193–207, esp. 203.
24. Valeš, *Historie jezuitského areálu*, 15.
25. Čornejová and Richterová, *The Jesuits and the Clementinum*; Horyna and Oulíková, *Kostel Nejsvětějšího Salvátora*; Oulíková, *Klementinum*.

26. Sievernich, "Die urbane Option des Ignatius von Loyola," 173–192. For more about the urban (and urbanist) character see Šroněk, "Tovaryšstvo Ježíšovo," 264–282; Lucas, *Landmarking*.

27. Buben, *Encyklopedie řádů*, 202.

28. Kroess, *Geschichte der böhmischen Provinz*, vol. 1, 230, 239, 489–491, 533–535.

29. Oulíková, *Klementinum*, 16–21.

30. Ibid., 14.

31. Ibid., 144.

32. Schmidl, *Historiae Societatis JESU*, vol. 1, 139.

33. Oulíková, *Klementinum*, 19.

34. Appuhn-Radtke, *Visuelle Medien*, 18–35.

35. Oulíková, *Klementinum*, 143.

36. Richter, *Der Triumph des Kreuzes*, 268.

37. Fiala, Mlčák, and Žurek, *Jezuitský konvikt*.

38. Land Archive in Opava, Olomouc branch (ZAO), fonds Arcibiskupství olomoucké (AO), Kopiář (Kop.) 1569, inv. no. 64, sign. 9, f. 139v.

39. ZAO–O, AO, Kop. 1569, inv. no. 64, sign. 9, f. 160r-v.

40. Moravian Land Archive in Brno (MZA), fonds G 83, Kop. XXVI., 1588, file no. 52, inv. no. 179, f. 520.

41. ZAO–O, AO, Kop. 1571, inv. no. 68, sign. 11, f. 22r.

42. Navrátil, ed., *Jesuité olomoučtí*, no. 47, p. 79; no. 48, 79–80.

43. ZAO–O, AO, Kop. 1572, f. 133v-134r.

44. Myslivečková, "Náhrobek zakladatele olomoucké univerzity," 105–114.

45. MZA, G 83, Kop. XXVI, 1588, file no. 52, inv. no. 179, f. 242–243.

46. Mlčák, "Areál jezuitské koleje v Olomouci," 184.

47. Jakubec, "Olomoucký jezuitský kostel," 150–156; Macháčková, "The 'Image' of the Jesuit Church," 141–146.

48. Dietrich, "Die erste Jesuitenkirche Bayerns," 158.

49. Jakubec, *Kulturní prostředí a mecenát olomouckých biskupů*, 263–264; ZAO–O, ACO, rkp. 109a, p. 507.

50. Rainer and Holeček, eds., "G. P. Mucante: Zpráva o cestě Slezskem a Moravou," 302.

51. MZA, fonds G 83, Kop. XXVII, 1589, file no. 53, inv. no. 180, f. 156.

52. ZAO–O, AO, Kop. 1571, inv. no. 68, sign. 11, f. 221r; ZAO–O, AO, Kop. 1572, inv. no. 69, sign. 12, f. 133v–134r, 135v; MZA, fonds G 83, Kop. XXI, 1584, file no. 47, inv. no. 174, 28.

53. MZA, fonds G 83, Opisy z archivů (Zemský archiv v Praze), file no. 64, inv. no. 199.

54. Samerski, "Von der Rezeption zur Indoktrination," 93–118; Jakubec, "Konfesionalizace a rituály potridentského katolicismu," 360–366.

55. Fiala and Mlčák, "Neznámé plány staré jezuitské koleje," 5.

56. Češková, "Jezuité a jejich mecenáši," 22, 27.

57. Šeferisová Loudová and Kroupa, "Kláštery ve městě II.," 429–433; Češková, "Jezuité a jejich mecenáši, "21–75; Eadem, "Plánování a výstavba," 210–222.

58. Češková, "Jezuité a jejich mecenáši," 25–27, 73.

59. Šeferisová Loudová-Kroupa, "Kláštery ve městě," 432.

60. Hoppe, *Was ist Barock?*, 25.

61. Češková, "Jezuité a jejich mecenáši," 58.

62. Jakubec, "Zbožná reprezentace," 38.

63. Jakubec, "Confessional Aspects," 121–127.

64. Češková, "Jezuité a jejich mecenáši," 67–70.

65. Deutsch, "Obraz a kult Salus Populi Romani," 35–43.

66. Jakubec, "Obraz Salus Populi Romani," 77–98. See the chapter by M. Deutsch in this volume.

67. Češková, "Jezuité a jejich mecenáši," 70–72.

68. Lombartová, "Počátky jezuitské koleje," 691–712.

69. Ibid., 694.

70. Krčálová, *Renesanční stavby B. Maggiho*, 20–23.

71. Gersdorfová and Kubíková, "Rožmberské mauzoleum," 416–417.

72. Vlček, "Český Krumlov," 209.

73. Čornejová, "Organizace jezuitského školství," 9–14, esp.10.

74. Brandon, "The Counter Reformation," 28–45; Hrubá, "Jiří Popel z Lobkovic," 132–144.

75. Brandon, "The Counter Reformation," 41–42.

76. Valeš, *Historie jezuitského areálu*, 16.

77. Buben, *Encyklopedie řádů*, 292.

78. "I will make every effort to facilitate the building of a different church with proper adornments closer to this college," cited in Valeš, *Historie jezuitského areálu*, 25.

79. Brandon, "The Counter Reformation," 35–36, 43.

80. Pánek, "Chomutovská divadelní hra," 31–78.

81. Mikulec, "Jezuitská bratrstva v Chomutově," 102–114.

82. Ibid., 113.

83. Novotný, "Jindřichohradecká kolej," 371–385; Jirásko et al., *Jindřichohradecká jezuitská kolej*; Hrdlička, *Víra a moc*; Novotný, "Jezuité a rekatolizace," 161–171.

84. Hrdlička, *Víra a moc*, 176.

85. Jirásko et al., *Jindřichohradecká jezuitská kolej*, 19.

86. Ibid., 22.

87. Ibid., 26.

88. Ibid., 26.

89. Hrdlička, *Víra a moc*, 187–189.

90. Jirásko et al., *Jindřichohradecká jezuitská kolej*, 37.

91. Hrdlička, *Víra a moc*, 260–264, 289–290, 303–304.

92. Ibid., 497–504.

93. Duhr, "Geschichte der Jesuiten," 176–178.

94. Ryba, ed., *Pavel Stránský, O státě českém*, 59; Bach, *Urkundliche Kirchen-Geschichte*.

95. Herzig, "Die Jesuiten im feudalen Nexus," 41–62; Knoz, *Pobělohorské konfiskace*, 408–411.

96. Schmidl, *Historiae Societatis Jesu*, 523–524.

97. Herzig, "Der Zwang zum wahren Glauben," 102–107; Herzig, *Małgorzata Ruchniewicz*, 109–112.

98. The recent theory strongly opposes the earlier theory of a "Jesuit style," see Wittkower, "Problem of the Theme," 2; Levy, *Propaganda*, 23–32; Bailey, "Le style jésuite n'existe pas," 38–89, esp. 39–44.

99. Bösel, "Jesuitenarchitektur," 1327–1346; Fidler, "Zum Mäzenatentum," 211–230; Baranowski, *Między Rzymem a Wilnem*, 198–221.

100. Levy, "Das 'jesuitische' der jesuitischen Architektur," 231–241; Eadem, "Jesuit Architecture Worldwide," 346–352.

101. Milobedzki, "Architektura polska," 26; Kaufmann, *Court, Cloister, and City*, 246–262.

102. Fürst, "The Impact of Jesuit Churches," 16–17.

103. Galewski, "Remarks on the Architecture," 200–201.

104. Charvátová, *Jindřichův Hradec*, 69–70; Poche, ed., *Umělecké památky Čech* 1, 618–619; Panochová, "Mezi zbraněmi," 154–158.

105. Jirásko, *Jindřichohradecká jezuitská kolej*, 19.

106. Panochová, "Mezi zbraněmi," 157.

107. Penz, "'Jesuitisierung' der alten Orden," 143–161.

108. Van Liere, Ditchfield, and Louthan eds., *Sacred History*.

109. Paprocký z Hlohol, *Zrdcadlo*, n.p. (chapter 375).

110. Sauter, *Die oberdeutschen Jesuitenkirchen*, 33–34.

111. Alexander, "Shaping Sacred Space," 164–179, esp. 176.

112. Levy, *Propaganda*, 197–204.

113. Prucek, ed., "Olomoucká souhrnná kronika," 144.

114. For general discussion see Hahn, "Sensing Sacred Space," 55–91.

115. *Initia et progressus Congregationis Assuptae in Academia Olomucensi Societatis Iesu*, Vědecká knihovna Olomouc, manuscript M2, 9, 22, 57.

116. Ibid., 63, 79.

117. Šroněk, "Tovaryšstvo Ježíšovo."

118. Coster and Spicer, eds., "Introduction," 6–7.

119. Malý, Maňas, and Orlita, *Vnitřní krajina*, 195–263.

120. Jakubec, "Olomouc a jezuitská mise," 23–29.

121. Malura, "Vojtěch Martinides a Matěj Vierius," 233–251.

122. Ibid., 248.

123. Burian, *Vývoj náboženských poměrů v Brně*, 33, 47, 61.

124. Češková, "Jezuité a jejich mecenáši," 52.

125. Fidler, "Několik poznámek," 183.

126. d'Elvert, "Gechichte des Theaters," 21.

127. Johns, "The Jesuits," 192–196.

128. Holubová, "Jezuité a významná mariánská poutní místa," 99–116; Jakubec, "Poutní místa," 307–321; Idem, "Kaple sv. Anny," 197–209.

129. MZA, fonds G 83, Opisy z archivů (Zemský archiv v Praze), file no. 64, inv. no. 199.

130. *Initia et progressus Congregationis Assuptae*, 66.

131. Fiala, "Dějiny jezuitského konviktu," 45.
132. *Initia et progressus Congregationis Assuptae*, 21.
133. Orlita, "Olomoučtí jezuité," 43–54; Mikulec, Jezuitská bratrstva, 102–114.
134. *Historia Domus probationis Societatis Iesu Brunae in Moravia pars posterior a. 1569–1747*, Wien, Österreichische Nationalbibliothek, Handschriftensammlung, Cod. 11958, f. 132v.
135. Valeš, *Historie jezuitského areálu*, 13.
136. Burian, *Vývoj náboženských poměrů v Brně 1570–1618*, 13.
137. Ibidem, 33, 47, 61. See also Peša and Dřímal, eds., *Dějiny města Brna*, 136.
138. Jakubec, *Kulturní prostředí a mecenát*, 72–75, 85–91, 126. See also MZA, G 83, Kopiář XXVIII, 1590, f. 100.
139. *Historia Domus probationis Societatis Iesu Brunae*, 655.
140. Schmidl, *Historiae Societatis JESU*, vol. 1, 574.
141. Quoted from Koláček, *200 let jezuitů v Brně*, 9.
142. Fiala, "Dějiny jezuitského konviktu v Olomouci," 33–177 (37).
143. Burke, *Hybrid Renaissance*, 23–25.
144. Kaufmann, "Italian Sculptors," 47–66; Idem, "Acculturation, Transculturation," 339–349.
145. Nising, "...*in keiner Weise prächtig*," 47.
146. Smith, "The Architecture of Faith," 161–174, esp. 173–174.
147. Kroess, *Geschichte der böhmischen Provinz II.*, 41.
148. Kaňák, (ed.), Jan Amos Komenský, *Historie*, 96, 216, 221.
149. Nising, "...*in keiner Weise prächtig*," 314; Bösel, "Jesuit Architecture in Europe," 63–122, esp. 122.
150. Zierholz, *Räume der Reform*, 13–14.
151. Bailey, "'Le style jésuite," 73.
152. Hills, "Taking Place," 309–339, esp. 328–330.
153. Zadrożny, "Terms Applied by Antonio Possevino," 165–179, esp. 178–179.
154. Ohlidal, "Präsenz und Präsentation," 207–217; Vácha, "*Sub utraque, sub una*," 116–133.
155. Levy, *Propaganda*, 77; Alexander, "Shaping Sacred Space."

BIBLIOGRAPHY

Manuscript and Archival Sources

Land Archive in Opava, branch Olomouc [Zemský archiv v Opavě, pracoviště Olomouc (ZAO-O)], Collection of the Olomouc Archbishopric (AO), Collection of Archbishop Consistory (ACO):

ZAO–O, AO, book of copies (correspondence) 1569, inv. no. 64, sign. 9.

ZAO–O, AO, book of copies (correspondence) 1571, inv. no. 68, sign. 11.

ZAO–O, AO, book of copies (correspondence) 1572, inv. no. 69, sign. 12.

ZAO–O, ACO, Ms. sign. 109a.

Moravian Land Archive in Brno [Moravský zemský archiv v Brně (MZA)], Collection G 83 Matice moravská:

MZA, G83, book of copies (correspondence) XXVI., 1588, box 52, inv. no. 179.
MZA, G 83, book of copies (correspondence) XXVI., 1588, box 52, inv. no. 179.
MZA, G 83, book of copies (correspondence) XXVII, 1589, box 53, inv. no. 180.
MZA, G 83, book of copies (correspondence) XXI, 1584, box 47, inv. no. 174.
MZA, G 83, book of copies (correspondence) XXVIII, 1590.
MZA, G 83, book of copies from Land Archive in Prague, box 64, inv. no. 199.

Research Library in Olomouc [Vědecká knihovna v Olomouc]:
Initia et progressus Congregationis Assuptae in Academia Olomucensi Societatis Iesu, Ms. sign. M2.

Austrian National Library, Vienna [Österreichische Nationalbibliothek, Wien (ÖNB)]:
Historia Domus probationis Societatis Iesu Brunae in Moravia pars posterior a. 1569–1747, Handschriftensammlung, Ms. sign. Cod. 11958.

Primary sources

Jesuité olomoučtí z protireformace. Akty a listiny z let 1558–1619. Edited by Bohumír Navrátil. Brno: nákladem Zemského výboru Markrabství moravského, 1916.

Komenský, Jan Amos. Historie o těžkých protivenstvích církve české. Edited by Miloslav Kaňák. Prague: Blahoslav, 1952.

Schmidl, Joannes. *Historiae Societatis JESU provinciae Bohemiae. Aab anno Christi 1555 ad annum 1592*, Pars I. Prague: Typis Universitatis Carolo Ferdinandeae in Collegio ad S. Clementem, 1747.

Secondary Studies

Alexander, John. "Shaping Sacred Space in the Sixteenth Century: Design Criteria for the Collegio Borromeo's Chapel." *Journal of the Society of Architectural Historians* 63 (2004): 164–179.

Appuhn-Radtke, Sibylle. *Visuelle Medien im Dienst der Gessellschaft Jesu. Johann Christoph Storer (1620–1671) als Maler der Katholischen Reform*. Regensburg: Schnell & Steiner, 2000.

Bach, A. *Urkundliche Kirchen-Geschichte der Grafschaft Glatz von der Urzeit bis zur unsere Tage*. Breslau: Gustav Fritz, 1848.

Bailey, Gauvin Alexander. "'Le style jésuite' nexiste pas: Jesuit Corporate Culture and the Visual Arts." In *The Jesuits. Cultures, Sciences, and the Arts 1540–1773*. Edited by John W. O'Malley, Steven J. Harris, and T. Frank Kennedy, 38–89. Toronto: University of Toronto Press, 2006.

Baranowski, Andrzej J. *Między Rzymem a Wilnem. Magnackie fundacje sakralne w Wielkim Księstwie Liteskim v czasach kontrreformacji na tle polityki dynastycznej w Europie Środkowej*. Warsaw: Instytut Sztuki Polskiej Akademii Nauk, 2006.

Bösel, Richard. "Grundsatzfragen und Fallstudien zur jesuitischen Bautypologie." In *Die Jesuiten in Wien. Zur Kunst- und Kulturgeschichte der österreichischen*

Ordensprovinz der "Gesellschaft Jesu" im 17. und 18. Jahrhundert. Edited by Herbert Karner and Werner Telesko, 193–209. Vienna: Verlag der Österreichischen Akademie der Wissenschaften, 2003.

Bösel, Richard. "Jesuit Architecture in Europe." In *The Jesuits and the Arts, 1540–1773.* Edited by John W. O'Malley and Gauvin Alexander Bailey, 63–122. Philadelphia: Saint Joseph's University Press, 2005.

Bösel, Richard. "Jesuitenarchitektur – zur Problematik ihrer Identität." In *Bohemia Jesuitica 1556–2006*, vol. 1. Edited by Petronilla Cemus and Richard Cemus SJ, 1327–1346. Prague: Karolinum, 2010.

Brandon, Mark Andrew. "The Counter Reformation of Jiří Popel z Lobkovic in Chomutov, 1591." *Porta Bohemica. Sborník historických prací* 3 (2005): 28–45.

Buben, Milan M. "Řeholní klerikové (jezuité)." *Encyklopedie řádů, kongregací a řeholních společností katolické církve v českých zemích.* Prague: Libri, 2012.

Burian, Vladimír. *Vývoj náboženských poměrů v Brně 1570–1618.* Brno: Nákladem Ústředního národního výboru, 1948.

Burke, Peter. *Hybrid Renaissance: Culture, Language Architecture.* Budapest: Central European University Press, 2016.

Cemus, Petronilla, and Richard Cemus SJ, eds. *Bohemia Jesuitica 1556–2006.* Prague: Karolinum, 2010.

Češková, Lenka. "Jezuité a jejich mecenáši při výstavbě a výzdobě kostela Nanebevzetí Panny Marie v Brně kolem roku 1600." In *Jezuité a Brno. Sociální a kulturní interakce koleje a města (1578–1773).* Edited by Hana Jordánková and Vladimír Maňas, 21–75. Brno: Statutární město Brno, Archiv města Brna, 2013.

Češková, Lenka. "Plánování a výstavba jezuitského kostela Nanebevzetí Panny Marie v Brně kolem roku 1600." *Průzkumy památek* 19, no. 2 (2012): 210–222.

Charvátová, Ema. *Jindřichův Hradec.* Prague: Odeon, 1974.

Čornejová Ivana, and Alena Richterová. *The Jesuits and the Clementinum.* Prague: National Library of the Czech Republic, 2006.

Čornejová, Ivana. "Organizace jezuitského školství před rokem 1773" *Z Českého ráje a Podkrkonoší* 2000: 9–14. [=Supplementum Series 5: *Minulost, současnost a budoucnost gymnazijního vzdělávání*]

Čornejová, Ivana. *Tovaryšstvo Ježíšovo. Jezuité v Čechách.* Prague: Hart, 2002.

Coster, Will, and Andrew Spicer, "Introduction: The Dimensions of Sacred Space in Reformation Europe." In *Sacred Space in Early Modern Europe.* Edited by Will Coster and Andrew Spicer, 1–16. Cambridge: Cambridge University Press, 2005.

Coster, Will, and Andrew Spicer, eds. *Sacred Space in Early Modern Europe.* Cambridge: Cambridge University Press, 2005.

d'Elvert, Christian. *Geschichte des Theaters in Mähren und Oestreichisch Schlesien.* Brno: Rohrer, 1852. [=Schriften der historisch-statistisch Section der k. k. mährisch-schlesien Gesellschaft zur Beförderung des Ackerbaues der Natur- und Landeskunde IV]

DeSilva, Jennifer Mara. "'Piously Made'. Sacred Space and the Transformation of Behavior." In *The Sacralization of Space and Behavior in the Early Modern World, Studies and Sources*, 1–32. Routledge: London, 2016.

Deutsch, Martin. "Obraz a kult Salus Populi Romani v náboženské politice a imaginaci brněnských jezuitů." BA thesis. Brno: Masaryk University, 2018.

Dietrich, Dagmar. "Die erste Jesuitenkirche Bayerns: Heilig-Kreuz in Landsberg." In *Rom in Bayern. Kunst und Spiritualität der ersten Jesuiten*. Edited by Reinhold Baumstark, 13–53. Munich: Hirmer, 1997

Dřímal, Jaroslav and Václav Peša, eds. *Dějiny města Brna*, vol. 1. Brno: Blok, 1969.

Duhr, Bernhard. *Geschichte der Jesuiten in den Ländern deutscher Zunge im XVI. Jahrhundert*, vol. 1. Freiburg im Breisgau: Herder, 1907.

Fiala, Jiří. "Dějiny jezuitského konviktu v Olomouci." In *Jezuitský konvikt. Sídlo uměleckého centra Univerzity Palackého v Olomouci. Dějiny – Stavební a umělecké dějiny – Obnova a využití*. Edited by Jiří Fiala, Leoš Mlčák, and Karel Žurek, 33–177. Olomouc: Univerzita Palackého, 2002.

Fiala, Jiří, and Leoš Mlčák. "Neznámé plány staré jezuitské koleje, školní budovy a kostela Panny Marie v Olomouci." *Zprávy Vlastivědného muzea v Olomouci* 292 (2006): 3–28.

Fiala, Jiří, Leoš Mlčák, and Karel Žurek. *Jezuitský konvikt. Sídlo uměleckého centra Univerzity Palackého v Olomouci. Dějiny – Stavební a umělecké dějiny – Obnova a využití*. Olomouc: Univerzita Palackého, 2002.

Fidler, Petr. "Několik poznámek k fenoménu jezuitské architektury." In *Morava a Brno na sklonku třicetileté války*. Edited by Jan Skutil, 182–206. Prague: Societas Praha, 1995.

Fidler, Petr. "Zum Mäzenatentum und zur Bautypologie der mittelterlichen Jesuitenarchitektur." In *Die Jesuiten in Wien. Zur Kunst- und Kulturgeschichte der österreichischen Ordensprovinz der "Gesellschaft Jesu" im 17. und 18. Jahrhundert*. Edited by Herbert Karner and Werner Telesko, 211–230. Vienna: Verlag der Österreichischen Akademie der Wissenschaften, 2003.

Fürst, Ulrich. "The Impact of Jesuit Churches on Ecclesiastical Architecture in Southern Germany." In *L'architecture religieuse europeénne au temps des Réformes: héritage de la Renaissance et nouvelles problématiques*. Edited by Monique Chatenet and Claude Mignot, 9–22. Paris: Picard, 2009.

Galewski, Dariusz. "Remarks on the Architecture of Jesuit Colleges in the Bohemian Province, Particularly in Silesia." In *Jesuits and Universities. Artistic and Ideological Aspects of Baroque Colleges of the Society of Jesu: Examples from Genoa and Wrocław*. Edited by Giacomo Montanari et al., 199–211. Wrocław: Wydawnictwo Uniwersytetu Wrocławskiego, 2015.

Gersdorfová, Zlata, and Anna Kubíková. "Rožmberské mauzoleum v českokrumlovském chrámu sv. Víta." In *Rožmberkové. Rod českých velmožů a jeho cesta dějinami*. Edited by Jaroslav Pánek, 416–417. České Budějovice: Národní památkový ústav, územní odborné pracoviště v Českých Budějovicích 2011.

Hahn, Philip. "Sensing Sacred Space. Ulm, Minster, the Reformation and Parishioners' Sensory Perception, c. 1470 to 1640." *Archiv für Reformationsgeschichte* 105 (2014): 55–91.

Harasimowicz, Jan. "Der Kirchenbau im konfessionellen Zeitalter." *Das Münster* 69, no. 1 (2016): 3–12.

Herzig, Arno. *Der Zwang zum wahren Glauben: Rekatholisierung vom 16. bis zum 18. Jahrhundert*. Göttingen: Vandenhoeck und Ruprecht, 2000.

Herzig, Arno. "Die Jesuiten im feudalen Nexus. Der Aufstand der Ordensuntertanen in der Grafschaft Glatz im ausgehenden 17. Jahrhundert." *Prague Papers on the History of International Relations* (1999): 41–62.

Herzig, Arno and Małgorzata Ruchniewicz. *Geschichte des Glatzer Landes*. Hamburg: Wissenschaftlicher Verlag Dokumentation & Buch, 2006.

Hills, Helen. "Taking Place: Architecture and Religious Devotion in Seventeenth-Century Italy." In *The Companions to the History of Architecture*, vol. 1. *Renaissance and Baroque Architecture*. Edited by Alina Payne, 309–339. Chichester: Wiley Blackwell, 2017.

Holubová, Markéta. "Jezuité a významná mariánská poutní místa v českých zemích." In *Na cestě do nebeského Jeruzaléma. Poutnictví v českých zemích ve středoevropském kontextu*. Edited by Jiří Mihola, 99–116. Brno: Moravské zemské muzeum, 2010.

Hoppe, Stephen. *Was ist Barock? Architektur und Städtebau Europas 1580–1770*. Darmstadt: Wissenschaftliche Buchgesellschaft, 2003.

Horyna, Mojmír and Petra Oulíková. *Kostel Nejsvětějšího Salvátora a Vlašská kaple*. Kostelní Vydří: Karmelitánské nakladatelství, 2006

Hrdlička, Josef. "Konfesionelle Konflikte in böhmischen und mährischen Städten unter adeliger Herrsachft von der Zwangkatholisierung." In *Religious Violence, Confessional Conflicts and Models for Violence Prevention in Central Europe (15th–18th Centuries)*. Edited by Joachim Bahlcke et al., 193–207. Prague: Historický ústav; Stuttgart: Universität Stuttgart, 2017.

Hrdlička, Josef. *Víra a moc. Politika, komunikace a protireformace v předmoderním městě (Jindřichův Hradec 1590–1630)*. České Budějovice: Jihočeská univerzita v Českých Budějovicích, 2013.

Hrubá, Michaela. "Jiří Popel z Lobkovic a prostředky rekatolizace na sklonku 16. století. (Příspěvek k dějinám rekatolizace v severozápadních Čechách)." *Ústecký sborník historický* 2000: 132–144.

Jakubec, Ondřej. "Confessional Aspects of the Art Patronage of the Bishops of Olomouc in the Period before the White Mountain Battle." *Acta Historiae Artium* 47 (2006): 121–127.

Jakubec, Ondřej. "Kaple sv. Anny na Olomouckém hradě a svatoanenský kult na Moravě kolem roku 1600." In *The Archdiocesan Museum at Olomouc Castle. Proceedings from the International Conference*. Edited by Ondřej Jakubec, 197–209. Olomouc: Muzeum umění Olomouc, 2010.

Jakubec, Ondřej "Konfesionalizace a rituály potridentského katolicismu na předbělohorské Moravě." In *Per saecula ad tempora nostra. Sborník prací k 60. narozeninám prof. Jaroslava Pánka*. Edited by Jiří Mikulec and Miloslav Polívka, 360–366. Prague: Historický ústav Akademie věd České republiky, 2007.

Jakubec, Ondřej. *Kulturní prostředí a mecenát olomouckých biskupů potridentské doby. Umělecké objednávky biskupů v letech 1553–1598, jejich význam a funkce*. Olomouc: Univerzita Palackého, 2003.

Jakubec, Ondřej. "Obraz Salus Populi Romani u brněnských jezuitů a obraznost potridentského katolicismu na předbělohorské Moravě." In *Jezuité a Brno. Sociální a kulturní interakce koleje a města (1578–1773)*. Edited by Hana Jordánková and Vladimír Maňas, 77–98. Brno: Statutární město Brno, Archiv města Brna, 2013.

Jakubec, Ondřej. "Olomouc a jezuitská mise ve střední Evropě." In *Olomoucké baroko. Proměny ambicí jednoho města*. Edited by Martin Elbel and Ondřej Jakubec, 23–29. Olomouc: Univerzita Palackého, 2010.

Jakubec, Ondřej. "Olomoucký jezuitský kostel a protimorový kult P. Marie Sněžné." In, *Olomoucké baroko. Proměny ambicí jednoho města*, vol. 1. Edited by Martin Elbel and Ondřej Jakubec. 150–156. Olomouc: Muzeum umění Olomouc, 2010.

Jakubec, Ondřej "Poutní místa, poutě a milostné obrazy v mecenátu a politice olomouckých biskupů raného novověku. Několik poznámek k poznání konfesionalizačních praktik na předbělohorské Moravě." In *Pielgrzymowanie i sztuka. Góra Świętej Anny i inne miejsca pielgrzymkowe na Śląsku*. Edited by Joanna Lubos-Kozieł, 307–321. Wrocław: Wydawnictwo Uniwersytetu Wrocławskiego, 2005.

Jakubec, Ondřej "Zbožná reprezentace – reprezentativní zbožnost. Poznámky k uměleckému mecenátu kardinála Františka z Dietrichsteina." In *Kardinál František z Dietrichsteina (1570–1636). Prelát a politik neklidného věku*. Edited by Leoš Mlčák, 32–42. Olomouc: Muzeum umění Olomouc, 2008.

Jirásko, Luděk, et al. *Jindřichohradecká jezuitská kolej: Národní muzeum fotografie*. Jindřichův Hradec: Národní muzeum fotografie, 2006.

Johns, Karl. "The Jesuits, The Créche and Hans von Aachen in Prague." *Umění* 49 (1998): 192–196.

Kaufmann, Thomas DaCosta. "Acculturation, Transculturation, Cultural Difference and Diffusion? Assessing the Assimilation of the Renaissance." In *Unity and Discontinuity: Architectural Relationships Between the Southern and Northern Low Countries (1530–1700)*. Edited byand Konrad Ottenheym and Krista De Jonge, 339–349. Turnhout: Brepols, 2007.

Kaufmann, Thomas DaCosta. *Court, Cloister, and City. The Art and Culture of Central Europe 1450–1800*. Chicago: University of Chicago Press, 1995.

Kaufmann, Thomas DaCosta. "Italian Sculptors and Sculpture Outside of Italy (Chiefly in Central Europe): Problems of Approach, Possibilities of Reception." In *Reframing the Renaissance: Visual Culture in Europe and Latin America 1450–1650*. Edited by Claire Farago, 47–66. New Haven: Yale University Press, 1995.

Knoz, Tomáš. *Pobělohorské konfiskace: moravský průběh, středoevropské souvislosti, obecné aspekty*. Brno: Matice moravská, and Masarykova univerzita, 2006.

Koláček, Josef. *200 let jezuitů v Brně*. Velehrad: Refugium, 2002.

Krčálová, Jarmila. *Renesanční stavby B. Maggiho v Čechách a na Moravě*. Prague: Academia, 1986.

Kroess, Alois. *Geschichte der böhmischen Provinz der Gesellschaft Jesu*, vol. 1. *Geschichte der ersten Kollegien in Böhmen, Mähren und Glatz von ihrer Gründung bis zu ihrer Auflösung durch die böhmischen Stände 1556–1619*. Vienna: Ambr. Opitz, 1910.

Kroess, Alois. *Geschichte der böhmischen Provinz der Gesellschaft Jesu*, vol. 2. *Geschichte der ersten Kollegien in Böhmen, Mähren und Glatz von ihrer Gründung bis zu ihrer Auflösung durch die böhmischen Stände 1556–1619.* Vienna: Mayer & Co., 1927.

Levy, Evonne. "Das 'jesuitische' der jesuitischen Architektur." In *Die Jesuiten in Wien. Zur Kunst- und Kulturgeschichte der österreichischen Ordensprovinz der 'Gesellschaft Jesu' im 17. und 18. Jahrhundert.* Edited by Herbert Karner and Werner Telesko, 231–241. Vienna: Verlag der Österreichischen Akademie der Wissenschaften, 2003.

Levy, Evonne. "Jesuit Architecture Worldwide. A Culture of Corporate Invention." In *The Companions to the History of Architecture*, Vol. 1. *Renaissance and Baroque Architecture.* Edited by Alina Payne, 346–352. Chichester: Wiley Blackwell, 2017.

Levy, Evonne. *Propaganda and the Jesuit Baroque.* Berkeley: University of California Press, 2004.

Líbal, Dobroslav. "Renesance a manýrismus." In *Umělecké památky Prahy. Staré Město, Josefov.* Edited by Pavel Vlček et al., 27–30. Prague: Academia, 1996.

Lippmann, Wolfgang. "Tipologie di chiese in Austria e Germania meridionale all'insegna delle riforme e delle lotte religiose (secc. XVI–XVII)." In *L'architecture religieuse européenne au temps des réformes.* Edited by Monique Chatenet and Claude Mignot, 153–172. Paris: Picard, 2009..

Lombartová, Veronika. "Počátky jezuitské koleje v Českém Krumlově." In *Český Krumlov: Od rezidenčního města k památce světového kulturního dědictví.* Edited by Martin Gaži and Petr Pavelec, 691–712. České Budějovice: Národní památkový ústav, územní odborné pracoviště v Českých Budějovicích, 2010.

Lucas, Thomas M. *Landmarking. City, Church and Jesuit Urban Strategy.* Chicago: Loyola Press, 1997.

Macháčková, Jana. "The 'Image' of the Jesuit Church of Our Lady of the Snow in Olomouc. Rome – Vienna – Wroclaw: Artistic Connections." In *Cultural Transfer. Umělecká výměna mezi Itálií a střední Evropou.* Edited by Magdaléna Nová and Marie Opatrná, 141–146. Prague: Univerzita Karlova v Praze, Katolická teologická fakulta, 2014.

Malura, Jan. "Vojtěch Martinides a Matěj Vierius – jezuitská meditativní próza ve znamení vizualizace a senzualismu." In *Jezuitská kultura v českých zemích. Jesuitischen Kultur in den böhmischen Ländern.* Edited by Gertraude Zand and Stefan Michal Newerkla, 233–251. Brno: Host, 2018.

Malý, Tomáš, Vladimír Maňas, and Zdeněk Orlita. *Vnitřní krajina zmizelého města. Náboženská bratrstva barokního Brna.* Brno: Statutární město Brno; Archiv města Brna, 2010.

Mikulec, Jiří. "Jezuitská bratrstva v Chomutově." In *Comotovia 2002. Sborník příspěvků z konference věnované výročí 750 let první zmínky o existenci Chomutova (1252–2002)* 102–114. Chomutov: Albis International, 2003..

Milobedzki, Adam. "Architektura polska około roku 1600." In *Sztuka około roku 1600.* Edited by Tereza Hrankowska, 23–29. Warsaw: Państwowe Wydawnictwo Naukowe, 1974.

Mlčák, Leoš. "Areál jezuitské koleje v Olomouci." InJezuitský konvikt. Sídlo uměleckého centra Univerzity Palackého v Olomouci. Dějiny – Stavební a umělecké dějiny – Obnova a využití. Edited by Jiří Fiala, Leoš Mlčák, and Karel Žurek, 179–199. Olomouc: Univerzita Palackého, 2002..

Myslivečková, Náhrobek. "'Zakladatele olomoucké univerzity' biskupa Viléma Prusinovského z Víckova." Historická Olomouc 1 (1998): 105–114.

Nising, Horst. "...in keiner Weise prächtig." Die Jesuitenkollegien der süddeutschen Provinz des Ordens und ihre städtebauliche Lage im 16.–18. Jahrhundert. Petersberg: Imhof, 2004.

Novotný, Miroslav. Jezuité a rekatolizace na Jindřichohradecku v první polovině 17. století, Studia Comeniana et historica 36 (2006): 161–171.

Novotný, Miroslav. "Jindřichohradecká kolej Tovaryšstva Ježíšova v letech 1594–1618." In Poslední páni z Hradce. Edited by Václav Bůžek, 371–385. České Budějovice: Jihočeská univerzita, 1998.

Ohlidal, Anna. "Präsenz und Präsentation. Strategien konfessioneller Raumbesetzung in Prag um 1600 am Beispiel des Prozessionswesens." In Formierungen des konfessionellen Raumes in Ostmitteleuropa. Edited by Evelyn Wetter, 207–217. Stuttgart: Franz Steiner Verlag, 2008.

Orlita, Zdeněk. "Olomoučtí jezuité a náboženská bratrstva v 16.– 18. Století." Střední Morava: vlastivědná revue 20 (2005): 43–54.

Ottenheym, Konrad, and Krista De Jonge, eds. Unity and Discontinuity: Architectural Relationships Between the Southern and Northern Low Countries (1530–1700). Turnhout: Brepols, 2007.

Oulíková, Petra. Klementinum. Prague: Národní knihovna České republiky, 2019.

Pánek, Jaroslav. "Chomutovská divadelní hra z roku 1594. Dramatický obraz náboženských, politických a národnostních rozporů v předbělohorské stavovské společnosti." In Comotovia 2002. Sborník příspěvků z konference věnované výročí 750 let první zmínky o existenci Chomutova (1252–2002), 31–78. Chomutov: Albis International, 2003.

Panochová, Ivana. Mezi zbraněmi vlčí múzy. Protobaroko v české a moravské architektuře 1620–1650 a jeho donátorské pozadí. PhD. Dissertation. Olomouc: Univerzita Palackého, 2003.

Penz, Helga. "'Jesuitisierung der alten Orden'? Annmerkungen zum Verhältnis der Gessellschaft Jesu zu den österreichischen Stiften im konfessionellen Zeitalter." In Jesuitische Frömmigkeitskulturen. Konfessionelle IInteraktione in Ostmitteleuropa 1570–1700. Edited by Anna Ohlidal and Stefan Samerski, 143–161. Stuttgart: Steiner, 2006.

Poche, Emanuel, ed. Umělecké památky Čech, vol. 1, Prague: Academia, 1977.

Prucek, Josef, ed. Olomoucká souhrnná kronika z let 1432–1656 sestavená Bedou Dudíkem. Část 2. Olomouc: Státní okresní archiv, 1983. [=Ročenka Státního okresního archivu v Olomouci 1983].

Rainer, Johann, and František J. Holeček. "G. P. Mucante: Zpráva o cestě Slezskem a Moravou v roce 1597." In In memoriam Josefa Macka (1922–1991). Edited by Miloslav Polívka and František Šmahel, 277–304. Prague: Historický ústav, 1996.

Rau, Susanne, and Gerd Schwerhoff, eds. *Topographien des Sakralen. Religion und Raumordnung in der Vormoderne.* Munich: Dölling und Galitz, 2008.

Richter, Katja. *Der Triumph des Kreuzes. Kunst und Konfession im letzten Viertel des 16. Jahrhunderts.* Berlin: Deutsche Kunstverlag, 2009.

Ryba, B., ed. *Pavel Stránský, O státě českém.* Prague: Sfinx, Bohumil Janda, 1946.

Samerski, Stefan. "Von der Rezeption zur Indoktrination. Die Annenbruderschaft in Olmütz (16./17. Jahrhundert)." In *Jesuitische Frömmigkeitskulturen. Konfessionelle Interaktione in Ostmitteleuropa 1570–1700,* edited by Anna Ohlidal and Stefan Samerski, 93–118. Stuttgart: Steiner, 2006.

Sauter, Marion. *Die oberdeutschen Jesuitenkirchen (1550–1650). Bauten, Kontext un Bautypologie.* Petersberg: Imhof, 2004.

Schilling, Heinz. "Die konfessionelle Stadt–eine Problemskizze." In *Historische Anstöße. Festschrift für Wolfgang Reinhard zum 65. Geburtstag am 10. April 2002.* Edited by Peter Burschel at al., 60–83. Berlin: Akademie Verlag, 2002.

Šeferisová-Loudová, Michaela, and Jiří Kroupa. "Kláštery ve městě II. (severní část)." In *Dějiny Brna,* vol. 7: *Uměleckohistorické památky, Historické jádro,* edited by Jiří Kroupa. Brno: Statutární město Brno: Archiv města Brna, 2015. 429–433.

Sievernich, Michael. "Die urbane Option des Ignatius von Loyola am Beispiel de Metropole Prag." In *Bohemia Jesuitica 1556–2006,* vol. 1. Edited by Petronilla Cemus, 173–192. Prague: Karolinum, 2010.

Smith, Jeffrey Chipps. "The Architecture of Faith. Lutheran and Jesuit Churches in Germany in the Early Seventeenth Century." In *Protestantischer Kirchenabu der Frühen Neuzeit. Grundlagen und neue Forschungskonzepte,* Edited by Jan Harasimowicz, 161–174. Regensburg: Schnell & Steiner, 2015.

Spicer, Andrew, and Sarah Hamilton, eds. *Defining the Holy. Sacred Space in Medieval and Early Modern Europe* (Aldershot: Ashgate, 2006).

Šroněk, Michal. "Tovaryšstvo Ježíšovo a město jako prostor řádové reprezentace." *Umění* 66 (2018): 264–282.

Vácha, Štěpán. "*Sub utraque, sub una.* Eine Quelle zur sakralen Topographie des rudolfinischen Prag (zum Jahr 1618)." *Studia Rudolphina* 12–13 (2013): 116–133.

Valeš, Vladimír. *Historie jezuitského areálu v Chomutově.* Chomutov: Středisko knihovnických a kulturních služeb, 2002.

Van Liere, Katherine, Simon Ditchfield, and Howard Louthan, eds., *Sacred History. Uses of the Christian Past in the Renaissance World* Oxford: University Press, 2012.

Vlček, Pavel. "Český Krumlov: Bývalá jezuitská kolej." In *Encyklopedie českých klášterů.* Edited by Pavel Vlček, Petr Sommer, and Dušan Foltýn, 208–10. Prague: Libri, 1997.

Wegmann, Susanne, and Gabriele Wimböck, eds., *Konfessionen im Kirchenraum. Dimensionen des Sakralraums in der Frühen Neuzeit.* Korb: Didymos-Verlag, 2007.

Wenzel, Kai. "Transformationen sakraler Räume im Zeitalter der Reformation. Programmatische Ausstattungsstücke in den Stadtkirchen der Oberlausitz." In *Korunní země v dějinách českého státu.* Vol. IV: *Náboženský život a církevní*

poměry v zemích koruny české ve 14.–17. století. Edited by Lenka Bobková and Jana Konvičná, 332–354. Prague: Filozofická fakulta Univerzity Karlovy v Praze, 2009.

Wittkower, Rudolf. "Problems of the Theme." In *Baroque Art: The Jesuit Contribution.* Edited by Rudolf Wittkower and Irma B. Jaffe, 1–14. New York: Fordham University Press, 1972

Zadrożny, Tadeusz. "Terms Applied by Antonio Possevino to Describe Architecture in his *Bibliotheca selecta de ratione studiorum.*" In *Art – Ritual – Religion.* Edited by Peter Martyn, 165–179. Warsaw: Instytut Sztuki Polskiej Akademii Nauk, 2003.

Zierholz, Steffen. *Räume der Reform. Kunst und Lebenkunst der Jesuiten in Rom, 1580–1700.* Berlin: Gebr. Mann Verlag, 2019.

Chapter 2

Marian Columns from Rome to Central Europe

The Transfer of Symbolic Triumph

Michal Šroněk

In Rome, the pontificate of Sixtus V (1585–1590) was a period of extraordinary construction projects and artistic ventures such as the construction of the Vatican Library and the creation of its pictorial decoration, which changed the town's urban form and gave the city a distinctive face. In the course of reshaping the street network and modifying piazzas, new features became dominant, often designed to be visible from long distances. They were not just landmarks of urban topography but particularly triumphant monuments. Such new ventures included the installation of four ancient Egyptian obelisks that had reached Rome as early as in the first centuries AD; they were placed in front of the then-finished St. Peter's Basilica, in front of the transept of the Lateran Basilica, at the end of the Basilica Santa Maria Maggiore, and in the Piazza del Popolo. At the same time, bronze statues of Sts. Peter and Paul were mounted on Trajan's and Marcus Aurelius's columns that celebrated Roman victories in Dacia and in the Danubian Lowlands. All the new installations incorporated monuments of the city's pagan past, which were "transformed into symbols of Catholic triumph and objects of veneration and prayer."[1]

In early seventeenth century, Pope Paul V continued these endeavors by erecting a monumental column in front of the Santa Maria Maggiore Basilica bearing the statue of the Virgin Mary crowned with twelve stars (the *Virgin Assumpta*) standing with Jesus on a half-moon [figure 2.1]. The bronze statue was cast by Guillaume Berthélot and Orazio Censore in 1614 and placed by Carlo Maderna on a spoliated marble Corinthian column transferred from Maxentius' basilica. This arrangement emphasized the significance of this ancient church, linked to the beginnings of Christianity in the town, and

represented the unity between the papacy and Rome. It sheltered a Roman Palladium, the miraculous image *Salus Populi Romani*, by this time a major devotional object for the people of Rome, which was honored by a new chapel (decorated 1611–1616). The juxtaposition of a Marian statue and an ancient marble thought to come from the Augustan Temple of Peace transformed imperial Roman peace ideology into the post-tridentine concept of

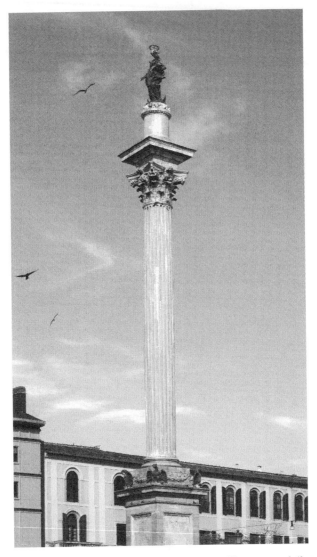

Figure 2.1 Column of the Virgin, Carlo Maderno, Guillaume Berthélot, Domenico Ferreri, et al., Rome, Piazza S. Maria Maggiore, 1613–1614.

Christian authority. The church also housed the tombstones of popes Sixtus V and Paul V, who were instrumental in developing the town at the end of the sixteenth and in the seventeenth centuries in terms of both preserving ancient treasures and building the post-tridentine church on their heritage, which also opened the door to the "baroquization" of Rome.

In late seventeenth and eighteenth centuries, this Marian column became a source of inspiration for a number of urban centers in Central Europe; the first three of them—in Munich, Vienna, and Prague—being particularly spectacular and symbolic undertakings in their own contexts. Beyond the execution of the actual monumental sculpture and its role in the urban concept of the city, the role model of Roman arrangement for its early Central European followers was ideological in at least two respects. First, a monumental Marian statue situated in public space embodied the triumph over paganism (symbolized by the Classical column). Less openly, it hinted symbolically at Mary's virginity through the Corinthian column, related to feminine fineness in works by Vitruvius, which Serlius connected directly to the immaculacy of the Virgin Mary.[2]

The three early Central European Marian columns acknowledged their Roman model in overall execution and iconography to varying degrees, but they acquired new meanings in their particular geographical, political, religious, and artistic contexts. The ancient monuments in Rome and Constantinople followed the tradition of imperial representation and celebrated imperial military triumphs; they were transformed to a glorification of triumphant Christianity and papal power in the new Roman arrangement. The subsequent Central European copies became instruments demonstrating the key role of secular powers in the local triumphs of the Counter-Reformation and the religious-political programs of their Catholic founders.

Between 1638 and 1648, the three monuments, very similar to each other, emerged in three Central European towns, all in the form of a column bearing a statue of the Virgin Mary surrounded by a balustrade with figures of angels combating evil creatures.[3] All three works were erected at the instigation of Catholic secular rulers, in Munich the Bavarian Duke Maximilian I of Wittelsbach and in Vienna and Prague the Emperor Ferdinand III Habsburg. The founders used these monuments to express their gratitude to the Virgin Mary for her protection and support in the dangerous times of the Thirty Years' War and declared the religious, political, and ideological program of the Counter-Reformation at the same time.[4] Created by the secular authorities, a closer look at all three cases discloses the important role that members of the *Societas Jesu* played in influencing the placement, form, and function of these monuments.

The Munich Marian column was built first, in 1638 [figure 2.2].[5] The immediate impulse for erecting it was the 1632 Swedish occupation of

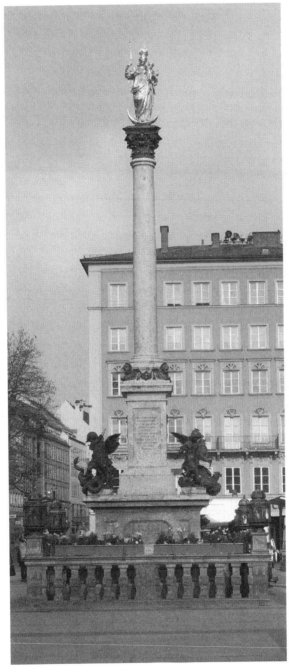

Figure 2.2 Column of the Virgin, Hubert Gerhard, Ferdinand Murmann, Munich, Marienplatz, 1598 (statue), 1638 (instalation).

Munich, when the town was saved from destruction by paying a large ransom amounting to 300,000 thalers. At that time, Duke Maximilian I made a promise to "establish a godly work" in memory of these events and asked several Jesuit clerics for their opinions. They suggested installing two Marian altars in the main Munich Church of the Virgin Mary (the *Frauenkirche*). Maximilian, however, decided otherwise, selecting not the enclosed space of a church, but *loco conspicuo*, that is, a highly visible place, Schrannenplatz (today's Marienplatz), a square in front of the Munich town hall in the center of the city.[6] This work, finally made in the form of a column carrying the statue of the Virgin Mary, was consecrated on November 7, 1638, in a procession held annually in memory of the victory of the Catholic League's armies at the Battle of White Mountain (1620), where Duke Maximilian, who initiated the creation of the column, had personally participated. On this occasion, Jesuit Jakob Balde composed an ode containing pleas to protect Bavaria "*Rem, Regem, Regionem, Religionem, conserva Bavaris Virgo Maria tuis.*" (Preserve, O Virgin and Patroness, for your Bavarian people, their goods, their government, their land, and their religion.)[7]

The corners of the balustrade surrounding the column carry four statues of *putti*, fighting a dragon, a lion, a basilisk, and a snake.[8] Following the Roman model, the marble column end is topped with a bronze Corinthian capital bearing a statue of the Virgin Mary, also in bronze, who is depicted as *Assumpta*, that is, standing on a half-moon and holding the baby Jesus. The statue was designed by the Dutch sculptor Hubert Gerhard (1540/50–1620) and commissioned by Duke William V in 1598. It was originally located on the main altar of the Munich *Frauenkirche*, but in 1638 it was moved to decorate the Marian column.

In 1647, a Marian column was erected in Vienna as a reminder of the danger the Swedes had posed to the city in 1645, when a supplicant procession was held and a miraculous sculpture of the Virgin Mary was displayed in St. Stephen's Cathedral for public adoration (the so-called *Schottenmuttergottes*).[9] At the time, Ferdinand III of Habsburg made a promise to establish a celebration of the holiday of the Immaculate Conception of the Virgin Mary and to build a column with a Marian sculpture following the Munich model in the Am Hof Square in front of the Jesuit professed house [figure 2.3].[10] Like the Munich column, the column in Vienna carries a statue of the Virgin Mary surrounded by a balustrade with four *putti*, who, similarly to the Munich column, are battling a snake, a basilisk, a lion, and a dragon. This work was created by the sculptor Johann Jacob Pock (1604–1651), who made it in marble according to a design by his brother, the painter Tobias Pock (1609–1683).[11] Unlike the Munich model, where the Virgin Mary is depicted as *Assumpta* with sovereign insignia and standing on a half-moon, the Mary on the Vienna column is depicted as Our Lady of the Immaculate Conception (*Immaculata*) in a way

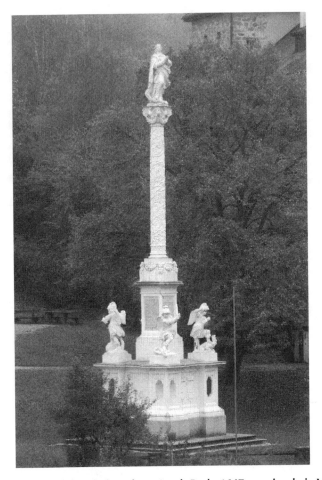

Figure 2.3 Column of the Virgin, Johann Jacob Pock, 1647, previously in Vienna, Am Hof, today Wernstein am Inn.

that became extremely popular in the Central European Habsburg countries. She is standing with one foot on a dragon whose neck is pierced by a short spear, hands clasped in front of her in a posture of prayer, her head wrapped in a starry gloriole, her eyes looking upward, and her hair hanging in long locks down her back. This column cannot be found in Vienna now; in 1667 it was replaced by a sculptural group with a similar iconographic concept commissioned by Emperor Leopold I. The original column was transferred to the town of Wernstein in Upper Austria and erected on the banks of the Inn, where it still stands today.[12]

Three years after the Vienna column, in 1650, a Marian column was erected in Prague Old Town Square.[13] The immediate impulse for its creation

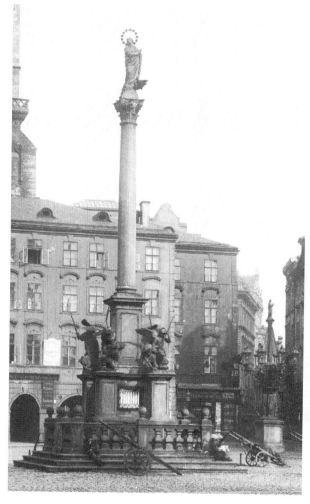

Figure 2.4 Column of the Virgin, Johann Georg Bendl, Prague, Old Town Square, 1650. Photographed by Jindřich Eckert at the turn of the 19th century.

was the successful defense of the Prague towns located on the right bank of the Vltava (the Old Town and New Town of Prague) after Prague Castle and Hradčany—the castle district and the Lesser Town—on the left bank were taken by Swedish armies in the closing months of the Thirty Years' War. For three months the Swedish forces tried unsuccessfully to break through the defenses of the Old and New Towns, but thanks to the zeal of the defenders, which included burgher militias and student units as well as regular military units, the attackers did not succeed. The fighting ended in the final days of

October 1648 and even continued for a couple of days after the Peace of Westphalia was signed. The defenders of the Old and New Towns put their merit to good use both politically and socially. As early as 1649, Emperor Ferdinand III of Habsburg elevated the heraldic attributes of the Old and the New Towns of Prague and granted noble status to all the members of the town councils, the council scribes, the commanders of municipal troops, and others.[14]

The news of the time affirms that the successful defense was officially attributed not only to the commitment of the defenders but also to the protection of the Virgin Mary.[15] In memory of those events, Emperor Ferdinand III ordered that a Marian column be erected in Prague modeled after the monument in Vienna [figure 2.4]. The Prague Marian column, however, was not only inspired by the recent events of the Thirty Years' War as in Munich and Vienna. It was also a response to the ecclesiastical and political developments in the Czech lands during the fifteenth and sixteenth centuries and to the victory over the Bohemian Reformation. Those events were marked by the sentencing of John Hus at the Council of Constance, his subsequent burning at the stake, and the events of the Hussite revolt, which resulted in a partial separation of the Czech Utraquist Church from the universal Catholic Church. In the second half of the fifteenth century, another Reformation Church emerged, that is, the Bohemian Brethren, and starting from the 1520s the Bohemian lands were, along with other Central European regions, strongly affected by European Reformation movements, first by Lutheranism, and later (to a much smaller extent) by Calvinism, and locally also by Anabaptism. Remarkably, the laws of the lands permitted only the activity of the Utraquist and Catholic churches for a long time (until 1609). Other Reformation churches (in particular the Lutherans) were backed by the officially recognized Utraquist Church or existed under the protection of tolerant nobility. Apart from significant religious pluralism where individual confessions existed in a state of so-called forced tolerance, the Czech lands had a weak central authority, which was counterweighted by a powerful and self-confident aristocracy and rich towns. The traditional arrangement of an estate-run kingdom, however, was opposed by the Habsburg monarchs, whose ideas of a functioning state were completely different. Although they relied traditionally on the Catholic Church, they reinforced central sovereign power wherever possible. The Habsburg assertion of their own model of government and unification of faiths that allowed only the Catholic religion was made possible when the revolt (1618–1620) of the Czech estates was defeated at the Battle of White Mountain (November 8, 1620).[16]

When the decision was made to construct the column, a search began for a place to install it. It is evident from the historical sources that, similarly to Vienna where the Marian column was erected in front of the Jesuit Am Hof

Church, in Prague there was also a requirement (at least by Jesuits themselves) to erect the Marian column in front of their order's St. Savior church (the principal shrine of the oldest Czech Jesuit college) in the Old Town's Clementinum complex facing the Charles Bridge. This is manifested by an undated document by an unknown Jesuit author called "*Causae, ob quas videtur expediens, erigi columnam et statuam Immaculatae Conceptioni Beatisimae Virginis ante templum Academicum Collegii Societatis Jesu Pragae iuxta pontem,*" which states twelve reasons to erect the column and statue of the Immaculate Conception of the Virgin Mary in front of the academic church of the Society of Jesus' college by the bridge (that is, the present day's Charles Bridge).[17] The Jesuit's arguments are:

1) Raising the monument accomplishes the emperor's will and promotes piety, and at the same time is congruent with celebrating the holiday of the Immaculate Conception of the Virgin Mary in the Jesuit church; 2) erecting the column would be a joint event for all the faculties of Prague University (run by the Jesuits at the time) and associated schools and the monument would be established at a quiet place close to the hospital of the Knights of the Cross; 3) Marian brotherhoods of the Jesuit college celebrate each holiday of the Virgin Mary by a procession that visits three Prague Jesuit churches and is joined by large numbers of people. This procession could make a stop at the column, which would not be possible if the column was located elsewhere; 4) in the St. Wenceslas Jesuit seminary, music is never missing and all the students are present on Saturday to join in the worship, so it would not be easy for ordinary citizens to avoid worshiping at the column where there are singers and other people; 5) as the Jesuit College holds a procession every year to celebrate the *Corpus Christi* holiday, it would be possible to increase the veneration of the statue and make one station there; 6) in the three towns of Prague there is no better place to erect the column than this visible location opposite the St. Savior Church as no other place is frequented more than the Prague bridge; 7) services held at the column can be watched from both sides of the bridge, from the Lesser Town, from the Castle, and from the emperor's palace; 8) no other place in Prague is so quiet[!] as it is enclosed, no carriages pass there, and it is quite visible; 9) no other place is more orderly as there are no shops nearby, no market with fish and vegetables; 10) it is a suitable place to stop for those who take part in processions coming from the Castle, the Lesser Town, and all three towns of Prague; 11) it is not easy to find a better place than this, which is located between the Old Town's bridge tower and the hospital spire, where a square area would be formed to replace a rubble site, to decorate the town, and to protect the bridge; 12) if storms or commotions

disturb services at the statue there is a nearby church able to shelter the pilgrims.

The arguments show the strong Jesuit interest in locating the Marian column in front of the Society's college. The author of the Jesuit document argued first using the of the statue, the Immaculate Conception of the Virgin Mary, which was closely related to the duty of teachers and graduates of Prague University to take an oath on the dogma of the Immaculate Conception, introduced by the order of Emperor Ferdinand III in 1650. The reasons were practical, promotional, and urbanistic, but taken from the Jesuit point of view: the column would become part of various processions and pious gatherings held by the Jesuits, it would be visible from the Lesser Town where the court was settled, and it would establish a landmark on the square and a pleasing view. Finally, the Jesuit author claimed that the area of present-day Křižovnické náměstí was easily accessible to residents of the Prague conurbation and was located in a busy area that everyone passed through in order to cross the river on the only (at the time) solid bridge across the Vltava. He emphasized that the place was calm as no carriages passed there, which was utterly untrue, as the banks of the Vltava were connected by a single stone bridge.[18] It is evident that the Jesuits were well aware of the importance of their favored location in front of the Jesuit church façade for the representation of their order as well as for showcasing the Marian cult in the area between the front of the Jesuit church and the Gothic tower that controlled access to the bridge. Although the column was clearly the sovereign's project, the Jesuits included its construction in their activities as a matter of course. In the end, however, their attempt to claim the column failed.

Comparing the location of the column considered by the unknown Prague Jesuit with the similar monuments in Rome, Munich, and Vienna shows different relevant considerations. The Roman choices of sites for triumphal monuments such as the obelisks in front of San Pietro, in the Piazza del Popolo, and the Marian column in front of the Basilica Santa Maria Maggiore took into account their distinctive visual effects in open spaces or street vistas. This effect in the Prague situation—which the Prague author drew attention to—could only apply from the opposite bank of the Vltava River, especially from the Castle and Imperial Palace. The relatively cramped space in front of the Jesuit church did not allow the monument to be appreciated by the viewer at a greater distance and in comparison with the surrounding architecture. An indisputable advantage of this location, however, would have been placing the column at a key point, the intersection of all the roads crossing the river. The Prague Jesuit design has some parallels in Vienna, where the Marian column was erected in one of the city's most spacious squares, in front of the order's Church of the Society of Jesus. The

square in front of the Jesuit church in Prague, however, was a much more intimate space than in Vienna; thus, the advantage of the proximity of the Jesuit church and the column was duly emphasized in the Prague document. The final Prague solution—placing the column in Old Town Square—was more similar to the situation in Munich, where Duke Maximilian I rather opted for an open square in front of Munich City Hall. Disregarding the Jesuit opinion, the Wittelsbach and Habsburg sovereigns both chose large, open, and central squares. In Prague, the column enters into deliberate confrontation with many other monuments.

The effort of the Old Town Jesuits to push through the installation of the Marian column in front of their St. Savior Church demonstrates excellently the ambitions of the society to advertise in the urban area. *Societas Jesu*, although also active in the countryside, was primarily an urban order, as is aptly characterized by this saying: *"Bernardus valles, montes Benedictus amabat, oppida Franciscus, magnas Ignatius urbes"* (Bernard loved valleys, Benedict mountains, Francis small towns, and Ignatius cities).[19] The founder of the society, St. Ignatius of Loyola, understood cities as an ideal missionary environment, a living body, and he understood the local activity of the order as "spiritual and social edification" reaching all social classes, generations, and national groups.[20] It was also linked to the efforts of the order's officials to acquire sites for constructing churches and schools in significant areas of the city—on squares and by important roads. Both St. Ignatius and the later Jesuit theologian and educator Antonio Possevino instructed the brothers in this spirit. A number of examples in architecture and other public projects demonstrate that these instructions were put into practice.[21] In the case of the Munich and Prague columns, there was clearly a shift in the perceptions of the monument. In Munich, the *patres* suggested making Marian altars as *memoria* in church interiors, while the Prague Jesuits tried to have the column built in front of their college. It is particularly symptomatic that in both cases the decision was made by the funder, that is, secular nobility, who understood the construction of the Marian column on multiple levels, not just as a declaration of faith and confession but also as a political manifestation.

The society's attempt to push through the construction of the Marian column in the square in front of St. Savior Church should therefore be perceived not only as a tool for *propaganda Fidae* but also as an attempt to represent the order itself. If the Jesuit concept were enforced, the Marian column would lose some of Ferdinand III's declaration, that is, the political message. Although Ferdinand III was strongly inclined in favor of the Society, and although the Viennese model of the Prague column was erected in front of the Jesuit church in the Am Hof Square, the political motivation eventually won. The monarch decided to build the Marian column in the Old Town

main marketplace, a location with much greater potential from the perspective of efforts to redefine the urban area, which was clearly one of his aims.[22]

THE URBAN PUBLIC REPRESENTATION OF
THE PRAGUE JESUITS TO AROUND 1650

The location of the Jesuit church and college was indeed a key point on the roads that connected the towns of Prague, that is, the Lesser Town, Hradčany, and Prague Castle situated on the left bank of the Vltava and the Old and New Towns of Prague on the right bank. Its strategic location was noted early by Peter Canisius, a court preacher in Vienna and the former rector of Ingolstadt University, who played a decisive role in founding the first Jesuit College in the Czech lands in 1556. Canisius's visit to Prague was preceded by Ferdinand I's of Habsburg entreaty, addressed to Ignatius, to send Jesuits to Bohemia. The founding of the Jesuit College was also supported by Archbishop Antonín Brus of Mohelnice, the superiors of prominent Prague monasteries, and representatives of Catholic noble families. Canisius gave an account of the situation in Prague directly to Ignatius in an elaborate letter, the contents of which attest his good knowledge of the local religious situation. Canisius considered the choice of location for the future college carefully; he rejected an offer to take over two monasteries in the Lesser Town and then chose a Dominican monastery with the St. Clement Church in the Old Town. The compound was not in good condition; it had flourished originally, but was damaged during the Hussite wars and never fully restored. Canisius, however, noted the practical advantages and potential of being situated at the bridgehead of the only bridge across the Vltava that connected the conglomerate of Prague towns at the time. He wrote to Ignatius:

> But let us turn our attention to the college in the monastery of the St. Clement, this place we liked because it is in the center of the town and comfortable for the young, and it has enough space for schools and classrooms, for living and sleeping rooms, and moreover an adequate area for the garden. And it needs only a small sum for complete reconstruction and alterations to a habitation state good enough for this first year.[23]

A handful of Dominican monks were moved to another place and the Jesuits who came to Prague a year later established a college that gradually developed into a large compound also encompassing, besides two churches and several chapels, a library, a printer's shop, a huge summer refectory, two mathematical halls, an astronomy tower, a gymnasium (high school), and the arts and theological faculties of Prague University. After the 1570s, Jesuits

gradually built the St. Savior Church; the west façade reached its present-day appearance in the early seventeenth century. The front design with three portals was united by pilasters that covered the façade from the ground level to the horizontal cordon, surmounted by a high gable with the order's IHS motto and a statue of St. Savior flanked with volute wings. The design brought a progressive Italian layout to Bohemia and was later followed in a number of buildings. The central portal was especially innovative, with figures of semi-recumbent angels gesturing with their hands at passers-by, inviting them to enter the church.

Although we are unable to assess the extent of the order's success among the residents of Prague, it is clear that, besides the sovereign, they were able to connect with a number of individuals from among the nobility and high clergy, who funded the construction and furnishings of the church, the front facade of which was noticeably dominant when passing between the Prague towns. That the Jesuits were seen as dangerous adversaries by the non-Catholics and opponents of the Habsburg lords is clearly attested by the fact that they were expelled from Prague at the beginning of the revolt of the Czech estates (1618–1620). The St. Savior Church was acquired by the Unity of the Brethren, who belonged to the radical side of the Reformation, characterized among other things by an aversion to images in religious practice. It is known that movable furnishings were removed from the St. Savior Church, although the extent of changes to the interior is not clear. It is known that the Holy Trinity and Virgin Mary altars (with the painting of Annunciation by Hans von Aachen) were transferred to what was then the Lutheran Holy Trinity Church in the Lesser Town, from where they were reclaimed after the Jesuits returned to Prague immediately following the defeat at White Mountain (late 1620). Pamphlet journalism at the time commented spitefully on the expulsion of the Jesuits.[24]

It is likely that the inglorious departure of the Society of Jesus and the transfer of their church to the hated Bohemian Brethren contributed to the demonstrative presentation of the order shortly after they returned to Prague. As early as a year and a half after their return and the restoration of the college, the Jesuits celebrated (June 19, 1622) the canonization of Ignatius of Loyola and Francis Xavier, in cooperation with the Minorites from St. James in the Old Town and the Augustinians from St. Thomas in the Lesser Town, by building a massive triumphal arch in front of the St. Savior Church.[25] It was funded by the vice-regent, Prince Charles of Liechtenstein, on behalf of Ferdinand II. A published description and a graphic depiction both describe it as a three-story building decorated by obelisks at the corners. A statue of each saint stood beside the main entry and the side entries were decorated by personifications of their virtues: for St. Ignatius Wisdom/*Sapientia* and Strength/*Fortitudo*, and for St. Francis Zeal for the soul/*Zelum animarum* and Temperance/*Castimonia*. The first extension reminded viewers of St.

Ignatius's European activities through personifications of Hispania, France, Germany, and Italy; the second extension, above the first, showed personifications of Japan, the Moluccas, China, and Ceylon to remind viewers of St. Francis Xavier's missionary activities in Asia. The top of the triumphal arch supported figures of the four continents carrying the earth's globe, on which the personification of the church was enthroned. Processions with carriages, paintings and sculptures carried on litters, statues of virtues, and depictions of the lives of both saints came from the Lesser Town, the Old Town, and the New Town, all proceeding toward the triumphal arch and St. Savior Church.

This was the first time that Prague dwellers saw such spectacular *theatrum sacrum* organized to celebrate new saints. More than a century later, the Jesuit historian J. Schmidl wrote that people from all over Bohemia were streaming to Prague to attend these festivities, held on June 19, to watch the procession on the squares, in the streets, and from windows and roofs. This is obviously a misrepresented image of the situation; in fact, a year earlier, celebrations of the John Hus feast were held in Prague churches on July 6, and the following year (i.e., sixteen days after the start of the Jesuit festivities) the Hus feast was prevented by locking all the Utraquist churches as a preventive measure. In this context, the grandiose celebrations of the canonization of both saints designed to portray them as supports ("columns") of the *Societas Jesu* can be understood as a demonstrative and confrontational declaration of the Jesuits' renewed presence in the town, as well as a celebration of the order's saints through a performance centered on the St. Savior Church and the square in front of it. This event was not held for the internal needs of the Society, local spectators were clearly expected; the processions culminated with sermons held in St. Savior Church addressing the faithful in Czech, German, and Italian, the most important Prague language groups of the time. It seems that Jesuits were interested primarily in Czech-speaking citizens, which is demonstrated by a number of prints dedicated to St. Ignatius of Loyola and St. Francis Xavier published around 1622 and then republished in Czech, including a biography of St. Ignatius, which was published repeatedly. A Czech translation was even published describing the Roman festivities held on the occasion of canonizing both new Jesuit saints.[26]

The Society also demonstrated its exceptional ability to enter the public space of the town at significant moments by participating in the celebrations of the translation of St. Norbert's relics to Prague, held by the Premonstratensian Order and the Prague Archbishop Ernst von Harrach at the beginning of May 1627.[27] The Jesuits presented themselves in an original and striking manner. As the procession with St. Norbert's relics passed through Prague, Old Town Square was an important stop. The abbot of the Premonstratensian Monastery at Strahov built a triumphal arch there, but according to a Jesuit design. The front, dedicated to the celebration of St. Norbert as a victor over heresy,

welcomed the new patron saint of the land with personifications of virtues—Piety, Wisdom, Prudence, Constancy, Diligence, and Zeal. The back of the construction celebrated Norbert as an archbishop, also using figures of virtues: Love, Vigilance, Leniency, Generosity, Justice, and Nobility. At the gate he was welcomed by a pageant where a personification of Bohemia and twelve Czech regions welcomed Norbert to the country in the presence of the land's patrons, who accepted him among themselves. This was not the end of Jesuit participation in the Norbertine celebrations; however, at the Clementinum College, Ignatius himself received the new saint. The celebrations continued for several days, and the rector of the university and the Clementinum College invited guests into the Jesuit gardens on the left bank of the Vltava to watch an unusual spectacle presented by Jesuits on the river, where boats with crews costumed as virtues celebrated St. Norbert as the disseminator of faith. At first sight, the Jesuits seemed to originate an event reminiscent of the ancient Roman *naumachia* (re-enactment of a naval battle) and transfer it to Bohemia, but it had a surprising local predecessor. In 1517, Praguers had celebrated the festival of St. John Hus and St. Jerome of Prague by bonfires, gunshots, and fireworks on the banks and waters of the Vltava and the bridge, although whether Prague Jesuits knew of this history has not been established. If so, their celebrations would have been a sophisticated appropriation of the local tradition and an interconfessional transfer.[28] As for the Norbertine celebrations, the Jesuits again showed their extraordinary ability to assert themselves at someone else's cost. This won them key locations in public space, allowing them to present themselves on the occasion of the translation of the Premonstratensian saint. The cult of Jesuit saints in the Czech lands evolved rich variety and had many and various manifestations; on the contrary, the cult of St. Norbert remained limited even though it was local (relics of the saint were kept in Prague) and had fertile ground in the numerous and prominent Premonstratensian monasteries, and Prague archbishops supported it.

Although the Jesuits did not succeed in pushing through the construction of the Marian column in front of their Old Town college, they continued their activities. They soon developed even more complex perspectives on presenting the order and its saints. From 1653 to 1659, Jesuits adapted the front of the St. Savior Church, turning it into the most significant element in the public presentation of their Old Town College. Designed by the architect Carlo Lurago, a portico was built in front of the flat façade of the church, clearly structured in reference to a triumphal arch.[29] This was clearly not a coincidence, as the façade faced the eastern front of the Charles Bridge Tower built in 1370s based on similar architectural idea of triumphal arch, only in the Gothic style, by the Emperor Charles IV of Luxemburg. At the same time, the front of the church was fitted with fourteen sculptures by the most prominent

Prague sculptor of the early Baroque, Johann Georg Bendl, artistically promi-
nent from the Marian column three years earlier. The design of the decoration
is hierarchical and reads from the gable top down. The top is finished by a
statue of St. Savior (Christ as the savior of the world) with IHS initials echo-
ing the church's *patrocinium* and at the same time Christ as the focal point
of Jesuit spirituality. Immediately below him is a niche where the Virgin
Mary is shown as the *Immaculata* (of the Immaculate Conception), that is,
not only as the Mother of God, but also as the immaculate virgin, by which
Jesuits also referred to the Marian type of *Immaculata Conceptio* used on the
column in the Old Town Square. The figure of St. Savior is flanked by two
pairs of statues of evangelists, here acting as witnesses to Christ's divinity.
The gable side wings are fitted with statues of St. Ignatius of Loyola and St.
Francis Xavier, who adopted the role of modern-day spreaders of the Gospel.
The statues of four Church Fathers—Sts. Augustine, Gregory, Ambrose, and
Hieronymus—stand on the portico cordon on the lowest level, referring to
the church's authority and teachings. The concept of the façade decoration
represents two basic dogmas of faith: the messianic role of Christ and the
Immaculate Conception of the Virgin Mary, corroborated by the evangelists
as eyewitnesses of the beginnings of the church and confirmed by the author-
ity of Church Fathers. The portrayal of two Jesuit saints in the hierarchy of
figures alongside Christ and the Virgin Mary is remarkable because they
are inserted between the evangelists and Church Fathers. This demonstrates
clearly the self-assurance of the Society, adopting the role of being direct fol-
lowers of Christ, the evangelists and apostles. The concept of the St. Savior
Church façade therefore represents a sort of *theatrum sacrum*, an impressive
confrontation with the front of the Gothic bridge tower from the perspective
of both its architectural design and its set of sculptural decorations, which,
unlike the tower, incorporate no components from secular donors.

THE MARIAN COLUMN IN THE OLD TOWN
SQUARE AND ITS USES BY THE JESUITS

The Marian column was finally raised in the Old Town Square thanks to the
emperor's intervention. Its construction proceeded quickly: in February 1650,
Dionysius Miseroni (1607–1661), gem cutter and custodian of the Prague
Castle's collections, was appointed the person in charge of this project;[30]
on June 8, the foundation stone was laid, and by September 26 of the same
year the sandstone column was erected; four days later, the statue of the
Immaculate Virgin Mary was finally raised. The symbolic completion of the
column two years after its construction took place during a visit to Prague by
Ferdinand III of Habsburg. A couple of days after the emperor's birthday,

on July 13, 1652, the monument was ceremonially consecrated in his presence by Prague Archbishop Ernst von Harrach.[31] Similarly to the column in Vienna, the one in Prague bore an inscription indicating Ferdinand as the builder: "*VIrgInI genItrICI sIne orIgInIs Labe ConCeptae propVgnatae et LIberatae VrbIs ergo Caesar pIVs et IVstVs hanC statVaM ponIt.*" (To the Virgin, Mother of immaculate conception, for defending and freeing the town, the pious and righteous emperor erected this statue.) Johann Georg Bendl, mentioned above, active in the town from the 1650s to the 1680s, designed the work.[32] Even though it was a sculptural commission, outside the experience of all the Prague artists of the time including Bendl, he managed it without difficulty. The sculpture is a monumental composition in which the dominant vertical of the column with the figure of the Virgin Mary contrasts markedly with four dynamic groups of battling angels. The Marian column, in an empty area of the Old Town market, the most prominent site in Prague Old Town, played a distinctive role in the urbanism of the area and must have had a stunning impact on contemporary spectators. A sculptural group 17 meters in height had not yet been made in Prague or elsewhere in the Czech lands by the mid-seventeenth century. Existing torsos show that the Virgin Mary turned her head, face, and the gesture of her clasped hands toward the heavens and that the groups of battling angels were composed as compact sculptural pairs, focusing on the eschatological battle between Good and Evil taking place outside of time.[33] Paradoxically, the monumentality of the work and its impact emphasized distance and deliberately excluded external communication links aimed at the spectator.

The transfer of the Marian column site to the Old Town Square definitely did not meet the hypocritical misgivings of the author of a Jesuit memorandum that pious processions could only be held if the Marian column were situated in front of the Jesuit church. On the contrary, regular services were held at the Marian column by the St. Vitus Chapter, singing the Litany of the Blessed Virgin Mary.[34] Even though the statue lost its immediate link to the buildings of the order's college due to the changed location, the Jesuits still appropriated the site to their benefit. They led processions of Marian student congregations from the Clementinum College on the holidays of the Immaculate Conception, the Nativity of Mary, the Assumption of Virgin Mary, and Good Friday.

Ferdinand III did not opt for the Old Town Square by coincidence. The Old Town market and the surrounding buildings are a place of extraordinary historical memory that the Habsburgs wished to appropriate specifically to declare their claims and Counter-Reformation program. Two dominant features formed the *genius loci* of the Old Town's market in this period.[35] One was the town hall, the political center of the Old Town of Prague, in operation here since 1338, with a massive Gothic town-hall tower and a

Renaissance window carrying the proud motto *Praga caput regni* (Prague, the head of the kingdom). It symbolized the power of the town, which the Habsburgs restricted systematically from the sixteenth century. Another site of confrontation stands on the other side of the square, the Church of Our Lady Before Týn, which had been the center of the Czech Utraquist Church for two centuries. Shortly after the Battle of White Mountain, the victors turned their attention to this church, constructing an ostentatious Catholic redefinition of the exterior and interior until all signs of its non-Catholic past were removed—the chalice as the symbol of Utraquism and the statue of King George of Poděbrady as the protector of the Utraquist confession. The church gable was fitted with a statue of the Virgin Mary and child with the attributes of the queen of heaven, and the statue of George of Poděbrady should have been replaced by a depiction of Emperor Ferdinand II, although this was not completed. Positioning the statue of the Virgin Mary on the church's front facade was the first step in an effort to dominate the square, commencing a "process of symbolic recatholicization of this key area."[36] The extreme sensitivity of the space of the square was emphasized by the fact that from the beginning until the end of the Thirty Years' War, it had been a place where "the state power ostensibly demonstrated its authority"[37] through exemplary acts of execution. The spectacularly morbid execution of the leaders of the estates' revolt in 1621 was notable, alternating with events that turned the square into a pretentious stage for both Protestant defamation and Catholic glorification of Mary. Catholic believers were particularly offended by the display of the medieval Marian relief of Stará Boleslav, a Palladium that reputedly served as a miraculous protector of the Czech lands, close to the gallows in the square during the Saxon occupation Prague from 1631 to 1632.[38] The moment of Marian triumph held in response to this earlier defamation was a ceremonial procession on the occasion of the Palladium's return to Bohemia that also stopped at the Týn church.[39] In this context, it is clear that constructing the Marian column, its festive consecration in 1652, and its integration into a series of regular services and processions represented a triumphant culmination of a ritual cleansing of the place and the land itself from the non-Catholic past.

For the Habsburgs, the figure of the Virgin Mary was one of the key pillars of the "state myth," the so-called *Pietas Austriaca*. Although they had controlled a vast area of Central Europe from the second quarter of the sixteenth century, they were still coping with the internal opposition of the estates, often non-Catholic, in Austria, the Czech lands, and Hungary, and at the same time contending with an external, almost mythical, enemy, the Turks. As Bridget Heal aptly wrote, the Virgin Mary served the Austrian Habsburgs as a symbol of Catholic renewal and *reconquista*.[40] The form of the Marian cult was shaped by two rulers in particular: Ferdinand II (1578–1637) and

his successor, Ferdinand III (1608–1657). In the Habsburg family, reverence for the Virgin Mary was strongly reinforced by links to Bavaria; the mother of the future Emperor Ferdinand II was Maria of Bavaria, daughter of Duke William V, and her son, Ferdinand, along with the future Duke Maximilian I, was educated by Jesuits in Ingolstadt. Both young men were members of the local Marian congregation at that time.[41] The militant character of the Habsburg *Pietas Austriaca* is well illustrated by the vow the future Emperor Ferdinand II made in 1598 during his pilgrimage to Loretto in Italy: he would banish sectarian preachers from Styria, Carinthia, and Carniola at risk of his own life. After the defeat of the Bohemian estates' revolt, he made the same promise about the Czech lands in Mariazell, a prominent pilgrimage site for Austrian lands.[42]

The key topic of Marian veneration for members of the Habsburg family was belief in the Immaculate Conception of the Virgin Mary,[43] a purely Catholic phenomenon that had an extraordinarily high interconfessional polemical and confrontational dimension. In 1622, a papal Church Constitution was issued forbidding both public and private denial of the Immaculate Conception of the Virgin Mary[44] and in 1629 Bishop Melchior Khlesl introduced celebrations of the holiday of the Immaculate Conception of the Virgin Mary in the whole Vienna diocese.[45] Emperor Ferdinand II himself turned to Pope Urban VIII to request its dogmatization as early as the 1620s.[46] In his work *Dissertatio polemica de prima origine augustissimae Domus Habsburgico-Austriacae*, the Habsburgs' biographer, Johann L. Schönleben, emphasizes that Ferdinand III, besides continuing the work of his father, who had purged the Austrian lands of heretics, again elevated the neglected cult of the Eucharist and was instrumental in spreading reverence for the Immaculate Conception of the Virgin Mary in particular. Schönleben emphasizes the three strong pillars of Ferdinand's extraordinary piety:

What elsewhere rested on the inconstant Fortuna, is now standing on the Austrian triple pillar. Zeal for the Catholic faith, veneration of the Eucharist, defence of the Immaculate Conception, these are foundations of the emerging Austrian Habsburg empire and by this moment it is still maintained by these principles.[47]

This idea materialized in Vienna in 1647 when the archbishop of Vienna consecrated the Marian column in the presence of the monarch, a papal nuncio, the court, and nobility. Ferdinand III, as the inscription on the pedestal has it, made the following dedication:

To God the most perfect and the highest, the supreme ruler of Heaven and Earth, through him monarchs govern, to [the] Virgin the Mother of God of Immaculate

Conception, through whom princes govern, in unique piety for the special sovereign and patroness of Austria accepted, I devote myself, my offspring, people, army, provinces, in short everything, in my belief and I give and consecrate and in eternal memory I erect this statue ex voto. Ferdinand III, Emperor.[48]

Ferdinand III chose the Virgin Mary, free of original sin, as a universal "ruler and patron of Austria"; she also became the symbol and warrantor that God's will supports the rule of the Habsburgs.[49] She represented the battling church, the defeater of Evil and Christ's enemies, Turks, Islam, heretics, and non-Catholics—hence she became the Virgin Mary Victorious.[50] The Immaculate Conception of the Virgin Mary assumed the role of the ideal embodiment of the pure teachings of the Catholic Church, where *Immaculata conceptio* impersonates *Immaculata religio*—immaculate and intact religion—at the same time.[51]

The figure of the Mother of God is therefore essential for understanding the significance of the Marian column. The Virgin Mary of Prague is depicted in the same manner as the *Immaculata Conceptio* in Vienna, that is, as the Virgin of Immaculate Conception. She is crushing a defeated dragon under her feet and an aureole of twelve stars shines around her head. Her hands are clasped in the gesture of prayer, long loose hair flows down her back; she therefore also represents a traditional iconographic type of the Virgin Mary as a virgin temple servant, "who with humility awaits the miraculous incarnation of the Holy Spirit"[52] as announced by the Archangel Gabriel (Luke 1:26–30).

Mary's depiction as expecting God's Incarnation was celebrated by students of the Jesuit-founded Marian sodality of the Annunciation of the Virgin Mary (*Sodalitas B. Virginis Annunciatae latina major*). During particularly ceremonial processions to the Marian column, they carried standards and a litter with a silver- and gold-plated statue of the Annunciation under a canopy. The iconographic shift from the Munich *Assumpta* to the Virgin Mary *Immaculata* on the Vienna and Prague Marian columns accentuated the initiation moment of the Incarnation and the beginning of a new history of Salvation, which resonated fully with the "renewal" of the Catholic faith in the lands of the Habsburg monarchy.[53] Besides being part of the Habsburg *Pietas Austriaca*, the theme of the Immaculate Conception of the Virgin Mary was also an ostentatious declaration of Catholicism and the cult of the Immaculate Conception of the Virgin Mary became a kind of touchstone of true faith (though it was only declared Church dogma by Pope Pius IX as late as 1845). As early as January 26, 1650, Ferdinand III ordered a mandatory oath on the Immaculate Conception at Prague University, where the Jesuit Order fully dominated the philosophy and theology faculties (as at a great many other European universities). The oath, which they took every year in

the Church of Our Lady Before Týn, was binding for student candidates for graduation, professors, deans, and rectors.[54]

On all three columns, the Marian theme is complemented with the theme of *putti* or angels combating creatures that embody evil. In Munich and Vienna, these are the dragon, lion, basilisk, and snake, a selection inspired by Psalm 91:13: "Thou shalt tread upon the lion and adder: the young lion and the dragon shalt thou trample under thy feet."[55] In the Prague sculpture, the angels combat devils, a lion, and a dragon. The subject of angels victorious over enemies is rooted in the text of the Revelation of St. John, chapter 12, which treats saving a mother in labor, identified with the Virgin Mary, from dark and evil creatures. As Peter Marshall and Alexandra Walsham aptly put it, the angel became a true weapon against heresy in the Counter-Reformation environment.[56] The topic was developed particularly strongly in Bavaria, where the Archangel Michael became a truly iconic warrior defeating the devil. This is eloquently illustrated in a work published to celebrate the completion of the Munich Church of the Archangel Michael, the so-called *Trophea Bavarica*, where the angel's victory is linked to the defeat of heretics—Luther, Calvin, and Zwingli.[57]

Besides the religious and historic context, the figure of the Virgin Mary and the subject of angelic battle were typical Counter-Reformation themes that linked the Marian columns in Munich, Vienna, and Prague.[58] In Prague and Vienna, moreover, the iconography of the Virgin Mary accented the Immaculate Conception, also a supremely Counter-Reformation topic as well as pro-Habsburg. In Prague, these connotations entered an environment that was an extraordinarily sensitive place of memory and the content of the message went far beyond verbal declarations of thanks to the Virgin Mary for her help in defending the town.

This triumphant symbolism of the Marian column, projecting the state ideology of the Habsburgs, was confirmed not only by the presence of Ferdinand III and his son at the column's consecration but also by later visits of his successor, Leopold I, to Prague. In 1679, in St. Savior Church, for example, university members, after hearing a ceremonial sermon and making a vow to profess faith in the Immaculate Conception of the Virgin Mary, took part in a procession of the Marian congregation from the Old Town Jesuit College.[59] Charles VI, too, who was staying in Prague in 1723 on the occasion of being crowned king of Bohemia, "with exemplary devotion" took part twice in processions to the Marian column on the holy days of the Assumption of Mary (August 15) and the Name of the Virgin Mary (September 12).[60]

In March 1694, the Marian column was integrated into the ceremonial funeral of Simon Abeles, a Jewish boy. Allegedly seeking to convert to Christianity with the Old Town Jesuits, he was supposedly killed by his own

father and a companion. Examination of the boy's body reputedly proved his violent death, and both alleged murderers were arrested and forced to confess by torture. The interpretation in this period highlighted Simon Abeles as a martyr for the Christian faith; his body was first displayed for worship at the Old Town town hall and then, in a ceremonial procession that included nobility, high clergy, imperial officials, and numerous members of the public, carried to the Church of the Our Lady before Týn, where it was buried. On the way to the church, the procession stopped at the Marian column, where Simon Abeles was presented to the Mother of God as a new martyr for the faith. The Marian column played a role in a staging that addressed the alleged obstinacy of the Prague Jewish community toward the Christian faith, exploiting anti-Semitism stimulated by printed flyers.[61] In this staging, the Marian monument functioned literally as a physical embodiment of the Virgin Mary.

Religious gatherings on the feast of the Immaculate Conception took place every year; in most cases, they were held in the Church of Our Lady before Týn. Besides university graduates and professors taking a mandatory vow, a sermon was preached on the topic of the Immaculate Conception and later published. The vast majority of speakers were members of the Society of Jesus; preachers from other orders that proclaimed their veneration of the Immaculate Conception of the Virgin Mary, Franciscans in particular, only spoke from time to time. It appears that the Marian column was a part of services and ceremonies dedicated to the Immaculate Conception that was intended for a select company, that is, the social and educated elite, who were more amenable to teachings on Mary's purity than common believers because the sermons were always in Latin. This exclusivity applied beyond the environment of the Jesuits and the orders following the rule of St. Francis of Assisi. The elite public was also the intended audience for a work treating the cult of Immaculate Conception of the Virgin Mary published in Prague by Juan Caramuel of Lobkowitz, a learned Benedictine. In this text, the Virgin Mary is the center of heaven, praised in a sophisticated manner in a poem with elaborate typography that allowed the creation of countless celebratory Marian invocations.[62]

Less educated believers were targeted through processions to the Marian column by canons from St. Vitus singing the Litany of the Blessed Virgin Mary, which were held every Saturday. A Gothic panel picture of the Virgin Mary with the baby Jesus, the so-called Virgin Mary of the Square (Rynecká), mounted in a niche in the column's base, was also connected to popular forms of devotion and venerated as a miraculous icon. The form of this painting copies the Palladium, the medieval metal relief depicting the Virgin Mary with Child that was venerated in Stará Boleslav, where Jesuits managed one of the most important Marian pilgrimage sites of the Czech

Baroque, linked to the cult of this Marian relief and connected to an older cult of St. Wenceslas. Czech Catholic writers skillfully supported its miraculous reputation, linking it with the cult of the patrons of the Czech lands.[63] The renown of this relief was paradoxically improved by the events of the Thirty Years' War, when Central Bohemia and Prague were occupied by the Saxon army. The Palladium was seized and the commander of the Saxon army had it mockingly exhibited next to the Old Town Square's gallows. After the Saxon troops left, the Palladium was taken to Germany and only recovered several years later. Even before the end of the war, there were voices connecting the column's construction with purifying the Marian memory at the place of its recent disgrace.

RECEPTION OF THE MARIAN COLUMN

Damien Tricoire[64] recently drew attention to the universal and triumphant dimension of Marian columns, which he understands correctly as expressions of the personal piety of their builders, and, in particular, as attempts to constitute new universal cult communities. This was the reason public areas were selected for them; as the Prague example shows, such locations had the potential to bear multiple meanings. Remarkably, these efforts did not originate in church environments; they came from lay nobility, for whom Marian reverence became a political instrument. In addition, the universal character of the Marian cult suited the mentality of the Jesuit Order and its ideal; expressed in present-day terms, it was their global mission.

It seems, however, that the degree of universality of such efforts was perceived differently by different individuals. This is clear from reactions to the installation of the Prague Marian column; contemporary records show that its reception was highly differentiated. The Prague column is a solid part of the Central European "Marian Triad" as it embodies the Habsburg program of *Pietas Austriaca*, but its ideological content was rather isolated in Bohemia. Prague Baroque historians thus commented quite dryly on the Marian column. They mention it as a monarchical monument or they address services held there, but they completely ignore the reasons for its creation and the context of its meaning.[65] It appears that the Prague Marian column as a symbol of Habsburg triumph over defeated domestic heretics and insurgents, was a source of unease among younger Prague writers even though they were fully dedicated to the Catholic Church.

And they were not alone—the papal response was surprisingly negative even though popes traditionally supported the veneration of the Immaculate Conception of the Virgin Mary at the Prague and Vienna Marian columns.[66] The popes did not mind the columns themselves, but rather the fact that a new

form of service, performed in public, was introduced under the patronage of secular nobility. Moreover, it was linked to a cult that was the subject of rupture among certain church bodies, namely, the Jesuits and Dominicans. These were arguments, however, to which no one at the Viennese court would lend an ear. The cult of the Immaculate Conception became part of state ideology, and its transfer to public space was clearly intended as a political deed of Habsburg triumph.

In these contexts, the most striking reflection of the Marian column is its depiction in the 1661 Prague University philosophy thesis of Johann Friedrich of Wallenstein, drawn by Karel Škréta and engraved by Melchior Küssel [figure 2.5]. At seventeenth- and eighteenth-century Central European universities, theses were produced by wealthy students from the ranks of the nobility and functioned as elaborate announcements of disputations and defenses to mark the closing of their studies. The theses consisted of a text part with a list of topics defended and a visual part (often created by a prominent artist) dedicated to a variety of themes—depictions of Biblical scenes, the Virgin Mary, and complicated allegories celebrating the defendant's family, his personal patron or the governing ruler. The large sheet of the Wallenstein thesis, with the Prague Marian column in the center, depicts a map of Europe inhabited by

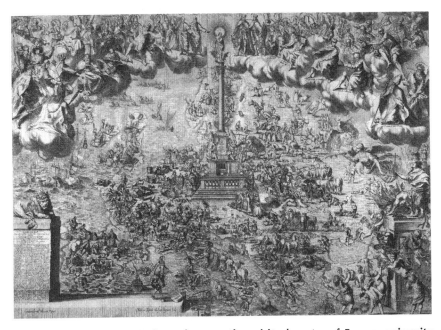

Figure 2.5 **The Prague Marian column as the spiritual center of Europe, university thesis of Friedrich of Wallenstein, copper engraving on paper by Melchior Küsell after a design by Karel Škréta, 1666.**

members of individual nations with their typical local activities or products. They express their respects to Bohemia and the column, serving here as the center of Marian veneration for the whole of Europe, which is emphasized by an inscription in Mary's gloriole: *"Beatam me dicent omnes generationes"* (All generations shall beatify me). Members of European nations worship at the column, even those from the non-Catholic areas of Europe, including their national patrons, followed by a body of seven electors and six Habsburg rulers led by Emperor Leopold I.[67] The commissioner of the thesis was Johann Friedrich von Wallenstein, future archbishop of Prague, who defended it under the leadership of his Jesuit professor, Johannes Tanner, and dedicated it symbolically to Leopold I, head of the Habsburg monarchy at the time.

In the thesis's dedication, he mentions the Marian column as a *"pomník[u] Neposkvrněné Panny . . . na náměstí v Praze"* [memorial to the Immaculate Virgin . . . in a Prague square], who is promoted to *"samotné centrum křesťanství"* [the very center of Christianity], where *"Bohorodička uložila své srdce"* [the Mother of God put her heart].[68] The column also worships the personification of Fame, flying in from the right, whose trumpet is decorated with a hanger depicting the birth of Jesus with the motto *Sine macula* (Without blemish), and trumpeting the motto *"Terrae medio in arbor ecce"* (Behold there was a tree in the middle of the earth, Daniel 4:7). The blessing of the nations of Europe applies, however, not only to the Virgin Mary but also to the nation of Bohemia and Prague in particular, to which the text on the column's pedestal refers *"Benedictionem omnium gentium dedit nobis dominus"* (The Lord gave the blessing of all the nations to us, Ecclesiastes 44: 25). The artist who created the thesis's depiction used a motif rooted in the first half of the sixteenth century, when the cartographer Johannes Putsch published a map of Europe designed as a female figure bearing a crown on her head (hence the later name *Europa regina*), with Bohemia as her heart, enclosed by mountains and hemmed in by a laurel wreath, shown as a medallion hanging on the chest. During the sixteenth century, this map was published repeatedly in multiple variants and the emphasis on Bohemia is interpreted as reflecting the fact that the Czech lands were a significant part of the Habsburg monarchy. The Wallenstein thesis clearly builds upon these earlier reflections of Catholic and evangelical intellectuals on Bohemia as the heart of Europe—*cor Europae*.[69]

In contrast to perceiving Bohemia as the heart of Europe, however, in the awareness of the Catholic world it was seen as the place where all the evil of heresy originated (meaning the period from the sentencing of John Hus, the Hussite revolution, and the resistance to Rome strengthened by the Lutheran Reformation in the sixteenth century), which also caused the Czech estates to revolt against the emperor in 1618. The perception of Bohemia as a heretical land rebelling against the emperor was so strong that after the

defeat of the revolt and the subsequent introduction of new rules, it was even incorporated in Bohemia's new constitution, the so-called Renewed Land Ordinance issued in 1627, where the introduction mentions a "rebellion" (meaning the revolt of 1618–1620) "through which not only their homeland but also all Christian kingdoms and lands are insurgent and in disorder."[70] This odium of betrayal attached to the inhabitants of the Czech kingdom lasted for decades.[71] After the Battle of White Mountain, it was a thorn in the side of the new elites, the nobility in particular, who were loyal to the Catholic Church and the Habsburg rulers and vehemently showed respect to the monarch as the highest natural secular authority, sanctified by the church and by tradition.[72] Seeking to purge the Czech past of the stigma of heresy, Catholic intellectuals and historians repeatedly based their accounts of Czech history on the ancient and glorious Catholic past of the land, the golden age, which they perceived particularly in the pre-Hussite period, accenting the rule of Emperor and King Charles IV as an exemplary monarch who secured prosperity and peace for his lands and supported the Church. This interest in the period of Charles's rule included attention dedicated to monuments of the land's Catholic past and developing the cult(s) of domestic saints.

In this context, the Wallenstein thesis is a work that seems to attempt to change the optics from Bohemia, the land of heretics and insurgents, to the current devoted branch of the church. The Marian column is styled in the role of the spiritual heart of Europe and all Christendom; not only dwellers of the whole continent pay tribute but also the patron saints of individual countries, who approach the Virgin Mary in their own mother tongues in the introductory words of the angelic salutation *Ave Maria*.

The emphasis on the topic of the Immaculate Conception suggests that the idea came from a member of the Jesuit Order. Besides the close link between the order and the cult of the Immaculate Conception, the environment of this order in Prague specifically gave rise to a number of prints addressing this topic as early as the mid-seventeenth century. In 1648, the professor of Holy Scripture lecturing at that time at the Faculty of Arts, Jiří Plachý (Ferus), published the very first book of sermons *Rosa pentaphylla* (Five-petalled Rose) in Bohemia devoted to the theme of the Immaculate Conception.[73] Three years later, Clementine Jesuits published a medieval eulogy written by the first Prague archbishop, Ernest of Pardubice, glorifying the Virgin Mary. This edition was dedicated to Ferdinand III, and the preface urged the emperor to continue spreading reverence for the Immaculate Conception in the same manner as King Philip III of Spain.[74] The book even contains a separate chapter (119), comparing Mary to a pillar symbolizing strength and purity of faith, in particular through references to the authority of the Biblical texts similar to those referring to the Lord. In this text, Mary is called not only the Virgin of Virgins but also the Column of Columns (*Haec est ergo sicut Virgo Virginum, ita Columna Columnarum*).

Who was the author of the complicated ideological concept of the Wallenstein thesis? It links the patriotic layer with an effort to rehabilitate Bohemia as an orthodox Catholic land, appearing here as the *cor Europae*, and celebrating Emperor Leopold I and the dominant motif of the Immaculate Conception of the Virgin Mary. The concept for this thesis must have originated from an educated and experienced intellectual capable of compiling different layers of significance and visual motifs. Given that Wallenstein defended the thesis at the Faculty of Arts of Prague University, which at that time was fully in the hands of Societas Iesu, I deem it almost certain that the person behind the concept was someone linked to the university, someone with a close relationship to the defendant himself.

The man who best meets the requirements for the authorship of the concept of the Wallenstein thesis was a professor of the Faculty of Arts of the Prague University who officiated at Wallenstein's defense, Johannes Tanner, theologian and historian. He authored a number of religious writings, but wrote in particular about the genealogy of old Czech aristocratic families—the Sternbergs and Wallensteins.[75] Moreover, Tanner knew Friedrich of Wallenstein personally for a long time and later was even his confessor. The close relationship of these two men can be seen in a text Tanner published on the occasion of Wallenstein's defense, a small book that contains a telling eulogy glorifying Friedrich of Wallenstein and the heroism of his famous ancestors. The author writes of Wallenstein's piety, which predestined him to become prefect of the student Marian congregation at the Faculty of Arts of Prague University, and of the good fortune that allowed him to defend a philosophical thesis in the name of the Mother of God and the Emperor Leopold. In a clear reference to the engraving in Wallenstein's university thesis, he mentions a monumental statue of the Virgin Mary installed by Emperor Ferdinand III in the Old Town Square as an expression of the triumph of the Queen of Heaven at a place where thirty years earlier, that is, in 1631, the image of the Palladium of the Czech lands had been dishonored by heretics.[76] This is not the only proof that the topic of the Immaculate Conception (connected with the Marian column) resounded in both Wallenstein's and Tanner's circles. In 1664, the Marian congregation of the Litoměřice Jesuit College prepared a written eulogy for Wallenstein celebrating the virtues and heroes of his family.[77] The manuscript contains an image of the Virgin Mary, who descends from the top of the column, and a lion, a heraldic animal of the Wallenstein family, which, confirms with its signature that it will love her forever. Tanner favored this topic as well; in 1685, he gave a sermon during the annual celebration of the Immaculate Conception in the Church of Our Lady before Týn *Oratio de Immaculata Conceptione Beatissimae Virginis*, the print of which he dedicated to his former student, at that time already the archbishop of Prague.[78]

In the Wallenstein thesis, the Prague Marian column is revered by members of all the European nations, including the inhabitants of the non-Catholic countries of Western and Northern Europe and by Orthodox believers in Russia. Here, Mary's Immaculate Conception became part of a unifying universal cult, similar to the metaphor in Paul's Epistle to the Corinthians, where Christ is the head of the body, that is, of the whole church.[79] In the environment of the Jesuit Order, the idea of the only sheepfold and the only shepherd (John 10:16) reverberated with the program of the global mission as rendered by Andrea Pozzo in the ceiling fresco of the Roman Church of St. Ignatius or by Johann Ch. Storer in a widely copied composition of the *Worldwide Activities of Societas Jesu*. In the Prague environment, this idea was developed in detail by Matyáš, brother of Johannes Tanner, also a member of *Societas Jesu*, who published four books on the missionary activities of the Society on all the known continents in the 1670s and 1690s, richly illustrated with allegories of the order's activities in the world and images of prominent Jesuits.[80]

The Marian column functioned as a *lieu de mémoire* with multiple layers of meaning: as a *memoria* of the defense of Prague in 1648, as a political and religious symbol of the victory over local heresy and revolt, as the center of the cult of the Immaculate Conception of the Virgin Mary, and as an object of public and personal piety. The Prague Marian column follows the triumphal idea embodied in the Roman column and emulates closely its predecessors in Munich and Vienna, although there the role of fighters with the creatures of evil was assumed by childish angry-looking *putti*, the Prague combatant angels are true heroic fighters overcoming evil in the struggle for Salvation. The distinction of the Prague column, however, lies not only in the sculptural, already fully Baroque rendition, but also in interwoven layers of meaning that were reflected in the different forms of piety that arose in relation to the column.

The column was primarily a memorial of the successful defense of the Old and New Towns of Prague from Swedish besiegers in 1648, to which the miraculous help of Virgin Mary supposedly contributed. In the dedicatory inscription, however, the monarch himself, as the column's commissioner, expresses thanks to the Mother of God, thus appropriating a share in the successful defense and celestial aid, including them in his political and religious myth of *Pietas Austriaca*.[81] The statue of the Virgin Mary on the top of the column was a personification of the then-unsanctioned dogma of the Immaculate Conception of the Virgin Mary, connected with processions of student Marian congregations and annual gatherings in the Church of Our Lady before Týn, where professors and graduates of Prague University swore an oath of devotion to the Immaculate Conception. All these activities were rooted in an environment of university professors and students and intended for the intellectual elite. They were more open to accepting the Immaculate Conception

than the general population, who were targeted by weekly processions organized by canons from the St. Vitus Church singing one of the most famous and widely known Marian hymns, the Litany of the Blessed Virgin Mary. The lower social strata were targeted by the cult of the image of the Virgin Mary of the Square, which stood in a pedestal niche and referred to the Palladium of the Czech lands and its apotropaic function. Unlike the Marian columns in Munich and Vienna, the Prague column's composition of meanings is much more varied and is related to varied expressions of piety among different social strata and groups. Remarkably, a substantial number of these practices were linked to the Jesuit Order, which demonstrated its extraordinary adaptability in this context. Even though the Old Town Jesuits did not manage to push through the location of the column in front of the order's college, they managed to appropriate it massively for the benefit of their own public activities.

NOTES

1. Ostrow, "Paul V, the Column of the Virgin, and the New Pax Romana," 352–377, 353.

2. Ostrow, "Paul V, the Column of the Virgin, and the New Pax Romana," 366.

3. For a summary of all three monuments see Walter Kalina, "Die Mariensäulen," 1, 43–61, and Susan Tipton, "*Super aspidem et basiliscum ambulabis*," 375–398.

4. Gotthard, *Der Dreißigjährige Krieg*.

5. Schattenhofer, *Die Mariensäule in München*; Kalina, "Die Mariensäulen," 46–48.

6. Schattenhofer, *Die Mariensäule in München*, 6; 38, note 2 (". . . ein gottgefälliges Werk anzustellen . . ."); Tricoire, "'Sklave sein heißt herrschen' Die Münchner und Prager Mariensäulen," 59–70, esp. 64–65.

7. Heal, *The Cult of the Virgin Mary*, 194.

8. The originals are kept in the Munich City Museum as works by the sculptor Ferdinand Murmann, see https://www.muenchner-stadtmuseum.de/sammlungen/angewandtekunst/putti.html.

9. Kurz, *Zur Geschichte der Mariensäule am Hof*; Kalina, "Die Mariensäulen," 48–55.

10. Kalina, "Die Mariensäulen,"45, and also Corethová, *Pietas Austriaca*, 69.

11. Kalina, "Die Mariensäulen," 48–52.

12. The column was transferred to Wernstein at the instigation of Count Georg Ludwig von Sinzendorff, owner of the Neuburg am Inn castle, which stands on a high slope on the opposite bank of the river.

13. Hojda, "Der Kampf um Prag," 403–412.

14. Fiala, Hrdlička, and Županič, *Erbovní listiny Archivu hlavního města*.

15. Norbert Zatočil z Levenburku, *Léto a Dennopis*, 57–58.

16. Evans, *The Making of the Habsburg Monarchy 1550–1700*, 195–234; Louthan, *Converting*.

17. *Causae, ob quas videtur expediens, erigi columnam et statuam Immaculatae Conceptioni Beatisimae Virginis ante templum Academicum Collegii Societatis Jesu Pragae iuxta pontem*, Národní archiv Praha, fond Jesuitica Nr. 116, new pressmark LIII/1–3, box Nr. 92. Many thanks to Kateřina Horníčková for helping me read this source and for commenting on this text.

18. Šroněk, "The Jesuits and Their Urban Visual Presence in the Bohemian Lands," 279–310.

19. Padberg, "How We Live Where We Live," 1–37, esp. 29, https://ejournals.bc .edu/ojs/index.php/jesuit/article/view/3824/3392, accessed 6.28.2018.

20. Sievernich, "The Evangelization of the Great City," 26–45, esp. 38.

21. Jesuit urbanism is addressed in inspiring works by Lucas, S. J., *Saint, Site and Sacred Strategy*; and idem, *Landmarking. City, Church and Jesuit Urban Strategy*. For Prague, arranged clearly, see Petra Nevímová, "Jezuitské koleje v Praze," 367–400, and Šroněk, "The Jesuits and Their Urban Visual Presence," 279–310. For details on the installation of the Jesuit sculptures on the Charles Bridge see Šroněk, "Der Statuenschmuck der Prager Karlsbrücke," 119–140.

22. Novotný, "Účast Jana Jiřího Bendla," 41–55; Blažíček, "Jan Jiří Bendl," 55–91; Blažíček, *Sochařství baroku v Čechách*, 72; Blažíček, "Jan Jiří Bendl," 97–116; Šperling, "Obnova průčelí kostela sv. Salvatora v Praze," 225–232. The concept for the decoration of the Clementinum St. Savior Church's façade was treated most recently in Šroněk, "Tovaryšstvo Ježíšovo," 264–282, and Šroněk, "The Jesuits and Their Urban Visual Presence," 279–310.

23. "*Ma tornando ad collegium in monasterio de S. Clemente questo luogo ci ha piacuto, perche e nel centro della cita et piu comodo alla gioventu, et tiene luogi sofficienti per le schole et classi per stancie et camere noc una buona parte del horto. Et se potre noc poche spese restaurare tutto, et adaptare a una buona habilitatione per questo primo anno.*" Letter from Peter Canisius: Petrus Canisius SJ, Epistulae et Acta I, (1541–1556), 544–552, quote on p. 548–549. See also Sievernich SJ, "Die urbane Option sed Ignatius von Loyla," 173–192. Most recently, see Šroněk, "Tovaryšstvo Ježíšovo," 264–282; idem, "The Jesuits and Their Urban Visual Presence," 279–310.

24. Niemetz, *Antijesuitische Bildpublizistik*, 88–96.

25. On that occasion a print was published depicting the construction in detail: *Relatio Supplicationis in Gratam festae canonisationis SS. Patrum Ignatii Loiolae, Fundatoris Societatis Iesu, & Francisci Xaverii Indiarum Apostoli memoriam Pragae e templo S. Iacobi Antiquae Urbis Ordinis S. Francisci, & S. Thomae Parvae Partis, Ordinis S. Augustini; Ad Salvatoris Societatis Iesu 19. Iuni magno Supplicantium concursu habicae* (Prague: Stephanus Bilina, 1622); Pötzl-Malikova, "Die Feiern anlässlich," 1239–1254.

26. The description of the Roman canonization ceremony for Ignatius of Loyola and Francis Xavier was translated into Czech: "Canonization is public and to all Christendom, through the Pope Gregory XV in year 22 given proclamation and confirmation of the saint and miraculous life of two cherubs of the Society of Jesus, namely, the St. Father Ignatius of Loyola, the founder of the same Order, and St. Francis Xaverius, preacher of the Holy Gospel in overseas countries, from the Italian language rendered to Czech." [Prague]: In Pavel Sessius [?], 1629. As early

as 1617, St. Ignatius's biography was translated by Pedro de Ribadeneira, *Swatey Swatého Diwy a Zázraky . . . Žiwot Jgnacya Logoli*. In 1639, another biography of Ignatius was published, authored by the Jesuit Mikołaj Łęczycki, *Sľáwa Swatého Jgnacya*.

27. The transfer of St. Norbert's relics to Prague, the ceremonies and triumphal arches, were recorded in period writings: *Octiduum S. Norberti triumphantis* (1627); *Translatio S-mi P-tris N-ri Norberti Consummata* (1628); Ioannes Chrysostom van der Sterre, *Echo S. Norberti triumphantis . . .* (1629); *Vita, mors et translatio S. Norberti* (1671). A detailed modern treatment of these sources was made by Straka, *Přenešení ostatků sv. Norberta* and most recently by Louthan, *Converting Bohemia: Force and Persuasion*, 1–646.

28. Palacký, *Dílo Františka Palackého*, 341. See also Seltzer, "Re-envisioning the Saint's Life in Utraquist Historical Writing," 147–166.

29. Naňková, "Architektura 17. století v Čechách," 249–278, esp. 255 and 277. The author identified that Lurago's front of St. Savior Church was directly inspired by a model for the front of the Cathedral of Florence, probably by Lodovico Cigoli (Florence: Museo dell'Opera del Duomo, date): model no. 130.

30. Distelberger, "Dionysio und Ferdinand Eusebio Miseroni," 109–193. Miseroni had already supervised construction work at Prague Castle since 1642, see p. 113.

31. Hengerer, *Kaiser Ferdinand III.*, 303, 514, note 16.

32. Bendl's authorship was long doubted, see Denkstein, Drobná, and Kybalová, *Lapidárium Národního musea*, 80. Initially, even Oldřich J. Blažíček doubted it, "Jan Jiří Bendl," 55–91, who wrote the first monograph on Bendl's life and work. See Novotný, "Účast Jana Jiřího Bendla," 41–55, including an edition of Bendl's petition for courtly liberty where he claims authorship of the Prague Marian column: ". . . *in Prag, auf dem Altstätter ring, ein memmorialseil zuer ehren der glorwüerdigen unbeflegten juengfrauen Mariae. . . .*" See also Blažíček, *Sochařství baroku v Čechách*, 72; see also idem, "Jan Jiří Bendl. Tři sta let od smrti," 97–116; Kořán, "Sochařství. Bendlův barokní realismus," 446; Vlnas, "Mariánský sloup a jeho náměstí, 219–226, in particular 222. Most recently, see Šroněk, "Johann Georg Bendl a mariánský sloup," 197–235.

33. On the theme of gazing upward, see Stoichita, *Das mystische Auge.*

34. For regulations on services at the column, see Teige and Herain, *Staroměstský rynk v Praze*, 245.

35. Vlnas, "Mariánský sloup," 219–226.

36. Vlnas, "Mariánský sloup," 220. Louthan expressed a similar opinion: "In these three decades, Old Town Square was being carefully transformed from a symbol of resistance to an icon of confessional orthodoxy." Louthan, "Religious Art," 53–79, quotation on p. 58.

37. Vlnas, "Mariánský sloup," 219–220. In addition to the so-called Old Town execution of 1621, deserters who willfully left their positions in the battle of Lützen in 1633 were executed there.

38. Ryneš, *Paladium země české. Kapitola*, 100–104 and 108, note 172–179; pp. 170–174, note 188.

39. Ekert, *Posvátná místa král. hl. města Prahy*, 305.

40. Heal, *The Cult of the Virgin Mary*, 194. "For the Austrian Habsburgs . . . Mary served as a symbol of Catholic renewal and reconquest." See also Matsche, *Die Kunst*, 142–148, 142–153. The work of A. Coreth is the classic study of the topic, Corethová, *Pietas Austriaca*.

41. Corethová, *Pietas Austriaca*, 64.

42. Corethová, *Pietas Austriaca*, 69.

43. Beissel, S. J., *Geschichte der Verehrung Maria sim 16 und 17. Jahrhundert*, 217–274.

44. Corethová, *Pietas Austriaca*, 96.

45. Corethová, *Pietas Austriaca*, 67.

46. Hengerer, *Kaiser Ferdinand III*, 227, 475–476, notes 203 and 204. On the Prague Marian column, see Hengerer, *Kaiser Ferdinand III*, 303 and 514, note 16.

47. Schönleben, *Dissertatio polemica* (1680), vol. 2, 167–170, quote on 167: "*Quae alias orbi insistebat Fortuna volubilis; firmata est Austriaco Tricolumnio. Fidei Catholicae zelus, Eucharistiae veneratio, Immacolatae Conceptionis propugnatio, haec sunt quibus coepit assurgere Habspurgo-Austriacum Imperium; et hactenus sustentatum est firmamentis.*"

48. DEO OPT. MAX. SVPREMO COELI TERRAEQUAE IMPERATORI: PER QVEM REGES REGNANT: VIRGINI DEIPARAE IMMACVLATE CONCEPTAE: PER QVAM PRINCIPES IMPERANT: IN PECVLIAREM DOMINAM: AVSTRIAE PATRONAM: SINGVLARI PIETATE: SVSCEPTAE: SE: LIBEROS: POPVLOS: EXERCITVS:

PROVINCIAS: OMNIA DENIQVE CONFIDIT: DONAT: CONSECRAT: ET IN PERPETVAM REI MEMORIAM STATVAM HANC EX VOTO PONIT FERNANDVS TERTIVS AVGVSTVS

Text of the inscription in a print entitled *Maria Virgo Immaculatae Concepta. Publico Voto Ferdinandi III. Rom: Imp: in Austriae Patronam Electa* (Vienna 1648). See also Corethova, *Pietas Austriaca*, 70–72.

49. Matsche, *Die Kunst im Dienst der Staatsidee Kaiser Karls VI*, 153.

50. Matsche, *Die Kunst im Dienst der Staatsidee Kaiser Karls VI*, 96, is also reminiscent of a verse in the breviary related to the Virgin Mary: "*Cunctas haereses sola interemisti*" [You yourself destroyed all heresies].

51. Matsche, *Die Kunst im Dienst der Staatsidee Kaiser Karls VI*, 96. See also similar formulations in Schreiner, "'*sygzeichen*.' Symbolische Kommunikationsmedien in kriegerischen Konflikten des späten Mittelalters und der frühen Neuzeit," in *Sprachen des Politischen*, 20–94, here, 70 "*Als unbefleckt empfangende Mutter Jesu verkörperte Maria die religio immaculata, die unversehrte und unverfälschte Lehre der katholischen Kirche.*" Numerous visual representations were devoted to this concept, for example, in an exemplary work by the Flemish painter Luigi Primo (Louis Cousin 1606–1667/8) kept in the Santa Maria di Monserrato Church in Rome, where the Virgin Mary of Immaculate Conception is depicted with the Holy Trinity, the apostles, and *putti* carrying symbols of the Litany of the Blessed Virgin Mary, saints and representatives of orders that contributed to defending the Immaculate Conception (Franciscans, Carmelites, Jesuits), bishops, cardinals, and popes. Figures of three defeated heretics lie at the very bottom—Mohammed, Luther, and Pelagius. See

Anselmi, *L'Immacolata*, 242–244. See also Cuadriello, "The Political Visualization of the Virgin of the Immaculate Conception," 121–145, and Stratton-Pruitt, *The Immaculate Conception in Spanish Art.*

52. Royt, "Marian Column in Old Town Square," 26–27.

53. For a brief mention of erecting the column see Hammerschmidt, *Prodromus gloriae Pragenae* (1723), 570. For the circumstances of its making and processions to the column see Rigetti and Pannich, *Historische Nachricht sowohl von der Errichtung der Wellischen* (1773), 210–214.

54. These assemblies were held in the presence of the archbishop, always on the first Sunday following the holiday of the Immaculate Conception of Virgin Mary, see Podlaha, "Učení o neposkvrněném početí Panny Marie v Čechách," 472–494 and 553–569; on the university oath, see 478. See also Beránek et al., *Dějiny Univerzity Karlovy 1622–1802*, vol. 2, 37.

55. Psalm 91: 13: *Super aspidem et basiliscum ambulabis et leonem et draconem conculcabis.* The link between these monsters and the four plagues: hunger, war, plague, and heresy as encountered in later literature, however, is of more recent date. It was first used by the Jesuit Joseph Meyer in his 1738 sermon delivered on the occasion of celebrating the centenary of the erection of the column, see Tipton, *"Super aspidem et basiliscum ambulabis,"* 386.

56. Marshall and Walsham, *Angels in the Early Modern World*, 22, 26. They mention the Domenichino painting in the San Genaro Church in Naples, where Archangel Michael crushes Luther and Calvin under his feet.

57. Baumstark, ed., *Rom in Bayern*, 41; Hess and Schneider, eds., *Trophaea Bavarica*, vol. 1, no. 4, 13.

58. Glasser, ed., *Wittelsbach und Bayern*; Heal, *The Cult of the Virgin Mary*, 148–206, esp, 188–206; Terhalle, ". . . ha della Grandezza de padri Gesuiti, 83–146 and 375–411, catalogue numbers 86–110. Most recently on the Archangel Michael Church, see Leuschner, "Propagating St. Michael in Munich," 177–202; Volk-Knüttel, "Der Hochaltar der Münchner Frauenkirche," 203–232.

59. Podlaha, "Dějiny kolejí jezuitských," 10:160–170. On Marian processions see also Volckman, *Gloria universitatis Carolo-Ferdinandeae Pragensis* (1672), 65–66.

60. Vácha, Veselá, Vlnas, and Vokáčová, *Karel VI. & Alžběta Kristýna*, 59.

61. Louthan, *Converting Bohemia*; Mikulec, "Katolická zbožnost a náboženské rituály v pobělohorské době," 166–196, esp. 174. There are a number of period reports; see, for example, two prints published in Prague on the occasion of the Simon Abeles case: Eder, *Virilis Constantia pueri duodennis Simonis Abeles in odium fidei Iudaeo parente, Lazaro Abeles* (1696), 74, and Eder, *Mannhaffte Beständigkeit Des zwölffjährigen Knabens Simons Abeles* (1698), 63–64.

62. Juan Caramuel of Lobkowitz, *Maria liber, id est primi Evangelicorum verbi* (1652). See Catalano, "Pražský mariánský sloup a pobělohorská restaurace katolicismu v Čechách," 38–63.

63. See also the chapter by K. Horníčková in this book.

64. Tricoire, "Sklave sein heißt herrschen," [59]–70, esp. 62–68.

65. Zatočil, *Léto a Dennopis*, 87: "A že jest Nejsvětější Trojice Svatá na přímluvu a Orodování Přeblahoslavené Rodičky Boží Panny Marie města tato pražská od

toho těžkého a nebezpečného obležení švejdského milostivě vysvoboditi ráčila, Jeho císařská a Královská Milost Ferdinand třetí k světský cti a slávě Božské, na poděkování a památku věčnou v létě 1650 slaup kamenný s obrazem Panny Marie na Staroměstském rynku . . . postaviti . . . poručiti ráčil." [And that the Holy Trinity, by the intercession and prayer of the beatified Mother of God Virgin Mary, condescended to free these towns of Prague from the heavy and perilous Swedish siege, His Imperial and Royal Grace Ferdinand III, to secular honor and the glory of God, as thanks and eternal memory, in 1650 condescended to order . . . building . . . a stone column with the image of Virgin Mary in the Old Town Market.] Hammerschmidt, *Prodromus gloriae Pragenae*, 570: "*Anno 1650, die 23. Maji inceperunt fodere fundamenta in foro Vetero-Pragae pro erigenda Columna, et Statua B. V. M. sine labe Conceptae. Quae benedicta est Anno 1652, die 13. Julii in praesentia Caesaris Ferdinandi III et Filii illius Ferdinandi IV. Idem Caesar Ferdinandus III. fecit perpetuam fundationem pro Canonicis Metropolitanis et Musicis, ut omnibus diebus Sabbathinis, et in festis B. V. M. ante hanc Columnam decantentur Litaniae Lauretanae.*"

66. Catalano, "Pražský mariánský sloup," 38–63.

67. For Wallenstein's university thesis from 1661, see Fechtnerová, *Katalog grafických listů univerzitních tezí*, vol. 3, Th. No. 463; Havlík, *Jan Fridrich z Valdštejna*; Hlaváček, "Centrum Christianitatis," 276–287.

68. From the dedication of Wallenstein's thesis.

69. Hlaváček, "Bohemia Cor Europae," 123–140.

70. *Cýsaře Řžijmské[ho] Vherského a Cžeského, [et]c. Krále [et]c. Geho Milosti FERDYNANDA Druhého [et]c. Obnowené Práwo a Zřjzenj Zemské Dědjčného Králowstwj Cžeského*, unpag. introduction.

71. Mikulec, "Das Odium des Verrats," 7–17. A certain embitterment over the disdainful attitude to Czechs is expressed by the Baroque historian František Beckovský: "*Z toho se poznává, že ne sami Čechové, ale také již jmenovaní národové i dědičných zemí stavové témuž císaři Ferdinandovi II. se sprotivili, proti němu bauřili, válčili a (jak nyní říkáme) rebelírovali, kteřížto národové, zvlášť dědičných zemí stavové, zapomenauce se na své Čechům podobné provinění, smějí jak pokautně tak také veřejně za rebellanty sami toliko Čechy dosavad potupně vyhlašovati, je u jiných národův v ošklivost i v zlau pověst uváděti, sami sebe, jako Pilát po hanebném proti Kristu Pánu prohřešení, umývati a sebe očišťovati; ale nechť oni se myjí, jak mohau a jak nejlépe umějí, vždyckny však zůstanau oni pokáleni.*" [And this shows that the Czechs, not by themselves, but also the already-mentioned nations and estates of hereditary lands, opposed the same Emperor Ferdinand II, rebelled against him, waged war and (as we say today) revolted, which nations, in particular the hereditary lands' estates, forgetting their own wrongdoings similar to those of Czechs, are allowed, both in secret and publicly, to declare ignominiously only the Czechs as insurgents, declare them nasty and ill-reputed in the eyes of other nations, and themselves, as Pilate after his shameful sin against Christ, wash and purify; but let them wash as well as they can and do best, they shall remain forever soiled.]

72. Mikulec, "Tradice a symbolika české státnosti," 171–191.

73. Plachý, *Rosa pentaphylla, hoc est: qvinqve sermones panegyrici* (1648).

74. *Ernesto primo Archiepiscopo pragensi* = Arnošt z Pardubic, *Mariale. Sive Liber* (1648).

75. Sommervogel, *Bibliothèque de la Compagnie de Jésus*; Koch S. J., *Jesuitenlexikon*, 1727; Čornejová and Fechtnerová, *Životopisný slovník pražské univerzity*, 463–465.

76. Tanner, *Amphitheatrum gloriae* (1661).

77. *Cataractae gratiarum octo rivis Nemus Walstainicum inundiatum . . . octo heroibus Ioanni Friderico, comiti a Waldstein . . . oratoria et poetica.* Národní knihovna Praha, rkp. sig. XXII C 47.

78. Tanner, *Oratio de Immaculata Conceptione* (1685).

79. I Corinthians 12: 12–14: "For as the body is one, and hath many members, and all the members of that one body, being many, are one body: so also is Christ. For by one Spirit are we all baptized into one body, . . . and have been all made to drink into one Spirit."

80. Tanner, *Societas Jesu usque ad Sanguinis et Vitae Profusionem Militans* (1675); ibid, *Societatis Jesu Apostolorum Imitatrix* (1674). The illustrations were drafted by the Prague artists Karel Škréta and Johann Georg Heinsch. German translations of both titles were also published in Prague. The book's ambition is shown by the fact that Tanner dedicated the first print directly to the order's general, Giovanni Paolo Oliva.

81. "To the Virgin, Mother of Immaculate Conception, for defending and freeing the town, the pious and righteous Emperor erected this statue."

BIBLIOGRAPHY

Manuscript and Archival Sources

National Archive Prague [Národní archiv Praha]:
Causae, ob quas videtur expediens, erigi columnam et statuam Immaculatae Conceptioni Beatisimae Virginis ante templum Academicum Collegii Societatis Jesu Pragae iuxta pontem, Collection Jesuitica no. 116, new sign. LIII/1–3, box 92 (Building of the college, contracts with craftsmen).
National Library Prague [Národní knihovna Praha]:
Cataractae gratiarum octo rivis Nemus Walstainicum inundiatum . . . octo heroibus Ioanni Friderico, comiti a Waldstein . . . oratoria et poetica., Ms. sign. XXII C 47.

Primary Sources

Beckovský, Jan František. *Poselkyně starých příběhův českých. Díl druhý, (od r. 1526–1715). Svazek třetí (L. 1625–1715. i s dodatky), sepsal Jan Beckovský; k vydání upravil Antonín Rezek*. Prague: Dědictví Sv. Prokopa, 1880.
Canisius, Peter. *Petrus Canisius SJ, Epistulae et Acta I, (1541–1556)*. Edited by Otto Braunsberger. Freiburg im Breisgau: Herder, 1896.

Cýsaře Ržijmské[ho] Vherského a Cžeského, [et]c. Krále [et]c. Geho Milosti FERDYNANDA Druhého [et]c. Obnowené Práwo a Zřjzenj Zemské Dědjčného Králowstwj Cžeského. Praha: Šumanská tiskárna, 1627.

Eder, Joann. *Virilis Constantia pueri duodennis Simonis Abeles in odium fidei Iudaeo parente, Lazaro Abeles Pragae crudeliter occisi 21. Februarij, Anno 1694.* Prague: Typis Universitatis Carolo-Ferdinandeae, 1696.

Eder, Johannes. *Mannhaffte Beständigkeit Des zwölffjährigen Knabens Simons Abeles, welche er, um den Christlichen Glauben zu behaupten, an Tag gegeben, da Ihn, Lazarus Abeles sein Jüdischer Vatter, aus Haß des Glaubens, zu Prag, 21. Hornung im Jahr 1694. grausam ermordet.* Prague: Endter, 1698.

Ernest of Pardubice. *Ernesto primo Archiepiscopo pragensi Mariale. Sive Liber. De Praecellentibus et eximiis ss. dei genitricis Mariae et eximiis SS. Dei Genitricis Mariae supra reliquas creaturas praerogativis.* Prague: Caesareo-Academicis, 1648.

Felíř, František Vácslav. *Letopis 1723–1756.* Edited by Jan Vogeltanz. Prague: Argo, 2011.

Hammerschmidt, Joan Florian. *Prodromus gloriae Pragenae.* Prague: Wolffgangi Wickhart, 1723.

Hess, Günter, and Sabine M. Schneider, eds. *Trophaea Bavarica. Bayerische Siegeszeichen.* Regensburg: Schnell und Steiner, 1997.

Jireček, Hermenegild, ed. *Obnovené právo a Zřízení zemské dědičného království Českého = Verneuerte Landes-Ordnung des Erb-Königreichs Böhmen 1627.* Prague: F. Tempský, 1888.

Kanonyzacy to jest, veřejné a všemu křesťanstvu skrze Řehoře papeže Patnáctého, léta 22. předložené vyhlášení a potvrzení svatého a zázračného života dvou Tovaryžstva Ježíšového cherubínův, jmenovitě sv. otce Ignaciá Loyoly, téhož řádu zakladatele a sv. Františka Xaverya, sv. Evanjelium v zámorských zemích zvěstovatele, z jazyka vlaského, v český uvedené. Prague: Pavla Sessia, 1629.

Łęczycki, Mikołaj. *Sľáwa Swatého Jgnacya Towaryšstwa Pána Gežjsse Zakľadatele. Ku Památce Zaľoženj Kosteľa při Městě Březnicy téhož S Jgnacya Towaryšstwa pod Gménem geho, a giných Swatých s nim do Počtu Swatých od Papeže Ržehoře toho Gména Patnácého Léta Páně 1622. Dne 12. Března wľožených. Nynj w Cžeském Yazyku wydaná.* Prague: Wytisstěný w Starém Městě Pražském w Staré Kollegi. Léta Páně, 1639.

Lobkovic, Juan Caramuel. *Maria liber, id est primi Evangelicorum verbi, quod liber est, et angelorum imperatrici ad scribitur dilucidatio, plus conceptus evangelici.* Prague: Typis Schiparzianis, 1652.

Maria Virgo Immaculatae Concepta. Publico Voto Ferdinandi III. Rom: Imp: in Austriae Patronam Electa. Vienna: Matthaeus Cosinerovius, 1648.

Octiduum S. Norberti triumphantis: Ut audiant, qui non viderunt. Repraesentantibus triumphatoris ipsius in monte Sion Pragæ filiis. Prague: Petrum Gelehn, 1627.

Paprocký z Hlohol a Paprocké Vůle, Bartoloměj. *Zrdcadlo Slawného Margkrabstwij Morawského: W kterémž geden každý Staw, dáwnost, wzáctnost, y powinnost swau vhléda.* Olomouc: Friedrich Milichthaler, 1593.

Plachý, Jiří František. *Rosa pentaphylla, hoc est: qvinqve sermones panegyrici, in praecipuas festivitates B. Mariae Virginis, qvinqve conceptionis, nativitatis, annvntiationis, pvrificationis, et assvmptionis.* Prague: Academicis, 1648.

Relatio Supplicationis in Gratam festae canonisationis SS. Patrum Ignatii Loiolae, Fundatoris Societatis Iesu, & Francisci Xaverii Indiarum Apostoli memoriam Pragae e templo S. Iacobi Antiquae Urbis Ordinis S. Francisci, & S. Thomae Parvae Partis, Ordinis S. Augustini; Ad Salvatoris Societatis Iesu 19. Iuni magno Supplicantium concursu habicae. Prague: Stephanus Bilina, 1622.

Ribadeneira, Pedro de. *Swatey Swatého Diwy a Zázraky schwáleného Obcowánj Žiwot Jgnacya Logoli Ržádu Towarystwa Gména GEŽJSSOWEHO Zakľadatele. Od Petra Rybadeneyry Včedlnjka a Towarysse geho hodnowěrně sepsaney a neyprw w Čzesstině wydaney.* Prague: Tobiáš Leopolt, 1617.

Rigetti, Peter, and Johann Christoph Pannich. *Historische Nachricht sowohl von der Errichtung der Wellischen Congregation unter dem Titel Mariä Himmelfahrt als auch des dazu gehörigen Hospitals B. V. Mariae ad S. Carolum Borromeum.* Prague: Johann Pruschinn Wittib, 1773.

Schönleben, Johann L. *Dissertatio polemica de prima origine augustissimae Domus Habsburgico-Austriacae.* Labaci: Johann Baptistae Mayr, 1680.

Sterre, Ioannes Chrysostom van der. *Echo S. Norberti triumphantis.* Antwerp: Guilielmum Lesteenium, 1629.

Tanner, Joannes. *Amphitheatrum gloriae, spectaculis leonum Waldsteinicorum adornatum.* Prague: Vniversitatis Carolo Ferdinandeae, in Collegio Societ. Iesv ad s. Clementem, 1661.

Tanner, Joannes. *Oratio de Immaculata Conceptione Beatissimae Virginis Dei Genitricis Mariae, Super Psalmum 86, PRAGAE in Basilica Teinensi, Dum Carolo-Ferdinandea Pragensis Universitas Votum de eodem mysterio pie asserendo more annuo renovare.* Prague: Universitatis Carolo-Ferdinandeae in Collegio Societatis Jesu ad S. Clementem, 1685.

Tanner, Matthias. *Apostolorum Imitatrix, seu gesta praeclara et virtutes eorum qui è societate Jesuin procuranda salute animarum, per Apostolicas Missiones, Conciones, Sacramentorum Ministeria, Evangelii inter Fideles et Infideles propagationem ceteraque munia Apostolica, per totum Orbem terrarum speciali ƶelo desudarunt.* Prague: Universitae Carolo-Ferdinandae,1694.

Tanner, Matthias. *Societas Jesu usque ad sanguinis et vitæ profusionem militans, in Europa, Africa, Asia, et America, contar Gentiles, Mahometanos, Judæos, Hæreticos, impios, pro Deo, Fide, Ecclesia, Pietate. Sive vita, et mors eorum qui ex Societate Jesu in causa fidei, & virtutis propugnatæ, violenta morte toto Orbe sublati sunt.* Prague: Universitae Carolo-Ferdinandae, 1675.

Translatio S-mi P-tris N-ri Norberti Consummata: referentibus iterum ipsius in monte Sion Pragæ Filiis. Prague: Pavli Sessii, 1628.

Vita, mors et translatio S. Norberti, Magdeburgensis Archiepiscopi, Germaniae Apostoli, Canonicorum Praemonstratensium Patriarchae. Prague: Archi-Episcopalibus, in Collegio S. Norberti: Paulus Tuchscherer, 1671.

Volckman, Martin Xaver. *Gloria universitatis Carolo-Ferdinandeae Pragensis trIgInta trIbus encomiis orbi divulgata.* Prague: Universitatis Carolo-Ferdinandeae, 1672.

Zatočil z Levenburku, Jan Norbert, *Léto a Dennopis celého královského Starého i Nového měst Pražských léta Páně 1648 patnácte neděl, dnem i nocí trvajícího obležení Švédského: Pravdivé a ubezpečlivé vypsání léta 1685 původem a nákladem Jana Roberta Zatočila z Levenburku.* Prague: Wytisstěný w Starém Městě Pražském: u Kateřiny Cžernochové,1685.

Secondary Literature

Anselmi, Alessandra. *L'Immacolata nei rapporti tra l'Italia e la Spagna.* Rome: De Luca Ed. d'Arte, 2008.

Baumstark, Reinhold, ed. *Rom in Bayern. Kunst und Spiritualität der ersten Jesuiten.* Munich: Hirmer, 1997.

Beissel, Stephan, S. J. *Geschichte der Verehrung Marias im 16.und 17. Jahrhundert. Ein Beitrag zur Religionswissenschaft und Kunstgeschichte.* Freiburg im Breisgau: Herder, 1910.

Beránek, Karel et al., *Dějiny Univerzity Karlovy II. 1622–1802.* Prague: Univerzita Karlova, 1996.

Blažíček, Oldřich J. "Jan Jiří Bendl, pražský sochař časného baroku." *Památky archeologické* 40 (1937): 55–91.

Blažíček, Oldřich J. "Jan Jiří Bendl. Tři sta let od smrti zakladatele české barokové plastiky." *Umění* 30 (1982): 97–116.

Blažíček, Oldřich J. *Sochařství baroku v Čechách. Plastika 17. a 18. věku.* Prague, 1958.

Catalano, Alessandro. "Pražský mariánský sloup a pobělohorská restaurace katolicismu v Čechách." In *Mariánský sloup na Staroměstském náměstí v Praze. Počátky rekatolizace v Čechách v 17. století,* edited by Ondřej Jakubec and Pavel Suchánek, 38–63. Prague: NLN, 2019.

Corethová, Anna. *Pietas Austriaca. Fenomén rakouské barokní zbožnosti.* Olomouc: Refugium Velehrad-Roma, 2013.

Cuadriello, Jaime. "The Theopolitical Vizualization of the Virgin of the Immaculate Conception. Intentionality and Socialization of Images." In *Sacred Spain. Art and Belief in the Spanish World,* edited by Ronda Kasl, 121–145. New Haven: Yale University Press, 2009.

Čornejová, Ivana and Anna Fechtnerová. *Životopisný slovník pražské univerzity. Filozofická a teologická fakulta 1654–1773.* Prague: Univerzita Karlova, 1986.

Denkstein, Vladimír, Zoroslava Drobná and Jana Kybalová. *Lapidárium Národního musea.* Prague: Státní nakladatelství krásné literatury, hudby a umění, 1958.

Diemer, Peter and Hubert Glasser, ed. *Wittelsbach und Bayern. Um Glauben und Reich. Kurfürst Maximilian I.* Munich: Hirmer, 1980.

Distelberger, Rudolph. "Dionysio und Ferdinand Eusebio Miseroni." *Jahrbuch der Kunsthistorischen Sammlungen in Wien* 75 (1979): 109–193.

Evans, Robert J. W. *The Making of the Habsburg Monarchy 1550–1700.* Oxford: Oxford University Press, 1985.

Fechtnerová, Anna. *Katalog grafických listů univerzitních tezí uložených ve Státní Knihovně ČSR v Praze*, 4 vols. Prague: Státní knihovna ČSR, 1984.

Fiala, Michal, Jakub Hrdlička, and Jan Županič. *Erbovní listiny Archivu hlavního města Prahy a Nobilitační privilegia studentské legie roku 1648*. Prague: Scriptorium, 1997.

František Ekert. *Posvátná místa král. hl. města Prahy: dějiny a popsání chrámů, kaplí, posvátných soch, klášterů a jiných pomníků katolické víry a náboženosti v hlavním městě království Českého*, 2 vols. Prague: Dědictví sv. Jana Nepomuckého, 1883–1884, reprint: Prague: Volvox Globator, 1996.

Gotthard, Axel. *Der Dreißigjährige Krieg. Eine Einführung*. Cologne: Böhlau Verlag, 2016.

Havlík, Jiří. *Jan Fridrich z Valdštejna. Arcibiskup a mecenáš doby baroka*. Prague: Vyšehrad, 2016.

Heal, Bridget. *The Cult of the Virgin Mary in Early Modern Germany. Protestant and Catholic Piety, 1500–1648*. Cambridge: Cambridge University Press, 2009.

Hengerer, Mark. *Kaiser Ferdinand III. (1608–1657) Eine Biographie*. Wien – Köln – Weimar: Böhlau, 2012.

Hlaváček, Petr. "*Bohemia Cor Europae*. Die geopolitischen und theologischen Vorstellungen über die Rolle Böhmens und Tschechen in der Reformationszeit." In *Religion und Naturwissenschaften im 16. und 17. Jahrhundert*, edited by Kaspar von Greyerz, Thomas Kaufmann, Kim Siebenhüner, and Roberto Zaugg, 123–140. Gütersloh: Gütersloher Verl.-Haus 2010.

Hlaváček, Petr. "*Centrum Christianitatis*: České království a vizualizace evropských národů na univerzitní tezi Jana Bedřicha z Valdštejna (1661)." In *O felix Bohemia! Studie k dějinám české reformace. K poctě Davida R. Holetona*, edited by Petr Hlaváček, et al., 276–287. Prague: Univerzita Karlova v Praze, Filozofická fakulta: Filosofia, 2013.

Hojda, Zdeněk. "Der Kampf um Prag 1648 und das Ende des Dreißigjährigen Krieges." In *1648 – Krieg und Frieden in Europa. 26. Europaratausstellung. Ausstellungskatalog*, edited by Klaus Bußmann and Heinz Schilling, 403–412. Muenster: Veranst.-Ges. 350 Jahre Westfäl. Friede, 1988.

Kalina, Walter. "Die Mariensäulen in Wernstein am Inn (1645/47), Wien (1664/66), München (1637/38) und Prag (1650)." *Österreichische Zeitschrift für Kunst und Denkmalpflege* 58, no. 1 (2004): 43–61.

Koch S. J. Ludwig. *Jesuitenlexikon. Die Gesellschaft Jesu einst und jetzt*. Paderborn: Bonifacius-Druckerei, 1934.

Kořán, Ivo. "Sochařství. Bendlův barokní realismus." In *Praha na úsvitu nových dějin. (čtvero knih o Praze) architektura, sochařství, malířství, umělecké řemeslo*, edited by Emanuel Poche et al., 446–448. Prague: Panorama, 1988.

Kurz, Joseph. *Zur Geschichte der Mariensäule am Hof und der Andachte derselben*. Vienna: In Kommission bei H. Kirsch, 1904.

Leuschner, Eckhard. "Propagating St. Michael in Munich: The New Jesuit Church and its Early Representations in the Light of International Visual Communications." In *Le monde est une peinture. Jesuitische Identität und die Rolle der Bilder*, edited by Elisabeth Oy-Marra and Volker R. Remmert, 177–202. Berlin: Akademie-Verlag, 2011.

Louthan, Howard. "Religious Art and the Formation of a Catholic Identity in Baroque Prague." In *Embodiments of Power. Building Baroque Cities in Europe*, edited by Gary B. Cohen and Franz A. J. Szabo, 53–79. New York: Berghahn Books, 2008.

Louthan, Howard. *Converting Bohemia: Force and Persuasion in the Catholic Reformation*. Cambridge: Cambridge University Press, 2009.

Lucas, Thomas M., S. J. *Landmarking. City, Church and Jesuit Urban Strategy*. Chicago: Loyola Press, 1997.

Lucas, Thomas M., S. J. *Saint, Site and Sacred Strategy. Ignatius, Rome and Jesuit Urbanism*. Vatican City: Bibl. Apostolica Vaticana, 1990.

Marshall, Peter, and Alexandra Walsham. *Angels in the Early Modern World*. Cambridge: Cambridge University Press, 2006.

Matsche, Franz. *Die Kunst im Dienst der Staatsidee Kaiser Karls VI. Ikonographie, Ikonologie und Programmatik des "Kaiserstils."* Berlin: de Gruyter, 1981.

Mikulec, Jiří. "Das Odium des Verrats und des Mythos der Loyalität. Die Böhmen in der Habsburgermonarchie in der ersten Hälfte des 18. Jahrhunderts." In *Polen und Österreich im 18. Jahrhundert*, edited by Walter Leitsch, Stanisław Trawkowski, and Wojciech Kriegseisen, 7–17. Warsaw: Wydawnictwo Naukowe Semper, 2000.

Mikulec, Jiří. "Katolická zbožnost a náboženské rituály v pobělohorské době." In *Mariánský sloup na Staroměstském náměstí v Praze. Počátky rekatolizace v Čechách v 17. století*, edited by Ondřej Jakubec and Pavel Suchánek, 166–196. Prague: NLN, 2019.

Mikulec, Jiří. "Tradice a symbolika české státnosti u barokních vlastenců." In *Vývoj české ústavnosti v letech 1618–1918*, edited by Karel Malý and Ladislav Soukup, 171–191. Prague: Karolinum, 2006.

Naňková, Věra. "Architektura 17. století v Čechách." In *Dějiny českého výtvarného umění II/1. Od počátků renesance do závěru baroka*, edited by Jiří Dvorský, 249–278. Prague: Academia, 1989.

Nevímová, Petra. "Jezuitské koleje v Praze." *Documenta pragensia* 20 (2002): 367–400.

Niemetz, Michael. *Antijesuitische Bildpublizistik in der frühen Neuzeit. Geschichte, Ikonographie und Ikonologie*. Regensburg: Schnell & Steiner, 2008.

Novotný, Vladimír. "Účast Jana Jiřího Bendla na výzdobě kostela sv. Salvátora v Praze." *Památky archeologické* 40 (1937): 41–55.

Ostrow, Steven F. "Paul V, the Column of the Virgin, and the New Pax Romana." *Journal of the Society of Architectural Historians*, 69, no. 3 (2010): 352–377.

Padberg, John W. "How We Live Where We Live." *Studies in the Spirituality of Jesuits* 20, no. 2 (1988): 1–37.

Palacký, František. *Dílo Františka Palackého. Svazek druhý. Staří letopisové čeští od roku 1378 do 1527 čili pokračování v kronikách Přibíka Pulkavy a Beneše z Hořovic z rukopisů starých vydané*, edited by Jaroslav Charvát. Prague: L. Mazáč, 1941.

Podlaha, Antonín. "Dějiny kollejí jezuitských v Čechách a na Moravě od r. 1654 až do jejich zrušení." *Sborník Historického kroužku* 10 (1909): 73–88, 158–174; 11

(1910): 64–78; 12 (1911): 84–94, 161–168; 13 (1912): 57–75; 14 (1913): 195–209; 15 (1914): 105–107.

Podlaha, Antonín. "Učení o neposkvrněném početí Panny Marie v Čechách před prohlášením učení toho za dogma." *Časopis katolického duchovenstva* 7–8 (1904): 472–494 and. 9: 553–569.

Pötzl-Malikova, Maria. "Die Feiern anlässlich der Heiligsprechung des Ignatius von Loyola und des Franz Xaver im Jahre 1622 in Rom, Prag und Olmütz." In *Bohemia Jesuitica 1556–2006*, vol 2, edited by Petronilla Cemus and Richard Cemus SJ, 1239–1254. Prague: Karolinum, 2010.

Royt, Jan. "Mariánský sloup na Staroměstském náměstí." *Dějiny a současnost* 16, no. 5 (1994): 26–27.

Ryneš, Václav. *Paladium země české. Kapitola z českých dějin náboženských.* Prague: Universum, 1948.

Seltzer, Joel. "Re-envisioning the Saint's Life in Utraquist Historical Writing." *The Bohemian Reformation and Religious Practice. Papers from the Fifth International Symposium on The Bohemian Reformation and Religious Practice held at Vila Lanna, Prague 19–22 June 2002.* 5. Part 1 (2004): 147–166.

Schattenhofer, Michael. *Die Mariensäule in München.* Munich: Schnell und Steiner, 1971.

Schreiner, Klaus. "sygzeichen." Symbolische Kommunikationsmedien in krieger-ischen Konflikten des späten Mittelalters und der frühen Neuzeit. In *Sprachen des Politischen: Medien und Medialität in der Geschichte*, edited by Ute Frevert and Wolfgang Braungart, 20–94. Göttingen: Vandenhoeck und Ruprecht, 2004.

Sievernich, Michael, SJ. "Die urbane Option sed Ignatius von Loyla am Beispiel der Metropole Prag." In *Bohemia Jesuitica 1556–2006*, vol. 1, edited by Petronilla Cemus and Richard Cemus SJ, 173–192. Prague: Karolinum, 2010.

Sievernich, Michael. "The Evangelization of the Great City. Ignatius Loyola's urban vision." *Review of Ignatian Spirituality* 80 (1995): 26–45.

Sommervogel, Carlos. *Bibliothèque de la Compagnie de Jésus. Première partie. Bibliographie, par les pères Augustin et Aloys de Backer. Seconde partie. Histoire, par le P. Auguste Carayon. Nouvelle édition, par Carlos Sommervogel . . .*, 9 vols. Brussels: Oscar Schepens; Paris: Alphonse Picard, 1890–1932.

Stoichita, Victor I. *Das mystische Auge. Vision und Malerei im Spanien des goldenen Zeitalters.* Munich: Fink, 1997.

Straka, Cyril. *Přenešení ostatků sv. Norberta z Magdeburku na Strahov (1626–1628).* Prague: Ladislav Kuncíř, 1927.

Stratton-Pruitt, Suzanne L. *The Immaculate Conception in Spanish Art.* Cambridge: Cambridge University Press, 1994.

Šperling, Ivan. "Obnova průčelí kostela sv. Salvatora v Praze." *Zprávy památkové péče* 25, no. 8 (1965): 225–232.

Šroněk, Michal. "Der Statuenschmuck der Prager Karlsbrücke in der Bildpropaganda der Gesellschaft Jesu. Die Brücke und ihre Ausschmückung in ihrer geschich-tlichen Entwicklung vom 12. bis zum 20. Jahrhundert." In *Jesuitische Frömmigkeitskulturen. Konfessionelle Interaktion in Ostmitteleuropa 1570–1700*, edited by Anna Ohlidal and Stefan Samerski, 119–140. Stuttgart: Steiner, 2006.

Šroněk, Michal. "Johann Georg Bendl a mariánský sloup v Praze." In *Mariánský sloup na Staroměstském náměstí v Praze. Počátky rekatolizace v Čechách v 17. století,* edited by Ondřej Jakubec and Pavel Suchánek, 197–235. Prague: NLN, 2019.

Šroněk, Michal. "The Jesuits and Their Urban Visual Presence in the Bohemian Lands." In *Faces of Community in Central European Towns: Images, Symbols, and Performances, 1400–1700,* edited by Kateřina Horníčková, 279–310. Lanham, MA: Lexington, 2018.

Šroněk, Michal. "Tovaryšstvo Ježíšovo a město jako prostor řádové reprezentace." *Umění* 66 (2018): 264–282.

Teige, Josef, and Jan Herain. *Staroměstský rynk v Praze.* Prague: Společnost přátel starožitností českých, 1908.

Terhalle, Johannes. ". . .ha della Grandezza de padri Gesuiti. Die Architektur der Jesuiten um 1600 und St. Michael in München." In *Rom in Bayern*, edited by Reinhold Baumstark, 83–146 and cat. 86–110, 375–411.

Tipton, Susan. "'Super aspidem et basiliscum ambulabis.' Zur Entstehung der Mariensäulen im 17. Jahrhundert." In *Religion und Religiosität im Zeitalter des Barock,* edited by Barbara Becker-Cantarino, Heinz Schilling and Walter Sparn, 375–398. Wiesbaden: Harrassowitz, 1995.

Tricoire, Damien. "Sklave sein heißt herrschen, Die Münchner und Prager Mariensäulen in ihrem religiösen und politischen Kontext." In *Transregionalität in Kult und Kultur,* edited by Marco Bogade, 59–70. Cologne: Böhlau Verlag, 2016.

Vácha, Štěpán, Irena Veselá, Vit Vlnas, and Petra Vokáčová. *Karel VI. & Alžběta Kristýna. Česká korunovace 1723.* Prague: Paseka, 2009.

Vlnas, Vít. "Mariánský sloup a jeho náměstí (poznámky o smyslu a místě)," *Zprávy památkové péče* 75, no. 3 (2015): 219–226.

Volk-Knüttel, Brigitte. "Der Hochaltar der Münchner Frauenkirche von 1620 und seine Gemälde von Peter Candid." In *Monachium sacrum. Festschrift zur 500-Jahr-Feier der Metropolitankirche Zu Unserer Lieben Frau in München,* edited by Hans Ramisch, 203–232. Munich: Deutscher Kunstverlag, 1994.

Internet Sources

[NN] München, Stadtmuseum, Putti from Mariancolumn: sculptor Ferdinand Murmann. https://sammlungonline.muenchner-stadtmuseum.de/objekt/putto-von-der-muench-ner-mariensaeule-im-kampf-mit-dem-loewen-krieg-10011759.html

https://sammlungonline.muenchner-stadtmuseum.de/objekt/putto-von-der-muench-ner-mariensaeule-im-kampf-mit-dem-drachen-hunger-10011760.html

https://sammlungonline.muenchner-stadtmuseum.de/objekt/putto-von-der-muench-ner-mariensaeule-im-kampf-mit-der-schlange-ketzerei-10011761.html

https://sammlungonline.muenchner-stadtmuseum.de/objekt/putto-von-der-muench-ner-mariensaeule-im-kampf-mit-dem-basilisken-pest-10011758.html Accessed August 5, 2021

Chapter 3

Devotional Image Series in Jesuit Missions

On the Early Modern Multiplication of the Image

Michal Šroněk and Kateřina Horníčková

For the Jesuits, the ideological conception of how to use the image in religious practice was a highly intellectual matter and under the full control of the order, whose concern was that Catholic content be expressed in the most compelling way to appeal most imaginatively to the widest possible audience. The choice of visual media, which used the widest possible range of image carriers, was also subordinated to the intention to make the maximum impact on the viewer. Different types of artistic creation were used, from altarpieces to prints, murals, sculpture, ephemeral architecture to music, performance, and theater, all adapted to a target audience and environment. A particular conceptual idea could thus be translated into different media according to the specific audience it was intended to affect and in what way. Different groups of viewers were addressed in different media.

The type of media and image qualities were subordinated to the context of the expected reception. The aim was to evoke an emotional effect in the viewer that would lead to a deeper religious experience for the believer, even an inner conversion. The media nature of the image depended on the physical medium (carrier), which also defined the context of placement and the physical nature of the image, which in turn impacted the level of reception and effect on the viewer. Therefore, the Jesuits paid close attention to selecting the media that were to carry images and to adaptating the image for these different media. The Jesuits, like Hans Belting much later, considered the media character (in German *Medialität*) of the image to be an important element in communicating with the viewer-believer.[1]

The Jesuit use of the image in religious practice was also characterized by two other factors that determined and framed the use of the image in a missionary setting. The first was the ability to link the global goals of the order's missionary activity with local inspiration and application, and the second was the desire to process knowledge thoroughly into an all-encompassing system unified in totality and complexity. Both approaches were manifested in, among other things, the attempt to grasp phenomena as fully as possible through imagery, which included creating pictorial collections of miraculous images and extensive cycles of narrative depictions of the legends of the saints. The spirit of both approaches had a universal-global and a local level and showed a striving for complete and comprehensive treatment.

In the milieu of the Jesuit Order, the idea that its mandate was to spread the Christian faith throughout the then-known world, despite distance or regional differences in culture, civilization, or religion, developed soon after it was founded. The Jesuits' global mission strategy took shape within this universal vision of the world. In this conception, the order's action is not determined by human decision and will, but is seen as a divine intention, confirmed by Christ himself and his words *"Ego vobis propitius ero"* that appeared to St. Ignatius in La Storta on the way to Rome with the program of the new order.

The quest for a unified and comprehensive grasp of the universe in its totality and in its local manifestations involved the idea of God as a universal entity whose principles operate globally in the same way and are graspable through a systematic knowledge of particulars.[2] The Jesuit understanding of the "unity and openness of divine inspiration" in the world linked the supernatural world directly to the earthly world, and the two systems were understood to be internally ordered according to the same unifying system.[3] Just as Mannerist collectors of the sixteenth century sorted their collections in cosmological order, which helped them grasp the world in a systematic way, the Jesuits approached the world as a whole from a similar angle. In the Jesuit conception, the world has a figurative nature, a kind of "(mental) image" (*"le monde est une peinture"*) that is subject to unified and reciprocal relationships and laws governing both the earthly and the supernatural.[4] This construct opened the way to a systematic grasp of the supernatural world by means similar to the "rational" means in the terrestrial world. In this conception, the supernatural exists "naturally" in the world, anchored in a particular place by the intrinsic reasons for its existence. The divine plan, in which reverence for the Christ and the Virgin Mary played a major role, was literally translated into the idea of an "invisible" divine safety net of salvation spread over the earth that was materialized in places where the divine miraculous action could be felt more strongly than elsewhere—a local manifestation with general universal validity.

JESUIT DEVOTIONAL IMAGE SERIES AND
THEIR GLOBAL DISSEMINATION

In carrying out their global mission, the Jesuits worked with visual media as universally and systematically as with other means of spreading the faith. With the idea of a comprehensive impact on the viewer, compendia that systematized different areas of knowledge, both secular knowledge and themes of faith, into coherent "scientific" units and "rational" frameworks took on an extraordinary role in the Jesuit environment. The effort to organize substances, including images, into series and sets arose from the contemporary drive for rationalization and classification in the natural sciences. In the field of systematic collection and compilation of image collections from a multitude of sources, this approach contributed outwardly to the impression of a deeper didactic treatment, if not the "scientific nature" of these image collections. Although extensive narrative cycles of, for example, the lives of the saints, already existed, the Jesuit image collections were a new kind of imagery in which religious ideas and the physical world intersect in an attempt to grasp and process the theme of holiness comprehensively in both its sacred and earthly manifestations. In addition to the intensive collection of the legends of saints, culminating in large-scale editorial projects such as the *Acta sanctorum, Patrologia latina et graeca*, these were initially collections of images of martyrdoms such as those painted in Santo Stefano Rotondo, the church of the Jesuit college of the Germanic and Hungarian nations (*Germanicum et Hungaricum*) in Rome, and other similar ensembles in the churches of San Apollinare and San Tomasso di Canterbury.

Jerónimo Nadal (1507–1580) was the one who brought this originally internal model into the setting of the Jesuit evangelizing mission. Although Ignatius of Loyola was the conceptual creator of the idea of active missionary work for the order, Nadal gave the Jesuit mission program its broad scope of action and, consequently, an imaginative tool.[5]

Nadal was fascinated by the expansion and multifocal global outreach of the order's missionary activity. The goal was the mobility not only of people but also of themes. The related effort to unify, systematize, and classify the evangelizing themes was similar to the systematization of natural species, giving them a kind of rational ordering that allowed for global intelligibility. Images were better suited than text to demonstrate dogmas and saints' narratives effectively on a wide scale and for different groups. Nadal's *Evangelicae historiae imagines* [figure 3.1] is a pictorial compendium of the life of Jesus, intended primarily for meditative contemplation and instruction, which covers a wide range of Gospel events associated with the life of Christ.[6] The visual narrative ideologically follows the tradition of medieval *Bilderbücher* (picture books), but in contrast to its medieval biblical

predecessors, the emphasis is not on the narrative itself, but on clarity and comprehensibility, didacticism, and also the dramatic and emotional nature of the situations presented, which are meant to be an impulse for contemplation. Nadal, as he states in the preface, explicitly followed the instructions of St. Ignatius, who himself, according to the testimony of Bartolomeo Ricci printed in the prologue to the *Vita Christi* of 1607, "nevertheless, whenever he was going to meditate on those mysteries of Our Savior, shortly before his prayer he looked at the pictures that he had collected and displayed around his room for this purpose."[7] According to the testimony of contemporaries, the *Evangelicae historiae imagines* were similarly intended to serve as a starting point and inspiration for young Jesuits' prayers and meditations. In addition, however, Nadal's cycle (and cycles like it) had an impact on the formation of a unified, specific visuality associated with the biblical narrative in the Jesuit catechetical setting, with dramatic focal emphasis, realistic representation, and narrative details that aimed at a meditative and instructive form of audience reception. Nadal's *Evangelicae historiae imagines* was the first work to attain a measure of global reception and to influence visual culture across continents.[8] It is only a slight exaggeration to say that the output of this press was the early modern equivalent of today's blockbuster novels.

The Jesuits initiated several such printed series with rich illustrations. A work little-noticed so far is the remarkable book by the Jesuit author Georg Scherer, *Preces ac meditationes piae in mysteria passionis ac resurrectionis Jesu Christi collectae . . . figuris aeneis ab Alberto Dürero olim sculptis ornatae* (Prayers and pious meditations on the mysteries of the Passion and Resurrection of Jesus Christ . . . decorated with copper plates once engraved by Albert (*sic!*) Dürer), published in Vienna in 1591 and in Brussels in 1612, with illustrations based on Albrecht Dürer's designs by the Dutch engraver Willem de Haen.[9] The pictorial accompaniment certainly benefited from the long-lasting interest in the German master's work, and at the same time may have been one of the reasons for the enduring popularity of Dürer's compositions in Central Europe deep into the seventeenth century. At the same time, the de Haen illustrations of Scherer's writing illustrate the transformation and updating of Dürer's original prints for a new purpose. Indeed, Willem de Haen copies the model precisely down to the typical signature and date, even though his initials make it clear that this is a re-creation. He fundamentally alters the lighting arrangements of the compositions, however, reinforcing the contrast between dark and light areas, which achieves greater drama, thus "Baroque-cizing" Dürer's work and moving it to a plane that was closer to the taste of the viewer at the turn of the sixteenth century and in the seventeenth. Such amendments, attempting to affect the viewer deeply emotionally, are a characteristic mark of the transformation of contemporary vision.

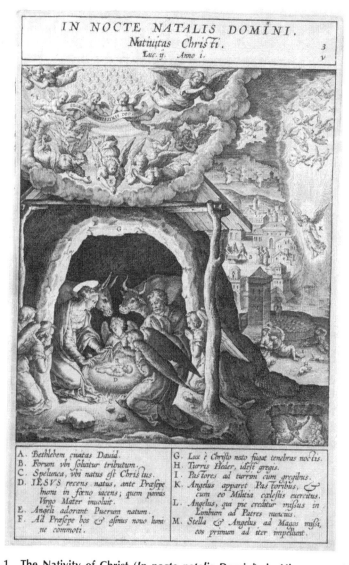

Figure 3.1 The Nativity of Christ (*In nocte natalis Domini*), in Hieronymus Natalis, Adnotationes et Meditationes. Copper engraving on paper by Hieronymus Wierix, Antwerp, 1595.

From around 1600s onward, large thematic sets of prints and illustrations such as those of Nadal and Scherer developed their own local circuits of reception in the mission areas in Central Europe, South America, and India. They were highly influential in creating a new visuality, all the more so when they conveyed basic doctrinal themes such as biblical narratives or

representations of saints in a style that conformed to the Counter-Reformation concept of a truthful and emotionally compelling image. The same was true in Bohemia and Moravia; the *Evangelicae historiae imagines* are widely extant in large numbers in the historical libraries of the Bohemian lands. In some specimens, it is possible to identify their owners' thanks to ownership markings, among whom the Jesuits predominate. Two volumes of Nadal's work, that is, *Adnotationes et meditationes* and *Evangelicae historiae imagines*, now in the National Library in Prague were part of the library of the Jesuit *casa professa* (the religious house that served the Jesuits who took their fourth vows) in Prague Lesser Town (Malá Strana). Another copy was owned by the Jesuit college in Jičín. Another copy, also kept in the National Library, bears a remarkable inscription proving that Nadal's writings were kindly (*ex liberalitate*) donated to the library of the Jesuit college in the Clementinum in 1595 by John of Pernštejn and his wife Marie Manrique de Lara Jr. The high esteem in which Nadal's *Evangelicae historiae imagines* were held is evidenced by a copy in the Austrian National Library in Vienna that probably belonged to Archduke Albrecht VII, called the Pious (brother of Emperor Rudolf II), who was governor of the Spanish Netherlands from 1596 to 1621. The leather binding of the book is exquisitely ornamented in gilt and silver, with the archduke's coat of arms and the Order of the Golden Fleece depicted in the center.

An editorial achievement that met similar global ambitions of the Society of Jesus is the monumental work of the Czech Jesuit Matthias Tanner (1630–1692), author of four works dedicated to the Jesuit Order and its prominent members.[10] All four of Tanner's writings are composed as collections of biographical medallions—elogies of particularly deserving members of the Society of Jesus. M. Tanner first published *Societas Jesu usque ad sanguinis et vitae profusionem militans* (The Society of Jesus Fighting until Blood and Life are spilled) in Prague in 1675 [figure 3.2].[11] The work consists of four parts, each devoted to the missionary activity of the Society of Jesus on one of the then-known continents: Europe, Africa, Asia, and America. The selection of the figures of the Order concentrates on those who gave their lives as martyrs in defense of the Catholic Church in Europe and the spread of Christianity in the world. The biographies are arranged chronologically in each section according to the date of death. The pre-title page of the entire book and the four title pages for each section show allegorical images of the activities of the Society of Jesus. Each biographical medallion of the 169 Jesuits is accompanied by a depiction of his martyrdom, executed according to the designs of Karel Škréta by the Augsburg engraver Melchior Küssell. In 1683, Tanner's book was republished in Prague in a German translation by the Jesuit Bartolomeus Christelius under the title *Die Gesellschafft Jesu Biß zur vergiessung ihres Blutes wider den Götzendienst, Unglauben, und*

Figure 3.2 The Society of Jesus, fighting for the Christian religion, displays trophies of its bravery on every continent. Title page of the book by Mathias Tanner, *Societas Jesu usque ad sanguinis et vitae profusionem militans*. Copper engraving on paper by Melchior Küsell after a design by Karel Škréta, 1675.

Laster (The Company of Jesus up to Sheding Their Blood Against Idolatry, Unbelief, and Vice).[12] The German version was expanded by twenty-six more biographies, probably written by M. Tanner. The book was published with Škréta's illustrations taken from the Latin edition of 1675. The newly

added medallions are illustrated with copper engravings designed by Johann Georg Heinsch (1647–1712), who succeeded Škréta after his death. In 1694, two years after Tanner's death, another of his works on the Jesuit order was published: *Societas Jesu Apostolorum imitatrix.*[13] The book is devoted solely to the European Jesuits and was probably intended as the first volume of a four-volume monumental work, but the sequels on the African, Asian, and American Jesuits were never published. This Tanner treatise is illustrated with 197 copperplates, largely designed by Heinsch. A German translation of this work was published in 1701, again by Christelius, entitled *Die Gesellschafft Jesu der Aposteln Nachfolgerin,* using illustrations from the Latin version.[14] While Tanner's 1675 book and its German translation focused on Jesuit martyrs, the scope of the second publication of 1694 and 1701 is broader—portraying, besides martyrs other members of the Society such as clergymen, preachers, nurses of the sick, teachers, and visionaries.

Illustrations from these books were published again in condensed form without texts by the Prague Jesuit Printing House in the Clementinum in two undated prints, *Societas Jesu Usque Ad Sanquinem pro Deo et Fide Christiana militans* and *Societas Jesu usque ad Sudorem & mortem, Pro Salute Proximi laborans,* of which only a few copies survive.[15] One of them, from the Jesuit college in Opava, bears the remarkable inscription "*pro usu infirmorum*" (for the needs of the sick), which hints at the intended reception of the pictorial collection volume.

Collecting the biographies of prominent men of the Society of Jesus, was not, of course, solely Tanner's creative concept. As early as the first half of the seventeenth century, entire collections of biographies of prominent members of the Society began to appear in book form in Europe, drawing, on manuscript elogia and the work of renowned Jesuit writers such as Juan Eusebio Nieremberg, Philippe Alegambe, Janos Nadasi, and Alonso de Andrade.[16] In addition to these sources, which Tanner cites in his second book, his first title was inspired by medieval martyrology, the modern *Martyrologium Romanum,* published in Rome in 1589 (largely authored by Cesare Baronio), and such writings as the *Theatrvm Crudelitatum Haereticorum,* authored by Richard Verstegen.[17] Inspiration also came from collections of biographical medallions of powerful and learned men, such as Paolo Giovio's famous work, *Elogia Virorum literis illustrium.*[18] Tanner's work not only drew on literary sources but also had pictorial antecedents in the murals depicting the suffering of early Christian martyrs in the Church of the Santo Stefano Rotondo that belonged to the Roman Jesuit college *Germanicum et Hungaricum.* Other similar Roman ensembles in the Church of San Apollinare depicted the martyrdom of St. Apollinare and San Tomasso di Canterbury in a set of images dedicated to Catholic martyrs in Protestant England.[19]

Tanner's writings, however, differed conceptually from previous works. He introduced the idea of a global, worldwide mission of the Society of Jesus that the members of the order carry out at the cost of their own lives. Whereas his predecessors had arranged the individual elogies chronologically or calendrically along the lines of the *Acta sanctorum*, Tanner arranged the biographical medallions according to the location of his heroes on each continent. He developed the idea of the global mission of the order that had emerged in the order's environment and was also reflected in artworks. Its earliest artistic representation is an engraving by Matthaus Greuter from 1616, in which members of the Society of Jesus work in the vineyard of Christ, surrounded by allegories of continents and provinces of the order. J. Miele and C. Bloemaert developed the same idea in the frontispiece of Bartoli's work *Historia della compagnia di Gesù* of 1653, which shows St. Ignatius, the globe, and the four continents.[20] The painter Barzonnet Stella, active in Rome between 1659 and 1664, conceived a similar painting, commissioned by the Jesuits at Chalons, a painting with Christ, the Jesuit saints, and the four parts of the world.[21]

A monumental treatment of this theme is Pozzo's ceiling fresco in the Church of St. Ignatius in Rome, which, however, was not created until after the publication of Tanner's first work. Tanner, a leading religious figure, was familiar with the ideas of his predecessors and developed them as a richly illustrated collection in a completely original form unlike his earlier works. The images of the suffering of the martyrs of the order were intended, like the paintings of the churches of S. Stefano Rotondo, S. Apollinare, and S. Tomaso di Canterbury, to encourage members of the order, through meditation, to inspire students to a similar zeal and imitation, and, alternatively, as the addition "*for usu infirmorum*" suggests, to comfort old, sick, and dying members.

Tanner's writings, with their rich pictorial accompaniment, are a representative work virtually without parallel. The only known equivalent is the book-length collection of elogies of Jesuit martyrs by António Francisco Cardim, *Fasciculus e Iapponicis floribus suo adhuc madentibus sangvine* (A bouquet of Japanese flowers still drenched in blood), published in Rome in 1646, and four years later in Portuguese translation in Lisbon, but dealing only with the order's missionary martyrs in Japan.[22] What is remarkable is that both works share a similar visual language in their depiction of the violent deaths of Jesuit missionaries. The depictions emphasize the brutality of the torturers using a variety of weapons and instruments, often unusual and exotic for Europeans. The aim of the painting is to heroize martyrdom—the martyr is often depicted alone, rarely with the figure of the Virgin Mary or St, Ignatius, often holding a cross as an attribute of faith with a gesture of surrender or prayer. These writings were intended to serve not only as instruments of instruction but

also as supports and tools to strengthen the religious identity of the order and to function as examples worthy of imitation. This is evidenced by the passage in a letter devoted to Tanner's writings in 1675, or 1683 at the latest, which testifies to the worldwide renown of the work and the attitude of Jesuit missionaries toward martyrdom for the faith. The author is the Czech Jesuit Šimon Boruhradský (1650–1697), who worked among the indigenous people in Mexico. In 1686, he wrote to the then-rector of the Clementine College, Emanuel de Boy, in Prague:

> I am writing . . . an account of the martyrdom of our Fathers in the Marian Islands . . . [and] I give the names of these overjoyed Fathers: they are P. Augustin Strobach, P. Karel Boranga . . . I have no doubt that . . . the news . . . has pleased all who desire overseas missions . . . I greet the worthy P. Matthias Tanner . . . most cordially and congratulate him on being able to include in his Book of Martyrs such worthy fellow-apostles and compatriots of ours.[23]

The purpose of Tanner's pictorial collections of Jesuit martyrs and famous figures was to systematize and reflect the scope of the Jesuit global mission and to embody it in an emotionally compelling series of images. Their broad coverage, collecting zeal, and commitment to completeness and organization corresponded fully with such works as Gumppenberg's *Atlas marianis* or Andrea Pozzo's ceiling fresco *Allegory of the missionary work of the Society of Jesus* in the Church of St. Ignatius in Rome. The ambition to reach beyond the Bohemian province is clearly expressed by the fact that it was published in German translation at the same time as the Latin edition (1675 and 1683) and by the fact that Tanner dedicated the first edition to Giovanni Paolo Oliva, the general of the order at the time.

THE SACRED WAY TO STARÁ BOLESLAV: A PILGRIM'S JOURNEY AS A DEVOTIONAL IMAGE SERIES

Jesuit efforts at systematization and universal treatment went beyond the pursuit of a detailed visual retelling of the bible. In the realm of textual and visual culture this translated into an effort to create the most complete material sets or collections of sacred Marian imagery. Their model was the systematization of Marian images and statues by the German Jesuit Wilhelm Gumppenberg (1609–1675). He authored two works intended to record all the known Marian images and statues, first in Europe and then throughout the world. First, in 1655, he published a methodological manual (*Idea Atlantis Mariani*) presenting a carefully worked out systematic plan for describing

and classifying individual Marian images and a call for information from different regions. It divides them into five groups according to the origin and discovery, the material, the form, the veneration, and according to their action; each is subdivided into several hierarchically organized subgroups (Index and *Catalogus*). This methodological preamble was followed by the publication of the first catalogue (1657–1659), and later by an expanded edition printed in Munich in 1672 under the title *Atlas Marianus, quo sanctae Dei genitricis Mariae imaginum miraculosarum origines duodecim historiarum centuriis explicantur* (The Marian Atlas, whereby the origins of stories of miraculous images of Mary, the Mother of God, of twelve centuries are explained).[24]

In the opening eighty-six pages, the author again presents the methodological tools for classifying individual Marian images, various indexes, and lists of contributors, followed by a 685-page description of 600 Marian images on the then-known four continents. The work focused on a single goal: to collect the most complete global series of miraculous Marian images and statues.

A number of Gumppenberg's followers worked to supplement the *Atlas* with other works on a regional scale. For example, the Jesuit Heinrich Scherer, who, in his *Atlas Marianvs*, first published in Munich in 1702, had compiled an inventory of Marian statues and images on all the continents and in all countries, accompanied by maps, in a framework constructed to show the most important locally created Marian images that were venerated in each nation.[25] Later, in 1735, Sebastian Kayser published *Austria Mariana*, an overview of Marian images worshipped in Viennese churches and chapels.[26] These and similar works systematized the miraculous Marian images and statues of a particular region, at the same time developing the idea of a comprehensive and universal Marian protection of the local and topographical areas of the region.

An attempt to build on Gumppenberg's popular work was also made in the Czech lands, where his book was well known. The libraries of the Czech Republic record more than twenty copies of various editions of Gumppenberg's *Atlas*; their original owners can be identified thanks to ownership records. The libraries of monastic institutions predominate: the Franciscans, Jesuits (e.g., the library of the Prague Clementinum), and the Premonstratensians; several copies were in the library of the Kinsky family. There was even an attempt to publish the Gumppenberg *Atlas* in a Czech translation by the priest and writer Antonín Frozín, who published a work, *Obroviště Mariana Atlanta* (Vast area of the Marian Atlas), with descriptions of ten famous Marian images in Europe and South America in 1704.[27]

The model of Gumppenberg's compendium was gradually Bohemianized. As early as 1658, the most famous Czech Jesuit, the historian Bohuslav Balbín, published a book about the Virgin Mary of Tuřany, *Diva Turzanensis*, in which he included an extensive list of Marian paintings and statues.[28] In the mid-1660s, he published the book *Diva Montis Sancti* about the Marian pilgrimage site on

Svatá Hora near Příbram, which was translated into Czech a year later under the title *Přepodivná Matka svatohorská* (The Most Wondrous Our Lady of Svatá Hora). In this edition he included the work of another local Jesuit author, Jiří Kruger [Georgius Crugerius], who, in addition to his interpretation of the Virgin Mary's love for the Bohemian lands, gave an overview of the Marian images and statues venerated there.[29] In 1717, an expanded form of Gumppenberg's book was published in Bohemia in a German translation by Augustin Sartorius, a monk from the Cistercian monastery in Osek, named *Marianischer Atlas*, which included most Czech miraculous Marian images.[30] The list of works here has a clear patriotic subtext that his modern editor sees as an expression of local Cistercian patriotism, even though the work was clearly inspired by Gumppenberg's global vision of the Marian cult and thus from the Jesuit understanding of the relationship between global and local manifestations of the supernatural. In the Central European missionary milieu this was a counterpart to the Italian *historiae sacrae*, legendary narratives of local saints.

In an effort to make a comprehensive impact on the faithful in a more solemn context, the project did not stop with printed Marian atlases. In Bohemia, we know of cases where printed pictorial collections of Marian images and statues were re-assembled into larger format visual media as a set of images placed in the spatial contexts of Marian pilgrimage sites. In 1685, the cloister ambits of the Franciscan Loreto complex (including copy of *Santa Casa* venerated in Loreto, Italy) in Hájek near Prague, were furnished with twenty-six hanging paintings depicting Marian images from Bohemia and Europe.[31] The same was the case in the ambits surrounding the Loreto chapel in Římov, a Jesuit-run pilgrimage site in southern Bohemia. Between 1686 and 1698, they were decorated with Marian symbols, invocations of the Loreto litany, scenes from the life of the Virgin Mary, and thirty-two depictions of venerated Marian images. A similar collection is known from the Loreto at the Hradčany in Prague, administered by the Capuchins, where thirty-seven Marian statues and images are painted alongside sequences of the Loreto litany. Another example is the Jesuit pilgrimage site on Svatá Hora near Příbram, where twenty statues of angels with cartouches bearing depictions of Czech Marian images were created at the turn of the seventeenth century. The most numerous collection, forty-seven depictions, of Marian images from Bohemia, Moravia, Silesia, and elsewhere in Europe, is known from the pilgrimage church of Our Lady of Victory in Prague on White Mountain from the period after 1729. This commemorated the miraculous support that, according to legend, was given to the army of the Catholic League, which defeated the army of the Bohemian Estates here in 1620. All of these Marian ensembles, in either textual or visual form, linked the universal plane of the cult of the Virgin Mary and her local manifestations into a single whole, constructing regional or provincial Marian veneration while also situating the

images in active contexts of pilgrimage practice. Moreover, in the interaction between the global and the regional, it was possible to link the Marian cult to the legends of local saints, further strengthening patriotic ties to the region and its devotional tradition.[32]

The murals (now-destroyed) of the stations along the pilgrimage route from Prague to Stará Boleslav (the Sacred Way) were among the oldest and most extensive collections of Czech Marian images. The paintings decorated forty-four chapels along the road to the most important pilgrimage site in Bohemia, administered by the Jesuits at that time. The pilgrimage route was created at the instigation of Johannes Tanner (1623–1694), a Jesuit professor at the University of Prague and brother of Matthias Tanner, who reportedly convinced members of the Czech nobility gathered at the Provincial Assembly to support the project.[33] Construction began in 1674 and was completed five years later. Only thirteen chapels have survived to the present day, but their paintings have completely disappeared. These lost paintings of the chapels, however, are captured in forty-four rather artless illustrations in an accompanying meditation booklet written by Johannes Tanner himself and illustrated by Samuel Dvořák, a Prague graphic artist, in 1679. The small book is entitled *Svatá cesta z Prahy do Staré Boleslavi* (The Sacred Way from Prague to Stará Boleslav) [figure 3.5 and 3.7] and follows the path of the pilgrimage route.[34] The Jesuit College of the New Town of Prague dedicated the booklet to Jan Ignác Dlouhoveský, a bishop's ordinary and canon of Stará Boleslav, one of the writers who repeatedly devoted himself to the cults of the Virgin Mary and St. Wenceslas.[35] It is essentially a pilgrimage handbook, a description

Figure 3.3 St. Wenceslas orders the building of Christian churches and the destruction of pagan idols. Oil on canvas by Karel Škréta, 1638.

of a pilgrimage journey, a literary genre that was widespread in the Baroque period, but the rich illustrations made it different from similar books.[36]

The pilgrimage route began at the former Poříčská Gate in Prague and continued through the present-day Prague districts of Karlín and Prosek, where it passed the Romanesque Church of St. Wenceslas, then went through the villages of Kbely, Vinoř, Podolanka, Dřevčice, Vrábí, and the town of Brandýs nad Labem to Stará Boleslav. It followed an old trade road leading from Prague

Figure 3.4 St. Wenceslas orders the building of Christian churches and the destruction of pagan idols, from the book by Aegidius à Sancto Joanne Baptista, *Wienec Blahoslawenému a wěčně Oslawenému Knijžeti Cžeskému.* Copper engraving on paper by Fr. Henricus, 1643.

to Stará Boleslav, where it divided into an eastern branch toward Poland and a northwestern branch heading to Liberec and Zittau. The path consisted of forty-four niche chapels, each topped with a triangular gable and flanked by pilasters on the corners. Their decoration consisted of three parts: the lower part depicted a scene from the legend of St. Wenceslas with a brief Latin inscription; the upper field in the shape of a lunette framed a depiction of one of the Marian statues or images venerated as miraculous in Bohemia, flanked by the name, titles, and coat of arms of the chapel donor. The placement of the Marian image refers to Mary's connection with heaven; the St. Wenceslas scene at the bottom, in contrast, is an exemplum from the model saint's life in the earthly world. Except for the first and last, the chapels were arranged alphabetically according to the original location of the Marian image. In an attempt to make it easier for the reader and pilgrim, Tanner writes that the distance between each chapel is equal to the length of Charles Bridge in Prague and the number of chapels corresponds to the number of the invocation in the Loreto Litany that was inscribed on the vault enclosing the niche of each chapel.

In terms of pictorial narrative, the pilgrimage begins with the station showing a gathering of Czech patron saints venerating the Stará Boleslav Palladium (the Virgin Mary of Stará Boleslav) and its creation from the metal of a pre-Christian pagan idol. This thematizes the legendary role of the main Marian image in the Christianization of Bohemia. This is followed by images of miraculous Marian statues and paintings, selected with an unmistakable Jesuit accent since almost a quarter of them come from shrines administered by the Society of Jesus. Tanner carefully justified the selection of each Marian image, emphasizing: (1) their antiquity; (2) that they perform miracles, demonstrate beneficence, and answer petitions and prayers; (3) that they are associated with extraordinary events, and (4) that they miraculously survive attempts to destroy them.

The selection of miraculous Marian statues or images clearly reflects a patriotic Bohemian concept—forty-one are found in Bohemia (some are mentioned in Gumppenberg's second edition[37]) and only one image each was selected from Moravia (*Svatotomská* from Brno, from St. Thomas Church), Silesia (*Vartenská*, of Wartha), and Kłodzko (*Kladská*). It is thus literally an *Atlas marianus bohemicus*, a horizontally constructed collection of Czech miraculous madonnas. It was inspired by Gumppenberg's concept and follows his systematic approach, but narrows the selection to madonnas from Bohemia, which are richly expanded. Thus, the selection of images is shifted to a patriotic, Land (similar to a province) level. These miraculous Marian statues not only represent earthly protection in the various local and regional manifestations found in Bohemia but also affirm the validity of the Tridentine doctrine of reverence for images, the key position of the Marian cult in Counter-Reformation piety, and its direct effect on the earth.

THE ST. WENCESLAS PILGRIMAGE CYCLE—
EXEMPLUM AND PROVINCIAL PATRIOTISM

The pictorial cycle of the pilgrimage route to Stará Boleslav has yet another level of communication. The Marian collection is supplemented by scenes from the legend of St. Wenceslas in the main fields of the individual chapels. Since the Middle Ages, the cult of St. Wenceslas had been linked to two places connected by the pilgrimage route—Stará Boleslav, where the prince was murdered by his brother, Boleslaus I, on September 28, 935 (or 929), and Prague Castle, where his remains were transported and interred in the rotunda of St. Vitus, the main church of the princedom. The rotunda was replaced by a Romanesque basilica and later a Gothic cathedral, which still commemorates the place where the saint's relics were first buried and the center of his cult, the Chapel of St. Wenceslas on the south side of the cathedral. The pilgrimage route thus connected the key sites of the cult of St. Wenceslas and, through its stations, also embodied the pilgrimage of St. Wenceslas to his own martyrdom and the journey of his body back to his burial at Prague Castle.

In the seventeenth century, a remarkable connection between the Stará Boleslav cult of St. Wenceslas and the cult of the Virgin Mary was established. At the beginning of this century, a Marian cult developed there, linked to a small medieval relief depicting the Virgin Mary with the Baby Jesus, the so-called Stará Boleslav Palladium. The first traces of its veneration as a miraculous image can be dated reliably to the end of the sixteenth century, but it only began to develop in the first decades of the seventeenth century in pilgrimages organized by the Prague Jesuits. The fundamental impetus for its rapid rise came from a book by the Metropolitan Canon of St. Vitus, Kašpar Arsenius of Radbuza, *O Blahoslawené Panně Marygi* (On the Blessed Virgin Mary), published in 1613 and again in 1629.[38] The first edition of the book states that the Marian relief was plowed up in a field at the beginning of the sixteenth century, but without giving details of its origin. The second edition gives a different version of the story, dating it back to the beginnings of Christianity in Bohemia; supposedly, St. Wenceslas had been carrying the relief when he was murdered. After his death, it was supposedly hidden in the ground and discovered again in 1160. The association of the Marian relief with St. Wenceslas proved to be quite fruitful, and younger authors worked further on the legend—the relief was said to have been made from the melted-down pagan idol of Krosina and Cyril and Methodius supposedly gave it to St. Ludmila, who allegedly gave it to her grandson, St. Wenceslas. Other Czech patron saints, St. Vojtěch (Adalbert), St. Prokop, and later St. John of Nepomuk, were gradually proclaimed as venerators of the Stará Boleslav Palladium. The relief became the centerpiece of the pantheon of the

country's patrons; its fame was enhanced by being stolen repeatedly during the Thirty Years' War, but it always returned and gained a reputation as the protective palladium of the Czech lands. The St. Wenceslas and Marian cults merged and Stará Boleslav became one of the most important pilgrimage sites in Bohemia, where pilgrims visited both the Romanesque Church of St. Wenceslas and the Church of the Virgin Mary built in the early seventeenth century. The development and intermingling of the two cults were pointedly described by the French historian Marie E. Ducreux who, inspired by Alphonse Dupronte, correctly observed that Stará Boleslav met perfectly the conditions for creating a pilgrimage site: it was filled with supernatural signs of the Virgin Mary and functioned at the same time as a place of memory sanctified by the presence of a saint.[39] During the seventeenth century, a number of Catholic writers contributed to creating a construct linking the two cults with reverence for other Bohemian saints, at the same time weaving together the dynastic constructs that tied the St. Wenceslas tradition to the Habsburg *Pietas austriaca*.[40]

The choices of the individual themes of the St. Wenceslas Sacred Way cycle emphasize St. Wenceslas as a good ruler caring for his subjects and at the same time present him as a pious prince. The idealized family tree at the end of the cycle constructs St. Wenceslas' kinship with Emperor Leopold I of Habsburg and his third wife, Eleonora Magdalene of Neuburg. It is also recalled that St. Wenceslas was not only venerated in the Czech lands but also in Rome, Silesia, Poland, Bavaria, and Denmark, thus his cult was not only provincial and regional but also transcended national borders. Nevertheless, the patriotic undertone of the whole construction is quite noticeable and follows the general trend that culminated among the domestic nobility and clergy during the reign of Leopold I.

The coats of arms galleries at the top of the edicules of each shrine were similarly patriotic. According to the coats of arms and titles given in Tanner's book, the donors of the individual chapels were recruited from among the Bohemian Catholic elite. Members of pre-1620 Czech nobility dominated— they funded twenty-seven chapels; clergy and religious orders contributed eleven, and men from noble families that had settled in the country after 1620 funded six. Thus, patriotic old Bohemian aristocrats, religious orders, and newly settled post-1620 nobility were integrated into existing socio-religious structure, as also reflected in the cycle.

The forty-four scenes of the St. Wenceslas legend in the chapels of the pilgrimage route and Dvořák's illustrations in Tanner's book were the most extensive pictorial treatment of this topic in Czech Baroque art, but not the oldest. It had predecessors that significantly influenced Tanner's concept. In the early 1640s, the painter Karel Škréta (1610–1674) and other painters created the St. Wenceslas Cycle [figure 3.3], thirty-two depictions for the

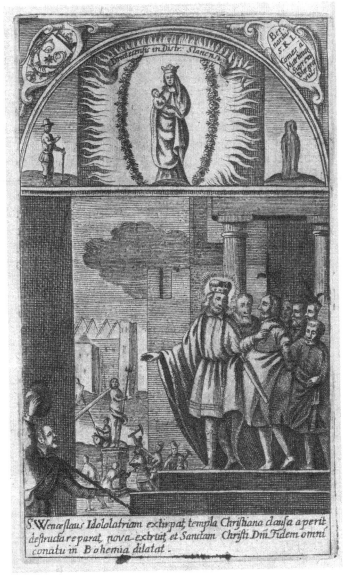

Figure 3.5 St. Wenceslas orders the building of Christian churches and the destruction of pagan idols, from the book by Johannes Tanner, *Swatá Cesta Z Prahy do Staré Boleslawě*. Copper engraving on paper by Samuel Dvořák, 1679.

ambit of the monastery of the Discalced Augustinian Hermits in Prague Na Zderaze in the New Town of Prague. This monumental cycle was one of the most influential Czech early Baroque pictorial collections of legends,

Figure 3.6 The death of Podiven from the book by Aegidius à Sancto Joanne Baptista, *Wienec Blahoslawenému a wěčně Oslawenému Knijžeti Cžeskému.* Copper engraving on paper by Fr. Henricus, 1643.

which—by virtue of showing the life of the main patron of the Czech lands and being of unusual artistic quality and extent—were an influential model, a point of reference, both for the Counter-Reformation narration of the saint's life and for the formation of the visual language of Baroque art in Bohemia. The selection of the thirty-two scenes from the legend of St. Wenceslas emphasized the motifs of Wenceslas as a good and pious ruler in addition to the key moments in the saint's life that shaped the narrative of the legend.

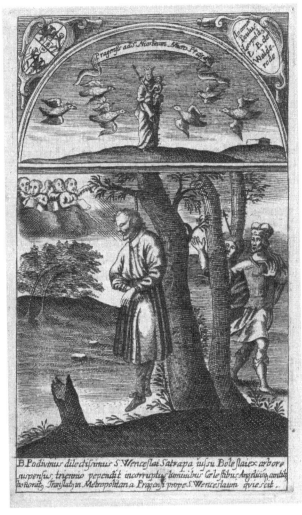

Figure 3.7　The death of Podiven from the book by Johannes Tanner, *Swatá Cesta Z Prahy do Staré Boleslawě*. Copper engraving on paper by Samuel Dvořák, 1679.

The commissioner, who also apparently conceived the idea, Aegidius à Sancto Joanne Baptista, the abbot of the monastery, relied on literary sources, mainly the medieval legend *Ut Annuncietur*, Václav Hájek of Libočany's Czech *Chronicle*, first published in 1541, and Jan Dubravius' *Historiae Regni Boiemiae* from 1552. In their pictorial renderings of the legend, Škréta and others partly followed an earlier cycle from the early sixteenth century on display in the Chapel of St. Wenceslas in the St. Vitus Cathedral in Prague. Abbot Aegidius attempted to spread the cult of St. Wenceslas and the glory of his

monastery by transferring the large-scale canvases of the cycle into a mobile and inexpensive medium, a printed booklet entitled *Wienec Blahoslawenému a wěčně Oslawenému Knijžeti Cžeskému* (A wreath for the blessed and eternally glorified prince of Bohemia) [figures 3.4, 3.6] with copperplate illustrations by Frater Henricus reproducing individual images of the cycle accompanied by explanatory texts.[41] The book, intended for a wide audience, was published repeatedly in various languages and aimed not only at promoting the painted cycle, normally hidden from the laity in the monastery's cloister, but skillfully connected it with the tradition of the saint's cult, reaching deep into the past.[42] The introduction includes a print reproduction of a medieval painting of St. Wenceslas' *vera effigies* (true likeness), a copy of which was also kept in the monastery. The compiler, however, did not create this print merely as an ordinary prayer book, but as an *exemplum* of the morals of a model Christian: ". . . that thou . . . not merely feed thine eyes with these material images, but rather make them a mirror and a living example to thyself and to stir up others to follow."[43] Each engraving is accompanied by a text that not only interprets the particular image but also presents the legendary story as a model of the behavior of a proper Christian. *Wienec* . . ., however, not only functioned as a tool of religious didactics but also became widely influential, as evidenced by the many copies and variations in quality, through a variety of media.[44] The dissemination of this series is a good example of the transfer of a pictorial narrative into different media and settings, with minimal variation of the overall legend narrative, but with an individual approach to the scenes as needed.

Soon these ideas transcended the confines of the Augustinian order and found great resonance with the Jesuits in particular. The Jesuit responses show a clear attempt to grasp this pictorial narrative model. The first echo is recorded in the book illustrations of Paul Kriger's writings, *Studně zdravohojitelná svatého Václava knížete, mučedlníka a dědice českého . . . nedávno vyprejštěná* (The Well of Health of St. Wenceslas, Prince, Martyr and Heir of Bohemia . . . Recently gushing), printed by the Prague Jesuit printing house in 1659.[45] The book was published in German translation under the tile *Fons Apollinis, oder Son[n]enBrun[n]en, das ist: das Leben deß heiligen Wenceslai Martyrers* (Apollo's Spring or Sunwell, that is, The life of St. Wenceslas Martyr).[46] Not only did both editions reproduce the original thirty-two illustrations by Frater Henricus from *Wienec*. . ., first published in 1643, but the illustrations of Kriger's books were even printed from the original plates.

It is not surprising, then, that the prints of Tanner's Sacred Way both display the same choice of themes and adopted some of the *Wienec*. . .'s compositions. Some of the compositions are almost direct copies, others transform the *Wienec*. . .'s compositions in the direction of giving the scene greater clarity and intelligibility, and still others are entirely new inventions. In terms of

the pictorial narrative, what is new here is that Tanner's stations on the Sacred Way expand scenes from *Wienec. . .* and topographically anchor them in physical locations associated directly with the life of St. Wenceslas. He also adds a reference to the palladium and the cult of miraculous Marian images as well as to local political representation in the coats of arms of the local nobility. In the spirit of the Jesuit emphasis on catechesis and instruction of the faithful, these images were to serve as models to follow, and, along with their Marian counterparts, were to be the subject of communal and individual religious contemplation along the various sections of the Sacred Way. Such multilayered reception addressing different groups of recipients was fully in keeping with Jesuit demands for image communication in devotional practice. As Marie E. Ducreux observed:

> The language of such a book collection of sacred emblems cannot be deciphered except by combining the various planes on offer. Reception depends on the ability of the viewer, pilgrim or reader to decipher the possible relationships between the content elements. The detailed layout here, which links three iconographic layers to three textual orders, accumulates interpretive capacities that converge and diverge according to the reader's choice and skill in deciphering their code.[47]

How far the model of the Augustinian St. Wenceslas' cycle reached is demonstrated by the frequent reproductions of this cycle. Among them there is a collection of fourteen monumental oil paintings for the Church of St. Wenceslas in Stará Boleslav that were commissioned by high clerics from the Stará Boleslav and Metropolitan chapters at approximately the same time as Tanner's Sacred Way. This commission may have been a response to the Jesuits appropriating the cycle for their commission of the Sacred Way and to promote the cult of the palladium in the Virgin Mary Church in Stará Boleslav. This shortened and compressed painted cycle appeared again as book illustrations in the German and Czech editions of book with engravings by Birkhart, published in Prague in 1732 and 1738:[48] *Kurtz Beschreibung Dess Herkommens, der Geburth, des Lebens und Todtes Dess Heiligen Wenceslai . . . in denen Historien beschrieben, und der Alt. Buntzlauer S. Wenceslai Kirchen gemahlet zu sehen*, and *Krátké Popsánj Narozenj Žiwota a Smrti Swatého Wácslawa . . . Kterak se takowé w rozličných Hystoryjch opisané a w Staro-Boleslawské Kostele Swatého Wácslawa malowané spatřuge . . .* (Short Description of the Nativity, Life and Death of St. Wenceslas . . . as it is depicted in the painted legend in Stará Boleslav Church of St. Wenceslas). In this book, the thirty-two original scenes of Škréta's St. Wenceslas cycle (and its graphic version, *Wienec. . .*), are compressed on fourteen sheets in which the main scene is accompanied by one or two scenes in small fields

in the background. Both language versions were published by the Prague archbishop's printing house. These prints adopted motifs from both the 1643 edition of *Wienec. . .* and Tanner's print of *Svatá Cesta*. This shows that the inspiration migrated across different milieus, from the Augustinians via the Society of Jesus up to archbishop and chapters, keeping a remarkable stability of themes and overall narrative. The pictorial narrative collection was transferred further into a wide range of visual media such as murals, stucco, and sculpture.[49] Jesuits not only adopted it but contributed decisively to disseminating it.

ACTIVATING THE MIND: PILGRIMAGE AS RELIGIOUS EXPERIENCE AND MULTIMEDIA ENTERPRISE

Pilgrimage was a distinctive phenomenon of early modern piety that gave the believer a strong personal and physical contact with the supernatural. At the same time, it was a successful tool of Counter-Reformation missionary strategy.[50] In making a pilgrimage, one becomes not only part of a symbolic space sanctified by a holy presence and moral example but also of a religious community united by a common emotional experience in which everything is directed toward a deeper experience of religious agency through time. The experience is phased by the different stations of the journey and the religious acts associated with them.[51] In the Sacred Way to Stará Boleslav, the journey itself was a medium for the experience of faith, where everything aims at the active spiritual participation and transformation of the pilgrim, whether it is a physical or only mental pilgrimage of the reader of Tanner's book. The ideal concept of the spiritual path is projected physically onto the topography in the real landscape and also embodied in the accompanying text and image. The spiritual guide here is St. Wenceslas himself, whose footsteps he follows. The pilgrim becomes acquainted with his life and deeds at each station and is accompanied by the combined protection of the Virgin Mary in her multiple manifestations that demonstrate her role as the special protector of the Czech land.

The use of pilgrimage to activate piety and enhance religious experience was not, of course, a Jesuit invention, but followed the tradition of pilgrimages to various places associated with the life and work of Christ, the Virgin Mary or saints or their "translation" into the form of the Stations of the Cross or the hut where the angel announced the birth of the Savior to Mary, which was then miraculously transported from Nazareth in the Holy Land to Loreto, Italy. The Franciscans developed the idea further by building the Stations of the Cross—for example, in Jindřichův Hradec, Bohemia, as early as the early sixteenth century. The Jesuits later adopted this model; they saw the potential

for combining spiritual and physical activity in the experience of faith. They applied this idea in the arrangements at "their" pilgrimage shrines, in Římov in South Bohemia and in Starý Hrozňatov in Cheb, among others. The Jesuits also used the advantages of a pilgrimage journey as a process of spiritual renewal in the formation of members of the order. In 1611, Louis Richeôme wrote a book conceiving the entire decoration of the novitiate of the college at the Church of San Andrea al Quirinale in Rome as a manual of meditative wandering, using memorial stations with images from the history of salvation, nature, the history of the order, and their martyrs. The images here are understood as *imagines agentes*, images that encourage meditation and piety in novices through imagery portraying particular settings and locales.[52] This idea was inspired by St. Ignatius himself, who had a personal encounter with Christ in La Storta on his way to Rome, and whose *Spiritual Exercises* can also be seen as a path of spiritual renewal. The collection of paintings of martyrs in the Santo Stefano Rotondo served a similar purpose.

While there was a general model in the Jesuit environment, the originality of Tanner's Sacred Way to Stará Boleslav lies in the complex interconnectedness of the visual and textual expressions, which form a parallel collection of interrelated images symbolizing the highest cultic and political protection of Bohemia. The pictorial collections carry a strong patriotic undertone and build on shared memory. Three types of visual media are used: a narrative pictorial account of the St. Wenceslas legend, a collection of depictions of Marian miracles, and a collection of heraldic symbols of the Czech Catholic nobility, each of which relates to the Czech lands in a different way. The verbal component of the work uses different genres; religious-educational texts, prayers, and invocations from the Loreto litany are combined with historical and genealogical information. All the verbal and visual media and contents were familiar and understandable to the faithful and had proven themselves in previous contexts. It ingeniously combined the planes of the Bohemian (St. Wenceslas) and the universal (the Virgin Mary), but in the latter case it works on both levels, regional (madonnas selected from Bohemian pilgrimage sites) and global (the invocation of the Loreto litany, inspiration from the *Atlas Marianus*). A pilgrimage on the Sacred Way to Stará Boleslav thus embodied the connection between the universal level of the global mission and its local expression. At the same time, the legend of St. Wenceslas and Bohemian miraculous images of the Virgin Mary anchored cosmological concepts of the supernatural in the local contexts of holy places in Bohemia. All of this created conditions for the Way's stations and Tanner's print to successfully address the reader, the viewer, and the pilgrim on various levels. The print then functioned as a "pocket guide" to the physical manifestations of the pilgrimage between Prague and Stará Boleslav, that is, the site of St. Wenceslas' martyrdom, and reverence for the Stará Boleslav palladium.

The act of making the pilgrimage, in turn, exploited the extraordinary potential of the emotional impact of the movement in symbolic space. The route follows the movement of Saint Wenceslas as he traveled from Prague to visit his brother in Stará Boleslav, where he met his martyrdom. Going in the opposite direction, the route was the translational procession transferring his remains from Boleslav to Prague (as the title of Tanner's book itself states): *Swatá cesta . . . S milého Wáclawa Dědice Czeského na smrt odgezdem a potom Těla Přenessenjm poswěcená . . .* that is, The Sacred Way of St. Wenceslas, Heir of the Czech Lands, Sanctified by His Journey to Death and the Translation of his Body. Thus, the actual spatial aspect of movement associated with "materializing" the topography of memory in Tanner's book, as well as the prayers, paraliturgical acts, and chanting performed during the journey, co-created and helped guide the pilgrims' understanding and reception of the Marian and St. Wenceslas' scenes. The narrative structure of the ensemble enhanced the religious experience of pilgrims. The consistency and sophistication of this link between universal Catholic concepts and local tradition and the emphasis on emotional forms and different levels of reception were important to the success of the Jesuits in Bohemia.

Post Scriptum

Hans Belting associates the close of the era of the venerated image with the end of the Middle Ages and a change in the media function of such images with the aestheticization of the artistic image in the early modern period. In his opinion, the modern period replaced the "loss of the venerated image" with flamboyant cult arrangements. He sees the Baroque cult as staging the (especially Marian) medieval image, a glamorization of that image, and a peculiar attempt to regulate the ritual display of the image to reinforce its cultic function.[53] We suggest that the multiplication of images and their transfer into various visual media and specific locales played an equally important role in strengthening the cultic value of the image. In the Counter-Reformation cultic setting, images ceased to be bound to their original material support and were "transposed" into other materials with the aim of evangelizing the faithful through multifaceted forms of reception bound to various locations and situations. This media "liberation" or release of the image from its original material support allows us to consider the primary idea of the image (the mental image) as a separate phenomenon. To conceive the image in its "intermedial state" means to multiply the forms of reception, which results in a stronger impact. The Jesuits recognized the reception potential of transposing the image onto other carriers along with an associated transformation of the image's functions, context, and modes of reception.

NOTES

1. Belting gives mediality its own value in examining the image: ". . . weshalb es notwendig ist, in der 'Physik der Bildes' der Medialität aller Bilder einen eigenen Stellenwert einzuräumen," in "Bild-Anthropologie. Entwürfe für eine Bildwissenschaft," 12.

2. Remmert, "Visuelle Strategien zur Konturierung eines jesuitischen Wissensreiches," 85–108.

3. Ibid., 108.

4. Quote in ibid., 108.

5. O'Malley, S. J., "To Travel to Any Part of the World: Jerónimo Nadal and the Jesuit Vocation," 3–4.

6. Buser, "Jerome Nadal and Early Jesuit Art in Rome," It is basically two books— a commentary on the Sunday readings from the text of the Bible entitled *Adnotationes et meditationes in Evangelia* and an accompanying volume of 154 illustrations chrono- logically following the Gospel account of the life of Christ entitled *Evangelicae histo- riae imagines.* These illustrations were produced over a long period of time, which is, among other things, evidence of an attempt to arrive at an ideal pictorial representa- tion of the biblical events. Their final form is the work of the influential and famous Flemish engravers Johannes (1549–c. 1618) and Hieronymus Wierix (1553–1619), who probably worked according to Nadal's instructions. Individual details of each illustration are cross-referenced to additional explanatory texts. Although the stylistic character of the illustrations reflects late Mannerism, its comprehensive presentation of the life of Christ, its clarity, and elaborate didactic apparatus made this quite an influ- ential work. Because Nadal died in 1580, the work was completed by his companion, Diego Jiménez, and not published until 1593 and 1594 in Antwerp.

7. Buser, "Jerome Nadal," 425.

8. Massing, "Jerome Nadal's *Evangelicae Historiae Imagines* and the Birth of Global Imagery," recently found a number of echoes of Nadal's *Imagines* not only in Italian, French, and Flemish art, but also in Central and South America, Ethiopia, India, Japan, and China, noting that Nadal's work was one of the first pictorial mas- terpieces to operate globally.

9. G. Scherer, *Preces ac meditationes piae in mysteria passionis ac resurrectio- nis Jesu Christi collectae per Georgium Scherer Societatis Iese. Figuris aeneis ab Alberto Dürero.*

10. Koch, *Jesuiten-Lexikon. Die Gesellschaft Jesu einst und jetzt,* 1728–1728; Šroněk, *Jan Jiří Heinsch (1647–1712),* 58–72; Linda: *Matěj Tanner (1630–1692).*

11. Tanner, *Societas Jesu usque ad sanguinis et vitae profusionem militans.*

12. Tanner, *Die Gesellschafft JESU Biß.*

13. Tanner, *Societas Jesu Apostolorum imitatrix.*

14. Tanner, *Die Gesellschafft Jesu der Aposteln Nachfolgerin.*

15. Discussed in part by Michal Svatoš, "*Societas Jesu militans, imitans*"; he also mentions two other uses of Tanner's prints, framed wooden plaques with cut-out illustrations of his writings about members of the Society, which are kept in Bavarian collections.

16. Nieremberg, *Ideas de virtud* ; Alegambe and Nadasi, *Heroes et victimae charitatis Societatis Iesu*; de Andrade, *Varones ilustresen sandidat, letras.*

17. *Theatrvm Crudelitatum Haereticorum Nostri Temporis.* Giovio, *Elogia Virorum literis illustrium.*

18. Ibid.

19. Monssen, *Rex Gloriose Martyrum*, 130–137; Monssen, "The Martyrdom Cycle in Santo Stefano Rotondo"; Noreen, *"Ecclesiae militantis triumphi*: Jesuit Iconography and the Counter-Reformation"; Müller-Bongard, Konzepte zur Konsolidierung einer jezuitischen Identität,"155–156. We know the appearance of the now lost paintings in the churches of San Apollinare and San Tomaso di Canterbury from prints by Ioann Baptista de Cavallieris, *Beati Apollinaris Martyris* and *Ecclesiae Anglicanae Trophea.* The painter was the Roman painter Nicolo Circignani.

20. Bartoli, *Historia della compagnia di Giesù.*

21. Kerber, *Andrea Pozzo*, 73.

22. Cardim, *Fasciculus e Iapponicis floribus suo adhuc madentibus sangvine.*

23. Kalista, *Cesty ve znamení kříže*, 33–34.

24. Balsamo and Fluckinger, "Introduction," *L'Atlas Marianus de Wilhelm Gumppenberg*, 9–27. The publishers have aptly described it as *Marie mondialisée*, but see it as carrying a certain imperial notion, 16.

25. H. Scherer, *Atlas Marianvs Sive Praecipuae Totius Orbis Habitati Imagines.*

26. Kayser, *Austria Mariana.*

27. Frozín, *Obrowisstě Maryánského Atlanta Swět.*

28. Balbín, *Diva Turzanensis sev historia originis.*

29. Balbín, *Diva Montis Sancti*; Balbín, *Přepodiwná Matka SwatoHorská Marya, W Zázracých, a Milostech swých na Hoře Swaté nad Městem Přjbrami Hor Strjbrných, den po dni wjc a wjc se stkwěgjcý . . . wytisstěná W Litomyssli v Jana Arnolta*, 1666.

30. Sartorius, *Marianischer Atlas*; Kvapil, ed., "Augustin Sartorius, Mariánský Atlas, Praha 1717 – koncepce barokního patiotismu vytvořená oseckými cisterciáky."

31. Podlaha, *Poutní místo Hájek s kaplí Loretánskou a klášterem františkánským.*

32. Von Herzogenberg,"Marianische Geographie an böhmischen Wallfahrtsorte."

33. Čornejová and Fechtnerová, *Životopisný slovník pražské univerzity*, 463–465.

34. Tanner, *Swatá Cesta Z Prahy do Staré Boleslawě.* The book was published repeatedly in Czech in 1685 and 1692, in Latin in 1690, and in German in 1680, 1699, and 1705.

35. Bitnar, "Český mecén výtvarného baroka [Jan Ignác Dlouhoveský]." Smyčková, "Mariánský ctitel: literární (sebe)prezentace J. I. Dlouhoveského," Idem, "Koncept 'svatých Čech' v díle J. I. Dlouhoveského."

36. Malura, "Barokní poutní knihy a zbožná praxe širokých vrstev." The 1679 edition of Tanner's *Svatá cesta* is available at: https://books.google.cz/books?vid=NKP :1002400445&printsec=frontcover#v=onepage&q&f=false

37. E.g., the Virgin Mary of Bechyně, České Budějovice, Hejnice, from the Capuchin monastery in Prague, Kájov, Bohosudov (Mariaschein), Chlum sv. Máří, from St. James Church in Prague, copy of the Madona of Foy from Prague, Svatá Hora near Příbram, Zelená Hora near Nepomuk, Vyšehrad in Prague, Zbraslav in Prague.

38. Arsenius z Radbuzy, *O Blahoslawené Panně Marygi.*
39. Ducreux, "Symbolický rozměr poutě do Staré Boleslavi."
40. Corethová, *Pietas Austriaca. Fenomén rakouské barokní zbožnosti.*
41. Aegidius, *Wienec Blahoslawenému a wěčně Oslawenému Knijžeti Cžeskému.*
42. The 1661 edition was even Latin-Czech-German: *D. Wenceslao Bohemorum Duci ac Martyri inclyto Sertum Ortus, Vitae, Necis è duabus Suprà triginta Iconibus.*
43. *Wienec Blahoslawenému,* unpaginated preface.
44. Šámal, "Barokní cykly svatováclavské."
45. Kriger, *Studně zdravohojitelná svatého Václava knížete*; Šámal, "Barokní cykly svatováclavské," 32–33.

In specimen 38 F 9 KNM there is a full-page pre-title sheet signed "Jo. Ch. Smi: sculp" depicting a gate with a medallion of St. Wenceslas with churches on both sides (St. Vitus and St. George at Prague Castle?). On the spiral columns there are medallions with scenes from the legend of St. Wenceslas, based on illustrations by Wienec; between them there is a view of the landscape with the well of St. Wenceslas surrounded by people and animals.

46. Kriger, *Fons Apollinis, oder Son[n]enBrun[n]en, das ist: das Leben deß heiligen Wenceslai Martyrers.* The German version is available at: Manuscriptorium.com
47. Ducreux, "Symbolický rozměr poutě do Staré Boleslavi," 607.
48. *Kurtze Beschreibung Dess Herkommens, der Geburth, des Lebens und Todtes Dess Heiligen Wenceslai. Krátké Popsánj Narozenj | Žiwota a Smrti Swatého Wáclawa.* Available at: http://www.digitalniknihovna.cz/mzk/view/uuid:dd950918–6758–4f2c-9f37–296a94d2e8a2?page=uuid:6708505e-0a5f-4bbe-8c3f-6412a328db61.
49. Šámal, "Barokní cykly svatováclavské."
50. On pilgrimage see: Mihola, ed. *Na cestě do nebeského Jeruzaléma.*
51. On the phenomenon of pilgrimage see Doležal and Kühne, eds. *Wallfahrten in der europäischen Kultur.*
52. Behrmann, "Le monde est une peinture," 21; Müller-Bongard, *Konzepte zur Konsolidierung einer jezuitischen Identität,* 155–156.
53. Belting, *Bild und Kult,* 544.

BIBLIOGRAPHY

Primary Sources

Aegidius à Sancto Joanne Baptista. *Wienec Blahoslawenému a wěčně Oslawenému Knijžeti Cžeskému Mučedlnijku Božijmu druhému Abelowi, Swatému Wáclawowi Z Dwauch a Třidcýti Růžj geho Swatého Narozenj Žiwota Smrti vwijteg Bratřj Bosácý Reformati Ržádu S Augustýna w Nowém Městě Pražském gakožto swého Klásstera Patronu a ochráncy nábožným srdcem dedycyrugi a offérugi Léta 1643.* (Cum Licentia Superiorum apud Ioannem Bilinam Vetero-Pragae. Anno 1643). Prague: Jan Bylina starší, 1643.

Alegambe, Philippe, and Janos Nadasi. *Heroes et victimae charitatis Societatis Iesu. Seu catalogus eorum, quie e Societate Iesu charitati animam deuouerunt.* Romae: Ex Typographia Varesii MDCLIIII.

Andrade, Alonso de. *Varones ilustres sandidat, letras, y relo de las almas de la Compania de Jesus.* En Madrid: por Ioseph Fernandez de Buendia, 1667.

Arsenius z Radbuzy, Kašpar. *O Blahoslawené Panně Marygi přečisté Rodičce Syna Božjho a o Diwjch kteřjž se děgj před gegjm Obrazem w Staré Boleslawi. Knižka nábožným Pautnijkům y giným Křestianům welmi vžitečná. Od důstogného Kněze Kasspara Arsenia z Radbuzy Officiala a Archidiacona Kostela Pražského Probossta Wyssehradského k žádosti mnohých wěrných Křestianůw w nowě sepsaná. S powolenjm Wrchnosti.* Wytisstěná w Starém Městě Pražském [Prague] v Kasspara Kargezya, 1613.

Balbín, Bohuslav. *Diva Montis Sancti, seu Origines et miracula Magnae Dei hominumque matris Mariae, quae in Sancto Monte regni Bohemiae, ad argentifodinas Przibramenses, quotidianâ populi frequentiâ, & pietate, in statua sua mirabili, aditur, & colitur: V. libris comprehensa.* Pragae: Typis in Collegio Societatis Jesu ad S. Clementem per Georgium Czernoch, 1665.

Balbín, Bohuslav. *Diva Turzanensis sev historia originis & miraculorum magnae dei hominumque matris Marie: cujus venerabilis statua, prope Brunam indicio coelestis lucis inrvbisinventa, magno populorum accursu honoratur.* Olomutii: Typis Viti Henrici Etteli, 1658.

Balbín, Bohuslav. *Přepodiwná Matka Swato Horská Marya, W Zázracých, a Milostech swých na Hoře Swaté nad Městem Přjbrami Hor Střjbrných, den po dni wjc a wjc se stkwěgjcý . . . wytisstěná.* W Litomyssli [Litomyšl] v Jana Arnolta, 1666.

Bartoli, Daniello. *Historia della compagnia di Giesù.* Roma: Manelfi, 1653.

Cardim, António Francisco. *Fasciculus e Iapponicis floribus suo adhuc madentibus sangvine.* Romae: Typis Heredum Corbelletti, 1646.

Cavallieris, Ioann Baptista de. *Beati Apollinaris Martyris, primi Ravennatum episcopi res gestae.* Roma: Officina Bartholomaei Grassi, 1586.

Cavallieris, Ioann Baptista de. *Ecclesiae Anglicanae Trophea.* Roma: Officina Bartholomaei Grassi, 1584.

Cavalleris, Ioann Baptista de. *Ecclesiae Militantis Trumphi.* Roma: Bartholomaei Grassi, 1583.

D. Wenceslao Bohemorum Duci ac Martyri inclyto Sertum Ortus, Vitae, Necis è duabus Suprà triginta Iconibus, totidemq[ue] Tetrastichis, uelut è Rosis quibusdam Contextum. F F. Excalceati, Regulâ Augustinenses, Claustro Neopragenses S[erenissi]mo. Suo Tutelari D. D. D. Retextum denuò in Typographia Vrbani Goliae A[nn] 1661. Tempore Congregationis Prouincialis eorundem FF. Excalceat: Prouintiae Germaniae in Conuentu Neopragensi Mense Maio. / Wěnec Blahoslawenému a wěčně oslawenému Knjžeti Cžeskému Mučedlnjku Božjmu druhému Abelowi S[vatém]v Waclawowi Ze dwauch a Třidceti Růžj geho S[vateh] Narozenj Žiwota a Smrti vwitý Bratřj Bosácý Ržádu Swatého Augustýna w Nowém Městě Pražském gakožto swého Klásstera Patronu a Ochráncý nábožným Srdcem dedicýrugj a offěrugj. Ehren=Kräntzlein So dem Heiligen vnd Glorwürdigsten Martyrer Wenceslao, Weyland Hertzogen Böheimb ec. Der Kirchen und deß Closter=Stiffts zu St. Wentzl in der Newen Stadt Prag Haubt=Patron vnd fürtrefflichen Schutz=Herrn Von zwey vnd dreyssig wolriechenden Rosen seines Allerseeligsten Anbeginnens Wandels vnd Endes Andächtig=demütigst zusammen

gewunden vnd auffgeopffert Von denen FF. Augustinern, Barfüssern im Closter bey obbemeldt St. Wentzel auff der Newen Stadt Prag. Prague: Urban Baltazar Goliáš, 1661.

Frozín, Antonín. *Obrowisstě Maryánského Atlanta Swět celý Maryánský w gedinké Knjžce nesaucýho.* Prague: Jiří Laboun, 1704.

Giovio, Paolo. *Elogia Virorum literis illustrium, quotquot vel nostra vel avorum memoria vixere.* Basilea: Perna, 1577.

Kayser, Sebastian. *Austria Mariana, Seu Gratiosarum Virgineæ Dei-Parentis Iconum per Austriam, Origines, progressus, ac beneficia singularia Honoribus . . . Dominorum AA. LL. Et Philosophiæ Neo-Baccalaureorum, Cum Per R.P. Sebastianum Kayser, e Soc. Jesu, AA. LL. & Philosophiæ Doctorem . . . In Antiquissima, & Celeberrima Universitate Viennensi Prima Philosophiæ Laurea donarentur Ab Illustrissima Poesi Academica dicata Anno M.DCC.XXXV.* Wiennae: Typis Leopoldi Ioannis Kaliwoda, 1735.

*Krátké Popsánj Narozenj | Žiwota a Smrti Swatého Wácslawa Mučedlnjka, Wegwody a Patrona Králowstwj Cžeského | Kterak se takowé w rozličných Hystoryjch popsané | a w Staro-Boleslawském Kostele Swatého Wácslawa malowané spatřuge. . . .*Vytištěno v Praze . . . u Matěje Högra Arci.Bisk. Impress. 1738.

Kriger, Paul. *Fons Apollinis, oder Son[n]enBrun[n]en, das ist: das Leben deß heiligen Wenceslai Martyrers, dieses Hochlöbl. Königreichs Böheimb HaubtPatrons : so vorhero anno 1643 allhier zu Prag zum erstenmahl in Druck außgangen: wie auch die vielfältige Gutthaten und Gnaden, so Menchen vnd Vieh zu Trost, durch den S. Wenceslai Brunnen zu OberLauterbach, in dem Churfürstl. Landgericht Schrobenhausen in OberBayern entsprungen: welche Beneficia vnlängst anno 1658. vnd 1659. beschrieben, vnd in Druck versertiger worden.* In der Alten Stadt Prag: expensis Michael Godfried Voigtens, 1661 [bey Vrban Goliasch].

Kriger, Paul. *Studně zdravohojitelná svatého Václava knížete, mučedlníka a dědice českého v Hořejším Lauterbachu kurfiřtského kraje Schrobenhauzu v Hořejších Bavořích nedávno vyprejštěná. Beneficus fons s. Wenceslai ducis Bohemiae et martyris.* W Praze [Prague] Letha MDCLIX Wytisstěna, Typographia Academica in Coll. Societ. Jesu ad. S. Clementem, 1659.

Kurtze Beschreibung Dess Herkommens, der Geburth, des Lebens und Todtes Dess Heiligen Wenceslai, Hertzogen, und Patrons Dess Böhmerlandes, Wir es in denen Historien beschrieben, und der Alt.Buntzlauer S. Wenceslai Kirchen gemahlet zu sehen. Prag . . . bey Mathia Höger . . . Artz-Bischofflichen Buchdrucker, 1732.

Nieremberg, Juan Eusebio. *Ideas de virtud en Algunos claros varonas de la Compania de Jesus.* Madrid: Por Maria de Quiñones. Año MDCXLIII.

Sartorius, Augustin. *Marianischer Atlas, Oder Beschreibung Der Marianischen Gnaden-Bilder Durch die gantze Christen-Welt.* Prag: Beringer, 1717.

Scherer, Georg. *Preces ac meditationes piae in mysteria passionis ac resurrectionis Jesu Christi collectae per Georgium Scherer Societatis Iese. Figuris aeneis ab Alberto Dürero olim artificiose sculptis ornatae.* Bruxelae: Rutgerus Velpius, 1612.

Scherer, Heinrich. *Atlas Marianvs Sive Praecipuae Totius Orbis Habitati Imagines Et Statuae magnae Dei Matris Beneficiis Ac Prodigiis Inclytae Succincta*

Historia Propositae Et Mappis Geographicis Expressae. Monachii: Typis Mariae Magdalenae Rauchin viduae, 1702.

Tanner, Jan. *Swatá Cesta Z Prahy do Staré Boleslawě K Neydustognёgssj Rodičce Božj Panně Maryi Cžtyřidcýti a čtyrmi krásnými Stawuňky podlé počtu Litanye Lauretánské Tytulů gegjmi Obrazy w Čechách slawnёgssjmi ozdobená: Ale před tjm dáwno S milého Wáclawa Dёdice Cžeského na smrt odgezdem a potom Těla Přenessenjm poswёcená: Nynj také malowánjm Žiwota a Zázraků geho okrásslená.* Vytištěno v Praze [Prague] . . . v koleji Tovaryšstva Ježíšova u sv. Klimenta . . . 1679.

Tanner, Mathias. *Societas Jesu usque ad sanguinis et vitae profusionem militans, in Europa, Africa, Asia et America, contra gentiles, mahometanos, Judaeos, Haereticos, impios, pro Deo, Fide, Ecclesia, Pietate. Sive vita et mors eorum . . .* Pragae: Typis Universitatis Carolo-Ferdinandeae, in Collegio Societatis Jesu ad S. Clementem, per Joannem Nicolaum Hampel Factorem . . . Anno M. DC. LXXV.

Tanner, Mathias. *Die Gesellschafft JESU Biß zur vergiessung ihres Blutes wider den Götzendienst, Unglauben, und Laster, Für GOTT, den wahren Glauben, und Tugendten in allen vier Theilen der Welt streitend: das ist: Lebens=Wandel, und Todtes=Begebenheit der jenigen, die auß der Gesellschafft JESU umb verthätigung Gottes, des wahren Glaubens, und der Tugenden, gewaltthätiger Weiß hingerichtet worden: Vorhero Lateinisch beschrieben Von R. P. Mathia Tanner . . .* Gedruckt zu Prag: Carolo-Ferdinandeische Universität Buchdruckerey, 1683.

Tanner, Mathias. *Societas Jesu Apostolorum imitatrix, sive gesta praeclara et virtutes eorum, qui e Societate Jesu in procuranda salute animarum, per Apostolicas Missiones, Conciones, Sacramentorum Ministeria, Evangelii inter Fideles et Infideles propagationem ceteraque munia Apostolica, per totum Orbem terrarum speciali zelo desudarunt . . .* Pragae: Typis Universitatis Carolo-Ferdinandeae, in Collegio Societatis Jesu ad S. Clementem . . . per Adalbertum Konias, Factorem. Anno M.DC. XCIV.

Tanner, Mathias. *Die Gesellschafft Jesu der Aposteln Nachfolgerin, Fürtreffliche Thaten und Tugenden der jenigen, welche aus Erwehnter Gesellschafft In Beförrderung des Seelen=Heyls, Durch Apostolische Ausfertigungen, eyfrige Predigen, Ausspendung der Sacramenten, Fortpflanntzung des Evangeliums, bey Glaubingen und Unglaubigen, wie auch durch andere Apostolische Verrichtungen, die gantze Welt mit ihrem Schweiß befeüchtet haben. Lateinisch beschrieben von . . . P. Mathia Tanner . . .* Gedruckt zu Prag in der Carolo-Ferdinandäischen Buchdruckerey der Societät Jesu bey St. Clement, durch Joannem Franciscum Starck, Factorn Anno 1701.

Tanner, Mathias. *Societas Jesu Usque ad Sanquinem pro Deo et Fide Christiana militans.* n.p., n.d. [The print in Brno, Moravian Land Library/Moravská zemská knihovna, has a handwritten note: *Collegii Societatis Jesu Oppaviae 1696 pro usu infirmorum.* Begins with: Duo Sacerdote SJ, Paulus a Valle].

Tanner, Mathias. *Societas Jesu Usque Ad Sudorem Et Mortem, Pro Salute Proximi Laborans.* n.p., n.d. [The print in Brno, Moravian Land Library/Moravská zemská knihovna, has a handwritten note: *Collegii Societatis Jesu Oppaviae 1696 pro usu infirmorum.* Begins with St. Ignatius].

Tanner, Mathias. *Societas Jesu Usque Ad Sudorem Et Mortem, Pro Salute Proximi Laborans.* n.p., n.d. [The print in Research Library Olomouc / Vědecká knihovna Olomouc, shelfmark 29 992, has a handwritten note: *Collegii Societatis Jesu Olomucii, A. 1693 Infirmariae inscriptus.* Begins with St. Ignatius].

Verstegen, Richard. *Theatrvm Crudelitatum Haereticorum Nostri Temporis. Antverpiae, Apud Adrianum Huberti, Anno M. D. LXXXVII. Cum Priuilegio.* Antwerpen: Hubertus, 1587.

Secondary Studies

Balsamo, Olivier Christin, and Fabrice Fluckinger. "Introduction." In *L'Atlas Marianus de Wilhelm Gumppenberg. Edition et traduction*, edited by O. Ch. Balzamo and F. Fluckinger, 9–26. Neuchâtel: Editions Alphil-Presses universitaires suisses, 2015.

Behrmann, Carolin. "Le monde est une peinture. Zu Louis Richeomes Bildtheorie im Kontext globaler Mission." In *Le Monde est une Peinture. Jesuitische Identität und die Rolle der Bilder*, edited by E. Oy-Marra, V. R. Remmert, and K. Müller-Bongard, 15–44. Berlin: Akademie Verlag, 2011.

Belting, Hans. *Bild und Kult. Eine Geschichte des Bildes vor dem Zeitalter der Kunst*, Munich: C.H. Beck, 1993.

Belting, Hans. *Bild-Anthropologie. Entwürfe für eine Bildwissenschaft.* Munich: Wilhelm Fink Verlag, 2001.

Bitnar, Vilém. "Český mecén výtvarného baroka [Jan Ignác Dlouhoveský]." *Dílo: list věnovaný původní tvorbě české, hlavně dekorativní* 32 (1941–1942): 132–137.

Buser, Thomas. "Jerome Nadal and Early Jesuit Art in Rome." *Art Bulletin* 58 (1976): 424–433.

Corethová, Anna. *Pietas Austriaca. Fenomén rakouské barokní zbožnosti.* Olomouc: Refugium Velehrad-Roma, 2013.

Čornejová, Ivana, and Anna Fechtnerová. *Životopisný slovník pražské univerzity. Filozofická a teologická fakulta 1654–1773.* Prague: Univerzita Karlova, 1986.

Doležal, Daniel and Hartmut Kühne, eds. *Wallfahrten in der europäischen Kultur: Tagungsband Příbram, 26.–29. Mai 2004. Pilgrimage in European Culture. Proceedings of the Symposium Příbram, May 26th–29th 2004.* Frankfurt am Main: Peter Lang, 2006.

Ducreux, Marie-Elizabeth. "Symbolický rozměr poutě do Staré Boleslavi." *Český časopis historický* 95 (1997): 585–620.

Herzogenberg, Johanna von. "Marianische Geographie an böhmischen Wallfahrtsorte. Der Weisse Berg; Rimau in Südböhmen; der Heilige Berg." *Alte und moderne Kunst* 16, no. 114 (1971): 9–21.

Kalista, Zdeněk. *Cesty ve znamení kříže.* Prague: Evropský literární klub, 1941.

Kerber, Bernhard. *Andrea Pozzo.* Berlin: Walter de Gruyter, 1971.

Koch, Ludwig. "Tanner, Matthias", in: *Jesuiten-Lexikon. Die Gesellschaft.* 1727–1728. Padernborn: Verlag, 1934.

Kvapil, Jan, ed. "Augustin Sartorius, Mariánský Atlas, Prague 1717 – koncepce barokního patiotismu vytvořená oseckými cisterciáky." *Ústecky sborník historický* (2000): 145–166.

Linda, Jaromír. "Matěj Tanner (1630–1692)." In *Minulostí západočeského kraje. Západočeské nakladatelství*, 28, 175–188. Plzeň: n.p., 1992.

Malura, Jan. "Barokní poutní knihy a zbožná praxe širokých vrstev." *Český lid* 104 (2017): 33–51.

Massing, Jean Michel. "Jerome Nadal's *Evangelicae Historiae Imagines* and the Birth of Global Imagery." *Journal of the Warburg and Courtauld Institutes* 80 (2017): 161–220.

Mihola, Jiří, ed. *Na cestě do nebeského Jeruzaléma. Poutnictví v českých zemích ve středoevropském kontextu*. Brno: Moravské zemské muzeum, 2010.

Monssen, Leif Holm. "*Rex Gloriose Martyrum*: A Contribution to Jesuit Iconography." *Art Bulletin* 63 (1981): 130–137.

Monssen, Leif Holm. "The Martyrdom Cycle in Santo Stefano Rotondo. Part I." *Acta ad archeologiam et artium historiam pertinentia* 80, no. 2 (1982): 175–317.

Monssen, Leif Holm. "The Martyrdom Cycle in Santo Stefano Rotondo. Part II." *Acta ad archeologiam et artium historiam pertinentia* 80, no. 3 (1983): 11–106.

Müller-Bongard, Kristina. "Konzepte zur Konsolidierung einer jezuitischen Identität." In *Le Monde est une peinture. Jesuitische Identität und die Rolle der Bilder*, edited by Elisabeth Oy-Marra, Volker R. Remmert, and Kristina Müller-Bongard, 153–176. Berlin: Akademie Verlag, 2011.

Noreen, Kirstin. "*Ecclesiae militantis triumphi*: Jesuit Iconography and the Counter-Reformation." *The Sixteen Century Journal* 29 (1998): 689–715.

O'Malley, S.J., John W. "To Travel to Any Part of the World: Jerónimo Nadal and the Jesuit Vocation." *Studies in the Spirituality of the Jesuits* 16, no. 2 (1984); 1–20.

Oy-Marra, Elisabeth, Volker R. Remmert, and Kristina Müller-Bongard, eds. *Le Monde est une peinture. Jesuitische Identität und die Rolle der Bilder*. Berlin: Akademie Verlag, 2011.

Podlaha, Antonín. *Poutní místo Hájek s kaplí Loretánskou a klášterem františkánským*. Prague: Nákladem vlastním, 1913.

Remmert, Volker R. "Visuelle Strategien zur Konturierung eines jesuitischen Wissensreiches." In *Le Monde est une peinture. Jesuitische Identität und die Rolle der Bilder*, edited by Elisabeth Oy-Marra, Volker R. Remmert, and Kristina Müller-Bongard, 153–176, 85–108. Berlin: Akademie Verlag, 2011.

Smyčková, Kateřina. "Mariánský ctitel: literární (sebe)prezentace J. I. Dlouhoveského." In *Salve regina: mariánská úcta ve středních Čechách*, 241–251. Prague: Ethnological Institute of the Academy of Sciences of the Czech Republic in cooperation with the State Regional Archive in Prague, 2014.

Smyčková, Kateřina. "Koncept 'svatých Čech' v díle J. I. Dlouhoveského." *Studia Comeniana et historica* 48 (2018): 11–26.

Svatoš, Michal. "Societas Jesu militans, imitans, laborans—Slavné skutky, ctnosti i mučednictví jesuitů v podání Matěje Tannera T. J., Karla Škréty a Johanna Georga Heinsche." *Listy filologické* 117 (1995): 288–305.

Šámal, Jindřich. "Barokní cykly svatováclavské. Jejich význam v obraze sv. Václava." PhD dissertation, Prague: Charles University, 1945.

Šroněk, Michal. *Jan Jiří Heinsch (1647–1712). Malíř barokní zbožnosti*. Prague: Gallery, 2006, 58–72.

Chapter 4

A Unique Sign of True Faith

*Medieval Marian Images and the
Jesuit Construction of the Past*[1]

Kateřina Horníčková

The Council of Trent (1545–1563) defined a program of Catholic renewal that included a grasp of the past that would serve, in a religious sense, as a model for renewing the present. The theologians of the Tridentine period understood the past as a means of establishing a solid defense of the Catholic faith, according to which the Catholic Church alone grew organically out of the early Christian Church. This view opposed similar claims made by religious dissenters and argued for the primacy of the Catholic Church.

This construction of the past, based on a controversial theological interpretation of church history, linked Renaissance understandings of rebirth with an older cyclical theory of time.[2] The cyclical perception of time in the sixteenth century rested on medieval roots, but was enriched in the Renaissance by the idea of rebirth.[3] The Catholic vision absorbed the model of a lost ideal and the idea of a return to the lost past as a basic principle that would enable a return to the ideals of antiquity to inspire Catholic rebirth, to become a model for overcoming internal differences in the church, and to achieve internal unity.[4]

Catholic historical interest was initially based primarily on ecclesiastical texts illustrating the *historia sacra* that were intended to attest the unbroken continuity of the apostolic and tridentine church against Protestant criticism. A generally growing interest in ancient monuments in the last decades of the sixteenth century aroused an intense interest in the monuments of Christian antiquity in Roman Catholic circles and prompted an effort to incorporate such monuments into the emerging post-Tridentine conception of history.[5] Efforts to incorporate early Christian monuments and narrate a new historical narrative within the *historia sacra* went beyond purely historical interest. In the spirit of contemporary antiquarianism, the view was that material

monuments and their study could supplement the knowledge of ancient authors and provide support for arguments in polemics with Protestants.[6] The heritage of the early Christian period was to be used to inform the vision of Counter-Reformation Catholicism on many, including on a moral level. In response to Protestant criticisms of the use of images and relics in religious practice, ancient and medieval works from early Christian Church history were used to reinforce the moral framework of post-Reformation Catholicism and thus incorporated into the Catholic narrative of the time. Despite the problems that incorporating late Christian antiquity into the historical narrative of church history posed for sixteenth-century theologians,[7] the basic idea of this vision was successfully adapted for missions to the confessionally mixed Transalpine regions.

THE CULT OF IMAGES AND MEDIEVAL WORKS AMONG THE JESUITS

The idea of renewing the church that the Societas Jesu promoted in its work in Central Europe (in line with similar efforts of other orders and ecclesiastical institutions) was firmly anchored in this concept. The idea that nations and societies could be reborn was already fully embedded in the teachings of Roman intellectual circles when Ignatius of Loyola and his friends came to Rome in 1540 and subsequently opened the Roman, and then the German and Hungarian (*Collegium Germanicum et Hungaricum*), Colleges. The Ignatian conception of Catholic reform was aimed directly at creating a new spiritual universal order, which the Jesuits saw as the main task of their education and missionary activities. This effort was related to the Jesuit understanding of the world and human existence, in which profane and sacred, private and public piety were combined into a single universal and God-governed whole.[8] By gradually forming an understanding of the world as a multifaceted and open system[9] that functioned in unity and was subject to God's uniform principles, the Jesuits sought to unite the physical and the spiritual, aiming at a profound Catholic renewal of the whole of society. The incorporation of the past into this (didactically ordered) system, in the sense of references to *historia sacra* using ancient works and monuments in their specific locations, offered the order a controllable opportunity to make an intense connection between everyday experience and direct communion with God through contact with holy places and objects. It also served as a reminder of the eternal tradition of the church in a form transferable to local contexts. This essentially medieval relationship to the sacred was anchored in a plausible, "rational," and "historically verified" framework of local tradition and Catholic morality in post-Tridentine

Catholicism.[10] Inspired by the Oratorians and writings of C. Baronio, the moral-historical concept of a return to the lost ideal of Christian antiquity was applied in a number of Jesuit writings that constructed the past to support the current interpretation of historical developments in the local contexts of Jesuit missions. Recent work explains attempts to re-narrate and forges history by projecting the Tridentine immaculate image of the solid and unified Christian Church ideal back to early Christian times to create a "perfect" image of Catholic purity in the ancient past, to be contrasted with the later corruption that justified the need for reform embodied in the Jesuit mission.[11] Other orders also sought to incorporate *historia sacra* meaningfully into the concept of Catholic renewal by reenacting early Christianity in the sacred topography of Rome.[12]

The Jesuit Roberto Bellarmino's (1542–1621) *Disputationes de controversiis christianae fidei adversus huius tempori hereticos*[13] systematically generalized the basic concept of post-Tridentine church history and became a key compendium of the Catholic version of history. He constructed a basic concept of education and conduct for a confessionally mixed environment where an adversary uses the same constructions of Christian dogma and thus confessional distinctions must be built on theological subtleties and contrasts. In the *Disputationes*, Bellarmino formulates arguments and a framework for action against Protestant heretics for use in missions based on an interpretation of the church's past. A single, solid, and unified Catholic Church that is repeatedly threatened by heresy is the basic vision of his conception of church history. In the second volume of his *Disputationes*, he writes that heresy actually underlies the development of the church because it forms a kind of "mirror of the true Church." In Bellarmino's historical construction, heresy, embodied by Protestant theology and non-Catholic churches in his time, is in fact a key prerequisite for establishing a new Catholic order. Bellarmino's writings were widely used by Jesuits throughout Europe, and in Bohemia this is indicated by the number of his titles owned by individual colleges.[14]

Bellarmino devoted considerable attention to the question of images. In his construction, the early Christian past is an unshakable authority against the Reformation, which is always iconoclastic. From this point of view, Bellarmino argues at length against heretical and Protestant iconoclasm and defends the cult of images on the grounds that God himself sanctioned it.[15] He discusses images in Book II, *De effectu sacramentorum*, speaking out against, among other things, the Protestant destruction of images of the Eucharist and Christ. Especially in Part II of the fourth controversy, *De ecclesia triumphante sive gloria et cultu sanctorum*, he defends the cult of saints, relics, and images, and the practice of pilgrimages and feasts against the iconoclasts.[16] For Bellarmino, these forms of cult are voluntary, not commanded by divine precept, but they are not dangerous, as Reformation theologians

claim, "because the faithful today can no longer fall into idolatry, for we are well instructed in its pitfalls."[17] He resolves the distinction between idols and images in an original way with the concept of truthfulness in images—ancient idols are false and Catholic images are true because they are bound to holy persons.[18] In a multiconfessional setting, Bellarmino believes that it is a sin to destroy images because they are representations of Christ or tied to holy persons and that if something comes from a Catholic setting and has ever been successfully used by the cult, it is still acceptable to the cult. In contrast to the distrust of medieval art in the art theory of the time, Bellarmino, like other post-Tridentine theologians, understood old (both ancient Christian and medieval) images as the heritage of an uncorrupted early church. This opened the way for using old images in the missionary concept of Catholic renewal.

Bellarmino also defends the decoration of churches against the teachings of the Protestants. It is understood as *decor domus Dei*, that is, everything that decorates churches adds to their beauty, richness, grandeur, and magnificence. All the objects of the Catholic liturgy are an addition to the service of God because it is not fitting for God to dwell in poor dwellings.[19] He compares church ornaments to the blossoms and fruit of the tree of the church; their presence attests its strength.[20] At the same time, Bellarmino concludes that it is not those who build and adorn the houses of the Lord who do harm, but only those who tear them down and thereby weaken the "roots of faith." According to Bellarmino, viewing beautiful and sublime works produces "good fruit" in the souls of the faithful; that is, beautiful and magnificent decorations in churches strengthen the faith and promote the catechesis of the faithful. God creates the beautiful, therefore He must Himself be beautiful, and thus the beautiful also helps in catechesis by its form.[21]

Bellarmino's conception of the image is based on Thomas Aquinas, who was defending—according to Bellarmino—the outward form of church rites and traditions against a "Cathar" literal interpretation of the biblical prohibition against images. Bellarmino, however, uses Aquinas' arguments to defend a new, Ignatian, interpretation of the older tradition.[22] Images, painted or carved "as if alive," astonish us; all the more must we be astonished by the God who made man out of mud.[23] For the actual presence of images in churches and the miracles performed through them, Bellarmino argues from early Christian authorities, for example, Theoderet,[24]

> "who wrote that in his time the churches of the martyrs were filled with images and likenesses of hands, feet, eyes, heads, and other limbs, which reminded [viewers of] the various gifts of healing that through votive offerings people received from the holy martyrs."

God can thus work miracles through images, preferably in places where contact with glorious images impacts souls so that they can better receive

these gifts.[25] But images are not to be collected for cult, but *pro exemplas* (as models) and only some are to be venerated—these images are then to have a solemn place in the church.[26]

Like their conception of history, the Jesuit conception of the image was based on the theological debates of the Council of Trent, whose decrees, including the one on images, the Jesuits themselves helped to shape.[27] It should be noted here that the Jesuit theologian Diego Laínez contributed substantially to the formulation of the Tridentine theory of the image. The successor of St. Ignatius and the bearer of his—essentially medieval—vision, Laínez elaborated it into a consistent theological system. For Laínez, just as for Ignatius, art is a means of manifesting faith and spreading spiritual truth among all; it is primarily used for spiritual communication. The role of art as an intermediary also gives it a specific, practical function: to distribute and use images in missions. This utilitarianism does not exclude spirituality, but, on the contrary, is complementary; together they form the basis of the Jesuit understanding of the role of the image in cult. [28]

As Hecht has shown at length, Paleotti and other post-Tridentine image theorists postulated, in the wake of the conciliar decrees, the conditions for creating a "true" Catholic sacred image, which required both the right spiritual disposition and a corresponding ambition in the creator to guarantee both the truthfulness and the proper origin of an image suitable for the cult.[29] The image (ideally a *vera effigies*) must preserve the likeness of the holy person as truly as possible. Artists must therefore adhere to the pictorial tradition of the original representation as the ancient Christians did.[30] At this point, however, theorists ran into the problem that preserved monuments (in contrast to texts) could not always be anchored in the context of early Christian practice beyond doubt and thus ceased to be a reliable argument in terms of theology.[31]

For the post-Tridentine theorists of image, Paleotti above all, the pictorial tradition serves as a self-disciplining control mechanism that prevents novelty, an artist's arbitrariness, and evaluation based solely on aesthetic impact.[32] Johannes Molan formulated this similarly, even preferring the pictorial tradition to the written tradition because it guarantees greater veracity.[33] The ancient image that is closest to the model thus acquires a special aura that is associated with maintaining the tradition of the image of the holy person. The theorists considered that the ideal of the "true" Catholic image is the early Christian image, confirmed, moreover, by early Christian authorities and by the tradition of the cult. The authority of ancient images is based, in Paleotti's view, on three points: first, by references to their existence in early Christian ecclesiastical authorities; second, by the actual existence of surviving ancient venerated images of miraculous origin (*acheiropoietoi*—"not-made-by-human-hands," St. Luke's images); and finally, by

contemporary finds of early Christian works showing the "true likeness" of saints or linked to holy places.[34] Among the reasons why images are holy, Paleotti lists:

> if they are sent from God, if they touched the body of Christ or the saints, if they were painted by St. Luke or were miraculously created as *acheiropoietoi*, they work miracles, have received ecclesiastical sanctification, or have become sacred through the subject they depict or through sacred places.[35]

Paleotti and Molanus completed the rehabilitation of the old image and helped formulate its function in post-Tridentine piety, within which the antiquity of the image is understood as a significant quality, evidence of its truth and origin, from which its authority then follows.[36]

In practice, the turn toward a more sympathetic attitude to surviving monuments in Rome reflected the words of Cesare Baronius, according to whom old images are valuable because they are "more original and more faithful to the truth."[37] Thus, in his conception of the continuity of the tridentine church and apostolic church, monuments play an important role. Federico Borromeo expressed the role of old images even more explicitly in his treatise *De pictura sacra libri duo* (1624), where he sighs how wonderful it would be if more "true representations" of saints were preserved (*imagines sanctorum expressae ad vivum*) that the "Greeks" once had (i.e., medieval icons), while Western Christianity has managed to preserve only a few of the authentic portraits of saints.[38] Artists have to be careful to preserve the few known facial features as the old models did. Borromeo emphasizes the didactic and preservation-oriented practices of art (meaning closely following the ancient models), as well as the morally understood authority derived from the authenticity of old images of the saints.[39]

In the last quarter of the sixteenth century in Rome, the study of ancient and medieval monuments in Rome was quite systematic, sparked by this greater appreciation of ancient objects. A better understanding of medieval symbolism came from findings from the demolition of the Lateran and competition in restoring the great Roman basilicas. Due to the Jesuits' close connections with the Oratorians' reading of Roman topography as *historia sacra*, and due to contacts with the historical works of Cesare Baronius and Onofrio Panvinio (d.1568), whose work was judged by a committee of Jesuits, the Jesuits also turned their interest more toward ancient objects and images.[40] They themselves followed the antiquarian approach and imitated the ancient style during their restoration of early Christian churches of St. Saba, St. Apollinare, and St. Stefano Rotondo that the German-Hungarian college received as their sanctuaries.[41]

The Marian cult, initiated in the Societas Jesu by St. Ignatius and followed intensely by many of the early figures of the order, was an integral part of the order's formation and staging of piety from the beginning,[42] but by the 1560s, at the latest, the veneration of old Marian images in the order's milieu was transformed into a particular strategy. Francisco de Borja, the third general of the SJ, was a keen devotee of sacred images, following in the footsteps of St. Ignatius. He addressed his sermons and meditations in Rome to the popularly venerated image of the *Salus Populi Romani* in Santa Maria Maggiore and sent the first copies, made in 1569, to important European figures and Jesuit colleges in Europe and beyond.[43] Rather than theologically based theories of the image, Bailey explains Borja's veneration of this image by St. Luke as essentially a medieval belief that the person depicted was present in the image and that copies could spread their spiritual power.[44] Borja drew inspiration and awareness of the power of the everyday and immediate impact of Marian images from the popular veneration of images, which was characteristic of local urban cults in medieval Italy. The Jesuits knew such cults from their own experience, for example, from the venerated medieval image of Madonna della Strada that hung on the exterior of their first church in Rome and was later solemnly moved to the interior of Il Gesù. It was important in the Czech environment that the founding figures of the order's support of the Marian cult were well known from the formation of the Czech Jesuit province and this was also connected with reverence for them. For example, Balbín quotes the words of Borja that "he who does not love Mary with all his heart cannot preserve the constancy of a pious life to the end and will not persevere through so many pitfalls."[45]

Veneration of popular images was the basis of a more sophisticated level of practical meditative and devotional reception of images in the environment of the order, already seen in Ignatius's *Spiritual Exercises*, as noted by Walter S. Melion.[46] Early Jesuit views on images developed against a backdrop of controversies over idolatry and Protestant attacks on the cult of saints and images in an atmosphere of controversy and apologetics that generally reflected the realities of the French rather than the Central European Reformation. This led the first Jesuit theologians to be cautious of the power of images and to cling to approaches that were tested and confirmed in the texts of the Scriptures and the Church Fathers.[47] In this spirit, for everyday religious practice and to be used in teaching the laity, the Jesuits ascribed a traditional didactic and anti-iconoclastic meaning to an image in the sense of a close relationship between copy and prototype.[48] During the second half of the sixteenth century, the Jesuits developed the concept of the meditative image, which they used to reinforce the cognitive and affective components of reception to help mediate moral and spiritual content for the audience.[49] Building on the medieval orthodoxy of the image, which offered a close association of the mental and physical image, Jesuit authors enriched it with a strong emphasis on the moral

quality of the image as a model to follow. The Incarnation is understood as a primordial God-created image that inspires the creation of other images *ad imitationem Christi* in the broadest sense.[50] Holy images are a kind of "image squared," *imagines imaginis Dei*, derived from Christ, the image of God. The dichotomy of the two approaches to the image, popular veneration and meditative practice, defined Jesuit image practices among the public, one form directed toward a sophisticated spiritual practice among members of the order and the elite, and the other toward presenting dogma to the faithful in a simplified notion of moral example and making the holy person present in order to mediate the wishes of the faithful. The didactic framing of the image paradoxically was close to the theological position toward images in early Bohemian Utraquism, but differed in its strong devotional dimension precisely with regard to the images worshipped.[51]

Moral formation through the image concerned not only Jesuit Christology but also Mariology, because Mary's ability to give her body to Christ made her capable of forming the body and soul of the faithful. Mary is able to mobilize her holy images to form real "images of Christ," that is, faithful in a metaphorical sense and in physical experience. The Jesuits' Marian devotion was anchored in the iconic archetype-image of the Madonna painted by St. Luke, from which all her other images—visual, textual, and rhetorical—are derived.[52] The archetypal images of the Madonna were thus understood simultaneously as a means of formation for the faithful, which encouraged their placement for the public in churches.

The shift in the Jesuits' perception of the image from a theoretical level toward its practical use in religious practice is expressed in Antonio Possevino's, SJ, *Tractatio de poesi et pictura ethnica*, published in 1595.[53] Possevino represented a new form of Jesuit cultural politics that assimilated the ancient past and converted it for the purposes of Catholicism. Although he retains the key postulate that the image must be in keeping with piety, Possevino's conception is more moralistic and turns attention to practical application, the question of the image's truthfulness, exactness, and emotional impact (as he demonstrates with the ancient statue of Laocoon).[54] Truthfulness does not need to be an accurate reflection of reality (*vir tantus verus esse, non verisimile vellet*); its accuracy is not visual, but moral. For Possevino, antiquity was an authority, but preferably to emulate morally.[55]

He was interested in both the public use of an image and its controlled reception; he demonstrates the ability of images to affect emotions in ancient and early Christian works.[56] Possevino believes that the aims of art are purely religious (painting is the "handmaid of theology," *ancilla theologiae*); works should be imbued entirely with a religious spirit, touch the inner spiritual chord of the viewer, and have an emotional effect on him.[57] The need for action is advocated by the connection of the texts, the emotional impact of the Passion of Christ, and martyrdoms. For Possevino, a painting is not a

work of art valued for its uniqueness, preciousness, and artistic execution, but essentially a symbolic-emblematic expression carrying an emotional and holy charge, and it should only be perceived by the viewer in this way. The function of the image for the Jesuits involved converting the image into an icon-symbol in the sense of a turn to the "sign" quality of the message (allegorization of the image) and carefully guiding the viewers' reception of such an image. The viewer is asked to open himself to the emotional and symbolic impact of the image and let it work on him. Possevino thus articulates a Jesuit understanding of the Baroque "turn to the viewer," a strictly controlled process that became the basis of the Jesuit reception of images.

This clearly shows that Paleotti's theoretical approach to the religious image underwent a certain functional transformation in the Jesuit milieu, which was more consistently focused on the use of the image in missionary religious practice and the reception practices of piety under the supervision of the order. This was characterized by melding public festivals and religious practices with the individual's everyday experience of protection through the cult of the local image, complemented by the Jesuit emphasis on their guidance in an internalized personal experience of faith, well illustrated by the copies of the Roman *Salus populi Romani* image that the Jesuits distributed in Central Europe. The public cult of this Roman palladium shifted to a certain exclusivity in the Jesuit context, where its reception was completely in the hands of the order; copies were destined for the interior of the colleges or offered for personal devotion to members of the royal houses of which the Jesuits were confessors.[58] In the Bohemian Lands, copies were intended primarily for the personal devotion of members of the college and high-profile visitors or publicly staged in altar settings of Jesuit churches so they would visualize the link to Rome.[59] The copy in Brno was only displayed for a limited time for local public veneration on feast days and special occasions.

Using images in Jesuit missionary practice was not only visual experience but also memorial and heterotopic. Both the medieval practice and meditative imagination are memorial practices linking an image (as a visual stimulus of piety) to a place and tend to conceptualize the image as a specific kind of *lieu de mémoire*, a site of spiritual memory.[60] The Jesuits understood the image as a self-referential medium that transcended the past, time, and space around it, attributing to it the ability to evoke memory within the collective memory of place.[61] The venerated image is a site of devotional and sacred memory, approachable through both an inner and a physical journey that takes place in the present but activates the past.[62] Considered *loca sancta* in their own right, venerated images took part in formulating the sacred topography of the *historia sacra* of Rome next to relics and ancient monuments, were installed on the altars in festive arrangements, and had religious performances, and meditations addressed to them.[63] From the earliest Jesuits onward, miraculous images of the Virgin Mary were seen spatially as constructing a patronage of

grace over a particular place or region. At the same time they became impor-
tant parts of a wider memorial sacred topography that referred to the active
cultic role of images in the tridentine sense. They attracted popular piety and
created symbolic topographies of local spiritual refuge and protection.[64]

The spatial dimension of the miraculous Virgin Mary images arose from
the experience of medieval cults with a locally anchored apotropaic function;
Marian images had had a locally defined sphere of action since the Middle
Ages. From the beginning of their existence, the Jesuits promoted local sites
of memory associated with famous images in Rome. When, in 1540, Ignatius
and his companions sought to acquire the church of Santa Maria della Strada
for the community's first presence in Rome, besides a strategic location at the
intersection of roads and enclaves in the center of the city, an older image of the
Madonna, the so-called della Strada, on the outer wall facing the Via Capitolina
probably also supported the selection.[65] According to legend, Ignatius himself
was said to have revered this image. Given the busy nature of the site, it was
probably an image that inspired a devotional pause, meditation, and active
pious remembrance amid the bustle of a city street. The Italian medieval folk
practice of venerating public street Marian images must have conformed to
the Jesuit ideal of *imagines agentes* (image-agents), for these images worked
in catechesis, spread holiness beyond the confines of the church, materialized
the neighborliness of the patron saint, worked miracles, healed and protected
against plague, helped the poor, protected against crime, warned against
blasphemy, and reminded passers-by of the need for an active religious life
and frequent prayer.[66] The Jesuits further cultivated this essentially medieval
model; during the construction of Il Gesù on the site of this church, the image
of the Madonna della Strada was removed, preserved, and then reinstalled in
the new building of Il Gesù in the chapel to the left of the high altar, where it is
still venerated today. The solemn, antiquarian-like decoration and arrangement
of the chapel in 1584 was the first solemn elevation of a medieval image, not
only in the Jesuit but also in an Early Modern Roman context, preceding the
refurbishing of the Capella Paolina in Santa Maria Maggiore by a quarter of a
century.[67] The conceptual framework and appropriation of existing cultic prac-
tice related to old images paved the way for medieval images of the Virgin to
be successfully appropriated into the interiors of Jesuit churches and included
in the concept of the Catholic renewal of the Christian cult.

THE MARIAN CULT IN THE BOHEMIAN JESUIT
MISSION: A TRANSFER OF CONCEPT

In the Transalpine regions, the Marian cult formed one of the pillars of
the spirituality of the Societas Jesu alongside the cult of the Eucharist and

Christocentric spirituality. In a confessionally mixed environment, private and public veneration of the saints, especially the Virgin Mary, was not only intended to satisfy the inner needs of Catholics but was also a public manifestation of Catholic piety as a feature distinguishing it from Reformation churches.[68] This new flowering of Marian devotion and Marian pilgrimages was closely related to the escalating religious-political conflicts and the politicization of the successes of the struggle against the "heretics," the victory over the Turks at Lepanto, and then over the Protestant estates at the Battle of White Mountain (Bílá Hora) in 1620. In Protestant and confessionally mixed areas, the Virgin Mary was increasingly presented as a symbol of the struggle against the "heretics" and as a symbol of the continuum with the ancient church.[69]

For the Jesuits on missions in the Protestant areas of Central Europe, the Marian cult was attractive not only because it provided a needed symbol of Catholic unity but also because it offered the opportunity to exploit local links to the past to strengthen Catholic faith through restoring local pilgrimage sites and the devotional veneration of Marian statues and images.[70] In Central European mission settings, Jesuit efforts to construct a topography of spiritual presence were part of a strategy to appropriate space that had recently been confessionally mixed. Creating a network of Catholic locales, like embryos of the new Catholic order, through re-vitalizing the veneration of older Marian images proved to be a particularly load-bearing strategy here.[71] In Italy, their value lay in their local protection and miraculous effect through their material presence; in Central Europe, however, this power was extended to form a direct link to the pre-Protestant past. In the context of Catholic renewal, the images were to function as local reminders—local spolia of a better past—whose power is reawakened in the present. In the mid-seventeenth century, applying this sacred topography concept of the regionally and locally bound apotropaic effect of Marian images resulted in Gumppenberg's *Atlas Marianus*, and its regionally focused derivations.[72]

In the confessionally mixed environment of Central Europe, the writings of Peter Canisius, *De Maria Virgine Incomparabili* (1577 and 1583),[73] a summary of Jesuit Marian doctrine supported by a pictorial accompaniment combining motifs from miraculous Roman icons, played a major role.[74] In Protestant areas these works served as an "antidote" to Protestantism, reinforcing Catholic identity in both a general dogmatic sense and the local sense of *loci memoriae* of the pre-Reformation past.[75] As early as the 1550s and 1560s,[76] Canisius, a deep Marian worshipper, initiated the distribution of German-language prints to celebrate the Virgin and foster the Counter-Reformation revival of the Madonna cult in Altötting, a popular late-medieval pilgrimage site in Bavaria near the Czech border.[77] After 1591 it came under Jesuit administration and was well known in Czech Catholic circles.[78] Later,

in Augsburg, Canisius saw how the Marian cult, pilgrimages, and festivals could function as a means of persuasion for conversion. In 1606, in Ingolstadt, the Jesuit Jakob Gretser published a defense of pilgrimages that promoted new religious practices during pilgrimages and processions, including flagellantism.[79] From the beginning, Jesuit activity in Germany was directed toward restoring Marian pilgrimages and shrines. For Catholics in Protestant settings, the practice of pilgrimage served as a distancing marker and made visible the reconquista of lost Catholic positions. The Jesuits in Austria acted similarly.[80]

For Canisius, the Jesuits' situation in predominantly non-Catholic Bohemia was even better than in Germany. As the representative of the German province, he had personally introduced the Jesuits to Bohemia in 1555–1556 and pushed for the Jesuits to take over the Dominican monastery at St. Clement's. Canisius was well-informed about the situation in Bohemia, and held hopes for their success: "*Deus suam largiatur gratiam, et faveat coeptis et conatibus nostris in has sylvescente vinea.*"[81] (May God grant his grace and favors our work in this vineyard full of weed.) He wrote positively in a letter to Ignatius of Loyola that the conditions in Bohemia were more suitable for introducing the order and bringing the Bohemians back to Catholicism than in Germany or Austria.[82] He saw a more favorable situation in Bohemia because the people took communion under both species, kept the decoration of the churches, and observed the rites, rituals, and external customs of the church. The Hussites, according to Canisius, were inconsistent in their beliefs, had few theologically educated clergy, and, above all, lacked the support of the elite for the "renewal of the Church."[83] He was probably aware that a majority of Utraquists accepted a certain degree of veneration for the Virgin Mary and the saints, believed in transubstantiation, worshipped the Corpus Christi, and decorated their churches with images. The potential of respecting the traditions of one's own Christian past for the renewal of the cult did not escape him either, but to what extent he was aware that the Utraquists also revoked the sacred past in their cultic repertoire is not certain. From the beginning, he realized the importance of using references to the country's Christian past in the form of venerating the patron saints of Bohemia. Reverence for the Corpus Christi among the "orthodox" Hussites was later emphasized by Bohemian authors of confessional polemics from Jesuit circles, such as Václav Šturm and Simon Brosius.

The Utraquists' adherence to the religious traditions of the Bohemian Church paradoxically complicated the situation for the Jesuits. Heal sees external forms of Marian devotion in the Palatinate, Southern Germany, and Austria as a product of Jesuit propaganda, appealing for its spectacles and allegorical presentations of historical themes with actualizing and polemical content,[84] contrary to this Bohemia, traditionally more tolerant, had a much broader base of support for the Marian cult, including other monastic orders

already long-established in Bohemia, local Catholic religious leaders and nobility, and also a more conservative segment of non-Catholics. In Bohemia, the Jesuits "shared" their interest in the use of the past not only with the "old" orders but also with the Czech Utraquists and Brus of Mohelnice, Archbishop of Prague (who defended the lay chalice for Bohemia at the Council of Trent against, among others, the Jesuit Diego Laínez). Like the moderate Lutherans in Germany,[85] the Utraquists in Bohemia held the Virgin Mary in high esteem, allowing her images in their churches and celebrating her feasts and liturgies, for instance, practicing early morning Marian Masses (called *rorates*), sung by laity, in Advent. Although various forms of veneration of the Virgin Mary were quite widespread among Bohemian non-Catholics, the more radical part of the non-Catholic faithful during the sixteenth century and the gradually "lutheranizing" Utraquists in the early seventeenth century remained sensitive to the veneration of both images and relics and excessive Marian devotion. Iconoclastic attacks were rare, however, because the functional coexistence of Catholics and Utraquists had been legislated since the religious peace of Kutná Hora (1485) and the Wladislaw Land Ordinance (1500).[86]

The year 1609, when Emperor Rudolph II issued the Majesty Letter for Religious Liberty, can be seen as something of a landmark in the development of religious coexistence. A Jesuit report says that after the Majesty Letter, at a time when the "Hussites" (i.e., Utraquists, at this point radicalizing under Protestant influence) were putting aside old religious customs including processions, Catholics celebrated processions and pilgrimages with all the more glory, apparently to distinguish themselves.[87] Thus, in Bohemia, the Catholics could only appropriate the cult of the Virgin Mary fully after some of the local non-Catholics had become more radicalized.

The most conspicuous pious practices that distinguished Catholics from the non-Catholic faithful in Bohemia were the ostentatious veneration of images and relics and the practice of pilgrimage to Marian and saints' sites. As in Germany and Austria,[88] the Marian cult in Bohemia was important in the persuasion to convert applied in confessionally divided areas or in areas with a predominantly non-Catholic population.[89] Comparison with the German situation shows that these forms of cult were successful in conversion, especially in confessional environments, but the Jesuits did not achieve much where the confessional situation was not exacerbated and the town was tolerant.[90]

MARIAN PILGRIMAGE SITES IN
CONSTRUCTING THE PAST

From the second half of the fifteenth century, Catholic nobility and monasteries recovering from the Hussite wars began to establish local pilgrimage sites

in the Bohemian lands, a strategy that proved partially successful around ca. 1500, but the efforts of this "first Counter-Reformation" were significantly dampened by the rise of Protestantism in the sixteenth century. Bohemian Catholic circles, headed by Archbishop Brus since the reestablishment of the Prague archbishopric in 1561, were acutely aware of the growing radicalization of confessional conflict and adopted a strategy of making Catholicism visible in confessionally mixed areas by visiting pilgrimage sites and abandoned monasteries as early as the late 1560s and early 1570s.[91] They understood pilgrimages as a visible mark of a return to Catholic religious practice and a recovery of "forgotten" sites of Catholic memory.[92]

Before 1620, individuals from the Catholic elite became the patrons of the restoration of pilgrimage sites, led by courtiers around Emperor Rudolf II of Habsburg, members of the Catholic nobility (the Kolowrats, Popel of Lobkovicz, the Berkas of Dubá, and others), church officials in the circle of the archbishoprics and metropolitan chapter, newly arrived orders (Capuchins), and the circle of people around the papal nuncio and the Spanish envoi. The Jesuits played important roles in these networks as confessors, teachers, and mediators of the conversions of nobles who came forward as models of lay piety; among them former students of Jesuit schools in particular played significant roles. Jesuits helped with pastoral care and catechesis; they preached in parish and affiliate churches, instructed the laity, published catechetical treatises (e.g., Canisius's Small Catechism was published in Czech as early as 1568), and organized pilgrimages and religious festivals. For example, in 1593, the Prague college acquired the goldsmith guild's chapel of St. Eligius housing his relics (donated by Charles IV), which the Jesuits displayed ceremonially every year.[93] They coordinated their activities with other actors like the papal nuncio, who, as early as 1584, drew up a plan for the recatholization of the country and submitted it to Rudolf, emphasizing the symbolic importance of the conversion of the Bohemian kingdom. Before the decisive battle at White Mountain, however, their activities had rather limited impact.[94]

Characteristically, patrons sought pilgrimage sites with a late-medieval tradition located near non-Catholic enclaves where the Catholic side held the right of patronage (or had taken it in the confessional tug-of-war). To revitalize them, the Jesuits used their network of personal contacts among the nobility, chapters, and former students passing into church administration and parish clergy. The Jesuits dignified them with sermons, important visits, and devotional services, leading pilgrimages from nearby towns and celebrating liturgies for feasts. They promoted reverence for relics and images and, after the 1580s, organized public festivals and helped establish Marian sodalities.[95] The expansion of cities into surrounding areas during the sixteenth century aided the development of these forms of piety, which saw the emergence of a number of shrines around towns, particularly cemetery churches and

hermitages, where local pilgrimages could be developed as collective expressions of urban Catholic piety.[96]

The Jesuits based Catholic renewal in Bohemia on "re-discovering" the Catholic origins of the country. They promoted the importance of pilgrimage sites as places of Catholic memory in the spirit of *historia sacra*. Soon after their arrival, the Jesuits actively sought out holy places (*loca sancta*) near the residences of their noble patrons, the capital, and newly founded colleges, and they also visited the monasteries of the old orders in Bohemia and Moravia. An example of this is the visits Jesuit notables made to the Premonstratensian monastery of Velehrad in 1586 and 1597, facilitated by Bishop Pavlovský, a student of the German-Hungarian College in Rome, where the bishop stressed the visiting Jesuits' interest in the old painted monuments and antiquities of the monastery.[97] Jesuits viewed ancient works of art as tokens of local sacred (i.e., Catholic) memory, where grace was concentrated and available to the faithful. The concept of the *loca sancta* among the Jesuits was later expressed succinctly by the superior of the Bohemian colleges, Johannes Miller, quite in the spirit of Bellarmino's vision of the saints and their places:

> God has appointed a wondrous place ("*wundersames Ort*") . . . God is everywhere and everywhere extends his goodness, but even before the world began he chose certain places and sanctified them where he is to be worshipped and asked for help and for divine gifts, which are there more abundantly provided. . . . Here also are to be found evidences of his power: miraculous images ("*Gnadenbilder*"), relics and other memorials ("*Gedächtnus*") and mysteries ("*Geheimnus*"), which in themselves provide for half of a miracle and are a clear sign of God's favor ("*halbe grosse Wunderwerck und Zeichen*").[98]

The sacred topography conceptualization of the Marian protection of Bohemia appeared early, in the first author of Marian eulogies, Kašpar Arsenius of Radbuza, a graduate of the Jesuit gymnasium in the Clementinum and the German-Hungarian College in Rome.[99] In his treatise, *O Blahoslavené Panně Marii* (On the Blessed Virgin Mary, 1613, 2nd edition 1629), Bohemia is protected by medieval Marian shrines on the north (Mariaschein, today Bohosudov), south (Kájov), east (Stará Boleslav), and west (Kladruby). Medieval miraculous images or statues of the Virgin Mary were the cult focus at all of these shrines. Ryneš, writing about Stará Boleslav, expressed his support for the original Jesuit inspiration of Arsenius' conceptualization—a plausible idea given that he was studying in Rome at the same time Bellarmino was teaching, although the concept of "reading landscape as a sacred landscape" was popular with other thinkers of the time as well.[100]

The Jesuit efforts in this respect were similar to those of other religious orders operating in Bohemia. The Franciscans and Capuchins, for example,

were both heavily involved, as were the "older" orders (Premonstratensians, Cistercians, and Benedictines). Compared to the older orders, the Jesuits were new to Bohemia and thus at a certain disadvantage in establishing themselves at these memorial sites. This handicap, however, was balanced by two factors: first, that after the archbishopric was restored the first archbishops were sympathetic to them, considered them strong theological support, and tolerated their preaching activities at pilgrimage sites (limited only by the Synod of Prague in 1605), and second, that through aristocratic patronage ties, they managed to gain access to some pilgrimage sites as preachers and caretakers. After the accession of Rudolf II of Habsburg in 1576, it was allegedly the Jesuits who initiated the restoration of the Marian pilgrimage churches in Stará Boleslav, and Krupka (Mariaschein, now Bohosudov), and the pilgrimage site in Svatý Jan pod Skalou,[101] although these shrines had functional historical links to other church institutions, in these cases the Prague Chapter, the Cistercians, and the Benedictines. The Jesuits were proactive in the "renewal" of the cult at these sites and helped to revive them as early as the decades before the Battle of White Mountain.

From the late 1560s onward, Jesuit preachers visited Stará Boleslav to deliver sermons (sermons and restorations are documented here from 1567) and accompanied their noble protectors to the Stará Boleslav palladium.[102] This site, administered by its own chapter of canons at the St. Wenceslas and Cosmas and Damian churches, was referred to in Jesuit documents as the "old mission" after the early 1570s and soon received its own commissioner in the Prague college.[103] After 1567, Jesuits from the College of St. Clement visited the Church of Our Lady in St. Boleslav, a place of memory associated both with the cult of the most popular Bohemian saint and with the Christianization of Bohemia, invited by the chapter dean, Urban Manětínský, who was installed there by the archbishopric.[104] The proximity and direct connection with the monarch's country seat in Brandýs nad Labem also played a role.[105] The Jesuits carried out missionary activities there, preached on the feasts of the Holy Trinity and the Annunciation (around which they concentrated pilgrimages and devotional activities), and organized individual and group pilgrimages and processions to the place where St. Wenceslas was martyred. At the beginning of the seventeenth century, visits of important noblemen accompanied by Jesuits increased, Jesuit students founded a Marian confraternity,[106] and the restoration of the site culminated in the foundation of a new church (1613, finished 1623) on the initiative and at the expense of Emperor Matthias and Empress Anna, and in the publication of a Marian eulogy.[107] The struggle for the memory of the site culminated in 1589, when the Utraquist masters of Prague University traveled to Stará Boleslav to honor St. Wenceslas as *memoria* in an attempt to support the historical ties of the Bohemian Church to the ecclesiastical past of Bohemia against the claims

of the Catholics. Their Jesuit colleagues soon followed them in a similar symbolic gesture of reclaiming the site for the Catholics.[108]

The Jesuits reinterpreted the place of the martyrdom of St. Wenceslas, the patron saint of the country, a memorial of the Christianization of Bohemia and the origins of the Bohemian Church, as a place of Catholic Marian *memoria* and associated it with veneration for a late-medieval image of the Virgin Mary with Child, the so-called Palladium of Stará Boleslav [figure 4.1]. The legendary connection of this relief with the cult of St. Wenceslas and St. Ludmila and through it with the origins of Christianity in Bohemia—Sts. Cyril and Methodius—provided it with the necessary authority of an old and "true" image (in Paleotti's sense).[109] The ancient appearance of the relief[110] contributed miraculous, material, and "historical" qualities and merits and was understood as evidence of pre-Hussite origin. In fact, this small metal relief is likely the result of the stylistic historicism

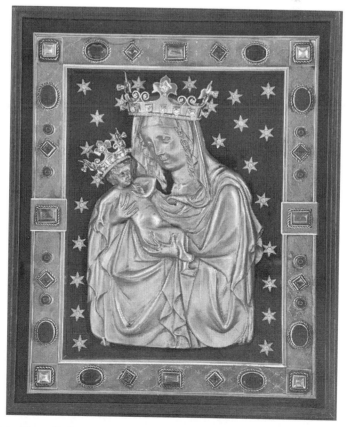

Figure 4.1 The Palladium from Stará Boleslav, copper and gold, Church of the Virgin Mary, 2nd half of the 15th century.

in the later fifteenth century, which used older forms as a reference to the pre-Hussite tradition.

On the North Bohemian estate of Jiří Popel of Lobkowicz, the Jesuits were given the patronage of thirty-nine parishes and churches in Lutheran Chomutov and the predominantly Protestant surrounding area, including the Minorite monastery in Krupka and the older nearby Marian shrine of Mariaschein (1588, now Bohosudov) before founding the Chomutov college (1589–1590). The Jesuit contribution to the establishment of cults and the preservation of medieval works is attested by the historian Johannes Schmidl, who names the Chomutov college as active in supporting local Marian cults in Mariaschein (where the Jesuits established a permanent residence), Chlum sv. Máří, and elsewhere in the area.[111] Quite a number of medieval monuments survived in Chomutov itself and the surrounding area, and several Marian cults were established there that the Jesuits supported and popularized in their printed eulogies.[112]

At Mariaschein, a site with a supposed late-medieval tradition, the Jesuits promoted the veneration of the medieval sculpture of Our Lady of Sorrows (a pietà).[113] The creation of the pilgrimage site and chapel in the sphere of influence of the Cistercian monastery of Osek was linked to the memory of Hussite battles in the area (allegedly, the Hussites slaughtered German knights at Krupka in June 1426 and the Sisters of the Holy Sepulchre hid the treasure and statue before they fled).[114] The place drew the attention of the Jesuits early; the Jesuit Václav Šturm, a theologian and the author of passionate writings defending the cult of images against the Unity of the Brethren, traveled to Mariaschein already in 1590. It is possible that he, as the administrator and preacher of the St. Giles and Virgin Mary Church in Třeboň, introduced the cult of the statue to Třeboň, where its altar still stands today. The Jesuits considered the statue (reportedly "of unknown material") to be an object under their control from then on, and during the Estates' revolt from 1618 to 1620 they took it and hid it, along with other treasures, in Duchcov.[115] Later, in 1668, the Jesuit Bartholomeus Christelius wrote a eulogy and pilgrimage book on the statue [figure 4.2].[116]

After the shrine was assigned to the college in 1591, occasional pilgrimages and sermons (in Czech and German) on holidays developed into regular annual pilgrimages. Soon afterward, visits by members of leading Catholic families played an important role in promoting the popularity of pilgrimages to Mariaschein. In 1596, Jesuits led Maria Manrique de Lara and her daughters via Mariaschein on their way to Kadaň (Kaaden), to the medieval Franciscan monastery with the Church of the Fourteen Holy Helpers, and a papal nuncio also visited the site. From around 1600, noble donations to the church and the first miracles (1608)[117] began, as did regular pilgrimages after a solemn archiepiscopal mass (1610) in the presence of high aristocracy and thirty clergies. The

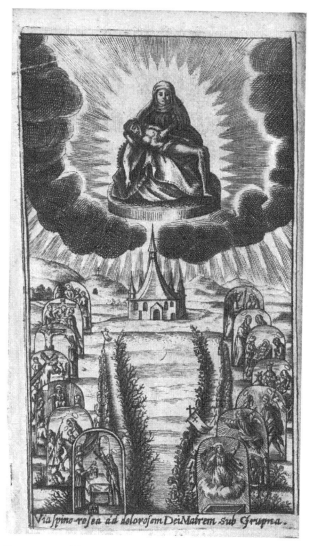

Figure 4.2 Front page of book by Bartholomäus Christel, *Via spino-rosea*, copper engraving on paper, Prague 1668.

ancient foundation also required appropriate donations to support the antiquity of the place; this is evidenced by the documented donation of an ancient chalice and a medieval illuminated Bible to the shrine.[118] The medieval objects helped the Jesuits construct the medieval tradition of the site retrospectively.

At the same time, in 1605, the *Litterae Annuae* mentions Our Lady of Wartha in Silesia (now Bardo in Poland) and, according to Balbín, the follow-ing year the Jesuits took over the care of this originally Cistercian pilgrimage

site. Although in the fourteenth century Christological feasts and those of St. Michael and St. Mary Magdalene were held here, for which indulgences were granted, during the fifteenth century the cult shifted toward the enthroned Marian statue to such an extent that it was taken to the Cistercian monastery at Kamieniec for protection when local religious tensions grew into open conflict in 1577. The restoration of the cult of the statue was symbolically manifested by a ceremonial procession and the transfer of the statue back from the Cistercian monastery in 1606.[119] The Jesuits also brought important visitors here (1609), seeing themselves as restorers of the old piety of the place and active agents of the Marian cult.[120]

Pleas to the miraculous statue often went through them; thus the Jesuits became indispensable mediators and interpreters. According to Balbín, there was supposedly never a year when the authors of the *Literae Annue* did not mention the statue.[121] Balbín himself, in his book on Our Lady of Wartha, admits that nothing is known of its origin, since it chose a remote and lonely place to operate in. He does not doubt that her cult is ancient, which he demonstrates through reference to old depictions of the site. In the case of the Wartha statue, the topos of miraculous rescue from "iconoclastic heretics" is emphasized particularly. The statue was credited with miraculously foretelling and averting three heretical calamities in particular: the Mongols (1241), from whom it was able to protect its region; the Hussites (1427); and, after them, Luther [figure 4.3].[122] The statue is also said to have survived a fire caused by heretics and that marks on it visibly attest its miraculousness and glory.[123]

The Jesuits also fostered a cult of the Marian statue in the former Johannite church in nearby Kłodzko, which was entrusted to them just after 1620. The cult of the statue there is linked to the medieval historical figure of the first archbishop of Prague, Ernest of Pardubice, a well-known Marian venerator and author of the Marian eulogium that the Jesuits published in an elaborate version as early as 1651. The statue's new staging in the interior of the post-1624 Jesuit church visually and compositionally (re-)presented the moment of Ernest's humiliation, when the statue allegedly turned away from him during the singing of the Marian antiphon.[124] In both cases, the statues served as material means of accusing local Protestants of neglecting local religious monuments and traditions.

The Jesuits had plenty of pilgrimage sites whose cults they could actively support within reach of the two pre-1620 South Bohemian colleges. In Jindřichův Hradec, where the confessional situation was complex similarly to Chomutov, the Jesuits organized pilgrimages to various churches as early as 1600, including to all the important shrines in the town and its surroundings.[125] In terms of topography, this was a strategy of building on the legacy of Jindřich IV of Hradec, who, around 1500, had made a significant contribution to promoting late-medieval pilgrimages to the surrounding shrines by

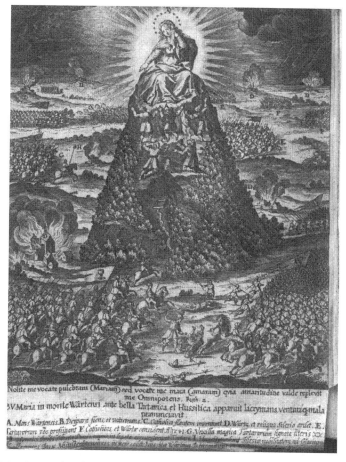

Figure 4.3 Our Lady of Wartha as a protector against Tatars and Hussites from the book by Bohuslav Balbín, *Diva Wartensis Origines, et Miracula Magnae Dei Diva Wartensis*; copper engraving on paper, Prague 1655.

obtaining indulgences and encouraging forms of piety outside the church, promoting shrines outside the city that included open-air crosses with the Crucifixion and the Stations of the Cross. The Jesuits renewed pilgrimages to St. Margaret's near Lásenice, where the medieval Lásenice Pietà is said to have originated, to St. Wenceslas in in Zárybničí, to St. Barbara west of the town, and St. Trinity behind walls, to the Franciscan church of St. Catherine and the Minorite church of St. John the Baptist, where John of Capistrano had preached and medieval statues of the Madonna, the Assumpta and St. Anna Selbstdritt are said to have come,[126] Most of these churches (except St. Catherine's) were also given to the Jesuits.[127] The Jesuits paid particular attention to reviving the Stations of the Cross pilgrimage way at the St. James

Church, a late-medieval Franciscan pilgrimage site founded as early as 1506; Maria Maximiliana of Hohenzollern financed its restoration in 1605.[128] In Hradec, the situation was favorable for linking back to local cultic memory and the Jesuits were able to capitalize on it by appropriating the town's churches and surrounding pilgrimage sites and adding a Marian dimension when they initiated the creation of a Marian sodality after 1600 (mentioned 1606). There are no extant sources from earlier years that would demonstrate the promotion of the cult of the Virgin Mary, but it is possible that greater attention to her cult was related to the year 1606, when the college chronicle mentions Pope Paul V in connection with the Assumption of the Virgin Mary. This may reflect the Jesuit knowledge of the beginning of the construction of the so-called Cappella Paolina in Santa Maria Maggiore for the Roman icon *Salus Populi Romani*. These efforts were further enriched after 1620 with the relics of two catacomb saints, one of whom, St. Hippolytus, was acquired for the Jesuit church as early as 1637.

In Český Krumlov, associated with the literary activity of several important personalities of the first generation of Czech Jesuits (Václav Šturm, Mikuláš Salius, and Jakub Colens),[129] the Jesuits promoted cult of the Virgin and revived the once-famous medieval Corpus Christi processions. As early as 1596, the Jesuits were "helping" the Cistercians operate the pilgrimage site of Kájov by leading pilgrimages to its Gothic Madonna statue, venerated since the late Middle Ages,[130] and in 1602 they organized a spectacular celebration of the Feast of the Assumption of the Virgin Mary in Krumlov. In Kájov, they organized pilgrims for an October Harvest Pilgrimage to Our Lady of Kájov (*Sabbatha Aurea*), during which the ancient Cistercian nocturnal liturgy, sung "according to the old way," aroused the Jesuits' interest.[131] After 1620, the Jesuits were involved in creating and promoting the post-1620 pilgrimage site with the Chapel of Our Lady of Loreto in Římov (founded in 1626) and later the Shrine of Our Lady of Sorrows at Kreuzberg near Český Krumlov. The medieval painting of Our Lady of Sorrows, installed on the altar of the new pilgrimage church in Kreuzberg in 1710,[132] was "discovered" in the Jesuit-run parish church of St. Vitus, where it had allegedly been venerated earlier.[133]

In Moravia, the Jesuits established themselves in both major centers, Brno and Olomouc; both foundations reflected the Jesuits' ability to adapt to local conditions, even in promoting the cult of images. In Olomouc, the Jesuits took over the former Minorite monastery, which housed a medieval Marian statue, now dated to around 1380 [figure 4.4], promoting its veneration from the beginning, for example, by founding Marian sodalities for priests, nobles, and students in 1575 and 1580.[134] The design for the new Jesuit church (never completed) even envisaged a passageway like that in the Marian pilgrimage church in Altötting in order to allow unhindered access to the statue on the

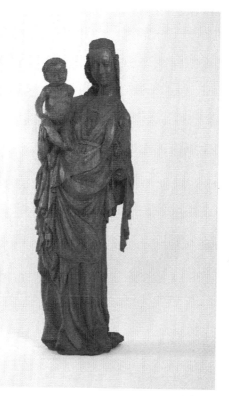

Figure 4.4 The madonna from the Minorite, later Jesuit, Church of the Virgin Mary of the Snow in Olomouc, lime wood, 1380.

high altar.[135] Reverence for the statue was also encouraged by the statue's legendary historical connection to the semi-mythical hero of the defense of Olomouc against the Mongols, Jaroslav of Sternberg, to whom they connected both the foundation of the monastery and the commissioning of the miraculous statue, thus pushing the date back some 140 years before its true creation.[136] Despite the statue's lavish staging in the new Jesuit church in the early eighteenth century, the Olomouc statue remained primarily an urban palladium with limited impact, probably due to competition from the Premonstratensian-run pilgrimage site at Svatý Kopeček that was promoted by a chapel with a miraculous image in 1633 and spectacularly rebuilt under the patronage of the Premonstratensians between 1669 and 1679.[137]

From the Jesuits' early devotional activities in Olomouc, it is clear that after their arrival the Societas Jesu retained a certain flexibility in choosing the most successful strategies for renewing the Catholic faith even though it consciously followed older local cultic traditions, much as the older orders had actively done in Bohemia. Through devotion to St. Anne in predominantly

Lutheran and German-speaking Olomouc, the Jesuits could refer to a local late-medieval tradition and also enrich the cult with an anti-Reformation barb by linking it to the post-Reformation cult of the *Immaculata conceptio*.[138] In line with other German-speaking merchant towns, where the cult of St. Anne became prominent around 1500, the feast of St. Anne had been celebrated in Olomouc since the end of the fifteenth century and there are references to pilgrimages to nearby Stará Voda to the Gothic statue of St. Anne in 1529. The Jesuits took full advantage of this tradition of devotional practice; as early as 1573 or 1574 they, too, instituted a pilgrimage to Stará Voda and had the altar of St. Anne transferred from the town church of St. Moritz to their own no later than 1575. In 1580, they reestablished the Fraternity of St. Anne, which was subordinated to the Roman Sodality of the Annunciation in 1590.[139] The success of this strategy is shown by the fact that between 1580 and 1590 the town council and board of the originally Protestant town gradually began to participate in these pilgrimages. Devotion to St. Anne here was a substitute for Marian devotion and served as a proxy for other cults such as the cult of St. Paulina, a catacomb saint brought by the Jesuits, newly introduced in 1623.[140]

In Brno, the situation was exceptional in that two medieval icons were located within the city walls from the 1570s onward, one in the care of the Augustinian hermits, called *Svatotomská* (of the St. Thomas Church), and the other, a copy of the Roman image *Salus populi Romani*, in the Jesuit novitiate. Because of the popularity of the "Black" Virgin of St. Thomas, enhanced especially after the miraculous repulse of the Swedish attack in 1645, to some extent the Jesuits resigned themselves to competition in publicly promoting their copy of the Roman image. They retained its direct veneration and visitation as an exclusive privilege within the college and novitiate, allowing the veneration of the faithful only on special occasions with temporary and carefully staged displays.[141] The Jesuits are also said to have been involved from 1607 in restoring the Marian pilgrimage site at Křtiny[142] that had originally belonged to a Premonstratensian monastery, and another site in Vranov u Brna after the Swedes burned it down in 1648, which had left the local Minim Friars in a difficult situation.[143] Medieval Marian statues were the cult centers of both of these memorial sites.

The Brno Jesuits' main interest, however, focused on supporting and then taking over (in 1666) the pilgrimage site of Tuřany, where, according to Balbín, they had taken refuge during their persecution after the Estates' Revolt.[144] The local statue of the Madonna of Tuřany [figure 4.5] had supposedly protected them miraculously from their persecutors.[145] The site was suitable for fostering a cult—the church was close to the predominantly Protestant town, but the surrounding area was owned by the bishops of Olomouc. It was later associated not only with protecting the fleeing Jesuits but also with the alleged desecration of the site by the Swedes,[146] which the statue was said to

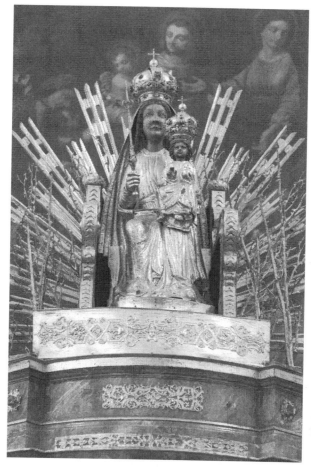

Figure 4.5 The Madonna of Tuřany, Brno, Tuřany, Church of the Annunciation of the Virgin Mary, lime(?) wood, around 1300.

have miraculously resisted; in reality it was kept safe in Wiener Neustadt. According to Balbín, the statue is proof of the Christianization of Moravia and came directly from Saints Cyril and Methodius. The statue shows its age; according to Balbín, it is proud of its old age, refusing to change anything about its ancient appearance.[147] In the Madonna of Tuřany, the Jesuits acquired an ideal palladium for Moravia, representing both tangible proof of the region's ancient Catholic traditions and an argument against iconoclasm based on the statue's own active resistance to it.

The early involvement of Jesuits in these locations shows that from the beginning, the Jesuits exploited the potential of Marian sites, statues, and images, which they actively sought out, and that they were open to any

opportunity to support local cults, drawing on their connections and knowledge of local history. In Brno, they tried to occupy several sites, including filling the space vacated by the Minim Friars and Premonstratensians; in Olomouc, they used the statues in the church they had acquired and did not hesitate to transfer the cult from the parish church. From the towns, they expanded into the countryside; for example, in 1641, the Jesuits from Kroměříž preached at the emerging pilgrimage site at Hostýn, but it was not until 1655 (i.e., a time when, according to Catholic sources, 80 percent of the local population still avowed "heresy") that Rottal, the owner of the estate and chairman of the Counter-Reformation Commission in Moravia, delivered a Marian image to replace an earlier one allegedly destroyed by the Protestants.[148] The Jesuits also cleverly exploited local support from bishops, the Catholic nobility, and their network of disciples and supporters among the ecclesiastical and secular elites. Whether they or the Catholic elite attached to them were the primary initiators of a cult is often unclear. The Jesuits, however, inspired by the Italian models of *historia sacra* and experienced from Rome in using the cult of ancient images, were aware of how important they were in religious practice and the construction of the past. Mobility and missionary vocation could be exploited wherever the potential of a nascent pilgrimage site was underutilized.

A comparison with the situation in Germany shows that Jesuit support for the Marian cult in Bohemia from the 1570s onward was not far behind similar efforts in southern Germany and Austria.[149] The external manifestations of the Virgin Mary cult in the Jesuit environment were inspired by similar developments in Italy after 1600, showing that the Jesuits reacted rather quickly to these incentives to Marian piety.[150] In Austria, the suitable natural disposition of sites was emphasized as the basis for the emergence of a cult place.[151] In Bohemia, Moravia, and Kłodzko, however, sites where there was potential for constructing an older cult tradition underpinned by the topos of surviving an attack or threat from "heretics" played a major role in the Catholic revival of pilgrimage sites. What the Marian pilgrimage sites in the Czech Lands had in common was the materialization of a place of Catholic memory in a medieval work whose uniqueness was attested by its age and survival from the Middle Ages to the present, often interpreted as survival "in spite of the iconoclasm of heretics." By reinstalling them in a new context, the ancient works took on new meanings; as Bohuslav Balbín writes, following Jiří Kruger [Georgius Crugerius], their very existence was in fact a miracle.[152] Later, Johannes Miller made a similar point; in Bohemia, the mere existence of an ancient painting or statue is enough to attribute special powers to it, for, as he says, it is a wonder that a work survived so many years unscathed, despite:

> dangers, fires, theft and plunder, the invasions of numerous enemies, even iconoclasts like the Hussites ("Bildersturmer, wie die Hussiten waren"), who

have criss-crossed the area over many years, destroying and burning everything by heretical hands and through similar events . . . preserved without damage miraculously and carefully to this day . . . and the strange miracles he worked while doing so, and through grace healed so abundantly and often, so there must be something special of God and his saints hidden in that image.[153]

The miraculous help granted to the Catholic army by the image of the Virgin Mary (held by the Carmelite Dominic à Jesu Maria) at the Battle of White Mountain (1620) confirmed the utility of remodeling the past through the veneration of medieval Marian images. In Bohemia, this became a functional strategy. The statues' medieval look implied that they had already miraculously survived iconoclastic attacks and thus they could be used to confront the country's non-Catholic past. In the spirit of post-Tridentine Catholicism this was compelling proof of the miraculous effect of the image, shifting the narrative of the Bohemian past to fit the post-Tridentine conception of *historia sacra*. The festive installation of this painting in the interior of the Carmelite Church of Our Lady of Victory (Santa Maria della Vittoria) in Rome in 1622 confirmed the painting's special status in the cult and also created a model of festivities that became characteristic for staging such works. As early as 1624, the first copy of this painting traveled back to Prague to be ceremoniously installed in the interior of the (originally Lutheran) Carmelite Church of Our Lady of Victory in Prague's Lesser Town, where it symbolically completed the denominational transformation of this church.[154]

After the battle at White Mountain, the triumphal and symbolic aspects of Habsburg political theology enriched the Marian cult in Bohemia.[155] The political-symbolic level was enhanced by Ferdinand II's promise to expel Protestant priests during a pilgrimage to the Madonna at Mariazell after the victory at White Mountain, his pilgrimage to Stará Boleslav in 1623 as the Czech equivalent of the Austrian enthronement pilgrimage to Mariazell, and putting the Habsburg lands under Mary's protection during the Swedish invasion of 1645.[156] Another symbolic act was the ceremonial return (1638) of the Stará Boleslav Palladium in the presence of Emperor Ferdinand III after it was defiled and removed by the Saxons in 1632.[157] The cult was strengthened even more by the spectacularly celebrated second and third return of the Palladium from Vienna (kept safe there from 1639 to 1646, and again from 1648 to 1650). The first return was staged by the Prague Premontratensiens; the Jesuits partly staged the third, accompanied by theatrical plays, festive processions, triumphal arches, and triumphal gates.[158] This demonstrates the importance of the relief in the Habsburg conception of the Counter-Reformation, which was also reflected in new ways of presenting the image in different media such as minting an honorary gold medal with the image.[159]

The confrontational period of the Thirty Years' War contributed to consolidating the cult of Marian statues and images in many places. The Jesuits kept the statues and images in their colleges, removed them to secret hiding places in times of danger, and tried in every way possible to strengthen their own ties to the miraculous images.[160] In the 1630s and 1640s, venerated images and statues were moved publicly several times, occasions used to reinforce reverence for them; they were moved from temporary storage in Jesuit colleges back to their original churches with great pomp, processions, and theatrical performances. The re-arrangement of these medieval statues and images, which Jesuit writers have since called their own (*Virgo nostra*), in altarpiece presentations during the war years was a further step to underline their uniqueness.[161] In the Central European contexts, the spectacular staging of Baroque altars communicated the uniqueness of the venerated image in a new triumphal context with the aim of actively working toward conversions.[162]

Translations and new decorative arrangements on altars in the Bohemian lands followed the arrangements of the miraculous images in Rome and Italy. This effective framing separated the medieval work from its original context, contextualized it in a new way, and emphasized its uniqueness and antiquity. This was inspired by a practice that had recently become popular among the leading orders and figures of post-Tridentine piety in Rome. First, the image of the Virgin della Strada (noted above) was solemnly installed in the Jesuit main church in 1584. Another example, Rubens' altarpiece of the Madonna della Vallicella in the church of Santa Maria in Vallicella (1606–1608), simulates the presentation of a venerated wall painting (located under the altar), admired and carried up to heaven by angels. The most famous example is the celebratory staging of the *Salus populi Romani* image in the rebuilt interior of the Capella Paolina in Santa Maria Maggiore (1606–1613), where the image is again shown being carried up to heaven by angels.[163] These examples were followed by other altar stagings of medieval venerated images in Santa Maria della Vittoria (1622) and Santa Maria in Via Lata (1636). Almost symbolically, in the 1660s this change of attitude toward ancient images was reflected in the interior of the Roman church of Santa Maria Aracoeli, where the Byzantine icon Maria Avvocata (Madonna di San Sisto) was installed to replace Raffael's Madonna.[164] As a corresponding example in the Czech context, consider the installation of a Marian statue within the new high altar of the Jesuit Church of Our Lady of the Snow in Olomouc (1721), discussed elsewhere in this volume. The thematic emphasis here is on the power of sacred images and statues and connects the domestic statue directly with its miraculous counterpart in Rome, the *Salus populi Romani*.[165]

From the 1620s onward, after their return from the exile during the Estates Uprising (1618–1620), the Jesuits enhanced their missionizing efforts with copies of venerated Marian images from other parts of Europe, which

they brought to Bohemia and exhibited on the altars of Jesuit colleges and churches in new arrangements, thus spreading reverence for the miraculous images of the *Salus Populi Romani*, the madonnas of Foy, Russia (the so-called Rušánská, of Rus), Passau (the so-called *Mariahilf* of Bavaria), and Piekary (Poland),[166] next to long supported pilgrimage sites of Altötting, Mariazell, and Częstochowa. In a sense, they can all be seen as reflecting the European dimension of the Jesuit mission and an affirmation of both the universal power of the Virgin Mary, which is freely transferable, and also the importance of an order that can possess and manipulate such significant images. Catholic patronage was fostered by new emigrés from the ranks of the nobility, administrators of estates and regions, and townspeople who supported the cults of the newly arrived images. This significantly strengthened the cult in the Jesuit environment.

In addition to the cults of these miraculous "imports," the Jesuits enriched the cult with other elements that accentuated the link to Rome or were inspired by religious practices in Italy. They built Calvaries on hills (*teatri montani*), changing suburbia into sacralized landscapes.[167] As early as 1622 they organized a grand celebration of the canonization of the Jesuit saints St. Ignatius and St. Francis Xavier in Prague with theatrical performances and ephemeral architectural staging. Together with the Capuchins, they played a major role in introducing the cult of relics of Roman catacomb saints, which they distributed to their colleges.[168] On the one hand, this can be interpreted as a response to the old monastic orders, who were claiming the cult of relics in Bohemia for themselves, and, on the other hand, these translations manifested a direct cultic link to the Rome of Early Christianity, the center of the Christian world, making a clear argument on the origins of Christianity. Although the translations of catacomb saints into Jesuit churches mostly date to the seventeenth and eighteenth centuries, the activities of the Jesuit Nicholas Lancicius were among the earliest. He brought the cult of St. Pauline to Olomouc (1623) and the cult of St. Hippolytus to Jindřichův Hradec (1637).

The promotion of these cults in the newly founded Jesuit colleges was multifaceted and intense, ingeniously combining the domestic cults with Rome as the center of the Catholic faith. After the 1620s, at the Jesuit college in Kutná Hora, the local seminarians developed a reverence for the local medieval statue of the enthroned Virgin Mary located in the gallery of the Jesuit church. From 1632 or 1633, students began praying to it, chanting, reciting litanies and special devotions there, and celebrating Marian feasts.[169] In 1636, the cult of the domestic Marian statue was completed when the body of St. Basileus was brought from the Roman catacombs. In 1640, St. Basileus was promoted as the patron saint of the Kutná Hora College with festivities and processions themed around the protection of the Kutná Hora Jesuits, the idea

of peace in the country after the Thirty Years' War, and the direct connection of Kutná Hora with Rome via the Elbe and Tiber rivers.[170]

Despite the efforts to introduce cults of imported saints and Marian images, it is clear that even after the Catholic victory of 1620 domestic medieval statues and images[171] dominated pilgrimages in Bohemia and the situation was apparently similar in Moravia and Kłodzko. Their cults did not diminish; on the contrary, their network and the activities around them grew.[172] The Jesuits contributed to the cult's "renewal" by searching for suitable additional domestic artworks in the vicinity of newly founded colleges. In 1632 and 1634, the Jesuits helped the local dean organize public pilgrimages to the

Figure 4.6 P. Georgius Pfefferkorn leading a procession to the Holy Mountain (Svatá Hora) near Příbram, pen and ink drawing on paper by Johann Georg Heinsch, 1694.

Marian statue in Svatá Hora near Příbram, owned by the Prague archbishop-ric. Interest in the statue rested on constructing a historical link to Ernest of Pardubice, the first Czech archbishop, a Marian worshipper whose veneration for the miraculous statue was known from his own record.[173] Under Jesuit patronage, it became the second most important Baroque pilgrimage destina-tion in Bohemia after Stará Boleslav. The Jesuit Georgius Ferus (Jiří Plachý) published its miracles in one of the first Jesuit Marian eulogies in Bohemia.[174] The Jesuits of Březnice college took over the management of the pilgrimage site in 1647 [figure 4.6].[175]

ANTIQUA PIETAS REVOCATA EST. MARIAN IMAGES AND THE CONSTRUCTION OF THE PAST

To promote the cult, Marian eulogies were issued to enhance the domestic statues, presenting the Bohemian lands as a traditionally Catholic landscape dedicated to the Virgin Mary.[176] The authors emphasized that Bohemia had been the center of the Marian cult since ancient times and that reverence for images was inseparable from the piety of the ancient Czechs. Based on the Bellarmino's controversial theological interpretation of church history, however, they also viewed the veneration of Marian images as both proof and a means of overcoming heresy and iconoclasm. They then saw their role as resuscitating this "ancient" veneration of the Virgin Mary, who the Czechs had supposedly always had a special relationship with, but that had been crippled by "wars," a common summary term for the conflict with the Hussites and Protestants.[177] The publication of Marian writings was not lim-ited to new texts. In 1651, for example, the Jesuits published *Mariale Arnesti*, a magnificent edition of a medieval collection of Marian eulogies by Ernest of Pardubice in order to highlight the long tradition of Marian devotion in Bohemia and an important representative of it.

The first Marian writing, noted above, came from the pen of Kašpar Arsenius of Radbuza, the canon, dean, and provost of the Vyšehrad chapter, a product of Jesuit theological formation. He studied at the Jesuit gymnasium in Prague and at the *Collegium Germanicum et Hungaricum* in Rome, where he became acquainted with the teachings of Bellarmino. Compared to the histor-ical erudition of his predecessor, Jiří Barthold Pontanus of Breitenberg, who tended to glorify Bohemian kings and saints in his writings, Arsenius' book on the Stará Boleslav Palladium credits solely the Virgin Mary with entirely and exclusively protecting the Bohemian lands.[178] Based on the Tridentine decrees, church authorities, and Bellarmino's concept, Arsenius emphasizes the benefits of the Catholic practice of pilgrimages and the veneration of images, referring to the Marian miracles currently taking place. This made a

clear statement in the atmosphere of confessional conflict after the Letter of
Majesty (1609). The interesting shift in Arsenius' dating of the Stará Boleslav
relief in the second edition of the book (1629), written in a completely dif-
ferent confessional situation, suggests that historical fidelity had to give way
to a new construction of the past and reinforce the Catholic appropriation of
Czech church history. The first edition links the relief and the beginning of
the pilgrimage site with King Vladislaus of Jagiellon (1471–1516), but in the
second edition Arsenius shifted the age of the relief to King Vladislaus I of
the Přemyslids (1140–1173), arguing that the relief was once connected with
St. Wenceslas.[179] This shift corresponds to the desire to move the age of the
work as far back in time as possible and thus meet post-Tridentine demands
for the ancient and "correct" origin of a cult image, embodied by the image's
link to a holy person and the beginnings of Christianity, unthreatened by
the Reformation. With this connection, Arsenius framed the contemporary
veneration of the image as a "natural" return to the cultic practice of early
Christianity in Bohemia, making the relief a physical witness to an ancient
church uncorrupted by heresy, a solitary trace (a kind of *vestigium*) connect-
ing contemporary Catholicism to its own ideal past.

After the Catholic victory in 1620, the number of Marian writings grew
significantly, a substantial number of them linked to the Jesuits. A now-lost
Marian eulogies by Jiří Plachý [Georgius Ferus], Clementine librarian and
prominent figure of the Czech recatholization,[180] circulated in the 1630s and
1640s and a book on Our Lady of Svatá Hora by Jiří Konstanc, a source
Balbín drew on, was published in 1652.[181] The 1651 work of another Jesuit
student, Friedrich Dörffel, on Our Lady of Chlum,[182] predating the *Atlas
Marianus*, anticipated the characteristic topoi concerning the ancient and
original Catholic faith corrupted by the later heresy of both Czechs and
Germans found later in Balbín's writings. The characteristic manifestation
of both Hussite and Lutheran heresies was the destruction of churches, their
ornaments, and wealth. The statue of Our Lady of Chlum was supposed
to have miraculously survived these horrors, but Dörffel concludes that
the church "must necessarily have been burned" by the heretics, since no
sources or pictorial relics survive in the church and the text of indulgences
mentions the renovation of the church. He also reports the statue's "miracu-
lous" survival from the attack by heretics; it is said that its base and back
were burned off.[183] The statue's age is its weapon, a testimony to its ability
to survive and thus to its iconic uniqueness. It was spolium and a message
from ancient Catholic times that had survived in isolation. Dörffel's text, like
Bellarmino's, reveals the method of rational description popular in Jesuit
circles, giving the impression of "scientific" proof, which makes it easy for
the reader to overlook the fact that Dörffel provides no evidence of a connec-
tion between a fire and a Hussite or other iconoclastic attacks on the church.

The controversial theological basis of the argument is, however, secondary to the cultic function of the statue and catechetical function of the book. From a theological perspective, the Marian statue is, through viewers' reception alone, both a reminder of Christ's righteousness and a moral instruction to follow him.

The publication of Gumppenberg's *Atlas Marianus* was the external impetus for the spread of the Marian cult and a new vision of Bohemian history, which gave a truly global dimension to the efforts to promote the cult of Marian statues.[184] The *Atlas Marianus* was a collective enterprise of the Societas Jesu, supported from the top of the order, which used Jesuit religious organizations and networks systematically to compile information on Marian cult sites in Europe and beyond. A total of 274 Jesuit contributors worked on the list.[185] At the start of the work in 1655, nine Jesuits from Bohemia wrote reports, but by 1659 and 1672 there were twenty-four, which shows the attention and support the project received in Bohemia. Among the contributors were important figures from the Bohemian province such as Jiří Kruger, Johannes Tanner, Andreas Schambogen, and Bohuslav Balbín.[186] The *Atlas* was followed by local (Latin, German, and Czech) editions and numerous inventories of provincial Marian statues and images in texts by Jesuit historians, pilgrimage handbooks, pamphlets, and devotional literature for the laity.[187]

In the matter of the cult of images and saints, the *Atlas* claimed the authority of Baronius and Bellarmino and ignored more theologically sophisticated theories of the image.[188] The *Atlas*'s slogans focused primarily on devotional practices, expressing close contact with the faithful through the name, place, local ties of miraculous history, and the historical context of place and action.[189] Unlike Italian image theorists, the emphasis in the *Atlas* was not on iconography but on the material nature of the image as an artifact; the entries describe the condition, preservation, and appearance of the statue or painting.[190] Deschamps believes that for Jesuits "in the field of missionary practice" the cult of miraculous images did not really need any theological patronage because the miracles and power of Marian images spoke for themselves.[191] Thus, the miraculous effect of Marian images was demonstrated as if "by itself" against the background of the memory of acts of Protestant iconoclasm, which were based on the idea that an image has no power. Thus, the existence and miracles of Marian images, described and arranged "scientifically" with a clear sense of order and classification, was a powerful and demonstrative argument against the Protestant interpretation of the image.

The *Atlas* placed the Czech Marian cults in an international context. In the first Latin and German editions, only Our Lady of Wartha and Our Lady of Chlum (both enthroned madonnas)[192] are mentioned in the second volume (published in 1657), and the Virgin Marys of Stará Boleslav, Zbraslav, and Brno were added in the third volume (published in 1659). The 1672 edition

of the *Atlas* mentions thirty-six Czech pilgrimage sites and this number was greatly enriched in Sartorius' German edition in 1717.

For two statues from the first edition, Wartha and Zbraslav, the miraculous effect of the image is directly related to surviving the iconoclasm of the "Hussites," a topos of attack repeated for other madonnas, such as the Madonna of Paderborn or Częstochowa. In the Czech environment, however, attacks—sometimes multiple—of heretics on a statue or image, whether by Tartars, Hussites or Protestants, became a regular part of Jesuit eulogies. For the Madonna of Paderborn, moreover, the Jesuit role in the installation of the cult (*re-inventio*) is specifically emphasized, as they claimed to have restored the statue to the cult after it was threatened by Protestants, a theme that also reverberated with Czech Jesuits such as Balbín.[193] In the immediate aftermath of the *Atlas*, Jesuit Marian collections such as the *Peregrinus Mariana Bohemiae* by Georgius Castulus, the Marian celebrations of Father Albert Chanovský (published, however, only in Tanner's *Vestigium Bohemiae Piae* in 1659), and Melchior Guttwirth's *Amores Mariani* were created as lists or topographies.[194] The authors repeat topoi about the unsuccessful destruction of the works by iconoclasts, typically the Hussites and Žižka.[195]

This was the framework in the writings of the Jesuit Jiří Kruger [Georgius Crugerius], from which Balbín drew; the Virgin Mary's special love for Bohemia, Moravia, and Silesia is reflected in the multitude of miraculous Marian statues geographically surrounding and covering the country in a kind of reduced version of the *Atlas Marianus* for the Czech kingdom. The Virgin Mary thus comes closer to "her land" through her images, despite the country's unkind treatment of her in the past:[196]

the third sign [of love the Virgin Mary's love for Bohemia] is (which is too strange) (that) through the heresy and wickedness of so many iconoclasts, who cut down, burned, and turned to naught the holy images, her more glorious painting or cutting of images did not come to an end, but lived to see our times, and the Mother of God shows her benefits to the people through them even to this day.[197]

In Kruger's work, many of the paintings also actively protected their cities from the Hussites and then returned to their places.[198] Kruger poetically records the growth of pilgrimage sites in his day and their spread into formerly non-Catholic areas where such shrines were absent:

the fourth sign of love [of the Virgin Mary's love for Bohemia] . . . that immediately after the heretical storm, or around it, not only in her old places, where she had first worked miracles from ancient times, she did not cease from them, but also made new places her favour, and enlightened and ennobled [the places] more and more by her gifts. It is not a difficult thing to prove, for whoever

remembers all the images of the Mother of God in Bohemia, which are used for pilgrimages in our times, where people receive various benefits from the Mother of God, he will easily confirm that half of them were not glorified before heresy.[199]

Kruger's construction clearly assigns the country's past to the lost ideal of an uncorrupted church destroyed by later heresy, but this lacks firm contours in his conception; it is rather a kind of abstract phantom.[200] For Kruger, the old paintings are physical traces of that uncorrupted past that prove the exceptional position of Marian veneration in Bohemia. Their celebration in his time demonstrated a turn toward restoring the true faith in the country.[201]

But this interpretation hid a problem. The Jesuit Johannes Miller lamented in the early eighteenth century that, due to the passage of time, wars, fires, and other destructive disasters, there were only a few images in Bohemia whose origins were known well enough.[202] The interpretation of this controversial theology denied that non-Catholics had either the Marian cult or any images of her in church interiors, thus all medieval-looking works were automatically attributed to the pre-Hussite Church. But in reality this contradicted the experience of missionaries; both the Utraquists and Lutherans clearly kept medieval images in their churches, although they did not venerate them in the same way. Contrary to the interpretation of Catholic theology, in practice the Utraquists and some Lutherans took a somewhat tolerant attitude to saints and images in churches and accorded medieval works different degrees of function in churches. Moreover, unlike Italy, there were few medieval texts in Bohemia from which to identify images suitable for veneration and even fewer references in the sources attesting the miraculous effect of pre-Hussite medieval images.[203] The Jesuits, for all their historiographic erudition, were aware that the context of a work's creation in the past could not be accurately ascertained. The absence of written sources made it difficult to meet Paleotti's condition that a work had to have correct (Catholic) provenance and intent.[204] The uncertainty surrounding the origins of works was the reason why the Jesuits looked for works with a connection to a historical figure (Sts. Cyril and Methodius, Ernest of Pardubice, or St. Ludmila). Alternatively, they sought works originating from a place with a tradition of medieval pilgrimages or tried to avoid the problem of a work's uncertain origin by exaggerating its antiquity or pointing out features of material or production that were beyond the creative ability of current artists.[205] This gave them a way to avoid the pitfalls of incorrect origin or possible heretical participation in the creation of the image.

For Bohuslav Balbín, the most important Czech Jesuit author of Marian eulogies, surviving iconoclasm was what guaranteed the sanctity of the work since this must necessarily be a miracle.[206] This relies on the work's apparent

antiquity, since only works that were "obviously" old could confirm their pre-Reformation origins beyond doubt. These works are important because they act as a means of converting heretics, capable of influencing even the hardened.[207] As early as his first Marian eulogy, *Diva Turzanensis* (1658), Balbín acknowledges that the Madonna of Tuřany (near Brno, Moravia) stands out for its extraordinary antiquity (*antiquitas*) and its origin from Sts. Cyril and Methodius, the apostles of ancient Moravia. The statue is proud of its ancient origin and antiquity; it will not allow itself to be repaired or repainted and thus deprived of the visible signs of age. She is acting for herself in order to stop any changes to the ancient look. Balbín felt the need to explain the importance of the work's antique look ("no wise man despises antiquity," "the old (colors) stood out and shone much brighter than the new"), which for him is a quality separate from art and artistic talent. In this Balbín reflects the lessons of both the post-Tridentine theorists of image and Possevino's treatise, although a similar reluctance of a work to let itself restored is known earlier for the Marian image in Częstochowa.[208] Old age is assumed to be the supreme authority even for contemporaries, for whom "the old becomes new again."[209]

In Balbín's *Diva Warthensis* (1660), the eulogy devoted to the Virgin Mary of Wartha (now Bardo, Poland), the age of the work is a key premise of the cult, linked to the place "far away, on the edge of the earth" that the Virgin Mary herself chose. The statue's age and miraculous effect are attested by the fact that it is credited with surviving attacks by the Tatars (1241) and Hussites (1427), as well as the eventual spread of Lutheranism in the area.[210] The age of the statue is also supported by an old mural in the choir of the church, similar to the depiction of Stará Boleslav Palladium mentioned in Balbín's *Epitome*.[211] The sanctity of the statue, in the absence of texts on the origins of the cult, is confirmed by pictorial media that "testify to the glory, without which we would have no evidence of the statue's origins or miracles."[212] The pictures used as evidence of the antiquity of the cult are themselves old, for, according to Balbín, he saw "the name of the painter" in old script on one of them and others are crudely painted.

In the case of the relief of the Stará Boleslav Palladium, Balbín states in the *Epitome historica* (completed 1669, printed 1677) not only that it is of medieval origin (*ad grecum morem*), but also that it has its own "authority of antiquity" (*antiquitatis authoritate*).[213] He ascribes the origin of the Stará Boleslav palladium to the ancient authority of the Stará Boleslav chapter and derives it from St. Ludmila, who was supposed to have received it from Sts. Cyril and Methodius.[214] The relief thus acquires an undisputed aura of the original Bohemian early Christian work consistent with the views of Palleotti, Molano, and Possevino. Here Balbín relies not on the text but on a painting depicting St. Ludmila receiving the Palladium from Sts. Cyril and

Methodius that he allegedly saw on the altar of St. Cosmas and Damian in the church of St. Boleslav. The image of the donation scene has documentary value for Balbín in confirming the age, Catholic origin, and authenticity of the relief, even though—if Balbín indeed saw such an image at all—the association with St. Ludmila (and through her with St. Wenceslas) corresponded to a shift in the dating of the relief only assigned in the second edition of Arsenius's writings (1629). Balbín, however, avoids the question of the age of the painting.[215]

To summarize his thoughts, Balbín sees the ancient work's special aura, which comes from its age, origin, and miraculous power. Balbín's argument of exceptionality is related to the works in two ways:

1. If a given object has survived the harsh conditions of the Bohemian heresy there must be something special about it. Thus, the very existence of the image under the conditions of its heretical past is proof of its authenticity and special status. Pointedly in this sense, the etching on the title page of the *Epitome historica* elaborates [figure 4.7] the motif of the post-apocalyptic destruction of Christian monuments in Bohemia where the figures of Heresy, War, and Time are depicted as the destroyers of monuments, while Incompetence sleeps, oblivious to the fact that old monuments are dying and that the virus of heresy "with its poisonous breath and its foul contagion is touching everything and flooding the books."

2. In the absence of written sources to attest the age of a work and the beginning of the cult, another image (altarpiece or wall painting) or object can be proof of the antiquity of the cult statue. The depiction of the donation or adoration of a statue becomes evidence of the age, authenticity, and cult value, while damage from burning on the statue provides evidence of the antiquity of the work and the cult and suggests survival of an attack.

This concept of a medieval work's aura was confirmed by Balbín's early eighteenth-century follower, Johannes Miller. According to him, the apparent age and survival in a heretical-iconoclastic milieu gives the old work special authority and status as a *vera effigies*, a true likeness, which must be honored. Miller writes of a Gothic statue that came from an old Minorite church in Olomouc taken over by the Jesuits[216] that respect was not restored for the statue until the Jesuits (or rather, the Brotherhood of the Assumption they founded) came and placed it on the altar for veneration.[217] Miller sees the survival of the statue as a miracle that confirms its uniqueness: the fire did not harm it even though it is wood and the statue also escaped the violence of heretics in 1619, who burned the college furnishings as firewood, and the Swedes in 1650, who occupied the monastery for a full year. The heretics were unable to destroy or burn the statue; it must have been by the

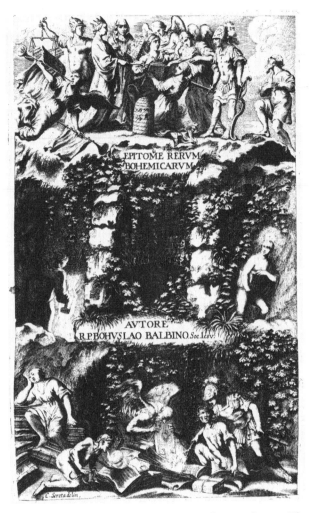

EPITOME RERVM
BOHEMICARVM

AVTORE
R.P.BOHVSLAO BALBINO. Soc. Iesv.

Figure 4.7 Front page of book by Bohuslav Balbín, *Epitome Historica rerum Bohemicarum*, copper engraving on paper, engraving by Matthaus Küssell after a design by Karel Škréta, Prague 1677.

action of a higher power that it always remained on its column.[218] According to Miller, this miraculous Marian statue was over 500 years old, supposedly dating from the thirteenth century, as evidenced by its ancient appearance and the artistic treatment of the figure. Although there are no surviving sources, Miller admits, its "correct origin" is confirmed by its link to the founder of the monastery, Jaroslav of Sternberg, and its survival of a fire and two heretical takeovers of the town.[219]

In the third part of *Historia Mariascheinensis*, from the beginning of the eighteenth century, Miller follows Balbín[220] in describing the "otherness" of the miraculous statue of Mariaschein, which artists cannot make or imitate, a topos also known from the Stará Boleslav palladium and Italian *acheiropoietoi*. The statue itself is active (like the Madonna of Tuřany), likes its "old shape and design" to which it always returns, and it somewhat stubbornly refuses to have a new coat of paint, even though its surface has been worn away by touching and kissing.[221] The sculpture exposes its age because that shows its special status, that it is a true likeness, a *vera effigies*.[222] Miller also enumerates the reasons for the otherness of these medieval works by referring to other works deemed ancient and holy; God endowed some paintings and statues with a miraculous sign,[223] either by the holiness of the person who painted the painting (St. Luke) or by the holiness of the person who owned the work (the palladium in Stará Boleslav that was commissioned by St. Ludmila and worn by St. Wenceslas on his breast), or by the holiness of the place where the image of Our Lady was kept (such as in Loreto), or by the place of origin of the image (such as some of the images of Our Lady that came to Europe from the Holy Land), or other reasons that we will know sometime in the future.[224]

An unfamiliar material and form that defy the hand of the artist are also among the signs of miraculous otherness.[225] Gumppenberg had already contrasted the expensive material of pagan idols with the humble, simple material of Marian statues through which Mary demonstrates her humility, preferring the "natural" to the artistic, the human.[226] Independence from the human factor thus reinforces the miraculous potential of the work and confirms its authenticity (and status of *vera effigies*) in the sense of the ancient images not made by human hands (*acheiropoietoi*). The desire to avoid doubts about the origins of works and to move them to an ideal age led authors not only to try to push the age of the work as far back into the Middle Ages as possible but also to suppress the role of the artist in their creation, which was easier for medieval works.[227]

The preference for a "non-artistic" origin was related to the problematic relationship between the aesthetic quality of a work and its truthfulness from the point of view of the Catholic cult. As demonstrated by Possevino's writings, Jesuit image theory postulates that old paintings are more truthful than (only) artistically beautiful or valuable paintings.[228] The problematic nature of excessive beauty in post-Tridentine images stems from conciliar theses that oppose lasciviousness, excessive ornamentation, and seductive beauty.[229] I would argue that this notion of a "moral" value in the medieval works' appearance is a Central European counterpart to what Bailey calls a "devout" style of Jesuit art, a simplified, austere, and "antiquarian" style, an aesthetic attitude rooted in the early Christian revival in Rome that had an important influence on the character of the Jesuits' own artistic production.[230] In this

vein, Balbín also argues that the "moral value" of great age and "an ancient manner" are more important than aesthetic quality, thus placing antiquity above beauty.[231] Gumppenberg makes a similar point in the 1672 edition of his *Atlas*, but relates beauty to material, form, and overall execution. Gumppenberg considers it rare that statues and paintings that are valued for their artistic achievement (*peritis artificibus*) become venerated. By favoring lowly materials and unpretentious form in statues, Mary expresses her humility, avoiding any possibility of misleading the viewer or the work having a bad effect on the viewer from the moral point of view.[232] Beautiful form is thus completely subordinated to the miraculous power that operates regardless of the aesthetic value of the work.[233]

Venerated statues of local origin in Jesuit-managed shrines, such as those at Tuřany, Wartha, Mariaschein, and Svatá Hora (and most Jesuit-imported copies of Madonna paintings or sculptures), were often of poor artistic quality, which is consistent with the views above. Even though aesthetically valuable works were venerated in Bohemia, generally originating from the monasteries of old orders, these examples rarely figured among the most revered works in the Jesuit context.[234] The main pilgrimage centers were built around statues that, due to their ancient and crude appearance, could be construed as ancient reminders of the local origins of Christianity. The antique "look" then strengthened a claim to ancient religion and survival of the heretical period. This look was needed to the extent that some statues were adjusted in the Baroque period to make them appear "older," and medieval altarpieces and objects were reinstalled in the cult.[235] Historicizing arrangements sometimes supported the antiquity of the statues, as in Miller's justification for mounting the Olomouc statue on a column "according to an ancient custom."[236] Elsewhere, evidence from the Jesuit environment shows historicizing modifications of church furnishings, sometimes with the clear aim of promoting the Jesuit order itself.[237] No thorough survey into this has yet been undertaken, but there are indirect indications that the Jesuits purposely sought out and collected medieval works and redistributed them to churches under their patronage or to their contacts. It is possible that a survey of the surviving stock of medieval works will confirm my hypothesis that what is preserved from the Middle Ages in the Czech lands is primarily what the Counter-Reformation pre-selected for us.

* * *

The retelling of Bohemia's past was essential to the success of the Jesuit mission in Bohemia. Bohemia had the longest non-Catholic tradition in Western Christianity, which also took on a political dimension that culminated in the seventeenth century with Rudolf II's Letter of Majesty and the revolt of the

Estates against the Habsburgs. A new retelling of the past had to deal with this memory of complicated Czech religious history; the main manifestation of the *damnatio memoriae* was the post-White Mountain destruction of non-Catholic monuments.[238] Bohemia thus became a touchstone for implementing Tridentine strategies, as well as an exemplary model for the punishment and eradication of heresy and the establishment of a new order.[239]

For the needs of the mission in the Czech lands, it was necessary to adapt the controversial theological concept of the struggle between the true church and heresy to the local narrative, to incorporate it into the interpretation of Czech history, and also to find the most comprehensible tangible evidence to popularize it. The situation here was often more confessionally complex than in German towns, at least in the sense of more nuanced attitudes among different religious groups toward the function of the image in a cult and the long tradition of the Bohemian Reformation. This posed a unique challenge for the Jesuits. At the same time, it confronted them with the tradition of the Bohemian Reformation in a different way than with Lutherans in Germany. This complicated their a clear-cut stand against non-Catholic cultic practice, which in Bohemia included a wide range of attitudes, from accepting the image in the cult to tolerating church decoration to radical iconoclastic attitudes. In this vision, medieval works, by their very existence and connection to the place and origins of Christianity, *die Schoensten Althentumer* as Johannes Miller calls them, were meant as arguments to recall the primacy of the Catholic religion, which styled itself as the sole heir of the medieval church in Bohemia. Looking back to the pre-Hussite Middle Ages as an ideal became the ideological content of the Catholic reform in Bohemia.

The medieval works whose cults were appropriated by the Jesuits served as material for and evidence of cultic traditions, linking the ideal of the original uncorrupted ancestral faith with its renewal in the present. In this respect, the Jesuit efforts in Bohemia coincided ideologically with (or were directly inspired by) those in Italy; within the framework of the early Christian revival in Rome, aesthetic reasons for new arrangements of early Christian monuments receded into the background and the value of antiquity and authenticity as a conscious reference to the early Christian past came to the fore. The church had no ancient roots in Bohemia, so Jesuit historiographers concentrated on retelling the past, appropriating the pre-Hussite Church with an emphasis on two periods: the period of Christianization (ninth to thirteenth century) and the reign of Charles IV of Luxembourg (1346 to 1378), which they defended against claims made previously by the Czech Utraquists.[240] The main themes in this narrative related to overcoming opposing forces, paganism, and heretics, which were, represented in Bohemia and Moravia by the Mongol invasion and Hussite and Protestant iconoclasm. In particular, the topos of the ideal Bohemia in the time of the Emperor Charles IV

of Luxembourg, in which Bohemia was regarded as a golden age, a holy land with a pure and heresy-free past in which the Catholic Church played a strong role, had strong recatholizing potential.[241] It was not only a lost ideal but above all a model for a present-day rectification of the situation. The past was constructed as a cyclical process, from pious founders to their corrupt followers to the Jesuits and their patrons as restorers, turning back the clock to the original religion with the renewal of society being a collective journey. Backed by this construct, it was possible to view recatholization activities as renewing old practices, of which the Jesuits themselves became the bearers.

In Bohemia, as in Italy, a work was given authority by its age, unusual and inartistic appearance and material, and the miracles it worked. Controversial theology, which viewed all strands of the Bohemian Reformation simplistically as iconoclastic, offered a Counter-Reformation tool in Bohemia by constructing a historical narrative based on available monuments that were reinterpreted as relics of ancient Catholic veneration defiled by heretics. In Italy, the idea of a return to the early Christian tradition of using images went hand in hand with piety tied to Byzantine images, considered early Christian. In Bohemia, it was possible to use other levels of the meaning of medieval Marian works besides miracle-working, such as proof of overcoming heresy and the argument of the miraculous effect of images against "iconoclasts." The very survival of an image in the environment of non-Catholic Bohemia was understood as its first miracle. Thus, in the construction of Counter-Reformation memory, medieval Marian images and statues not only played the role of reminders of the pre-Hussite past as evidence of the original faith but also of overcoming the iconoclasm of non-Catholic opponents. The historical interpretations that were constructed around these objects were less about the object itself than about its staging as spolium in the interpretation of history.[242] Miraculous images became part of a broader interpretation of the post-Tridentine Catholic renewal and physical evidence of a "return" to the medieval tradition of the Czech Church.

This construction combined an essentially medieval approach to images and religious practice with a concern for functionality in local conditions, historical interest, thorough theological justification, and broadly applied strategies. The very existence of a medieval work was self-referential to the Catholic cult of images, to the origin of the Catholic faith in Bohemia, and to the aims of the Tridentine goal of restoring Catholicism. By linking cultic memory and the historical interpretation of a reborn Catholic Bohemia against the backdrop of a defeated Protestant past, the Jesuits in their texts could thus interpret medieval works as material visible *vestigiae* of the original, heresy-free church of the past and as spolia of the religious wars, both used to construct the Counter-Reformation history of the Bohemian Church and to restore the cult.

In this controversial theological construct of history, the image materializes the connection between the past and the present. This connection has a strong material dimension because it builds on works seen as both vectors of cultic memory and moral models that are fragments of the destruction of heretics and evidence of the wars with them, which in Bellarmino's interpretation grounded the existence of the true church and its movement toward purity of faith. The veneration of medieval Marian images functioned as a transference through time, through a tangible and visible past in the present, to instruct and guide believers in the right direction (see Balbín's concept of the past as teacher) on the path to personal and collective spiritual renewal. The cult of Marian images also offered other bonuses; because of its moral level, it could be used for conversion and for constructing the Virgin Mary's protection of particular places, regions, or the whole country. In this protective function, physically present through images and statues and topographically dispersed, the Jesuit understanding of universal world missions as a complex society-wide task came into play.

Jesuit texts refer repeatedly to Bohemian heresy and iconoclasm as a point of reference against which to formulate an image of the ideal pre-Hussite era. The authors were aware that in this narrative Hussite iconoclasm had major Counter-Reformation potential. The Hussites became a neuralgic point for the anti-Reformation interpretation of history in Bohemia, representing far more than just an "unpleasant memory" of domestic heresy and religious schism. They became a convincing argument for affirming the authenticity of the Catholic cult of images and relics. It was therefore logical that Jesuit authors constantly returned to Hussitism in their texts and referred to it in their artistic creations.[243] As early as the construction of the first Jesuit church in Prague, St. Savior, the intention was to refer to the ancient tradition of the place, to the *"old church destroyed by Žižka"* and to the Jesuits as its restorers.[244] As with Catholic commissions of works in Germany,[245] a historicizing appearance as a sign of pre-heretic origin was reflected in paintings, architectural forms, and liturgical furnishings.[246] The Jesuits actively sought forms of liturgy, manuscripts, and other antiquities to serve as material evidence of local ancient tradition. Age was proof of originality; the Jesuits sought to place the works as far back in the past as possible, either at the beginnings of Christianity or in the time of Charles IV of Luxembourg. Using these interpretations, the emergence of local cults could then be pushed further into the past and incorporated as an original Catholic tradition. The interruption of the cult could thus be thematized as a temporary misdirection. Propagandistically attuned anachronism and antiquarianism thus lay at the base of Catholic Counter-Reformation renewal.[247]

A return to the lost ideal of a past uncorrupted by heresies through the cult of medieval Marian images was inherent in the Counter-Reformation

strategy that the Jesuits used successfully in Bohemia. Applying this concept in the Czech lands was radical.[248] I take the liberty of rejecting the notion that the early Christian ideal did not take hold in Central Europe because medieval tradition prevailed over theological reasons.[249] An integral part of the Counter-Reformation strategy here was using medieval traditions as the Central European equivalent of the early Christian ideal. Thus, applying the early Christian concept in Central Europe did not pose a major problem; medieval works replaced early Christian works as references to the local origins of Christianity. Similarly to Italy, in Bohemia old images, viewed as surviving spolia from original, uncorrupted times, were used to construct the (dis)continuity of church history. In Bohemia, then, the medieval tradition was not a survival; on the contrary, it was purposefully created to serve the new anti-Reformation construction of history in the triumphant return of the Catholic Church.

NOTES

1. "Ein sonderliches Kenn- und Denckzeichen des ersten rechten Glaubens," Dörffler, *S. Maria Culm*, D2.

2. "By the 16th century the idea of 'rebirth' had become a generally accepted concept (of the past) in the European imagination." Eisenbichler, "Introduction," 16.

3. Eisenbichler, "Introduction," 2009, 18. During the sixteenth century different interpretations and opinions coexisted, some of which looked back with the idea of using the past as a "foundation stone for an entirely new vision of the world." This was not a single evolutionary idea of rebirth, however, but a plurality of intertwining tendencies, some of which were marked by renewal and rebirth and others by the continuation of medieval processes and revisions of the past within a continuum.

4. Ditchfield, *Liturgy, Sanctity and History*, 7–8.

5. Mariani, Il "Cristianesimo primitivo," 134. Ditchfield, *Liturgy, Sanctity and History*, 2002, 6.

6. For the "authority" of the works and the originality of the sources, see Mariani, Il "Cristianesimo primitivo," 5.

7. Even in Italy, this vision posed practical problems. While the Late Classical period represented an ideal past, it often did not fit the practical needs of the post-Tridentine church (Bronková, "Bellarmino – Possevino – Villalpando," 1166). In Central Europe it was not possible to use local historical links to antiquity because they played no role in local history. Thus, for the needs of the countries whose contact with the ancient world was limited and not linked to local origins of Christianity, the idea of ancient Christian antiquity had only limited use as an ideal for a renewed and purified Tridentine Church. For the attempt to use this concept in Central Europe, see Krasny, "New Branches of the Roman Trunk," 134–47.

8. Behrmann, *Le monde est une peinture*, 19.

9. Remmert, *Visuelle Strategien*, 108.

10. Ditchfield, *Liturgy, Sanctity and History.*

11. Olds, *Forging the Past*, 5. These works reached extreme popularity despite their intentional bias.

12. The Oratorians were the first to shape that concept, Ditchfield, *Historia magistra sanctitatis*, 8. Ditchfield, *Reading Rome as a sacred landscape*, 169, on the inspiration for the Jesuits, 190–1.

13. *Disputationum Roberti Bellarmini de Controversiis christianeae fidei adversus huius tempori hereticos. . .*, (Ingolstadt 1586, 1588, and 1593) (the second complete edition appeared in Venice in 1596, Richgels, "The Pattern of Controversy," 3). I used Roberto Bellarmino, *Disputationum Roberti Bellarmini Politiani, S.J. S.R.E. Cardinalis De controversiis christianae fidei adversus huius temporis haereticos Quattuor tomis comprehensarum Venetiis 1721 apud Joannem Malachinum* (following the Venice edition 1596), especially parts in vol. 2: *Quarteae Controversio generalis De ecclesia, quae triumphat in coelis. De ecclesia triumphante sive de Gloria et cultu sanctorum*, 335ff. and *Controversio tertia De Romano pontifice, De doctrina Antichristi* (in the following Bellarmino, *Disputationum . . . De Controvesiis*). It is based on his lectures at the Roman College from 1576 to 1588 and from 1570 to 1576 in Louvain; Krasny, *Visibilia signa*, 61. Baumgarten, *Konfession, Bild und Macht*, 2004; Richgels, "The Pattern of Controversy," 3–15.

14. Bellarmino's texts were distributed in Bohemia and translated into Czech as early as the seventeenth century: copies of *Apologia Roberti Bellarmini* (Cologne 1610) printed by the Prague Collegium Societatis Jesu, were held in the Jesuit Klementinum College and the Augustinian canonry of Borovany; *Nebeský Řzebřjk . . . [De Ascensione Mentis in Deum per Scalas Rerum Creatarum]*, was printed in Prague in 1630. *Disputationum Roberti Bellarmini De controversiis christianae Fidei adversus huius temporis*, the 1586–1588 edition, was in the colleges in Prague, Jindřichův Hradec, Jičín, Uherské Hradiště, and Chartreuse of Valdice. On Cardinal Dittrichstein's knowledge of Bellarmine, see Krasny, *Visibilia signa*, 61.

15. Krasny, *Visibilia signa*, 63–64.

16. Bellarmino, *Disputationum . . . De Controvesiis*, Liber II, caput XIII, 211. Bellarmino, *Disputationum . . . De Controvesiis, vol. 2, Quarteae Controversiu generalis De ecclesia*, 335f.

17. Bellarmino, *Disputationum . . . De Controvesiis, II, Quarteae Controversiu generalis De ecclesia*, 377, 384.

18. Bailey, "Italian Renaissance and Baroque Painting," 127; Baumgarten, "Konfession, Bild und Macht," 67.

19. Krasny, *"Res quibus superna Hierusalem*," 54. Krasny, *Visibilia signa*, 71.

20. Krasny, *"Res quibus superna Hierusalem*," 54, Bellarmino, *Disputationum . . . De Controvesiis*, vol. 2, *Quarteae Controversiu generalis De ecclesia*, 339.

21. Krasny, *"Res quibus superna Hierusalem*," 56.

22. Krasny, *"Res quibus superna Hierusalem*," 54.

23. Krasny, *Visibilia signa*, 62.

24. *". . . qui de martyros scribit, suo tempore temple Martyrum fuisse plena tabellis vel simulacris manuum, pedum, occulorum, capitum et caeterorum humanorum*

mebrorum, quibus indicabantur varia dona sanitatum, quae hominesvi votorum a sanctis Martyribus acceperant." Theodoret (Ad Graecos 8) cited in Bellarmino, *Disputationum . . . De Controvesiis, Controversio* III, *De Romano pontifice Liber* III, caput XV, *De miraculis sanitatum proter imaginum venerationem*, 372.

25. Krasny, *Visibilia signa*, 66. Bellarmino, *Disputationum . . . De Controvesiis, Controversio* III, *De Romano pontifice Liber* III, caput XV, *De miraculis sanitatum propter imaginum venerationem*, 372: (after Eusebius): *ea muliere, quam Dominus curavit a sanguinis fluxu statuam aeream Salvatori erectam: herbam autem quamdam sub ipsa statua nasci consuevisse, quae ubi crevisset usque ad finibrias imagines eamque attigisset, omnium malorum genera curabat. Quo miraculo evidens est, Deum approbare voluisse sacrarum imaginum cultum.* See also Bellarmino, De Controvesiis, *Quarteae Controversiu generalis De ecclesia*, 399.

26. Bellarmino, *Disputationum . . . De Controvesiis, Quarteae Controversiu generalis De ecclesia*, 408–10.

27. Oberholzer, "Diego Laínez come theologo," 87–8, with citations of authorities in the Appendix, 208–235; Salviucci Insolera, "La formulazione del Decreto sulle immagini," 101–18. For conciliar orders see, for example, http://history.hanover.edu/texts/trent/ct25.html. For the Bohemian application of the decree on images, Royt, *Obraz a kult* (2011), 16–21. Royt's seminal work on the cult of images, focusing on the Jesuit perspective and strategies for the use of cult images in the early phase of their activity in the Czech Lands, was a great support for me in writing this chapter.

28. Salviuci Insolera, *Laínez e arte*, 567.

29. Hecht, *Katholische Bildertheologie*, 199; Paleotti, *Discourse on sacred*, 108, 110. [add ref to translation ed.]

30. Herklotz, "Historia sacra und mittelalterliche Kunst," 93; Feld, "Das Bild im Tridentinischen Katolizismus," 202, fn. 40, quoting Carlo Borromeo, *Instructionum fabricae et suppellectilis ecclesiasticae libri II* of 1577: "*sancti cuius imago exprimenda est, similitudo quoad eius fieri potest, referenda est.*"

31. Hecht, *Katholische Bildertheologie*, 199.

32. On tradition as a justification for the cult, see Hecht, *Katholische Bildertheologie*, 163–244.

33. Joannes Molanus, *De picturis et imaginibus sacris* (Louvain 1570), *De Historia SS imaginum et picturarum*, 1594. Molanus, *De historia SS imaginum et Picturarum pro vero earum usu contra abusus libri quattuor auctore Joanne Molano* (Louvain 1771).

34. For the origin, miracles, and authority of holy images in antiquity, see Paleotti, *Discourse on sacred*, 125–30 for the broader context, idem, 99–102. Hecht *Katholische Bildertheologie*, 199; on context, 201–214; on St. Luke's madonnas, 220–227.

35. Royt, *Obraz a kult*, 27.

36. Galewski, *Jezuici wobec tradycji*, 39; Hecht, *Katholische Bildertheologie*, 201–27; on medieval works as theological arguments, see also Jurkowlaniec, *Epoka nowożytna wobec średniowiecza*.

37. Herklotz, "Historia sacra und mittellterliche Kunst," 50–55.

38. Royt, *Obraz a kult*, 19–21.

39. Herklotz, "Historia sacra und mittelalterliche Kunst," 58.

40. Herklotz, "Historia sacra und mittelalterliche Kunst," 50–1.

41. Bailey, *Between Renaissance and Baroque*, 127–8 showed that the rector of the college, Michele di Loreto (Lauretano), took the initiative in this.

42. On the Jesuit use of the Marian cult and images in India, see Osvald, "Goa and Jesuit Cult and Iconography," 169.

43. Bailey, "Italian Renaissance and Baroque Painting," 126. Noreen, "The icon of Santa Maria Maggiore, Rome," 666. The first copy of this icon in a Jesuit setting introduced the practice of placing these images in colleges; the image was placed in the *casa professa* novitiate in Rome and the same model was used in Bohemia, see Deutsch's study in this volume.

44. Bailey, "Italian Renaissance and Baroque Painting," 126.

45. Balbín, *Tuřanská madona aneb Historie původu a zázraků*, 30.

46. On the specific Jesuit "culture of images," see Melion, "Introduction," 6–7. On the visuality and sensuality of the Spiritual Exercises, see Bailey, "Italian Renaissance and Baroque Painting," 125; Levy, "Early Modern Jesuit Arts," 66–87.

47. De Boer, "The Early Jesuits," 53–4, 56.

48. De Boer, "The Early Jesuits," 69–70. Deschamps, "Von Wunderthaetigen Mariaebilder," 196–197, 204–206.

49. Behrmann, *Le monde est une peinture*, 29.

50. Melion, "Introduction," 4.

51. Šroněk, "Artykuly na držení kompaktát," 386–7.

52. Melion, "Introduction," 6.

53. Possevino, *Tractatio de poesi*. The treatise is his own practically oriented vision of art in the service of the Church, based on ancient and Renaissance theory and rhetoric, omitting contemporary theorists, and mentioning Paleotti only briefly, Donnelly, "Antonio Possevino SJ as a Counter-Reformation Critic of the Arts," 153–164; Dekonick, "Une Bibliotheque tres selective," 71–80.

54. Possevino, *Tractatio de poesi*, 281.

55. Dekonick, "Une Bibliothèque trés sélective," 78. On this point, however, the position of the Jesuits was not unanimous; some Jesuits were skeptical about the ancient heritage, cf Krasny, *Visibilia signa*, 37–8.

56. Possevino, *Tractatio de poesi*, 281–282, 294–302, 303–309. According to him, the ancient Greeks already placed and displayed images in public places where many people went. Bailey, "Italian Renaissance and Baroque Painting," 127.

57. Dekonick, "Une Bibliothèque trés sélective," 78.

58. E.g., in 1578, Elizabeth of France, daughter of Maximilian II, received a copy of the painting for her personal use; Aurenhammer, *Die Mariengnadernbilder Wiens*, 47.

59. They were found in the Jesuit colleges in Brno, and Olomouc, in St. Clement's in Prague, and St. Barbara's in Kutná Hora; for a close analysis see M. Deutsch and K. Sterba in this volume.

60. It represents "a visual and mnemonic system that functions as a border crossing and creates a global political topography" ("political" is a questionable term from my perspective, however). Topographical thinking among Jesuits originated

the creation of local sites of memory (*Gedächtnisorten*) within Jesuit complexes. The meditation on images here was influenced by Classical conceptions of *memoriae*, which distinguish between places (Orte, *loci*) and images (Bilder, *imagines*) in order to underline the active role of images (*imagines agentes*) for remembering, Behrmann, *Le monde est une peinture*, 21.

61. The Jesuit concept of the image illustrates perfectly the time quality of an image—in chronological cycles the image "more actively generates the effect of doubling or bending of time" . . . "a strange kind of event, whose relation to time is plural," Nagel and Wood, *Anachronic Renaissance*, 9. Didi-Huberman, *Před časem*, 14, puts it similarly for any image: the image is a "montage of heterogeneous times" and its anachronistic features are a multiple vector of different times, not just a direct reference to a particular time and place.

62. Behrmann, *Le monde est une peinture*, 21 (ft. 27); Oy-Marra and Remmert, "Einleitung," 10.

63. Ditchfield, *Reading Rome as a sacred landscape*, 169.

64. On the place, effect, and presence of saints, Bellarmino, *Disputationum . . . De Controvesiis, Controversio* II, *liber* III, *caput* XIII, 203–4.

65. Lucas SJ, *Saints, Site and Sacred Strategy*, 30, 113–4.

66. Muir, "The Virgin on the Street-Corner," 25.

67. Lucas SJ, *Saints, Site and Sacred Strategy*, 114. More on the chapel decoration in Bailey, *Between Renaissance and Baroque*, 215, and in my forthcoming book. ARSI, Collection (Fondo) Il Gesù (CDG), Busto I, document no. 67.

68. Heal, *The Cult of the Virgin Mary*, 153.

69. Vocelka, "Barocke Frömmigkeitsformen in Wien," 379–82.

70. Heal, *The Cult of the Virgin Mary*, 148–149: "Mary became, as Canisius wished, an emblem of Catholic allegiance, a rallying point for the Catholic cause," 149. Cf. also Jakubec in this volume.

71. Šroněk, *De Sacris Imaginibus*, 12–57.

72. *L'Atlas Marianus de Wilhelm Gumppenberg*. The Jesuits were inspired by the Franciscans in the formation of sacred topography, see also Cruz Gonzales, *Landscapes of Conversion*. For Bohemian Marian Atlanti see Šroněk–Horníčková in this volume.

73. Canisius, *De Maria Virgine*; Heal, *The Cult of the Virgin Mary*, 148f.

74. Melion, *Que lecta Canisius*.

75. Heal, *The Cult of the Virgin Mary*, 148.

76. Mindera, *Maria Hilf*, 9, reproduces a print of the Loreto litany *Ordnung der Letaney von unseren Lieben Frawen, wie sy zu Loreto all Sambstag gehalten*, printed 1550 in Dillingen.

77. In 1570, Canisius performed an exorcism on a young woman in the pilgrim chapel there; a description of the miracle was published the following year by the provost of the church, M. Eisengrein, see Heal, *The Cult of the Virgin Mary*, 155–6.

78. Hlobil, "Multiplikace," 537–39, describes Bedřich of Donín's (1607) travel diary and relationship of archbishop Zbyněk Berka of Dubá and Lipá, who was a canon there, to this site. There are many Baroque copies of the Madonna of Altötting in the Czech lands, some linked directly to conversion.

79. Heal, *The Cult of the Virgin Mary*, 151ff. Mindera, *Maria Hilf*, 9; Gretser, *Jacobi Gretseri . . . de sacris et religiosis peregrinationibus.*

80. See Aurenhammer, *Die Mariengnadernbilder Wiens*, 15–16; on the role of orders in pilgrimages, 18.

81. Canisius, Petrus, *Beati Petri Canisii*, Letter no. 175, [1555], 545–546.

82. Schmidl, *Historia Societatis*, vol. 1, 89.

83. Canisius, Petrus. *Beati Petri Canisii*, Letter no. 174. *CANISIUS SANCTO IGNATIO. Praga 15. Iulii 1555*, 545–546. Schmidl, *Historia Societatis*, vol. 1, 89, notes that a Czech translation of Canisius's catechism was printed as early as 1568.

84. Heal, *The Cult of the Virgin Mary*, 200–1.

85. Hrachovec, "*Maria honoranda.*"

86. The veneration of the Virgin Mary varied greatly among Protestant movements and the differences cannot be ignored, cf. Heal, *The Cult of the Virgin Mary*, 64–103, 282, 122–8, in Nurnberg, for example, 103–107. Mostly, other solutions (returning or selling the works) were preferred to iconoclasm; Heal, *The Cult of the Virgin Mary*, 104; this was also true in Bohemia and Moravia. For religious coexistence, Horníčková, "Framing the Difference," 119–123.

87. Ryneš, *Palladium země české*, 69–70, 156, ft. 120.

88. For bi-confessional, but tolerant, Augsburg see Heal, *The Cult of the Virgin Mary*, 150.

89. Ducreux, *Piété Baroque et Recatholisation en Boheme*, 86–7; Šroněk, *De sacris imaginibus*, 22–8, 54–6 (it can also be assumed that it had educational influence on nobles and through noble donations, 28–57). For pilgrimages in Bohemia see Ducrcaux, "Symbolický rozměr poutě do Staré Boleslavi"; Ducreux, "Několik úvah o barokní zbožnosti," Kořán, "Kult mariánských obrazů," 127, Jeřábek, "K otázce vzniku poutních míst," 148.

90. In Bohemia, for example, in Kolín, part of the population was Protestant, but the city was Utraquist and tolerant. The Jesuits did not achieve much here because the burghers continued the local customs in the cult of the Virgin Mary. The Jesuits were unable to gain a monopoly on conversion and established themselves here relatively late. For a similar case, see Heal, *The Cult of the Virgin Mary*, 207–236. The Jesuits had limited success also in the Catholic towns of České Budějovice and Plzeň.

91. Hlaváček, "Catholics, Utraquists and Lutherans in North-western Bohemia," 288.

92. For the renewal of sites see Šroněk, *De sacris imaginibus*, 12–57.

93. Schmidl, *Historia Societatis*, vol. 2, 8.

94. Ducreux, *Piété Baroque*, 87; Ducreaux, "Symbolický rozměr," 586; Ryneš, *Paladium země české*, 50; Stloukal, "Papežská politika," 156.

95. Mikulec, *Barokní bratrstva v Čechách*; Mikulec, "Piae confraternitates v pražské diecézi," 269–342.

96. Gaži and Hansová, *Svatyně za hradbami měst*, 89, 115.

97. Correspondence of Bishop Pavlovský and Abbot Jakub Bělský at Velehrad, ZAO- O, AO, book of copies 1586, inv. no. 97, sign. 23, f. 48r: in 1586 the bishop sends the rector of Olomouc college, Bartolomeus Villerius, and another Jesuit (B. Hostounský) to the monastery: "*desiderio sacra canobii istius Loca sanctorum*

*huius ordinis fratrum sanquine aspersa invisendi atque anita illius pictatis monu-
menta in veteribus eiusdem Monasterii ruinis spectandi habite istuc ad D. Vram
proficiscuntur."*
 1597, 1. 10. letter to an abbot in Velehrad: *"jsouce zde u nás patres societatis a
jeden z nich, totiž pater Gallus Šerer [Scherer], slyšíc o starožitnosti a antiquitatibus
kláštera vašeho, žádostiv byl to tam místo viděti, protž teď jeho a s ním také patra
Petrusa . . . aby ten klášter zhlídnouti mohli, vypravujeme."* . . . there are here with us
patres societatis, and one of them, namely, *pater* Gallus Scherer [Scherer], hearing
of the antique monuments of your monastery, asked to see the place, and now we are
sending him and with him also *pater* Petrus . . . that they may see the monastery."
MZA, collection G 83 Matice moravská, book of copies XXXIV, 1597, box 59, inv.
no. 187, f. 720. I thank Ondřej Jakubec for this information and valuable consultation.
 98. Miller, *Historia Mariascheinensis*, 11–12. Compare Bellarmino,
Disputationum . . . de controversiis christiane, Liber II, De incarnatione Lib II, Cap.
XIII, *"et sancti non erunt ubique, sed in certo loco,"* 204.
 99. Canon of the St. Vitus Chapter, provost of Vyšehrad Chapter and general
vicar, http://biography.hiu.cas.cz/Personal/index.php/ARSENIUS_z_Radbuzy_Ka
%C5%A1par_%E2%80%A013.9.1629.
 100. Ryneš, *Paládium*, 73, cites the Jesuits (without citing a source) as the reviv-
ers of these cults, although he is not sure about the stone statue of the Virgin Mary
in the Benedictine monastery in Kladruby. Pro ideu posvěcené krajiny např. u Karla
Boromejského ("leggere il passegiato sacro della citta eterna") ad., Ditchfield,
Historia magistra, 7.
 101. Balbín, *Epitome historica*, 16; Kořán, "Legenda a kult sv. Ivana," 230 (fn.
34), (quote from *Historia fundationis colegii Pragensis*, NK sign. I A 1, 242, and
Litterae annue from 1608, and 1603). Ryneš, *Paladium země české*, 46–7 (a critical
review of Balbín, 123). On Jiří Barthold Pontanus of Breitenberk, a former student at
the Prague Jesuit college, see Kořán, "Kult mariánských obrazů," 127.
 102. Balbín, *Epitome historica*, 16; Ryneš, *Paladium země české*, 46–7; Ducreux,
Piété Baroque, 88–9, states that there are reports of only a few visits and miracles from
noble circles: Bořita of Martinice, Berka of Dubá, and other courtiers before 1620.
 103. Kratochvíl, "Kolegiátní kapitula," 145. Ryneš, *Paladium země české*, 46–8,
Ryneš dates these activities to 1567 and Balbín to 1570, Balbín, *Epitome historica*,
15. Čornejová, *Jezuité v Čechách*, 181.
 104. Kratochvíl, "Kolegiátní kapitula," 144–5. Schmidl, *Historia Societatis*, I,
237. Ryneš, *Paládium země české*.
 105. Carlo Carpi, "View of Brandýs nad Labem and Stará Boleslav during the
Swedish siege," reproduction in Dobalová, *Zahrady Rudolfa*, vol. 2, 225; on building
the residence, 222–225. The engraving shows the direct connection the churches had
with the castle across the island and the bridge on the Elbe. Visits of the royal family
(Leopold Wilhelm) are recorded in Balbín, *Tuřanská madona*, 19.
 106. Ryneš, *Paladium země české*, 52–56, counted 21 figures, two-thirds of whom
went directly to the Virgin Mary image.
 107. Vácha, "Šlechtické kaple v kostele Panny Marie," 18; on the decoration
before 1650: 19–23.

108. "The Utraquist universitarians do not want to venerate the image, they visit it 'as a monument' in an effort to openly demonstrate their ties to the Bohemian Church," Čornejová, "Tovaryšstvo Ježíšovo," 181.

109. Vácha, "Šlechtické kaple v kostele Panny Marie," 20. Schmidl, *Historia Societatis*, vol. 1, 235–6.

110. The date of the relief is a matter of debate, summarized in Ryneš, *Paladium země české*, 36–39. The prevailing opinion is that it was created in the second half of the fifteenth century during the first wave of recatholization under the Jagiellonian dynasty and that the elaboration consciously used older forms as a reference to the pre-Hussite tradition.

111. Schmidl, *Historia Societatis*, vol. 4, no. 2, 629.

112. An early cult developed around the Madonna of the cemetery chapel in Březno near Chomutov (mentioned by Balbín in *Diva Turzanensis*); the Virgin Mary in Hope from Květnov, and the Madonna of St. Mary in Chlum (mentioned in the first volume of the *Atlas Marianus*), cf. Kvapil, *Augustin Sartorius*, 154, 159; see also the map of Marian cults in northern Bohemia, 160. According to the legend, the Březno statue survived an iconoclastic attack; Sartorius, in the German version of the Marian Atlas (1717), mentions a legend about the bloody marks that appeared on the statue after its discovery in a pit where it had been thrown by a raging heretic, Royt, *Obraz a kult* (1999), 225–228; Kvapil, *Augustin Sartorius*, 161. Another venerated statue, legendarily dated to the pre-Hussite period, is listed in 1687 in "Hájek u Červeného Újezda." After the Jesuits took over, the medieval altar with the Asumpta from the Church of the Assumption of the Virgin in Chomutov also remained in place. For the concept of the northeast Bohemian plain as a Marian land see Kvapil, idem, 162–5.

113. Kocourek, *Der Walfahrtsort Bohosudov*, 504. Emperor Rudolf II owned Mariaschein, even though the site lay on the Protestant estate of Kekule von Stradonicz. Restored by Jiří the Younger of Lobkowicz, his successor gave it to the Jesuits.

114. Kriss and Rittenbeck, *Wallfahrtsorte Europas*, 124.

115. Kocourek, *Der Walfahrtsort Bohosudov*, 504.

116. Christelius, *Via Spino-Rosea*, front page.

117. For donations by Catholic nobles after 1596, see Miller, *Historia mariascheinensis*, 31–33.

118. Schmidl, *Historia Societatis*, vol. 2, 431.

119. Kriss and Rittenbeck, *Wallfahrtsorte Europas*, 80.

120. Balbín, *Diva Wartensis Origines*, 97; "*antiqua quadantenus revocata est Pietas.*"

121. Balbín, *Diva Wartensis Origines*, 99–100.

122. Balbín, *Diva Wartensis Origines*, 164.

123. Balbín, *Diva Wartensis Origines*, 197: "*Gloriosa enim sunt vulnera quae post Impietatem miraculis superatam in triumphis feruntur.*"

124. Kapustka, "*ad cujus tumulum,*" 98L.

125. Hrdlička, *Víra a moc*, 218–22.

126. Mikeš, "The Pieta of Lásenice," 89.

127. Hrdlička, *Víra a moc*, 218–22.

128. Schmidl, *Historia Societatis*, vol. 2, 412.

129. Kalista, *Století andělů a ďáblů*, 47–8.

130. Kroess, *Geschichte*, vol. 1, 665–666.

131. Schmidl, *Historia Societatis*, vol. 2, 105: "*Vigiliarum antiquarum speciem,*" "*vigiliae veteris more.*"

132. Gaži and Hansová, *Svatyně za hradbami měst*, 241.

133. The question remains whether the veneration of the famous "beautiful madonna" [referring to the art style] of Krumlov (today in the Kunsthistorisches Museum in Vienna) is related to the Jesuits. The statue had a baroque metal crown decorated with precious stones when it was found, so it was certainly venerated in the baroque period, but we do not know where.

134. https://www.muo.cz/sbirky/sochy--45/madona-z-kostela-panny-marie-sne-zne--318/. On the Marian confraternity, see Sterba, "Von Sichtbarem," 34 (ft. 287), 230 and elsewhere. The statue was transferred to the new Church of Our Lady of the Snow, where it was placed on the main altar and incorporated into the new decorative program of the church. On Jesuit confraternities, see O'Malley, "Die ersten Jesuiten," 226–229; Samerski, "Von der Rezeption zur Indoktrination," 94, 96. They were popular in Bohemia and Moravia from the 1590s.

135. Pavlíček, "Jezuitský Kostel," 81–4.

136. Sterba, "Vom Sichtbaren," 230, quoting Miller "Anfang und End," 1714. On Tanner and the legend, see Linda, "Matěj Tanner," 175–188. Cf. Sterba in this volume.

137. Sterba, "Vom Sichtbaren zum Unsichtbaren," 35.

138. Samerski, "Von der Rezeption," 109, 112. Sterba, "Vom Sichtbaren," 322.

139. Samerski, "Von der Rezeption," 112.

140. Samerski, "Von der Rezeption," 104, 114.

141. See M. Deutsch in this volume. Malý, "Civic Ritual, Space and Imagination," 157–180.

142. Mahr, *Walfahrtsorte Südmährens*, 29–30.

143. Mahr, *Walfahrtsorte Südmährens*, 24.

144. On the Jesuit and other writings on this pilgrimage site see Vykypělová, "Český spis Divotvorná Marije," 277–299. The author confirms the role of Cardinal Dittrichstein in founding the site, Jesuit links to the local priests (G. Pistorius, M. Petrasius), and the efforts of Jesuits to promote the site from ca. 1640 at the latest (Andreas Schambogen), ibid., 278, ft. 5, 289.

145. Balbín, *Tuřanská madona*.

146. Mahr, *Wallfahrtsorte Südmährens*, 17.

147. Balbín, *Tuřanská madona*, 19, 97–100.

148. Jeřábek, "K otázce vzniku poutních míst," 148, 151.

149. Heal, *The Cult of the Virgin Mary*, 199.

150. For the year 1606, when building of Marian chapels in Santa Maria Maggiore and Santa Maria in Vallicella in Rome started, the Pope Paul's V elevation of the image *Salus Populi Romani* was noted in the college Chronicle of Jindřichův Hradec together with the existence of a Marian sodality there. In the same year the statue of Wartha was solemnly brought out of safekeeping. It is probably not a coincidence that

between 1598 and 1603 Filippo Spinelli, brother of the Jesuit Marian writer and theologian Pietro Antonio Spinelli, was papal nuntio in Prague, and kept close contacts with the Jesuits.

151. Aurenhammer, *Die Mariengnadernbilder Wiens*, 29.

152. Crugerius, *O lásce blahoslavené Panny Marie*; Balbín, *Tuřanská madona*.

153. Miller, *Historia Mariacheinensis*, 2.

154. Sterba, "Vom Sichtbaren," 124. In 1650, copies of this painting were sent to the Johannite church in Strakonice and in 1708 to the pilgrimage church at Bílá Hora.

155. Ducreux, *Piété*, 90–1.

156. Heal, *The Cult of the Virgin Mary*, 196.

157. Royt, *Obraz a kult* (2011), 212–217. On Habsburg piety see Mikulec, *Náboženský život*, 89.

158. Schmidl, *Historia Societatis*, vol. 4.2, 631. Royt, *Obraz a kult* (2011), 215–218.

159. Balzamo, Christin, and Flückiger, *L'Atlas Marianus*, 404.

160. This was also true for the Paladium of Stará Boleslav (Ryneš, *Paladium země české*, 100), Wartha (Balbín, *Diva warthensis Origines*, 98), Mariaschein (Kocourek, *Der Walfahrtsort Bohosudov*, 505), and Tuřany statues. The Jesuits begged the Tuřany madonna for protection when fleeing Brno (Balbín, *Tuřanská madona*, 29).

161. Balbín, *Diva warthensis Origines*, 98.

162. Galewski, *Jezuici wobec tradycji średniowiecznej*, 43–46.

163. Noreen, "The icon," 660–672. Architectural framing of cult statues or images is known from as early as the Middle Ages, but in the seventeenth and eighteenth centuries altar installations took on grandiose dimensions that replaced the frames. Hamburger, "Rahmenbedingungen," 123.

164. Sterba, "Vom Sichtbaren," 72.

165. Sterba, "Vom Unsichtbarem," 74, 78, fig. 118; Sterba in this volume.

166. Royt, *Obraz a kult* (2012), 67, 160–68.

167. Gaži and Hansová, *Svatyně za hradbami*, 126–127.

168. Ryneš, *Čtení o Oenestinovi mučedníku*, 20.

169. Hanuš, *Dějiny a původ koleje kutnohorské*, 40.

170. Hanuš, *Dějiny a původ koleje kutnohorské*, 41.

171. Royt, *Obraz a kult*, (2012), 295.

172. Kořán, "Etika miraculosy," 501, writes that the cult of imported images dominated after 1620. Not quite—rural pilgrimage shrines with domestic statues retained the cult, but the cults of imported images attracted more publicity as urban cults. They were located at Jesuit colleges and churches, attracted the daily reverence of townspeople, and were the subjects of urban festivals and feasts.

173. Bartlová, "Uměleckohistorické úvahy," 215.

174. Ducreux, *Piété*, 87. Holubová, *Panna Marie Svatohorská*, 18. For unpreserved writings of Plachý see Fechtnerová, "Klementinští knihovníci," 90.

175. Holubová, *Panna Marie Svatohorská*, 18.

176. Ducreaux, *Symbolický rozměr*, 586.

177. Schmidl, *Historia Societatis*, 629.

178. Royt, *Obraz a kult* (2012), 32; Arsenius z Radbuzy, *Pobožná Knížka O Blahoslavené Panně Marii*.

179. Ryneš, *Paladium země české*, 40, 130, fn. 58; Royt, *Obraz a kult* (2012), 93.

180. Fechtnerová, "Klementinští knihovníci," 90–91, refers to two of his now-lost Marian eulogies, *Zázraky Panny Marie Swatohorské* (published during the 1630s), and *Trůn milosti mariánské* (1640).

181. Constantius, *Sucurre miseris*; Ducreux, *Piété*, 88.

182. Dörffel, *S. Maria Culm*, D2; Dörffel studied theology at the university; one copy was in the Chomutov college.

183. Dörffel, *S. Maria Culm*, D2.

184. Published 1657 to 1659, enlarged edition 1672, Balzamo and Flückiger, *L'Atlas Marianus*. The first edition includes the Madonna of Wartha, 280–285, Chlum sv. Máří, 286–292, St. Boleslav, 403–406, Zbraslav, 407–409, and Brno, 410–412, with a mistakenly identified print of the Madonna of Tuřany and not the Svatotomská Madonna that is described there. Royt, *Obraz a kult* (2012), 40.

185. A letter of invitation to collaborate on the *Atlas* was sent to the provincials of the orders in 1652 and the printed concept for the *Idea Atlantis Mariani* was sent in 1655 (Trent 1655). Deschamps, "Von Wunderthatigen," 204, classifies the information in the *Idea Atlantis Marianis*. On Idea also Royt, *Obraz a kult* (2011), 44–51.

186. Cf. Royt, *Obraz a kult* (2012), 40.

187. In 1673 a German translation of Gumppenberg's longer *Atlas Marianus* (1672) was published by the Jesuit Maximilian Wartenberg, followed by another by Augustin Sartorius (Augustin Sartorius, *Marianischer Atlas*, Prague, 1717); Kvapil, "Augustin Sartorius," 145–166, where he added other venerated Czech Marian statues. Royt, "Image and Cult," 17, 41–2. There is also an Atlas in the Czech language by A. Frozín, cf. also Šroněk-Horníčková in this volume. For the purposes of this chapter, I will omit a more extensive treatment of this literature; there are many separate scholarly studies; Royt, "Obraz a kult" 1999, and 2012 gives an overview of the literature for the Czech setting. I will also omit Marian eulogies from the Jesuit milieu that treat only certain aspects of Marian veneration, such as Juan Eusebius Nieremberg's *Trophea Mariani* (1658). Cf. also Šroněk-Horníčková in this volume.

188. Delfosse, "L'Atlas Marianus, une enteprise collective," 133. Deschamps, "Von Wunderthatigen," 205.

189. Balzamo and Fluckiger, "Introduction," 22.

190. Balzamo and Fluckiger, "Introduction," 21.

191. Deschamps, "Von Wunderthatigen," 205–206.

192. Balzamo and Flückiger, *L'Atlas Marianus*, vol. 2, 21; for Wartha (Bardo), 280–5; Chlum sv. Máří (Culm), 286–292.

193. Simon, "*Ad maiorem Mariae gloriam*," 155.

194. With a few exceptions, I concentrate here on selected Marian works written by Jesuit authors before 1700. Other important texts both outside and inside the Jesuit milieu were written by J. I. Dlouhoveský, J. Beckovský, Jindřich Labe, and others, which I cannot include here, Royt, *Obraz a kult*, 33–37.

195. Royt, *Obraz a kult* (2012), 40.

196. Ducreaux, *Piété*, 92.

197. Royt, *Obraz a kult*, 40. Crugerius, *O lásce blahoslavené Panny Marie*, 450–61.

198. Crugerius, *Sacerrimae memoriae inclyti regni Bohemiae coronae*. Cf. Royt, *Obraz a kult*, 41.

199. Crugerius, *O lásce blahoslavené Panny Marie*, 457, cf. Ducreux, *Piété*, 92–93, fn 54

200. Ducreux, *Piété*, 93, fn 54.

201. Royt, *Obraz a kult*, 40.

202. Miller, *Historia Mariascheinensis*, 1.

203. Hrdina, "*Indulgentiae ad ymagines*," 87–102. One of the few accounts of the miraculous effect of the work is the account in Ernest of Pardubice's biography of a miracle by the image of the Virgin Mary in Kłodzko. Jesuit interpretation linked Ernest's testimony to the local statue no later than the Jesuit takeover of the church in 1624 and this connection also contributed to the Jesuits' efforts to push for its beatification. They also attributed to Ernest the making of the venerated Madonna of the Jesuit pilgrimage site on the Svatá Hora (Holy Mountain); Royt, *Obraz a kult*, 101–2, 103. Kapustka, "*ad cujus tumulum*," 97–118; Galewski, *Jezuici wobec tradycji średniowiecznej*, 179. About mistakenly exchanging the Kłodzko statue for a painting, see Tanner, Miller, and Balbín, see Royt, *Obraz a kult*, 104.

204. An example of the importance of the "correct" provenance of a medieval work for survival in the Counter-Reformation is the purposeful manipulation of the history of an Utraquist work in the painters' guild memorandum of 1661. The stone canopy erected over the tomb of Bishop Luciani (d.1506) in the Church of Our Lady before Týn in Prague was deliberately misinterpreted in the memorandum and its dating moved back to the time of Charles IV in an attempt to oppose the destruction of the work due to its Utraquist origin. In its defense, the painters argued for the style of the work (Gothic architecture) as proof of its Catholic origin. With its erudite argumentation to avoid the destruction of an aesthetically valuable monument that the painters' guild considered part of its altarpiece, it is a unique example of a sophisticated, if falsified, argument in favor of a different confessional interpretation of an ancient work. Šroněk, "The Representation Practises," 177–178.

205. Many Marian pilgrimage sites are connected with the outlying areas of Bohemia. They were established in reaction to Hussitism in the German-speaking mountainous and border regions.

206. Balbín, *Diva Wartensis*; Royt, *Obraz a kult*, 19–20.

207. For an example of conversion in front of an image, see in Balbín, *Diva Warthensis*, 102.

208. Maniura, *Pilgrimage to Images*, 190–7 (the legend printed 1514–24).

209. Balbín, *Diva Turzanensis*, 27, Balbín, *Tuřanská Madona*, 19, 62, 97–100.

210. Balbín, *Diva Warthensis*, 160. For the miraculous survival of the statue of two invasions of infidels (the Tatars in 1241 and the Hussites in 1427), and an attack by Lutherans, see ibid. 90.

211. Balbín, *Diva Warthensis*, 57.

212. Balbín, *Diva Warthensis*, 103: "*Tabulae vetustae priorum saeculorum de Wartensis Divae origine loquentes . . . minimum miraculum numerum . . . picturis expressit . . . rudibus iis quidem, ut aetas illa ferebat, sed multum ad Virginis gloriam*

conferentibus . . . sine his enim nec sacrae imaginis Originem, nec miracula haberemus. Pictoris nomen in una tabularum arcanis notis effictum est, caeterum ipse Stephanus manu sua tabulas scripsit, ut testatur . . .," 88–89.

213. Balbín, *Epitome historica*, 239: "*ipsâ in primis effigie (quae ad grecum morem, ùt cuilibet patet, in metallo adornata est) deinde totius Venerabilis et antiquisssimi Capituli Bolesaviensis et antiquitatis authoritate tueri se possunt.*"

214. Balbín, *Epitome historica*, 239: "*. . . quippe in infimo Templo Boleslaviae in Altari S. Cosmae et Damiani, Imago visitur, quae sanctos illos duos Episcopos Cyrillum et Methodium exhibit, S. Ludmille duci Bohemiae hoc Divae Virginis signum donantes;at si cui placeat, sanctam Ludmillam . . . authorem imaginis hujus facere.*" Cf. Royt, *Obraz a kult* (2012), 94 (with the debate on the origin and material of the relief and on the role of B. Podiven in hiding the relief among the roots of a tree).

215. Balbín, *Epitome historica*, fol. b3.

216. The cult of this fourteenth-century statue culminated in Miller's concept for the new church of Our Lady of the Snow, where it was transferred along with the late Gothic Crucifixion from the old church in 1717. Sterba, "Vom Sichtbaren zum Unsichtbaren," 74, 78. Mlčák, "Areál jezuitské koleje v Olomouci," 183, 191–192.

217. Miller, *Anfang und End*, 51–3; Sterba, "Vom Sichtbaren zum Unsichtbaren," 127.

218. Miller, *Anfang und End*, 43–48, Sterba, "Vom Sichtbaren zum Unsichtbaren," 127.

219. Miller, *Anfang und End*, 43–47.

220. Miller, *Historia Mariascheinensis*.

221. Miller, *Historia Mariacheinensis*, 9, The statue returned "*in seiner alten Gestalt/und Beschaffenheit /wie es noch bis dato ist/verblieben.*"

222. Miller, *Historia Mariascheinensis*, 8.

223. Miller, *Historia Mariacheinensis*, 8. "*. . . daß solcher Gestalt / wie die gemeine Erfahrung uns lehret / offt eines Gnaden-Bilds zehen und mehr Contrafee, auch von einem Beruhmtesten Entwerffern/Mahlern/ und Bildstechern verfertigt werden / und nicht ein einziges also zutrifft /daß man darunter mit Fug zu setzen könnte: Vera effigies,*" 10, No one can recognize the material, which is white but harder than chalk, similar to gypsum.

224. Miller, *Historia Mariacheinensis*, 2–3.

225. Miller, *Historia Mariacheinensis*, 8–9.

226. Dekoninck, "Les Silènes de Gumppenberg," 214.

227. The authors also mention other evidence of miraculous origins, such as the discovery of old paintings and statues in trees, Royt, *Obraz a kult*, 113–114.

228. Dekonick, "Une Bibliotheque tres selective," 80.

229. Hecht, *Katholische Bildertheologie*, 503.

230. Bailey, *Between Renaissance and Baroque*, 125.

231. Balbín, *Tuřanská Madona*, 100.

232. "*. . . quia rarae sunt Virginis Statuae et Imagines, a peritis mundi artificibus multum aestimatae,*" quote from Gumppenberg *Atlas Marianus* (vol. 2, 1672) in Dekoninck, "Les Silènes de Gumppenberg," 215, fn. 27, Dekoninck explains this by

the humility (*kenosis*) of the statues, both material and artistic, so as not to risk seduction, 215.

233. Dekoninck, "Les Silènes de Gumppenberg," 215.

234. The Jesuits were not oblivious to the artistic quality of the works. In the eighteenth century, chronicler Schmidl, *Historia Societatis, vol. 1, Effigies haec (opus periti Artificis)*, refers to the Palladium itself as skillfully crafted. In the Jesuit surroundings, aesthetically demanding statues were venerated as well, but they did not reach such prominence (with the exception of the Palladium), and their importance lay in their miraculous *fama* and age, not appearance. These works include, for example, the Madonnas of Kłodzko (linked to Ernest of Pardubice, but overshadowed by the cult of Virgin Mary of Wartha), Údlice (placed in the church in 1658; ĽT [Ľubomír Turčan], "Madona z Údlic," 145), Český Krumlov, Kájov, Klatovy, Kutná Hora). They also appear in parish accounts of miraculous images from 1676 and 1700, Royt, *Obraz a kult*, 285–90.

235. This approach was chosen for adapting the medieval Madonna of Velké Meziříčí, where the Baroque adjustments to the venerated statue were intended to emphasize the statue's stiffness and hieratic look in order to make it appear "older." Míchalová and Kruntorád, "Madona velkomeziříčská," 440–7. Also an "old ark" (a painted medieval altarpiece) and a stone ciborium were returned to liturgical use there as a result of local denominational conflict, see Hrdlička, "Public Expression," 214, 219–220. Cf. Schmidl, *Historia Societatis*, vol. 2, 21.

236. Miller, *Anfang und End*, 51–53.

237. The Jesuits made gothicizing modifications to the Utraquist altar in St. Catherine's Church in Chrudim, adding the monogram IHS and a new extension. A monstrance from Chrudim, made before 1630 from Utraquist liturgical chalices, also has Gothic forms. The Jesuit IHS with a cross and three nails is painted on the host above the chalice, which is held by a medieval statue of St. John the Evangelist from the Church of St. Barbara in Horní Ves near Chomutov, secondarily placed on the main altar of the church from the second half of the seventeenth century. ĽT [Ľubomír Turčan], "VII-13, Sv. Jan Evangelista a Sv. Petr z Chomutova," 264–5.

238. Šroněk and Horníčková. "Prague and Bohemia during the Thirty Years War."

239. Bronková, "Bellarmino – Possevino – Villalpando," 1166; Smith, "The Art of Salvation in Bavaria," 572.

240. Cf. Čornejová, *Tovaryšstvo Ježíšovo*, 181.

241. Mikulec, "Historische Argumentation im Konfessionellem Zeitalter," 478–9.

242. Kapustka, ". . . *ad cujus tumulum*," 98.

243. These hints were everywhere, even in the histories of colleges, Hanuš, *Dějiny a původ koleje kutnohorské*, 38, quoting the hand-written *Historia collegii* (History of the Kutná Hora college): "Jak Čechy pijí z kacířského kalicha a počaly se sytiti krví od těla Kristova oddělenou a když to druhé nebylo orthodoxními uznáváno, jak odtud vznikly války v útrobách země, které Žižka a jiní hlasatelé vedli. Ranění však obrátili se k nebeským patronům, aby žádali beránka neposkvrněného, aby potvoru kacířskou v nich potřel a radost míru zjednal." / "How Bohemia drank from the heretical cup and began to be satiated with blood separated from the body of Christ, and when the

latter was not recognized by the orthodox, how hence the wars in the bowels of the land came into existence, which Žižka and other heralds waged. The wounded, however, turned to heavenly patrons to ask the immaculate Lamb to bruise the heretical monster in them and to make peace."

244. IK [Ivo Kořán], "Kostel sv. Salvátora v Klementinu," 110. See also the chapter by Jakubec in this volume.

245. Heal, *The Cult of the Virgin Mary*, 170.

246. Galewski, *Jezuici wobec tradycji średniowiecznej*, 199, 201–2; the figures of the medieval founders played similar roles in the decoration program, 205. I will not address the problem of Gothic-informed Baroque architecture and the blending of styles in the Baroquization of medieval churches, as these specific forms of medieval historicism go beyond my topic.

247. The "political" use of Marian images in Bohemia was noted by Kořán, "Etika miraculosy," 506. Kapustka, "*ad cujus tumulum*," 97, introduced the term "propagandistic activism" as a contrast to the ahistorical-style terminology used in architecture.

248. Cf. Louthan, *Converting Bohemia*.

249. Krasny, *Visibilia signa*, 62.

BIBLIOGRAPHY

Manuscripts and Archival Sources

Roman Archive of the Society of Jesus [Archivum Romanum Societatis Iesu (ARSI)], Collection Il Gesù (CDG), Busto I, document no. 67.

Land Archive in Opava, branch Olomouc [Zemský archiv v Opavě, pracoviště Olomouc (ZAO-O)], Collection of the Olomouc Archbishopric (AO) ZAO–O, AO, book of copies 1586, inv. no. 97, sign. 23, f.48r. Correspondence of Bishop Pavlovský and Abbot Jakub Bělský at Velehrad.

Moravian Land Archive in Brno [Moravský zemský archiv v Brně (MZA)], Collection G 83 Matice moravská:

MZA, G83, book of copies XXXIV, 1597, box 59, inv. no. 187, f. 720.

State District Archive in Olomouc [Státní okresní archiv Olomouc (SOkAO)];

Müller, Joannes. *Anfang und End der alten wie auch der unter dem Titel und Nahmen Mariae-Schnee, in dem Collegio der Gesellschaft Jesu in Olmütz neu auferbauten Kirche*, O. O. 1714. M 1–1, Sign. 1737, inv. no. 5708, internet access at http://digi.archives.cz/da/permalink?xid=06E6CCF4549E11E49A600025649FE690&scan=415c82e66c4d4941af2c23246b0de6ab&parentType=10048 (last accessed 13.05.2021)

Primary Sources

Arsenius z Radbuzy, Kašpar. *O Blahoslavené Panně Marii, přečisté Rodičce Syna Božího, a o Divích, kteříž se dějí před jejím obrazem v Staré Boleslavi.* Praha, K. Kargesius, 1613.

Arsenius z Radbuzy, Kašpar. *Pobožná Knížka O Blahoslavené Panně Marii, přečisté Rodičce Syna Božího, a o Divích, kteříž se dějí před jejím Obrazem v Staré Boleslavi*. Prague, P. Sessius, 1629.

Balbín, Bohuslav. *Diva Wartensis Origines, et Miracula Magnae Dei, Hominumque Matris Mariae quae a tot retro saeculis Wartae in limitibus Silesiae, Comitatusque Glacensis, magna populorum frequentiâ colitur. Clarissima Miraculis Libris duobus comprehensa et nunc primum in lucem edita, Impensis Reverendissimi et Amplissimi domini D. Simonis Abbatis Camencensis. Authore P. Bohuslao Aloysio Balbino è Soc. Iesu cum facultate Superiorum Pragae Formis Caesareo-Academicis, cum privilegio sac. Caes. Maj. MDCLV*.

Balbín, Bohuslav. *Epitome Historica rerum Bohemicarum; quam ob venerationem Christiannae antiquitatis, et priimae in Bohemia Collegialis Ecclesiae honorem Boleslaviensem Historiam placuit appellare. In ea, Plaeraque in Historijs nostris incerta, controversa, obscura; multa item ab aliis praeterita, summâ fide, diligentiâ, claritate et brevitate Quinque libris explicantur, et statuuntur; Adjecti sunt Libri duo (VI. et VII.) de Antiquissimo Boleslaviensis Ecclesiae Collegio; déque Origine et Miraculis Magnae DEI Matris, quae ibidem in Basilicae sua summâ Populi veneratione colitur. Authore Bohuslao Balbino è Societate Jesu. Cum Gratia et privilegio Sac: Caes: Maiestatis. Pragae, Typis Universitatis Carolo-Ferdinandeae, in Collegio Societatis Jesu,ad Sanctum Klementem, per Joannem Nicolaum Hampel factorem. Anno M.DC.LXXVII*.

Balbín, Bohuslav. *Tuřanská Madona, neboli, Historie původu a zázraků veliké matky Boha i lidí Marie, jejíž ctihodná socha, nalezená v trní blízko Brna, označená nebeským světlem, je velkými zástupy lidí uctívána, nyní poprvé důst. p. Bohuslavem Aloisem Balbínem z Tovaryšstva Ježíšova sepsaná léta 1658 s povolením představených [z latinského originálu Diva Turzanensis seu Historia originis & miraculorum magnae dei hominuque Matris Mariae a R.P. Bohuslao Aloysio Balbino conscripta . . . přeložil a poznámkami opatřil Zdeněk Drštka]*. Brno: Facta Medica, 2010.[incl. reprint of edition 1658].

Balzamo, Nicolas, Olivier Christin, and Farbrice Flückiger, eds. *L'Atlas Marianus de Wilhelm Gumppenberg. Édition et traduction*. Neuchâtel: Alphil-Presses 2015.

Bellarmino, Roberto. *Disputationum Roberti Bellarmini Politiani, S.J. S.R.E. Cardinalis De controversiis christianae fidei adversus huius temporis haereticos Quattuor tomis comprehensarum*. Venice: Joannes Malachinus, 1721.

Bellarmino, Roberto. *Nebeský Řžebřjk / To gest: Wstupowánij Mysli Lidské od Země do Nebe k Bohu Stwořiteli / po Stupnijch rozdjlných wsselikého na Swětě Stwořenij. Od Roberta Bell'armjna . . . wystawen*. Prague: Jan Bilina mladší, 1630.

Canisius, Petrus. *Beati Petri Canisii, Societatis Jesu, Epistulae et Acta*, vol. 1, edited by Otto Braunsberger. Freiburg 1896. Letter no. 174. CANISIUS SANCTO IGNATIO. Praga 15. Iulii 1555, 545–6. https://jesuitonlinelibrary.bc.edu/?a=d&d =petricanisii-01.2.2.175&e=-------en-20--1--txt-txIN------- .

Canisius. Petrus. *Beati Petri Canisii, Societatis Jesu, Epistulae et Acta*, vol. 1, edited by Otto Braunsberger, Freiburg 1896. Letter no. 175. CANISIUS SANCTO IGNATIO. Augusta Vindelicorum 3. Augusti 1555. https://jesuitonlinelibrary.bc .edu/?a=d&d=petricanisii-01.2.2.176&e=-------en-20--1--txt-txIN-------

Canisius, Petrus. *De Maria Virgine Incomparabili et dei genitrice sacrosancta libri quinque.* Ingolstadt: Sartorius, 1577. https://books.google.at/books?id=6h5--UNiwa8C&printsec=frontcover&redir_esc=y#v=onepage&q&f=false

Castulus, Georgius. *Peregrinus Mariana Bohemiae Tempe Obiens.* Prague, 1665.

Crugerius, Georgius. *Sacerrimae memoriae inclyti regni Bohemiae coronae et nobilium . . . Litomisslii: Typis J. Arnolti,* 1667. https://babel.hathitrust.org/cgi/pt?id=mdp.39015059445125&view=1up&seq=10.

Crugerius Georgius. "O lásce blahoslavené Panny Marie k Zemím české, moravské a slezské." In Bohuslav Balbín, *Přepodiwná Matka SwatoHorská Marya, W Zázracých, a Milostech swých na Hoře Swaté nad Městem Přjbrami Hor Střjbrných, den po dni wjc a wjc se stkwěgjcý,* translated by Matěj Václav Šteyer, 450–61. Litomyšl: Jan Arnolt, 1666.

Christelius, Bartholomeus. *Via Spino-Rosea. Leid- und Dornweeg /freud- und Rosensteeg Allen zu der Schmerzhaften Mutter Gottes unser Graupen Andächtigen Wahlfährten.* Prague: Urban Goliasch, 1668.

Dörffel, Frideric. *S. Maria S. Maria Culm. Das ist gründliche Historia dess Wunder Bildnus un Kirchen S. Maria zu Cul mim Königreich Böhaim,* 1651.

Gretser, Jacobus. *Jacobi Gretseri Societatis Jesu . . . de sacris et religiosis peregrinationisbus libri quattuor eiusdem de Catholicae Ecclesiae processionibus et supplicationisbus libri duo . . .* Ingolstadti: Adami Sartorii, 1606.

Konstanc Jiří. *Sucurre miseris. Svatohorská Panna Maria, Nejslavnější rodička Boží, v Čechách nad Příbrami, pravé, spasitedlné, mnohonásobně.* Prague: Outočiště, 1652.

Kvapil, Jan, ed. "Augustin Sartorius, Mariánský Atlas, Praha 1717 – koncepce barokního patiotismu vytvořená oseckými cisterciáky." *Ústecky sborník historický* (2000): 145–166.

Miller, Johannes. *Historia Mariascheinensis Das ist: Außfuehrlicher Bericht Von dem uralten und Wundertätigen Vesper-bild Der Schmerzhaften Mutter Gottes MARIA Welches zu Maria-Schein/ Unweit Graupen/ im Königreich Böheim In der Kirchen unser Lieben Frauen von etlichen HundertJahren her Zu offentlicher Verehrung vorgesteller / Und Wegen vieler Wunder – und Gnaden-Wercken sehr beruehmt ist / verfertiget von P. Joannes Miller der gesellschaft Jesu Priester in Jahre 1710 .* Alt-Stadt Prag in der Akademischen Buchdruckerey des Collegii S. J. bey St. Clement durch Joachimum Johannem Kamenitsky p.t. Factory, 1710).

Paleotti, Gabrielle. *Discourse on Sacred and Profane Images.* Introduction by Paolo Prodi. Translated by William Mc Cuaig. Los Angeles: Getty Research Institute, 2012.

Possevino, Antonio. *Antonii Possevini Societatis Jesu Tractatio de poesi et pictura ethnica, humana et fabulosa collata cum vera, honesta et sacra.* Lugduni: Apud Joannem Pillehotte, 1597. https://books.google.de/books?id=pf7NFhmASNYC&printsec=frontcover&hl=cs&source=gbs_ge_summary_r&cad=0#v=onepage&q&f=false.

Schmidl, Johannes. *Historiae Societatis Jesu Provinciae Bohemiae,* vol. 4.2. Pragae: Typis Universitatis Carolo Ferdinandeae in Collegio ad S. Clementem, 1747.

Secondary Studies

Aurenhammer, Hans. *Die Mariengnadernbilder Wiens und Niederösterreichs inder Barockzeit. Der Wandel ihrer Ikonographie und ihrer Verehrung.* Vienna: Museum für Volkskunde, 1956.

Bailey, Gauvin Alexander. "Italian Renaissance and Baroque Painting under the Jesuits and its Legacy Throughout Catholic Europe, 1565–1773." In *The Jesuits and the Arts, 1540–1773*, edited by John W. O'Malley, S. J., Gauvin Alexander Bailey, and Giovanni Sale, S. J., 123–198. Philadelphia: Saint Joseph's University Press, 2005.

Bailey, Gauvin Alexander. *Between Renaissance and Baroque. Jesuit Art in Rome (1565–1610).* Toronto: University of Toronto Press, 2003.

Balzamo, Christin, and Fabrice Fluckiger, eds. "Introduction." In *L'Atlas Marianus de Wilhelm Gumppenberg. Édition et traduction*, edited by Nicolas Olivier Christin Balzamo, et Farbrice Flückiger, 9–27. Neuchâtel: Alphil-Presses, 2015.

Bartlová, Milena. "Uměleckohistorické úvahy o vizi Arnošta z Pardubic." In *Arnošt z Pardubic (1297–1364). Osobnost – okruh – dědictví*, edited by Lenka Bobková, Ryszard Gładkiewicz, and Petr Vorel, 215–228. Wroclaw – Prague – Pardubice: Univerzita Karlova, Univerzita Pardubice 2005.

Baumgarten, Jens. *Konfession, Bild und Macht. Visualisierung als katholisches Herrschafts- und Disziplinierungskonzept in Rom und im habsburgischen Schlesien (1560–1740).* Hamburg: Dölling und Galitz, 2004.

Behrmann, Carolin. "'Le monde est une peinture.' Zu Louis Richeomes Bildtheorie im Kontext globaler Mission." In *Le monde est une peinture*, edited by Elisabeth Oy-Marra and Volker R. Remmert, 15–44. Berlin: Akademie Verlag, 2015.

Bronková, Johana. "Bellarmino - Possevino - Villalpando: dreierlei Auffassungen vom Sakralraum." In *Bohemia Jesuitica 1556–2006*, vol. 2, edited by Petronilla Cemus and Richard Cemus SJ, 1165–1180. Prague: Univerzita Karlova v Praze, Karolinum, 2010.

Cruz Gonzales, Cristina. "Landscapes of Conversion: Franciscan Politics and Sacred Objects in Late Colonial Mexico." PhD Dissertation, university, 2009.

Čornejová, Ivana. *Tovaryšstvo Ježíšovo. Jezuité v Čechách.* Prague: Hart, 2002.

de Boer, Wietse. "The Early Jesuits and the Catholic Debate about Sacred Images." In *Jesuit Image Theory*, edited by Wietse de Boer, Karl A.E. Enenkel, and Walter S. Melion, 51–73. Leiden: Brill, 2016.

Dekonick, Ralph. "Une Bibliothèque tres selective. Possevino et les arts." *Littératures Classiques* 66, no. 2 (2008): 71–80.

Dekoninck, Ralph. "Les Silènes de Gumppenberg; L'Atlas Marianus et la matière des images miraculeuses de la Vierge au regard du culte marial dans les anciens Pay-Bas." In *Marie Mondialisés. L'Atlas Marianus de Wilhelm Gumppenberg et les Topographies sacrées de l'époque moderne*, edited by Olivier Christin, Fabrice Flückiger, and Naïma Germani, 211–221. Neuchâtel: Alphill-Presses, 2014.

Delfosse, Annick. "L'Atlas Marianus, une enteprise collective." In *Marie Mondialisés. L'Atlas Marianus de Wilhelm Gumppenberg et les Topographies sacrées de l'époque moderne*, edited by Olivier Christin, Fabrice Flückiger, and Naïma Germani, 133–143. Neuchâtel: Alphill-Presses, 2014.

Deschamps, Marion. "Von Wunderthaetigen Mariaebilder. De la defense et de l'illustration des saintes images de Marie." In *Marie Mondialisés. L'Atlas Marianus de Wilhelm Gumppenberg et les Topographies sacrées de l'époque moderne*, edited by Olivier Christin, Fabrice Flückiger, and Naïma Germani, 195–209. Neuchâtel: Alphill-Presses, 2014.

Deutsch, Martin. "Obraz a kult Salus Populi Romani v náboženské politice a imaginaci brněnských jezuitů." MA thesis. Masaryk University: Brno, 2018.

Didi-Huberman, Georges. *Před časem*. Brno: Barrister a Principal, 2008.

Ditchfield, Simon. *Liturgy, Sanctity and History in Tridentine Italy. Pietro Maria Campi and the Preservation of the Particular*. Cambridge: Cambridge University Press, 2002.

Ditchfield, Simon. "Historia magistra sanctitatis. The Relationship betweeen Historiography and Hagiography in Italy after the Council of Trent." In *Nunc alia tempera, alii mores: storici e storia in eta post-tridentina*, edited by Massimo Firpo, 3–23. Florence: Olschki, 2005.

Ditchfield, Simon. "Reading Rome as a sacred landscape (1586–1635)." In *Sacred Space in Early modern Europe*, edited by William Coster, and Andrew Spicer, 167–192. Cambridge: Cambridge University Press, 2005.

Dobalová, Sylva. *Zahrady Rudolfa II. jejich vznik a vývoj*. Prague: Artefaktum, 2009.

Donnelly, J. P. "Antonio Possevino SJ as a Counter-Reformation Critic of the Arts." *Journal of the Rocky Mountain Medieval and Renasisance Association* 3 (1982): 153–164.

Ducreaux, Marie Elizabeth. "Symbolický rozměr poutě do Staré Boleslavi." *Český časopis historický* 95 (1997): 585–620.

Ducreux, Marie Elizabeth. "Několik úvah o barokní zbožnosti a o rekatolizaci Čech." *Folia historica bohemica* 22 (2006): 143–177.

Ducreux, Marie-Elisabeth. *Piété Baroque et Recatholisation en Boheme au XVIIe Siècle, in Baroque en Boheme*. Lille: Université Charles de Gaulle, 2002,

Eisenbichler, Konrad, ed. *Renaissance medievalism*. Toronto: Centre for Renaissance and Reformation Studies, 2009.

Fechtnerová, Anna. "Klementinští knihovníci od roku 1609 do roku 1773." *Miscelanea oddělení rukopisů a vzácných tisků* 2 (1986): 77–153.

Feld, Helmut. "Das Bild im Tridentinischen Katolizismus." In *Der Ikonoklasmus des Westens*, edited by Helmut Feld, 193–252. Leiden: Brill 1990.

Galewski, Dariusz. *Jezuici wobec tradycji średniowiecznej. Barokizacje kościołów w Kłodzku, Świdnicy, Jeleniej Górze i Żaganiu*. Cracow: Universitas, 2012.

Gauvin Alexander Bailey. "Italian Renaissance and Baroque Painting Under the Jesuits and Its Legacy Throughout Catholic Europe, 1565–1773." In *The Jesuits and the Arts, 1540–1773*, edited by John W. O'Malley, S. J., Gauvin Alexander Bailey, and Giovanni Sale, S.J., 123–198. Philadelphia: Saint Joseph's University Press, 2005.

Gaži, Martin, and Jarmila Hansová, *Svatyně za hradbami měst*. České Budějovice: NPÚ – ÚOP České Budějovice, 2012.

Hamburger, Jeffrey F. "Rahmenbedingungen der Marienfrömmigkeit im späten Mittelalter." In *Schöne madonnen am Rhein*, edited by Robert Suckale, 120–137. Bonn: Seeman 2009.

Hanuš, Bohumil. *Dějiny a působení jezuitského řádu kutnohorského.* Kutná Hora: Kuttna 2012.

Heal, Bridget. *The Cult of the Virgin Mary in Early Modern Germany, The Cult of the Virgin Mary in Early Modern Germany: Protestant and Catholic Piety, 1500–1648.* Cambridge: Cambridge University Press, 2016.

Hecht, Christian. *Katholische Bildertheologie im Zeitalter von Gegenreformation und Barock.* Berlin: Gebr. Mann, 1997.

Herklotz, Ingo. "'Historia Sacra' und mittelalterliche Kunst während der zweiten Hälfte des 16. Jahrhunderts in Rom." In *Baronio e l'arte.* Atti del convegno internazionale di Studi Sora 10–13 Ottobre 1984, 21–74. Sora: Romeo De Maio, 1985.

Hlaváček, Petr. "Catholics, Utraquists and Lutherans in Northwestern Bohemia, or Public Space as a Medium for Declaring Confessional Identity." In *Public Communication in European Reformation, Artistic and other Media in Central Europe 1380–1620,* edited by Milena Bartlová and Michal Šroněk, 279–297. Prague: Artefaktum, 2007.

Hlobil, Ivo. "Multiplikace Altöttinské Madony v českých zemích a na Slovensku." *Umění* 39, no. 6 (1991): 537–539.

Holubová, Markéta. *Panna Marie Svatohorská, Příspěvek k barokním vazbám jezuitské rezidence a poutního místa.* Prague: Etnologický ústav AVČR, 2015.

Horníčková, Kateřina. "Framing the Difference. Visual Strategies of Religious Identification in the Czech Utraquist Towns." In *Reformation as Communication. Reformation als Kommunikationsprozess: böhmische Kronländer – Sachsen – Mitteleuropa,* edited by Petr Hrachovec, Gerd Schwerhoff, Minfried Müller, Martina Schattkowsky, 219–236. Stuttgart: Vanderhoeck and Ruprecht, 2020.

Hrachovec, Petr. "Maria honoranda, non adoranda. Studie k poznání role obrazů a umělecké výzdoby v luteránském kostele éry konfesionalizace." In *In puncto religionis. Konfesní dimenze předbělohorské kultury Čech a Moravy,* edited by Kateřina Horníčková and Michal Šroněk, 233–251. Prague: Artefactum, 2013.

Hrachovec, Petr. *Die Zittauer und ihre Kirchen (1300–1600). Zum Wandel religiöser Stiftungen während der Reformation.* Leipzig: Leipziger Universitätsverlag, 2019.

Hrdina Jan. "Indulgentiae ad ymagines aneb 'odpustkové obrazy a sochy' v předhusitských Čechách. K funkci obrazu před husitstvím." In *In puncto religionis. Konfesní dimenze předbělohorské kultury Čech a Moravy,* edited by Kateřina Horníčková and Michal Šroněk, 87–102. Prague: Artefactum, 2013.

Hrdlička, Josef. *Víra a moc. Politika, komunikace a protireformace v předmoderním městě (Jindřichův Hradec 1590–1630).* České Budějovice: Jihočeská univerzita v Českých Budějovicích, 2013.

Hrdlička, Josef. "Public Expression of Religious Transformation in Moravian Towns (1550–1618)." In *Faces of Community in Central European Towns,* edited by Kateřina Horníčková, 211–228. Lanham: Lexington Books, 2018.

IK [Ivo Kořán], *Kostel sv. Salvátora v Klementinu, Umělecké památky Prahy – Staré město/Josefov.* Edited by Pavel Vlček, 109–114. Prague: Academia 1996.

Jeřábek, Richard. "K otázce vzniku poutních míst a jejich vlivu na život a kulturu venkovského lidu." *Český lid* 48, no. 4 (1961): 146–153.

Jurkowlaniec, Grażyna. *Epoka nowożytna wobec średniowiecza, Pamiątki przeszłości, cudowne wizerunki, dzieła sztuki.* Wrocław: Wydawnictwo Unywersitetu Wroclawskiego 2008.

Kalista, Zdeněk. *Století andělů a ďáblů. Jihočeský barok.* Prague: HaH, 1994.

Kapustka, Mateusz. ". . . *ad cujus tumulum vigilat ignis.* Jezuicka Tradycja nagrobka Arnošta z Pardubic w XVII. wieku." In *Tradice Arnošta z Pardubic v kultuře Kladska,* edited by Ryszard Gladkiewicz and František Šebek, 97–118. Wroclaw – Pardubice: Východočeské muzeum v Pardubicích, 2008.

Kocourek, Ludomír. "Der Walfahrtsort Bohosudov." In *Wallfahrten in der europäischen Kultur: Tagungsband Příbram, 26.-29. Mai 2004,* edited by Hartmut Kühne and Jan Hrdina, 501–510. Frankfurt am Main: Peter Lang, 2006.

Kořán, Ivo. "Etika miraculosy." *Umění* 43, no. 6 (1995): 501–513.

Kořán, Ivo. "Kult mariánských obrazů v předhusitských Čechách a v době Balbínově." In *Bohuslav Balbín a kultura jeho doby v Čechách. Sborník z konference Památníku národního písemnictví,* edited by Zuzana Pokorná a Martin Svatoš, 127–129. Prague: Památník národního písemnictví, 1992.

Kořán, Ivo. "Legenda a kult sv. Ivana." *Umění* 35 (1987): 219–239.

Krasny, Piotr. "New Branches of the Roman Trunk. The Issue of Early Christina Revival in CE." *Ars* 46 (2013): 134–147.

Krasny, Piotr. "*Res quibus superna Hierusalem ab ecclesia in terris peregrinate collitur*: nauka sw. Roberta Bellarmina o roli dziel sztuki w zyciu." *Folia historiae artium* 11 (2007): 43–64.

Krasny, Piotr. *Visibilia signa ad pietatem excitantes: teoria sztuki sakralnej w pismach Roberta Bellarmina, Cezarego Baroniusza, Rudolfa Hospiniana, Fryderyka Boromeusza i innych pisarzy kościelnych epoki nowożytnej.* Cracow: Uniw. Jagiellońskiego, 2010.

Kratochvíl, Miroslav. "Kolegiátní kapitula ve Staré Boleslavi: hospodářské poměry v raném novověku." MA thesis. Prague, Charles University Prague, 2014.

Kriss, Rudolf, and Lenz Rettenbeck. *Wallfahrtsorte Europas.* Munich: Hornung-Verlag, 1950.

Kroess, Alois. *Geschichte der böhmischen Provinz der Gesellschaft Jesu, vol. 2. Geschichte der ersten Kollegien in Böhmen, Mähren und Glatz von ihrer Gründung bis zu ihrer Auflösung durch die böhmischen Stände 1556–1619.* Vienna: Mayer 1927.

Kröss, Alois. *Geschichte der Böhmischen Provinz der Gesellschaft Jesu. Geschichte der ersten Kollegien in Böhmen, Mähren und Glatz. Von ihrer Gründung bis zu ihrer Auflösung durch die böhmischen Stände 1556–1619,* vol. 1. Vienna: Opitz, 1910.

Kröss, Alois. *Geschichte der Böhmischen Provinz der Gesellschaft Jesu. Die Böhmische Provinz der Gesellschaft Jesu unter Ferdinand III. (1637–1657),* vol. 2.2. Vienna: Opitz, 1938.

Kröss, Alois. *Geschichte der Böhmischen Provinz der Gesellschaft Jesu. Die Zeit von 1657 bis zur Aufhebung der Gesellschaft Jesu im Jahre 1773,* vol. 3. Olomouc: Refugium Velehrad-Roma – Prague: Česká Provincie Tovaryšstva Ježíšova, 2012.

Levy, Evonne. "Early Modern Jesuit Arts and Jesuit Visual Culture." *Journal of Jesuit Studies* 1 (2014): 66–87.

Linda, Jaromir. "Matěj Tanner (1630–1692)." In *Minulostí západočeského kraje*, 175–188. Plzeň: Západočeské nakladatelství, 1992.

LT (Lubomír Turčan). "Madona z Údlic." In *Bez hranic. Umění v Krušnohoří mezi gotikou a renesancí*, edited by Jan Klípa and Michaela Ottová, 145. Prague: Národní galerie, 2015.

LT (Lubomír Turčan). VII-13, "Sv. Jan Evangelista a Sv. Petr z Chomutova." In *Bez hranic. Umění v Krušnohoří mezi gotikou a renesancí*, edited by Jan Klípa and Michaela Ottová, 264–5. Prague: Národní galerie, 2015.

Mahr, Albin. *Wallfahrtsorte Südmährens*. Konigstein: Taunus, 1961.

Malý, Tomáš. "Civic Ritual, Space and Imagination: Coronation of the Icon from Brno (1736)." In *Ritualizing the City. Collective Performances as Aspects of Urban Construction from Constantine to Mao*, edited by Ivan Folletti and Adrien Palladino, 157–180. Rome: Viella 2017.

Maniura, Robert. *Pilgrimage to the Images in the Fifteenth century.The Origins of the Cult of Our Lady in Częstochowa*. Woodbridge, and Rochester, NY: Boydell and Brewer, 2004.

Melion, Walter Simon. "*Que lecta Canisius offert et spectata diu*: The Pictorial Images in Petrus Canisius's De Maria Virgine of 1577 /1583." In *Early Modern Eyes*, edited by Walter S. Melion and Lee Wandel Palmer, 207–266. Leiden: Brill, 2010.

Miarelli Mariani, Gaetano. Il "Cristianesimo primitivo" nella reforma cattolica e alcune inzidenze sui monumenti del passato." In *L'Architettura a Roma e in Italia (1580–1621)*, vol. 1, edited by Gianfranco Spagnesi, Arri de XXIII Congresso di Storia dell'Architettura, Roma, 1988, Rome, 1989.

Míchalová, Zdeňka, and Matěj Kruntorád, "Madona velkomeziříčská mezi reformací a restaurováním." *Umění* 67, no. 5 (2019): 440–447.

Mikeš, Jan. "The Pieta of Lásenice and the Sculpture of the Late Beautiful Style in South Bohemia." *Bulletin of the National Gallery* 18–19 (2008–2009): 21–30, 87–92.

Mikulec, Jiří. "Historische Argumentation im Konfessionellem Zeitalter, Kaiser Karl IV. und die Rekatholisierung Böhmens im 17. Jahrhundert." In *Konfessionelle Pluralität als Herausforderung. Koexistenz und Konflikt in Spätmittelalter und früher Neuzeit*, edited by Joachim Bahlcke, 477–488. Leipzig: Leipziger Universitätsverlag, 2002.

Mikulec, Jiří. "Piae confraternitates v pražské diecézi na sklonku 17. století." *Folia Historica Bohemica* 15 (1991): 269–342.

Mikulec, Jiří. *Barokní bratrstva v Čechách*. Prague: Nakladatelství Lidové Noviny, 2000.

Mindera, Karl. *Maria Hilf. Ein Beitrag zur religiösen Volkskunde*. Munich: Don Bosco, 1961.

Mlčák, Leoš. *Areál jezuitské koleje v Olomouci, in Jezuitský konvikt. Sídlo uměleckého centra Univerzity Palackého v Olomouci*. Olomouc: Univerzita Palackého, 2002.

Muir, Edward. "The Virgin on the Street-Corner: The Place of the Sacred in Italian Cities." *Religion and Culture in the Renaissance and Reformation*, edited by Stephen Ozment Kirksville, 25–40. Mo.: Sixteenth Century Publishers, 1989.

Muller, Jeffrey. *The Jesuit Strategy of Accommodation, Jesuit Image Theory*. Brill: Leiden, 2016.

Nagel, Alexander, and Christopher S. Wood. *Anachronic Renaissance*. Zone Books: New York, 2010.

Noreen, Kirsteen. "The Icon of Santa Maria Maggiore, Rome: An Image and Its Afterlife." *Renaissance Studies* 19, no. 5, Special Issue: The Biography of the Object in Late Medieval and Renaissance Italy (2005): 660–672.

O'Malley, John W., *Die ersten Jesuiten*. Würzburg: Echter Verlag, 1995.

Oberholzer, Paul S.J., "Diego Laínez come teologo del Concilio e la presenza gesuita nel concetto della sua identità." In *Immagini e Arte Sacra nel Concilio di Trento*, edited by Lydia Salviucci Insolera, 85–100. Rome: Artemide 2016.

Olds, Katrina B. *Forging the Past: Invented Histories in Counter-reformation Spain*, 2015, 2, http://web.b.ebscohost.com.proxy.uchicago.edu/ehost/ebookviewer/ebook?sid =9ab4cb9c-1701-438a-bc6c-220967a710a3%40pdc-v-sessmgr03&vid=0&format=EB

Osvald, Maria Cristina. "Goa and Jesuit Cult and Iconography before 1622." *Archivum historicum societatis Iesu* 147 (2005): 155–173.

Oy-Marra, Elisabeth, and Volker R. Remmert, "Einleitung." In *Le monde est une peinture. Jesuitische Identität und die Rolle der Bilder*, edited by Elisabeth Oy-Marra and Volker R. Remmert, 9–13. Berlin: Akademie Verlag, 2011.

Pavlíček, Martin. "Jezuitský Kostel Panny Marie Sněžné." In *Olomoucké baroko. Výtvarná kultura let 1620–1780*, vol. 2, edited by Ondřej Jakubec and Marek Perůtka, 81–84. Olomouc: Muzeum uměni Olomouc, 2010.

Remmert, Volker R. "Visuelle Strategien zur Konturierung eines jesuitischen Wissensreiches." In *Le monde est une peinture. Jesuitische Identität und die Rolle der Bilder*, edited by Elisabeth Oy-Marra and Volker R. Remmert, 85–108. Berlin: Akademie Verlag, 2011.

Richgels, Robert W. "The Pattern of Controversy in a Counter-Reformation Classic: The Controversies of Robert Bellarmine." *The Sixteenth Century Journal* 11, no. 2 (Summer 1980): 3–15, Catholic Reformation (Summer, 1980). Stable URL: https:// www.jstor.org/stable/2540028

Romano, Antonella. "Multiple Identities, Conflicting Duties and Fragmented Pictures: The Case of Jesuits." In *Le monde est une peinture. Jesuitische Identität und die Rolle der Bilder*, edited by Elisabeth Oy-Marra and Volker R. Remmert, 45–69. Berlin: Akademie Verlag, 2011.

Royt, Jan. *Obraz a kult*, 1st ed. Prague: Karolinum, 1999.

Royt, Jan. *Obraz a kult*, 2nd enlarged ed. Prague: Karolinum, 2011.

Ryneš, Václav. *Čtení o sv. Oenestinovi mučedníku. Příspěvek k dějinám české barokní zbožnosti*. Prague: Hynek Viceník, 1948.

Ryneš, Václav. *Paladium země české*. Prague: Univerzum, 1948.

Salviucci Insolera, Lydia. "Laínez e l'arte." In *Diego Laínez (1512–1565) and his generalate*, edited by Paul Oberholzer, SJ, 565–591. Rome: Instituto historico Societatis Iesu, 2015.

Salviucci Insolera, Lydia. "La formulazione del Decreto sulle immagini nei manoscritti di p. Diego Laínez." In *Immagini e Arte Sacra nel Concilio di Trento*, edited by Lydia Salviucci Insolera, 101–118. Roma: Artemide, 2016.

Samerski, Stefan. "Von der Rezeption zur Indiktronation. Die Annenbruderschaft in Olmütz (16/16. Jahrhundert)." In *Jesuitische Frömmigkeitskulturen. Konfessionelle Interaktion in Ostmittelaeuropa 1570–1700*, edited by Anna Ohlidal and Stefan Samerski, 93–118. Stuttgart: Franz Steiner, 2006.

Simon, Fabien. "*Ad maiorem Mariae gloriam*. Wilhelm Gumppenberg et Athanase Kircher, deux jésuites au service d'une Contr-Réforme mariale et savante." In *Marie mondialisée. L'Atlas Marianus de Wilhelm Gumppenberg et les topographies sacrées de l'époque moderne*, edited by Olivier Christin, Farbrice Flückiger, and Naima Ghermani, 145–162. Neuchâtel: Alphill-Presses, 2014.

Smith, Jeffrey Chipps. "The Art of Salvation in Bavaria." In *The Jesuits: Cultures, Sciences and the Arts, 1540–1773*, edited by John O'Malley et al., 568–599. Toronto: University of Toronto Press, 1999.

Sterba, Katrin, "Vom Sichtbaren zum Unsichtbaren, Vom Sichtbaren zu Unsichtbaren. Studien zur Visualisierung katholischer Dogmen in der Jesuitenkirche und Fronleichnamskapelle der Stadt Olmütz." PhD. Dissertation. Innsbruck: University of Innsbruck, 2018.

Stloukal, Karel. *Papežská politika a císařský dvůr na předělu XVI a XVII věku.* Prague: Universita Karlova, 1925.

Šroněk, Michal. "Artykulové smluvení na držení kompaktát a teorie náboženského obrazu v době pohusitské." *Umění* 58 (2010): 384–387.

Šroněk, Michal, and Kateřina Horníčková. "Prague and Bohemia during the Thirty Years War." In *Bellum et artes. Central Europe in the Thirty Years War*, edited by Claudia Brink, Susanne Jäger, and Marius Winzeler, 167–179. Leipzig: Leibniz Institute for the History and Culture of Eastern Europe and Sandstein Verlag, 2021.

Šroněk, Michal. "The Representation practises of Prague Painters Guild." In *Faces of Community in Central European Towns: Images, Symbols, and Performances, 1400–1700*, edited by Kateřina Horníčková, 149–193. Lanham: Lexington Books, 2018.

Šroněk, Michal. "Visual Culture and the Unity of Brethren." In *Public Communication in European Reformation*, edited by Milena Bartlová and Michal Šroněk, 335–370. Prague: Artefaktum, 2007.

Šroněk, Michal. *De sacris imaginibus. Patroni, malíři a obrazy předbělohorské Prahy.* Prague: Artefaktum, 2013.

Thomas, Lucas, S. J., ed. *Saints, Site and Sacred Strategy. Ignatius, Rome and Jesuit Urbanism*, Vatican: Bibliotheca Apostolica Vaticana, 1990.

Vácha, Štěpán. "Šlechtické kaple v kostele Panny Marie ve Staré Boleslavi. Oltářní výzdoba a fundace v 17. století." *Umění* 58, no. 1 (2010): 17–41.

Vocelka Karl, "Barocke Frömmigkeitsformen in Wien als Mittel der Konfessionalisierung." *Documenta Pragensia* 33 (2014): 379–402.

Vykypělová, Taťána. "Český spis *Divotvorná Marije Starodávní a častou pobožností poutníků oslavená v Tuřanech* z roku 1657 a jeho vztah k Balbínovu spisu *Diva Turzanensis*." *Wiener Slawistischer Almanach – Sonderband* 82 (2013): 277–299.

Chapter 5

Salus Populi Romani

The Roman Palladium *of the Jesuit Church in Brno*

Martin Deutsch

THE SALUS POPULI ROMANI CULT AND ITS DISSEMINATION BY THE JESUITS

To this day, the copy of the Roman miraculous painting of Our Lady of the Snows in the Brno Jesuit church is worshipped as the city's palladium (a powerful protective image). In 1573, Jesuits brought the painting from their college in Prague to support the novices in Brno. The painting is one of the first copies of the cult image of Our Lady of the Snows, also called *Salus Populi Romani*.[1] It was sent to Prague in 1571 and two years later it reached the newly established Jesuit novitiate in Brno, where it became the object of the novices' devotion during daily worship and their meditation tool during spiritual practice. In addition to catechizing young Jesuits, a function the painting fulfilled for the subsequent two centuries, it was worshipped by lay people as a miraculous palladium in times of plague or war and also served as an instrument of religious persuasion. Although Brno already had one Byzantine icon (in the Augustinian church) the Jesuit image assumed an important place in the identity of both the order and the city. It was publicly worshipped in the time of danger, that is, during the Swedish siege (1645) and Turkish incursions (1683), and plagues.

Its prototype, a Hodegetria icon (an icon depicting Mary as the Mother of God) known as *Salus Populi Romani*, was displayed since 1613 in Pope Paul V's chapel in the Santa Maria Maggiore basilica on the Esquiline Hill in Rome. It is traditionally considered one of the *acheiropoieta*, that is, "icons not made by human hands."[2] In 1577, the Jesuit theologian Peter Canisius (1521–1597) published a Mariological treatise *De Maria Virgine*

incomparabili, et Dei Genitrice Sacrosancta (in Ingolstadt in 1577) offering extensive information about the painting's origin and its copies.[3] According to Canisius, it was possible that St. Luke painted several images of the Virgin and that these were then copied. Canisius thus links the Roman painting directly with its prototype or its early medieval copies that represented the Virgin's true likeness, just like St. Luke's original.[4] In the early Middle Ages, copies of this icon and other types of images of the Virgin attributed to St. Luke were made to replace the Virgin's absent bodily relics, and in the fifth century these copies played an important role in the fight against the Nestorians, who refuted the Virgin's role as *Theotokos*, the bearer of God.[5] In 431, the Council of Ephesus condemned Nestorianism as heresy, unambiguously declaring the Virgin Mary as the Mother of God. As confirmation, Pope Sixtus III had a new Marian church built between 432 and 440 near the original fourth-century basilica of Our Lady in Rome.[6] This original church, built by Pope Liberius (352–366), is known for the miraculous event of snowfall in August, reflected in the other title of the *Salus Populi Romani* painting—Our Lady of the Snows.[7] In 1568, this story was included in the Roman breviary for the feast of Our Lady of the Snows (August 5) as part of the second round of evening prayers.[8]

The icon itself is first mentioned at the end of the sixth century in connection with the plague procession of Pope Gregory the Great (540–604) described in the Golden Legend.[9] In the following centuries, too, the icon was regarded as a miraculous protector from disasters of all kinds. Since at least the eighth century, processions were organized on the day of the Virgin's Assumption, when the icon of Christ was carried from the Sancta Sanctorum chapel in the Lateran palace to the basilica of Santa Maria Maggiore to "meet" the Mother of God.[10] From the socio-religious point of view, this was the event of the year because the presence of the pope and the *caponieri* (representatives of the Roman people) demonstrated the unity of the citizens of Rome and the church.[11] At the end of the procession, the images bowed to each other, enacting both Mary's assumption and her confirmation as the Queen of Heaven who, as *coredemptrix*, holds a significant role in the salvation of humankind.[12] This theological concept was important in the post-Tridentine Counter-Reformation policy in the sixteenth and seventeenth centuries and was strongly endorsed by the Jesuit Order.

The extraordinary reverence enjoyed by the true image of the Mother of God is evident from indulgences granted by Pope Boniface VIII (1235–1303) to all worshippers of the icon. Later, the image was venerated as an *apotropaicum* in the war against the Ottoman Turks. It was not until the sixteenth century, however, that the painting's Counter-Reformation potential was fully realized in the context of the Council of Trent. Originally placed above the so-called Porta Regina in the left aisle near the entry to what was then the

basilica's baptistry, and later on the marble tabernacle in the lefthand side of the chancel,[13] the painting was transferred to the new chapel of Paul V (pontificate 1605–1621) in 1613. This chapel had a clear Counter-Reformation iconographic agenda. In order to fully comprehend the whole narrative concept, the spectator must first stop in front of the chapel to view the fresco by Baldassare Croce above the portal, depicting the Virgin Mary's death. Inside the chapel, the miraculous image of Our Lady of the Snows is placed in the center of the lavishly adorned altarpiece, flanked by bronze angels evoking the Virgin's Assumption. The narrative culminates in the dome with the scene of the Virgin's coronation. The emphasis on these themes was clearly aimed against the Protestant theology, who condemned the cult of the Virgin and the belief in her soteriological significance.[14] The Virgin's role as coredemptrix resonates throughout the chapel—her assumption was understood as a victory over sin and death, confirming her part in human salvation.[15] Underlying the whole concept, the chapel's function as a funeral shrine for both its founder, Paul V, and his predecessor, Clement VIII (pontificate 1596–1602), further accentuates the Virgin's role as co-redemptrix.

For the Jesuit Order, Counter-Reformation renewal and re-conceptualization of the Virgin's cult (and her images) became important tools for their missionary activities and religious formation. The Virgin Mary played an important role in Jesuit history, beginning with Ignatius's spiritual conversion during his convalescence and subsequent pilgrimage to Our Lady of Montserrat in 1522:

> One night as he lay sleepless, he clearly saw the likeness of our Lady with the holy Child Jesus, and because of this vision he enjoyed an excess of consolation for a remarkably long time. He felt so great a loathsomeness for all his past life, especially for the deeds of the flesh . . . and he decided to pass one whole night in vigil consecrating his arms before the altar of Our Lady of Montserrat, where he had decided to set aside the garments he was wearing and clothe himself in the livery of Christ.[16]

The Virgin is also said to be the author of the spiritual exercises and the order's constitution: she dictated them to Ignatius, who wrote down this Christian wisdom as it was being conveyed to him.[17] The exercises and the order's constitution are therefore the embodiment of the Virgin's love for Jesuits. Just like Ignatius, whom the Virgin accompanied in the critical moments of his life, every Jesuit is advised to turn to her (and her images) on his spiritual journey. Each of Ignatius's exercises contains direct dialogues with the individual figures of the Holy Trinity and the Virgin Mary.[18] The latter is addressed as "Our Lady" and "Our Mother," suggesting that the Jesuit community's relationship with the Virgin was familiar and intimate.[19]

Ignatius advises believers to follow her and pray for her intercession, distinguishing two steps in the process: first, pleading with the Mother to intercede for him with the Son, then the Son and the Mother plead with the Father.[20] In his spiritual journal, Ignatius describes that during his prayers, and also transubstantiation, he saw and felt the Virgin as a part of Christ: "In my prayers to the Father and the Son, and during his transubstantiation, I did not see and feel anything but her, as someone who is a part of all this or a gate. . . . During the transubstantiation it became clear that her body is in the body of her Son."[21] This indivisible unity of the Virgin and Christ as seen through Ignatius's "inner eye" was best expressed in the Virgin's miraculous images, including the one discussed in this study.

In Central Europe, the most influential Mariological treatises included the aforementioned *De Maria Vergine incomparabili, et Dei Genitrice Sacrosancta* by the Jesuit Peter Canisius, advocating for the orthodox worship of the Mother of God. In the fifth part of the book, Canisius disagrees with Reformation theologians about the Virgin's miraculous apparitions before saints and church teachers. In reaction to Philip Melanchton's commentary concerning inappropriate and untrue stories about church priests viewing the Virgin's apparitions, Canisius defends these visions as breakthrough moments in the saints' lives.[22] He describes the Virgin's apparitions before Gregory of Nyssa (335–394), Basileus the Great (330–379), Martin of Tours (316–397), Popes Liberius and Gregory the Great, James the Apostle, and others, often citing from their own works. Further on, Canisius points out that the new Protestant and other churches—in his view, inventions of the devil—struggle with great persistence against both miracles and painted or carved images of the Mother of God and the saints.[23] This is an allusion to Andreas Karlstadt (1486–1541), perhaps the most fanatical among the new iconoclasts and author of *Von Abtuhung der Bylder* (On the Removal of Images, Wittenberg 1522).[24] In Canisius's opinion, Karlstadt's iconoclasm exceeds even the "rampages of the Turks."[25] Appealing to the first and second commandments, Karlstadt refuted the arguments of church authorities, condemning as idolatry any kind of devotion to the overly decorated paintings on church altars that would distract the believer from the Scripture and inner prayer.[26] In contrast, Canisius defends the cult of holy images based on the resolution of the Second Council of Nicaea, which was binding for the Tridentine decrees and which drew on Exodus and the First Book of Kings (guides for cult objects; how to build the temple for the Ark of the Covenant).[27] In further chapters, Canisius mentions church teachers and sovereigns who owned the St. Luke-attributed Madonnas or copies of them, which early Christians had sought avidly. It is said that while St. Luke made the image according to the Virgin's true appearance, the sitter imbued it with her own beauty.[28] Canisius then lists miracles connected with these

paintings as well as the Virgin's many prominent worshippers from St. Luke to Canisius himself.[29]

Canisius's meditative approach to Marian imagery is important for understanding the Jesuits' relationship to Marian images.[30] Each of the five volumes of this extensive work is prefaced by an illustration and poem by Philipp Menzelius (1546–1613), a professor of medicine in Ingolstadt. These poems interpret the illustration and simultaneously explain its connection to the following text. For example, an engraving entitled: "The most beautiful Virgin, unique among women, the only one that is at once a daughter,

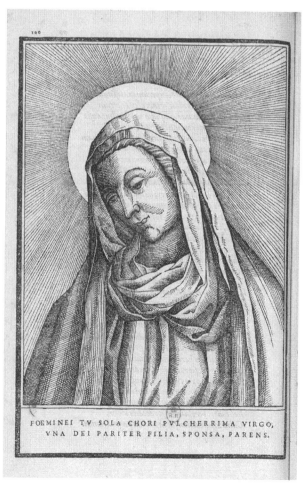

Figure 5.1 The Virgin Mary as Pulcherrima Virgo, from the book by Petrus Canisius, *De Maria Virgine Incomparabili*, copper engraving on paper, Ingolstadt 1577.

a bride, and the Mother of God"[31] [figure 5.1] is accompanied by a poem praising the Virgin's impeccable nature and describing her as the "'epitome of virginity' and the most perfect *imitatrix*, who transformed her life into an image for us to imitate."[32] In the next stanza, Menzelius shows the Marian image through the Virgin's eyes, or rather, through her experience with the mystery of incarnation. The image is meant to function as a meditation tool, a mirror in which the Virgin is represented in her multilayered relationship with Christ, allowing the viewer to take part in her self-cognition.[33] The third stanza is a warning to all heretics, demanding that they resign to truth "whose inextinguishable light emanates from this sacred page" (the page referring to the poem and the illustration, but also to Canisius's text).[34] The engraving *Pulcherrima Virgo* accompanying Menzelius's poem is related to the last chapter of the first book, where Canisius emphasizes Mary's exemplary life, her piety, virtues, and general wisdom. Based on the teachings of the Church Fathers, he also recommends that imagery be used wisely because images are truer than words in helping to grasp the events of Mary's life and the mystery of incarnation.[35] According to Canisius, the Virgin is herself the author of her images, which mirror her life of devout contemplation.[36]

Within the Jesuit Order, devotion to the Virgin was disseminated through images such as the miraculous image of Our Lady of the Snows, copies of which were sent to various places where the order was active. Jesuits had been engaged in the theological debates about the role and function of holy images since the sixteenth century and they also took part in creating the decree discussing the invocation, veneration, relics of saints, and sacred images during session 25 of the Council of Trent (December 3–4, 1563).[37] Francisco de Borja, the order's third general (1510–1572; general 1565–1572) decided to deploy the image of Our Lady of the Snows in the order's missionary and confessionalizing activities as well as in the spiritual training of future Jesuits. In 1569, the Jesuits received permission from Pope Pius V to create copies of this miraculous image. The production of the copies was supervised by Charles Borromeo (1538–1584), the archbishop of Milan and the Santa Maria Maggiore archpriest at the time, who himself had been ordained before the icon of Our Lady of the Snows.[38] The production of the first copies was limited in order to enhance the sacredness of both St. Luke's prototype and these copies. The Jesuits placed the first copy in their professed house in Rome,[39] and Jesuit General Borja gave further copies to European sovereigns such as Ferdinand II of Austria (1529–1595) and his son, Charles of Austria (1560–1618), the Spanish king, Philip II (1527–1598), and Queen Elisabeth of Austria (1554–1592).[40] These early gifts reveal the Jesuit dissemination strategy: some copies were meant for sovereigns, others for Jesuit missionaries or Jesuit colleges and probation houses. In general, however, the early copies were spread, at least in Europe, as objects for semi-private

and community-exclusive devotion and formation rather than as objects for public display. Francisco de Borja's letter to the Portuguese Queen Catherine of Austria (1507–1578) suggests that Borja saw the icon as useful for private devotion and strengthening one's faith.[41] He informs the queen about the fame associated with the icon, recommends that she place it on the altar of a private chapel, and encouraging her to deepen her devotion to the Virgin.[42] Further reproductions were sent overseas to the Americas with Jesuit missionaries such as Ignazio de Azavedo (1527–1570) and Matteo Ricci (1552–1610) to help them convert indigenous peoples.[43] As early as 1570 Peter Canisius received a copy of the icon for the Jesuit university college in Ingolstadt, Bavaria, where it became the main object of worship for two Marian sodalities (one larger and one smaller, both founded in 1577) and the elite congregation named *Colloquium Marianum*, founded in 1595.[44] The Brno copy discussed in this study was originally sent by Francisco de Borja to the novices in Prague's Clementinum college in 1571 [figure 5.2]. Further copies were then made directly in Jesuit probation houses. Between 1589 and 1595, a copy was made for the novitiate chapel of St. Matthew in the Jesuit church of St. Stephen in Cracow[45] and in 1629 the Jesuit novitiate of St. Anne in Vienna received another copy of the icon.[46] Further copies, dated to the final third of the sixteenth century, can be found in the student chapel of the pontifical university (Università Gregoriana) in Rome, in Jesuit colleges in Messina and Caltagirone in Sicily, at the Jesuit university in Pont-à-Mousson, Lorraine,[47] and in Jaroslaw, Poland (1576).[48] Over the course of the seventeenth and eighteenth centuries, the Jesuit milieu produced a number of copies of copies for pilgrimage sites and Jesuit missions and the miraculous image was also disseminated through print reproductions.

THE BRNO COPY OF OUR LADY OF THE SNOWS AND THE BEGINNINGS OF ITS CULT

The beginning of the Jesuit college in Brno dates back to 1570, when the bishop of Olomouc, Wilhelm Prusinovský of Víckov (1534–1572), invited the Austrian Jesuit preacher Alexander Höller (1536–1611) to Brno (Höller was the Brno college's rector in 1572–1578 and 1578–1580).[49] The Jesuits were not able to settle fully in Brno before 1572, however, when Emperor Maximilian (1527–1576) and Pope Gregory XIII authorized the foundation document (November 22, 1572).[50] Thanks to financial contributions from members of both church and secular aristocracy, the Jesuits were able to practice their confessionalization politics while also enlarging their college and commissioning artworks. Prominent supporters of the Brno Jesuits included Ladislav Berka of Dubá (1560–1613), cardinal and bishop of Olomouc Franz

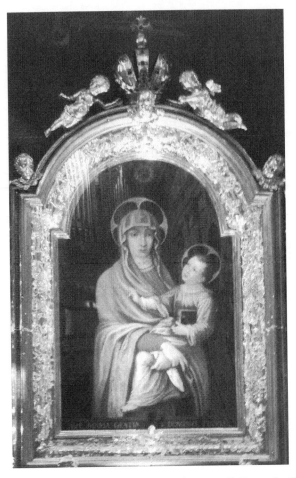

Figure 5.2 The Brno copy of the painting Salus Populi Romani, Church of the Assumption of the Virgin Mary in Brno, oil on canvas stretched on a wood panel, 1573, condition after restoration of the painting in 2019.

Dietrichstein (1570–1636), Helena of Tovar (d.1600), Maximilian II of Dietrichstein (1596–1655), Jan of Rottal (1605–1674), and Anna Francisca Leslie (1621–1685).[51]

The transfer of the novitiate from Prague to Brno in 1573 was a milestone in the history of the Brno Jesuit college. For the next two centuries, the Brno novitiate provided education and spiritual training to numerous prospective Jesuits, many of whom later set out on overseas missions, became prominent scholars or rose to high ranks in the order's hierarchy. In 1573, Brno welcomed the first group of novices from Prague, headed by Edmund Campion (1540–1581), an Englishman and future martyr, who, according to later Jesuit

sources, brought with him the copy of the miraculous icon of Our Lady of the Snows that had been sent to Prague novices in 1571 by the General Francisco de Borja.[52] The icon's *translatio* was likely performed in secret, as Brno was mostly Protestant in the late sixteenth century, and there were instances of iconoclasm.[53] The miraculous image was subject to strict protection, so it is only natural that there are no early accounts of its transfer to Brno. The first mentions of the *translatio* come from the seventeenth and eighteenth centuries, appearing in works by the Jesuit historiographers and hagiographers Daniele Bartoli (1608–1685), Bohuslav Balbín (1621–1688, prefect of the Brno Jesuit Latin sodality of the Assumption of the Virgin, 1652–1653), Johannes Miller (1650–1723, rector of the Brno college, 1715–1718), Johannes Schmidl (1693–1762), and in archival documents.[54] Schmidl writes that the novices brought the painting from Prague to Brno in 1573 and "that today (in 1747) it is surrounded by silver and precious stones on an altar that is equally precious and glowing."[55] He also describes how, in 1574, the Virgin appeared to Campion as Our Lady of the Snows in the garden of the provisional probation house in Petrov.[56] Like Canisius, Schmidl draws on Church Fathers (St. Ambrose and Abbot Rupert of Deutz, 1075–1129) when speaking about Our Lady of the Snows from Brno as a living example of devotion and religious teaching.[57] In his multivolume work on the history of the Bohemian Jesuit province, Johannes Miller writes: "The image of the Virgin made after Our Lady the Major [author's note: Majoris refers to the basilica of Santa Maria Maggiore] was commissioned by the order's third general, Francisco de Borja, who first sent it to our novitiate of St. Clement in Prague but then it was transferred to our novitiate in Brno."[58] These lines clearly show that this particular copy was made for the novitiate and was primarily supposed to serve novices.

The icon, now part of the high altar in the Jesuit church of the Assumption of the Virgin in Brno, is likely to have been placed first in the provisional Jesuit novitiate in the Grodeckys' house near the collegiate chapter of Saints Peter and Paul.[59] Precisely when the icon was transferred to its present location is unknown, but it must have been soon after 1578, when the Jesuits acquired the former Herburg monastery, immediately settling in and starting renovations of the church and monastery buildings. Archival sources show that by 1581 morning services and vespers were held in the church and a bell and two altars were consecrated there.[60] It appears that the Jesuits used the church for everyday liturgy despite its damaged condition. The miraculous image was first placed in the church and then moved to the novitiate chapel, which has yet to be localized on the defunct monastery's premises. Researchers have paid little attention to the chapel, despite the fact that plans of the monastery from the early seventeenth century, vedutae (panorama views), one university thesis, and a few period descriptions may help identify the space.

Johannes Miller describes three places in the novitiate where masses and other sacred rituals were performed: "*Caeterum intra Collegium tri loca sunt, in quibus missa dicuntur, et pietatis alia exercitia peraguntur.*"[61] The first was the oratory above the sacristy on the Epistle side of the chancel, indicated in the plans as the novices' choir (*chorus novitiorum*). The second place was the chapel "at the end of the novitiate" that contained a richly adorned altar with the painting of Our Lady of the Snows, and the third was the chapel with the altar of the Holy Cross (Miller describes it as an altar towering in a novitiate chapel, luxuriously decorated in 1716).[62] The expression "at the end of the novitiate" likely means the end of the southeast wing of the building in the college's former fourth courtyard, indicated as *sacello* on a plan from 1600.[63] This novitiate chapel may have been consecrated as early as 1580, when the Jesuits renovated three wings in the monastery's original cloisters.[64]

The Brno Jesuit college was renovated and expanded gradually, with partial modifications taking place throughout the seventeenth century.[65] A 1645 veduta of Brno by Hans Benno Beyer and Hans Jörg Zeisser captures the Jesuit college with its four courtyards and the elongated eastern wing where the novitiate chapel was probably located. The southern part clearly portrays a smaller cloister and the original monastery buildings. A later veduta (1690) by Folpert van Allen captures the monastery's southeastern side and the whole Jesuit college with the greatest clarity; the premises remained the same until the late eighteenth century, when the order was abolished.[66] Michael Elbel's Olomouc university thesis (engraved graphic sheet with official announcement of graduation, often decorated with religious or allegorical motives), created by Martin Antonín Lublinský (1636–1690), a prominent artist and thesis designer, gives further information about the chapel's location. The thesis depicts Martin Středa (1587–1649), rector of the Brno college at the time, as he floats above Brno on the last day of the Swedish siege, the day of the Assumption of the Virgin, in 1645 [figure 5.3].[67] In addition to this central motif, Středa also appears in one of the medallions depicting the miraculous image of Our Lady of the Snows; the lower part of the medallion shows him kneeling before the altar with a crucifix standing on the mensa.[68] This scene likely takes place in the southeast cloister of the fourth courtyard, evident from the cloister wing adjoining the church's apse that is visible in the background. This may be the only existing iconographic source depicting the college's fourth courtyard and the southeast wing of the novitiate where the novitiate chapel is presumed to have been located.

Středa's depiction also illustrates the role the image played in the Jesuits' emotional and spiritual life. In what are almost hagiographic accounts, the authors of Středa's biographies often portray him as exemplary, virtuous, and pious, that is, in a way corresponding with the depiction in Elbel's university thesis work.[69] According to records in the college chronicle, Středa spent

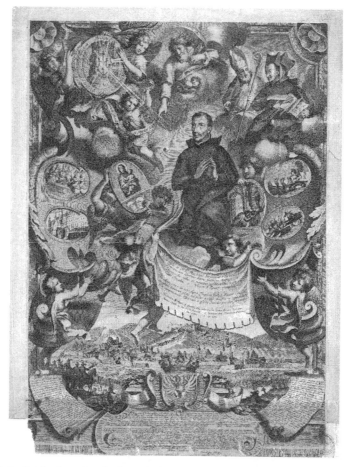

Figure 5.3 P. Martinus Stredonius adoring the Salus Populi Romani, from the university thesis of Michael Elbel, copper engraving on paper by Martin Antonín Lublinský, Olomouc 1689.

the last five years of his life praying for a good death every night before the painting of Our Lady of the Snows: "in his last five years, preparing for approaching death, he would kneel before the image of Our Lady every night, immersed in meditation."[70] On another depiction, the university thesis of Lorenz Bontzer of 1686, who studied at the Jesuit university in Olomouc, the designer Martin A. Lublinský was inspired by a quote from Ecclesiasticus (Eccl 24,24) and depicted the image of Salus populi Romani as the source of divine love, hope, awe, and knowledge [figure 5.4].

No sixteenth-century records survive of what the altar holding the miraculous painting looked like. A 1651 record in the college chronicle mentions a gift of 130 guldens for the new altar for the "ancient icon of the Virgin Mary,"

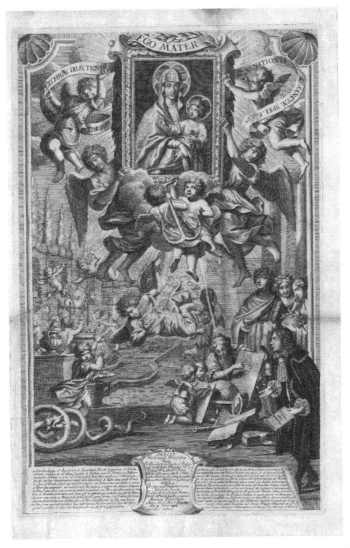

Figure 5.4 **Salus Populi Romani as a protector against sin and the patron of Lorenz Bontzer, from the university thesis of Lorenz Bontzer, engraving paper by Leonhard Hackenauer after a design by Martin Antonín Lublinský, 1686.**

donated to the novitiate by Francisco de Borja "more than seventy years ago."[71] The new altar in the novitiate is mentioned again in 1692, this time in the rector's journals. This altar, consecrated in accordance with its titular dedication on the feast of Nativity of the Virgin, was commissioned by Anton Franz Collalto, a North Italian aristocrat who owned extensive property in Moravia.[72] A depiction of the altar likely appears in the Prague university thesis of Ignatius

Ossendorff from 1698, showing a lavishly decorated acanthus altarpiece with the miraculous image of Our Lady of the Snows in the middle surrounded by sculptures of putti and angels [figure 5.5]. The Brno copy of the miraculous icon features two significant iconographic details, both of which are visible in the thesis work: cruciform halos on both the Virgin and Christ and the opening words of the *Ave Maria* prayer in the bottom part of the painting. Any later copies (such as that in the Jesuit church of Our Lady of the Snows in Olomouc) containing these iconographic elements are certain to have reproduced the Brno version rather than the Roman original. The altar depicted in Ossendorff's thesis can therefore be associated with the Brno novitiate and its miraculous icon.

The altarpiece features an inscription in the medallion above the painting referring to the Virgin as the throne of wisdom, crowned teacher of teachers (i.e., the Jesuits), Our Lady of the Snows, and the Thrice-Admirable Mother: "*Sedi Sapientiae incoronata Magistrorum Magistrae Lilio Super Nivem Candido Virgini Matri Ter Admirabili Mariae Majori ad Nives irriguo Fonti gratiorum.*" The Virgin as the highest teacher is a direct reference to the novitiate milieu and the education of young Jesuits. The two putti in the lower part display medallions featuring Solomon's throne (left) and a lily (right). The throne symbolizes the Virgin's wisdom and the lily her innocence—both mentioned in the line from the twelfth chapter of Luke cited in the inscription band carried by four putti: "not even Solomon in all his splendor was dressed like one of these."[73] Roses, forget-me-nots, and pomegranates depicted among the acanthus leafwork on the altar also refer to Mary's innocence and purity based on the symbolism in the Old Testament Song of Songs. Pomegranates allude to the original sin of Adam and Eve which, the church teaches, was expiated by the Virgin Mary as the second Eve when she conceived the Savior unblemished by sin. While the cruciform halos in the thesis depiction are associated with the Brno copy of the miraculous Our Lady of the Snows, the title *Mater ter admirabilis* in the medallion is connected with the Ingolstadt copy that Peter Canisius acquired in 1570. After 1595, this copy was the primary subject of worship for the elite Marian congregation named *Colloquium Marianum*, which shaped the main figures of Bavarian Catholicism and the Counter-Reformation.[74] The title is tied to the litany prayers during which worshippers repeated three times the invocation *Mater Admirabilis.*[75] Jacob Rem (1546–1618), a Jesuit and the congregation's founder, made this manner of praying mandatory after he fell into a trance during the litany prayers before the image of Our Lady of the Snows and only regained consciousness after having uttered the *Mater Admirabilis* invocation. In Rem's view, the Virgin was particularly fond of this invocation.[76] Ossendorff's university thesis is therefore quite valuable for the questions addressed here: (1) it captures the appearance of the altarpiece of Our Lady of the Snows in the Brno Jesuit novitiate at the end of the seventeenth century; (2) it connects two places

where the icon was worshipped, that is, the Brno and Ingolstadt colleges; and (3) it reflects religious practices associated with both copies of the cult image.

Ossendorff's thesis is interesting for yet another reason. The lower part of the icon features a gilded relief inscription from the turn of the 1680s quoting the opening words of the *Ave Maria.* This relief once covered the same, older, inscription at the bottom part of the icon.[77] Between 1705 and 1708, the Jesuits added a decorative silver cover inlaid with precious stones, which was used until 1957.[78] The cover has been lost, but a photograph from the 1940s

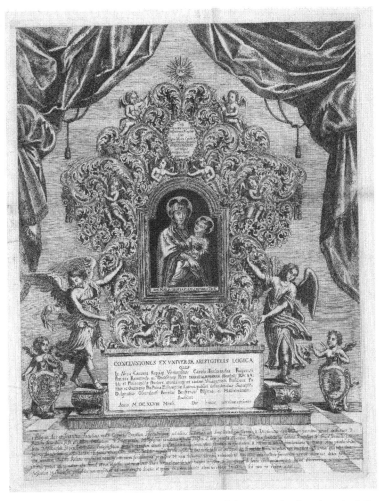

Figure 5.5 Depiction of the altar of Our Lady of the Snow in the chapel of the novices in the Jesuit novitiate and college in Brno, from the university thesis of Ignatius Ossendorff, copper engraving on paper, Charles-Ferdinand Univerzity, Prague 1698.

captures its appearance as corresponding with the 1747 description by the historiographer Schmidl [figure 5.6]. The date of 1680 is further confirmed by Ossendorff's 1698 work, where the gilded relief inscription is clearly visible.

Decorating holy images was seen as important by church authorities such as Gabriele Paleotti (1522–1597) and Charles Borromeo (1538–1584). Gold, silver, and precious stones emphasized the holiness, uniqueness, and miraculous power of these cult images.[79] The reference to the angelic greeting *Hail Mary* was meant to fuel imaginative meditation about the mystery of the Virgin's annunciation and the incarnation of Christ. The silver mount adorned with climbing rose motifs surrounding the Virgin and Christ could also open a number of catechizing and contemplative themes concerning the Virgin's purity and Christ's sacrifice. The painting's Roman prototype in the chapel of Paul V was also "clothed" in a decorative covering which, according to the celebratory speech given on the occasion of the icon's 1613 transfer to the chapel, represented the heavenly throne holding the Virgin as the Queen of Heaven.[80] The Brno copy of the icon also contains this allusion to the Virgin's heavenly throne or heavenly Jerusalem.

THE CULT OF MARIAN IMAGES IN THE BRNO JESUITS' RELIGIOUS PRACTICE AND IMAGINATION

The Jesuit constitution and school regulations (*Ratio studiorum*) required Jesuit colleges to establish student sodalities dedicated to the Virgin. The various forms and aspects of Marian worship in the Brno college can be studied from printed religious guidebooks and the sodalities' regulations, pilgrimage booklets, and also archival documents such as annual reports, rectors' journals, and college chronicles. Sodality members and novices were personally consecrated to the Virgin, as is evident from a consecration text in *Manuale Congregationis*, a 1617 booklet published by the Brno sodality of the Assumption of the Virgin (the larger Latin student sodality),[81] and a remarkably well-preserved sheet of paper discovered during the restoration on the reverse side of the Brno copy of Our Lady of the Snows.[82] Dated to 1680, this sheet contains the consecration prayer of Georgius Aloisius Firmus, the novice master at the time, to the Virgin Mary, queen of heaven and earth, immaculate and most gracious Mother of God. Firmus invokes the Virgin to protect the novices' hearts so that they will persevere and flourish in their calling. It is therefore quite certain that the consecration ritual took place in the novitiate chapel in front of the image of Our Lady of the Snows. This also shows that this image was perceived as miraculous or "grace giving," an attribute that appears in devotional prints on the frontispiece of the manual for Brno novices entitled *Usus meditandi tyronibus* (Prague 1665) [figure 5.7].[83]

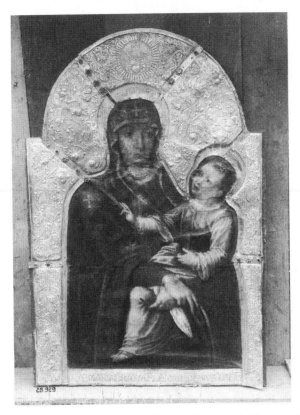

Figure 5.6 Silver cover on the image Salus Populi Romani (documentation photograph).

In addition to *Manuale Congregationis,* the student sodality of the Assumption of the Virgin published other manuals that encouraged believers to worship sacred images in general, without special reference to the image of Our Lady of the Snows. *Sodalis Marianus* (1653) was written by the prominent Jesuit historiographer and hagiographer Bohuslav Balbín (1621–1688), who was involved in the Brno novitiate's activities, and *Fons vitae sive acquae salientis* (1658) was authored by the student sodality prefect Johann Weyer (1598–1675, prefect 1658–1660).[84] These manuals are instructional in character and accentuate Marian devotion, prescribed primarily for Saturday. Some of them explicitly refer to the Tridentine decrees, including one regarding the veneration of saints and images of Christ and the Mother of God: "*Firmisime assero imagines Christi ac Deiparae semper, nec non aliorum Sanctorum habendas et retinendas esse, atque eis debitum honorem ac venerationem impertiendam.*"[85] Balbín's *Sodalis Marianus* includes a breviary, recommendations for prayers and meditations according to the liturgical

calendar, hours of the Virgin, hours for the deceased, guardian angel hours, and little hours for the Immaculate Conception of the Virgin.[86] There are also chapters about the annual, monthly, weekly, and daily habits and rituals of a Marian sodality member. Balbín does not specifically mention the icon of Our Lady of the Snows, but gives general recommendations concerning the veneration of images in the novitiate during all Marian feasts, especially the feast of the Assumption of the Virgin.[87] Both the Jesuit church and the college featured a number of other images of the Virgin, such as the Madonna sculpture on the facade of the church (Virgil Spazio 1593, now in the niche of the church tower above the main entrance), the Madonna of Foy (first mentioned in 1624), the sculpture of Our Lady of Sorrows (1649), another painting of Our Lady of the Snows in the novitiate (1656), and the painting of Our Lady of Piekary (1693, now on the altar of Our Lady of Piekary in the church's north aisle).

While sodality members gathered during services near their altars in the church or in the lyceum building, novices used their own chapel with the altar of Our Lady of the Snows. In addition to daily mass, rosary prayers, litanies, and hours, the novices' two-year formation included a four-week period of spiritual exercises, caring for the sick, and making pilgrimages. Ignatius's exercises, the core spiritual practice for the Jesuits, challenged the novice to examine his conscience, distinguish between the good and bad spirit, and unconditionally follow Christ in order to unite with God. Based on imagination and the use of all of the senses, these exercises drew from the life of St. Ignatius of Loyola, which was filled with mystical experiences and visions. The final chapter of Ignatius's treatise contains exercises ordering practitioners to praise the adornments in the church setting, venerate images, and worship saints and their relics, although it does not specifically recommend using visual media during meditation nor offer a list of suitable meditation topics. The imaginative character of the exercises, however, became the foundation for the Jesuit concept of the internal image. Jesuit commentators on Ignatius's spiritual approach recommended artworks in meditation practice as tools for activating mental images and stimulating memory. The Jesuit Bartolomeo Ricci (1542–1613) writes about the collection of images that Ignatius of Loyola used to prepare for meditation: "Whenever he was going to meditate on those mysteries of Our Savior, shortly before his prayer he looked at the pictures that he had collected and displayed around his room for this purpose."[88] Francisco de Borja also believed that visual depictions of stories from the Gospels are highly beneficial for meditation.[89] Shortly before his death in 1556, Ignatius of Loyola entrusted the Jesuit Jerónimo Nadal with the task of composing *Evangelicae historiae imagines* (Antwerp 1593), an illustrated book for Jesuit novices.[90] This illustrated publication was meant as a tool for contemplation, which shows the importance images played in Jesuit

spirituality.[91] Here, the visual approach to meditation practice is evident from the way images and texts are arranged in relation to one another; the illustrations contain marks along the base referring to the textual part, entitled *Adnotationes et Meditationes in Evangelia* (Antwerp 1595), which consists of meditative texts, interpretation, and commentaries on Gospel scenes. The meditator could thus easily skip from the illustrations to the corresponding texts and the other way round. The same arrangement can be found in emblematic manuals by Flemish Jesuits such as Johannes David (1545–1613) and Antoine Sucquet (1574–1627).

Spiritual exercises in the Brno novices' chapel were recorded in the college chronicle and rector's journals.[92] The Virgin was seen as an intercessor and protector of the novice's heart during the spiritual exercises. The miraculous image of Our Lady of the Snows offered not only a contemplative mirror reflecting all the Virgin's virtues but also the experience of true maternal love through the relationship of the Mother and the Son. This was clearly an important theme for Jesuits; Peter Canisius writes about the Virgins desire to become the Mother of the Savior and Bohuslav Balbín, in his pilgrimage manual *Diva Turzanensis* (Olomouc 1658), describes the Virgin's love for her soon-to-be-born Son as follows:

> The Blessed Virgin rejoices as she is both the Virgin and the Mother of God: she loves, and her love surpasses the love of all seraphs and cherubs; she is thankful for her task; she is humble and in her humility she calls herself and offers herself as God's servant; she bows to the majesty of embodied Word; she desires to see Christ, who will soon be born, and take care of him as a mother should, in the name of all humankind.[93]

The college housed a number of other images of the Virgin, attesting to the need for intense contact with the Virgin's maternal presence. This experience of "true presence" was further enhanced by relics (a lock of hair) kept in the novitiate chapel. As part of the Octaves during Marian feasts and vigils, the novices would kiss the Virgin's reliquary with the hair: "at eight there was litany in the church, then preparation for the examination of conscience with the ministers in the novitiate; prayer was followed by litany and kissing the Virgin's relics, then rest."[94] It has yet to be determined whether the reliquary was originally fixed to the miraculous image of Our Lady of the Snows or not.

Religious practices in the Brno novitiate can also be studied from the instructions for the members of the order.[95] This is a valuable source which gives the best insight into the religious life inside the novitiate. In addition to many practical instructions for the novices concerning the care for altars, windows, chandeliers, garments, and the image of Our Lady of the Snows, this

booklet contains a schedule for an eight-day cycle of daily spiritual exercises that includes recommended readings and references to particular passages. For example, the second day of the cycle is dedicated to the Virgin and four contemplation themes are recommended: (1) the angels' Fall and Adam's sin, (2) one's own sin, (3) pride, (4) greed. At the same time, it is recommended that the novice read "On Contrition of the Heart" from Thomas à Kempis's *The Imitation of Christ*.[96] In the state of contrition of heart, one becomes aware of one's sinful nature and unburdens one's conscience by leading an ascetic and God-fearing life. The goal of this exercise is to examine one's conscience, recognize one's sins, and repent. The Virgin, as an intercessor before God the Father and the Son, is one's "companion" and protector on this journey.

In addition to Kempis, the Jesuits also used emblematic books in their meditative and catechizing practices, such as the *Paradisus sponsi et sponsae* and *Pancarpium Marianum* (Antwerp 1607) by Johannes David.[97] *Pancarpium Marianum* is especially important for studying the way the Virgin was perceived at the time because it uses the Old Testament typology to reflect on the multilayered relationship between Christ and the Virgin (bridegroom and bride, God and man), flooding the reader with images of the Virgin's blessings and virtues. The engraving entitled *Sancta Dei Genitrix* (Holy Mother, Bearer of God) [figure5.8] is a typical example of this rich symbolism. It depicts Christ in the manger with the Virgin, two angels, and Joseph (letters B, A) with a fountain (D), and a mirror (C) in the upper part of the image. A fountain or well symbolizes the source of life and salvation referring to the Virgin or Christ's sacrifice and the mirror is a symbol of Mary's wisdom. In both cases, these are Old Testament types: "On that day a fountain will be opened to the house of David and the inhabitants of Jerusalem, to cleanse them from sin and impurity . . . For she is the reflection of eternal light, the spotless mirror of the power of God, the image of his goodness."[98] Another illustration, entitled *Mater Pulchrae Dilectionis*, shows the Virgin kneeling by the bed where her Son sleeps among roses, forget-me-nots, myrtle, and peonies [figure 5.9]. In the top part, the royal bride kneels before King Solomon's throne as an allusion to the Song of Songs and the relationship between Christ and the Virgin (C). In contrast, selfish love (between men and women, believers and God) is represented as Amnon, who feigned illness in order to seduce his half-brother Absalom's sister Tamar (D).[99] Created by the Galle brothers (Theodor, 1571–1633, Cornelius, 1576–1650), the book's engravings provide an array of themes that were highly useful in combination with the visual and spiritual contact with the altarpiece of Our Lady of the Snows in the novitiate chapel. Through Old Testament motifs, these images opened the path to multilayered perception of the Virgin and her life.

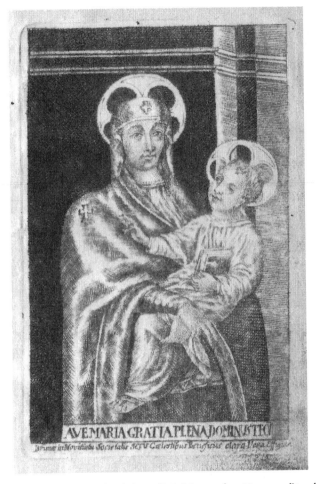

Figure 5.7 Front page of the book by Mikołaj Łęczycky, *Usus meditandi tyronibus,* copper engraving on paper, Prague 1739.

The novices' everyday religious practice included prayers such as the rosary, hours, and litanies. The *Ave Maria* prayer, quoted in the gilded relief inscription on the icon of Our Lady of the Snows, was often repeated as part of this practice. Moreover, the *Ave Maria* concludes many of the contemplative exercises and Marian prayers practiced in the novitiate. In combination with the angelic salutation, the miraculous image of Our Lady of the Snows inspired the novices to contemplate Christ's dual nature, accentuating both the human and divine essence of Christ. In the *Diva Turzanensis,* the pilgrimage manual written by Bohuslav Balbín for novices traveling to the Madonna

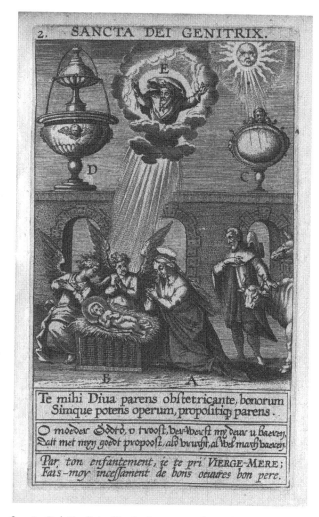

Figure 5.8 *Sancta Dei Genitrix*, illustration no. 2, from the book by Johannes David, *Pancarpium Marianum*, copper engraving on paper by Theodor and Cornelius Galle, Antverps 1607.

of Tuřany, a site close to Brno, the prayers recommended on this occasion include contemplation of the Virgin's virtues and blessings as they became apparent during the annunciation:

1. The Virgin's eternal "chosenness" to become the Blessed Mother;
2. The immaculate conception in full grace;
3. The incarnation in the virginal womb, virginal birth and nurturing;

4. Joys that the Blessed Virgin felt upon the resurrection and ascension of her Son and upon the descent of the Holy Spirit;
5. Her assumption and celebration above all angelic choirs.[100]

The novices may have "experienced" these virtues and blessings as if emanating from the painting. Christ's virginal conception is accentuated by the white scarf and the angelic salutation *Ave Maria* opening the dialogue

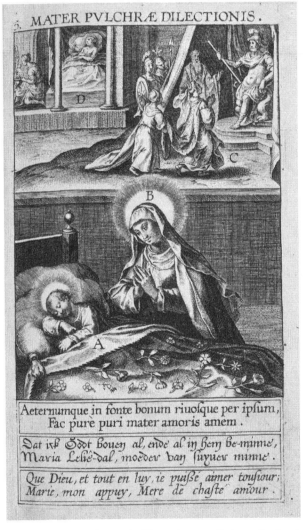

Figure 5.9 *Mater Pulchrae Dilectionis*, illustration no. 5, from the book by Johannes David, *Pancarpium Marianum*, copper engraving on paper by Theodor and Cornelius Galle, Antverps 1607.

between the Archangel Gabriel and the Virgin: "'How will this be,' Mary asked the angel, 'since I am a virgin?' The angel answered, 'The Holy Spirit will come to you, and the power of the Most High will overshadow you.'"[101] The reliefs of thorns on the icon's silver cover and rose blossoms among the acanthus leaves on the altarpiece in the novitiate chapel also referred to the Virgin's innocence and purity. As a reference to the Virgin's assumption and coronation, the altarpiece featured two angel figures "transporting" Mary's intact body to heaven and two putti crowning the "image." Further suitable themes for contemplation during all liturgical feasts in the year appear in the manual for Brno novices mentioned above, *Usus meditandi tyronibus*, by the Lithuanian Jesuit Mikołaj Łęczycki (1574–1653) [figure 5.7]. On the feast of the Assumption of the Virgin, it was recommended that novices contemplate the Virgin's pious and exemplary death, the presence of the apostles in her final hour, and the subsequent assumption of both her soul and her intact body directly to heaven without the obstacle of purgatory.[102] Balbín's *Diva Turzanensis* also exhorts the novices to commit to intense Marian worship. The chapter on "rituals for the feast of the assumption of the blessed Virgin" says the following:

> Day 1: From this moment I will love you, O sweet Mother, who is loved by many in heaven and on earth. Day 2: From this moment I will serve you like I have never served you before, O Mother, Mistress, Queen . . . Day 4: From this moment I will cling unto you; I, who am exposed to a great many enemies; I, who in God's righteousness have been made to humbly beg for forgiveness. Are you not the refuge of the wretched? . . . And just as on earth, where nothing is denied to one who comes with a plea on the anniversary of the great benefaction, so the Blessed Virgin will not deny anything today. And so contemplation will help you gain everything you ask for or find everything that you lack.[103]

Further on, Balbín reminds readers that this is also the day when the Jesuit Order was born, when the first Jesuits took their vows at Montmartre in Paris.[104] On the day of the Assumption of the Virgin in 1646, the novitiate chapel was the site of forty-hour and hundred-hour prayers for the Czech Jesuit province and its "Brno home." These rites were repeated in the following years in front of the Jesuit church's high altar, along with fifteen-hour votive prayers for victory over the Swedes.[105]

On the feast of Our Lady of the Snows, traditionally celebrated on August 5, the novices performed morning sung masses, catechism, and vespers.[106] On those days, the liturgy was enriched with "church and spiritual songs" from the book *Marianische Kirchfahrt* (Kłodzko 1682), written by the Jesuit Johann Dilatus (1628–1689).[107] The chapters in this book concerning the pilgrimage to nearby Tuřany are complemented with hymnographic texts for

each of the Marian feasts. A poem for the feast of Our Lady of the Snow refers to the original miracle of snow on the Esquiline Hill in Rome and the building of the Marian church: "If you want to know / how to spend your money / get up and go to Esquiline Hill. Where there was once snow / is now a ground plan of a church / bury your treasure there / on that wide church square."[108] Dilatus compares the miraculous August snow to the dew on Gideon's fleece, God's sign from the Old Testament Book of Judges: "Gideon! What you desired / was given to you twice by God / the dew collected on the fleece, leaving the ground dry. And the next time the ground was wet and your fleece remained dry."[109] The Esquiline miracle was also depicted in the 1737 fresco on the vault of the novitiate chapel, which unfortunately perished without any descriptions of its iconography.[110]

Jesuit sources record a number of mystical experiences and miraculous recoveries in connection with the Brno icon of Our Lady of the Snow. The first such event occurred in 1574, when Our Lady of the Snows appeared to Edmund Campion in the garden of the provisional novitiate at Petrov. The Virgin was dressed in red, a portent of Campion's martyrdom in England.[111] Of the many instances of the icon's miraculous aid, we cite the following story:

A novice, who could not decide what career to choose, became suddenly ill and doctors thought he could no longer be helped. The novice feared the flames of purgatory because he had read about Denis the Carthusian and his purgatory experience and he thought that his entry into the novitiate would not suffice to free him from sin and make him repent. He therefore sought solace with Our Lady of Mercy, who appeared to him in the form of the painting of Our Lady of the Snows. The Virgin was followed by two saint Virgins (or angels) and one Jesuit priest. The Virgin ordered the priest to sit at the table and get his paper and ink ready for writing. The boy was then lifted up in his bed to those who graciously came to his assistance. The Virgin asked the boy what his name was and when he responded fearlessly, she ordered the Jesuit priest to write the boy's name in the book. This filled the novice with unspeakable joy. He prayed the Ave Maria and later on, when he came to his senses, he was told to keep his vision secret. After that, the Virgin and her entourage disappeared. The novice recovered from his illness and went on to study theology and philosophy, growing so fond of the Jesuit order that he decided to stay and become a Jesuit. Thanks to his vision, he became the order's exemplary servant and a model of obedience and humility for other novices.[112]

This story contains salient analogies with the Jesuit exercises concerning life choices and self-cognition recommended for the first and the last week of the practice. The motif of miraculous apparition during illness can be seen as a sudden epiphany parallel to the conversion of Ignatius of Loyola in his

convalescence period. The moment when the novice's name is inscribed in the book correlates with the ritual of consecration to the Virgin upon entry into the novitiate or sodality, during which the new member's name is entered in a membership album.

Although it may appear that the Brno icon only served the insular novice community, this cult image was in fact widely popular because, as an apotropaic object, it was often displayed on the high altar of the Jesuit church. Its numerous damaged spots suggest that it was accessible to believers, who affixed votive gifts to it.[113] Johannes Miller (rector of the Brno college 1716–1718) writes that the miraculous image of Our Lady of the Snows had its regular place in the novitiate chapel, but whenever needed, it was transferred to the high altar of the Jesuit church: "In difficult times, [the icon] was displayed on the high altar as a refuge and solace for sinners."[114] By "difficult times" Miller likely means plague (1571, 1584, 1632, 1645, 1679, 1710) and war (the Swedish siege in 1645 and Turkish raids in 1566, 1593, 1599, 1623, 1683). During the Swedish siege, Brno inhabitants pinned their hopes on the Virgin, whose true face they believed was captured in St. Luke's miraculous images: Our Lady of St. Thomas in the Augustinian church and Our Lady of the Snows in the Jesuit church.[115] The image of Our Lady of the Snows was probably available for public worship during the Turkish siege of Vienna in 1683. There is also a document attesting to its being displayed publicly on the occasion of the visit of the Bavarian Elector Maximilian Emmanuel (1662–1726), the victor over the Turks: "His Highness the Bavarian Elector, the commander of Catholic troops, visited us. At first he briefly and politely greeted the students and then he was present at the mass in the church. There, the painting of the Virgin given to the novices by Francisco de Borja was displayed on the high altar."[116] The icon was placed on the church altar once again in 1710, when the plague started spreading from Hungary to Moravia.[117] It was also displayed regularly during important feasts and celebrations. One such celebration took place during Francisco de Borja's canonization on the Octave from August 9, 1671: "The altar was adorned with resplendent sanctuary displaying the image of Our Lady of the Snows, created from the prototype in Rome."[118] This celebration was held in the presence of the hetman of the Moravian province, Franz Karl of Kolowrat-Liebsteinsky (1620–1700; Hetman 1667–1700), Augustinian and Premonstratensian prelates, and all the Jesuit sodalities including the Tuřany brotherhood of St. Isidore. All the participants received Borja's biography and prints depicting the new saint with the miraculous image of Our Lady of the Snows.

Several archival records show that important visitors sometimes came to honor the miraculous icon in the novitiate chapel. In 1675, Eleonore of Austria, queen of Poland (1653–1697, queen 1670–1673), visited the Brno novitiate, and her first steps led to the novitiate chapel: "her carriage stopped near the closest

bedrooms, where she briefly greeted and beckoned the present novices, pro-
ceeding to the novitiate, where the much-worshipped holy icon from Francisco
de Borja is kept, and on to the refectory to watch a short school play about the
Guardian Angel."[119] Between 1696 and 1698, other rulers and both secular and
church aristocrats visited the miraculous icon in the novitiate chapel, such as the
highest Imperial Hofmeister Ferdinand Josef Dittrichstein (1636–1698), com-
mander of the Spilberk city fortress Philip Christopher Breüner (1641–1710),
the Polish queen-widow Marie Casimire d'Arquien (1641–1716), and Moravian
Provincial hetman Franz Karl of Kolowrat-Liebsteinsky.[120]

In all likelihood, the painting of Our Lady of the Snows also served as a
confessionalization tool. The Brno Jesuits used their church for conversions
of non-Catholics and the cult paintings of the Virgin and Jesuit saints in the
church may have served during instruction in the Catholic faith and for refut-
ing reform teachings. The Jesuits had an effective way of using copies of
these images during their missions and activities in the parishes around Brno
that they administered.[121] The Brno Jesuits succeeded in converting a number
of prominent aristocratic heretics[122] and also Turks, Jews, convicts, and pros-
titutes. In some cases, sources explicitly mention the role of Marian images in
these conversions. For example, a brief record in the college chronicle from
1680 tells the story of a woman who decided to convert to Catholicism when
she saw an image of the Virgin in the Jesuit church.[123]

The Brno *Salus populi Romani* image, however, had to share popularity
with another St. Luke image—the icon of the Madonna of St. Thomas, origi-
nally kept in the Marian chapel of the local Augustinian monastery.[124] This
ancient Hodegetria-type icon came to Brno as a gift from Emperor Charles IV
(1316–1378) to his brother John Henry of Luxembourg (1322–1375) when the
monastery church of St. Thomas in Brno was consecrated in 1356. This paint-
ing was worshipped as the miraculous apotropaic image that had protected
the city from various diseases, plague epidemics, Turkish expansion, and
Swedish and Prussian sieges. The Madonna of St. Thomas, sometimes called
the Thaumaturga of Brno, was carried in processions during the feast of the
Assumption of the Virgin in commemoration of the victory over the Swedes
(held annually from 1645 onward) and during plague epidemics (in 1679 and
1713).[125] Unlike the image of Our Lady of the Snows, the Madonna of St.
Thomas received a major honor, namely, a canonical coronation performed
by the bishop of Olomouc, Wolfgang Hannibal Schrattenbach (1660–1738),
on May 10, 1736. Next to the Madonna of Svatá Hora and Madonna of Svatý
Kopeček, the Madonna of St. Thomas became the third miraculous image
in the Czech lands to receive an official canonical coronation, which signifi-
cantly enhanced its value as a cult object.[126] The coronation ritual offered the
city and church officials (Augustinians in particular) an opportunity to show
off their splendor and publicly manifest the city's self-identification with the

cult of this image.[127] Following the Battle of White Mountain (1620), both the Madonna of St. Thomas and Our Lady of the Snows were objects of systematic parallel veneration, and rather than being rivals,[128] they complemented each other, differing in their functions, public accessibility, and the social interactions associated with them.

Analyzing the perception of religious practices around the Brno copy of Our Lady of the Snows leads to a better understanding of the role images and the cult of the Virgin Mary played in the Jesuit milieu. Like the Cracow and Vienna copies of this icon, the Brno version was primarily meant to serve Jesuit novices, for whom the Virgin was the main intercessor and protector during their religious formation, a demanding period of spiritual exercises, renunciation, self-examination, pilgrimages, and caring for the sick. The image was systematically venerated by prospective Jesuits in their novitiate chapel, offering them intimate contact with the Virgin and Christ and opening the mysteries of Mary's life for them. This was further accentuated in the iconography of the new Marian altarpiece in the chapel (1692), depicted in the university thesis of Ignatius Ossendorff from 1698. The miraculous image was a perfect meditative mirror reflecting the story of Mary's contemplative life filled with determination to follow God's will. It also served as a catechizing and didactic tool, explicitly referring to the dogma and teachings about the Virgin Mary and reminding the novices to perform their daily Marian rites. As the Virgin's "true likeness," the image was the object of novices' mystical visions. Unlike the Madonna of St. Thomas, owned by the Brno Augustinians, Our Lady of the Snows was not carried in processions (so far we know from the sources), but it had a considerable socio-religious impact as it was often displayed on the high altar of the Jesuit church and publicly worshipped during plagues, wars, feasts, and celebrations, and visits of ecclesiastic and secular aristocrats. These public displays also helped Jesuits convert non-Catholics, as is evident from the college chronicle. Public accessibility, albeit temporary, distinguished the Brno copy of the icon from the Ingolstadt copy, called *Mater ter admirabilis* (thrice-admired Mother), which was only available to members of the elite congregation *Colloquium Marianum*.[129] The Brno Our Lady of the Snows was multifunctional, playing its religious-formative role "inside" the novitiate while also participating in wider social interactions "outside" of it.

NOTES

1. See Wolf, *Salus Populi Romani*, ix, 4–9.

2. During the ISIMAT restoration project (2014–2017) it was found to be a late medieval reproduction of an early medieval model see Thieme, Sand, and Bellucci,

"Die frühen römischen Marienikonen," 279–281. During the restoration (2017–2018, Vatican Museums), the painting was dated to the period between the eleventh and thirteenth centuries. For more about *Salus Populi Romani* see Wolf, *Salus Populi Romani,* 37–160. Kitzinger, "On Some Icons," 132–150; Amato, *De vera effigie Mariae*; Guarducci, *La più antica icone di Maria*; Andaloro, "L'icona della Vergine," 124–127; Tristan, *Les premières images chrétiennes*; Leone, *Icone del Roma.*

3. Canisius, *De Maria Virgine,* 690: *"Facessat et cum suo sarcasmo Melanchton, ut cui hoc sive dictum, sive convitium apud Manlium legimus; In Italia habent impurisimas et obscenas fabulas de Maria, quae apparavit Monachis."*

4. Melion, *"Quae lecta,"* 262.

5. Bacci, *Il pennello dell'evangelista,* 238–240; Ostrow, *Art and Spirituality,* 122–123.

6. Ostrow, *Art and Spirituality,* 122–123.

7. The miracle is first mentioned in the first half of the thirteenth century by the Dominican monk Bartolomeo da Trento in his work *Liber epilogorum in gesta sanctorum* (1244–1246), see Cecchelli and Armellini, *Le chiese di Roma,* vol. 1, 282–291.

8. Vrabelová, *"Imago gratiosa,"* 96.

9. According to the Golden Legend by Jacobus de Voragine (1230–1298), when Rome was affected by the plague in 590 Pope Gregory the Great led a procession carrying the icon of the Virgin Mary from the basilica of Santa Maria Maggiore to the church of St. Peter. At one point, Archangel Michael appeared above the Castel Sant'Angelo, hiding away a bloody sword, a sign of the end of the plague, while an angelic chorus sang the Marian Easter antiphon *Regina Coeli Laetare* (Rejoice, O Queen of Heaven), Wolf, *Salus Populi Romani,* 130, 156–160; Ostrow, *Art and Spirituality,* 123.

10. These processions were abolished in 1566 by Pope Pius V due to unrest disturbing the holy ritual. Based on documents from the eighth to the sixteenth century, Wolf, *Salus Populi Romani,* 37–78, analyzed the course of the processions, see also Kitzinger, "A Virgin's Face," 11–12; Belting, *Bild und Kult,* 363–368 and idem, *Likeness and Presence,* 313, 323–327; Perry, "Sacred image," 36–37.

11. Ostrow, *Art and Spirituality,* 123–125.

12. Ostrow, *Art and Spirituality,* 123–125; see also Kitzinger, *A Virgin's Face,* 11–12; 16–17.

13. Ostrow, *Art and Spirituality,* 125.

14. Ostrow, *Art and Spirituality,* 163–178.

15. The Roman city council had the tabernacle made in the fourteenth century, see Ostrow, *Art and Spirituality,* 163–178.

16. Ignác z Loyoly, *Souborné dílo: duchovní cvičení,* 121; 128–129.

17. *Imago primi saeculi,* 72–74: *"scripsit illa quidem Ignatius, sed dictante Maria . . . unde homo militaris et litterarum rubis nisi ab hac magistra sua tantam hausisset lucem, tantam christinae sapientiae perfectionem . . . nec minus societatis constitutiones ac leges opus sunt ut humano maius ita dignissimum diva virgine magistra."* See Salviucci Insolera, *L'mago primi saeculi.*

18. Ignác z Loyoly, *Souborné dílo: duchovní cvičení,* 29.

19. Hollweck, "Maria in den Exerzitien," 10–11.

20. "I wanted to receive the Holy Father's grace through the Mother and the Son, so I first turned to the Mother to plead with her Son and the Holy Father, and then I prayed to the Son to help me, along with his Mother, to receive the grace of God." Ignác z Loyoly, *Souborné dílo: duchovní cvičení*, 352.

21. Ignác z Loyoly, *Souborné dílo: duchovní cvičení*, 364.

22. Canisius, *De Maria Virgine*, 690.

23. Canisius, *De Maria Virgine*, 695.

24. Canisius, *De Maria Virgine*, 695: "*hic vero, quorum aetate nostra princeps Andreas Carolstadius fuit, adeo se feros ac rabiosas declarant, ut ad seditiones in populis, ad profanationes in templis, ad clades et caedes calamitates que in provinciis excitandas, imo nostro iam saeculo passim excitatas nati esse videantur, quorum in imagines aedesque sacras grassantium furor, si ex aequo iudicaverimus, omnem Turcarum feritatem ac barbarorum sevitiam superare videatur.*" See Mangrum and Scavizzi, 21–45.

25. Canisius, *De Maria Virgine*, 695.

26. Mangrum and Scavizzi, *A Reformation Debate*, 7–8.

27. Canisius, *De Maria Virgine*, 696.

28. Melion, *Quae lecta*, 262–263.

29. These worshippers include St. Ignatius of Antioch (35–107), John of Egypt (d. 394), John of Damascus (650, possibly 749/754), and others, see Melion, *Quae lecta*, 262–263.

30. Melion, *Quae lecta*, 229–233.

31. "*Foeminei tu sola chori pulcherrima Virgo, Una Dei pariter filia, sponsa, parens,*" see Melion, *Quae lecta*, 229–233; Canisius, *De Maria Virgine*, 99–100.

32. Canisius, *De Maria Virgine*, 99.

33. Melion, *Quae lecta*, 223–225.

34. Melion, *Quae lecta*, 225.

35. Melion, *Quae lecta*, 227–228.

36. Melion, *Quae lecta*, 229.

37. Wietse de Boer, "The Early Jesuits," 53–73.

38. Ostrow, *Art and Spirituality*, 127–128, see also Baumstark, *Rom in Bayern*, 493; Noreen, "The Icon of Santa Maria Maggiore," 662; eadem, "Replicating the Icon of Santa Maria Maggiore," 22–27.

39. This copy is now on display in the chapel of St. Stanislaus Kostka in the former Jesuit novitiate Sant' Andrea al Quirinale see Baumstark, *Rom in Bayern*, 493.

40. Noreen, "The Icon of Santa Maria Maggiore," 663–666. In 1578, Elisabeth of Austria, the French queen-widow at the time, brought her copy of Our Lady of the Snows to Vienna. It was first kept in the original monastery of Poor Clares at Josephplatz, founded by the queen in 1580, later moved to the Augustinian Church of St. Augustine. This miraculous image was regarded as the imperial family's *palladium*. In Pope Clement IX's view, it was thanks to Our Lady of the Snows that Eugene of Savoy defeated the Turks at Petrovardín on August 5, 1716. For more about the Viennese copies of the icon, see Aurenhammer, *Die Mariengnadenbilder*, 91–93.

41. Suau, *Histoire de Saint Francois de Borgia*, 143.

42. Ibid., 143: "*Que le Saint-Esprit, notre bien et notre consolation véritable, donne à V. A. une aussi abondante consolation que le désire votre serviteur! Je l' supplie, en retour du souvenir que V. A. a gardé de celui qui fut, dans le monde, son ancien serviteur, et qui, en religion, reste son très fidèle intercesseur, et don tle devoir est de s'affliger de tout ce qui, l à-bas, afflige V. A., de se réjouir de tout ce qui lui donne joie et paix . . . L'Image qu'il porte à V. A. es tun des plus remarquables trésors que puisse posséder une reine dévote à la Mère de Dieu. C'est la copie du portrait qu'a peint saint Luc, et qu'on conserve, avec une souveraine vénération, à Sainte-Marie Majeure. Je demande à V. A. de la placer dans sa chapelle, à l'autel de son oratoire, et de l'entourer de la vénération dont S. S. Elle-même l'honore.*"

43. Noreen, *The Icon of Santa Maria Maggiore*, 664; see also D'Elia, "La prima diffusione," 126–127; Baumstark, *Rom in Bayern*, 493.

44. Noreen, *Replicating the Icon of Santa Maria Maggiore*, 25.

45. Bieś and Grzebień, *Obrazy Matki Bożej Śnieżnej*, 52–53.

46. Aurenhammer, *Die Mariengnadenbilder*, 93.

47. Noreen, *The Icon of Santa Maria Maggiore*, 666.

48. This is the earliest copy of the icon in Poland, see Bieś and Grzebień, *Obrazy Matki Bożej Śnieżnej*, 30.

49. For more about the history of the Brno Jesuit college, see MZA, *Počátky brněnské koleje*, Collection Cerroni, G12, book 203 or ÖNB, *Historia Domus probationis*, fol. 4r-62v.; Volný, *Die Königliche Haupstadt Brünn*, 47–49; Kameníček, "O vzniku prvních dvou kolejí," 109–111; Burian, *Vývoj náboženských poměrů*, 107; Koláček, *200 let jezuitů v Brně*; Češková, "Umělecké památky z doby kolem roku 1600," 344–355; Jordánková and Maňas, *Jezuité a Brno*; Kroupa, *Dějiny Brna*, 427–462.

50. Schmidl, *Historiae Societatis Jesu*, 341–354; see also Burian, *Vývoj náboženských poměrů v Brně*, 3–15, and Jakubec, "Obraz Salus Populi Romani," 87.

51. ÖNB, *Historia Domus probationis*, fol. 447r-511r; Češková, "Jezuité a jejich mecenáši," 21–75.

52. Schmidl, *Historiae Societatis Jesu*, 362.

53. In 1596, a Lutheran destroyed and burned an altar dedicated to the Virgin Mary in Troubsko near Brno. Soon after, he met his death while feasting at the local inn. See ÖNB, *Historia Domus probationis*, fol. 15r.

54. Miller, *Historia Provinciae Bohemiae*, 257; Schmidl *Historiae Societatis Jesu*, 361–362; see Osolsobě, "Mystérium a charisma," 99–111.

55. Schmidl, *Historiae Societatis Jesu*, 362: "*quae hodie in Eorundem Contubernio tota argento et gemmis circumsusa, in ara aeque pretiosa ac nitida, ab Externis etiam ob caelestia beneficia multùm colitur, et celebratur.*"

56. Schmidl, *Historiae Societatis Jesu*, 362; see also Osolsobě, "Mystérium a charisma," 103.

57. Schmidl, *Historiae Societatis Jesu*, 361–362.

58. Miller, *Historia Provinciae Bohemiae*, 257: "*Imago Majestate Virgineam prae se ferens quam S. Franciscus Borgia tertius S. I. Generalis ex Prototypo Marie Majoris Romae desumi curravit, et Novitiatui nostro, tunc Praga ad S. Clemente(m) fixo sed paulo post Bruna translatio, misit.*"

59. The house belonged to the provosts Jan and Václav Grodecky of Brod (1565–1572; 1573–1574).

60. ÖNB, *Historia Domus probationis*, fol. 8r: *"Nam die Sanctae Catharinae sacro anno (15)83 a mane pere in vesperu usque in Templo ato occupavit et campanam benedicendo et duo altaria consecrando."*

61. Miller, *Historia Provinciae Bohemiae*, 151–158.

62. Miller, Historia Provinciae Bohemiae, 153: *"Altera ara non minus eleganter quam pretiose constructa, stat in fine Novitiatus, Icone Beatissimae Virginis e Prototypo Roma Beatissimae Virginis dicta Majoris, sive ad Nives, picta, et a S. Francisco Borgia S. tertium Generali Pragam, ubi Novitiatus eo tempore fuit, submissa,atque paucis elapsis annis, cum Novitiatu Brunam est translata, multum celebris et clara."*

63. MZA, Collection E25, box. 8, sign. 35 A, fol. 1, 2.

64. For more about the renovation of the cloisters, see ÖNB, *Historia Domus probationis*, fol. 10r.

65. For example, the novitiate chapel was enlarged in 1627, see ÖNB, *Historia Domus probationis*, fol. 86r. Further renovations (the chapel of St. Francis Xavier) were carried out in 1671 by John Baptist Erna and around 1730 by the Brno architect Maurice Grimm (1669–1757).

66. The plan for further expansion of the premises dates to 1815, when the monastery buildings were used by the army (from 1783 onward). See Holub and Kolařík, "Poznámky k topografii," 490–494.

67. Martin Středa was the rector of both the Prague and Brno colleges (1629–1634; 1637–1638; 1641–1646) and the provincial superior of the Bohemian Province (1638–1641). During the Swedish siege, Středa established a student legion (members of the sodality of the Assumption of the Virgin) and through his organizing skills and exemplary devotion, he significantly contributed to the Brno citizens' victory, see Tenora, *Život sluhy Božího*, 508–524.

68. This thesis is thoroughly analyzed in Zelenková, "Martin Antonín Lublinský," 146–147.

69. Schwertfer, *Vita Reverendi Patris*, 150–158; see also Tenora, *Život sluhy Božího*, 470–492.

70. ÖNB, *Historia Domus probationis*, fol. 112r: *"Ab ultimo quinquennio proripiebat ipse se noctibus prope singulis e strato, et ante Deiparae Virginis Imaginem in genua provolatus statum hominis iam iam morituri in se ipso viva Meditatione exprimebat. Mox in spiritu ad fores divinae misericordiae accedebat supplex et mortem peccatorum pessimam affectuosissime deprecatus bonam ac pretiosam morte sanctorum Dei sibi donari enixissime flagitabat, illud cum affectu ingeminans: Rex meus et Deus meus! Dona mihi animam meam, pro qua oro, et beatam ex hac vita migrationem, pro qua obsecro."*

71. ÖNB, *Historia Domus probationis*, fol. 121r: ". . . *e quibus pars major cessit in usus Domus alia in sumptus altaris novi pro exornanda Novitiatus vetusta imagine Beatissimae Virginis, ante annos scilicet plusquam septuaginta Tyrocinio Brunensi Roma a B. Francisco Borgia missa."*

72. MZA, E25, inv. no. 227, file. 37, Rector's Diary, 1680–1706 (8. 9. 1692): *"Nativitas B. V. Celebravi primum Sacrum in Novitiatu ad novum Altare quod erigi curavit Excelsissmus Dominus Comes Collalto, communicarunt ibidem omnes Charissimi."* The consecration was followed by a mass in the church, the Latin sodalities' collective communion and at three in the afternoon there was a pilgrimage to the miraculous sculpture of the Madonna of Vranov (in the pilgrimage church of the Nativity of the Virgin) and evening exercises led by the college's rector, Ernest Schambogen (1660–1730). Count Collalto was a frequent guest of the Brno Jesuits and often invited the rectors to his manor. He had a chapel of Our Lady of Passau built in his main residence in Brtnice (1672–1673) as an expression of gratitude to the Virgin for his recovery from illness, see Chocholáč, "Návštěvy," 575–595.

73. Luke 12: 28. For the whole passage see Luke 12: 22, compare also Matt. 6: 28–30.

74. Noreen, *Replicating the Icon of Santa Maria Maggiore*, 35.

75. Noreen, *Replicating the Icon of Santa Maria Maggiore*, 31.

76. Noreen, *Replicating the Icon of Santa Maria Maggiore*.

77. Grossová, "Stříbrná montáž," 117–132.

78. Today, the only preserved decorative element is the relief inscription with the punch mark of the goldsmith Johann Keller. By comparing the relief inscription with other preserved works by Keller it was possible to date the inscription more precisely to the turn of the 1680s, see Grossová, "Stříbrná montáž," 124–127.

79. Ostrow, *Art and Spirituality*, 156, see also Canisius, *De Maria Virgine*, 77.

80. Ostrow, *Art and Spirituality*, 161.

81. Malý, Maňas, and Orlita, *Vnitřní krajina*, 228–230.

82. The painting was restored between August 24, 2017, and August 6, 2019. I thank the restorer, Renata Bartoňová, and Father Josef Čunek, then rector of the Jesuit church of the Assumption of the Virgin in Brno, for allowing me to study the painting.

83. Łęczycki, *Usus meditandi*, frontispiece.

84. Malý, Maňas, Orlita, *Vnitřní krajina*, 230–231.

85. *Manuale Congregationis*, 42. My thanks to Mgr. Vladimír Maňas, Ph.D. for providing this material.

86. Maňas and Orlita, "*Sodalis Marianus* Bohuslava Balbína," 135–157.

87. Balbín, *Sodalis Marianus*, 334–336.

88. Smith, *Sensuous Worship*, 40.

89. "In order to achieve greater facility in meditation, one places before oneself an image showing the gospel story; and thus before commencing the meditation, one will gaze upon the image and take especial care in observing that which it has to show, in order the better to contemplate it as one meditates, and to derive greater benefit from it; because the function of the image is, as it were, to give taste and flavour to the food one has to eat, in such a way that one is not satisfied until one has eaten it; . . . And this takes place with greater certainty, since the image conforms closely to the gospel, and because meditating can easily deceive one, as one takes one thing for another and leaves out the traces of the Holy Gospel, which one should respect both in small and large details, and so should not incline either to left or right." Smith, *Sensuous Worship*, 42.

90. Smith, *Sensuous Worship*, 42, see also Nadal, *Annotations and Meditations*. The book includes 153 engravings by the Antwerp-based print makers Johanne and Hieronymus Wierix.

91. Smith, *Sensuous Worship*, 41.

92. ÖNB, *Historia Domus probationis*, fol. 102v; 106r; 118v; MZA, fonds E25, Inv. no. 227, file 37 Rector's Diary 1680–1706, File 43, book 237, Rector's Diary 1731–1739, File 38, book 228, Rector's Diary 1739–1746.

93. Melion, *Quae lecta*, 228–231; Balbín, *Tuřanská Madona*, 218.

94. See, for example, MZA, Collection E25, file 43, book 237, Rector's Diary 1731–1739. (Year 1731): "Examen *post quod Lytaniae lauretanae et oscula capillorum B: V: M: quies . . .*" (September 14, 1732): "*Examen cum litaniis et osculo capillorum B: V: quies . . .*" (August 4, 1732) [during vespers before the feast of Our Lady of the Snows]: "*examen cum ministris, post examen Lytaniae Lauretanae et osculu reliquiarum B. M. quies.*"

95. VKOL, *Directorium pro membris*, end of the seventeenth century.

96. VKOL, *Directorium pro membris*, f. 21.

97. MZA, Collection E25, file 43, book 237, Rector's Diary 1731–1739. September 13, 1732: "*hora septima lectio Publica ex Pancarpio Mariano et P. Lancicio lectisternia, lectio officiorum,*" see also David, *Paradisus*.

98. *The Bible*, Zachary 13:1; Book of Wisdom 7:26. For more about the depiction of a well as the source of life and salvation, see also David, *Paradisus*, 12, Fig. 2.

99. David, *Paradisus*, 25, Fig. 5; *Bible*, Sam 13: 1–22.

100. Balbín, *Tuřanská Madona*, 219.

101. *Bible*, Luke 1: 35.

102. Łęczycki, *Usus meditandi*, 632: "*Primum Punctum. Considera statum, in quo fuit anima Beatissimae Virginis morti proximae erga homines, erga Deum, erga conscientiam propriam; et vide an tibi sit speranda proportionata quies laetitiàque in illa ultima hora . . . Considera ipsum abscessum animae ex corpore Virginis rectà coelos petentis finè ullis purgatorij impedimentis, magnúmque Angelorum sanctorum comitatum.*"

103. Balbín, *Tuřanská Madona*, 225–226.

104. Balbín, *Tuřanská Madona*.

105. ÖNB, *Historia Domus probationis*, fol. 105r: "*In Sacello domestico binis vicibii nunc 40., nunc 100. horarum preces fudimii pro publicis Provinciae, et privatis Domus necessitatibus. Tyrones nostri in ingeniosa pietate in peruigilio Santi nostro Patriarchae coram eii Icone noctem totam mutatis inter se stationibus orantes excubarunt . . . Dies Assumptae in Caelum Deiparae Sacer, veluti primus a soluta obsidione Svecia Anniversarius solenni cum gratiarum actione et inusitata pietate est celebratus. Cuindecim horas ante summam Templi nostri Aram inter laudis et pareneses continenter insumptimus*"

106. For records from 1680 to 1706 see MZA, fonds E25, inv. no. 227, file 37, Rector's Diary 1680–1706 (5. 8. 1680): "*Solennitas in Novitiatu propter festum Beatissimae Matris ad Nives pridie vesperae ipso die sacrum Cantatum Hora septima et vesperae Hora tertia durarunt lecta sacra usque ad decimam . . .*" (1692*): "Festum Beatissimae Virginis ad nives. Hora septima cecini Sacrum in Novitiatu celebrarunt*

ibidem complures Sacerdotes etiam . . ." (1697): *"Hora septima cantatum habui in Novitiatu, sub quo tempore Credo Charissimi communicarunt, praesens adorat Excelsissimus Dominus Comendans."*

107. Dilatus, *Marianische Kirchfahrt*.

108. Ibid., 322: *"Wann ihr aber wissen wollet / Wie / und was ihr stissten sollet / Stehet auff und gehet hin / Auff den Hühel Exquilin. Wo der Ort mit Schnee bedecket / Ist die Feld=Maaß außgestecket / Da vergrabet euren Schatz / In dem weiten Kirchen-Platz."*

109. Ibid., *"Gedeon! Was du begehret / hat dir zwensach Gott gewähret. Daß auffs Fell der Tau sich feßt / und die Erden nicht beneßt. Auch hergegen daß die Erden / Rings herumb betaut mußt werden / Und da Lämmer=Fell allein / Truden ohne Tau solt sein,"* 320; *"Schneeweiß Jesu kleider waren / Petrus hat mit Lust erfahren / Daß der herzlich wird belohnt / Wer daselbst mit Jesu wohnt,"* 325.

110. ÖNB, *Historia Domus probationis*, fol. 399r.

111. Osolsobě, *Mystérium a charisma*, 103.

112. ÖNB, *Historia Domus probationis*, fol. 52v.

113. A number of damaged spots from affixing votive gift were discovered during the restoration (August 24, 2017, to August 15, 2019, report by Renata Bartoňová).

114. Miller, *Historia Provinciae Bohemiae*, 257: *"Ingruente aliqua graviore publica necessitate, pro solatio, et refugio Saecularium, etiam in Ara majore Templi nostri exponitur."*

115. Balbín, *Tuřanská Madona*, 40, 164; see also Tenora, *Život sluhy Božího*, 517–518.

116. ÖNB, *Historia Domus* probationis, fol. 220v: *"Serenissimus elector Bavariae redux ab Caesarae militiae dignatus e nos invisere. Primum quidem in area scholarum cum gustu spectavit brevem et aptam tempori salutationem de qua dicetis et de Scholis. Deinde Misseae Sacrificium audivit in templo nostro in quo pro ara majori fuit exposita B. V. Majoris imago, per S. Borgiam olim Novitiis transmissit"*

117. ÖNB, *Historia Domus probationis*, fol. 326r.

118. ÖNB, *Historia Domus* probationis, fol. 181v.: *"Aram ornabat in aureo radio Conspicuīs Deus Eucharistis; huic imminebat imago S. Maria Maioris ex prototypo Romano desumpta."*

119. ÖNB, *Historia Domus* probationis, fol. 196v: *". . . proximum porta cubiculum transitera substitisset excepta est a nostro brevi salutatione, deinde per dispositos, et reverenter inclinatos nostrorum ordines processit ad Novitiatum, et sacram Beatissimae Virginis iconem a S. Francisco Borgia submissam devote venerata est. Hinc ad Refectorium descendit, ubi brevi melodramate Societes illi custodias Angelorum attribuit."*

120. ÖNB, *Historia Domus* probationis, fol. 271v; 276r; 282v.

121. Jesuits were active in Boleradice, Velké Meziříčí, Jevišovice, Brtnice, Polná, Oslavany, Mikulov, and other places, see ÖNB, *Historia Domus probationis*, fol. 84r, 87r, 95r, 117r,v, 120r,v.

122. The college chronicle records the conversion of the brothers Maximilian and Gundakar of Liechtenstein (1578–1643; 1580–1658) and Paul Strigelius in 1600, see ÖNB, *Historia Domus* probationis, fol. 52v, 53v.

123. ÖNB, *Historia Domus probationis*, fol. 213r.

124. In 1783, the monastery was abolished and the Augustinians moved into the former (defunct) monastery of Cistercian nuns in Staré Brno.

125. Sperát, *Thaumaturga Brunensis*, 12, and Malý, *Obrazy a rituál*, 130–133.

126. For more about the canonical coronations of Marian images in the Czech lands, see Vrabelová, "Imago gratiosa," and Malý, *Obrazy a rituál*.

127. Malý, *Obrazy a rituál*, 71–73; 82–83; 124–144.

128. Malý, *Obrazy a rituál*, 129–130.

129. Noreen, *Replicating the Icon of Santa Maria Maggiore*, 26–27.

BIBLIOGRAPHY

Manuscripts and Archival Sources

Austrian National Library, Vienna [Österreichische Nationalbibliothek (ÖNB)]:
Historia Domus probationis Societatis Iesu Brunae in Moravia pars posterior a. 1569–1747 (Chronicle of the Brno Jesuit college and noviciate), Ms. Cod. 11958.

National Library of the Czech Republic, Prague [Národní knihovna České republiky (NK)]:
Miller, Johannes. *Historia Provinciae Bohemiae Societatis Jesu*, Liber IV, Prague 1723, Ms. sign. XXIII.C.104/5.

Research Library in Olomouc [Vědecká knihovna v Olomouci (VKOL)]:
Directorium pro membris Societatis Jesu, end of seventeenth century, Ms. sign. M II 41.

Moravian Land Archive in Brno [Moravský zemský archiv, Brno (MZA)]:
Collection E25, inv. no. 227, file 37 Rector's Diary [Deník rektora] 1680–1706, file 43, book 237 Rector's Diary [Deník rektora] 1731–1739, file 38, book 228 Rector's Diary [Deník rektora] 1739–1746.

Collection E25, box 8, sign. 35 A.

Počátky brněnské koleje, Collection Cerroni, G12, book 203.

Primary Sources

Balbín, Bohuslav. *Sodalis Marianus Brunensis selectis precibus*. Olomutij ex Officina Typographica Dorotheae Hradeczky, 1653.

Balbín, Bohuslav. *Tuřanská Madona, neboli, Historie původu a zázraků veliké matky Boha i lidí Marie, jejíž ctihodná socha, nalezená v trní blízko Brna, označená nebeským světlem, je velkými zástupy lidí uctívána, nyní poprvé dúst. p. Bohuslavem Aloisem Balbínem z Tovaryšstva Ježíšova sepsaná léta 1658 s povolením představených*. Translated from the Latin by Zdeněk Drštka. Brno: Facta Medica, 2010.

Canisius, Petrus. *De Maria Virgine Incomparabili et Dei Genitrice Sacrosancta*. Ingolstadii: Eycudebat David Sartorius, 1577.

David, Johannes. *Paradisus Sponsi et Sponsae in Quo Messis Myrrhae et Aromatum ex instrumentis ac mysteriis Passionis Christi colligenda. Et Pancarpium Marianum, Septemplici Titulorum serie distinctum: vt in B. Virginis odorem curramus, et Christus formetur in nobis.* Antverpiae: Joannes Moretus, 1607.

Dilatus, Johannes. *Marianische Kirchfahrt, Zu dem Uralten Gnaden-Bild Mariae von Dörnern. Abgetheilet in den Anzug, Einzug, und Abzug. Darinnen Vielerley Gesänger von den Geheimnussen deß Lebens Jesu und Mariae. Wie dann auch Gottselige Ubungen zu beichten, zu Communiciren, Meß zu hören, und andere tägliche Werck zu verrichten fürgestellet werden. Jesu und Mariae zu Lieb und Lob, deren Liebhabern aber zu Nutz und Trost, eingerichtet und in Druck verfertiget / Von P. Joanne Dilato, der Societät Jesu Priestern.* Glatz: Andreas Franz Pega, 1682.

Ignác z Loyoly. *Souborné dílo: duchovní cvičení, vlastní životopis, duchovní deník.* Velehrad: Refugium, 2005.

Imago primi saeculi Societatis Iesu: a provincia Flandro-Belgica eiusdem Societatis repraesentata. Antverpiae: Ex officina Plantiniana B. Moreti, 1640.

Kempenský, Tomáš. *Čtyři knihy o následování Krista.* Brno: Cesta, 2001.

Łęczycki, Mikołaj. *Usus meditandi tyronibus et proficientibus in via spirituali accommodatus.* Pragae: Typis Universitatis Carolo-Ferdinandeae in Collegio Soc. Jesv ad S. Clementem,1665.

Manuale Congregationis B. Mariae Virginis Assumptae Brunae. Brunae, Typis Christophori Haugenhofferi. M.DC.XVII.

Nadal, Jerónimo. *Annotations and Meditations on the Gospels*, vol. 1–3, trans. and edited by Frederick A. Homann, S. J. Philadelphia: St. Joseph's University Press, 2003–2007.

Paleotti, Gabriele. *Discourse on Sacred and Profane Images.* Introduction by Paolo Prodi. Translated by William McCuaig. Los Angeles: Getty Research Institute, 2012.

Salviucci Insolera, Lydia. *L'imago primi saeculi (1640) e il significato dell' immagine allegorica nella compagnia di Gesú.* Rome: Editrice pontificia università gregoriana, 2004.

Schmidl, Johannes. *Historiae Societatis Jesu Provinaciae Bohemiae* Pars I., Liber IV. Pragae, Typis Universitatis Carolo Ferdinandeæ in Collegio S. J. ad S. Clementem, per Jacobum Schweiger Fa& orem. 1747.

Schwertfer, Wentzel. *Vita Reverendi Patris Martini Stredonii Soc. Jesu.* Pragae: Typis Universitatis Carolo Ferdinandeæ in Collegio Societatis Jesu ad S. Clementem Anno, 1673.

Secondary Studies

Amato, Pietro. *De vera effiigie Mariae: Antiche icone romane.* Milan: A. Mondadori, 1988.

Andaloro, Maria. "L'icona della Vergine 'Salus Populi Romani.'" In *La basilica romana di Santa Maria Maggiore*, edited by Carlo P ietrangeli, 124–127. Rome: Nardini, 1987.

Aurenhammer, Hans. *Die Mariengnadenbilder Wiens und Niederösterreich in der Barockzeit: der Wandel ihrer Ikonographie und ihrer Verehrung.* Vienna: Österreichischen Museums für Volkskunde, 1956.

Bacci, Michele. *Il pennello dell'evangelista. Storia delle immagini sacre attribuite a san Luca.* Collana: Piccola Bibliotheca Gisem, 1998.

Baumstark, Reinhold. *Rom in Bayern: Kunst und Spiritualität der ersten Jesuiten.* Munich: Hirmer, 1997.

Belting, Hans. *Bild und Kult: eine Geschichte des Bildes vor dem Zeitalter der Kunst.* Munich: C. H. Beck, 1990.

Belting, Hans. *Likeness and Presence: A history of the Image Before the Era of Art.* Chicago: University of Chicago Press, 1994.

Bieś, Andrzej Paweł, and Ludwik Grzebień. *Obrazy Matki Bożej Śnieżnej (Salus Populi Romani) w Polsce na przełomie XVI i XVII wieku.* Cracow: Wam, 2016.

Burian, Vladimír. *Vývoj náboženských poměrů v Brně 1570–1618.* Brno: Ústřední národní výbor, 1948.

Cechelli, Carlo, and Mariano Armellini. *Le chiese di Roma dal secolo IV al XIX.* Rome: Tipografia Vaticana, 1942.

Češková, Lenka. "Umělecké památky z doby kolem roku 1600 v jezuitském kostele Nanebevzetí Panny Marie v Brně." *Zprávy památkové péče* 72, no. 5 (2002): 344–355.

Češková, Lenka. "Jezuité a jejich mecenáši při výstavbě a výzdobě kostela Nanebevzetí Panny Marie v Brně kolem roku 1600." In *Jezuité a Brno: Sociální a kulturní interakce koleje a města (1578–1773)*, edited by Hana Jordánková and Vladimír Maňas, 21–75. Brno: Archiv města Brna, 2013.

Chocholáč, Bronislav. "Návštěvy u nejvyššího zemského komorníka: dvůr a hosté Františka Antonína hraběte Collalta v Brně koncem 17. století." In *Aristokratické rezidence a dvory v raném novověku*, edited by Václav Bůžek and Pavel Král, 575–595. České Budějovice: Jihočeská univerzita, 1999.

D'Elia, Pasquale M. "La prima diffusione nel mondo dell' immagine di Maria Salus Populi Romani." *Fede e Arte* 2 (1954): 301–311

Grossová, Anna. "Stříbrná montáž obrazu Salus Populi Romani a barokní liturgické stříbro bývalé jezuitské koleje v Brně." *Brno v minulosti a dnes* 32 (2019): 117–132.

Haskell, Francis. *Patrons and Painters: A Study in the Relations between Italian Art and Society in the Age of the Baroque.* New Haven: Yale University Press, 1982. not in footnotes.

Hollweck, Thomas S. J. "Maria in den Exerzitien." In *Jesuiten* 3 (2007): 10–11.

Holub, Petr, and Václav Kolařík, "Poznámky k topografii nejbližšího okolí bývalého herburského kláštera v Brně." *Brno v minulosti a dnes* 18 (2005): 490–494.

Jakubec, Ondřej. "Obraz Salus Populi Romani u brněnských jezuitů a obraznost potridentského katolicismu na předbělohorské Moravě." In *Jezuité a Brno: Sociální a kulturní interakce koleje a města (1578–1773)*, edited by Hana Jordánková and Vladimír Maňas, 77–98. Brno: Archiv města Brna, 2013.

Jordánková, Hana and Vladimír Maňas, eds. *Jezuité a Brno: Sociální a kulturní interakce koleje a města (1578–1773).* Brno: Archiv města Brna, 2013.

Kameníček, František. "O vzniku prvních dvou kolejí Jesuitských na Moravě." *Sborník historický* 3 (1885): 109–111.

Kaufmann, Thomas. *Vykoupení a zatracení: dějiny reformace.* Translated by Jan Dobeš. Prague: Argo, 2020.

Kessler, Herbert. *Ani Bůh ani člověk: slova obrazy a středověká úzkost z výtvarného umění.* Brno: Barrister & Principal, 2016.

Kitzinger, Ernst. "The Cult of Images in the Age before Iconoclasm." *Dumberton Oaks Papers* 8 (1954): 84–150.

Kitzinger, Ernst. "On Some Icons of the Seventh Century." In *Late Classical and Mediaeval Studies in Honor of Albert Mathias Friend,* edited by Kurt Weitzmann, 132–150. Princeton: Princeton University Press, 1955.

Kitzinger, Ernst. "A Virgin's Face: Antiquarianism in Twelfth-Century Art." *The Art Bulletin* 62 (1980): 11–12.

Knoz, Tomáš. *Pobělohorské konfiskace: moravský průběh, středoevropské souvislosti, obecné aspekty.* Brno: Matice moravská, 2006.

Koláček, Josef. *200 let jezuitů v Brně.* Velehrad: Refugium, 2002.

Kroess, Alois. *Geschichte der böhmischen Provinz der Gesellschaft Jesu I. Von ihrer Gründung bis zu ihrer Auflösung durch die böhmischen Stände 1556–1619: I., Geschichte der ersten Kollegien in Böhmen, Mähren und Glatz.* Vienna: Buchhandlung Ambr. Opitz Nachfolger, 1910.

Kroupa, Jiří. *Dějiny Brna 7: uměleckohistorické památky, historické jádro.* Brno: Archiv města Brna, 2015.

Leone, Giorgio. *Icone del Roma e del Lazio I. e II.* Rome: L'Erma di Bretschneider, 2012.

Lucas, M. Thomas. "Virtual Vessels, Mystical Signs: Contemplating Mary's Images in the Jesuit Tradition." *Studies in the Spirituality of Jesuits* 35, no. 5 (2003): 1–33.

Malý, Tomáš and Pavel Suchánek. *Obrazy očistce: studie o barokní imaginaci.* Brno: Matice moravská, 2013.

Malý, Tomáš, Vladimír Maňas, and Zdeněk Orlita. *Vnitřní krajina zmizelého města: náboženská bratrstva barokního Brna.* Brno: Archiv města Brna, 2010.

Malý, Tomáš. *Obrazy a rituál: římské korunovace divotvorných Madon a koncept barokní kultury.* Brno: Nakladatelství Lidové noviny, 2019.

Maňas, Vladimír. "Hudební aktivity náboženských korporací na Moravě v raném novověku." Phd dissertation. Masaryk Univerzity, 2008.

Maňas, Vladimír, Zdeněk Orlita, and Martina Potůčková. *Zbožných duší úl: náboženská bratrstva v kultuře raněnovověké Moravy.* Olomouc: Muzeum umění Olomouc, 2010.

Maňas, Vladimír and Zdeněk Orlita. "Sodalis Marianus Bohuslava Balbína v kontextu tištěných příruček mariánských kongregací 17. století." In *Jezuité a Brno: Sociální a kulturní interakce koleje a města (1578–1773),* edited by Hana Jordánková and Vladimír Maňas, 135–157. Brno: Archiv města Brna, 2013.

Mangrum, Bryan D., and Giuseppe Scavizzi. *A Reformation Debate: Karlstadt, Emser and Eck on Sacred Images: Three Treatises in Translation.* Toronto: Victoria University, 1998.

Margherita Guarducci. *La più antica icone di Maria. Un prodigioso vincolo fra oriente e okcidente.* Rome: Libreria dello Stato, 1989.

McAlister, Amber Blazer. "From Icon to Relic: The Baroque Transformation of the Salus Populi Romani." *Athanor* 13 (1995): 31–41.

Melion, Walter Simon and Lee Palmer Wandel. *Early Modern Eyes*. Leiden: Brill, 2010.

Melion, Walter Simon., *"Quae lecta Canisius Offert Et Spectata Diu*: The Pictorial Images in Petrus Canisius' De Maria Virgine of 1577/1583." In *Early Modern Eyes*, edited by Walter Simon Melion and Lee Palmer Wandel. 207–266. Leiden: Brill, 2010.

Mostaccio, Silvia. *Early Modern Jesuits between Obedience and Conscience during the Generalate of Claudio Acquaviva (1581–1615)*. Farnham: Routledge, 2014.

Noreen, Kirstin. "Replicating the Icon of Santa Maria Maggiore: The Mater ter admirabilis and the Jesuits of Ingolstadt." *Visual Resources: An International Journal of Documentation* 24, no. 1 (2008): 19–36.

Noreen, Kirstin. "The Icon of Santa Maria Maggiore, Rome: An Image and Its Afterlife." *Renaissance Studies* 19, no. 5 (2005): 660–672.

O'Malley, John W. *The Jesuits: Cultures, Sciences, and the Arts, 1540–1773*. Toronto: University of Toronto Press, 2006.

O'Malley, John W. *Trent and All That: Renaming Catholicism in the Early Modern Era*. Cambridge: Harvard University Press, 2000.

O'Malley, John W. *Trent: What Happened at the Council*. Cambridge: Harvard University Press, 2013.

O'Malley, John W., and Gauvin Alexander Bailey. *The Jesuits and the Arts, 1540–1773*. Philadelphia: Saint Joseph's University Press, 2005.

Osolsobĕ, Petr "Mystérium a charisma: význam brněnského noviciátu pro Edmunda Campiona." In *Jezuité a Brno: Sociální a kulturní interakce koleje a města (1578–1773)*, edited by Hana Jordánková and Vladimír Maňas, 99–108. Brno: Archiv města Brna, 2013.

Ostrow, Stephen. *Art and Spirituality in Counter-Reformation Rome: The Sistine and Pauline Chapels in S. Maria Maggiore*. Cambridge: Cambridge University Press, 1996.

Oulíková, Petra. *Klementinum*. Prague: Národní knihovna České republiky, 2019.

Oy-Marra, Elisabeth, and Volker Remmert. *Le monde est une peinture: Jesuitische Identität und die Rolle der Bilder*. Berlin: Akademie Verlag, 2011.

Rahner, Hugo. *Ignác z Loyoly a dějinné pozadí jeho spirituality*. Velehrad: Refugium, 2012.

Ranum, Patricia M. *Beginning to be a Jesuit: Instructions for the Paris Novitiate circa 1685*. St. Louis: The Institute of Jesuit Sources, 2011.

Ryneš, Václav. "Z dějin úcty Panny Marie Foyenské v Čechách." In *Zprávy české provincie Tovaryšstva Ježíšova*, [n.e.], 4–14. Praha: Provinciální prokuratura T.J., 1948.

Schatz, Klaus. *Všeobecné koncily: ohniska církevních dějin*. Brno: Centrum pro studium demokracie a kultury, 2014.

Smith, Jeffrey Chipps. *Sensuous Worship: Jesuits and the Art of the Early Catholic Reformation in Germany*. Princeton: Princeton University Press, 2002.

Sperát, Ivo. *Thaumaturga Brunensis: Divotvůrkyně brněnská*. Brno: Ivo Sperát, 2011.

Suau, Pierre. *Histoire de Saint Francois de Borgia: troisième Général de la Compagnie de Jésus (1510–1572)*. Paris: G. Beuachesne & cie, 1910.

Tenora, Jan. *Život sluhy Božího P. Martina Středy z Tovaryšstva Ježíšova*. Brno: Dědictví sv. Cyrilla a Methoděje, 1898.

Trapp, Mořic. *Die K. K. Garnisonskirche in Brünn*. Brünn: Selbstverlag, 1886.

Tristan, Frédérick *Les premières images chrétiennes. Du symbole à l'icône, IIe VIe siècle* Paris: Fayard, 1996.

Volný, Řehoř. *Die Königliche Haupstadt Brünn und die Herrschaft Eisgrub: topographisch, statistisch und historisch geschildert*, Brno: Selbstverlag, 1836.

Vrabelová, Dana. "Imago gratiosa: korunované Madony ve střední Evropě v době baroka." PhD dissertation, Charles University, 2013.

Warner, Marina. *Alone of All her Sex: The Myth and the Cult of the Virgin Mary*. New York: Vintage Books, 1983.

Wazbinski, Zygmunt. "St. Luke of Bavaria by Engelhard de Pee." *Journal of the Warburg and Courtauld Institutes* 52 (1989): 240–245.

Wietse de Boer, Karl A. E. Enenkel. "The Early Jesuits and the Catholic Debate about Sacred Images." In *Jesuit Image Theory*, edited by Wietse de Boer, Karl A.E. Enenkel, and Walter Melion, 53–73. Leiden: Brill, 2016.

Wittkower, Rudolf. *Baroque Art: The Jesuit Contribution*. Fordham: Fordham University Press, 1972.

Wolf, Gerhard. "Regina Coeli, Facies Lunae, et in Terra Pax: Aspekte der Ausstattung der Capella Paolina in Santa Maria Maggiore." *Römischer Jahrbuch der Bibliotheca Hertziana* 27–28 (1991–1992): 324–326.

Wolf, Gerhard. *Salus Populi Romani: die Geschichte römischer Kultbilder im Mittelalter*. Weinheim: Acta Humaniora, 1990.

Zelenková, Petra. "Martin Antonín Lublinský (1636–1690) jako inventor grafických listů: pohled do barokní grafiky druhé poloviny 17. století." PhD dissertation, Prague: Charles University, 2008.

Zierholz, Steffen. *Räume der Reform: Kunst und Lebenskunst der Jesuiten in Rom. 1580–1700*. Berlin: Gebruder Mann, 2019.

Chapter 6

Jesuit Saints in the Czech Lands

Cultic Staging of Religious Images in Jesuit Churches

Štěpán Vácha

Research on the production, function, and reception of religious images in the environment of the Jesuit order is quite sophisticated at present and to a great extent defines the character of the discourse on the art of the Early Modern period.[1] Italy has traditionally been the focus for scholarship, not only as the ideological focus of the development of the order but also as the center for the great artistic innovations of the period. The other regions of Europe, including Central Europe, are treated similarly and in recent years the focus has even extended to the colonial world, where the Society of Jesus was active.[2] This study deals primarily with paintings of Jesuit saints in the Czech Lands, in particular Sts. Ignatius of Loyola and Francis Xavier, who occupied a central position in the artistic commissions of the Jesuit order because of Jesuit spirituality and corporate identity.[3] I will not provide a comprehensive summary of Jesuit saints' iconography here; however, the focus will be on the saints' representational depictions, which simultaneously developed the reputation of granting special divine mercy or having miraculous effects. These images achieved mass popularity and great renown even though many of them had questionable artistic quality, echoing Goethe's opinion "*Wundertätige Bilder sind meist nur schlechte Gemälde.*"[4] That is clear from the way they were staged in sacred space and by the various written testimonies that recorded their cultic presentation and the responses of viewers at the time.

The painting *St. Francis Xavier with the Madonna* on the main altar of the church at the Jesuit residence in Opařany in southern Bohemia, among the oldest preserved representative depictions of the saint in the Czech Lands, is a good illustration of this kind of devotional staging [figure 6.1]. This anonymous work, displaying anachronistic features looking back to Late

Renaissance style, decorated the small local church consecrated in 1657. Even though miracles were not linked to this particular image in sources, over the course of the following decades, it became the object of the living veneration of St. Francis Xavier in this area.[5] This is undoubtedly the reason why the painting was reused in the decoration of the new main altar when a new structure by Kilian Ignaz Dientzenhofer was built (1733 to 1735),[6] despite the fact that it clearly did not fit the surrounding high-quality interior decorations. In contrast, its devotional function was all the more emphasized in this arrangement: the heads of the main protagonists have embossed metal halos, Francis has a gilded heart attached to his chest, and the picture frame carried by angels has a radiant halo.

Figure 6.1 The main altar in the church of St. Francis Xavier in Opařany, painting of St. Francis Xavier, before 1657, altar 1733–1735.

As I will show in this study, this and other cases are ideal examples to illuminate the problem of the status and function of religious paintings in the Early Modern period and consequently to evaluate the role various visual media played in spreading the cult of Jesuit saints and incorporating it in the religious practice of the Bohemian Jesuits and their audience.

The religious image of the seventeenth and eighteenth centuries was characterized by high theoretical and aesthetic demands. The concept of the "affective image" was applied, for which diverse formal techniques and means of expression, developed in the High Renaissance to engage the viewer and hold his attention, were used in the service of Catholic reform and the cultivation of piety.[7] At the same time, the Council of Trent (1563) formulated the theological definition of a religious image, to be understood not merely as a depiction of a saint or illustration of a holy story, but also as an effective instrument for establishing a spiritual link between the believer and his or her heavenly protector. Implicit in this is the belief that the graces and miracles attributed to the saint thus invoked can manifest themselves in the material substance of the pictorial medium in supernatural or even magical ways, such as when the depicted saint changes facial expression, moves, even speaks, sheds tears, or sweats blood.[8] Even in today's Roman Catholic Church a religious image has the status of an intermediary for God's mercy and mystical experience; however, the production of such images diverged completely from the development of the visual arts in the nineteenth and twentieth centuries.[9]

The link between a painting and internal imagination played a significant role in Jesuit spirituality.[10] Over the first century of its existence, the Society of Jesus, like only a few other church bodies, developed a truly complex program for applying the visual arts in religious life. This program drew from the meditative approach of the internal (imaginative) perception of seen objects (based on *Spiritual Exercises* by St. Ignatius of Loyola) combined with the conclusions of the Council of Trent on venerating images of the holy. Humanist education and rhetorical teachings on the triple impact on the listener (*docere—delectare—movere*), cultivated intensively at schools run by the Jesuits, were also essential for the correct reception of an image.[11] Although applying the principles of rhetoric in the visual arts was of interest to a range of Catholic theologians and art theorists in the sixteenth century;[12] it was the Jesuits who applied these ideas to pastoral work with the broader levels of society and when educating young people, in particular when organizing school plays and tableaux vivant.[13]

Although discourse about the visual arts and religious images was more developed in Italy or the Spanish Netherlands, Czech Jesuits were also aware of these attitudes and practices and adapted them to local conditions in their pastoral and missionary work. Corresponding to the cultivation of

the spiritual imagination, namely, creating an inner "gallery," are reports of particularly pious laymen in the spiritual care of the Jesuits who transformed their dwellings into veritable picture galleries of sacred art otherwise common in the monasteries and palaces of the clergy. Countess Františka Slavatová of Meggau (1609–1676), who embodied the post-Tridentine ideal of holiness in her life, had the walls of her dwelling decorated with images of saints so that walking through the chambers and corridors became for her a "domestic pilgrimage" ("Hausprocession").[14] According to Bohuslav Balbín, Maria Maximiliana, the countess of Sternberg née von Hohenzollern-Sigmaringen (1583–1649), was surrounded by religious paintings (*sacris imaginibus*) not only in her rooms but even in her carriage when she was travelling.[15] Jiří A. František Procházka de Lauro (1682–1746), a student of the Jesuits and later dean in Beroun, Central Bohemia, describes a similar case; preaching in 1736, he praised Count Maximilian Josef Bechinie of Lažany (d. 1766) because in his travels abroad:

> he did not have collected any scantily clad Dianas, Proserpinas and Venuses or other similar idols from pagan temples to adorn his rooms and cabinets with, but has our paintings [i.e., images of saints] all around him, he loves them and they encourage him to love the true God by often gazing upon them.[16]

Not only the choice of subject matter but also the emphasis on aesthetic representation was part of the impressiveness of the religious image cultivated by the Czech Jesuits. Bartolomeus Christelius, author of a hagiographic biography of Countess Františka Slavatová of Meggau, put a prayer in the mouth of this pious aristocrat that refers to God as "a magical wizard" (*Tausendkünstler*) "who can do anything"; submission to his power is compared to an artist creating "a beautiful image" from a rough block of wood:

> Almighty God, who can do all things, and is a magical magician for whom nothing is impossible. Now, if artists and carvers can make out of a rough and clumsy piece of wood the most beautiful images with which God is worshipped, how much more zealously and better can You, my merciful God, make out of me, a clumsy, rough log and stick, an image, yes, a beloved image, true to Your likeness and after Your pattern, that is, a man adorned with virtues.[17]

The Czech Jesuits also paid attention to the appropriateness (*decorum*) of an image in liturgical space. A prime example is the replacement of the painting on the main altar of the Church of St. Ignatius in the New Town in Prague about ten years after its creation for a new one by Johann Georg Heinsch (1688). The rector of the New Town college, Wenceslas Scheligowsky, writes in a report that "the previous image was not liked by many, especially

women, due to the excessive nudity of some of the figures."[18] Although there is no further detailed information about its appearance, it can be assumed that the public dismay was caused by a naturalist depiction of the human vices, illustrated by a scene with St. Ignatius delivering the statement: *"Quam sordet mihi terra, dum coelum aspicio."* ("How foul the earth is when I look up at the heavens!")[19] Hence, Heinsch supplied the replacement painting, *The Welcoming of St. Ignatius into Heaven*, in which throngs of modestly dressed angels in long gowns met the criteria for celebrating the title patron of the church and met with the approval of the Jesuits.[20]

GEMINAE SOCIETATIS AND STAGING OF THEIR IMAGES IN JESUIT SACRAL SPACE

The cults of Sts. Ignatius and Francis Xavier developed in the Jesuit environment alongside one another to a great extent and even enhanced each other because they were both canonized in 1622. The center for their veneration was Il Gesù in Rome, the mother church of the order, where representative paintings of both Jesuits (currently in the Pinacoteca Vaticana) were hung in the presbytery along the sides of the main altar on the occasion of the jubilee year of 1600.[21] They subsequently became the center of the cult attention of believers and gradually a number of votive items were attached to them.[22] Regular altars with paintings of the saints were built in the side arms of the transept of Il Gesù only after 1622. Ignatius' body was placed under the first of them, and the relic of the right hand of St. Francis, which blessed and baptized thousands of converts in India and Japan, was brought from Goa and displayed on a second altar.[23]

Venerating Sts. Ignatius and Francis Xavier was fundamental for the identity and internal cohesion of Society of Jesus. The annual reports (*litterae annuae*) written by the individual colleges of the Czech province to inform other colleges and the office of the general of the order clearly indicate that significant attention was paid to the celebration of holidays and the organization of religious services under the patronage of both saints.[24] The rubrics describing the miscellaneous expressions of veneration directed at both saints over the course of the year are listed first in the structure of the annual reports, followed by sections dedicated to Marian veneration and the activities of the religious brotherhoods and other cults.[25] The holidays of St. Ignatius and St. Francis Xavier, celebrated on July 31 and December 3, were the highlights of the liturgical year in the life of each college.[26] Similarly, St. Francis's birthday was highly celebrated. Thus, readers of the reports, whether members of other colleges or the order generalate in Rome, were informed about the number of people present at feasts, the participation of prelates and renowned

persons from different towns and regions, and the course of the celebration of festivities including temporary decoration of the church. The lists of requests for and granting of mercies by the intercession of both saints for the previous year are an essential part of the annual records.

Celebrating the main patrons of the order as post-Tridentine ideals of holiness, the Jesuits presented them to the various layers of society as models for emulation or recommended them as miracle workers and intercessors in spiritual and material needs. Their lives and virtues became the subject of numerous literary treatments and staged performances. Moreover, churches and altars were consecrated to St. Ignatius and St. Francis, and their biographies were depicted in pictorial cycles.[27] To sum up, both saints, aptly referred to as *geminae Societatis columnae* (twin columns of the Society),[28] were present practically everywhere in the environment of the Jesuit order and their physical appearance was mediated through various visual media: paintings, ceiling paintings, graphic illustrations, statues, and even necklace medallions.

As Claudia Gerken has illustrated with the canonization campaigns of the model saints of the post-Tridentine Catholic Church in the early seventeenth century, the fame (*fama*) of a saint, including the number of miracles attributed to him, was largely dependent on the intensity of the propaganda provided by the cult's promoters.[29] In the case of Sts. Ignatius and Francis, it was the Jesuits themselves, a large and powerful ecclesiastical corporation with influential supporters in the Roman Curia. Until the 1590s, the lack of miracles recorded at Ignatius' intercession was an obstacle that prevented canonization. Only thanks to ongoing efforts by the Jesuits did Ignatius' grave in the church of Il Gesù become the center of attention for a number of believers and pilgrims soon after 1600.[30]

Ignatius' canonization campaign took place at a time when the Catholic Church strictly regulated the cult of saints. Since building altars to saints who had not yet been canonized was not permitted and any other public cult expressions were banned, printed materials played a key role in spreading their popularity.[31] Holy images portraying a candidate for canonization made it possible to spread awareness and veneration among believers quickly at relatively low cost. Thus, Ignatius, earlier honored as the founder of the order and a mystic, was transformed over a short period of time into a powerful miracle worker who devout people from various social classes could turn to. His beatification (1609) and canonization (1622) were a result of a mass propaganda effort that the Jesuits made throughout the Catholic world.

Veneration for both saints was introduced to the Czech Lands extremely early, that is, even prior to the Battle of White Mountain (Bílá Hora) in 1620. Paintings of both saints were placed along the sides of the main altar in the chancel of the Church of St. Savior at the Jesuit college of the Clementinum in Prague in 1603 and 1610 (see below). There was an altar with a painting of

St. Ignatius in the Jesuit church in Brno as early as 1606 to 1608 (see below) and also in the Olomouc Church of St. Mary of the Snow around the time of the canonization in 1621–1622.[32]

The pair of counterpart altars consecrated to St. Ignatius and St. Francis Xavier in the college Church of St. Mary Magdalene in Jindřichův Hradec (South Bohemia) are the oldest preserved in Bohemia.[33] The first was commissioned in 1641 by Count Wilhelm Slavata of Chlum and Košumberk, a local lord and owner of the demesne, and the second a year later by his son, František Vít.[34] The iconography of the paintings is derived from graphic reproductions of compositions for altarpieces painted by Gérard Seghers in the late 1620s.[35] The first depicts St. Ignatius with the Virgin Mary, who is dictating the order's constitution, and the second depicts St. Francis Xavier's vision of the Mother of God with Jesus.

Other cases of paintings of Sts. Ignatius and Francis Xavier in Jesuit churches in Bohemia and Moravia show that their iconography was diverse. In contrast to the mystical visions in the paintings in Jindřichův Hradec, large canvases in altar retables in the side aisles of the college Church of St. Barbara in Kutná Hora (Central Bohemia) accentuate the earthly actions of both saints.[36] The first, an anonymous work, depicts *St. Ignatius Distributes Alms to the Poor*, and the second, painted by Johann Georg Heinsch in 1698, represents *St. Francis Xavier Baptizing an Indian Prince*.[37]

Of particular interest among the chapels in Jesuit college churches, which are consecrated to the main saints of the order, are those along the sides of the chancel in the Church of St. Mary of the Snow in Olomouc, connected by a pair of low portals.[38] Spatially separated from the rest of the church, these spaces could accommodate large gatherings; their position contrasts that of the other chapels, which open into the main nave with high arcades. The special status of both chapels is emphasized by memorial artifacts, that is, old gravestones in the walls, linked to patrons from the Olomouc college: the Olomouc Bishop Wilhelm Prusinovský (d. 1572) in the chapel of St. Ignatius and the chapter dean, Jan Breuner (d. 1638), in the chapel of St. Francis Xavier.

As is apparent from the diaries of the rectors of the Olomouc college, members of the college gathered in both chapels on the feast of the Circumcision of the Lord on January 1, a special occasion for the Jesuit order, when the members renewed their monastic vows.[39] The chapel thus primarily served the Jesuits themselves, who could worship there in large groups or as individuals, separate from other services in the church. The Jesuit character of both spaces is communicated by the rich pictorial decoration in various visual media, remarkable in terms of complexity.

The scenes from the lives of both saints on the walls and arches were created in 1743 by the local artist Johann Christoph Handke (1694–1774), who

also painted large oil paintings with additional scenes from their lives that hung under the window.[40] The grisaille painted medallions in the passages from the chapel to the chancel relate the miraculous effects of both saints, among them those enabled through their images, to which worshippers turned in prayer. Hammered copper reliefs depicting similar scenes decorate the pedestals of the columns of the altar retables. The altars, built as early as 1720, are in the form of retable architecture with sculptural groups of the Holy Trinity and the Holy Family accompanied by angels in the upper part.

The images with the "true appearances" (*verae effigiei*) of the saints are installed on the altar mensas in front of paintings entitled *The Vision of St. Ignatius in La Storta* and *The Calling of St. Francis Xavier*, which present the decision both Jesuits made to dedicate themselves to Christ. The former painting, ascribed to the Prague painter Jan Jiří Hering (d. 1648),[41] depicts the renowned mystical vision of St. Ignatius in 1537 in a chapel in the village of La Storta (Rome), where he was staying with his companions on the way to Rome. Christ, carrying the cross, appeared to the saint and ensured him of his support during his time in the Eternal City with the words *Ego vobis Romae propitius ero* (I will be merciful to you in Rome).

This mystical experience of St. Ignatius in La Storta, interpreted in retrospect as a key event for the founding and naming of the Jesuit order and also used to propagate its Christocentric spirituality, became a frequent theme in Ignatius' iconography at the beginning of the seventeenth century.[42] Flemish engravers such as Jean-Baptiste Barbé and Valérien Regnard were the first to produce pictorial depictions of this topic[43]—their engravings served as models for the oldest painted depictions, for example, the painting in the chapel in the country seat of Count William V in Schleissheim, Bavaria, from shortly after Ignatius' beatification.[44]

The altarpiece in the Jesuit church of the Assumption of the Virgin Mary in Brno is another early example of this story [figure 6.2].[45] Although the side altar with the patronage of the Holy Cross in the Brno church was consecrated as early as 1602, its pictorial decoration was only added in 1606–1608, commissioned by the important Moravian nobleman Ladislav Berka of Dubá and his wife, Eliška of Žerotín, who attributed the successful birth of her first son to prayers to St. Ignatius. Although the altar bore a formal consecration to the Holy Cross and illustrates it suitably with Christ carrying the cross, the choice of this patrocinium was apparently a solution to the problem that Ignatius had not yet been canonized at that time and thus could not have an altar dedicated to him. It is usually surmised that the painting was imported from Italy or Spain, although another recent theory suggests that this is the work of a Prague painter, possibly an artist from the Rudolfine circle. In any case, the composition of the scene is based on an engraving by Hieronymus Wierix that is part of the undated cycle, *Passio Domini Nostri Iesu Christi*.[46]

THE MIRACULOUS IMAGE OF ST. IGNATIUS IN
THE CHURCH OF ST. SAVIOR IN PRAGUE

Although the primary functions of paintings of the saints were to instruct the faithful and visually complement the liturgical space, some of them gained reputations as devotional or miracle-making images. An early example of a miraculous image depicting St. Ignatius was situated in the Prague Jesuit Church of St. Savior as early as the beginning of the seventeenth century. According to Jesuit reports, only written later, in the 1670s, the papal nuncio at the court of Emperor Rudolph II, Filippo Spinelli, dedicated a painting of St. Ignatius (*effigiem penicillo expictam*) to the Church of St. Savior.[47] This may have occurred in the year 1603, at the conclusion of his four-year diplomatic mission in Prague.[48] Since Ignatius had not even been beatified at the time, the painting, in correspondence with canon law, could not have been placed on the altar and was instead situated (similarly to the Roman church of Il Gesù) in the chancel on the right (Gospel) side of the main altar (*ad dextrum Arae majoris latus*).[49]

This first representative depiction of the founder of the order in the Czech Lands dates to a time when the canonization campaign in Rome was in full swing. In the overall European context, the Prague image represents a very early response to the developing cult of Ignatius, which testifies to the importance of Prague not only as an imperial seat but also as the envisioned center of Catholic renewal in Central Europe. The reason for this gift could have been personal: Filippo Spinelli consecrated the church in 1602, and shortly before his departure, he buried there two members of his family who had died in Prague during an epidemic.[50] Spinelli's initiative, however, corresponded fully with the atmosphere of that time; the Prague Jesuits had been preparing the city to accept the image of the still-uncanonized Ignatius since 1599 by recording various graces (*beneficia*) attributed to his power.[51] Among the prominent persons who were healed at that time, the wife of the Imperial Privy Councillor Andreas Hannewald is mentioned by name.[52] Grateful worshippers soon attached wax *ex voto* gifts to the painting and, in 1608 and 1612, new miracles were recorded and connected to the image. In 1605, the metropolitan provost, Jiří Barthold Pontanus of Breitenberg, donated another gilded relief depicting the uncanonized saint.[53] The altar in honor of St. Ignatius in the St. Savior church was erected only in 1624, dated from a reference by the order's historian, Johannes Schmidl.[54]

In the concluding chapel of the northern side aisle of the church, two paintings of St. Ignatius' mystical visions have been preserved until today.[55] One of them, traditionally linked with the gift of nuncio Spinelli, is installed directly on the Baroque altar; the other hangs on the wall of the same chapel to the left. The paintings are not dated or signed and differ in size,

iconography, and quality of style. The smaller one on the altar depicts St. Ignatius kneeling before a table where a closed book is lying [figure 6.3]. The scene is situated in a cell, which is apparent from the open doors in the background. Ignatius's beret lies on the ground and he gazes upward at the Holy Trinity in the heavens; a ray of light with the monogram IHS shines in from the window opposite. The painting is not of very high artistic quality; some of the details (especially the figure of the Holy Trinity) suggest that it can be stylistically classified as an early Baroque painting of the 1620s and 1630s.

The other, larger, painting, assumed to be of northern Italian origin from around 1600, [figure 6.4][56] depicts the mystical meeting of St. Ignatius with Christ in La Storta, actually the founding scene of the Jesuit order. Classical ruins in a darkened landscape frame the central group, with the outlines of a tower and the churches of Rome lit up in the background. God the Father, accompanied by angels, appears in clouds in the upper part. The group of Ignatius's companions is reduced to two not-particularly-visible figures at the right edge.

The second painting enjoyed considerable respect in the first half of the seventeenth century because it served as the original for two replicas: the first, signed by Jan Jiří Hering and dated to 1638, was made for the first church building at the Jesuit college in Hradec Králové,[57] and the second, overpainted significantly in the eighteenth century, is located in the side chapel of the college church in Olomouc. This one is also hypothetically linked with Hering and its origin is dated to 1621 or 1622 in light of the report that the altar was established in honor of this saint.

The existence of two paintings with a similar theme from approximately the same period in the St. Savior Church can be explained by one painting being a gift from a papal nuncio and the other linked with the establishment of the altar in honor of St. Ignatius in 1624. The next report comes as late as 1673, when the annual report of the Clementinum College records that Spinelli's painting was brought to the saint's chapel as a "hidden treasure" and placed in the "beautiful altar."[58]

The writer of the annual report from 1673 also mentions that on the occasion of the installation of Spinelli's painting on the altar a devotional book was published in the Czech language that contained one hundred miracles from the intercession of St. Ignatius. This was undoubtedly the *Swatý Ignatyus z Lojoly, zakladatel Towaryšstwa Pána Gežjsse* (St. Ignatius of Loyola, Founder of the Society of Lord Jesus), printed that year at the Clementinum college.[59] According to the annual report, the book reportedly contained a depiction of Spinelli's painting, although none is known from any of the preserved copies. The oldest known reproduction of the painting is on the title page of the devotional booklet *Spráwa o Obrazu S. Ignatiusya* (Report on the Painting of St. Ignatius) published in 1684 [figure 6.5]. Devotional engravings

were also made in later years as well as a small painted copy, located on the mensa of the side altar of St. Ignatius in the Jesuit church in Hradec Králové.[60]

The first print, *Swatý Ignatyus z Lojoly, zakladatel Towaryšstwa Pána Gežjsse*, mentions devoted worshippers of Spinelli's painting in an earlier period. St. Ignatius was generally known as a protector of pregnant women, mothers, and birth and it is therefore understandable why, after the painting was installed on the altar in 1673, the Jesuits focused on women when they handed out medallions and engravings depicting the saint.[61] These included women of renown, such as the countess of Salm, Maria Eusebia of Sternberg, wife of the count of Martinic, and Countess Marie Maximiliana of Hohenzollern-Sigmaringen, mentioned above, wife of the count of Sternberg.

Spinelli's painting acquired significant popularity due to the miracles which accompanied it. In the booklet *Swatý Ignatyus z Lojoly* from 1673, two incidents among others are mentioned that are also depicted on the decorated frame of the painting, which is dated to 1738; in the painting a nobleman on the left and a lady on the right both kneel and kiss the left hand of St. Ignatius. The first account, which contained the personal testimonial of the metropolitan canon Jan Ignác Dlouhoveský of Dlouhá Ves, occurred sometime prior to 1655, when an unnamed nobleman, who had earlier had negative feelings about the Jesuit order and St. Ignatius, honored the painting with a kiss as a sign of penitence:

> when he came closer to the painting of St. Ignatius, his left hand, painted on the image as if outstretched, was kissed [by the nobleman] with great veneration, and two strange things were recorded there. First that the hand which touched him was completely wet, . . . secondly that St. Ignatius reached his hand . . . out of the painting.[62]

A similar supernatural phenomenon, attributed from an earlier period, was experienced by a noblewoman (whose identity Dlouhoveský did not mention), who called upon the saint for a happy birth: "When she wanted, however, to kiss his hand as painted on the image, she couldn't because of the grating: and behold this holy man . . . (has) given an outstretched hand from the image to be kissed."[63]

A painting that "comes to life" and is able to communicate with viewers is a popular literary topos in many legends about miraculous paintings and sculptures.[64] This Prague case is quite similar to the legend connected with the altar image of St. Philip Neri by Guido Reni from 1614, which is located in the saint's burial chapel in the Roman church of Santa Maria in Vallicella.[65] St. Philip is depicted kneeling, with wide open arms, in the so-called *Ergebenheitsgestus* (gesture of surrender) that expresses complete

Figure 6.2 The vision of St. Ignatius in La Storta, oil on wood, unknown artist, Brno, Church of the Assumption of the Virgin Mary, 1606–1608.

submission to the power of God's mercy and will.[66] The subject of the saint's intense gaze is the Madonna with Jesus; the neutral background emphasizes the supernaturalness of the scene. There is also a similar account of the saint in the painting moving and blessing those present with his hand during a mass shortly after his canonization in 1622.

As Gerken says of Reni's painting, "since the hand, open out toward the viewer, practically goes beyond the picture frame," every monastic or believer who worshipped before Neri's grave would have felt included in the saint's intercessions.[67] This kind of depiction has to be viewed not only in the context of a mystical vision but also in connection with a pious

Figure 6.3 St. Ignatius' vision of the Trinity, oil on canvas, unknown painter, Prague, Old Town, Church of St. Savior, Chapel of St. Ignatius, early 17th century.

beholder because the saint calls for support from the highest authority with a gesture of his outstretched left hand. Such an interpretation is also valid for the Prague painting of St. Ignatius and it is also the key to understanding its wide popularity. The Baroque reproductions of this painting make it apparent that St. Ignatius had a crowned heart with pendants attached on his chest while his head and outstretched hand were similarly emphasized by halos.[68] The hand, specifically, was the center of attention for dedicated worshippers. By 1738, the newly installed marble retable was adapted so as to allow believers to approach the painting and venerate the hand of Ignatius with a kiss.[69]

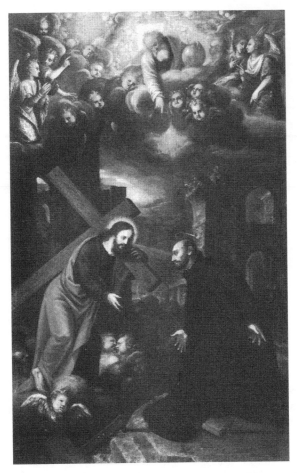

Figure 6.4 St. Ignatius' vision in La Storta, oil on canvas, unknown painter, Prague, Old Town, Church of St. Savior, Chapel of St. Ignatius, early 17th century.

Although it is clear that the second painting of the Vision in La Storta [figure 6.4] initially enjoyed considerable respect (see its replicas in Hradec Králové and Olomouc), the situation changed in the middle of the seventeenth century. The subject of the adoration became not an elaborate painting with a supernatural depiction of the beginning of the Society of Jesus, but the early Baroque painting simpler in composition, the subject of which is a simple adoration of the Holy Trinity by a saint [figure 6.3]. It was probably only then that the historical report of the gift of the papal nuncio was linked to this painting in order to emphasize its importance and legitimize it properly.

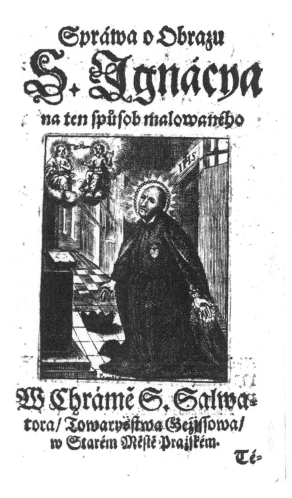

Figure 6.5 Front page of book *Spráwa o Obrazu S. Ignácya*, copper engraving on paper, 1684.

THE MIRACULOUS PAINTING OF ST. FRANCIS XAVIER IN THE ST. SAVIOR CHURCH IN PRAGUE

The annual reports of the Clementinum college in Prague make it apparent that veneration of Spinelli's painting of St. Ignatius rose and fell a number of times. During the 1730s, its fame was overshadowed by the miraculous painting *The Death of St. Francis Xavier*, which was venerated in the last chapel of the southern nave of the Savior church [figure 6.6].[70] The popularity of the cult of this painting experienced a massive rise and went far beyond the Clementinum college. The painting, commissioned specifically by the Jesuits

of the Old Town of Prague, was painted in 1733 by the Ljubljana painter Johann Michael Reinwaldt (ca. 1666–1740) as a copy of his own original from 1715, which was venerated in the pilgrimage chapel in Radmirje not far from Styrian Oberburg (Gornjigrad, today in Slovenia).[71] This pictorial "prototype" became a source of many miracles over a short period of time and provided a powerful impulse for the development of Xaverian piety in the wider region.

The first painting of the newly beatified Francis Xavier was exhibited in the chancel of the Savior church in Prague in 1610 and served as a counterpart to Spinelli's painting of St. Ignatius. It was commissioned by the Catholic nobleman Bedřich of Donín.[72] The altar proper consecrated to this saint in the final chapel of the southern nave was commissioned by Francis of Sternberg in 1646.[73] Almost ninety years later, at the beginning of the 1730s, the Old Town Jesuits viewed the existing cultic arrangement of the saint's chapel as insufficient for a growing Xaverian veneration. They therefore began a new initiative that included a painting by Reinwaldt. Its miraculous potential was guaranteed by a direct link with the famous original and its painter. According to similar stories about other creators of religious works, Reinwaldt successfully completed the work only after confessing, receiving Holy Communion, and fasting.[74] The original painting in Radmirje was ritually touched and received a blessing from the bishop of Ljubljana. After its move to Prague, it was supplied with a costly frame with Venetian glass (at a cost of 100 tolars) and exhibited for public worship in the St. Savior church.[75]

Along with the presentation of the painting in the Clementinum church, the Jesuits launched a massive media campaign that included a diverse network of colleges, patrons, supporters of the order, and simple believers. Francis's printed hagiography booklet, with a nine-day prayer attachment, was released in the Czech language (*typis vulgari*) that same year in a print run of three thousand pieces.[76] In addition, twelve thousand graphic reproductions of the miraculous painting were also distributed to propagate the faith. The annual report explicitly states that this was for "satisfying the increased piety of people, for the comfort of those who visit [the place] as well as to attract those who are not interested."[77] The preparation of the print plates was entrusted to an unnamed "famous artist," who cannot be identified owing to the great number of "true imitations" ("wahrhafte Abbildung") of the miraculous painting of St. Francis Xavier in the Savior church that were created over the course of the eighteenth century.[78]

The annual reports of the Clementinum college from the following years repeatedly report lengthy accounts of supernatural healing and help in need as well as listing votive gifts. The first miracles took place immediately after the exhibition of the painting in 1733; soldiers among the worshippers had leg pains treated by applying copper-engraving copies of the painting.[79] The

following year, the Old Town Jesuits distributed three thousand prints of a prayer to the saint and two thousand devotional books. The Ursulines at Hradčany (Prague) had a painted copy of the painting made for the side altar of their church and it became quite popular to place prints of paintings on sore parts of the body for healing.[80]

Thousands of First Fridays devotional books were printed in 1735 and two thousand booklets were distributed among worshippers of the painting. Magical practices linked to these images were also recorded for that year; believers used the images as a means of healing or took home water consecrated in the name of St. Francis that they used as medicine.[81] A dean in Mnichovice (not far from Prague) had an altar in the church made for a copy of the painting.[82] On November 29, 1735, the rector of the Clementinum college, Johannes Seidel, addressed a letter to the consistory of the Prague archbishopric requesting a commission to examine selected miracles attributed to the power of the painting and a declaration that it was miraculous.[83] The Jesuits repeated these requests again in August and September of the following year and they received the relevant decree on November 22, 1737.[84]

In 1736, the chapel was remodeled into an artistically unified Baroque interior that has been preserved until the present [figure 6.6]. The painting was moved to the newly established marble retable with allegorical statues of China and India, and a tabernacle made of gilded copper was added to the altar mensa.[85] References to Francis' missionary activity in the Far East in the form of heads of Indian natives are also apparent on the marble screen and the gilded heads of the pilasters. The interior is enhanced by the ceiling fresco by Václav Vavřinc Reiner of the Holy Trinity assisted by angels.[86] A devotional book in both Czech and German was also printed in the same year in a print run of two thousand, along with other printed materials with prayers to the saint.[87]

The Jesuits had twenty-three painted copies of the image made in the year 1737 alone, in addition to other paintings commissioned by various worshippers.[88] An unnamed Prague painter made an additional forty copies the following year. The renown of the painting now extended even beyond the borders of the Czech Lands; a certain unnamed Count Fugger sent some small valuables (*preciosa cimelia*) to Prague by courier to have them touched to the painting.[89] On the occasion of the feast of St. Francis Xavier an enormous replica of the miraculous painting, accompanied by allegorical figures of Bohemia and Styria, was hung in the Savior church under the cupola.[90]

Veneration of the painting of St. Francis Xavier continued to develop successfully, according to annual reports from the Clementinum college, which continued to repeat similar lists of cured persons and votive gifts and the number of devotionals printed. A number of painted copies commissioned by the Jesuits are preserved in churches of the order. One hangs on the wall in St. Barbara's church in Kutná Hora, a Jesuit church since the seventeenth

Figure 6.6 **Chapel of St. Francis Xavier with the painting of Death of St. Francis Xavier by Johann Michael Reinwaldt, Prague, Old Town, Church of St. Savior, established in 1736.**

century, and other copies are installed as altar paintings on the retables in the Jesuit church of the Assumption of the Virgin Mary in Brno and the pilgrimage church in Mariaschein (Bohosudov).[91] According to the annual reports, copies of this miraculous painting were even made by the Ursulines and the Servites at the Church of St. Michael in the Old Town.[92]

The annual reports indicate that the piety initiated by the Jesuits themselves tended to have a vernacular character, reflecting a pragmatic relationship of the

faithful with the painting as a refuge from the difficulties of life, despite the fact that the theme of the image itself did not necessarily lend itself to this kind of interpretation. This distinction becomes apparent compared to another focal point of the Xavier cult in Prague, the chapel of St. Francis Xavier at the Jesuit college in the New Town, established in 1660.[93] According to historical descriptions of the no-longer-extant decoration of the main and two side altars, the saint was presented on the altar images as a patron of the living, the dying, and the deceased. The Xaverian cult among the Jesuits in the New Town was markedly linked with *ars moriendi*—the final things of man and preparation for a good death.[94]

* * *

As seen in the individual cases of venerated images in the Czech Lands during the Baroque period, publicity and an effective media campaign linked with the expected performance of miracles were the greatest factors that determined the success of a cult. This is evidenced by the annual reports, which paid considerable attention to the miraculous images in the Czech province of the Jesuit Order. Devotional books, printed prayers, and numerous copies of the sacred image for the masses of believers were an effective means of communication. Painted copies ensured the establishment of local centers of the cult and helped spread it; costly temporary decorations of the church on the occasions of religious feasts and saints' days were an essential part of cult promotion. The Jesuits even went much further, actively promoting magical practices even though they contradicted the official teaching of the Catholic Church on the proper veneration of saints by means of images.

For an art historian, it may seem startling how the sophisticated conceptualization of a sacred painting as cultivated in the devotional handbooks of the Jesuit authors Jérôme Nadal, Antoine Suquet, and Johannes David is completely absent in the cases mentioned here,[95] but I do not think this means that in Central Europe the Tridentine theology of the image was ignored. Contemporary reports on the spiritual guidance of the particularly devoted noblewomen Františka Slavatová of Meggau and Maria Maxmiliana of Sternberg, as well as public responses to the visual arts (e.g., the case of the altarpiece by Jan Jiří Heinsch in the Church of St. Ignatius), confirm this. This phenomenon points particularly to the great difference between Jesuit devotional theory and practice. If the Jesuits wanted to succeed on a large scale, subtle Ignatian spirituality could not be applied in mass-shared piety. The pastoral practice of the time among the Jesuits for the majority of the population, without regard to social status or education (see the above examples of responses from both nobles and simple soldiers), was completely pragmatic and intellectually undemanding. The key role was played by the material essence of the sacred image and the possibility of physical contact

between the believer and the image, either in the form of kissing it or placing it on an injured or diseased part of the body. Given the cosmopolitan nature of the Jesuit order, similar devotional practices were also used in other cultural areas of their missionary activities.

NOTES

1. For a critical overview of the research see Levy, "Early Modern Jesuit Arts."

2. Bailey, *Art on the Jesuit Missions*; Kaufmann, *Toward a Geography of Art*, 239–271.

3. From the summary literature on the veneration of both saints of the order in the Czech Lands see the thematically focused proceedings on the veneration of St. Francis Xavier in Štěpánek, ed., *Svatý František Xaverský* as well as Holubová, "Strategie šíření," 343–362, and Andrle, "Sv. František Xaverský a jeho kult." On St. Ignatius, see Černý, "Sv. Ignác z Loyoly a Panna Marie Klatovská."

4. Goethe, "Venezianische Epigramme", in Goethe, *Gedichte*, epigram no. 15.

5. For an overview of the miracles ascribed to St. Francis Xavier in Opařany, see Hejna, *Paměti statků*, 56–57.

6. For a summary discussion of the decor in the Opařany church, see Kunešová and Mádl, "Malířská výzdoba."

7. Hall, *The Sacred Image*, 6–15.

8. On this phenomenon specifically see Kretzenbacher, *Das verletzte Kultbild.*.

9. See the case of the painting of *Jesus Christ as the Divine Mercy* painted based on a vision of St. Faustina Kowalska, first by Eugeniusz Kazimirowski (1934) and later by Adolf Hyła (1943 resp. 1944). Hyła's version, which spread on a mass scale thanks to copying, is viewed as the most widely distributed religious painting of the twentieth century, see Gaskell, "Jesus Christ."

10. Melion, "Introduction"; Levy, "Early Modern Jesuit Arts," 75–81; Bailey, "Italian Renaissance and Baroque Painting," Smith, *Sensuous Worship*; Bailey, "The Jesuits and Painting in Italy"; Pfeiffer, "The Iconography of the Society of Jesus"; Bailey, "Italian Renaissance and Baroque Painting under the Jesuits; Pfeiffer, "The Iconography of the Society of Jesus"; Smith, *Sensuous Worship*; Bailey, "The Jesuits and Painting in Italy, 1550–1690."

11. Funiok and Schöndorf, eds., *Ignatius von Loyola*; for the Czech environment, see Svatoš, "*Nova et vetera*: rétorika na jezuitských gymnáziích," 877–891; Bobková-Valentová, *Každodenní život učitele*.

12. Hecht, *Katholische Bildertheologie im Zeitalter von Gegenreformation und Barock*, 204–215, and Hecht, *Katholische Bildertheologie der frühen Neuzeit*, 274–284.

13. For the Czech environment, see Bobková-Valentová, *Každodenní život učitele*, 86–118; Jacková, *Divadlo jako škola ctnosti a zbožnosti*. The relationship between Jesuit theater and the imagery in Ignatius's *Spiritual Exercises* has been dealt with by Petr Polehla, *Jezuitské divadlo ve službě zbožnosti a vzdělanosti*.

14. Christelius, *Praecellens viduarum speculum fürtrefflicher Wittib-Spiegel*, 264–265, who also cited from the diary of the countess: "Heut von 1. Uhr bis halber zwey hab ich die Bilder auf dem Gang besucht und bei einem jeden gute Anmütungen erweckt allezeit mit Ehrerbittung die Füße geküßt und demütig Reverenz gemacht. Warbey mir die Zeit sehr bald hingangen; hab mich dareby recht wol befunden, ein aufgemuntertes Gemüt und innigliche Frölichkeit gehabt." Compare Kypta, *Zrcadlo nábožnosti a dobročinnosti*, 152–153, and also Valeš and Konečný, "Telč, moravská výspa pražského barokního malířství."

15. Balbinus, *Miscellanea Historica Regni Bohemiae*, 128: "*Imaginibus piis, sed maxime S. Veronicae tabulis mire afficiebatur, iisque plurimum, ut dolori suo pabulum daret, tenebatur; cubiculi partes omnes, imo et ipse, quo vehebatur, currus sacris imaginibus collucebat; . . .*" Compare Mikulec, "Barokní zbožnost v Balbínově době a díle," 44.

16. Procházka de Lauro, *Apoštolský učedlník a slavný Kristův*, A2/b; compare Vácha, *Imaginum elegantia*, 253.

17. Christelius (1694), 297: "O allmächtiger Gott! der du ja alles kannst und vermagst und ein Tausendkünstler bist, dem nichts unmöglich ist. Können nun die menschliche Künstler und Schnitzler aus einem groben ungeschickten Holz die schönste Bilder machen, wardurch auch Gott verehret wird; wie viel ehender und besser kannst du mein Barmherziger Gott! aus mir ungeschicktem groben Block und Stock ein Bild, ja ein liebwehrtes Bild, nach deinem Ebenbild und nach deinem Exempel, einen mit Tugenden gezierten Menschen machen."

18. "*Quia praecedens Imago multis, ac praesertim faeminis ob nuditatem nimiam quorundam personarum valde displacuit, curata est nova Gloriam Sancti Patris repraesentans, picta a Domino Joanne Heintsch Pragensium Pictorum facile nobilissimo.*" Vienna, Österreichische Nationalbibliothek (further ÖNB), Cod. 11998 (*Informationes et rationes triennales rectorum collegii Societatis Iesu ad S. Ignatium Neo-Pragae a. 1653–1750*), fol. 51v (written in 1690); compare Nevímová, "Novoměstská jezuitská kolej a kostel sv. Ignáce v Praze," 170 and 173.

19. In 1679, the rector of the New Town college, Václav Zimmermann, wrote with deserved pride about the thematically original concept of the first painting, "*Occurrit etiam notandum quod pro magna Imagine in magno Altari forte non male quadiaret pictura quae exprimeret S. Ignatium cum illo Quam sordet mihi terra dum Coelum auspicio. Posset enim formari elegans opus,*" Vienna, ÖNB, Cod. 11998, fol. 38v

20. Heinsch's painting survived the modernization of the interior in the eighteenth century and ended up finally used for the new altar retable, see Neumann, *Malířství XVII.*, 100, 121–122, cat. no. 48, pl. 112; see also Nevímová, "Novoměstská jezuitská kolej," 173, and Šroněk, *Jan Jiří Heinsch*, 160 (bibliography).

21. Summarizing the question of early paintings of both still-uncanonized saints in the Il Gesù, see König-Nordhoff, *Ignatius von Loyola*, 76–96, and Gerken, *Entstehung und Funktion*, 103–105 and 161–163.

22. Göttler, "Actio" in Paul, 16–17.

23. Osswald, "Die Entstehung einer Ikonographie," 65; see also Eckhard Schaar and Carlo Marattas "Tod des heiligen Franz Xaver im Gesù," 247–264.

24. On the annual reports of the Czech order province, see Bobková-Valentová, *Litterae annuae provinciae Bohemiae (1623–1755)*, 27–28.

25. Bobková-Valentová, *Litterae annuae provinciae Bohemiae* (1623–1755).

26. Compare Holubová, "Strategie šíření kultu," 347–348.

27. For example, Ourodová-Hronková, *Světecké obrazové cykly na jihu Čech*, 239–301, and Petra Nevímová, "Cyklus nástěnných maleb na chodbách pražského Klementina," in *Pocta Josefu*.

28. Sterba, "Vom Sichtbaren zum Unsichtbaren. Studien zur Visualisierung katholischer Dogmen in der Jesuitenkirche und der Fronleichnamkapelle der Stadt Olmütz in der heutigen Tschechischen Republik," PhD dissertation, 273.

29. Gerken, *Entstehung und Funktion*.

30. Ibidem, 10, 78, 101–105; see also König-Nordhoff, *Ignatius von Loyola*, 38–40; Levy, *Propaganda and the Jesuit Baroque*, 127–128.

31. Gerken, *Entstehung und Funktion*, 74–91.

32. Vyvlečka, *Příspěvky k dějinám kostela Panny Marie Sněžné v Olomouci*, 33, lists the building of the altars in honor of both Jesuit saints; Schmidl, *Historiae Societatis*, 277, makes only a reference to the altar of St. Ignatius commissioned by the cathedral provost, Václav Pillar of Pilch in 1621.

33. The altars are currently installed in the Jindřichův Hradec Church of St. John the Baptist, Poche, ed., *Umělecké památky Čech*, vol. 1, 615. On the construction of the chapel of St. Mary Magdalene recently, see Uličný et al., *Architektura Albrechta z Valdštejna*, 931–933.

34. This was mentioned by Schmidl, *Historiae Societatis Jesu*, 730, although Novák, "Slavatové a umění výtvarné," 18, and other authors following him argue for the building of the first altar as early as 1625.

35. Vey and Seghers, "A Vision of St. Ignatius of Loyola," 268–271; Bieneck, *Gerard Seghers (1591–1651). Leben und Werk*, 138–141.

36. Štroblová and Altová, eds., *Kutná Hora*, 418–419; Rollová, "'Arcularius' Jiří Ridel SJ (1639–1680)," 1378. The actual retables were made earlier, in 1675 and 1676, but the paintings were in all likelihood later replacements for works of lower quality. Compare the original paintings in the extension of the altar of Saint Francis.

37. On Heinsch's painting, see Šroněk, *Jan Jiří Heinsch*, 162 (bibliography).

38. Sterba, "Vom Sichtbaren zum Unsichtbaren," 273–291; Macháčková, *Jezuitská malířská kultura*, 25–30 and 68–99; Macháčková, The "Image" of the Jesuit Church of Our Lady of the Snow, 144.

Altrichter, Togner, and Hyhlík, *Olomouc. Univerzitní kostel Panny Marie Sněžné*, 17–18.

39. MZA, collection E 28 (Jesuits in Olomouc), cart. 45, inv. no. 5, *Diarium rectoris Collegii Olomucensis*, 1714–1726, here fol. 133v ("*utroque choro*"; 1. 1. 1720), fol. 219v ("*in choris Templi consueta votorum renovatio*," 1. 1. 1724). In a record about the renewal of the vows 1 January 1748, he even writes about "*choro veteranorum, ac juniorum*," idem, cart. 45, inv. no. 8, *Diarium rectoris Collegii Olomucensis*, 1745–1761, fol. 167r.

40. On the paintings in the chapel of St. Francis Xavier in particular, see Togner, *Jan Kryštof Handke (1694–1774)*, 34–35, no. 10 and 11.

41. The problematic character of this early dating and authorial designation has been pointed out by Opatrná "Umělecká tvorba malíře Jana Jiřího Heringa,"188, 198–199; compare Panoch, "Nad malířským dílem Jana Jiřího Heringa (1587–1648)," 97, and Mlčák, "Příspěvky k dějinám barokního malířství v," 321.

42. Fleming, "St. Ignatius of Loyola's 'Vision at La Storta,'" in *Foundation, Dedication and Consecration in Early Modern Europe*, 225–249.

43. Fleming, "St. Ignatius of Loyola's 'Vision at La Storta,'" 232, pl. 2 and 3; Pfeiffer, "The Iconography," 213.

44. Baumstark, in *Rom in Bayern. Kunst und Spiritualität der ersten Jesuiten*, 319–321, cat. no. 32; Niehoff, *Mit Kalkül & Leidenschaft: Inszenierungen*, 24–25, cat. no. 1.

45. Češková, "Jezuité a jejich mecenáši," 70–72; Češková, "Umělecké památky," 350–354.

46. Češková, "Umělecké památky," 355. Although Berka had close ties to the imperial court, the style of the painting cannot be clearly connected with any Rudolfine artist active at the court and it is also difficult to place it in the artistic context of Prague. See also Sykora, "Zwei Bilder in der ehemaligen Jesuiten-Kirche zu Brünn": 74–76.

47. The first mention of the painting of St. Ignatius as a gift from nuncio Spinelli is in the annual report from the year 1673 (see below). Compare Schmidl, *Historiae Societatis Jesu*, part 2, 315–316.

48. On the activity of Filipp Spinelli in the Czech Lands, see Stloukal, *Papežská politika a císařský dvůr*.

49. Schmidl, *Historiae Societatis Jesu*, part 2, 315.

50. Tomáš Černušák, The papal Nuntius Filippo Spinelli in Prague, *Paginae historiae* 31 (forthcoming).

51. Schmidl, 199–200 (the year 1599), also 290–291 (the year 1602).

52. Schmidl, *Historiae Societatis Jesu* (1749), 350–351 (year 1604). On Andreas Hannewald with respect to his commissioning activity, see Šroněk, "Johann Barvitius als Mäzen im rudolfinischen Prag," 54.

53. Schmidl, *Historiae Societatis Jesu* (1749), 394; the miraculous power of the painting is mentioned in connection with the years 1608 (p. 497) and 1612 (pp. 659–660). Compare Šroněk, *De sacris imaginibus*, 23.

54. Schmidl, *Historiae Societatis Jesu* (1754), 539.

55. Compare Opatrná, "Umělecká tvorba," 181–202; compare Panoch, "Nad malířským dílem," 95 and 97; see also Oulíková, *Klementinum*, 161.

56. Šroněk, *Pražští malíři 1600–1656*, 49.

57. Panoch, "Nad malířským dílem Jana Jiřího Heringa," 97; Hrubý and Panoch, eds., *Ke slávě Ducha*, 62–64, cat. no. 44, pl. 13 (catalogue entry by Panoch); Opatrná, *Umělecká tvorba malíře Jana Jiřího Heringa*, 187–188.

58. "*Posuerat priori saeculo, Eminentissimus Cardinalis Spinola perpetuum sui erga Beatum Ignatium affectus monumentum effigiem ejus peramabilem quae ad latus Epistolae arae primae in templo Salvatoris collocata clarere coepit plurimis praecipue in puerperas beneficiis, illustrari miraculis. Quare ne thesaurus hic lateret absconditus, ipso Sancti festo die, icon in speciosum altare inclusa, ad sacellum Sancti ejusdem Patriarchae translata est, et notior effecta centum miraculorum a*

P. Bartholo collectorum libello vernacula lingua S. Ignatii et una nostrae imaginis prodigia continente inter confluentes liberaliter disperso." Vienna, ÖNB, Cod. 11963 (*Litterae annuae*, 1670–1674), fol. 635rv.

59. Book record no. K01948 s.v. Dlouhoveský 1673. The metropolitan canon Jan Ignatius Dlouhoveský of Dlouhá Ves is only the author of the *Prawdiwá, upřímná a wěrná zpráwa a wyswědčení o obrazu S. Ignatiusya*, which introduces the account of one hundred miracles recorded by a Jesuit referred to in *Litterae annuae* as Bartholus (Vienna ÖNB, Cod. 11963 (*Litterae annuae*, 1670–1674), fol. 635rv). This is probably a reference to Bartolomeus Christelius (1624–1701), the author of a range of devotional books.

60. Zářecká, "Kulturně-historický vývoj jezuitské koleje a kostela Nanebevzetí Panny Marie v Hradci Králové (1636–1773)," 100–101; she incorrectly identifies the saint in the image as St. Francis Xavier. This mistaken identification was mentioned earlier by Kořán, "Umění a umělci baroka v Hradci Králové. Část první," 61, note 13, who, however (also mistakenly) identifies the author of the painting as J. J. Hering, as pointed out by Michal Šroněk, "Barokní malířství" 17. století v Čechách, 325.

61. Vienna, ÖNB, Cod. 11963, fol. 807v; compare ibidem, fol. 117v (1676[recte 1675]); fol. 130r (1676).

62. Dlouhoveský 1673. See note 58.

63. Ibid.

64. Kretzenbacher, *Das verletzte Kultbild*, compare also Gerken, *Entstehung und Funktion*, 120–134.

65. Gerken, *Entstehung und Funktion*, 133, 166–170.

66. Wiese and Otto, *Die religiösen Ausdrucksgebärden des Barock und ihre Vorbereitung durch die italienische Kunst der*, 5–28; Ohm, *Die Gebetsgebärden der Völker und das Christentum*, 252, 261–262.

67. Gerken, *Entstehung und Funktion*, 168.

68. Similarly, on the Brno painting of the *Mystical Vision of Saint Ignatius in La Storta* (fig. 6.4) halos were added around the heads of Christ and Ignatius and perforations from attached offerings were found when restoring the image. Miraculous cures and help during difficult births were attributed to the painting, see Češková, "Umělecké památky z doby kolem roku 1600 v jezuitském kostele Nanebevzetí Panny Marie v Brně," 350, and Sykora, "Zwei Bilder in der ehemaligen Jesuiten-Kirche zu Brünn," 75–76.

69. Vienna, ÖNB, Cod. 11976 (*Litterae annuae* 1735–1738), fol. 672r: "*Et ne liberior populo impediretur accessus, ad pium manus beneficae osculum, artifice dextera effectum est, ut pars arulae inferior pro sacrificio adaptata pro libitu commode amoveri, rursumque ut placuerit admoveri possit.*"

70. Oulíková, *Klementinum*, 162–163, refers briefly to the painting (inaccurately dating the exhibition of the painting in the church to 1734); see also Ekert, *Posvátná místa král. hl. města Prahy*, 377–378. Vlček et alii, *Umělecké památky Prahy. 1. díl: Staré Město. Josefov*, 113, the painting is mistakenly listed as possibly the work of Jan Jiří Hering from around 1630. This is also taken up by Jan Andrle, "Sv. František Xaverský a jeho kult," 19.

For details, see Vajchr, *Jména příběhu*, 444–453.

71. Friess and Gugitz, "Die Franz Xaver-Wallfahrt zu Oberburg. Eine untersteierische Barockkultstätte und die räumliche Reichweite ihres Einflusses," 83–140; Csatkai, "Beiträge zu den mitteleuropäischen Darstellungen des Todes des heiligen Franz Xaver im 17. und 18. Jahrhundert," 293–301.

72. Schmidl, *Historiae Societatis Jesu* (1749), 567.

73. Vienna, ÖNB, Cod. 11961 (*Litterae annuae 1636–1650*), fol. 380r: "[1646] . . . *cuius rei ara in sacello Bohemico D. Xaverii erecta, impensis 1500 imperialium Illustrissimi D. D. Francisci Liber. Baron. de Sternberg.*"

74. Vienna, ÖNB, Cod. 11975 (*Litterae annuae 1731–1734*), fol. 434v. On the concept of "the pious painter" (*pictor christianus*) in the Early Modern period, compare Wimböck, *Guido Reni (1575–1642): Funktion und Wirkung des religiösen Bildes*, 23–35.

75. Vienna, ÖNB, Cod. 11975, fol. 434v-435r.

76. Ibidem, fol. 434v. According to the *Knihopis* (electronic catalogue of Czech historical prints), there is no evidence for such a print for the year 1733. The closest in time is the prayerbook *Desátek Od dáwna schwálené Pobožnosti Ke Cti a Sláwě Swaté*[h]*o Frantisska* by Theodor Smackers, published by the printing house of the Old Town Jesuits in 1734 (Book record no. K01870). For more on the Xaverian nine-days prayers (*novenas*), see Holubová, "Strategie šíření kultu," 345–346.

77. Vienna, ÖNB, Cod. 11975, fol. 435r: "*Ad majus insuper populi, devotionem frequentantis solatium, aut ignorantis illicium sculpitur a praeclaro artifice juxta ectypon vera Sancti effigies hic subinde distribuenda, . . .*"

78. A significant number of devotional engravings with Saint Francis Xavier that follow Reinwaldt's painting are held in the graphics collection in the Strahov library Prague.

79. For curative and therapeutic effect of cult images, see Gage, *Painting as Medicine in Early Modern Rome: Giulio Mancini and the Efficacy of Art*, 6–8.

80. Vienna, ÖNB, Cod. 11975, fol. 600r-602r.

81. Vienna, ÖNB, Cod. 11976 (*Litterae annuae 1735–1738*), fol. 118v-119v.

82. Ibidem, fol. 120r-120v; compare Podlaha, *Posvátná místa království Českého. Arcidiecéze Pražská. Díl I. Vikariáty: Českobrodský, Černokostelecký, Mnichovický a Prosecký*, 182.

83. Prague, National Archive, collection of the Archive of the Prague Archbishopric, cart. 1240, sign. D 19, fasc. XI/1735. A selection of miracles are included in the request. There is also a reference to the request submitted to the Prague consistory in the annals of the Clementinum for that same year. Venna, ÖNB, Cod. 11976, fol. 121r.

84. See the letters of the church preacher Klement Winter registered on August 28 and September 12, 1736, and another one, signed by him but undated in the Prague National Archive, collection of the Archive of the Prague Archbishopric, cart. 1240, sign. D 19, fasc. XI/1735. The actual decree could not be found, but its issue is explicitly stated on a nine-night-prayers engraving by the Prague engraving family Müller (the graphics collection in the Strahov library Prague, sign. GS 12971).

85. Vienna, ÖNB, Cod. 11976, fol. 291v: "*Celebratum est hoc festum more praecipuarum* [. . .], *araque nova marmorea, parergis*[?], *et statuis plene deauratis pretiose decorata, quam* Ill[ustrissi]mus *ac* R[everen]d[issi]*mus D.D. Celsissimi Archi-Praesulis Nostri Suffraganeus pridie festi ritu solenni consecravit. Eminet in hac ara ad tenerrimam Xaverophilorum devotionem sub vitro veneto positus, ad normam Oberburgensis Iconis amabilissime effigiatus moriens Xaverius, qui in dies magis, magisque beneficiis inclarescit.*" On the tabernacle, see ibidem, fol. 293r. There is a reference to the almost-completed altar ("*nova ara, jam pene perfecta*") in a letter of Klement Winter on August 28, 1736.

86. Preiss, *Václav Vavřinec Reiner*, 755 and 1003–1004, dates Reiner's fresco to 1734–1735, which was also taken up by Oulíková, *Klementinum*, 163, who interprets the scene as the saint's soul being accepted into heaven.

87. Vienna, ÖNB, Cod. 11976, fol. 293v.

88. Ibidem, fol. 478r.

89. Ibidem, fol. 677r.

90. Ibidem, fol. 674v.

91. Šeferisová-Loudová and Kroupa, "Kláštery ve městě II. (severní část)," 450, and Drbalová, "*Ad maiorem Dei gloriam*, 58–59 (having no knowledge of the Prague model) mistakenly dates the painting to the period after 1671 following the building of the chapel. Adaptations to the interior of the chapel took place around 1744, when the painting was probably painted—compare Samek, *Umělecké památky Moravy a Slezska 1. A–I*, 201–202.

92. Vienna, ÖNB, Cod. 11976 (*Litterae annuae* 1735–1738), fol. 293v (year 1736).

93. Oulíková, "Bývalá kaple sv. Františka Xaverského na Novém Městě pražském," 547–556, and "Deset misijních let sv. Františka Xaverského ve výtvarném umění, in *Svatý*," 154–160.

94. See Knihopis no. K13968 and K13967.

95. Compare Melion, "Introduction: The Jesuit Engagement with the Status and Functions of the Visual Image," 1–49.

BIBLIOGRAPHY

Manuscript and Archival Sources

Austrian National Library, Vienna [Österreichische Nationalbibliothek Wien (ÖNB)]:
Informationes et rationes triennales rectorum collegii Societatis Iesu ad S. Ignatium Neo-Pragae a. 1653–1750, Vienna, ÖNB, Cod. 11998.
Litterae annuae 1636–1650, Vienna, ÖNB, Cod. 11961.
Litterae annuae, 1670–1674, Vienna, ÖNB, Cod. 11963.
Litterae annuae 1731–1734, Vienna, ÖNB, Cod. 11975.
Litterae annuae 1735–1738, Vienna, ÖNB, Cod. 11976.
Moravian Land Archive [Moravský zemský archiv v Brně (MZA)], collection E 28 (Jesuits in Olomouc):

MZA, collection E 28 (Jesuits in Olomouc), cart. 45, inv. no. 5, *Diarium rectoris Collegii Olomucensis, 1714–1726.*

MZA, collection E 28 (Jesuits in Olomouc), cart. 45, inv. no. 8, *Diarium rectoris Collegii Olomucensis, 1745–1761.*

National Archive Prague [Národní archiv v Praze, (NA)]:

Prague National Archive, collection of the Archive of the Prague Archbishopric, cart. 1240, sign. D 19, fasc. XI/1735.

Strahov library Prague [Knihovna Královské kanonie premonstrátů na Strahově]: Graphic collection, sign. GS 12971.

Primary Sources

Bohuslaus, Balbinus. *Miscellanea Historica Regni Bohemiae Decadis I. Liber IV. Hagiographicus seu Bohemia Sancta.* Prague: Typis Georgii Czernoch, 1682.

Christelius, Bartholomaeus. *Praecellens viduarum speculum fürtrefflicher Wittib-Spiegel.* Brno: František Ignác Sinapi, 1694.

Dlauhoveský de Longa Villa, Jan Ignác. *Swatý Ignácyus z Lojoly / Zakladatel Towaryšstwa Pána Gežjsse / Před y po smrti zázraky sľawný / zwľásstě pak pracugjcých ku porodu a maľých dětj Diwotworný Zástupce.* Prague: w Ympressy Universitatis Carolo-Ferdinand: w Kollegi Towaryšstwa Gežjssowa, 1673.

Dlauhoveský de Longa Villa, Jan Ignác. *Spráwa o Obrazu S. Ignácya na ten spůsob malowaného W Chrámě S. Salwatora / Towaryšstwa Gežjssowa / W Starém Městě Pražském.* [rub tit. l.] *Témuž Kosteľu / od Kardinaľa Filipa Sspinella v Cýsaře Rudolffa Druhého Legata Aposstolského / před Lety darowánem A nynj w Kaple S. Jgnácya dotčeného Kostela k obecné Pobožnosti postaweném.* Prague: w Ympressy Universitatis Carolo-Ferdinand: w Kollegi Towaryšstwa Gežjssowa, 1684.

Gabriele Paleotti. 1582 (1961). *Discorso intorno alle imagini sacre e profane, Bologna 1582,* reprinted In *Trattati d'arte del Cinquecento. Fra Manierismo e Controriforma, vol. 2, Gilio – Paleotti – Aldrovandi,* edited by Paola Barocchi. Bari: Laterza, 1961. (Scrittori d'Italia 221).

Procházka de Lauro, Jiří František. *Apoštolský učedlník a slavný Kristův Mučedlník S. Apollináriš biskup ravennátský v starožitném collegiálním a kanovnickým chrámě pod tím jménem a titulem v královském Novém Městě Pražském na hoře Větrově zdáwna založeném v podobenství krásné a jasné od první velikosti nemnoho vzdálené hvězdy při vejroční téhož svatého památce krátkou řeči představený.* Prague: u Jana Julia Geřábka, 1736.

Schmidl, Joannes. *Historiae Societatis Jesu Provinciae Bohemiae Pars II.: Ab Anno Christi MDXCIII. ad Annum MDCXV.* Prague: Typis Universitatis Carolo-Ferdinandeæ in Collegio S. J. ad S. Clementem, per Jacobum Schweiger Factorem. 1749.

Schmidl, Joannes. *Historiae Societatis Jesu Provinciae Bohemiae Pars III.: Ab Anno Christi MDXCVI. ad Annum MDCXXXII.* Prague: Typis Universitatis Carolo-Ferdinandeæ in Collegio S. J. ad S. Clementem, per Jacobum Schweiger Factorem. 1754.

Schmidl, Joannes. *Historiae Societatis Jesu Provinciae Bohemiae Pars IV.: Ab Anno Christi MDCXXXXIII. usque ad Annum MDCLIII*, vol. 1. Prague: Typis Academicis per Joannem Georgium Schneider factorem, 1759.

Secondary Studies

Altrichter, Michal, Milan Togner, and Vladimír Hyhlík. *Olomouc. Univerzitní kostel Panny Marie Sněžné*. Velehrad: Historická společnost Starý Velehrad, 2000.

Andrle, Jan. "Sv. František Xaverský a jeho kult." In *Františku nebeský, vyslanče přesmořský. Podoby úcty k sv. Františku Xaverskému v českých textech 17. a 18. století*, edited by Alena A. Fidlerová and Jan Andrle, 5–28. Příbram: Pistorius & Olšanská, 2010.

Appuhn-Radtke, Sibylle. *Visuelle Medien im Dienst der Gesellschaft Jesu. Johann Christoph Storer (1620–1671) als Maler der katholischen Reform*. Regensburg: Schnell + Steiner, 2000.

Bailey, Gauvin Alexander. "'Le style jésuite n'existe pas.' Jesuit Corporate Culture and the Visual Arts." In *The Jesuits. Cultures, Sciences, and the Arts. 1540–1773*, edited by John W. O'Malley, Gauvin Alexander Bailey, Steven J. Harris, and T. Frank Kennedy, 38–89. Toronto: University of Toronto Press,1999.

Bailey, Gauvin Alexander. "Italian Renaissance and Baroque Painting under the Jesuits and its Legacy throughout Catholic Europe." In *The Jesuits and the Arts, 1540–1773*, edited by John W. O'Malley and Gauvin Alexander Bailey, 125–198. Philadelphia: Saint Joseph's University Press, 2005.

Bailey, Gauvin Alexander. "The Jesuits and Painting in Italy, 1550–1690: The Art of Catholic Reform." In *Saints & Sinners: Caravaggio & the Baroque Image*, edited by Franco Mormando, 151–178. Chicago and London: University of Chicago Press, 1999.

Bailey, Gauvin Alexander. *Art on the Jesuit Missions in Asia and Latin America, 1542–1773*. Toronto: University of Toronto Press, 1999.

Baumstark, Reinhold, ed. *Rom in Bayern. Kunst und Spiritualität der ersten Jesuiten*. Munich: Hirmer Verlag, 1997.

Baumstark, Reinhold, Frank Büttner, Markus Dekiert, Andrea Gottdang, eds. *Ulrich Loth: zwischen Caravaggio und Rubens*. Munich: Hatje Cantz, 2008.

Bedřich, Martin. "Vizualizace v barokní literatuře." *Česká literatura – časopis pro literární vědu* 57 (2009): 469–485.

Belting, Hans. *Bild und Kult. Eine Geschichte des Bildes vor dem Zeitalter der Kunst*, 2nd ed. Munich: Verlag C. H. Beck, 2000 (2nd revised edition).

Bobková-Valentová, Kateřina. "*Litterae annuae provinciae Bohemiae* (1623–1755)." *Folia Historica Bohemica* 25 (2010): 23–49.

Bobková-Valentová, Kateřina. *Každodenní život učitele a žáka jezuitského gymnázia* Prague: Karolinum, 2006.

Catellani, Andrea. "Before the Preludes: Some Semiotic Observations on Vision, Meditation, and the 'Fifth Space' in Early Jesuit Spiritual Illustrated Literature." In *Ut pictura meditatio: The Meditative Image in Northern Art, 1500–1700*, edited

by Walter S. Melion, Ralph Dekoninck, and Agnes Guiderdoni-Brusl, 157–202. Turnhout: Brepols, 2012.

Černý, Karel. "Sv. Ignác z Loyoly a Panna Marie Klatovská jako zdroje milosti." *Barokní jezuitské Klatovy. Sborník textů ze sympozia v Klatovech 27.–29. dubna 2007* (2007): 23–31.

Češková, Lenka. "Jezuité a jejich mecenáši při výstavbě a výzdobě kostela Nanebevzetí Panny Marie v Brně kolem roku 1600." In *Jezuité a Brno. Sociální a kulturní interakce koleje a města (1578–1773)*, edited by Hana Jordánková and Vladimír Maňas, 21–75. Brno: Statutární město Brno, Archiv města Brna, 2013.

Češková, Lenka. "Umělecké památky z doby kolem roku 1600 v jezuitském kostele Nanebevzetí Panny Marie v Brně." *Zprávy památkové péče* 72 (2012): 344–355.

Csatkai, André. "Beiträge zu den mitteleuropäischen Darstellungen des Todes des heiligen Franz Xaver im 17. und 18. Jahrhundert." *Acta historiae artium Academiae Scientiarum Hungaricae* 15 (1969): 293–301.

Danto, Arthur Coleman. Review of: David Freedberg, *The Power of Images. Studies in the History and Theory of Response* (Chicago: University of Chicago Press, 1989). *The Art Bulletin* 72 (1990): 341–342.

Dobalová, Sylva. "Pašijový cyklus." In *Karel Škréta. 1610–1674. Doba a dílo*, cat. exhibition, edited by Lenka Stolárová and Vít Vlnas, 311–339. Prague: Národní galerie v Praze, 2010.

Dobalová, Sylva. *Pašijový cyklus Karla Škréty. Mezi výtvarnou tradicí a jezuitskou spiritualitou*. Prague: Nakladatelství Lidové noviny, 2004.

Dolejší, Kateřina "'Naše zvědavé století se chce bavit novotou a nenadálou krásou.' Symboly ilustrované barokní tisky olomouckých jezuitů." PhD dissertation, Masaryk University in Brno, [Brno], 2013.

Ekert, František. *Posvátná místa král. hl. města Prahy. Dějiny a popsání chrámů, kaplí, posvátných soch, klášterů i jiných pomníků katolické víry a náboženosti v hlavním městě království Českého*, vols. 1–2. Prague: Dědictví sv. Jana Nepomuckého, 1883 and 1884.

Feigenbaum, Gail, and Sybille Ebert-Schifferer, eds. *Sacred Possessions. Collecting Italian Religious Art, 1500–1900*. Los Angeles: Getty Research Institute, 2011.

Fleming, Alison C. "St Ignatius of Loyola's 'Vision at La Storta' and the Foundation of the Society of Jesus." In *Foundation, Dedication and Consecration in Early Modern Europe*, edited by Maarten Delbeke and Minou Schraven, 225–249. Leiden: Brill, 2012.

Freedberg, David. *The Power of Images. Studies in the History and Theory of Response*. Chicago: University of Chicago Press, 1991.

Friess, Edmund, and Gustav Gugitz. "Die Franz Xaver-Wallfahrt zu Oberburg. Eine untersteierische Barockkultstätte und die räumliche Reichweite ihres Einflusses." *Österreichische Zeitschrift für Volkskunde* 61, n. s. (1958): 83–140.

Funiok, Rüdiger, and Harald Schöndorf, eds. *Ignatius von Loyola und die Pädagogik der Jesuiten: ein Modell für Schule und Persönlichkeitsbildung*. Frankfurt am Main: Peter Lang, 2017.

Gaehtgens, Thomas W. "Historienmalerei. Zur Geschichte einer klassischen Bildgattung und ihrer Theorie." In *Historienmalerei. Geschichte der klassischen*

Bildgattungen in Quellentexten und Kommentaren, vol. 1, edited by Thomas W. Gaehtgens and Uwe Fleckner. Berlin: Dietrich *Reimer Verlag*, 1996.

Gaskell, Ivan. "Jesus Christ as the Divine Mercy by Eugeniusz Kazimirowski. The Most Influential Polish Painting of the Twentieth Century?" *Ars* 42 (2009): 81–93.

Gerken, Claudia. *Entstehung und Funktion von Heiligenbildern im nachtridentinischen Italien (1588–1622)*. Petersberg: Michael Imhof Verlag, 2015.

Goethe, [Johann Wolfgang], *Gedichte*, ed. Erich Trunz, 16th ed., Munich: C. H. Beck, 1996.

Göttler, Gabriele. "'Actio' in Peter Paul Rubens' Hochaltarbildern für die Jesuitenkirche in Antwerpen." In *Barocke Inszenierung: Akten des internationalen Forschungscolloquiums an der Technischen Universität Berlin, 20.–22. Juni 1996*, edited by Joseph Imorde, 10–31. Emsdetten: Ed. Imorde, 1999.

Hall, Marcia B. *The Sacred Image in the Age of Art. Titian, Tintoretto, Barocci, El Greco, Caravaggio*. New Haven: Yale University Press, 2011.

Hanke, Jiří. "Olomoučtí jezuité a svatí." In *Bohemia Jesuitica 1556–2006*, edited by Petronilla Čemus, vol. 1, 419–429, Prague: Karolinum, 2010.

Hecht, Christian. "Das Bild am Altar. Altarbild – Einsatzbild und Rahmenbild – Vorsatzbild." In *Format und Rahmen. Vom Mittelalter bis zur Neuzeit*, edited by Hans Körner, and Karl Möseneder, 127–143. Berlin: Dietrich Reimer, 2008.

Hecht, Christian. "Das katholische Retabel im Zeitalter von 'Gegenreformation' und Barock." *Das Münster* 61 (2008): 323–328.

Hecht, Christian. *Katholische Bildertheologie der frühen Neuzeit. Studien zu Traktaten von Johannes Molanus, Gabriele Paleotti und anderen Autoren*, 2nd ed. Berlin: Gebrüder Mann, 2012.

Hecht, Christian. *Katholische Bildertheologie im Zeitalter von Gegenreformation und Barock: Studien zu Traktaten von Johannes Molanus, Gabriele Paleotti und anderen Autoren*. Berlin: Gebrüder Mann, 1997.

Hejna, Josef. *Paměti statků: Opařanského, Podbořského, Dobronického a Stadleckého*. Tábor: J. Hejna, 1885.

Herold, Miroslav. "Klatovský kostel Neposkvrněného početí Panny Marie a sv. Ignáce z Loyoly. Příběh jedné stavby Tovaryšstva Ježíšova (1656–1773)." In *Barokní jezuitské Klatovy. Sborník textů ze sympozia v Klatovech 27.–29. dubna 2007*, edited by Karel Mráz and Václav Chroust, 111–160. Klatovy: Klatovské katakomby, 2007.

Hess, Günter. "Die Kunst der Imagination. Jacob Bidermanns Epigramme im ikonographischen System der Gegenreformation." In *Der Tod des Seneca. Studien zur Kunst der Imagination in Texten und Bildern des 17. und 18. Jahrhunderts*, edited by Günter Hess, 49–72. Regensburg, 2009.

Holubová, Markéta. "Strategie šíření kultu sv. Františka Xaverského v prostoru regionu vymezeného působením jezuitské koleje v Telči." *Český lid* 106 (2019): 343–362.

Hrubý, Vladimír, and Pavel Panoch, eds. *Ke slávě Ducha. Sedm století církevního výtvarného umění v královéhradecké diecézi*. Pardubice: Východočeská galerie v Pardubicích, 2003.

Jacková, Magdaléna. *Divadlo jako škola cnosti a zbožnosti: jezuitské školské drama v Praze v první polovině 18. století*. Prague: Filozofická fakulta Univerzity Karlovy, 2011.

Jakubec, Ondřej. "'Je třeba vyvarovat se veškeré necudnosti.' Cenzurní zásahy jezuitů v tiscích Emblematum liber." In *Pictura verba cupit. Sborník příspěvků pro Lubomíra Konečného*, edited by Beket Bukovinská and Lubomír Slavíček, 257–269. Prague: Aretfactum, 2006.

Jakubec, Ondřej. "Modalita a konfesionalita sakrálních staveb v českých zemích 16. a počátku.a počátku 17. století." In *In puncto religionis. Konfesní dimenze předbělohorské kultury Čecha Moravy*, edited by Kateřina Horníčková and Michal Šroněk, 49–72. Prague: Artefactum, 2014.

Jakubec, Ondřej. "Obraz Salus Populi Romani u brněnských jezuitů a obraznost potridentského katolicismu na předbělohorské Moravě." In *Jezuité a Brno. Sociální a kulturní interakce koleje a města (1578–1773)*, edited by Hana Jordánková and Vladimír Maňas, 77–98. Brno: Statutární město Brno, Archiv města Brna, 2013.

Jakubec, Ondřej. "Olomoucký jezuitský kostel a protimorový kult P. Marie Sněžné. Ondřej Jakubec." In *Olomoucké baroko. Výtvarná kultura z let 1620–1780. 1. Úvodní svazek. Proměny ambicí jednoho města*, edited by Martin Elbel and Ondřej Jakubec, 150–156. Olomouc: Muzeum umění Olomouc, 2010.

Jakubec, Ondřej. *Kde jest, ó smrti, osten tvůj? Renesanční epitafy v kultuře umírání a vzpomínání raného novověku*. Praha: Nakladatelství Lidové noviny, 2015.

Kaufmann, Thomas DaCosta. *Toward a Geography of Art*. Chicago and London: The University of Chicago Press, 2004.

Konečný, Lubomír. "The Emblem Theory and Practice of Bohuslav Balbín, S. J." In *In Nocte Consilium. Studies in Emblematics in Honor of Pedro F. Campa*, edited by John T. Cull and Peter M. Daly, 223–238. Baden-Baden: Koerner, 2011.

Konečný, Lubomír, Karel Škréta, and Francois Le Roy, SJ. "Almost a Detective Story." *Bulletin of the National Gallery in Prague* 10 (2001): 27–35; 87–92.

König-Nordhoff, Ursula. *Ignatius von Loyola. Studien zur Entwicklung einer neuen Heiligen-Ikonographie im Rahmen einer Kanonisationskampagne um 1600*. Berlin: Gebrüder Mann, 1982.

Kořán, Ivo. "Umění a umělci baroka v Hradci Králové." Part 1, *Umění* 19 (1971): 35–69.

Kretzenbacher, Leopold. *Das verletzte Kultbild. Voraussetzungen, Zeitschichten und Aussagewandel eines abendländischen Legendentypus*. Munich: Bayerischen Akademie der Wissenschaften, 1977.

Kunešová, Jana, and Martin Mádl. "Malířská výzdoba jezuitské rezidence a kostela sv. Františka Xaverského v Opařanech." *Památky jižních Čech* 2 (2009): 87–120.

Kypta, Jan Evangelista. *Zrcadlo nábožnosti a dobročinnosti, čili Život Františky, hraběnky Slavatové, rozené hraběnky z Meggawů, vdovy a paní na Jindřichově Hradci a Telči*. Jindřichův Hradec and Tábor: Aloisius Landfrass, 1862.

Levy, Evonne. "Early Modern Jesuit Arts and Jesuit Visual Culture." *Journal of Jesuit Studies* 1 (2014): 66–87.

Levy, Evonne. "Jesuit Architecture Worldwide: A Culture of Corporate Invention." In *Companions to the History of Architecture, Vol. 1: Renaissance and Baroque Architecture*, edited by Harry Francis Mallgrave, 340–372. Chichester, Malden, MA and Oxford: Wiley Blackwell, 2017.

Levy, Evonne. *Propaganda and the Jesuit Baroque.* Berkeley: University of California Press, 2004.

Linka, Jan. "Rozjímání iuxta morem Societatis v české provincii Tovaryšstva Ježíšova aneb Lanciciovo století (1636–1739)." *Folia Historica Bohemica* 26 (2011): 57–75.

Macháčková, Jana. "Jezuitská malířská kultura na Moravě. Obraz ve vizuální kultuře olomouckých jezuitů." MA thesis. Palacký University, Olomouc, 2013.

Macháčková, Jana. "Obrazy v bočních kaplích jezuitského kostela P. Marie Sněžné v Olomouci: vztah k ikonografickému programu chrámu." *Zprávy Vlastivědného muzea v Olomouci: společenské vědy* 306 (2013): 89–102.

Macháčková, Jana. "The 'Image' of the Jesuit Church of Our Lady of the Snow in Olomouc: Rome – Vienna – Wroclaw – Artistic Connections." In *Cultural Transfer: umělecká výměna mezi Itálií a střední Evropou*, edited by Magdaléna Nová and Marie Opatrná, 141–146. Sborník příspěvků mezinárodní konference studentů doktorských studijních programů, Prague: Univerzita Karlova v Praze, Katolická teologická fakulta, 2014.

Machalíková, Pavla. "The Sacred Image in Bohemia in the First Third of the 19th Century." *Umění* 62 (2014): 529–551.

Mai, Ekkehard. "Historia! – Von der Figurenmalerei in Theorie und Praxis seit dem 16. Jahrhundert." In *Triumph und Tod des Helden: europäische Historienmalerei von Rubens bis Manet*, edited by Ekkehard Mai and Anke Repp-Eckert, 15–29. Mailand: Electa, 1988.

Malura, Jan. "Působení na smysly v meditativních textech české barokní literatury." In *Wielkie tematy kultury w literaturach słowiańskich,* edited by Małgorzata Filipek, Ilona Gwóźdź-Szewczenko, Joanna Kula, Anna Paszkiewicz, Jadwiga Skowron, 261–271. Wrocław: University of Wrocław, 2015.

Malura, Jan. *Meditace a modlitba v literatuře raného novověku.* Ostrava: Ostravská univerzita v Ostravě, 2015.

Malý, Tomáš, and Pavel Suchánek. "Mezi realitou a symbolem: k historické interpretaci (barokního) ztvárnění očistce." *Opuscula historiae artium* 53 (2009): 53–82.

Malý, Tomáš, and Pavel Suchánek. *Obrazy očistce. Studie o barokní imaginaci.* Brno: Matice moravská, 2013.

Melion, Walter S. "Introduction: The Jesuit Engagement with the Status and Functions of the Visual Image." In *Jesuit Image Theory*, edited by Wietse de Boer, Karl A. E. Enenkel, and Walter S. Melion, 1–49. Leiden: Brill, 2016.

Mikulec, Jiří. "Barokní zbožnost v Balbínově době a díle." In *Dělám to k větší slávě Boží a chvále vlasti. Bohuslav Balbín a jeho doba. Barokní jezuitské Klatovy 2014 – sborník příspěvků*, edited by Alena Bočková et al., 35–48. Klatovy: Město Klatovy, 2014.

Mlčák, Leoš. "Příspěvky k dějinám barokního malířství v Olomouci (Jan Jiří Hering, Jan Jiří Heinsch, Jan Kryštof Handke, Josef Ignác Sadler)." *Zprávy památkové péče* 55 (1995): 321–324.

Neumann, Jaromír. *Malířství XVII. století v Čechách. Barokní realismus.* Prague: Orbis, 1951.

Nevímová, Petra. "Ikonografický program původní výzdoby jezuitského kostela sv. Ignáce v Praze na Novém Městě." *Umění* 45 (1997): 186–201.

Nevímová, Petra. "Cyklus nástěnných maleb na chodbách pražského Klementina." In *Pocta Josefu Kollmannovi. Sborník k životnímu jubileu,* edited by Alena Pazderová, 214–227. Prague: Státní ústřední archiv, 2002.

Nevímová, Petra. "Funkce obrazu v umění jezuitského řádu." In *Dějiny umění v české společnosti: otázky, problémy, výzvy. Příspěvky přednesené na Prvním sjezdu českých historiků umění,* edited by Milena Bartlová, 107–115. Prague: Argo, 2004.

Nevímová, Petra. "Novoměstská jezuitská kolej a kostel sv. Ignáce v Praze." *Pražský sborník historický* 30 (1998): 151–186.

Nevímová, Petra. "Vliv Spirituality Tovaryšstva Ježíšova na výzdobné programy řádových kostelů." In *Úloha církevních řádů při pobělohorské rekatolizaci. Sborník příspěvků z pracovního semináře ve Vranově u Brna ve dnech 4.–5. 6. 2003,* edited by Ivana Čornejová, 217–249. Prague: Univerzita Karlova, Ústav dějin Univerzity Karlovy – Archiv Univerzity Karlovy, 2003.

Niedermeier, Nina. "The Artist's Memory: How to Make the Image of the Dead Saint Similar to the Living: The 'Vera Effigies' of Ignatius of Loyola." *Horti Hesperidum* 5 (2015): 157–199.

Niehoff, Franz, ed. *Mit Kalkül & Leidenschaft: Inszenierungen des Heiligen in der bayerischen Barockmalerei,* vol. 2: Katalog. Landshut: Museen der Stadt Landshut, 2004.

Novák, Josef. "Slavatové a umění výtvarné." *Památky archaeologické a místopisné* 29 (1917): 17–36.

Ohm, Thomas. *Die Gebetsgebärden der Völker und das Christentum.* Leiden: Brill, 1948.

Opatrná, Marie. "Umělecká tvorba malíře Jana Jiřího Heringa." BA thesis Charles University. Prague, 2011.

Osswald, Maria Cristina. "Die Entstehung einer Ikonographie des Franz Xaver im Kontext seiner kultischen Verehrung in den Jahren von 1552 bis 1640." In *Franz Xaver – Patron der Missionen. Festschrift zum 450. Todestag,* edited by Rita Haub and Peter Hamm, 60–80. Regensburg: Schnell + Steiner, 2002.

Oulíková, Petra. "Barocke Konzepte, Entwürfe und Beschreibungen von Wandmalereien in den Jesuitenkirchen und -Kollegien der Böhmischen Jesuitenprovinz." *Ars* 47 (2014): 16–25.

Oulíková, Petra. "Bývalá kaple sv. Františka Xaverského na Novém Městě pražském." In *Všechno je milost. Sborník k poctě 80. narozenin Ludvíka Armbrustera,* edited by Vojtěch Novotný, 547–556. Prague: Karolinum, 2008.

Oulíková, Petra. "Deset misijních let sv. Františka Xaverského ve výtvarném umění." In *Svatý František Xaverský a jezuitská kultura v českých zemích,* edited by Pavel Štěpánek, 154–160. Olomouc: Univerzita Palackého v Olomouci, 2014.

Oulíková, Petra. "Obrazové cykly v jezuitských řádových domech." In *Locus pietatis et vitae. Sborník příspěvků z konference konané v Hejnicích ve dnech 13.–15. září 2007,* edited by Ivana Čornejová, Hedvika Kuchařová, and Kateřina Valentová, 435–446. Prague: Univerzita Karlova v Praze and Scriptorium, 2008.

Oulíková, Petra. "Poznámka k jezuitským sousoším na Karlově mostě." In *Obrazy uctívané, obdivované a interpretované. Sborník k 60. narozeninám profesora*

Jana Royta, edited by Miroslav Šmied and František Záruba, 381–396. Prague: Nakladatelství Lidové noviny, 2015.

Oulíková, Petra. "Poznámka k Pašijovému cyklu Karla Škréty." In *Karel Škréta a malířství 17. století v Čechách a Evropě. Sborník příspěvků z odborného kolokvia pořádaného Národní galerií v Praze v klášteře sv. Anežky České ve dnech 23.–24. března 2010*, edited by Lenka Stolárová, 39–47. Prague: Národní galerie v Praze, 2011.

Oulíková, Petra. *Klementinum*. Prague: Národní knihovna České republiky, 2019.

Ourodová-Hronková, Ludmila. *Světecké obrazové cykly na jihu Čech*. České Budějovice: Národní památkový ústav, územní odborné pracoviště v Českých Budějovicích, 2011.

Panoch, Pavel. "Herman Hugo v jezuitské Praze: Příspěvek k náboženské emblematice 17. století v Čechách." In *Karel Škréta (1610–1674). Dílo a doba. Studie, dokumenty, prameny*, edited by Lenka Stolárová and Kateřina Holečková, 275–287. Prague: Národní galerie v Praze, 2013.

Panoch, Pavel. "Nad malířským dílem Jana Jiřího Heringa (1587–1648)." In *Karel Škréta a malířství 17. století v Čechách a Evropě. Sborník příspěvků z odborného kolokvia pořádaného Národní galerií v Praze v klášteře sv. Anežky České ve dnech 23–24. března 2010*, edited by Lenka Stolárová, 89–97. Prague: Národní galerie v Praze, 2011.

Drbalová, Petra. "Ad maiorem Dei gloriam. Umělecká výzdoba jezuitského kostela Nanebevzetí Panny Marie v Brně." MA thesis. Brno: Masaryk University, 2011.

Pfeiffer, Heinrich. "The Iconography of the Society of Jesus." In *The Jesuits and the Arts, 1540–1773*, edited by John W. O'Malley and Gauvin Alexander Bailey, 201–228. Philadelphia: Saint Joseph's University Press, 2005.

Poche, Emanuel, ed. *Umělecké památky Čech*, vol. 1. (A-J). Prague: Academia, 1977.

Podlaha, Antonín "Zprávy o chrámu sv. Salvátora v Klementinu v Praze z druhé polovice XVIII. století (Dokonč.)." *Památky archaeologické a místopisné* 27 (1915): 224–230.

Podlaha, Antonín. *Posvátná místa království Českého. Arcidiecéze Pražská. Díl I. Vikariáty: Českobrodský, Černokostelecký, Mnichovický a Prosecký*. Prague: Dědictví sv. Jana Nepomuckého, 1907.

Polehla, Petr. *Jezuitské divadlo ve službě zbožnosti a vzdělanosti*. Červený Kostelec: Pavel Mervart, 2011.

Preiss, Pavel. *Václav Vavřinec Reiner. Dílo, život a doba malíře českého baroka*. Prague: Academia, 2013.

Rheinbay, Paul. *Biblische Bilder für den inneren Weg. Das Betrachtungsbuch des Ignatius-Gefährten Hieronymus Nadal (1507–1580)*. Egelsbach: Hänsel-Hohenhausen, 1995.

Rollová, Anna. "'Arcularius' Jiří Ridel SJ (1639–1680)." In *Bohemia Jesuitica 1556–2006*, vol. 2, edited by Petronilla Cemus, 1375–1385. Prague: Karolinum, 2010.

Samek, Bohumil. *Umělecké památky Moravy a Slezska*, vol. 1.: A–I. Prague: Academia, 1994.

Schaar, Eckhard, and Carlo Marattas. "'Tod des heiligen Franz Xaver' im Gesù." In *Munuscula discipulorum. Kunsthistorische Studien. Hans Kauffmann zum 70.*

Geburtstag 1966, edited by Tilmann Buddensieg, 247–264. Berlin: Verlag Bruno Hessling, 1968.

Schurhammer, Georg. "Das Wahre Bild des hl. Franz Xaver? (Zum 3. Dezember)." In Georg Schurhammer, *Gesammelte Studien. Herausgegeben zum 80. Geburtstag des Verfassers. IV. Varia. I. Anhänge*, edited by László Szilas, 213–215. Rome: Institutum Historicum S.I., 1965.

Smith, Jeffrey Chipps. *Sensuous Worship. Jesuits and the Art of the Early Catholic Reformation in Germany*. Princeton and Oxford: Princeton University Press, 2002.

Sterba, Katrin. "Vom Sichtbaren zum Unsichtbaren. Studien zur Visualisierung katholischer Dogmen in der Jesuitenkirche und der Fronleichnamkapelle der Stadt Olmütz in der heutigen Tschechischen Republik." PhD dissertation. Leopold-Franzens-Universität Innsbruck, Innsbruck, 2018.

Stloukal, Karel. *Papežská politika a císařský dvůr pražský na předělu XVI. a XVII. věku: La politica papale e la Curia imperiale a Praga alla fine del cinquecento ed al principio del secento*. Prague: Filosof. fakulta University Karlovy, 1925.

Suda, Stanislav. *Březnické kostely: přednášku . . . proslovil autor na schůzi „Bozně" dne 11. května 1934*. Prague: Bozeň, spolek rodáků a přátel města Březnice, 1935.

Svatoš, Martin. "Nova et vetera: rétorika na jezuitských gymnáziích a řečnická praxe v českých zemích v 17. a 18. století." In *Bohemia Jesuitica 1556–2006. Tomus 2*, edited by Petronilla Čemus, 877–891. Prague: Karolinum, 2010.

Sykora, Eduard. "Zwei Bilder in der ehemaligen Jesuiten-Kirche zu Brünn." *Mittheilungen der K. K. Central-Comission zur Erforschung und Erhaltung der Kunst- und historischen Denkmale. Neue Folge* 20 (1894): 74–76.

Šeferisová Loudová, Michaela, and Jiří Kroupa. "Kláštery ve městě II. (severní část)." In *Dějiny Brna, vol. 7: Uměleckohistorické památky. Historické jádro*, edited by Jiří Kroupa, 401–470. Brno 2015.

Šroněk, Michal. "Barokní malířství 17. století v Čechách." In *Dějiny českého výtvarného umění II/1. Od počátků renesance do závěru baroka*, edited by Rudolf Chadraba, 324–356. Praha: Academia, 1989.

Šroněk, Michal. "*De sacris imaginibus. Patroni, malíři a obrazy předbělohorské Prahy.*" Prague: Artefactum, 2013.

Šroněk, Michal. "Der Statuenschmuck der Prager Karlsbrücke in der Bildpropaganda der Gesellschaft Jesu." In *Jesuitische Frömmigkeitskulturen. Konfessionelle Interaktion in Ostmitteleuropa 1570–1700*, edited by Anna Ohlidal and Stephan Samerski, 119–140. Stuttgart: Franz Steiner Verlag, 2006.

Šroněk, Michal. "Johann Barvitius als Mäzen im rudolfinischen Prag." *Studia Rudolphina* 8 (2008): 49–57.

Šroněk, Michal. "The Jesuits and their Urban Visual Presence in the Bohemian Lands." In: *Faces of Community in Central European Towns. Images, Symbols, and Performances, 1400–1700*, edited by Kateřina Horníčková, 279–309. Lanham: Lexington Books, 2018.

Šroněk, Michal. "Tovaryšstvo Ježíšovo a město jako prostor řádové reprezentace." *Umění* 66 (2018): 264–282.

Šroněk, Michal. *Jan Jiří Heinsch (1647–1712). Malíř barokní zbožnosti.* Prague: Správa Pražského hradu, 2006.

Šroněk, Michal. *Pražští malíři 1600–1656. Mistři, tovaryši, učedníci a štolíři v Knize Staroměstského malířského cechu. Biografický slovník.* Prague: Artefactum, 1997.

Štěpánek, Pavel, ed. *Svatý František Xaverský a jezuitská kultura v českých zemích* Olomouc: Univerzita Palackého v Olomouci, 2014.

Štroblová Helena, and Blanka Altová, eds. *Kutná Hora.* Prague: Nakladatelství Lidové noviny, 2000.

Togner, Milan. *Jan Kryštof Handke (1694–1774). Malířské dílo.* Olomouc: Univerzita Palackého v Olomouci, 1994.

Uličný, Petr, et al. *Architektura Albrechta z Valdštejna. Italská stavební kultura v Čechách v letech 1600–1635.* Prague: Nakladatelství Lidové noviny, 2017.

Vácha, Štěpán. "*Imaginum elegantia.* K estetické působivosti náboženského obrazu v českých zemích v 17. a 18. století." *Umění* 62 (2014): 251–275.

Vácha, Štěpán. "Noch eine büßende Maria Magdalena von Joseph Heintz d. Ä." *Studia Rudolphina* 10 (2010): 178–195.

Vajchr, Marek. *Jména příběhu.* Prague: Revolver Revue, 2016.

Valeš, Tomáš, and Michal Konečný. "Telč, moravská výspa pražského barokního malířství." In *Karel Škréta (1610–1674). Dílo a doba. Studie, dokumenty, prameny,* edited by Lenka Stolárová and Kateřina Holečková, 263–274. Prague: Národní galerie v Praze, 2013.

Vlam, Grace A. H. "The Portrait of S. Francis Xavier in Kobe." *Zeitschrift für Kunstgeschichte* 42 (1979): 48–60.

Vlček, Pavel, Dušan Foltýn, and Petr Sommer. *Encyklopedie českých klášterů.* Prague: Libri, 1997.

Vlček, Pavel, et al. *Umělecké památky Prahy. 1. díl: Staré Město. Josefov.* Prague: Academia, 1996.

von zur Mühlen, Ilse "*Imaginibus honos* – Ehre sei dem Bild. Die Jesuiten und die Bilderfrage." In *Rom in Bayern. Kunst und Spiritualität der ersten Jesuiten,* edited by Reinhold Baumstark, 161–170. Munich: Hirmer Verlag, 1997.

Vyvlečka, Josef. *Příspěvky k dějinám kostela Panny Marie Sněžné v Olomouci.* Olomouc: Našinec, 1917.

Wiese Georg, and Gertrud Otto. *Die religiösen Ausdrucksgebärden des Barock und ihre Vorbereitung durch die italienische Kunst der Renaissance.* Stuttgart: Kohlhammer, 1938.

Wimböck, Gabriele. *Guido Reni (1575–1642): Funktion und Wirkung des religiösen Bildes.* Regensburg: Schnell + Steiner, 2002.

Wittkower, Rudolf, and Irma B. Jaffe, eds. *Baroque Art. The Jesuit Contribution.* New York: Fordham University Press, 1972.

Zářecká, Klára. "Kulturně-historický vývoj jezuitské koleje a kostela Nanebevzetí Panny Marie v Hradci Králové (1636–1773)." BA thesis Charles University. Prague, 2006.

Zdeněk Orlita, "Olomoučtí jezuité a náboženská bratrstva v 16.-18. století." *Střední Morava. Vlastivědná revue* 20 (2005): 43–54.

Chapter 7

From Visible to Invisible

Teaching Catholic Dogma in the Jesuit Church and Corpus Christi Chapel in Olomouc

Katrin Sterba

In an increasingly secularized world, Baroque church interiors are difficult for viewers to understand today, partly due to the loss of liturgical and theological knowledge. These spaces are relevant as historical contexts, however, because the Baroque design of sacred spaces not only had an aesthetic function but also the purpose of making religious teachings a sensual experience for the faithful.[1]

The resolutions of the Council of Trent (1545–1563), on the veneration of images in particular, had a decisive influence on the decoration of Baroque interiors because they defended Catholic dogma against the criticism of the Reformation and stipulated that the content of the faith should be illustrated to the faithful through the pictorial decoration of church interiors.[2] In this context, images played a decisive role as didactic media because they were able to present the Catholic teaching of faith directly to viewers.[3] In this context, the focus of church interior decoration was especially on points of Catholic dogma that were criticized and rejected by Protestants. These were, in particular, the teachings on the Eucharist, the veneration of the Virgin Mary, and the veneration of the saints and their images.[4]

The reworking of Catholic Church interiors in the seventeenth century did not result in a break with the previous Catholic tradition in the dogmatic, liturgical or artistic sense, but on the contrary consolidated it.[5] The tendencies that had emerged in the sixteenth century continued, enriched with new impulses, increased, and intensified.[6] At the same time, Rome always remained the intellectual and artistic center where artistic concepts were established, including those that influenced the decoration of Baroque church

269

interiors and were subsequently adopted in the provinces.[7] The Societas Jesu in particular contributed to their dissemination. This reform order, which also operated from Rome through its centralized structure and sent its friars to all parts of the world for missionary work, made use of already-established visualization strategies. At the same time, however, in accordance with the principle of accommodation,[8] its members also adopted local traditions and particularities to help advance the process of re-catholicization in Protestant mission areas. These missionary didactic visualization strategies are demonstrated here in an in-depth iconographic study of the artistic decoration of the Jesuit Church of Mary of the Snow in Olomouc. Its church decoration, read here in a multiple layers, is an example of how the Societas Jesu implemented its mission in Moravia through pastoral and artistic activity.

CONFIRMATION OF CATHOLIC IMAGE PRACTICE IN CHURCH DECORATION

In the sixteenth century, Olomouc in central Moravia, the seat of a bishopric (1063) and university (1573), competed with Brno to be the capital of Moravia. This competition lasted until 1641, when the royal court was moved to Brno and Olomouc lost this status, keeping, however, the important position of a religious center in Moravia.[9] Although the Societas Jesu arrived as early as 1566, founded the university, and received support from the bishop and Catholic clergy,[10] it had to defend itself against fierce resistance from the local Protestant burghers and gentry. It only succeeded in fully implementing Counter-Reformation policy after 1650, when the Swedish siege of Olomouc (1642–1650), the final stage of the Thirty Years' War, ended. Before the war, the city was distinguished by magnificent Romanesque, Gothic, and Renaissance buildings, but the city lay in ruins after the troops withdrew, then suffered from plague epidemics and a great city fire in the first half of the seventeenth century.[11] This played out in the broader context of the Catholic League's victory over the Protestant estates at the Battle of White Mountain (1620) and the Renewed Land Ordinance issued for Moravia in 1628, which resulted in fundamental changes in politics and society.[12]

In 1567, the Societas Jesu took over the Minorite church in Olomouc dedicated to the Virgin Mary and the late medieval monastery of St. Francis, both dating from the Gothic period.[13] The monastery was deserted, so a complete reconstruction was planned.[14] The Jesuits made efforts to purchase houses in the immediate vicinity so they could expand the monastery grounds,[15] but these plans could only be implemented from the seventeenth century onward. The first building to be replaced was the old Konvikt (student dormitory) (1660–1667), followed by the new school building (1701–1708), the Jesuit

College (1711–1722), the Seminary of St. Francis Xavier (1717–1720), and the new Konvikt with a Corpus Christi Chapel (1721–1724). The new Mary of the Snow Church in Olomouc (1712–1716) [figure 7.1] was also constructed, with most of its interior decoration completed in the first half of the eighteenth century.[16] No uniform program was followed; rather, the decoration consisted of multilayered presentations of dogmatic concepts intertwined with reactions to past and recent regional events which the Jesuits used to communicate the truth of Catholic doctrines to the faithful.

Like most churches of the Baroque period in Central Europe, the interior of the Mary of the Snow Church in Olomouc was rich in sculptural and pictorial decoration; a number of altarpieces and devotional images were installed and the walls and ceiling covered with murals. Protestant accusations of idolatry

Figure 7.1 Church of the Virgin Mary of the Snow, Olomouc 1712–1716.

targeted devotional paintings in particular, which led to them being promoted as a distinctive feature of the Catholic Church.[17] They had an important mediating function in sacred space, as the Swabian jurist Konrad Braun explains in the preface to his treatise *De imaginibus*:

> Visit any church deprived of images and contemplate the people listening to the Word of God. After the sermon you will see everyone fleeing from the church without any devotion or order. Then go to a church decorated with paintings and pictures. After the sermon you will see many devotees lingering in the church, bowing their knees before the altars and silently visualizing and memorizing what they have heard in the form of real figures, and on top of that paying due reverence to God and the saints.[18]

The images in Catholic churches were seen to have a double function, a didactic effect, and a trigger for the veneration of saints. Devotional images, viewed publicly or privately, are the only images that can be venerated in a deeper sense.[19] Sacred images, *imagines sacrae*, are considered particularly worthy of veneration. These include images such as the *acheiropoieta*, images not made by human hands that can be traced back to Christ himself.[20] The decisive factor for these images is their proximity to Christ; they are more worthy of veneration the more directly they trace back to Christ. *Semiacheiropoieta* such as the Roman icon *Salus Populi Romani*, said to have been painted by St. Luke with the help of angels, also belong to this category of images.[21] Other images in Catholic sacred space have primarily a didactic function, as they vividly demonstrate religious and salvation-historical themes to the viewer.[22] Compared to scripture, they have the advantage of being memorized more quickly, more directly, and more permanently than printed texts.[23] This group of pictures includes not only wall and ceiling paintings but also most altarpieces, reredos, and architectural sculpture.[24] The didactic function of decorative images was confirmed by the Decree on Images at the Council of Trent on December 3, 1563,[25] which emphasized that "through the narratives of the mysteries of our redemption, as expressed in paintings and other mimetic representations, . . . the people are educated and encouraged to remember and persevere in the consideration of the articles of faith."[26] These images can also increase the piety of the faithful and their love for God.[27] At the same time, the decree reaffirms that "images of Christ, the Virgin Mother of God and the other saints, which must be and remain above all in the houses of God, must be shown the due respect and veneration," because "through the images which we kiss and before which we uncover our heads and kneel, we adore Christ and venerate the saints whom they represent."[28]

The first diocesan synod in Olomouc adopted and implemented the Tridentine resolutions as early as 1568.[29] The didactic use of images among

both the laity and its members suited the image practice of the Societas Jesu, which attributed great effectiveness to images and used them specifically in catechesis, missions, and meditation.[30] The decisive importance that the Society of Jesus attached to images in catechesis can be traced back to the *Exercitia spiritualia*, the spiritual exercises of Ignatius of Loyola.[31] These were obligatory for the members of the Order and were intended, through various strategies of observation and repetition, to lead the meditating person to knowledge of himself and unity with God.[32] The senses played a decisive role in this because, in the Jesuit understanding, God uses external things as well as the power of the imagination in order to be perceived by people.[33] Artistic images or pictorial imagination are used on two levels in this method of meditation: the *compositio loci* and the *applicatio sensuum*.[34] The *compositio loci* serves to set up a "scene" in the imagination;[35] at the beginning of the meditation, the retreatant should imagine a specific place in a very concrete way.[36] External images such as paintings or staged scenes could provide the practitioner with a stimulus for composing such internal imaginary settings.[37] *Applicatio sensuum*, the "application of the senses,"[38] is another integral part of the Jesuit method of prayer.[39] With this method, it is no longer only the sense of sight that is addressed but also the senses of hearing, smell, taste, and touch. This method of prayer, however, is not to be understood as a process of pure imagination,[40] but is an intensification of prayer in that it is a matter of going from the outside to the inside.[41] In this process, the spiritual senses are also addressed in order to contemplate content that cannot be grasped with the external senses, so that the person meditating can be led to the highest sensory experience.[42]

To show the direct efficacy of images as dogma against the Protestants, miraculous images were thematized in Jesuit church decoration. In the context of preaching or catechesis, they often served both to teach the efficacy of Mary and inspire devotion to and meditation on the Virgin Mary image.[43] The altarpiece and the ceiling painting in the main nave of the Jesuit Church in Olomouc present the miraculous Roman icon *Salus Populi Romani* made by St. Luke as an active agent. The image was said to have miraculous and apotropaic powers even outside of Rome,[44] which is why it was used to ward off the plague that threatened Moravia in the seventeenth and eighteenth centuries.[45]

Although the Jesuits in Olomouc did not have a copy of the Roman cult image, the icon can be seen twice in the Mary of the Snow Church as a picture within a picture: first, on the altarpiece, and second, on the ceiling painting in the nave.[46] The altarpiece, painted in 1721 by Johann Georg Schmidt, illustrates the church's patron saint with the legend of the origin of Santa Maria Maggiore in Rome. The upper half shows the icon being carried in by angels and the lower half depicts the Miracle of the Snow in Rome [figure 7.2].[47] The ceiling

Figure 7.2 Altarpiece showing the miracle of Salus Populi Romani. Oil on canvas by Johann Georg Schmidt on the main altar of the Church of the Virgin Mary of the Snow, Olomouc, 1721.

painting, created by Karl Joseph Haringer in 1716–1717, shows the plague procession of Gregory the Great with the icon and thus illustrates an image miracle [figure 7.3].[48] These themes are closely connected with the cult image and the place where it was installed in Rome. Both pictures illustrate Mary's efficacy; one time she makes it snow in Rome in the summer, another time she delivers the residents of Rome from the plague. During the procession of Gregory the Great with the icon of Mary, the Marian antiphon *Regina Coeli* is said to have been sung for the first time.[49]

The text of the Marian Easter antiphon is also repeated on the banners in the central nave, supporting conclusions about the reason for changing the patronage of the church, which coincided with the time when Olomouc was ravaged by a severe plague.[50] While the old Minorite church still bore the patrocinium of the Assumption of Mary, it had been planned to give the church the title of Mary Queen of Angels when the foundation stone was laid on June 12, 1712.[51]

Figure 7.3 The miraculous Roman icon Salus Populi Romani in the Plague Procession of Gregory the Great, ceiling painting by Karl Joseph Haringer, in the main nave of the Jesuit church in Olomouc. Church of the Virgin Mary of the Snow, Olomouc, 1716–1717.

After a plague epidemic outbreak in Olomouc from 1713 to 1715, however, the completed church was given the consecration title of Mary of the Snow on February 16, 1716.[52] The change of patronage was an explicit reference to the origin of the Roman church of Santa Maria Maggiore and the icon *Salus Populi Romani* kept there.[53] The ceiling painting depicting the historical plague procession in Rome allowed viewers to establish a connection between the plague procession in Rome and the one in Olomouc. In terms of a visualization strategy, this could be deduced as: Just as Mary had already worked miracles in Rome and freed the people of Rome from the plague, the Mother of God was also responsible for ending the plague in Olomouc.

The procession participants on the fresco thank the Mother of God for her help and venerate her by kneeling and praying before the icon. This illustrated that Mary and the saints work through their images and that therefore it was right—entirely in the sense of the decree on images—to venerate saints and the Mother of God, Mary, with external forms of expression such as kneeling in prayer. Protestants generally disapproved of these gestures of veneration and saw them as idolatry, since from the outside it was not possible to distinguish whether the faithful were venerating the image itself or the saints depicted.[54] In the Catholic tradition, the veneration of images is based on the doctrine of the prototype, which says that the person represented in the image is venerated, not the material image.[55] This became particularly clear in connection with the *vera effigies* ("true likeness"), the close visual resemblance of the image to the original prototype,[56] which is why *acheiropoieta* or images by St. Luke such as the Roman icon *Salus Populi Romani* were venerated in church interiors.

The doctrine of the prototype had to be communicated to the faithful because of its importance for the veneration of saints depicted in images. In Olomouc, the ceiling of the Chapel of St. Francis Xavier, where St. Francis Xavier appears to a friar on his sickbed, illustrates the doctrine of the prototype.[57] What is decisive here is that the saint in the vision corresponds exactly with the *vera effigies* of the saint. The image-theological argument here is that images of saints really show the true appearance of the venerated saints. This is also the case in Olomouc because the frontal image on the altar below—which is open for veneration[58]—corresponds both with the *vera effigies* image of the saint and with the depiction of Francis Xavier in the vision on the ceiling painting.[59] Consequently, the ceiling painting could illustrate to the faithful that the saint presented to them here really does look as he is depicted on the altar image. The ceiling painting thus visually confirms the truthfulness of the images on the altar.

TEACHING THE EUCHARIST

Ignoring the variety of attitudes to the Eucharist among the Reformation denominations, theologians described their Reformation opponents as criticizing the Catholic Church's practice of images and also as rejecting the teachings on the Real Presence, transubstantiation, and adoration of the Eucharist. With their criticism of the Eucharist practices, the radical Reformation theologians hit a spot central to the Catholic Church's faith, for it is precisely the Eucharistic doctrine of the "transubstantiation" of bread and wine into the body and blood of Christ[60] that is part of the *Mysterium fidei* of the Catholic faith and its celebration is the highlight of every Catholic Mass.[61]

In response, council theologians[62] defended the Catholic celebration and worship of the Eucharist and, similarly to the Catholic practice of images, made it ostentatiously visual in Catholic sacred spaces.

In 1551, with the Decree on the Most Holy Sacrament of the Eucharist, the Council theologians confirmed that "through the consecration of bread and wine, there is a transformation of the whole substance of the bread into the substance of the body of Christ."[63] According to Catholic teaching, Jesus Christ is therefore "truly, really and substantially contained in the blessed sacrament of the Holy Eucharist . . . under the form of those sensual things."[64] In the Catholic understanding, the transformation of the essence of bread and wine into the real somatic presence of Christ means that Christ is permanently present in the Eucharistic gifts after consecration. Thus, this permanent real presence legitimizes and demands that the Eucharist be adored.[65] From this it was deduced that the host could be venerated in the context of celebrations, carried in processions, and shown publicly "to the people for adoration."[66] The Tridentine Eucharistic Decree was adopted in the Statutes of the Diocesan Synod of Olomouc in 1568.[67]

These decisions of the Council of Trent had far-reaching consequences for Baroque sacred space; immediately upon entering, the church visitor's gaze falls on the altar retable. The altar architecture contributes to this; the entire interior decoration of the nave is oriented toward the high altar.[68] Due to its furnishings and central position in the room, the altar is designated as the place for celebrating the Holy Mass and must be easily visible to visitors during the liturgy.[69] Extra-liturgically, the altar retable has the function of presenting the Eucharist placed on the altar for adoration, the place of Eucharistic devotion outside the celebration of Mass.[70]

In Olomouc, too, the Eucharist is kept at the main altar and its location is distinguished by a large altar structure. At the main altar, Jesus Christ is present in various forms: in the revolving tabernacle, he is somatically present in the form of the Eucharist, albeit invisibly.[71] In the tabernacle and on the altarpiece he appears as the infant Jesus on the arm of his mother. In the altarpiece, angels venerate his name as a monogram.[72] Thus, Christ is presented to viewers in various manifestations in which he can be recognized and venerated.

The IHS monogram, an abbreviation of the name of Jesus, is of particular significance on the altarpiece; it names and represents Christ at the same time.[73] In the Baroque period, the IHS monogram was often imprinted on wafers, identifying them as the body of Christ and creating a direct link for the faithful between the Christogram and the host.[74] This connection between the Jesus monogram and the host was intended to make it clear to the faithful that the universal glorification of the divine name of Jesus,[75] as called for in the Epistle to the Philistines[76] and illustrated by the angels on the altarpiece, took place above all in him offering himself as a sacrifice.[77] The IHS

monogram, however, not only represents Jesus Christ but also refers to the Societas Jesu. The Franciscans had already spread the monogram[78] when the Societas Jesu chose Jesus Christ as its central spiritual figure and designated the IHS monogram as the symbol of the order and used it on many of its buildings and works of art.[79] Thus, the letters IHS are not only a reference to the name of Jesus and the host but also an allusion to the order itself.[80]

References to the Jesuit Order and the Eucharist can also be found in the veneration of Eucharistic saints.[81] In order to increase devotion to the Eucharist, medieval saints, such as St. Barbara,[82] or modern religious saints, such as St. Ignatius of Loyola, were given a decidedly Eucharistic interpretation in Jesuit churches. The latter had a side chapel dedicated to him in Olomouc, where the pictorial decoration ascribes special significance to the celebration of the Eucharist described in his *vita*.[83] The chapel's ceiling painting shows Ignatius in the Church of Manresa, where he is taking part in a Mass alongside other believers [figure 7.4]. In front of him, the priest holds up the host with both hands, in front of which Christ appears in the form of a naked boy in a halo. Ignatius, distinguished by a halo, is visibly moved in contrast to the other faithful present there, making it clear that he alone perceives the figure of Christ in the halo. Besides Ignatius, the spectators are the only witnesses to the presence of Christ in the elevation of the Host.

The ceiling painting not only illustrates the Eucharistic event in the life of the saint, but also refers to the real Mass taking place below at the altar, since it makes what is happening invisibly at the altar during the celebration of the Mass and the elevation of the host visible to the viewers depicted in the painting. As in the ceiling painting, the priest at the altar raises the host during the celebration of the Mass, which at that moment is transformed into the body of Christ. But while the transformation at the altar remains invisible to the visitor and can only be believed, the ceiling painting visualizes the transformation of the bread into the body of Christ by means of the saint's miraculous experience. In this way, the invisible event at the altar becomes visible and is confirmed to be true.[84] The doctrine of transubstantiation could thus be explained to the viewers, confirmed as true, and linked to the biography of the founder of the order.

This picture, only part of the chapel decoration, shows the way Eucharistic motifs were built into the multilayered meanings of Baroque church interior decoration. The motifs were not shown in isolation, but embedded in a portrayal of the life of the founder of the order, as, for example, in Olomouc. The life of St. Ignatius of Loyola was particularly suitable for this purpose, since he was not only a defender of the doctrine of the Eucharist, but illustrated biographies were already available at the time that visualized his personal devotion to the Eucharist. Depictions of Ignatius celebrating Mass were therefore particularly suitable, since they could convey Catholic doctrine to the faithful and at

Figure 7.4 Ignatius taking part in a mass in the church of Manresa with a vision of Christ appearing in the host, ceiling painting by Johann Christoph Handke in the St. Ignatius Chapel, Church of the Virgin Mary of the Snow, Olomouc, 1743.

the same time highlight the merits of the order's founder. But this was not the only way to visualize the general Eucharistic doctrine within specific affirmative contexts. While the portrayal of Ignatius in the Loyola Chapel was based on the order's own history, the ceiling painting in the adjacent Corpus Christi Chapel makes a deliberate link to a local event from the thirteenth century.

THE LOCAL CONNECTION: VISUALIZING THE EUCHARIST IN THE OLOMOUC CORPUS CHRISTI CHAPEL

The present Corpus Christi Chapel was built between 1721 and 1724 and the interior was decorated in 1728.[85] The chapel was erected on the site of an earlier structure, a late Gothic Corpus Christi chapel that had been donated to the Jesuits in 1591.[86] The late Gothic altarpiece, which has not survived,[87] illustrated a local Host miracle.[88] This miracle narrative was depicted

monumentally in the new Baroque building and can still be seen today in the
ceiling frescoes painted by Johann Christoph Handke in 1728 [figure 7.5].[89]

The scenario depicted in the ceiling frescoes came from various sources,
which merged in the sixteenth and seventeenth centuries to form a locally
specific legend and subsequently expanded to include a Eucharistic miracle.
The core of the legend is the "Tartar siege" of the city of Olomouc in 1241,
during which the commander, Jaroslav von Sternberg, is said to have sur-
prised the enemy camp and cut off the arm of Peta, the enemy captain, where-
upon the Tartars fled.

In his 1655 work, *Diva Wartensis*, the Jesuit Bohuslav Balbín adds two ele-
ments to this legend: First, the Angelic salute, that is, the Hail Mary prayer
that the commander and his soldiers prayed before the battle, and second, the
promise that Jaroslav made before the battle that if he won he would build a
church for the Mother of God—the former Minorite church.[90] A Eucharistic

Figure 7.5 The miracle of the Host; ceiling frescoes painted by Johann Christoph
Handke in the Corpus Christi Chapel, Olomouc, 1728.

miracle in connection with the victorious battle of Olomouc was first reported in 1661 by the Jesuit Johannes Tanner in his book *Vestigia Virtutis Et Nobilitatis Sternbergicae* [figure 7.6].[91] According to Tanner, Jaroslav and his troops received the Eucharist before the battle. Since five hosts remained after the Mass, Jaroslav of Sternberg is said to have ordered that a small cabinet in the form of a tabernacle be made for them. This was strapped to the back of a donkey and accompanied a priest in battle. When the priest opened the box, the hosts had turned into flesh. After the victorious battle, the priest presented the transformed hosts to the crowd. The tabernacle was tied to the donkey's back again and it walked back to Olomouc on its own, where the hosts were placed in the Corpus Christi Chapel with great veneration.[92] As Johannes Tanner writes, in the late Gothic Corpus Christi Chapel the altarpiece and paintings on the walls reminded visitors of the Host miracle for eternity.[93] The Corpus Christi Chapel in Olomouc is thus part of a tradition that can also be seen in other sacred buildings with similar histories, since almost all buildings that were erected as a result of such a miracle were decorated inside to illustrate the miracle.[94]

As the legend went, the former Minorite church was built next to the chapel that had played a decisive role in the Host Miracle because it was where the commanders received the Eucharist and took the five remaining hosts with them into battle, and also where the unattended donkey returned with the hosts that had become flesh, which were subsequently also kept there. In the seventeenth century, the emphasis in texts of the Jaroslav legend shifted from the battle "with Tartars" to Jaroslav's piety, his endowment, and the miracle of the host. Jesuit historians, Bohuslav Balbín and Johannes Tanner, were instrumental in this new emphasis.

That the Corpus Christi Chapel was not built until the fifteenth century[95] did not diminish the significance of the legend for the Corpus Christi Chapel, newly built by the Jesuits, and the adjacent Jesuit church. On the contrary, the medieval legend offered the Jesuit Order the opportunity to trace the church foundation back to an ancient local event, and, even better, to a miracle of the host, without having to mention the Minorites, who were given the monastery when it was founded. By reusing the local legend, the Society of Jesus followed a trend of the seventeenth and eighteenth centuries, when the old orders and monasteries rediscovered their monastic past, investigated it scientifically, and tried to visualize it through art in order to legitimize their existence, strengthen their monastic, religious, and social identity, and make it visible in pictures.[96] In doing this, the old orders preferred to fall back on their founders, to whom the deed of foundation was solemnly issued, presented or confirmed on the ceiling paintings, which led to the idea that the founders were continuously present and that their work continued into the present.[97] The Society chose not to celebrate the founders of the college, but rather made a reference to the local memory and at the same time succeeded

in conveying a Eucharistic teaching to the faithful by resorting to the local miracle legend of Jaroslav.[98]

The medieval legend was illustrated on the altarpiece of the Corpus Christi Chapel. The altarpiece is now lost, but copper engravings from the seventeenth century give an idea of what the painting looked like.[99] Tanner's book also

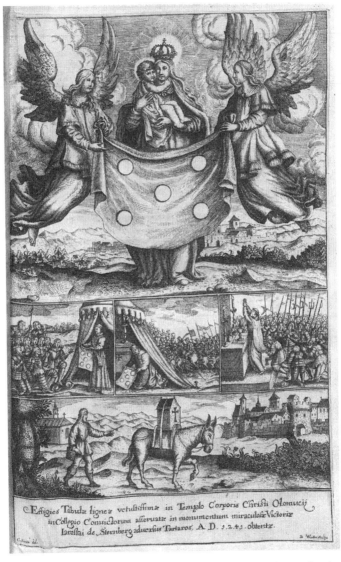

Figure 7.6 The miracle of the Host during Jaroslav of Sternberg's battle with the Tartars, from the book by Johannes Tanner, *Vestigia Virtutis Et Nobilitatis Sternbergicae*, engraving by Daniel Wussin after a design by Karel Škréta, 1661.

Figure 7.7 Immaculata Conceptio; the infant Jesus with St. Aloysius Gonzaga and St. Stanislaus Kostka by Augustin Johann Thomasberger, upper part of the Guardian Angel Altar, Church of the Virgin Mary of the Snow, Olomouc, 1722.

has such an image by the Prague engraver Daniel Wussin (1626–1691) after a design by Karel Škréta (1610–1674) [figure 7.6].[100] The composition of the engraving closely resembles an engraving by the French engraver Jacques Granthomme (1550/60–1622) made around 1600.[101] Granthomme's engraving, however, does not show the legend of Olomouc, but the Spanish Eucharistic miracle of Daroca, said to have taken place on February 24, 1239, during Spanish battles against the Moors.[102] The Spanish legend of the Blood Corporal of Daroca was probably brought to Olomouc by Spanish friars.[103] The Societas Jesu in Olomouc seems to have purposefully spread the Eucharistic transubstantiation miracle in order to promote Eucharistic doctrine and the veneration of consecrated hosts. Eucharistic miracles served to convince both doubting priests and the population of the transubstantiation, the change in essence of the Eucharistic gifts,[104] because the miraculous host was understood as visible proof of the Real Presence of Christ in the Eucharistic bread.[105]

Neither the Host Miracle nor the victorious battle of Jaroslav is directly depicted on the ceiling of the Corpus Christi Chapel painted in the eighteenth century. Only the scenes above the cornice refer to the medieval legend; the remaining part of ceiling decoration focuses on the heavenly intercession for his task [figure 7.5]. Above the main altar of the chapel, Commander Jaroslav of Sternberg kneels at the altar with a group of men in front of a communion

table and receives communion from a priest. Above the triumphal arch, angels and putti, two of which present the model of the previous church on the right, float on a bank of clouds. The third angel, above, holds a brightly shining star in his hands—a motif from the coats-of-arms of Sternberg family. Opposite them Mary is hovering, pointing with her left hand to the star below her. Her gaze, however, is directed upward toward the opening sky, where Jesus Christ, lying as the sacrificial lamb with the cross on the globe, and God the Father with the dove of the Holy Spirit, appear. Above the singers' choir on the opposite end of the chapel, a warlike army prepares for battle while two angels with a trombone and timpani hover above them. Above them on the left is the Archangel Michael with a flaming sword and next to him another angel throws down tongues of flames. The battle was thus shifted to the celestial zone and consequently also decided by the divinity.

Comparison with the design for the ceiling painting,[106] in which the stair-like composition is clearer, shows that it depicts Virgin's intercession.[107] As in the ceiling painting, in the design Jaroslav von Sternberg receives the host at the altar in the lower area, asking Mary for victory in the upcoming battle. The Mother of God kneels above him on a bank of clouds, her pointing gesture toward the star alluding to the count of Sternberg's request, while her hand pressed to her breast replaces the motif of the breasts shown to the Son.[108] Her gaze is directed toward the Trinity above her, where Jesus Christ, depicted with his wounds, is turning to God the Father next to him to grant his request to the one seeking help. The diagonal composition of the healing staircase makes Mary's function as an intercessor before Christ and a protector in battle even clearer than in the ceiling painting.[109]

The ceiling painting is complemented by six cartouches that are placed between the windows or doors and windows at the level of the music gallery.[110] The cartouches complement the events depicted on the ceiling and allow the visitor to interpret the scenes of the ceiling painting in terms of the miracle of the host in salvation history. To do this, the three cartouches on the south with scenes from the Olomouc Tartar legend have to be read together with the three cartouches opposite on the north that depict the Old Testament. The Old Testament scenes are prefigurations of the medieval legend motifs. Their relationship can be interpreted as typological, just as the models from the Old Testament are interpreted as a prefiguration of the New Testament.[111]

Thus, on the southwestern cartouche, Jaroslav's victory over the Tartar, Peta, is paralleled by God's victorious battle against the Egyptian pharaoh on the opposite cartouche.[112] In both cases the infidel is overcome by God or, in Jaroslav's case, with God's help. The central cartouche on the south shows the miracle of the hosts with the angel using both hands to present the corporal with the five hosts transformed into flesh. Opposite it is the depiction of the gathering of manna, for manna is one of the Old Testament types that

point ahead to the Eucharist.[113] The last two cartouches above the altar also refer to the Eucharist: the southern one shows a donkey with a tabernacle on its back and an angel pointing the way. Opposite it, the Ark of the Covenant is depicted making its own way. Both containers refer to the real physical presence in the Eucharist; the tabernacle conceals the hosts that have become flesh, while God was already mysteriously present in the Ark of the Covenant as he would later be in the Sacrament of the Altar.[114]

The parallelism of the six cartouches in the Olomouc Corpus Christi Chapel shows that the three cartouches of the Jaroslav legend must be read as *antitypoi* to the Old Testament events. Thus it was the reception and the consecrated hosts carried into battle, that is, the presence of God, which enabled Jaroslav to defeat the Tartars. At the same time, the real somatic presence of God was revealed in the hosts transformed into flesh, which also illustrates and proves transubstantiation. The cartouches give the ceiling painting an explicitly Eucharistic reading, confirmed by the verses of the fifth stanza of the medieval hymn *Verbum supernum prodiens* by Thomas Aquinas on the ceiling. The hymn is a Corpus Christi Office, a collectively sung prayer that transports the faithful into a state of joy and gratitude for the Eucharistic gift.[115] The verses comment on the events depicted and underline the decidedly Eucharistic reading of the events.[116]

Thus, the painted triumphal arch on the eastern side of the ceiling above the altar gives a view into a sacred space, where the opening verses of the fifth stanza can be read on the cornice, written in yellow letters: *"O! SALUTARIS HOSTIA!"*—"O saving Victim." The verse refers to the Eucharist that is displayed on the altar in a monstrance and distributed to Jaroslav and his men. At the same time, the heavens open above them and clouds and angels seem to come into the sacred space. This visualizes what the inscription on the cloud bank, *"QUÆ COELI PANDIS OSTIUM"* "Who expandest the door of Heaven," describes: It is the consecrated Host that effects the opening of heaven. On the globe where the sacrificial lamb lies is written: *"DA ROBUR; FER AUXILIUM"*—"Give strength; bear aid," which in view of the Jaroslav legend is to be understood as a request for divine assistance in the battle against the Tartars. More generally, the verse can also be interpreted as humanity on earth imploring Christ to help them in the face of enemy attacks, just as he already helped the inhabitants of Olomouc in the legendary Tartar battle in the thirteenth century. Opposite this, above the war camp, is the verse *"BELLA PREMUNT HOSTILIS"*—"Hostile wars press," with the martial motif shifted to the celestial zone, where on the northern side the Archangel Michael, wearing armor, has drawn his sword to attack while his celestial companion holds tongues of flame in his hands.

Only the verses of the fifth stanza of the hymn *Verbum supernum prodiens*, in which the host is directly addressed, were selected for the ceiling painting.[117] The efficacy of the Eucharist is made visual as the consecrated

host is received at the altar and the heavens open, for this reveals the somatic presence of God. For the believer, this means that just as heaven opened for Jaroslav von Sternberg when he received the Host and God heard his petition, so, too, will heaven open for all the faithful celebrating the Eucharist at the altar below and God will hear their prayers. On the opposite side, above the music choir, the effectiveness of the host in dangerous situations is once again illustrated, as it alone is able to give strength and aid in difficult situations.

In the singers' choir part, the ceiling painting shows the warriors preparing for the battle against the Tartars, although on closer inspection, the warriors are Turks, not Tartars.[118] The historical event depicted here becomes the Turkish siege of Vienna in 1683; the contemporary depiction of the Turks updated the medieval legend. The victory of Jaroslav von Sternberg over the pagan Tartars could be placed in parallel with recent historical events, the Turkish siege of Vienna and the related Battle of Kahlenberg.[119] Since the victory in the medieval legend on the painting is attributed to the efficacy of the Eucharist, it follows for the viewer that the victorious resistance of the capital of the Habsburg Empire and the defeat of the Ottomans can also be attributed to divine assistance. By updating the legend of Jaroslav, it was possible to show the faithful that the miraculous activity and efficacy of the Eucharist reached right up to the present day.

PROTECTORS AND MODELS: FROM CHRIST AND THE VIRGIN MARY TO JESUIT SAINTS

In Catholic theology and practice, Mary, as the Mother of God, has always held a special position in the plan of salvation, for example, as mediatrix and co-redemptorix. After reformers strongly criticized Mary's mediation, there was an ostentatious increase in the veneration of Mary among Catholics.[120] Since the Jesuits themselves were great devotees of the Mother of God and used her image specifically in missionary work, they tried to implement Marian devotions in Olomouc with the help of Marian brotherhoods and congregations.[121]

In Olomouc, Mary's special position is evident in the ceiling painting of the eastern tower of the Church of Mary of the Snow. There, Mary is asking her Son to protect Moravia kneeling before Jesus Christ on a bank of clouds hovering over a map of Moravia, in an abbreviated intercession.[122] The viewers are included in the action here, in that they not only witness Mary acting as an intercessor, but they can themselves become supplicant believers who turn to the Mother of God with their concerns, which she in turn presents to her Son. The fact that these petitions are heard is proven by the ceiling painting in the central nave with its depiction of the Roman plague procession.

The depiction of the intercession on the ceiling is accompanied by a counterpart[123] in the western tower showing *The Appearance of the Risen Christ before Mary*, a pictorial theme employed increasingly in the early modern era.[124] This motif has been the subject of controversy[125] since it cannot be traced back to a biblical text or medieval pictorial tradition;[126] Ignatius of Loyola was convinced that the Son of God first appeared to his mother after his resurrection,[127] and asserts this in the Spiritual Exercises,[128] where the fourth week of the Exercises meditates on the resurrection and ascension of Christ and the risen Christ appears to his mother.[129] The resurrection of Christ, which reveals God's intervention, gives people comfort and hope.[130]

The ceiling painting in the western tower of the Church of Mary of the Snow shows exactly this moment. Christ floats down on clouds with only a martyr's palm in his right hand, and approaches his mother, who recoils from his appearance. On her chair lies the crown of thorns, a sign of her Son's suffering, which she has been contemplating. She still looks incredulously at her Son, who points to the wound in his side with his stigmatized left hand to show that he was truly dead and is now risen again. Mary—in contrast to the viewers—does not yet seem to have fully grasped the significance of this divine appearance. Whereas on the ceiling painting opposite it is Mary who addresses her Son with the intercessions of the faithful, here it is Christ, who, through his appearance, communicates to her the comforting message of the Resurrection, which is shown in written form in selections from the Marian antiphon on the banners in the central nave and is sung during the liturgy, especially on Easter.[131] In both cases, Mary's prominent position is clear because of her proximity to her Son and it is clear that the grace or consolation is for the faithful, that is, for those who contemplate the image.

Mary's miraculous activity over the centuries is shown visually on the main altarpiece and the ceiling painting in the nave, and supplemented by the installation of a Gothic statue of Mary from the Minorite monastery church on the main altar of the Mary of the Snow Church. This sculpture is said to have miraculously survived various dangers unscathed and was especially praised for "miraculously" surviving the Swedish occupation of Olomouc.[132] At the beginning of the eighteenth century, Johannes Miller, Jesuit theologian and the builder of the Mary of the Snow Church, linked the statue to Jaroslav of Sternberg's alleged foundation of a church and monastery in the mid-thirteenth century.[133] The Jesuits used the ancient statue to manifest visually a long tradition of Marian devotion in Moravia since the Middle Ages,[134] unnaturally and violently interrupted by the sixteenth-century Reformation.

Not only the veneration of Mary but also the veneration of saints was questioned critically by Protestant reformers. With the reform decree of December 3, 1563, on the veneration of images, the Council of Trent theologians defended the installation of images of saints in Catholic sacred space

because the images of saints were seen as having catechetic and didactic purposes.[135] Although not the principal subject of Protestant writings, the cult of saints was seen as problematic in connection with the installation of images in church interiors.[136] With regard to the cult of saints, thus, care had to be taken that "the faithful were conscientiously instructed especially about the intercession and invocation of the saints, the veneration of relics and the lawful use of the images."[137] This task was entrusted to the bishops and priests who were to teach the faithful:[138]

> that the saints, who reign together with Christ, offer their prayers for men to God, that it is good and useful to invoke them fervently and to have recourse to their prayers and their powerful help for the attainment of benefits from God through his Son, our Lord Jesus Christ, who alone is our Savior and Redeemer. . . . The sacred bodies of the holy martyrs and those of others living with Christ must also be venerated by the faithful; for they were living members of Christ and temples of the Holy Spirit, and they shall be raised by Him to eternal life and glorified.[139]

Through their moral lives and devotion to the faith, saints function as both examples and mediators in the Catholic Church; as role models, they demonstrate faith and piety for imitation.[140] As mediators, the saints occupy a special position with Mary, since they can mediate between God and believers. It follows that they must not only be portrayed but also venerated, like their relics.[141]

The Society of Jesus, along with other reform orders, also strove to revive and reform the medieval cult of saints.[142] Ignatius of Loyola called for the following rules to be observed: "Praise relics of saints, venerating those and praying to them; praise stations, pilgrimages, indulgences, pardons, crusades and lit candles in churches."[143] In addition to venerating relics, catacomb saints, and patron saints of countries and places, the Society of Jesus was particularly committed to venerating its own saints, paying great reverence to its founder, Ignatius of Loyola, and his companion, Francis Xavier. As early as March 12, 1622, the canonization of both the order's founder and the famous missionary was celebrated with pomp in all the Jesuit colleges of the Bohemian province of the order. In Olomouc, the celebrations lasted eight whole days, during which church services were held and sermons preached, processions went through the city, scenes from the lives of the saints were staged as theater performances, a battle play was enacted, and bread and images of the saints were distributed in the city. Subsequently, the feast was celebrated as a religious festival of the first rank every year on 31 July.[144]

The joint representation of Sts. Ignatius of Loyola and Francis Xavier is an integral part of the decoration of many Jesuit churches.[145] Already in the

mother church in Rome, Il Gesù, the altars of the two Jesuit saints are placed opposite each other as counterparts in the transept arms.[146] While the veneration of St. Francis Xavier is based on his admirable merit of missionizing the world, especially Asia,[147] St. Ignatius has a special role as the founder of the Jesuit Order.[148] The Societas Jesu itself called the two saints *geminae Societatis columnae*,[149] the pillars of the society, and equated their function for the order with that of the Apostles Peter and Paul for the Catholic Church because while one presided over the church or the order in Rome, the other preached the Gospel to the people.[150]

The parallel between the two apostles and the two Jesuit saints is also clear from the façade of Olomouc's Mary of the Snow Church: there, the Apostles Peter and Paul flank the main entrance of the church, while in the uppermost register the two saints of the order are facing the Virgin Mary with the Child Jesus. In accordance with the parallelism, St. Ignatius of Loyola is placed above St. Peter in the façade extension and St. Francis Xavier is placed above St. Paul. The placement of the two Jesuit saints on the façade corresponds to the placement of the chapels dedicated to them inside the church. The chapels, adjacent to the choir, are similar both in the structure of their altars and in the wall and ceiling paintings that illustrate the lives and miracles of the saints. In 1722, for the 100th anniversary of their canonization, two triumphal columns with statues of these saints of the order were to have been erected in front of the church façade—a project that was never completed.[151]

Besides Sts. Ignatius of Loyola and Francis Xavier, Sts. Aloysius Gonzaga and Stanislaus Kostka, often depicted together, are among the most prominent Jesuit saints. Although St. Stanislaus was never as strongly venerated as St. Aloysius in the Bohemian province of the order,[152] he is one of the best-known Jesuit saints despite his short life and lack of public activity. This popularity may explain why a separate altar was erected for him in the new Jesuit church after 1714.[153] In 1564, Stanislaus, son of a Polish noble family, went to Vienna to study, where he joined the St. Barbara Brotherhood and came in contact with the Society of Jesus for the first time.[154] It is said that Mary herself invited him to join the Jesuit Order, appearing to him during an illness and placing the Child Jesus in his arms. In another vision, St. Barbara, accompanied by angels, is said to have appeared to the sick Stanislaus and given him the Eucharist.[155] Both visions, the basis of his devotion to the Eucharist and Mary, found their way into his iconography.[156] Stanislaus Kostka died in 1568 at the age of 18. The first descriptions of his life appeared shortly after his death, praising his talent, diligence, pure morals, piety, and courage.[157] His renunciation of worldly pleasures and his turn to the religious life were considered particularly exemplary. Kostka became the patron of the novices of the Societas Jesu in particular and of student youth in general and he was canonized together with Aloysius Gonzaga in 1726.[158]

Like Stanislaus Kostka, Aloysius Gonzaga came from a noble family. His first communion, in 1580 at the age of 12, which he received from the hands of the bishop of Milan, Charles Borromeo—after he had made a full confession—was a decisive experience. This event is said to have further strengthened his piety and therefore became an integral part of his iconography as a saint.[159] In 1585, he entered the novitiate in Rome, where he cared for plague sufferers, from whom he contracted the disease and died on June 21, 1591, at the age of 23. The report of his self-sacrificing care of the sick spread rapidly from Rome, which led to his beatification being celebrated as early as 1605; he was also invoked as a patron saint against the plague.[160] In 1726, when Gonzaga was canonized together with Kostka, the Jesuits celebrated the event with great festivities[161] and it can be assumed that the canonization of the two Jesuits was also celebrated in Olomouc because there is evidence of early veneration in the Olomouc diocese. Cardinal Francis of Dietrichstein had already obtained permission from Pope Paul V to publicly venerate Blessed Aloysius on May 21, 1605.[162] Furthermore, it is documented for Olomouc that the city became the home to a St. Aloysius Congregation. As early as the mid- eighteenth century, the congregation numbered more than 9,000 members, who undertook to carry something of St. Aloysius with them, to keep Aloisian Sundays, and to have two masses read annually in his honor.[163] There is also evidence of over 150 ex voto gifts for St. Aloysius alone from devotees, which is more than for any other saint in the church.[164] In addition, the Society of Jesus in Olomouc also possessed an Aloysius relic.[165] The saint functioned as an important role model for the students at the college. Thus, frequent reception of the Eucharist— and with it the regular hearing of confession—could be spread based on the saint's legend and devotional practices linked to him. St. Aloysius, and also St. Stanislaus, through their exemplary behavior, thus became the ideal of a pure youth, by whose example it was possible to connect with Christ in the Eucharist through intense prayer and inner in the church commitment.[166] The two images, today on the mensa of the Aloysius altar and in a framed picture in the Corpus Christi chapel, both show the saints receiving the host and served to visualize their Eucharistic devotion.

The cartouche inscription of today's Aloysius Chapel in the Virgin Mary of Snow church indicates that it was originally to be dedicated to three Jesuit saints, but the veneration of the saints was narrowed down to Aloysius Gonzaga in the first half of the eighteenth century. In the side chapel this is evidenced by the ceiling painting by Johann Christoph Handke, painted in 1729,[167] and the sculptural decoration created by Johannes Ignatius Rokitzky and Johann Michael Schardtel in 1746/1747.[168] The reasons for this may be related to the popularity of the saint specific to Bohemia and Moravia.[169] The Aloysius Gonzaga Brotherhood in Olomouc, founded in

the mid-eighteenth century, had the task of promoting the veneration of Aloysius among the sodalists, which probably also contributed to this.[170]

That these two Jesuit saints were already venerated before their canonization in 1726 is shown by the altarpiece of the Guardian Angel Altar, created around 1722 [figure 7.7].[171] There, the Virgin Mary—depicted as *Immaculata Conceptio* with the infant Jesus—is flanked by the two Jesuit saints. Although neither of them has an attribute attached to him, they can be clearly identified. St. Aloysius Gonzaga in the rochet on the left looks up at the Blessed Mother with emotion, while the Child Jesus turns toward St. Stanislaus Kostka, which can be interpreted as a reference to the vision in which Mary is said to have placed the Child Jesus in his arms. The two Jesuit saints, depicted here as fervent devotees of Mary, were examples to be followed. As patrons of young students, they served the scholars of the college as models for venerating Mary as Maria Immaculata, which had to be publicly defended at graduation.[172] The placement of the young Jesuit saints in the immediate vicinity of Mary in this depiction emphasizes their special position as saints of the order.

During the plague epidemic at the beginning of the eighteenth century, the Societas Jesu succeeded in establishing the Jesuit saints Sts. Aloysius Gonzaga and Franz Xavier as plague saints and thus spread their cults. At the same time, they established connections with other saints. For example, they linked new saints with those already established in the Middle Ages in order to promote their veneration in the Bohemian province. This can also be seen in the decoration of the chapels and the altars on the right side because all four side chapels are dedicated to saints who have a special relationship to the plague or death.

At the entrance to the St. Barbara Chapel a relief shows the early Christian saint and patron saint of the dying, accompanied by an angel, appearing to St. Stanislaus Kostka and handing him the Eucharist.[173] That the giving of the viaticum must be seen in connection with the plague epidemic is confirmed in the adjacent chapel of St. Charles Borromeo,[174] for on the altarpiece[175] the Milanese bishop gives Holy Communion to plague patients.[176] This altarpiece is flanked by statues of two late medieval plague patrons: St. Sebastian and St. Roch.[177] The top picture shows St. Rosalia of Palermo, also a plague saint, whose veneration was especially spread by the Societas Jesu.[178] Reference is made to the adjacent chapel of St. Aloysius of Gonzaga, not only by the reception of Holy Communion from the hands of Charles Borromeo but also by his death as a result of caring for plague patients.

The last chapel, just before the altar on the right, is dedicated to St. Paulina, a Roman catacomb saint[179] whose bones were discovered in Rome in the sixteenth century.[180] Her relics were translated to Olomouc on June 12, 1623, during a terrible epidemic.[181] Consequently, during plagues in the seventeenth

and eighteenth centuries, the Society of Jesus in Olomouc tried to spread the veneration of St. Paulina as a local protector from plague. To promote the saint, the date for the feast of laying the foundation stone of the new Olomouc Jesuit church was put on June 12, 1712—the saint's anniversary.[182] The popularization of this catacomb saint was initially achieved by linking her cult to devotion to St. Anne, who had enjoyed special veneration in Olomouc since the Middle Ages and to whom the chapel on the opposite side of the church is dedicated.[183] The Jesuits succeeded only partially in their efforts to promote "their" saint in the local context, as her cult remained limited to the city of Olomouc and its immediate surroundings.[184] In general, it can be said that even in the selection of saints and their legends for church decoration, the Society of Jesus responded to local events and the needs of the population by promoting the veneration of plague saints, reviving the veneration of medieval saints, and specifically fostering the cults of the Jesuit Order's saints including those used to inspire and support the college students with their model piety. A uniform program of salvation history, however, was apparently not pursued.[185]

TEACHING INVISIBLE DOGMAS
THROUGH VISIBLE IMAGES

The interior decoration of the Mary of the Snow Church shows that while the main task of the decoration concept was reinforcing Catholic beliefs by visualizing and conveying Catholic dogma, the Societas Jesu also took inspiration from local events.[186] Changes to the patrocinium of the church, the dedication and decoration of the St. Aloysius Gonzaga Chapel and the side chapels of Mary and the Guardian Angel were reactions to contemporary events.[187] Hubert Jedin noted this function of art when he described ecclesiastical art in the age of the Counter-Reformation as:

> a servant of controversial theology by seizing the doctrines disputed by Protestantism, the veneration of the Mother of God and the saints and their relics, the sacraments, especially the presence of Christ in the Eucharist, the sacrifice of the Mass, good works, the papacy and its history, . . . all this was an actual, if not always intended, execution of the Council's decree.[188]

In Olomouc, that art decoration was intended to support and reflect Catholic doctrine is shown by the multitude of pictorial motifs chosen to show scenes in which central Catholic dogmas could be illustrated. In conveying these dogmas visually, the Societas Jesu was guided by established compositions and biblical and hagiographic narratives.[189] The aim was always to visualize the doctrines with the help of already-established pictorial subjects in order

to illustrate complex theological dogmas, such as the doctrine of the image prototype or the somatic presence in the Eucharist. The order deliberately used scenes from the *vitae* of its own saints in order to establish their veneration and communicate dogma through *exempla*. The fact that the teachings of the faith were conveyed by means of pictures was entirely in keeping with Catholic pictorial practice and Jesuit didactics, where a high value is ascribed to the image generally, not limited to the context of Ignatian spirituality. In addition to the decorative and didactic roles of images, the display and veneration of the sacred image have been central to the teachings of the Catholic Church since the early modern period.[190] At the same time, the wall and ceiling paintings in Catholic Church spaces of the seventeenth and eighteenth centuries conformed to the Tridentine pictorial decree, since they visualize biblical episodes or the *vitae* of saints and also convey vividly some of the teachings of the Council of Trent itself.

The practice of presentation of Catholic doctrines in sacred space through images and pictorial decoration is reflected in the architectural and decorative redesign of Catholic churches at the end of the sixteenth and beginning of the seventeenth century.[191] This redesign of church space for Catholic sacred art did not entail a substantial break with the Catholic artistic tradition due to the Reformation. On the contrary, the new liturgical, aesthetic, and catechetical reforms of church space in the early modern period continued an older tradition. Despite this continuity, the decrees of the Council of Trent and the subsequent liturgical reforms had a great influence on art because they reaffirmed and intensified already-existing liturgical traditions of the Catholic Church. At the same time, the Tridentine decisions and liturgical reforms gave new impetus to art by confirming and enhancing already-established art forms. The decoration of the Jesuit church and chapel in Olomouc is one example that shows how the visual concepts of the invisible dogmas which were established in Rome, the center of the Jesuit Order, were adopted and adapted in the provinces, and how the Council of Trent resolutions were implemented in local religious practice while reflecting back on the Roman model.

NOTES

1. Brossette, *Die Inszenierung des Sakralen*, 12.
2. Wohlmuth, "Bild und Sakrament im Konzil von Trient," 87–92.
3. Appuhn-Radtke, *Visuelle Medien*, 26–27.
4. Jedin, "Entstehung und Tragweite des Trienter Dekrets," 424–425.
5. Hecht, "Das katholische Retabel," 326. Hecht refers here to the early modern altar retable.
6. Post-Tridentine sacred space was not only determined by the resolutions of the Council of Trent but by reforms introduced even earlier. About its development

see van Bühren, "Kirchenbau in Renaissance und Barock," esp. 93–94, 116–119; Stabenow, "Auf dem Weg zum *theatrum sacrum*"; Ganz, *Barocke Bilderbauten*; Kummer, "Doceant Episcopi."

7. The visualization strategies of Baroque art go back to ancient rhetoric. The intention of Latin rhetoric was transferred to painting in art theory after Alberti. The goal of the speaker, "*persuasio*," is to persuade or convince, which he achieves by means of "*docere*," "*delectare*," and "*movere*"—teaching the mind, delighting the senses, and moving the soul or will (see Hundemer, *Rhetorische Kunsttheorie*, 224). See also Hundemer, "Argumentative Bilder" and Büttner, "Rhetorik und barocke Deckenmalerei."

8. For the accommodation principle, see in detail Sievernich, "Von der Akkomodation zur Inkulturation."

9. See Mlčák, *Olomouc Stadtführer*, 8–12. For Olomouc religious matters see Wolný, *Die Markgrafenschaft Mähren*, 60; Paleczek, "Kirchliche Strukturen," 43.

10. Fiala, "Jezuitská akademie," 27.

11. Fiala, "Jezuitská akademie," 33–36; Mlčák, *Olomouc Stadtführer*, 10. On the plague and the great fire at the beginning of the eighteenth century, see Mlčák, "Mor, hlad, války"; Kovářová, "Požár Olomouce."

12. Alexander, *Kleine Geschichte*, 233; Winkelbauer, *Ständefreiheit und Fürstenmacht*, 27–28.

13. On this see Fiala, "Jezuitská akademie," 28; Kröss, *Geschichte der Böhmischen Provinz*, vol. 1, 308–311; Buben, *Encyklopedie řádů*, 258; Mlčák, "Areál jezuitské koleje v Olomouci," 179; Jakubec, "Olomouc. Bývalý konvent minoritů," 475.

14. See Kröss, *Geschichte der Böhmischen Provinz*, 1, 310.

15. See Mlčák, "Jezuitský konvikt," 37; Jakubec, "Renesanční a manýristické umění," 322.

16. On the building history of the Jesuit complex in Olomouc, see Pavlíček, "Barokní architektura," 437–442; Mlčák, "Areál jezuitské koleje v Olomouci"; Pavlíček, "Komplex jezuitských budov"; Pavlíček, "Jezuitský Kostel Panny Marie Sněžné."

17. See Hersche, "Die Allmacht der Bilder," 400.

18. Quoted from Kummer, "Doceant Episcopi," 510 (translation by the author). See also Jedin, "Entstehung und Tragweite des Trienter Dekrets," 155–156.

19. Hecht, *Katholische Bildertheologie*, 110.

20. See in detail Hecht, *Katholische Bildertheologie*, 199–220.

21. On the Semiacheiropoieta and the image of St. Luke, see Hecht, *Katholische Bildertheologie*, 220–227, 236; Wolf, *Salus Populi Romani*, 14, 141–145; Belting, *Bild und Kult*, 70–72; Ostrow, *Art and Spirituality*, 122; Benini, "Salus Populi Romani," 85–99, here 86–87.

22. Hecht, *Katholische Bildertheologie*, 120.

23. Appuhn-Radtke, *Visuelle Medien*, 27.

24. Hecht, *Katholische Bildertheologie*, 121. The visual decoration of church rooms has the function of supporting pastoral activity. See Stabenow, "Auf dem Weg zum '*theatrum sacrum*,'" 131.

25. Wohlmuth, *Dekrete der Ökumenischen Konzilien* 3, 774–776.

26. Wohlmuth, *Dekrete der Ökumenischen Konzilien* 3, 775 (translation by the author).

27. Wohlmuth, *Dekrete der Ökumenischen Konzilien* 3, 775.

28. Wohlmuth, *Dekrete der Ökumenischen Konzilien* 3, 775 (translation by the author).

29. In the Olomouc Diocesan Statutes of 1568, the chapter *De imaginibus* confirms the two functions of images and the correct use of images. See Dudík, *Statuten*, 41.

30. Lundberg, *Jesuitische Anthropologie*, 161–181; Appuhn-Radtke, *Visuelle Medien*, 24–35; Spengler, *Spiritualia et pictura*, 115–135; Schneider, *Kirche und Kolleg*, 299–308.

31. Ignatius of Loyola (*Gründungstexte der Gesellschaft Jesu*, 85–269) used images during meditation as a spiritual exercise as a means of convincingly finding and strengthening faith (Hundemer, *Rhetorische Kunsttheorie*, 226). See also Appuhn-Radtke, *Visuelle Medien*, 27; Schneider, *Kirche und Kolleg*, 300; Zierholz, "To Make Yourself Present," 421–425.

32. Loyola, *Gründungstexte der Gesellschaft Jesu*, 92 [EB 1], quoted here from the Spanish autograph. The exercises last four weeks and describe a gradual ascent to union with God (see Spengler, *Spiritualia et pictura*, 116).

33. Lundberg, *Jesuitische Anthropologie*, 161, 163.

34. For the methods see Appuhn-Radtke, *Visuelle Medien*, 29; Schneider, *Kirche und Kolleg*, 299–304.

35. Appuhn-Radtke, *Visuelle Medien*, 29; Loyola, *Gründungstexte der Gesellschaft Jesu*, 124 (EB 47); Zierholz, "To Make Yourself Present," 424–431.

36. Rahner, "Anwendung der Sinne," 439; Fabre, *Ignace de Loyola*, 25–74.

37. Appuhn-Radtke, *Visuelle Medien*, 29; Lundberg, *Jesuitische Anthropologie*, 164; Spengler, *Spiritualia et pictura*, 118.

38. On the method of *applicatio sensum*, see esp. Rahner, "Anwendung der Sinne"; Fabre, *Ignace de Loyola*, 25–74; Appuhn-Radtke, *Visuelle Medien*, 29–30; Schneider, *Kirche und Kolleg*, 299–304.

39. Loyola, *Gründungstexte der Gesellschaft Jesu*, 134 (EB 66–70). This is the fifth exercise of the first week. See also the reflection on the first day of the second week (Loyola, *Gründungstexte der Gesellschaft Jesu*, 148–151 [EB 101–109]). See here Rahner, "Anwendung der Sinne," 437; Sudbrack, "Die 'Anwendung der Sinne' als Angelpunkt der Exerzitien"; Schneider, *Kirche und Kolleg*, 301–303; Zierholz, "To Make Yourself Present," 424–431.

40. Schneider, *Kirche und Kolleg*, 301.

41. Rahner, "Anwendung der Sinne," 438.

42. See Schneider, *Kirche und Kolleg*, 301.

43. To what extent the ceiling paintings were explicitly referred to in the context of instruction must remain open, but the banners on the ceiling painting in the nave suggest that the Marian antiphon was sung during the service and its meaning explained by means of the furnishings. Although mainly illustrations from devotional books were used to inspire meditation (see Appuhn-Radtke, *Visuelle Medien*, 3, 28–35), it cannot be ruled out that the furnishings of church rooms could also have

served as inspiration for meditation, as the house chapel in Dillingen attests (see Schneider, *Kirche und Kolleg*, 301).

44. The contracts between the rectors of the college and the artists—for example, the rector Karl Pfefferkorn and Karl Joseph Haringer—which have been preserved in the Moravian Provincial Archives in Brno, suggest that the decoration program was designed by the Society of Jesus and not by the patrons. No written instructions on the iconographic program survive, but contracts with the artists show that they were to adhere to the model or concept or submit one, from which it can be deduced that the question of the content was settled by the Jesuit Order itself (MZA, Boček Collection G 1, sign. 12278 (contracts with artists), fol. 59–78 and 83–84). In the eighteenth century, the church building and its furnishings were mainly financed by private donors or members of the order. On the question of patrons in the Societas Jesu in general, see Haskell, "The Role of Patrons"; Schneider, Kirche und Kolleg, 305–308.

45. On the icon *Salus Populi Romani* see Gumppenberg, *Marianischer Atlass*, 7–12; Wolf, *Salus Populi Romani*; Sterba, *"Didactica picta,"* 24–26.

46. On this cult, see the chapter by Deutsch in this volume, where he suggests that the Brno copy rather than the original was a model for Olomouc church decoration. Functioning as a city palladium, the cult of the image was limited to Rome until the early modern period, but after the order's general, Francis Borja, advocated for the acquisition of copies of it in the second half of the sixteenth century, they became widespread in contexts of the Jesuits and their patrons. On the copies and the worldwide distribution of the icon, see Benini, *"Salus Populi Romani"*; Jakubec, "Olomoucký jezuitský kostel"; Sterba, *"Didactica picta,"* 24–27.

47. The Jesuit Wilhelm Gumppenberg collected the story of the icon in Santa Maria Maggiore and other accounts of miraculous images of the Virgin Mary in his multi-volume Marian Atlas. Gumppenberg, *Marianischer Atlass*, 7–10. See also Sterba, *"Ora pro nobis,"* 286–288.

48. Gumppenberg, *Marianischer Atlass*, 11; Wolf, *Salus Populi Romani*, 131–135; Sterba, *"Ora pro nobis,"* 288–290.

49. *Regina Coeli* was another name for the Roman icon, which only received its current name, *Salus Populi Romani*, in the nineteenth century; Wolf, *Salus Populi Romani*, 19. On the Marian Antiphon see Heinz, "Die marianischen Schlussantiphonen," 351–353; Sterba, *"Ora pro nobis,"* 290–292.

50. Jakubec, "Olomoucký jezuitský kostel," 154–155.

51. Laying the foundation stone of the church was deliberately set for 12 June, as on that day every year the reliquary translation of St. Paulina to Olomouc was commemorated. See Johannes Müller's diary entry from June 12, 1712 (Diář rektora olomoucké koleje 1703–1713, MZA, E 28, B Rukopisy, kniha 4, 213r-214r); see Jakubec, "Olomoucký jezuitský kostel," 150.

52. See here Karl Pfefferkorn's diary entry of February 16, 1716 (Diář rektora olomoucké koleje 1714–1723, MZA, E 28, B Rukopisy, kniha 5, 47v). The change of patronage is interpreted in research as a reaction to the plague epidemic of the years 1713 to 1715. See Jakubec, "Olomoucký jezuitský kostel," 155; Pavlíček, "Jezuitský Kostel Panny Marie Sněžné," 84.

53. The rector of the Jesuit College, Johannes Müller, notes about the function of the patrocinium of churches: "*Es bringt der allgemeine brauch der Catholischen kirch mit sich, dass, wan eine kirch wider den titel und nahmen MARIA geweÿhet wird, auch ein besonderer Ehrentitel beÿgefüget werde als wie zu Rom die Kirchen genaenet seÿn: . . . Zweÿtens auss andacht zu einem Gewissen Ehrentitel des kirchen-Stifters, der die kirche baut. Drittens wegen eines grossen Wunderwerks, als wie zu Rom die kirche MARIA Major auch genannt wird MARIA-Schnee*" (Müller, *Anfang und End*, 40–41).

54. On external forms of image veneration, see Hecht, *Katholische Bildertheologie*, 144–150.

55. The doctrine of the prototype was formulated as early as the second Council of Nicaea (787), stating: "For the honoring of the image passes on to the original figure, and those who venerate the image venerate in it the person of the sitter" (see Wohlmuth, *Dekrete der Ökumenischen Konzilien* 1, 136). See also Wirth, "Soll man Bilder anbeten?" 30–31.

56. Hecht, *Katholische Bildertheologie*, 96 on the "*vera* effigies," 96–104; on the Acheiropoieta, Luke's images, and other venerable images 199–227.

57. See Sterba, "*Didactica picta*," 27–30.

58. On the function of the frontispiece see Hecht, "Das Bild am Altar," 135.

59. Comparing written and pictorial sources shows that this visualization strategy transcended orders; this type of representation was repeated several times by the Jesuits and also used specifically by other orders to convince the faithful of the true representation of the saints, as the pictorial decoration by Wenceslas Lorenz Reiner in the Church of St. John Nepomuk of the Ursulines in the Hradčany district of Prague attests. See Hecht, *Katholische Bildertheologie*, 96; Sterba, "*Didactica picta*," esp. 27–30.

60. Wohlmuth, *Dekrete der Ökumenischen Konzilien* 3, 695, 697; the doctrine of transubstantiation had been established at the Lateran Council of 1215, but was rejected by Calvin and Zwingli, 693–698.

61. Jedin, *Geschichte des Konzils von Trient*, 32.

62. Jedin, *Geschichte des Konzils von Trient*, 283–285.

63. Wohlmuth, *Dekrete der Ökumenischen Konzilien* 3, 695 (translation by the author).

64. Wohlmuth, *Dekrete der Ökumenischen Konzilien* 3, 693 (translation by the author).

65. Wohlmuth, *Dekrete der Ökumenischen Konzilien* 3, 697–698.

66. Wohlmuth, *Dekrete der Ökumenischen Konzilien* 3, 698 (translation by the author).

67. Dudík, *Statuten*, 49–50.

68. Post-Tridentine church space had a tendency to theatricalize by using the presbytery as a stage and enhancing the lay space as an auditorium, see Stabenow, "Auf dem Weg zum 'theatrum sacrum,'" 125, 127; see also Terhalle, ". . .ha della Grandezza de padri Gesuiti," 104–105; van Bühren, "Kirchenbau in Renaissance und Barock," 97; Hecht, "Das katholische Retabel," 323. The church interiors of the fifteenth and sixteenth centuries, in comparison, were only whitewashed, as

the example of Santa Maria del Popolo still shows today (see Kummer, "Doceant Episcopi," 514, 523; Ganz, *Barocke Bilderbauten*, 95–98; Ganz, "Rückeroberung des Zentrums," 265–267). In the wake of the Tridentine decree on images, the Roman churches were redesigned at the end of the sixteenth century (Kummer, "Doceant Episcopi," esp. 532; van Bühren, "Kirchenbau in Renaissance und Barock," 116–118).

69. Schnell, "Liturgie der Gegenwart," 150; Hecht, "Das katholische Retabel," 323; van Bühren, "Kirchenbau in Renaissance und Barock," 98; Stabenow, "Auf dem Weg zum *theatrum sacrum*," 128.

70. van Bühren, "Kirchenbau in Renaissance und Barock," 99 and 97; Stabenow, "Auf dem Weg zum '*theatrum sacrum*,'" 128; Hecht, "Das katholische Retabel," 327–328; Wipfler, "Im Zentrum der Liturgie?," 315.

71. According to the Baroque concept of piety, closeness to Christ could be experienced by the faithful in the altar sacrament, which was kept hidden, so to speak, in the altar tabernacle, but was also presented in public in a monstrance during devotions and prayer meetings and given to the faithful during communion. See Müller, "Katholische Volksfrömmigkeit," 399.

72. As Appuhn-Radtke has noted, Christ was already depicted in three different guises on the 1588/1589 altarpiece by Antonio Maria Viani on the left side altar in the Jesuit Church of St. Michael in Munich. He is depicted as a blessing infant Jesus on his mother's lap, in Eucharistic form in the monstrance at their feet, and in his most holy name at their heads (see Appuhn-Radtke, "Innovation durch Tradition," 247–248). Whereas in the Munich painting Christ is shown in the Eucharistic form as a host in the monstrance, in Olomouc the altar tabernacle fulfills the same function.

73. LThK 2, column 1178–1179; Appuhn-Radtke, "Innovation durch Tradition," 243–250.

74. Stephan, "Und das Wort ist Bild geworden," 84.

75. Stephan, "Und das Wort ist Bild geworden," 84.

76. For the representation of the Christogram and the veneration of the name of Jesus, see Appuhn-Radtke, "Innovation durch Tradition"; Schneider, *Kirche und Kolleg*, 181–185, 249–254.

77. Stephan, "Und das Wort ist Bild geworden," 84; this was also noted by the Council Fathers.

78. Appuhn-Radtke, "Innovation durch Tradition," 244; Schneider, *Kirche und Kolleg*, 181, 249–250.

79. Stephan, "Und das Wort ist Bild geworden," 83–84.

80. Stephan, "Und das Wort ist Bild geworden," 83–97, illustrates this connection with Gaulli's ceiling fresco in Il Gesù, but these concepts can also apply to other rooms.

81. Eucharistic saints have a particularly intimate relationship with the Holy Eucharist (Holböck, *Das Allerheiligste und die Heiligen*, 33).

82. Saint Barbara is an early Christian saint, one of the Fourteen Helpers in Need, who was venerated as the patron saint of death in the Middle Ages. This led to her attribute, the tower, being largely replaced by the chalice and host from the sixteenth century onward, LCI 5, column 304–306; Cassidy-Welch, "Prison and sacrament,"

378. Through the miraculous help of St. Barbara, the young Jesuit and later saint Stanislaus Kostka is said to have had the Blessed Sacrament administered during his illness. See Holböck, *Das Allerheiligste und die Heiligen*, 44–45, 212–216; Jetter, *Die Jesuitenheiligen*, 26.

83. Two images in the side chapel of St. Ignatius of Loyola show the saint during a Eucharistic celebration: the Miracle of the Flame and the Vision of Christ in the Host.

84. The visualization of the divine mystery is not limited to the image, but can be expressed in different media, see Ganz and Lentes, *Ästhetik des Unsichtbaren*; Hofmann, *Bildtheologie*; Melion, Pastan, and Wandel, *Quid est sacramentum?*; van Bühren, "Revelation in the Visual Arts."

85. Fiala, "Kaple Božího Těla," 149–150; Pavlíček, "Barokní architektura," 441.

86. Pavlíček, "Barokní architektura," 441; Mlčák and Mlčáková, "Mědirytiny," 71; Dolejší and Mlčák, "Zobrazení legendy," 110.

87. When the altarpiece was created, when it was removed or whether it was destroyed can no longer be determined today. See Mádl, "Handkeho skica," 508–509; Dolejší and Mlčák, "Zobrazení legendy," 108.

88. Tanner, *Geschichte derer Helden von Sternen*, 118; Mlčák and Mlčáková, "Mědirytiny," 69; Mlčák and Mlčáková, "Barokní Legenda," 261; Mádl, "Handkeho skica," 509; Dolejší and Mlčák, "Zobrazení legendy," 107–108, 110.

89. Handke's journeyman Johannes Drechsler was also involved in the painting. See Fiala, "Kaple Božího Těla," 150.

90. Balbin, *Diva Wartensis*, 172–173.

91. Tanner, *Vestigia Virtutis* (unpaginated).

92. Tanner, *Vestigia Virtutis*.

93. Tanner, *Geschichte derer Helden von Sternen*, 118.

94. Browe, *Die eucharistischen Wunder*, 155.

95. Mlčák and Mlčáková, "Barokní Legenda," 257; Dolejší and Mlčák, "Zobrazení legendy," 110.

96. Herzog and Weigl, "Vorwort," 15.

97. Matsche, "Fundant et ornant," 161.

98. Construction of the monastery complex took many years and many changes were made. The Jesuits took over the monastery complex, dating from the early Middle Ages, from the Minorites and financed their buildings through various benefactors. In the beginning they were mainly supported by Catholic clergy, especially the Olomouc bishops Wilhelm Prusinovský of Víckov, Jan Grodecký of Brod, Stanislav Pavlovský of Pavlovice, and Francis of Dietrichstein. From the eighteenth century onward, support came from the nobility, burghers, and members of the order themselves.

99. Tanner, *Vestigia Virtutis*. See also Mádl, "Handkeho skica," 508–509; Zelenková, *"Vidi stellas undecim,"* 328; Dolejší and Mlčák, "Zobrazení legendy," 108.

100. Zelenková, *"Vidi stellas undecim,"* 328; Mádl, "Handkeho skica," 508; Dolejší and Mlčák, "Zobrazení legendy," 109.

101. Mádl, "Handkeho skica," 508, Anm. 16; Dolejší and Mlčák, "Zobrazení legendy," 108–109.

102. Described in Browe, *Die eucharistischen Wunder*, 146–147. For the legend of Daroca see de la Cueva, *Historia*; Browe, *Die eucharistischen Wunder*, 150; Matern, *Zur Vorgeschichte und Geschichte der Fronleichnamsfeier*, 19–20.

103. At the end of the sixteenth and beginning of the seventeenth century, two Spanish Jesuits held the office of rector at the college: Hutardus Perez (1526–1594) from 1566 to 1580 and Petrus Ximenes (1554–1633) from 1600 to 1607 and from 1618 to 1622. Matching Granthomme's creative period, it is clear that Petrus Ximenes had the idea and commissioned the now-lost altarpiece, which was probably made in the first quarter of the seventeenth century and today survives only as a copy in an engraving. For the two rectors of the college, see Fechtnerová, *Rectores*, 323–324. See also Dolejší and Mlčák, "Zobrazení legendy," 108.

104. Browe, "Die eucharistischen Verwandlungswunder," 286–287.

105. Guster, *Die Hostienmonstranzen*, 69.

106. For Handke's design for the Corpus Christi Chapel in Olomouc see Mádl, "Handkeho skica"; Mádl, "Jaroslav ze Šternberka."

107. LCI 2, column 346–352.

108. By showing the breasts with which she nourished her Son, Mary wants to persuade Christ. See ML 5, 165; ML 6, 86; Hecht, *Katholische Bildertheologie*, 490.

109. ML 5, 165; ML 6, 86.

110. Several art historians have already dealt with the depiction on the cartouches and their interpretation: Togner, "Kaple Božiho těla," 337; Mlčák and Mlčáková, "Mědirytiny k barokní legendě," 71–72; Mlčák and Mlčáková, "Barokní Legenda," 257–258; Fiala, "Kaple Božího Těla," 153; Dolejší and Mlčák, "Zobrazení legendy," 112–113.

111. This is based on the Sermon on the Mount, in which Jesus says: "Do not think that I have come to abolish the Law and the Prophets. I have not come to abolish, but to fulfil" (Matt. 5:17). See Braun-Niehr, "*In figuris praesignatur*," 125, 128.

112. All the inscriptions and their meaning have been examined: see Mlčák and Mlčáková, "Mědirytiny k barokní legendě," 71–72; Mlčák and Mlčáková, "Barokní Legenda," 257–258; Fiala, "Kaple Božího Těla," 153; Dolejší and Mlčák, "Zobrazení legendy," 112–113.

113. RDK 6, column 173–175; LCI 3, column 150–153; Braun-Niehr, "*In figuris praesignatur*," 124.

114. Stephan, "Und das Wort ist Bild geworden," 97.

115. MGG 7, column 593–594; Tück, *Gabe der Gegenwart*, 325–326, 274; Browe, *Die Verehrung*, 149–150; Hoping, *Mein Leib*, 228.

116. About the hymn *Verbum supernum prodiens* see Tück, *Gabe der Gegenwart*, 274–280.

117. Tück, *Gabe der Gegenwart*, 279–280.

118. Ryška, *Freska Jana Kryštofa Handkeho*, [6].

119. Ryška, *Freska Jana Kryštofa Handkeho*, [7]; Mlčák and Mlčáková, "Barokní Legenda," 262.

120. Samerski, "Maria zwischen den Fronten," 359; De Fiores, "Maria," 175.

121. Orlita, "Gemeinschaft der Frommen im Wandel. "

122. LCI 2, column 346–352; Hecht, *Katholische Bildertheologie*, 490–492.

123. Both pictures are said to have been painted by the Olomouc painter Johann Christoph Handke between 1730 and 1732. In the research literature, these ceiling paintings are usually dated around 1732 (see Altrichter, Togner and Hyhlík, *Olomouc*, 17). Cerroni also dates the painting of the two fields to the years 1730 to 1732, although he mentions different themes than those depicted there today. See Cerroni, *Geschichte der bildenden Künste* 2, 65v.

124. The first depictions of this scene appeared in the fourteenth century and were disseminated through woodcuts in the fifteenth century, but depicted more frequently around 1500. See Karger, "Wie Christus unser Herr erschien unserer Herrin," 116, 119; Hecht, *Katholische Bildertheologie*, 489–490.

125. The image theologian Johannes Molanus, among others, spoke out against this motif; Hecht, *Katholische Bildertheologie*, 489. See also Karger, "Wie Christus unser Herr erschien unserer Herrin," 126–128; Maron, *Ignatius von Loyola*, 36–37; ML 1, 268.

126. In the Byzantine liturgy, a hymn is sung which originated around 800 and which says: "You (Mary) are the first to receive the greeting of joy, because you are the cause of joy of the whole earth circle." Quoted here from Braun, *Maria und der Auferstandene*, 4. See also Hecht, *Katholische Bildertheologie*, 489; ML 1, 268–270.

127. The thesis of the Son of God appearing to Mary was spread by the *Legenda aurea* of Jacobus de Voragine and the *Vita Christi* of Ludolph of Saxony, both books that Ignatius of Loyola read. See Karger, "Wie Christus unser Herr erschien unserer Herrin," 113–114; Maron, *Ignatius von Loyola*, 37–38.

128. Loyola, *Gründungstexte der Gesellschaft Jesu*, 236 (EB 299); Braun, *Maria und der Auferstandene*, 13.

129. Maron, *Ignatius von Loyola*, 167. As early as 1593, this event was illustrated in Jerónimo Nadal's *Evangelicae historiae imagines* (see Nadal, *Evangelicae historiae imagines*, 135).

130. Haub and Paal (ed.), *Die Exerzitien des heiligen Ignatius*, 98–100; Braun, *Maria und der Auferstandene*, 26–39.

131. Heinz, "Die marianischen Schlußantiphonen."

132. Johannes Müller, rector of the college, emphasized this in his notes in 1714; Müller, *Anfang und End*, 43–48. See also Horníčková in this volume.

133. In reality, the wooden statue of the Virgin Mary was only created around 1380; today, a copy stands on the altar. See Müller, *Anfang und End*, 44; Machytka, "Gotická socha," 3, 5.

134. Royt and Samerski, Maria, 177–186. Samerski, "Maria in Mähren," 118

135. Jedin, "Entstehung und Tragweite des Trienter Dekrets," 172, 174. See also Stabenow, "Auf dem Weg zum 'theatrum sacrum,'" 131.

136. Köpf, "Protestantismus und Heiligenverehrung," 329–330; Röder, "Luther," 33.

137. Wohlmuth, *Dekrete der Ökumenischen Konzilien* 3, 774 (translation by the author).

138. Jedin, "Entstehung und Tragweite des Trienter Dekrets," 424; Polonyi, *Wenn mit Katakombenheiligen aus Rom neue Traditionen begründet werden*, 39–40; Meier, *Handbuch der Heiligen*, 239.

139. Wohlmuth, *Dekrete der Ökumenischen Konzilien* 3, 774–775 (translation by the author).

140. See Jedin, "Entstehung und Tragweite des Trienter Dekrets," 172.

141. See Jedin, "Entstehung und Tragweite des Trienter Dekrets," 154.

142. See Angenendt, *Heilige und Reliquien*, 244.

143. Loyola, *Gründungstexte der Gesellschaft Jesu*, 262 (EB 358) (translation by the author). See also O'Malley, *Die ersten Jesuiten*, 311–314.

144. See Kroess, *Geschichte der Böhmischen Provinz* 2.2, 834; for explanations, 824–835. See also Pötzl-Malikova, "Die Feiern," 1250–1254.

145. Huber, *Katholische Kirche*, 403. See also Vácha's chapter in this book.

146. König-Nordhoff, *Ignatius von Loyola*, 77; Gerken, *Entstehung und Funktion*, 161–163.

147. On the life and missionary work of Franz Xavier see Schurhammer, *Franz Xaver*; Haub; Oswald. *Franz Xaver;* Schneider, *Kirche und Kolleg*, 106, Anm. 583.

148. On the life Ignatius of Loyola see Haub, *Die Geschichte der Jesuiten*, 8–25. See also the introduction to the Pilgrim's account in Loyola, *Gründungstexte der Gesellschaft Jesu*, 1–6.

149. Bolland, *Imago*, 83. See also Schneider, *Kirche und Kolleg*, 233. Christine Schneider has shown that this image of the two Jesuits as *geminae Societatis columnae* was already widespread in Jesuit literature in the seventeenth century (Schneider, *Kirche und Kolleg*, 233 and Anm. 1222). On the parallel position of Peter and Paul in Jesuit iconography and its dissemination in the Bohemian Province of the Order, see also Nevímová, "Poznámka k ikonografii jezuitského řádu," 394–395.

150. Schneider, *Kirche und Kolleg*, 233; Bolland, *Imago*, 83; Nevímová, "Poznámka k ikonografii jezuitského řádu," 394–395.

151. Pavlíček, "Barokní architektura," 440; Pavlíček, "Sochaři a sochařství," 128.

152. Kröss, *Geschichte der Böhmischen Provinz* 3, 917, 921.

153. Müller, *Anfang und End*, last page [not paginated]; Vyvlečka, *Příspěvky k dějinám kostela*, 77; Hanke, "Olomoučtí jezuité a svatí," 421.

154. Koch, *Jesuiten-Lexikon*, col. 1687–1688; Holböck, *Das Allerheiligste und die Heiligen*, 44–45, 212–216; Jetter, *Die Jesuitenheiligen*, 26–27.

155. Koch, *Jesuiten-Lexikon*, col. 1688; Jetter, *Die Jesuitenheiligen*, 26.

156. Koch, *Jesuiten-Lexikon*, col. 1687–1688; Jetter, *Die Jesuitenheiligen*, 26–27; Meier, *Handbuch der Heiligen*, 271.

157. Koch, *Jesuiten-Lexikon*, col. 1687; Jetter, *Die Jesuitenheiligen*, 26–27; Meier, *Handbuch der Heiligen*, 272.

158. LCI 8, column 389.

159. LCI 5, column 100–101; Koch, *Jesuiten-Lexikon*, column 43–45; Jetter, *Die Jesuitenheiligen*, 27–28; Meier, *Handbuch der Heiligen*, 273.

160. LCI 5, column 100; Koch, *Jesuiten-Lexikon*, column 44.

161. In the capitals of Vienna and Prague these celebrations lasted eight days and the canonization was also celebrated festively in the other colleges, albeit on a

smaller scale. For the festivities in Vienna see Pötzl-Malikova, "Berichte," in Prague see Kröss, *Geschichte der Böhmischen Provinz* 3, 917–920.

162. Kerber, *Andrea Pozzo*, 181.

163. Kroess, *Geschichte der Böhmischen Provinz* 3, 920.

164. Hanke, "Olomoučtí jezuité a svatí," 428.

165. Hanke, "Olomoučtí jezuité a svatí," 427; Buben, *Encyklopedie řádů*, 265.

166. Müller, "Katholische Volksfrömmigkeit," 403.

167. Cerroni, *Geschichte der bildenden Künste* 2, 65v.

168. Contracts from the years 1746/1747 have been preserved concerning the construction of the Aloysius Gonzaga Chapel (MZA, E 28, B 3/23 und B 3/24).

169. Kroess, *Geschichte der Böhmischen Provinz*, vol. 2.2, 834–835; Kröss, *Geschichte der Böhmischen Provinz*, vol. 3, 920–921; Hanke, "Olomoučtí jezuité a svatí," 425.

170. Orlita, "Olomoučtí jezuité," 47–48; Maňas and Orlita. "Olomouc," 99.

171. The attribution of the altarpiece is based on stylistic studies and the fact that most of the altarpiece decoration was created by Thomasberger, but there is no other evidence. See Macháčková, *Jezuitská malířská kultura na Moravě*, 147–148.

172. Kroess, *Geschichte der Böhmischen Provinz* 2.2, 639, 738.

173. For St. Barbara see LCI 5, column 304–311; for St. Stanislaus Kostka see LCI 8, column 389–390.

174. See LCI 7, column 273–275.

175. The altarpiece was painted by Franz Joseph Wickart in 1721; see Togner, *Barokní malířství v Olomouci*, 66.

176. Bach, *Karl Borromäus*, 109–110; Meier, *Handbuch der Heiligen*, 305. The fact that Charles Borromeo is venerated as a plague saint is also due to his biography; when the plague broke out in Milan in the summer of 1576, Borromeo, unlike many others, stayed in the city, organizing help and personally caring for the sick.

177. The figures were made by Moravian sculptor Augustin Johann Thomasberger, as attested by a contract signed on June 23, 1722, MZA, Bočkova sbírka, G 1, 12268/25c, fol. 76–77. Since the fourteenth century, both saints have usually been depicted together and venerated as plague saints. LCI 8, column 275–278, column 318–324.

178. Franz Joseph Wickart also created the 1721 essay painting of St. Rosalia. Togner, *Barokní malířství v Olomouci*, 66. After her bones were translated to Palermo in the plague year of 1624, she became a patron saint against the plague. LCI 8, column 288–289; Huber, *Katholische Kirche*, 407.

179. For St. Paulina see Zelenková, "*CONTRA PESTEM NOBIS FAVE*"; Sterba, "*Ora pro nobis*," 292–298.

180. The rediscovery of the Roman catacomb Anonima di via Anapo in 1578 was accidental, Polonyi, *Wenn mit Katakombenheiligen*, 40–42, 54; Angenendt, *Heilige und Reliquien*, 250–251; Meier, *Handbuch der Heiligen*, 242, 251.

181. Zelenková, "*CONTRA PESTEM NOBIS FAVE*," 28; Mlčák, "K ikonografii sv. Pavlíny," 393; Schünke, *Beiträge zur kirchlichen Kunst- und Kulturgeschichte*, 15; Jakubec, "Olomoucký jezuitský kostel," 154–155.

182. Schünke, *Beiträge zur kirchlichen Kunst- und Kulturgeschichte*, 16; Mlčák, "K ikonografii sv. Pavlíny," 395; Jakubec, "Olomoucký jezuitský kostel," 150.

183. By depositing the bones of St. Paulina at the altar of St. Anne, who was venerated as Mary's mother and as the patron saint of miners in northern Moravia, the Jesuits managed to establish the new saint by tying her in with a local cult. The long veneration of St. Anne is also evidenced by the St. Anne Brotherhood, which was established in Olomouc at the end of the fifteenth century, Samerski, "Von der Rezeption zur Indoktrination," 97–98, 114; Hanke, "Olomoučtí jezuité a svatí," 425–426. St. Paulina did not receive her own altar until 1682 and the construction of her own chapel took place in 1685. See Müller, *Anfang und End*, 19; Vyvlečka, *Příspěvky k dějinám kostela*, 47; Hanke, "Olomoučtí jezuité a svatí," 424.

184. Zelenková, *"CONTRA PESTEM NOBIS FAVE,"* 27; Jakubec, "Protimorové procesí."

185. This is also evidenced by the altars on the Gospel side, which were dedicated to St. Anne, St. Joseph, the Archangel Michael, and the Guardian Angel.

186. See Appuhn-Radtke, *Visuelle Medien*, 26.

187. The artistic decoration of the Jesuit colleges in Dillingen and Wrocław, in contrast, should be interpreted differently, as they were based on a precise and almost elitist program that was primarily addressed to the friars rather than the laity. In my opinion, this is also evident when comparing the Corpus Christi Chapel, where the Old Testament references and inscriptions are directed at the university student, but the church refers more to the needs of the faithful. This does not mean that salvation-historical messages were not also conveyed here, but because of the many changes, I doubt that the decoration was based on a uniform program from the beginning. I would rather see the program as a kind of reaction to contemporary events, which, in addition to dogmatic instruction, was intended to give the faithful particular pastoral comfort and hope.

188. Jedin, "Entstehung und Tragweite des Trienter Dekrets," 424–425 (translation by the author). See Karcher, "Ursache und Wirkung," 85–86.

189. Thus, they oriented themselves to medieval traditions, local legends, or regional events, as evidenced by the decoration of the Jesuit church.

190. See Hecht, *Katholische Bildertheologie*, 119; Wimböck, "Kirchenraum, Bilderraum, Handlungsraum," 46.

191. See Signori, "Einheit in der Vielfalt?" 227.

BIBLIOGRAPHY

Archival and Manuscript Sources

Moravian Land Archive in Brno [Moravský zemský archiv v Brně (MZA)]:
Cerroni, Johann Peter. *Geschichte der bildenden Künste in Mähren und dem österr. Schlesien*, vol. 2. O. O. 1807. Collection Cerroni G 12, sign. I-33.
Boček Collection G 1, sign. 12278 (contracts with artists).

State District Archive in Olomouc [Státní okresní archiv Olomouc (SOkAO)]:
Müller, Joannes. *Anfang und End der alten wie auch der unter dem Titel und Nahmen Mariae-Schnee, in dem Collegio der Gesellschaft Jesu in Olmütz neu auferbauten Kirchebeschrieben von Johann Müller [Miller], Rektor des Kollegiums.* O. O. 1714. M 1–1, Sign. 1737, inv. no. 5708, internet access at http://digi.archives.cz/da /permalink?xid=06E6CCF4549E11E49A600025649FE690&scan=2116ea246a3 3477780397ac8f763bddb (last accessed 02.04.2021)

Primary Sources

Balbin, Bohuslav Aloys. *Diva Wartensis, Oder Ursprung und Mirackel Der großmächtigsten/Gottes/ und der Menschen Mutter Mariæ, Welche von so viel hundert Jahren hero zu der Warten/ In den Graentzen deß Landes Schlesien/ und der Graffschafft Glatz/ mit unzehlbahr-grossen Wahlfahrten verehrt wirdt/ und hoch mit Wunderwercken leuechtet.* Prague 1655.

Bolland, Johannes. *Imago primi saeculi Societatis Jesu a provincia Flandro-Belgica eiusdem Societatis repraesentata.* Antwerp: Moretus, 1640.

Dudík, Beda. *Statuten der Diöcese Olmütz vom Jahre 1568.* Brno [Brünn]: Břeža, Winiker & Co, 1870.

Loyola, Ignatius de. *Exercitia spirtualia,* Rome, 1548.

Tanner, Johannes. *Geschichte derer Helden von Sternen. Oder Deß Uhralten und Ruhmwürdigsten Geschlechtes von Sternberg.* Prague, 1732. Online: http://data .onb.ac.at/ABO/%2BZ20050230X (20.01.2018)

Tanner, Johannes. *Vestigia Virtutis Et Nobilitatis Sternbergicae In Regno Bohemiae, Honori Illustrissimorum Dominorum D D. Wenceslai Adalberti Balthasaris Josephi, Et Joannis Norberti Xaverii Leopoldi, Liberorum Baronum à Sternberg . . . Dum absoluto triennali Philosophiae stadio eandem Philosophiam publicè . . . Propugnarent, dicata.* Prague, 1661.Online: http://www.mdz-nbn-resolving.de/urn/resolver.pl?urn=urn:nbn:de:bvb:12-bsb11195886–3 (last access: 10.04.2021)

Secondary Studies

Alexander, Manfred. *Kleine Geschichte der böhmischen Länder.* Stuttgart: Reclam, 2008.

Altrichter, Michal, Milan Togner and Vladimír Hyhlík. *Olomouc. Univerzitní kostel Panny Marie Sněžné.* Velehrad: Historická společnost Starý Velehrad, 2000.

Angenendt, Arnold. *Heilige und Reliquien. Die Geschichte ihres Kultes vom frühen Christentum bis zur Gegenwart.* Munich: Beck, 1994.

Appuhn-Radtke, Sibylle. "Innovation durch Tradition. Zur Aktualisierung mittelalterlicher Bildmotive in der Ikonographie der Jesuiten." In *Zur Kunst- und Kulturgeschichte der österreichischen Ordensprovinz der "Gesellschaft Jesu" im 17. und 18. Jahrhundert,* edited by Herbert Karner and Werner Telesko, 243–259. Vienna: Verlag der Österreichischen Akademie der Wissenschaften, 2003.

Appuhn-Radtke, Sibylle. *Visuelle Medien im Dienst der Gesellschaft Jesu. Johann Christoph Storer (1620–1671) als Maler der Katholischen Reform.* Regensburg: Schnell und Steiner, 2000.

Bach, Hedwig. *Karl Borromäus. Leitbild für die Reform der Kirche nach dem Konzil von Trient. Ein Gedenkbuch zum 400. Todestag.* Cologne: Wienand, 1985.

Belting, Hans. *Bild und Kult. Eine Geschichte des Bildes vor dem Zeitalter der Kunst.* Munich: Beck 1991.

Benini, Marco. "Salus Populi Romani. Die Verbreitung der römischen Ikone in aller Welt." In *Pater Jakob Rem. 400 Jahre "Dreimal wunderbare Mutter" in Ingolstadt*, edited by Rita Haub and Isidor Vollnhals. Ingolstadt: Deutsche Jesuiten, 2004.

Braun, Karl. *Maria und der Auferstandene.* Lindenberg im Allgäu: Kunstverlag Josef Fink – Kißlegg: fe-medienverlags GmbH, 2017.

Braun-Niehr, Beate. "*In figuris praesignatur.* Der typologische Bilderkreis für Eucharistie und Messopfer." In *Trotz Natur und Augenschein. Eucharistie – Wandlung und Weltsicht*, edited by Ulrike Surmann and Johannes Schröer, 124–131. Cologne: Greven, 2013.

Brossette, Ursula. *Die Inszenierung des Sakralen. Das theatralische Raum- und Ausstattungsprogramm süddeutscher Barockkirchen in seinem liturgischen und zeremoniellen Kontext*, vol. 1. Weimar: Verlag und Datenbank für Geisteswissenschaften, 2002.

Browe, Peter. *Die Verehrung der Eucharistie im Mittelalter.* Munich: Hueber, 1933.

Browe, Peter. *Die eucharistischen Wunder des Mittelalters.* Breslau: Müller & Seiffert, 1938.

Browe, Peter. "Die eucharistischen Verwandlungswunder des Mittelalters." In Peter Browe. *Die Eucharistie im Mittelalter. Liturgiehistorische Forschungen in kultur-wissenschaftlicher Absicht*, edited by Hubertus Lutterbach and Thomas Flammer, 265–289. Muenster: LIT-Verl., 2003.

Buben, Milan M. *Encyklopedie řádů, kongregací a řeholních společností katolické církve v českých zemích*, vol. 4, part 3. Prague: Libri, 2012.

Büttner, Frank. "Rhetorik und barocke Deckenmalerei. Überlegungen am Beispiel der Fresken Johann Zicks in Bruchsal." *Zeitschrift des deutschen Vereins für Kunstwissenschaft* 1, no. 43 (1989): 49–72.

Cassidy-Welch, Megan. "Prison and Sacrament in the Cult of Saints: Images of St. Barbara in Late Medieval art." *Journal of Medieval History* 35 (2009): 371–384.

de la Cueva, Caspar-Miguel. *Historia del misterio diuino del sanctissimo sacramento del altar que esta enlos corporales de Daroca . . .* Caragoca: Viuda de J. Escarilla, 1553.

De Fiores, Stefano. "Maria in der Geschichte von Theologie und Frömmigkeit." In *Handbuch der Marienkunde*, vol. 1, edited by Wolfgang Beinert and Heinrich Petri, 99–266. Regensburg: Verlag Friedrich Pustet, 1996.

Dolejší, Kateřina, and Leoš Mlčák. "Zobrazení legendy o zázračném vítězství Jaroslava ze Šternberka nad Tatary." In *Olomoucké baroko. Proměny ambicí jednoho města*, vol. 1, edited by Martin Elbel and Ondřej Jakubec, 107–113. Olomouc: Muzeum Umění Olomouc, 2010.

Fabre, Pierre-Antoine. *Ignace de Loyola. Le lieu de l'image. Le problème de la composition de lieu dans les pratiques spirituelles et artistiques jésuites de la seconde moitié du XVIe siècle.* Paris: Éd. de l'École des Hautes Études en Sciences Sociales, 1992.

Fechtnerová, Anna. *Rectores collegiorum Societas Iesu in Bohemia, Moravia ac Silesia usque ad annum MDCCLXXIII iacentum, pars II/Rektoři kolejí Tovaryšstva Ježíšova v Čechách, na Moravě a ve Slezsku do roku 1773.* Prague: Národní knihovna v Praze, 1993.

Fiala, Jiří. "Jezuitská akademie a univerzita v Olomouci (1573–1773)." In *Univerzita v Olomouci (1573–2013)*, edited by Jiří Fiala, Zdeněk Kašpar, Leoš Mlčák et al., 25–58. Olomouc: Univerzita Palackého, 2013.

Fiala, Jiří. "Kaple Božího Těla." In *Chrámy, kostely, svatyně a kaple v Olomouci*, edited by Jiří Fiala, 149–153. Olomouc: Danal, 2008.

Ganz, David. *Barocke Bilderbauten. Erzählung, Illusion und Institution in römischen Kirchen 1580–1700.* Petersberg: Imhof Verlag, 2003.

Ganz, David. "Rückeroberung des Zentrums, Anschluss an die Vergangenheit und institutionelle Selbstdarstellung. Konfessionalisierung im römischen Kirchenraum 1580–1600." In *Konfessionen im Kirchenraum. Dimensionen des Sakralraums in der Frühen Neuzeit*, edited by Susanne Wegmann and Gabriele Wimböck, 263–283. Korb: Didymos-Verlag, 2007.

Ganz, David and Thomas Lentes, eds., *Ästhetik des Unsichtbaren. Bildtheorie und Bildgebrauch in der Vormoderne.* Berlin: Reimer, 2004.

Gerken, Claudia. *Entstehung und Funktion von Heiligenbildern im nachtridentinischen Italien (1588–1622).* Petersberg: Michael Imhof Verlag, 2015.

Gumppenberg, Wilhelm. *Marianischer Atlaß, Von Anfang vnd Vrsprung Zwölffhundert Wunderthätiger Maria-Bilder.* Beschriben in Latein Von R. P. Guilielmo Gumppenberg: Anjetzo Durch R. P. Maximilianum Wartenberg in das Teutsch versetzt / beede der Societet JESU. Erster Theil. Munich: Sebastian Rauch, 1673.

Guster, Holger. "Die Hostienmonstranzen des 13. und 14. Jahrhunderts in Europa." PhD. dissertation, Heidelberg: University of Heidelberg, 2009. http://archiv.ub.uni-heidelberg.de/volltextserver/10179/1/Dissertation_Bildband.pdf (last accessed: 10.04.2021).

Hanke, Jiří. "Olomoučtí jezuité a svatí." In *Bohemia Jesuitica 1556–2006*, vol. 1, edited by Petronilla Cemus, 419–429. Prague: Karolinum, 2010.

Haskell, Francis. "The Role of Patrons: Baroque Style Changes." In *Baroque Art: The Jesuit Contribution*, edited by Rudolf Wittkower and Irma B. Jaffe. New York: Fordham University Press, 1972.

Haub, Rita. *Die Geschichte der Jesuiten.* Darmstadt: WBG, 2007.

Haub, Rita and Bernd Paal, eds., *Die Exerzitien des heiligen Ignatius. Bilder und Betrachtungen.* Würzburg: Echter, 2006.

Haub, Rita and Julius Oswald. eds. *Franz Xaver – Patron der Missionen. Festschrift zum 450 Todestag.* Regensburg: Schnell und Steiner, 2002

Hecht, Christian. "Das Bild am Altar. Altarbild – Einsatzbild und Rahmenbild – Vorsatzbild." In *Format und Rahmen. Vom Mittelalter bis zur Neuzeit*, edited by Hans Körner and Karl Möseneder, 127–143. Berlin: Riemer, 2008,

Hecht, Christian. "Das katholische Retabel im Zeitalter von 'Gegenreformation' und Barock." *Das Münster* 61 (2008): 323–328.

Hecht, Christian. *Katholische Bildertheologie der frühen Neuzeit. Studien zu den Traktaten von Johannes Molanus, Gabriele Paleotti und anderen Autoren.* Berlin: Gebr. Mann Verlag, 2012.

Heinz, Andreas. "Die marianischen Schlußantiphonen im Stundengebet." In *Lebendiges Stundengebet. Vertiefung und Hilfe*, edited by Martin Klöckener and Heinrich Rennings, 342–367. Freiburg: Herder, 1989.

Hersche, Peter. "Die Allmacht der Bilder. Zum Fortleben ihres Kults im nachtridentinischen Katholizismus." In *Macht und Ohnmacht der Bilder. Reformatorischer Bildersturm im Kontext der europäischen Geschichte*, edited by Peter Blickle, André Holenstein, Heinrich Richard Schmidt et al., 391–405. Munich: Oldenbourg 2002.

Herzog, Markwart and Huberta Weigl, "Vorwort." In *Mitteleuropäische Klöster der Barockzeit. Vergegenwärtigung monastischer Vergangenheit in Wort und Bild*, edited by Markwart Herzog and Huberta Weigl, 11–19. Konstanz: UVK-Verl.-Ges., 2011.

Hofmann, Peter. *Bildtheologie. Position – Problem – Projekt.* Paderborn: Ferdinand Schöningh, 2016.

Holböck, Ferdinand. *Das Allerheiligste und die Heiligen. Eucharistische Heilige aus allen Jahrhunderten der Kirchengeschichte.* Aschaffenburg: Pattloch, 1979.

Hoping, Helmut. *Mein Leib für euch gegeben. Geschichte der Theologie der Eucharistie.* Freiburg: Herder, 2015.

Huber, Kurt Augustinus. *Katholische Kirche und Kultur in Böhmen. Ausgewählte Abhandlungen.* Muenster: LIT, 2005.

Hundemer, Markus. "Argumentative Bilder und bildliche Argumentation: Jesuitische Rhetorik und barocke Deckenmalerei." In *Zur Kunst- und Kulturgeschichte der österreichischen Ordensprovinz der "Gesellschaft Jesu" im 17. und 18. Jahrhundert*, edited by Herbert Karner and Werner Telesko, 261–273. Vienna: Verlag der Österreichischen Akademie der Wissenschaften, 2003.

Hundemer, Markus. *Rhetorische Kunsttheorie und barocke Deckenmalerei. Zur Theorie der sinnlichen Erkenntnis im Barock.* Regensburg: Schnell und Steiner, 1997.

Jakubec, Ondřej. "Olomouc. Bývalý konvent minoritů 'U sv. Františka' s kostelem P. Marie, následně kolej jesuitů s kostelem P. Marie Sněžné se školami a konviktem s kaplí Božího těla." In *Encyklopedie moravských a slezských klášterů*, edited by Dušan Foltýn et al., 473–481. Prague: Nakl. Libri, 2005.

Jakubec, Ondřej. "Olomoucký jezuitský kostel a protimorový kult P. Marie Sněžné." In *Olomoucké baroko. Proměny ambicí jednoho města*, vol. 1, edited by Martin Elbel and Ondřej Jakubec, 150–156. Olomouc: Muzeum Umění Olomouc, 2010.

Jakubec, Ondřej. "Protimorové procesí s ostatky sv. Pavlíny v olomouci roku 1623." In *Olomoucké baroko. Výtvarná kultura let 1620–1780*, vol. 2, edited by Ondřej Jakubec and Marek Perůtka, 295. Olomouc: Muzeum uměni Olomouc, 2010.

Jakubec, Ondřej. "Renesanční a manýristické umění." In *Dějiny Olomouce*, vol. 1, edited by Dušan Jindřich Schulz, 311–331. Olomouc: Univerzita Palackého, 2009.

Jedin, Hubert. "Entstehung und Tragweite des Trienter Dekrets über die Bilderverehrung." *Tübinger theologische Quartalsschrift* 116 (1935): 143–188, 404–429.

Jedin, Hubert. *Geschichte des Konzils von Trient*, vol. 3. Freiburg: Herder, 1970.

Jetter, Christina. *Die Jesuitenheiligen Stanislaus Kostka und Aloysius von Gonzaga. Patrone der studierenden Jugend – Leitbilder der katholischen Elite. Untersucht in der Oberdeutschen und der Rheinischen Ordensprovinz bis zur Aufhebung des Jesuitenordens 1773*. Würzburg: Echter, 2009.

Karcher, Eva. "Ursache und Wirkung des Bildverständnisses des Konzils von Trient." In *Die Kunst und die Kirchen. Der Streit um die Bilder heute*, edited by Rainer Beck, Rainer Volp and Gisela Schmirber, 82–92. Munich: Bruckmann, 1984.

Karger, Michael. "'Wie Christus unser Herr erschien unserer Herrin.' Zur Entstehung und Deutung der ersten Auferstehungsbetrachtung in den 'Geistlichen Übungen' des heiligen Ignatius von Loyola." *Geist und Leben. Zeitschrift für christliche Spiritualität* 64 (1991): 106–128.

Kerber, Bernhard. *Andrea Pozzo*. Berlin: de Gruyter, 1971.

Koch, Ludwig. *Jesuiten-Lexikon. Die Gesellschaft Jesu einst und jetzt*. Paderborn: Verlag Bonifacius-Druckerei, 1934.

Köpf, Ulrich. "Protestantismus und Heiligenverehrung." In *Heiligenverehrung in Geschichte und Gegenwart*, edited by Peter Dinzelbacher and Dieter R. Bauer, 320–344. Ostfildern: Schwabenverlag, 1990.

Kovářová, Stanislava. "Požár Olomouce v roce 1709." In *Olomoucké baroko. Proměny ambicí jednoho města*, vol. 1, edited by Martin Elbel and Ondřej Jakubec, 136–141. Olomouc: Muzcum Umění Olomouc, 2010.

König-Nordhoff, Ursula. *Ignatius von Loyola. Studien zur Entwicklung einer neuen Heiligen-Ikonographie im Rahmen einer Kanonisationskampagne um 1600*. Berlin: Gebr. Mann Verlag, 1982.

Kröss, Alois. *Geschichte der Böhmischen Provinz der Gesellschaft Jesu. Geschichte der ersten Kollegien in Böhmen, Mähren und Glatz. Von ihrer Gründung bis zu ihrer Auflösung durch die böhmischen Stände 1556–1619*, vol. 1. Vienna: Opitz, 1910.

Kröss, Alois. *Geschichte der Böhmischen Provinz der Gesellschaft Jesu. Die Böhmische Provinz der Gesellschaft Jesu unter Ferdinand III. (1637–1657)*, vol. 2.2. Vienna: Opitz, 1938.

Kröss, Alois. *Geschichte der Böhmischen Provinz der Gesellschaft Jesu. Die Zeit von 1657 bis zur Aufhebung der Gesellschaft Jesu im Jahre 1773*, vol. 3. Olomouc: Refugium Velehrad-Roma – Praha: Ceska Provincie Tovarysstva Jezisova, 2012.

Kummer, Stefan. "'Doceant Episcopi.' Auswirkungen des Trienter Bilderdekrets im römischen Kirchenraum." *Zeitschrift für Kunstgeschichte* 56/4 (1993): 508–533.

LCI = *Lexikon der christlichen Ikonographie*, 8 vols. Darmstadt: Wissenschaftliche Buchgesellschaft, 2012.

Loyola, Ignatius von. *Gründungstexte der Gesellschaft Jesu*. Translated by Peter Knauer. Würzburg: Echter 1998.

LThK = Lexikon für Theologie und Kirche, edited by Walter Kasper et al., 11 vols. Freiburg: Herder, 1993–2001.

Lundberg, Mabel. *Jesuitische Anthropologie und Erziehungslehre in der Frühzeit des Ordens (ca.1540-ca. 1650)*. Uppsala: Almqvist & Wiksell, 1966.

Macháčková, Jana. "Jezuitská malířská kultura na Moravě. Obraz ve vizuální kultuře olomouckých jezuitů." MA thesis, Olomouc: Univerzita Palackého 2013. Internet access at https://theses.cz/id/ul7f5s/00173031–877759567.pdf (last accessed: 10.04.2021)

Machytka, Lubor. "Gotická socha Madony v kostele Panny Marie Sněžné v Olomouci." *Zprávy Vlastivědného ústavu v Olomouci* 140 (1968): 1–6.

Mádl, Martin. "Handkeho skica ze Strahovské obrazárny a malba v olomoucké kapli Božího Těla." *Umění* 54 (2006): 504–512.

Mádl, Martin. "Jaroslav ze Šternberka před bitvou s Tatary. Jan Kryštof Handke." In *Olomoucké baroko. Výtvarná kultura let 1620–1780*, vol. 2, edited by Ondřej Jakubec and Marek Perůtka, 275–277. Olomouc: Muzeum uměni Olomouc, 2010.

Maňas, Vladimír and Zdeněk Orlita. "Olomouc v období jediného oficiálního vyznání a jeho náboženská bratrstva." In *Olomoucké baroko. Výtvarná kultura let 1620–1780*, vol. 3, edited by Ondřej Jakubec and Marek Perůtka, 90–99. Olomouc: Muzeum umění Olomouc, 2011.

Maron, Gottfried. *Ignatius von Loyola. Mystik, Theologie, Kirche*. Darmstadt: Vandenhoeck und Ruprecht, 2001.

Matern, Gerhard. *Zur Vorgeschichte und Geschichte der Fronleichnamsfeier besonders in Spanien. Studien zur Volksfrömmigkeit des Mittelalters und der beginnenden Neuzeit*. Muenster: Aschendorff, 1962.

Matsche, Franz. "'Fundant et ornant.' Orte und Formen der bildlichen Präsentation von Stiftern in barocken Klöstern Süddeutschlands." In *Mitteleuropäische Klöster der Barockzeit. Vergegenwärtigung monastischer Vergangenheit in Wort und Bild*, edited by Markwart Herzog and Huberta Weigl, 137–161. Konstanz: UVK-Verl.-Ges, 2011.

Meier, Esther. *Handbuch der Heiligen*. Darmstadt: WBG, 2010.

Melion, Walter S., Elizabeth Carson Pastan, and Lee Palmer Wandel, eds. *Quid est sacramentum? Visual representation of sacred mysteries in early modern Europe, 1400–1700*. Leiden: Brill, 2020.

MGG = *Die Musik in Geschichte und Gegenwart. Allgemeine Enzyklopädie der Musik*, 20 vols, edited by Ludwig Fischer. Kassel: Bärenreiter, 1994–2008.

ML = *Marienlexikon*, 6 vols, edited by Remigius Bäumer and Leo Scheffczyk. St. Ottilien: EOS-Verl., 1988–1994.

Mlčák, Leoš. "Areál jezuitské koleje v Olomouci." In *Jezuitský konvikt. Sídlo uměleckého centra univerzity palackého v Olomouci. Dějiny – Stavební a umělecké dějiny – Obnova a využití*, edited by Jiří Fiala, Leoš Mlčak and Karel Žurek, 179–199. Olomouc: Univerzita Palackého, 2002.

Mlčák, Leoš. "Jezuitský konvikt." In *Významné Olomoucké památky II. Sborník příspěvků ze semináře. Olomouc 13.-14.09.2002*. Olomouc, 2002, 36–58.

Mlčák, Leoš. "K ikonografii sv. Pavlíny, barokní patronky Olomouce." *Zprávy památkové péče* 10 (1993): 393–399.

Mlčák, Leoš. "Mor, hlad, války a živelné pohromy v Olomouci." In *Olomoucké baroko. Proměny ambicí jednoho města*, vol. 1, edited by Martin Elbel and Ondřej Jakubec, 125–135. Olomouc: Muzeum Umění Olomouc, 2010.

Mlčák, Leoš, ed. *Olomouc Stadtführer. Kunstdenkmäler.* Olomouc: Statutarische Stadt Olomouc, 2011.

Mlčák, Leoš and Kateřina Mlčáková. "Mědirytiny k barokní legendě o zázračném vítězství Jaroslava ze Šternberka nad Tatary u Olomouce." *Střední Morava. Kulturně historická revue* 13 (2001): 65–77.

Mlčák, Leoš and Kateřina Mlčáková. "Barokní Legenda o zázračném vítězství Jaroslava ze Šternberka nad Tatary u Olomouce." In *Jezuitský konvikt. Sídlo uměleckého centra univerzity palackého v Olomouci. Dějiny – Stavební a umělecké dějiny – Obnova a využití,* edited by Jiří Fiala, Leoš Mlčak and Karel Žurek, 253–265.Olomouc: Univerzita Palackého, 2002.

Mlčák, Leoš, and Kateřina Mlčáková, "Mědirytiny k barokní legendě o zázračném vítězství Jaroslava ze Šternberka nad Tatary u Olomouce." In *Střední Morava. Kulturně historická revue* XIII (2001): 65–77.

Müller, Wolfgang. "Katholische Volksfrömmigkeit in der Barockzeit." In *Barock in Baden-Württemberg. Vom Ende des Dreißigjährigen Krieges bis zur Französischen Revolution,* vol. 2, edited by Gertrude von Knorre, 399–408. Karlsruhe: Badisches Landesmuseum, 1981.

Nadal, Jerónimo. *Evangelicae historiae imagines, ex ordine Evangeliorum, quae toto anno in Missae sacrificio recitantur, im ordinem temporis vitae Christae digestae.* Antwerp: Martinus Nutius, 1593.

Nevímová, Petra. "Poznámka k ikonografii jezuitského řádu." In *Barokní Praha – barokní Čechie 1620–1740. Sborník příspěvků z vědecké konference o fenoménu baroka v Čechách (24.-27.9. 2001),* edited by Olga Fejtová, Václav Ledvinka, and Jiří Pešek et al., 389–402. Prague: Scriptorium, 2004.

O'Malley, John W. *Die ersten Jesuiten.* Würzburg: Echter, 1995.

Orlita, Zdeněk. "Gemeinschaft der Frommen im Wandel. Marianische Kongregationen in Mähren zwischen dem Tridentinum und der Aufklärung." In *Frühneuzeitforschung in der Habsburgermonarchie. Adel und Wiener Hof – Konfessionalisierung – Siebenbürgen,* edited by István Fazejas, Martin Scheutz, Csaba Szabó et al., 309–333. Vienna: Institut für Ungarische Geschichtsforschung, 2013.

Orlita, Zdeněk. "Olomoučtí jezuité a náboženská bratrstva v 16.-18. Století." *Střední Morava. Vlastivědná Revue* 20 (2005): 43–54.

Ostrow, Steven F. *Art and Spirituality in Counter-Reformation Rome. The Sistine and Pauline Chapels in S. Maria Maggiore.* Cambridge: Cambridge Univ. Press, 1996.

Paleczek, Raimund. "Kirchliche Strukturen und Organisation in den böhmischen Ländern." In *Die Landespatrone der böhmischen Länder. Geschichte – Verehrung – Gegenwart,* edited by Stefan Samerski, 33–44. Paderborn: Schöningh, 2009.

Pavlíček, Martin. "Barokní architektura." In *Dějiny Olomouce,* vol. 1, edited by Jindřich Schulz, 430–445, Olomouc: Univerzita Palackého, 2009.

Pavlíček, Martin. "Jezuitský Kostel Panny Marie Sněžné." In *Olomoucké baroko. Výtvarná kultura let 1620–1780,* vol. 2, edited by Ondřej Jakubec and Marek Perůtka, 81–84. Olomouc: Muzeum uměni Olomouc, 2010.

Pavlíček, Martin. "Komplex jezuitských budov." In *Olomoucké baroko. Výtvarná kultura let 1620–1780,* vol. 2, edited by Ondřej Jakubec and Marek Perůtka, 79–81. Olomouc: Muzeum uměni Olomouc, 2010.

Pavlíček, Martin. "Sochaři a sochařství baroka v Olomouci." In *Olomoucké baroko. Výtvarná kultura let 1620–1780*, vol. 2, edited by Ondřej Jakubec and Marek Perůtka, 119–141. Olomouc: Muzeum uměni Olomouc, 2010.

Pötzl-Malikova, Maria. "Berichte über die Feierlichkeiten anlässlich der Kanonisation der Heiligen Aloysius Gonzaga und Stanislaus Kostka in der österreichischen Ordensprovinz." In *Zur Kunst- und Kulturgeschichte der österreichischen Ordensprovinz der "Gesellschaft Jesu" im 17. und 18. Jahrhundert*, edited by Herbert Karner and Werner Telesko, 157–164. Vienna: Verlag der Österreichischen Akademie der Wissenschaften, 2003.

Pötzl-Malikova, Maria. "Die Feiern anlässlich der Heiligsprechung des Ignatius von Loyola und des Franz Xaver im Jahr 1622 in Rom, Prag und Olmütz." In *Bohemia Jesuitica 1556–2006*, vol. 2, edited by Petronilla Cemus, 1239–1254. Prague: Karolinum, 2010.

Polonyi, Andrea. *Wenn mit Katakombenheiligen aus Rom neue Traditionen begründet werden. Die Wirkungsgeschichte einer Idee zwischen Karolingischer Reform und ultramontaner Publizistik*. St. Ottilien: EOS-Verlag, 1998.

Rahner, Hugo. "Die 'Anwendung der Sinne' in der Betrachtungsmethode des hl. Ignatius von Loyola." *Zeitschrift für katholische Theologie* 79 (1957): 434–456.

RDK = *Reallexikon zur Deutschen Kunstgeschichte*, 10 vols. Zentralinstitut für Kunstgeschichte München. Stuttgart: J.B. Metzler, 1937–2014.

Röder, Alexander. "Luther, der Bildersturm und die 'wahre' Heiligenverehrung." In *Heilige: die lebendigen Bilder Gottes*, edited by Markus Pohlmeyer-Jöckel, 25–36. Muenster: LIT, 2002.

Royt, Jan and Stefan Samerski, "Maria." In *Die Landespatrone der böhmischen Länder. Geschichte – Verehrung – Gegenwart*, edited by Stefan Samerski, 175–197. Paderborn: Schöningh, 2009.

Ryška, Jaroslav. *Freska Jana Kryštofa Handkeho v olomoucké kapli Božího Těla z roku 1728*. Olomouc: Studie galerie výtvarného umění, 1968.

Samerski, Stefan. "Maria in Mähren im Zeitalter der Konfessionalisierung – ein mühsamer Weg." In *Maria in der Krise. Kultpraxis zwischen Konfession und Politik in Osteuropa*, edited by Agnieszka Gąsior, 117–127. Cologne: Böhlau Verlag, 2014.

Samerski, Stefan. "Maria zwischen den Fronten. Bayerische Einflüsse auf die Pietas Austriaca und die ungarische Eigentradition in der zweiten Hälfte des 17. Jahrhunderts." *Ungarn-Jahrbuch* 27 (2004): 359–371.

Samerski, Stefan. "Von der Rezeption zur Indoktrination. Die Annenbruderschaft in Olmütz (16./17. Jahrhundert)." In *Jesuitische Frömmigkeitskulturen. Konfessionelle Interaktion in Ostmitteleuropa 1570–1700*, edited by Anna Ohlidal and Stefan Samerski, 93–118. Stuttgart: Franz Steiner Verlag, 2006.

Schneider, Christine. *Kirche und Kolleg der Jesuiten in Dillingen an der Donau. Studien zu den spätbarocken Bildprogrammen "UT IN NOMINE IESU OMNE GENU FLECTATUR."* Regensburg: Schnell und Steiner, 2014.

Schnell, Hugo. "Liturgie der Gegenwart in Kirchen des Barock." *Das Münster* 18 (1965): 147–156.

Schurhammer, Georg. *Franz Xaver. Sein Leben und seine Zeit*, 4 vols. Freiburg: Herder, 1955–1973.

Schünke, Robert. *Beiträge zur kirchlichen Kunst- und Kulturgeschichte von Olmütz.* Neutitschein: Selbstverlag des Verfassers, 1916.

Sievernich, Michael. "Von der Akkomodation zur Inkulturation. Missionarische Leitideen der Gesellschaft Jesu." *Zeitschrift für Missionswissenschaft und Religionswissenschaft* 86, no. 4 (2002): 260–276.

Signori, Gabriela. "Einheit in der Vielfalt? Annäherungen an den 'vorreformatorischen' Kirchenraum." In *Konfessionen im Kirchenraum. Dimensionen des Sakralraums in der Frühen Neuzeit,* edited by Susanne Wegmann and Gabriele Wimböck, 215–234. Korb: Didymos-Verlag, 2007.

Spengler, Dietmar. *Spiritualia et pictura. Die Graphische Sammlung des ehemaligen Jesuitenkollegs in Köln. Die Druckgraphik.* Cologne: SH-Verlag, 2003.

Stabenow, Jörg. "Auf dem Weg zum 'theatrum sacrum.' Bedeutungen der theatralen Analogie im Kirchenraum der Gegenreformation in Italien." In *Konfessionen im Kirchenraum. Dimensionen des Sakralraums in der Frühen Neuzeit,* edited by Susanne Wegmann and Gabriele Wimböck, 115–136. Korb: Didymos-Verlag, 2007.

Stephan, Peter. "Und das Wort ist Bild geworden. Der 'Triumph des Namens Jesu' in Giambattista Gaullis Deckenfresko von Il Gesù." *Una Voce Korrespondenz* 48, no. 1 (2018): 70–147.

Sterba, Katrin. "*Didactica picta.* Eine Untersuchung zur Bilddidaktik in der Jesuitenkirche in Olmütz." *Opuscula Historiae Artium* 69 (2020): 18–34.

Sterba, Katrin. "*Ora pro nobis deum alleluia.* Die Jesuiten in Mähren und ihr gegenreformatorisches Wirken in der Stadt Olmütz / Olomouc am Beispiel der Kirche Maria Schnee." *Jahrbuch des Bundesinstituts für Kultur und Geschichte der Deutschen im östlichen Europa* 22 (2014).

Sudbrack, Joseph. "Die 'Anwendung der Sinne' als Angelpunkt der Exerzitien." In *Ignatianisch. Eigenart und Methode der Gesellschaft Jesu,* edited by Michael Sievernich and Günter Switek, 96–119. Freiburg: Herder, 1990.

Terhalle, Johannes. ". . .*ha della Grandezza de padri Gesuiti.* Die Architektur der Jesuiten um 1600 und St. Michael in München." In *Rom in Bayern. Kunst und Spiritualität der ersten Jesuiten,* edited by Reinhold Baumstark, 83–146. Munich: Hirmer 1997.

Togner, Milan. *Barokní malířství v Olomouci.* Olomouc: Univerzita Palackého, 2008.

Togner, Milan. "Kaple Božího těla v Olomouci." *Umění* 21 (1973): 331–343.

Tück, Jan-Heiner. *Gabe der Gegenwart. Theologie und Dichtung der Eucharistie bei Thomas von Aquin.* Freiburg: Herder, 2014.

van Bühren, Ralf. "Kirchenbau in Renaissance und Barock. Liturgiereformen und ihre Folgen für Raumordnung, liturgische Disposition und Bildausstattung nach dem Trienter Konzil." In *Operation am lebenden Objekt. Roms Liturgiereformen von Trient bis zum Vaticanum II,* edited by Stefan Heid, 93–120. Berlin: Be.bra, 2014.

van Bühren, Ralf. "Revelation in the Visual Arts." In *The Oxford Handbook of Divine Revelation,* edited by Balázs M. Mezei, Francesca Murphy, and Kenneth Oakes, 622–640. New York: Oxford University Press, 2021.

Vyvlečka, Joseph. *Příspěvky k dějinám kostela Panny Marie Sněžné v Olomouci.* Olomouc: Nákladem denníku "Našinec" v Olomouci, 1917.

Wimböck, Gabriele. "Kirchenraum, Bilderraum, Handlungsraum. Die Räume der Konfessionen." In *Konfessionen im Kirchenraum. Dimensionen des Sakralraums in der Frühen Neuzeit*, edited by Susanne Wegmann and Gabriele Wimböck, 31–54. Korb: Didymos-Verlag, 2007.

Winkelbauer, Thomas. *Ständefreiheit und Fürstenmacht. Länder und Untertanen des Hauses Habsburg im konfessionellen Zeitalter*, part 2. Vienna: Ueberreuter, 2003.

Wipfler, Esther P. "Im Zentrum der Liturgie? Zur Funktion von Altaraufsätzen im Mittelalter und in der frühen Neuzeit – ein Überblick der Entwicklung im deutschsprachigen Raum." *Das Münster* 61 (2008): 315–322.

Wirth, Jean. "Soll man Bilder anbeten? Theorien zum Bilderkult bis zum Konzil von Trient." In *Bildersturm. Wahnsinn oder Gottes Wille?*, edited by Cécile Dupeux, Peter Jezler and Jean Wirth, 28–37. Zürich: Wilhelm Fink Verlag, 2000.

Wohlmuth, Joseph. "Bild und Sakrament im Konzil von Trient." In *Wozu Bilder im Christentum? Beiträge zur theologischen Kunsttheorie*, edited by Alex Stock, 87–103. St. Ottilien: EOS, 1990.

Wohlmuth Joseph, ed. *Dekrete der Ökumenischen Konzilien*, vol. 3, Konzilien der Neuzeit: Konzil von Trient (1545–1563), Erstes Vatikanischen Konzil (1869/70), Zweites Vatikanischen Konzil (1962–1965), Indices. Paderborn: Schöningh, 2002.

Wohlmuth, Joseph, ed. *Dekrete der Ökumenischen Konzilien*, vol. 1, Konzilien des ersten Jahrtausends. Vom Konzil von Nizäa (325) bis zum vierten Konzil von Konstantinopel (869/70). Paderborn: Schöningh, 1998.

Wolf, Gerhard. *Salus Populi Romani. Die Geschichte römischer Kultbilder im Mittelalter*. Weinheim: VCH, Acta Humaniora, 1990.

Wolný, Gregor. *Die Markgrafenschaft Mähren. Topographisch, statistisch und historisch geschildert*, vol. 5. Brno: Karl Winiker 1846.

Zelenková, Petra, "'Contra pestem nobis fave' Příspěvek k ikonografi i svaté Pavlíny, patronky proti moru v barokní Olomouci." *Opuscula Historiae Artium* 49 (2005): 27–45.

Zelenková, Petra. "'*Vidi stellas undecim* . . .' Šternbergské alegorie na grafických listech podle Karla Škréty." *Umění* 54, no. 4 (2006): 327–342.

Zierholz, Steffen. "To Make Yourself Present. Jesuit Sacred Space as Enargetic Space." In *Jesuit Image Theory*, edited by Wietse de Boer, Karl A. E. Enenkel, and Walter S. Melion, 419–461. Leiden: Brill, 2016.

Chapter 8

Rivalry and Inspiration

The Jesuits and Other Religious Orders in the Czech Lands after 1620

Martin Mádl

After 1627, the Catholic denomination was the only official church available to the people of Bohemia and Moravia, making them usually understood as more or less unified homogeneous Catholic territories. Promotion of the Catholic faith and related activities in the Bohemian lands after the Battle of White Mountain (1620) were entrusted to religious institutions with diverse spiritual and cultural traditions and varying social and political aims and strategies. Due to their differing religious, social, economic, and political interests, the relationships among these institutions were competitive and sometimes even markedly discordant, frequently accompanied by intrigue and open conflict. This did not rule out mutual fascination and inspiration, however, as is seen in the field of fine art. In Bohemia, rivals to the Jesuits included, in particular, the Dominicans, the Franciscans, and the archbishopric of Prague, but also different monastic orders, including Benedictines and Cistercians.[1]

The situation in Austria was similar, open conflict between the Jesuits and the Benedictines culminated there early in the eighteenth century. In Vienna in 1712, the Hungarian Jesuit, Gábor Hevenesi (1656–1715), published his pamphlet *Cura Salutis*, which went through multiple reprints and was spread among the students at the Vienna Jesuit school and elsewhere. Written as a fictional dialogue between a novice and his confessor, it pointed out the benefits of the Society of Jesus and its superiority over other monastic orders. Coenobites, in contrast, were criticized for their contemplative and secluded life, which was seen to lead them to idleness, indolence, bickering, and other vices. The pamphlet's publication triggered a reaction from the Benedictines; Bernhard Pez (1683–1735), a renowned Benedictine writer from Melk,

responded with an apologetic epistle that circulated in print. There he empha-
sized that Benedictines, in the course of their activities, managed to achieve
everything that Jesuits aspired to, although Benedictine duties, divided
between contemplation and work, were double those of the Jesuits.[2]

Similar controversies were common over various areas of ecclesiastical
life and tensions among church institutions in the Catholic Church. Open
manifestations of such conflicts were not in the interest of the church authori-
ties, however, as they had a negative impact on the awareness of the Catholic
Church's unity among believers. Perhaps this is why they are rarely reported
in the literature of the period.

Questions to be addressed here are: How were relationships and the rivalry
among church institutions reflected in their visual communication? How were
the different orders represented? What role, inspirational or controversial, did
the Society of Jesus play? How did various church institutions use the fine
arts, more or less openly, to take a stand against their rivals? How did Jesuit
spirituality inspire other orders, and how was this spirituality manifested in
their artistic production?

RELIGIOUS ART AS A TOOL OF
MONASTIC PROPAGANDA

In her provocative and inspiring book on art as a tool of propaganda of the
Societas Jesu, the Canadian researcher Evonne Levy points out that the
Catholic art of the Early Modern period did not express exclusively religious
content. In the form of propaganda, it was able to mediate and spread varied
messages with ideological and political implications.[3] Such messages, spread
through the means of art, targeted various religious and social groups, a broad
spectrum of the population that included parishioners, members of religious
confraternities, pilgrims, political authorities, and even other ecclesiastical
institutions.[4]

In the Catholic environment, distinctive characteristics and motifs were
frequently used to indicate the valid religious content and specific spiritual-
ity of the commissioner and also the ideology and strategy of the various
church orders, who were often in more or less open dispute. Paintings reflect-
ing such tensions, or even amplifying them, are surprisingly frequent in the
Catholic milieu and played an important role in the internal communication
among religious institutions. Because conventional iconography makes
images easy to interpret, modern interpreters focusing on conventional ico-
nography sometimes underrate hidden meanings that show the competition
among the different orders in favor of an overall understanding of religious
subjects. Religious, and political meanings (in the sense of inter-institutional

communication), however, can supplement each other in artworks or they can be layered, overlapping each other.

Not only church interiors, but also their outward-facing exteriors, were influenced by disputes among religious institutions. The facades of many monastic churches in both urban and rural environments should be understood as deliberate religious and political manifestations that, apart from general Christian symbols and images, routinely displayed distinctive attributes of particular monastic orders and statues of the orders' patrons. In Prague Lesser Town, for example, the tower of the newly built parish church of St. Nicholas belonged to the town council; nevertheless, the Jesuits allegedly intended to install statues of their order's saints there. The town council reportedly prevented this, based on a deed from 1737, and requested that statues of Czech patrons be placed there.[5] Similarly, the council insisted on decorating the tower with the town's emblem and resisted displaying Jesuit emblems and a sculpture of *fama triumphana*, which they understood as a celebration of the order.[6]

Monastic themes routinely penetrated church interiors, where they often competed with motifs related to the patron saint the church was dedicated to or with theological and mariological motifs. The St. Nicholas Church in Prague Lesser Town is a typical example; it shows a blend of mutually complementary motifs related to the titular patron saint as well as a celebration of St. Ignatius and the missionary activities of the Jesuit order.[7] In contrast, in the St. Nicholas Benedictine Church in the Old Town, motifs glorifying St. Nicholas were combined with paintings celebrating Saint Benedict (the order's founder),[8] and similar examples are numerous.

The theme of the large mural by the prominent Prague fresco painter Wenceslas Lorenz Reiner (1689–1743), dated 1734, that covers a large part of the nave in the Old Town's Dominican St. Giles Church is based on an interpretation of Pope Innocent III's mystical vision [figure 8.1]. This allegorical work represents St. Dominic and other patron saints of the Dominican order—St. Thomas Aquinas, St. Peter of Verona, Blessed Ceslaus, St. Antoninus of Florence, St. Vincent Ferrer, Pope Pius V, St. Raimundus de Pennaforte, and St. Hyacinth—saving the endangered Catholic Church, which is represented by the collapsing Basilica of St. John Lateran (shown as a round-domed church in the painting, however) from a joint attack of its arch-foes, militant Muslims and heretics lead by Beranger, St. Thomas's French opponent accused of heresy, and Martin Butzer, the German reformer. The names of individual protagonists are known thanks to the written description of concept for its design.[9] The central theme of this painting can be understood as a celebration of the combative and triumphant Catholic Church in its conflict with paganism and heresy. This subject, however, is overlapped by other content emphasizing the spiritual, historical, and political

importance of the order of the Preacher Friars, which assumed the role of the single rescuer and main pillar of the church.

There is no doubt that the pictorial decoration of this Dominican church was driven by propaganda aimed against the Dominicans' competitors, the *Societas Jesu* in particular. This is illustrated by Reiner's other ceiling paintings in the Dominican church, the themes of which provoked open protests from the Jesuits immediately after their creation. One of them, located on the northern nave vault, originally showed a theological disputation held under the mystical supervision of St. Thomas Aquinus and St. Augustine, presided over by the personified Church among advocates of Thomas's learning from the ranks of the Dominicans, Benedictines, Carmelites, Augustinians, and other orders, against the proponents of the ideas of the Spanish Jesuit

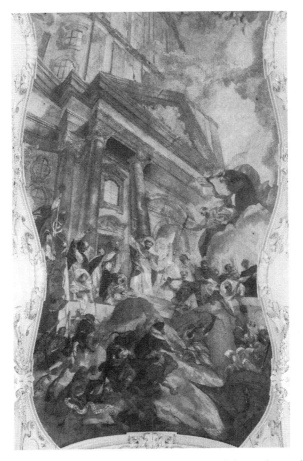

Figure 8.1 The vision of Pope Inocent III, detail with Dominican saints, ceiling painting by Wenceslas Lorenz Reiner, St. Giles Church, Prague, Old Town, 1743.

theologist Luis de Molina (1535–1600). The Prague Jesuits complained to the Prague archbishop and succeeded in having the Jesuit portrayal removed from the painting. The Jesuit fathers also complained about the concept of a painting on the wall of the organ-loft that depicted the expulsion and slaughter of Dominicans by the Hussites, accompanied by the exclamation "*Ad te clamamus exules, o clemens*" [To thee do we cry, poor banished, O clement]. Although the quotation is extracted from the Latin hymn *Salve regina*, intended for Virgin Mary (who is depicted here as well) it also refers furtively to the fact that in 1556 the Prague Dominicans had to vacate the monastery by the St. Clement Church and yield it to Jesuits, who gradually built their Clementinum College there. Almost two centuries later, the Dominicans still perceived this as an injustice and did not hesitate to refer to it in the multi-layered meanings of their mural. The concept of this painting probably also embraced less remote conflicts between the orders, which included a controversy over their influence at Prague University.[10]

The Jesuits presented similar content in a celestial celebration of the order's saints. The large and complicated fresco in the Wrocław church of the Blessed Name of Jesus, painted between 1703 and 1706 by Johann Michael Rottmayr (1656–1730), raises the question of whether the most conspicuous element in this allegorical painting is the celebration of the name of Jesus as a universal theological motif or whether it is at the same time a display of the religious and political importance of the Society of Jesus. In this painting, the concept and basic layout refer back to Baciccio's famous fresco in the Church of Il Gesù in Rome; the Jesuit order is represented by the central motif of the "IHS" monogram, which is specifically formed in the shape of the order's emblem and lifted up toward a triumphant chariot pulled by the apocalyptic Tetramorph. Next to this motif is a glorification of the order's co-patrons of the church, St. Ignatius of Loyola and St. Francis Xavier, ascended to heaven. These two lead crowds of martyrs, with other Jesuit saints in the forefront, although saint rulers and prominent church prelates are also present. On balconies of the architecture, painted as an illusion, stand the highest church and secular dignitaries: Pope Clement XI, Emperor Leopold I, both successors to the throne, the Roman king, Joseph I, the Spanish king, Charles (later Emperor Charles VI), and the German prince-elector and prince of Wrocław, Bishop Francis Louis of Palatinate-Neuburg, at the head of crowds representing the nations of the four continents. These were the highest contemporary representatives of ecclesiastical and state power, shown here watching the celestial apotheosis of the Jesuits, which emphasized the enormous political importance of the whole allegory.[11] The four continents refer to the universal character and scope of the Jesuit mission legacy.

Similar works from this period, that is, the seventeenth and eighteenth centuries, present the united members of one sole church order and emphasize

its exceptional status in the history of salvation. Most are characterized by two or more layers of meaning designed to emphasize the importance of the institution that ordered the work. The first layer, the theological one, demonstrates ostentatiously the immediate relationship of the order's patrons with God himself or with Mary, the Mother of God. In monumental art, the order's patrons are habitually depicted in heaven, that is, out of earthly time, often in a higher celestial hierarchy, where they usually assume a prominent position in the pantheon of other saints, sometimes close to the Holy Trinity. The other layer of these paintings bears historical and hagiographic meanings. The careful selection of the order's patrons shows the spectator not only the outcome of virtuous lives and the deeds of individual saints in their celestial glory but also, through them, the historical importance of the order that these saints represented. Similar references to the origins and long history appear in particular in the artistic output of old orders who had witnessed the beginnings of the country's Christianization, which set them apart from new orders, including the Jesuits.

Some mural paintings also represent gatherings of representatives of various orders, assembled around the main order's patron, usually the author of the order's statute. This overlap further emphasizes the importance of the order that commissioned the artwork by showing the founder's broad impact on the development of monastic life in general. Such a motif can be found in Reiner's painting, dated 1728, on the nave vault of the Augustinian Saint Thomas Church in Prague's Lesser Town. It depicts Saint Augustine in clouds, using his coat to shield members of contemplative, mendicant, and knightly orders directed by his monastic rule. This community also includes high church dignitaries, even a pope.[12]

Other monastic orders also used literary and artistic means to stress their exceptional historical and political status. The most distinctive among them were probably the Benedictines and other communities following the rule of St. Benedict, who emphasized their historical role, among other things, in reaction to the behavior of newly established orders like the Jesuits. Besides Benedict's monastic rule, the basic source of Benedictine spirituality and the order's visual representation was the hagiographic legend of St. Benedict in *The Dialogues* attributed to Gregory the Great (540?–604). Chapter XXXV of *Dialogue II* discusses a vision in which Saint Benedict saw the whole world in a single sunbeam. In the seventeenth century, Benedictine theologians explained this moment as prophesying the expansion of Benedictine monasticism and monasteries.[13] This subject became a model for other paintings, in which Saint Benedict, to whom God revealed the world in a blaze of sun, is depicted in the community of his followers. A mural, dated 1733, is painted above the choir of Church of Finding the True Cross and Saint Hedwig in Silesian Wahlstatt (Legnickie Pole), which belonged to the provostry

established there by the Bohemian Břevnov and Broumov Abbey. Created by the Bavarian painter Cosmas Damian Asam (1686–1739), it depicts the order's patriarch in the company of the emperor, the pope, high church dignitaries, and a host of representatives of various monastic, mendicant, and knightly orders. This further amplifies the significance of the Benedictine order as a founder and pillar of the church.[14]

In 1736, the Broumov painter, Johann Hausdorf, painted the ceiling of the All Saints' Church in Heřmánkovice, located on the estates of the Broumov Benedictine monastery. This artistically unambitious painting by a provincial painter, influenced by Asam's work, depicts the celestial hierarchy; the top of the scene is occupied by the Holy Trinity with the Virgin Mary, St. John the Baptist, and the Apostles. They are surrounded by a host of saints placed around the ceiling, more than one hundred of which can be identified by their attributes. The conventional hagiographic theme corresponds with the church's patrocinium. The choice of saints and their positions in the fresco, however, indicate a specific propagandist purpose: the largest group of saints is composed of Benedictine patron saints in particular, led by St. Benedict and his followers, St. Maurus and St. Placidus. Representatives of orders governed by Benedict's rule and representatives of other monastic communities stand close by. In contrast, St. Ignatius of Loyola, founder of the Society of Jesus, is located inconspicuously in the background, where he can easily remain unnoticed among the other figures. The intention to emphasize the spiritual and political importance of the Benedictines and to minimize the significance of other orders, in particular the Jesuits, seems evident in this work.[15] This slightly clumsy painting in a small rural church conveys the concept of glorifying the order just as much as the images found in large Benedictine minsters,[16] where Saint Benedict and leading representatives of his order appear in prominent places in the ecclesiastical hierarchy, which is dominated by the Holy Trinity. Such examples are distant from the Heřmánkovice painting in terms of territory, time, and quality, yet the painting in Heřmánkovice expresses the same Benedictine idea of Saint Benedict's privileged status in the God's plan of salvation and hence the privileged historical status of the Benedictine order in Bohemia compared with religious newcomers like the Jesuits.

THE IGNATIAN INSPIRATION IN THE COMPETITION FOR SPIRITUAL SUPREMACY

One of the pillars of Ignatian spirituality is the principle of following and imitating Christ. Before his conversion, Ignatius also read—besides *Vita Christi* by Ludolph of Saxony (c. 1295–1378) and *Flos Sanctorum* by

Jacobus de Voragine (c. 1230–1298)—an influential mystical work by the Augustinian Thomas à Kempis (c. 1380–1471), *De Imitatione Christi*, which, along with other works originating in the spiritual movement of *Devotio moderna*, became one of his sources when he wrote his *Spiritual Exercises*.[17] In these works, the key role is played by the self-formation of the believer based on imitating Christ's example, concentrating on specific episodes from Christ's life evoked visually in one's mind and thus personally experienced. According to Ignatius, it is necessary that those who wish to serve God offer their whole person and commit themselves to imitating Christ's acts and virtues:

> Eternal Lord of all things, in the presence of Thy infinite goodness, and of Thy glorious mother, and of all the saints of Thy heavenly court, this is the offering of myself which I make with Thy favor and help. I protest that it is my earnest desire and my deliberate choice, provided only it is for Thy greater service and praise, to imitate Thee in bearing all wrongs and all abuse and all poverty, both actual and spiritual, should Thy most holy majesty deign to choose and admit me to such a state and way of life.[18]

The theme of following and imitating Christ also influenced seventeenth- and eighteenth-century spirituality and fine arts associated with other religious orders besides the Jesuits.[19]

In reflecting on his own spiritual journey, Ignatius stressed not only the importance of following Christ but also of imitating saints. In his own biography, he recalls that Saint Dominic and St. Francis were examples to him and that he tried to imitate them and act like them.[20] Ignatius himself was presented by his followers in the environment of the Society of Jesus as the paramount follower and imitator of the Son of God. Following and imitating the example of saints as Christ's followers, that is, including St. Ignatius, could be grounded on the text of Paul's *Epistle to the Philippians*: *Imitatores mei estote, fratres, et observate eos qui ita ambulant, sicut habetis formam nostram* ("Brethren, be followers together of me, and mark them which walk so as ye have us for an example") (Phil. 3:17).[21]

The Jesuits reserved a prominent place for Ignatius in the community of saints, honoring him as a saint and forming and spreading his cult in visual and other media even before his canonization in 1622.[22] The idea of St. Ignatius as a follower of Christ was developed by Ignatius's biographers and other Jesuit theologians, rhetors, and historians. They emphasized how important it was for the founder of the Society of Jesus to imitate Jesus Christ and at the same time also introduced the idea of imitating Christ through following and imitating the example of Ignatius: "*Si Ignatius . . . imitator exstitisset Apostoli, sicut Paulus Christi, facile ferrem Iesuitas esse imitatores*

Ignatii." [If Ignatius proved to be the imitator of the Apostle Paul, just like Paul used to be the imitator of Christ, than the Jesuits may easily become imitators of Ignatius], *"Iesuitas esse imitatores Ignatii, si Ignatius esset imitator Christi"* [Jesuits are Ignatius's imitators if Ignatius is the imitator of Christ].[23] The effort to get closer to Ignatius's example is well illustrated by a portrait of Ignatius's companion Pedro de Ribadeneira (1527–1611), an engraving by Theodor Galle (1571–1633) dated 1611. Ribadeneira is depicted in the Jesuit cassock, with a radiant monogram and a picture of St. Ignatius, who looks much like him.[24] The principle of imitation and the concept of reflecting Christ's life, deeds, and virtues in the life, virtues, and acts of St. Ignatius and other Jesuit saints were crucial for the proselytic activities of the Jesuit order as well as an endorsement of their cult.

The motif of the Jesuits as the most faithful imitators of Christ appears regularly in Jesuit prints and monumental paintings, which were made to inspire deeper contemplation and imitation of Christ in the viewers. The Jesuits believed that close contemplation of sensually perceptible images and the creation of mental images served as techniques for grasping the complex abstract meanings of *imitatio*.[25] The order's emblems embedded in these images helped attribute the required pious qualities to the Jesuits as the bearers of Christ's legacy; thus, these paintings also served to promote the order's representation. In 1674 and the following years, the Prague Jesuit printing shop published the *Spiritual Exercises* by Ignatius of Loyola with engravings by the Prague engraver Samuel Dvořák (d. 1689).[26] The chapter *"Contemplatio Regni Iesu Christi"* is introduced by an allegorical motif clearly inspired by the same motif in Antoine Sucquet's book *Via vitae aeternae* (1620),[27] which was a popular guide to meditation and spiritual exercises using a series of paintings with interpretations of allegorical and emblematic themes. Dvořák's engraving represents Christ carrying the Cross, accompanied on his path of suffering by his believing followers. Christ's imitators are dressed in monastic robes and a Jesuit is depicted in a leading position among them.

Related themes can also be found in the monumental decoration of Jesuit churches and the order's houses. Christ carrying the cross accompanied by his followers adjoins the fictitious portrait of Thomas à Kempis, "Doctor Domesticus," in a large allegorical painting by Johann Hiebel (1679–1755) from 1724 on the vault of the library hall in the Prague Clementinum college. [figure 8.2][28] The painter, Johann Ezechiel Vodňanský (c. 1673–1758), used a similar motif on the vault of the Saint Francis Xavier Chapel in the Prague New Town's Jesuit Saint Ignatius Church in 1741, where the motif of three crucified Jesuit martyrs accompanies the scene with Christ and his followers.[29] Christ with the Cross, accompanied by his followers in monastic robes, is portrayed on the vault of the southern aisle of the Brno Jesuit Church of the Assumption of Virgin Mary above the altar dedicated to the Jesuit

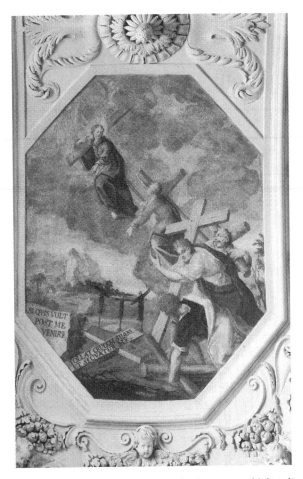

Figure 8.2 The following of Christ, ceiling painting by Jan Ezechiel Vodňanský, Chapel of St. Francis Xavier, St. Ignatius Church, Prague, New Town, 1741.

martyrs tortured to death in Japan. According to the written description of the concept, the scene represents "The path of the Holy Cross to heaven." A Bavarian painter, Felix Anton Scheffler, created the painting in 1744.[30]

The influence of Jesuit illustrated writings that served as guides for meditation and developed the theme of following and imitating Christ, however, was not confined to the Jesuit order's milieu. Jesuit texts targeting the imagery of believers naturally caught the attention of other orders whose libraries held this kind of Jesuit text. The Benedictine theologian Karl Stengel (1581–1663), abbot of Anhausen an der Brenz Cloister, played an important role in spreading Jesuit texts outside of Jesuit settings. Stengel came from Augsburg, studied at the local Jesuit school, and entered the novitiate at the

local Benedictine Sts. Ulrich and Afra Monastery. Karl's brother, Georg, entered the Jesuit order. In Augsburg, Karl Stengel developed an extensive knowledge of book production and corresponded with various intellectuals, including the Prague canon and preacher Johann Sixt von Lerchenfels (c. 1550–1629). In 1617, he published a German translation of Joannes David's book *Paradisus sponsi et sponsae* and in 1625 a translation of Sucquet's *Via vitae aeternae*.[31]

Another Benedictine author, the Dutch theologian Benedictus van Haeften (1588–1648), prior of Afflingen, authored a series of meditational writings, some of which were illustrated by Rubens. In 1629, in Antwerp, Haeften published a book on meditation, *Schola cordis*, and in 1635 he published *Regia via crucis*. In terms of their stress on the visual component of meditation as well as on the nature of their illustrations, both of these writings, later published in a number of other languages and reprinted repeatedly, are greatly indebted to Jesuit illustrated literary production, in particular the illustrated work of the Belgian Jesuit Herman Hugo (1588–1629), *Pia desseria*, dated to 1624, and Sucquet's book *Via vitae aeternae*. The cover page of Haeften's book, *Regia via crucis*, showing a depiction of Christ with the Cross accompanied by his followers, is a direct response to Jesuit themes developing the topic of following and imitating Jesus Christ.[32] An echo of Jesuit meditation books is also present in *Der Schmerzhafte Lebens Weeg Christi*, a book published in 1682 in Wrocław at the behest of Bernard Jan Rosa, abbot of the Cistercian monastery in Silesian Krzeszow, which also draws on sources of Cistercian spirituality and mysticism. Its frontispiece shows the popular allegory of following Christ.[33]

The chapter hall of the Benedictine archabbey in Břevnov is decorated by a series of paintings intended for meditation that bears biblical and apocryphal motifs depicting the life of Jesus Christ; they were painted in 1745 by Franz Lichtenreiter (1700–1775). They also include paintings that paraphrase the Jesuit emblematic image of following Christ, showing Christ with the Cross followed by monks of different church orders carrying crosses on their shoulders, with the Benedictine representative at the forefront. The choice, as well as the minor modification of an original Jesuit theme, was certainly not random, and it had religious and political importance in this setting [figure 8.3].[34]

The context shows that the interest of the Benedictines, and possibly other "old" orders that used the Jesuit rendition of the motif of *Imitatio Christi*, did not arise from the need to spread the concept of belief in Christ as promoted by Jesuits. In reaction to the assertive manner of the Jesuits, these orders started to accord a prominent status to the Son of God in their spirituality; from the historical perspective, they had followed and imitated him long before the establishment of the Society of Jesus. The concept of following and imitating Christ re-intensified in the spirituality of the Order

Figure 8.3 The following of Christ, ceiling painting by Franz Lichtenreiter, Chapter Hall, Benedictine Monastery Prague, Břevnov, 1745.

of St. Benedict particularly in the seventeenth century, when this order was confronted most strongly by the Jesuits. Benedictines even disputed with the Augustinians and Jesuits over the recognition of the authorship of *De Imitatione Christi*. While Augustinians and Jesuits rightfully attributed books on imitating Christ to the Augustinian monk Thomas à Kempis, Benedictines stubbornly maintained for a long time that the author was Giovanni Gersen (Gessen), alleged abbot of Santo Stefano Monastery in Vercelli in the thirteenth century. One of the main proponents of Gersen's authorship was the Benedictine historian Costantino Gaetani (1568?–1650), active at Montecassino. Later he became prefect of the Vatican library and cooperated for several years with Cardinal Cesare Baronio. He wrote a book called *Venerabilis viri Ioanis Gessen, Abbatis, Ord. S. Benedicti: De Imitatione Christi*, published in Rome in 1616. Following in his steps, other Benedictine scholars spoke out on the matter as well.[35] Another book published under Gaetani's name was *Religiosa S. Ignatii sive S. Enneconis Fundatoris Societatis Iesu*, printed in Venice in 1641, which attacked Ignatius's authorship of *Spiritual Exercises*. Ignatius is renounced as a spiritual author in this work, referring to his allegedly inadequate education at the time when he was supposed to have written the Exercises, that is, before he commenced his university studies. The book names García de Cisneros (1455–1510), the abbot of the Montserrat Benedictine monastery from 1493 to 1510, as the author, which caused considerable opposition among the Jesuits. Reservations

about the book were summarized by a Jesuit in Milan named Giovanni Rho (1590–1662) in *Achates ad D. Constantinum Caietanum . . ., Adversus Ineptias, et Malignitatem Libelli Pseudo-Constantiniani*, published in Lyon in 1644. At the General Chapter in Ravenna in 1644, representatives of the Benedictine order officially dissociated themselves from the book.[36] Today, however, it is generally accepted that Abbot Cisneros and his mystical work had a substantial influence on Ignatius, who visited Montserrat in 1522, that is, immediately before writing the *Spiritual Exercises*.[37]

These disputes demonstrate the latent, deeply rooted aversion between Benedictines and Jesuits and the mistrust that the older orders had in the Society of Jesus, even though they could not express it openly and officially. These disputes help in understanding the sense that some literary and artistic works in the Benedictine contexts carried, in addition to their Christian meaning. Perhaps in response to the behavior of the Jesuits, who represented unwanted competition to the Benedictines and other monastic orders, the idea that the most rigorous imitator and the most important successor of Jesus Christ in his life and deeds was none other than the patriarch of the Benedictine order, Saint Benedict himself, arose in the Benedictine environment as early as the mid-seventeenth century. According to Benedictine interpreters, he also followed the Son of God in his death, which, according to Gregory's *Dialogues*, he suffered standing, with his hands raised toward heaven, that is, similarly to Christ. This similarity between Christ and Benedict was noted by Benedictus van Haeften in his book *S. Benedictus Illustratus*, published in Antwerp in 1644, referring to the motto of the Roman Flavian emperors *"Imperatorem stantem mori oportere"* [An emperor ought to die standing up]:

> Undefeated as an athlete, stronger than disease and death that have not subdued him and that he accepted standing. Therefore, he firstly got accustomed to spread the Flavian motto: "An emperor ought to die standing up." And thus, like Jesus Christ, King of all Kings and Ruler of all Rulers, he breathed his last standing . . . Our famous Patriarch, neither lying nor sitting nor kneeling but standing upright, ready to enter the heavenly Jerusalem as pilgrim.[38]

Similarly, Benedict van Haeften's book analyses and interprets individual parts of Saint Benedict's life against the background of New Testament texts that depict the life of Jesus Christ. This concept is the basis of the emblematic collection *S. Benedictus Christiformis* devised by Juan Caramuel of Lobkowitz (1606–1682), a Cistercian and Benedictine prelate and prominent polyhistor, who also served for a time as the superior of the Montserrat Benedictine monastery (Emmaus) in Prague. Illustrations and texts from this collection, published in Prague in 1648 and again in 1680, show scenes from the lives of Jesus and Saint Benedict arranged in parallel, trying to present Benedict

as an imitator of Christ [figure 8.4]. The concept of epic religious scenes with enclosed texts and what they illustrate resembles Jesuit works, particularly the richly illustrated collection of New Testament motifs *Evangelicae Historiae Imagines* by the Jesuit Jerónimo Nadal (1507–1580), published in Antwerp in 1593. The illustration on the cover sheet of Caramuel's collection shows an artist-draftsman creating a picture modeled on a statue of the crucified Christ, that is, a motif also used in some Jesuit prints. According to the model of Christ, the artist is drawing none other than Saint Benedict. The relationship between this motif and illustrations in Jesuit meditation books is evident, although there are shifts in meaning [figure 8.5].[39]

Figure 8.4 The death of St. Benedict, from the book by Juan Caramuel of Lobkowitz, S. Benedictus Christiformis, copper engraving on paper, Prague 1680.

Figure 8.5 Title page (detail) from the book by Juan Caramuel of Lobkowitz, S. Benedictus Christiformis, copper engraving on paper, Prague 1680.

It would be a mistake to explain the affinity to the Jesuit concept by Caramuel's affection for Jesuits. As a superior of a Benedictine monastery, Caramuel was a member of the international Benedictine community, who perceived the Jesuits as their competitors in various respects. In Prague, where the book was printed, Caramuel held the post of vicar-general and cooperated closely with Bishop Ernst Adalbert von Harrach of Prague. As Harrach's supporter, he sought to strengthen the position of the archbishopric in the re-catholization efforts, in the spiritual administration of Bohemia, and also in the administration of Prague University, where the archbishop was trying to assert his influence against the Society of Jesus. At the same time, Caramuel faced the power of Jesuits, with their openly hostile attitude and often aggressive behavior. Thus, he was not inspired by a fondness for the Jesuits, although he himself respected Jesuit scientists and maintained contact with the renowned Jesuit scientist Athanasius Kircher (1602–1680). His intention was to use Jesuit models to promote his own monastic order.[40]

The frontispiece of a book called *Cistercium Bis-tertium* by Augustin Sartorius (1663–1723), a Cistercian monk from the monastery of Osek, is

an example of the apparent resonance of Jesuit books and the metaphoric image they devised in the Cistercian context. The book was published in Prague Old Town in 1700 and dedicated to the history and importance of the Cistercian order. Balthasar van Westerhout (1656–1728), an engraver from Antwerp based in Prague, made the illustration following the design of the Osek painter Andreas Jahn. The allegorical scene is set in a hall where two painters are seated, both finishing their paintings. The painter to the right works on a painting of the Cistercian order patriarch, Saint Bernard; the painter on the left is depicting a newborn, behind whom a duke's cap lies on a table. Three additional paintings hang on the hall's pilasters. They depict Emperor Leopold I and his two sons, the king of Germany, later the Roman emperor, Joseph I (1678–1711), and his younger brother, Archduke Charles (1685–1740), later the Spanish king and emperor. The newborn being painted is most likely Joseph's newborn son Leopold Joseph (1700–1701), soon after deceased. In the upper part of the composition, Our Lady and Christ are depicted in heaven, with the sun shining from behind them. Beneath them, a personification of Austria with the Austrian emblem reflects the sunbeams onto the portraits of the monarchs. Milk is gushing from Mary's breast onto the palette of the artist painting Saint Bernard; blood spurts from the wound in Christ's side. A band held by Austria bears a Latin quotation from the Song of Songs: *"Dilectus meus candidus et rubicundus"* [My beloved is white and ruddy] (Cant. 5:10); a band in the upper part bears the inscription: *"Color idem pingit utrosque"* [The same color paints both]. The scene is set in an acanthine frame with emblems of lands of the Habsburg monarchy and trophies. The allegories and accompanying texts evoke two visions of Saint Bernard and the two main symbolic sources of Cistercian spirituality: Christ's blood and Mary's milk. The colors of the blood and milk are also related to the heraldic colors of the Austrian (Babenberg) coat of arms.[41]

In the Jesuit milieu in the first half of the seventeenth century, a metaphor spread of a believer trying to follow and imitate the Son of God, illustrated by the motif of a painter seeking as faithful a depiction of Christ as possible. The book *Veridicus Christianus* by the Jesuit Joannes David, published in Antwerp in 1601, contains in the introduction to a chapter entitled *"Orbita probitatis ad Christi imitationem"* [The honest path to follow Christ], an enigmatic image of ten painters watching Christ carrying the Cross while each of them depicts this event as a different motif on his canvas. Only one of them—the one in the center foreground—has correctly depicted Christ carrying the Cross.[42] This scene epitomizes the Jesuit idea of a "correct vision" leading to a correct imitation. Similarly, in 1620, the Belgian Jesuit, Antoine Sucquet (1574–1627), published his work *Via vitae aeternae* with illustrations by Boetius à Bolswert (1585–1633), a meditation handbook with images as means leading to spiritual encouragement.[43] Among other

subjects of illustrations and their interpretations, a motif emerges of a painter who, similarly to a believer's soul, watches and imitates the example of Jesus Christ, Our Lady, and saints. One of the captioned depictions in the book shows a landscape where several saints stand or sit; next to the Virgin Mary and the Archangel Michael one can recognize St. Paul, St. Anthony the Hermit, St. Jerome, and also Ignatius of Loyola in a priest's cassock, with an open book and the monogram "IHS." The humble Jesuit painter in the foreground is sitting by an easel, trying to depict the character of Ignatius of Loyola according to the living model. The painter can be understood here as an embodiment of a soul being guided to follow and imitate the example of saints and patrons. Ignatius is a model without further commentary; at the time of the book's first publication, he had not yet been canonized.

Another depiction in the book shows a painter in a company of angels painting Christ carrying the Cross. At the same time, he is watching a landscape with Golgotha, where Christ is climbing carrying the Cross on his shoulder, followed by his disciples, who also carry crosses. In the background on the left, those who have laid their crosses aside fall into hell, while those who have persevered in following Christ enjoy the grace of God. Hinting at the same idea, the motif of an artist attempting to accurately imitate Christ or the saints was adopted in Bohemia for the frontispiece of *Occupatio animae Jesu Christo Crucifixo devotae*, a book by the Jesuit François Le Roy, published in Prague in 1666. The frontispiece was designed by the well-known Bohemian painter Karel Škréta (1610–1674). The engraving represents the crucified Christ, who is being depicted by personifications of souls; one is painting a picture of Christ on a heart-shaped surface and the other is chiseling a statue of the crucifix.[44]

In addition to the metaphorical motif of an artist imitating his model as a model for a proper *imitatio*, Westerhout's frontispiece engraving for *Cistercium Bis-tertium* also adopted the motif of reflected light from among Jesuit symbols used in both Jesuit tracts on catoptrics[45] and also in prints and paintings, the most famous of which is Pozzo's *Celebration of the Missionary Activities of Society of Jesus* on the vault of the Roman St. Ignatius Church. Compared to Jesuit works, the use of this rather superficial allegory to introduce a book that celebrates the spiritual merit of the Cistercian order is surprising because here political motifs overshadowed the spiritual charge of its original Jesuit models. Celebrating the Austrian ruler and his successors was central to the message of Westerhout's engraving, in which transcendental motifs were profaned by reference to the emperor, his sons, grandson, and the lands he ruled, and used to present a pictorial sanctification of their absolutist government. A somewhat forced, and as a result not very convincing, the parallel between the Bernardine mystics and the representation of the Habsburg sovereign dynasty here instrumentalized the political ambitions of

the Cistercian order rather than celebrating its historical, spiritual, and cultural contributions. Such a political arrangement relativizes the meaning of the central metaphor of two painters; in this prominent visual eulogy on the Habsburg rulers, one may ask who and what the figures of the two painters actually represent; in Jesuit writings, they had originally embodied the souls of believers following Christ's and saints' examples.

JESUIT THEMES AND SYMBOLS AS SOURCE OF INSPIRATION IN OTHER ORDERS

Another subject that Jesuits emphasized when representing their order was their missionary activity, seen in the persons of St. Francis Xavier and other Jesuit missionaries. Missionary motifs were treated in a number of artworks from the Jesuit milieu. The most spectacular visual celebration of Jesuit missions was Pozzo's famous painting on the vault of the St. Ignatius Church in Rome from 1685 to 1694.

Other church orders also responded to this characteristic element of Jesuit spirituality. The university thesis of the Salzburg Benedictines, designed by the Austrian painter Johann Karl von Reslfeld (1658–1735) and created by the Augsburg engraver Leonhard Heckenauer (1655–1704) in 1701, depicts the celestial triumph of St. Benedict linked to his vision of the world in a sunbeam, here related to the spiritual primacy and historical world expansion of the Benedictine order. On the lower left, Benedictine missionaries are surrounded by ancient inhabitants of non-European continents accepting baptism at the hands of Benedictines.[46] The constellation and stylization of this group and other motifs are strikingly similar to the usual depiction of St. Francis Xavier and other Jesuit missionaries. Reslfeld's large engraving served as a direct model for multiple concepts in monumental paintings. Among others, it was the basis of the decoration of the abbatial Sts. Peter and Paul Church of the Benedictine Monastery in Lower Bavarian Oberalteich. The vault was painted by the Swabian painter Joseph Anton Merz (1681–1750) in 1731.[47]

Motifs of Benedictine missionaries are also present in the Sts. Peter and Paul Benedictine Church in South Moravian Rajhrad, painted in 1726–1727 by Johann Georg Etgens (1693?–1757), a painter from Brno. In the central cupola of this church, Etgens painted a vision of St. Benedict, to whom God revealed the world in a sunbeam. Allegorical paintings in the pendentives are tied to this theme. They represent the four continents, into which characters of medieval missionaries from the Benedictine order are set. St. Boniface is shown as the apostle of Europe, St. Boellius as the apostle of America, St. Brendanus as the apostle of Africa, and St. Bononius as the apostle of Asia [figure 8.6].[48] By presenting the world expansion of their order and the merits

Figure 8.6 St. Bononius as the Apostle of Asia, ceiling painting by Johann Georg Etgens, Church of St. Peter and Paul, Benedictine monastery Rajhrad, 1726–1727.

of Benedictine missionaries in Christianizing all the continents, the Rajhrad Benedictines were unquestionably trying to compete with the Jesuits, at the same time pointing out that Benedictine missions had preceded Jesuit activities by centuries. The missionary motifs in Benedictine art occur in rather isolated places, therefore their iconography was not well established. Formal and iconographic means for depicting the missionaries in the Rajhrad ceiling painting, that is, the postures and theatrical gestures of missionaries, the humble postures of the persons being baptized as well as their exotic picturesque costumes, were undoubtedly also borrowed from Jesuit art. Figures in the paintings with St. Boellius and St. Brandanus are very close to figures on the stone sculptural group of St. Francis Xavier on the Prague Charles Bridge, created by Ferdinand Maximilian Brokoff (1688–1718) in 1711. Benedictines could also acquaint themselves with the themes shown in this statue through a period engraving by Augustin Petr Neuräutter (c. 1673–1749).[49]

As early as the lifetime of St. Ignatius, the most distinctive emblem of the order became the monogram (trigram) "IHS" in an aureole, with the motif of the cross above the middle "H" and three nails beneath it. This monogram, omnipresent in the Jesuit milieu, represents respect for the name of Jesus and at the same time is the most privileged and ambitious attribute of the Society of Jesus. This was not their invention, however, respect for the name of Jesus was spread from early Christianity. It drew on certain New Testament texts, in particular Paul's second epistle to the Philippians (Phil. 2: 9–11):

> Wherefore God also hath highly exalted him, and given him a name which is above every name: That at the name of Jesus every knee should bow, of things in heaven, and things under the earth; And that every tongue should confess that Jesus Christ is Lord, to the glory of God the Father.

The specific form of the stylized monogram of the name of Jesus evolved from older forms of christograms in use since early Christianity. It originated in a medieval abbreviation of the Greek version of the name of Jesus ("Ἰησοῦς") transcribed in Latin. It appeared in the Franciscan environment, where respect for Jesus' name was allegedly introduced early by Ubertino of Casale (1259–c. 1329). In 1420s, a sign bearing a Gothic minuscule monogram "ihs" in the sun disk was used by St. Bernardino of Siena (1380–1444) for self-representation, which was continued by his successor, St. John of Capistrano (1386–1456). Thanks to the Franciscan Observants, the sign was spread over Christian Europe; later St. Ignatius of Loyola and his followers adopted it, making it an emblem of their order. The monogram of Jesus' name, first in minuscule, later in a majuscule form, was employed as early as the first order's seals and in the frontispieces of Jesuit writings. It was also applied to liturgical objects, on Jesuit architecture, and used in the contexts of various artistic projects initiated by Jesuits.[50]

Depictions of the "IHS" monogram in Jesuit monumental art, like Baciccio's famous fresco, dated 1674–1679, on the vault of the Roman Jesuit Il Gesù Church, reflect and, in an exalted manner, amplify the exclusive sovereign character of this theological motif. In Jesuit spirituality and Jesuit fine arts, the "IHS" monogram is sometimes presented as an imminent reflection of the presence of God and as the main source of the apostolic activities of the Society of Jesus. An exquisite example of this concept is Pozzo's painting in St. Ignatius Church [figure 8.7]. At the same time, the "IHS" monogram used by St. Ignatius on his seal served as an attractive sign marking Jesuit prints from the mid-sixteenth century, appearing on façades and in the interiors of Jesuit churches and houses, in their artworks, on vestments, liturgical artifacts, and in other locations. In practice, this symbol was used as an identifying sign of the order

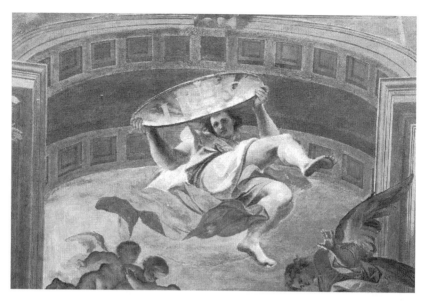

Figure 8.7 Allegory of the missionary work of the Society of Jesus, detail with the IHS monogram, ceiling painting by Andrea Pozzo, St. Ignatius Church, Rome, 1688–1694.

and its successful concept. Given its graphic simplicity and aptness, it can be, with a certain hyperbole, understood as a corporate logo in the modern sense.

The "IHS" sign—the symbolic representation of Jesus Christ the Son of God, Redeemer and Savior—has never lost its deeper universal theological meaning for the Catholic Church. It was probably the privileged and exclusive character of the "IHS" symbol on the one hand, and its overuse by the Society of Jesus and the related level of profanation on the other hand, that irritated other church orders. The extensive panegyric work *Cistercium bistertium* (1700) by Augustin Sartorius contains a chapter called "*Cistercienses-Jesuitae*," that is, Cistercian Jesuits. Starting with "Jesuit name [i.e. the Jesuit respect for the name of Jesus], sweet, holy, new, but the idea itself is old . . ." he continues with an overview of respect for the name of Jesus, stretching long before the establishment of the Jesuit order to St. Paul, the Venerable Bede, and St. Bernard. In the concluding composition in verse, St. Bernard, who followed Christ through his whole life, and his followers were glorified as "Jesuits":

". . . Ergo *Bernardus fuit Jesuita?*
Tu dicis, & est ita!
Tota *Berdnardi vita* fuit *JESU vita* . . .
. . . *Quialis Pater, talis Filius.*
Omnes *Bernardi* Filii sunt *JESU Socii,*

Et in rhythmo,
Omnes *Bernarditae* sun *Jesuitae* . . ."[51]
. . . Was Bernard a Jesuit, then?
You say and it is so that
The whole Bernard's life was the life of Jesus . . .
Like Father, like Son.
All Bernard's sons are companions of Jesus
And in the rhythm
All Bernardines are Jesuits . . .

The poem lists and celebrates corresponding deeds and similar character traits of Cistercian and Jesuit saints and their two main protagonists, St. Bernard and St. Ignatius, and concludes in a conciliatory tone on the closeness of both orders in their spiritual efforts. The author indicates awareness of the incompatibility of the two orders by metaphorically comparing Cistercians with water and Jesuits with fire, as well as by comparing the colors of the orders, Cistercian white and Jesuit black, in another part of the poem. The monumental "IHS" symbol can also be seen on the facades of other Cistercian churches, such as Plasy or Žďár nad Sázavou.

Reactions to the Jesuit symbol were also present in the Benedictine environment. Bonifacius Gallner (1678–1727), emblematist of the Melk Benedictine Abbey, compiled a collection of emblems, *Regula Emblematica Sancti Benedicti* (before 1725), treating the text of the Benedictine statute. Some of the emblems contain depictions with the "IHS" monogram in a form known from the Jesuit milieu. Gallner's collection was printed in Vienna as late as 1780, after his death; themes originating from it, however, could have circulated earlier among the Benedictines [figure 8.8].[52]

In 1733, the Břevnov and Broumov abbot, Otmar Daniel Zinke (1664–1738), had Cosmas Damian Asam (1686–1739) paint the interior of the Benedictine Provost Holy Cross and St. Hedwig Church in Silesian Wahlstatt (Legnickie Pole). He painted a magnificent scene of "Finding the True Cross" on the ceiling of the nave vault, accompanied by several allegorical motifs. The peak element of the content of the whole composition is a depiction of the triumphant Savior in heaven, above whom a monumental "IHS" monogram appears under a crimson canopy carried by angels. The founder of the church, Abbot Zinke, is depicted in the bottom part of the painting, accompanied by brothers of the order. In this context he is presented as a devotee of the Holy Cross and Jesus Christ the Savior and his Holy Name.[53] This painting's concept may have been a Benedictine response to the decoration of the Jesuit church of the Name of Jesus in Wrocław, where, as mentioned above, Johann Michael Rottmayr painted a celebration of the Name of Jesus in the form of the "IHS" monogram on the vaulting. In their painting, the

(28)

NIHIL PRAEPONATVR.

XXVIII.

fieri non vult, alii non faciat. 10. Abnegare femet ipfum fibi, vt fe-
quatur Chriftum. 11. Corpus caftigare. 12. Delicias non amplecti.
13. Ieiunium amare. 14. Pauperes recreare. 15. Nudum veftire.
16. Infirmum vifitare. 17. Mortuum fepelire. 18. In tribulatione
fubuenire. 19. Dolentem confolari. 20. A faeculi actibus fe facere
alienum. 21. *Nihil amori Chrifti praeponere.* 22. Iram non perficere.
23. Iracundiae tempus non referuare. 24. Dolum in corde non te-
nere. 25. Pacem falfam non dare. 26. Charitatem non derelinque-

Figure 8.8 Emblem in Bonifacius Gallner, *Regula Emblematica Sancti Benedicti,* copper engraving on paper, Vienna 1780.

Wahlstatt Benedictines expressed their objections to the Jesuits, represented by the monogram, claiming an exclusive position in following Jesus. The Benedictines, similarly to the Jesuits, proclaimed their merits in re-catholicizing Protestants in Silesia. Unlike the Jesuits, however, the Benedictines reminded viewers that they continued the traditions of an ancient Benedictine monastery founded there by St. Hedwig as early as the thirteenth century in honor of her son, killed in the Battle of Wahlstatt [figure 8.9].

In the Austrian and Czech lands, Benedictines could indeed claim reverence for the name of Jesus and use it to express their position compared with their competitors, the Jesuits. This, however, did not satisfy their own need

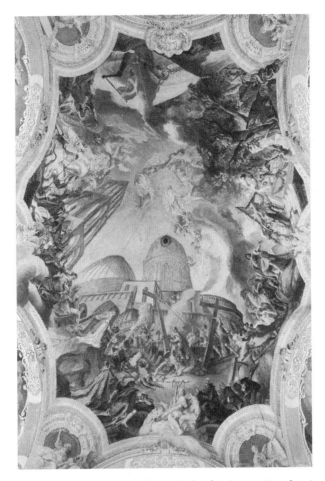

Figure 8.9 Finding the Holy Cross, ceiling painting by Cosmas Damian Asam, Church of St. Cross and St. Hedwig, Legnickie Pole (Wahlstatt), 1733.

to visualize their spiritual and political identification. They realized that they had to seek a different new universal symbol for this purpose; nonetheless, it had to be one that could be compared to the motif of the Name of Jesus. The Benedictines found the symbol, a stylized motif of the Holy Cross, as late as at the turn of the seventeenth century.

The veneration of the Holy Cross is, of course, ubiquitous in Christianity regardless of confession. The instrument of Christ's Passion is the most fundamental sign by which Christians declare their faith. In Benedictine prototexts, which include Benedict's statute and biography, traditionally attributed to Gregory the Great, however, they do not explicitly emphasize reverence for the Cross. The image of St. Benedict as a devotee and follower

of Christ's Cross is more frequent in seventeenth-century Benedictine texts that reinterpret Benedict's biography.[54] The central area on the vault of St. Margaret's Church in Břevnov is dedicated to the veneration of the Holy Cross, around which the Břevnov patrons, St. Margaret, Alexius, and Boniface, are assembled. The Cross in gloriole has to be understood as the culmination of the complex iconographic concept of the church. Saints from other sections of the image look up to it—St. Adalbert with the Five Saint Brothers, and saints who, according to tradition, came from the Břevnov monastery, that is, St. Anastasius, St. Prokop, St. Radim, and B. Gunther. As a counterbalance to the Cross, St. Benedict also stands, posing in heaven with his hands spread in the spirit of the interpretations of his legend. The manner in which the Cross is presented here is comparable to the context of the monogram "IHS" on Jesuit projects.[55] In the Benedictine milieu around 1700, the so-called Benedict's Cross became popular in the form of a medal showing initials that evoked the exorcist formula *"Crux sacra sit mihi lux, numquam draco sit mihi dux"* [May the holy cross be my light! May the dragon never be my overlord!]. The origin and meaning of the medallion with Benedict's Cross was treated in the writing of Magnoald Ziegelbauer, a Benedictine historian from Zwiefalten, who was also staying in Břevnov. In his book from 1743, *Disquistio Sacra Numismatica de origine, quiddit Ate, Virtute, Pioque usu Numismatum seu Crucularum S. Benedicti Abbatis . . .*, he states about Benedict's Cross:

> Firstly, if understood, its primary and special meaning concerns undoubtedly the reverence of the Holiest Cross itself and the Crucifixion of our Savior, Lord Jesus Christ . . .
>
> Finally, at the same time it is unique in reverence and honor of St. Father Benedict, which is created in before our eyes in the holy medal with the Cross that we are accepted by this Patron Guardian, filled with faith that under his protection and guard we will not fear evil.[56]

Benedict's Cross, therefore, refers to the central object and source of faith. At the same time, however, it becomes an apotropaic symbol that protects the faithful from evil as well as a motif celebrating Saint Benedict.

The history of Benedict's Cross can be traced back to 1414, when it was depicted in one of the illuminations of the Metten Bible, although here the cross is in the form of a cross-shaped staff in the hands of St. Benedict. The text is added on the staff and on an attached band.[57] The reproduction of this illumination and information about it was included in *Thesaurus Anecdotorum Novissimus*, a collection from 1721 created by Bernhard Pez, librarian and historian from Melk (1683–1735).[58] Only later, however, at the turn of the seventeenth century, did Benedict's Cross spread in its

characteristic form of an oval medal that could be distributed as a medal and at the same time permeate monumental art. It was depicted on the vault of the Benedictine church in Melk between 1720 and 1722 by Johann Michael Rottmayr [figure 8.10]. In the Czech lands a large protective image of Benedict's Cross was used on the façades and roofs of Benedictine churches, where the sign is visible from afar.[59]

The meaning of Benedict's Cross was perceived and presented in the Benedictine environment similar to the manner in which the Society of Jesus presented and understood the "IHS" monogram [figures 8.11, 8.12]. Among the initials of the exorcist prayer that covered the Benedictine cross, the "IHS" monogram was used in the upper, that is, the most important, section [figures 8.10, 8.12]. Both symbols—the stylized Jesuit monogram "IHS" and Benedict's Cross—had deep religious meaning and were related to a distinctive form of devotion and monastic spirituality. Both symbols evolved into

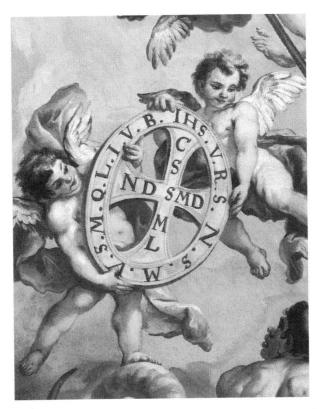

Figure 8.10 Celebration of St. Benedict, detail with Benedict's cross, ceiling painting by Johann Michael Rottmayr, Church of Sts. Peter and Paul, Benedictine monastery Melk, Austria, 1720–1722.

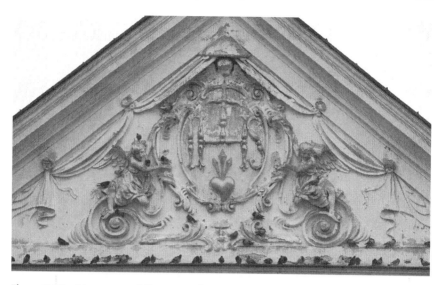

Figure 8.11 Monogram of the name of Jesus, St. Ignatius Church, Klatovy.

distinctive signs, a sort of logo, used by the orders for identification and propaganda. Although the success of Benedict's Cross lagged behind the popularity of the worldwide spread of the Jesuit attribute, the intention was similar.

Among the members of other orders, the Jesuits were also known for using allegories and symbols in a much more sophisticated manner than just for identification and propaganda. The Ignatian *Exercitia Spiritualia*, following the mystical tradition and piety of the Late Middle Ages, used imagination, figurativeness, and sensual experience and developed the theory of the metaphorical image, which clearly influenced Baroque art and culture in Central Europe to a greater extent than has been noted heretofore.[60] The "iconomystical" theory cultivated by the German Jesuit Jacob Masen (1606–1681) had a verifiable influence; he included it in his treatise *Speculum Imaginum Veritatis Occultae*, first published in Cologne in 1650 and re-issued and enlarged many times. Masen was held in high esteem by the Czech Jesuit erudite Bohuslav Balbín (1621–1688), who praised his monastic colleague in his *Verisimilia Humaniorum Disciplinarum*, first published in 1666. Balbín deemed Masen an author worthy of being browsed day and night by advanced poets. According to Balbín, only *pater* Masen could turn an aspirant into a poet, thus he refers to Masen as the leading master of his time. Allegedly, only he can offer perfect guidance on symbols, so it is useless to add anything to his teachings.

Masen originated the art of "iconomysticism" (*ars iconomystica*) and the category of "figurative image" (*imago figurata*). He distinguished between a "faithful" mimetic image (*imago propria*) and an image with a hidden,

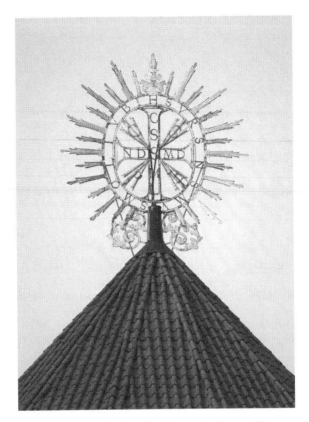

Figure 8.12 Benedict's Cross, Church of St. Margaret, Prague, Břevnov.

figurative meaning (*imago translata*), a synonym for a figurative image. If the faithful image is the work of painters, then the figurative image is the work of poets. Likewise, Balbín also later remarked on the affinity of emblems and symbols with poetry and notes that both are works of poetic talent because an inscription or an epigram is written in verse and a symbol is interpreted by hemistichs and lemma, or even an epigram.

According to Masen, the *imago figurata* is more important for understanding and expressing an image of the world and it is more fitting than the word—the word only affects vision and hearing, but a symbolic image affects all the senses (taste and smell became a frequent motif of emblems). While languages differ, the image is universal, also speaking to the deaf and mute, to those present as well as those absent. It communicates the author's idea faster than the spoken word or written text. Symbolic art can capture characteristics and meanings of spiritual things—not just one feature or meaning, but multiple varied features and meanings. The symbolic image is

the language in which God speaks to us through the Holy Scripture. It can be demonstrated with multiple examples; meaning is frequently expressed in the Holy Scripture using symbols and figurative expressions where such expression is impossible through things that are similar to each other. Perception, which is subject to the mind and cognition, understands a great deal through such examples.

A clear resonance of Masen's iconomysticism and examples of the literary emblems he mentions can be found in works of an educated painter, Martin Antonín Lublinský (1636–1690). Lublinský attended Jesuit schools in Silesia and in Olomouc, where he entered the monastery of Discalced Augustinians. He was employed as an art adviser by the bishop of Olomouc, Charles II of Liechtenstein-Castelkorn, and other Olomouc prelates. He was the author and inventor of university theses and other engravings.[61] In addition, Lublinský also designed large ceiling cycles of paintings for the Premonstratensian pilgrimage Church of the Visitation of Our Lady at Svatý Kopeček (Holy Hill) near Olomouc[62] and for the Piarist St. Anne's pilgrimage church in Stará Voda near Libavá.[63] Both cycles concern the Immaculate Conception of the Virgin Mary, that is, a theme that had no direct basis in canonical biblical texts and at the time not even in ecclesiastical dogma. Premonstratensians and Piarists lacked their own distinctive theological and iconographic resources to present such an exclusive and attractive theme in their churches. In both cases, Lublinský therefore included emblematic paintings in the cycles, quoting paradigms extracted from a treatise, *Speculum Imaginum Veritatis Occultae*, by a Jesuit author that contains a collection of sample literary emblems, some dedicated to the immaculate motif. Masen's book, however, did not inspire Lublinský to mere imitation. He understood it as a solid theoretical and conceptual basis for preparing the concepts behind his paintings, helping him form the metaphorical composition of paintings and create the syntax of individual symbolic components. Lublinský's emblems, which go beyond the conventions of his time, are relatively complex and not easily understandable by those unacquainted with Masen's treatise. A good example is the "SINE MACULA" [Untainted] emblem, the imago of which represents a girl with a mirror, an eagle, and an angel watching the sun through a telescope.[64] It was evidently inspired by Masen's original literary emblem, to which Lublinský only added the Latin lemma:

Aquila solem intuens. Sola capax solis.
Par aquilae Virgo est, caelesti lumine gaudent:
Illa capax magni Solis, et illa Dei,
Seraphim incomprehensae visionis.
Epi[phanius]. or[atio]. de Deip[ara].[65]

Eagle watching the Sun. The only one able to gaze at the sun.
Equivalent to the eagle is the Virgin, she enjoys the light of heaven:
One is worthy of the great Sun, and she is worthy of God.
Ungraspable from the perspective of Seraphs.
Epifanius, Sermon on the Mother of God.

With such a sophisticated level of visual and textual metaphorical construction, one can hardly expect that the motifs used in the churches at Svatý Kopeček and Stará Voda could be comprehensible to the thousands of pilgrims heading there from towns and rural areas. The difficulty of comprehending such images may have been the reason why similar emblems with complex content ceased to be constituent components of monumental church decorations around 1700.

In general, the impact of the art and propaganda of the Jesuit order on other church institutions in Bohemian lands was greater than has been appreciated so far. At the time, there was intense exchange and communication among the Jesuits and other orders in the field of fine arts and visual culture as well as in other areas. Other church orders were fascinated by how the Jesuits effectively visualized and instrumentalized religious subjects to influence believers. Impulses received from the Jesuit milieu also served to emphasize distinctions and negative delimitation among the orders. Some of the traditional monastic orders that perceived the Jesuits as rivals adopted forms of Jesuit propaganda specifically to use against them.

The art of monastic orders today is usually researched from the perspective of their internal history and spirituality, used as a basis for iconographic analyses. The study of specific propagandist elements of ecclesiastical art, in particular comparing the decorative systems in their sanctuaries, offers a better understanding of the nature and specific contexts of the artistic commissions ordered by mutually competing church institutions within the seemingly united Counter-Reformation strategies of the Catholic Church. I have argued that art also served to promote, mutually delimit, justify, and manifest specific religious and political aims and interests among institutions under the surface of the unified Catholic Church. It helps reveal the heterogeneous nature of local manifestations of Counter-Reformation piety that were based on individual and self-projected monastic traditions and competition for spiritual supremacy within the Bohemian space. It is quite clear, nevertheless, that the Jesuit impulse was essential for shaping the public expressions of spirituality of Czech post-White-Mountain religious orders, whether as a source of inspiration to intensify spiritual practices, an incentive to self-reflection, presentation of their own merits, or as an object of mutual demarcation.

NOTES

1. For manifestations of animosity directed against the Jesuits in post-White Mountain Bohemia, see Sousedík, "Některé projevy antijesuiitismu," 21–28. Sousedík, *Valerián Magni*, 44–45; Raková (Čornejová), "Cesta ke vzniku Karlo-Ferdinandovy univerzity," 7–40; Čornejová, 23–34 Pavel Preiss covers controversies between the Prague Jesuits and Dominicans that were directly reflected in the artistic expressions of both orders and in their mutual criticism, Preiss, "*Thomismus contra Molinismus*," 187–195; idem., "Zum Prager Bilderstreit über das Problem des Thomismus und Molinismus," 219–224. For the Prague archbishopric, see Catalano, *Boemia e la riconquista delle coscienze*. A protracted dispute was also underway during the seventeenth and eighteenth centuries between the archbishops of Prague and the abbots of the Břevnov (Breunau) and Broumov Benedictine Archabbey, who claimed the right of exemption, that is, to be released from the authority of the archbishop's consistory, *Acta Processus*; Krásl, "Opat Anselm Vlach," 12–23; Menzel, "Exemptionsstreit," 53–136; Vilímková and Preiss, *Ve znamení břevna a růží*, 129–130, 148–161.

2. Hevenesi, *Cura Salutis*; Pezius, *Epistolae Apologeticae*. Compare also Garberson, *Eighteenth-Century Monastic Libraries*, 22–23; Benz, *Zwischen Tradition und Kritik*, 562–564; Wallnig, *Critical Monks*, 147–148.

3. Levy, *Propaganda and the Jesuit Baroque*.

4. On the influence of various church institutions on lay communities, compare also Mikulec, "Klášter a barokní společnost," 281–300.

5. Herain, *Stará Praha*, 119; Preiss, *František Karel Palko*, 130–131.

6. Doktorová, "Reading the Prague Lesser Town Square," 241.

7. Preiss, "Der Wandel des ikonographischen Programms," 339–402.

8. Hamacher, "Prag. Sankt Niklas in der Altstadt," 265–267, Cat. No. F XXV; Mádl, "Praha – Staré Město. Klášter s kostelem sv. Mikuláše," 764–801 (further bibliography here).

9. Preiss, *Václav Vavřinec Reiner* (1971), 100–101, Cat. No. 116; idem., *Václav Vavřinec Reiner* (2013), 774–787; 1000–1003, Cat. No. F 18 (further bibliography here).

10. Preiss, *Thomismus contra Molinismus*; idem, Zum Prager Bilderstreit; idem, *Václav Vavřinec Reiner* (2013), 759–769. On the dispute between the Thomists and the Molinists, see also Svoboda, "Boží předurčení a svoboda rozhodování," 559–568.

11. Kundmann, *Promptuarium Rerum Naturalium et Artificialium*, 19–21; Hubala, *Johann Michael Rottmayr*, 39–44, 147–152, Cat. No. F 13; Wojtyła, "Od wschodu słońca aż po zachód jego," 113–148; Karner, "Die schlesischen Jesuitenkirchen," 1347–1373 (esp. 1353–1355); Oulíková, "Reflexe úcty Jména Ježíšova," 101–102.

12. Preiss, *Václav Vavřinec Reiner* (1971), 90, Cat. No. 90; idem., *Václav Vavřinec Reiner* (2013), 605–631 (613–617), 994–996, Cat. No. F14.

13. Haeften, *S. Benedictus Illustratus*, 169.

14. Menzel, *Abt Othmar Daniel Zinke*, 76–93; Hamacher, "Wahlstatt," 258–260, Cat. No. F XXII; Vilímková and Preiss, *Ve znamení břevna a růží*, 241–244; Mádl, "Lehnické Pole," 866–895 (879–881, Cat. No. XXIIIa/2.a).

15. Mádl, "Heřmánkovice," 468–490.

16. High-quality examples include the painting by Johann Michael Rottmayr (1654–1730) in the dome of the Holy Trinity Church in Salzburg from 1697 to 1699, Asam's painting from 1714 on the vault of the Saint Jacob's Abbey Church in Ensdorf (Upper Palatinate), the fresco by the Tyrolean painter Johann Jakob Zeiller (1708–1783) in the cupola of the Benedictine Church of the Assumption of Mary in Ettal (Upper Bavaria) from the end of the 1740s and 1750s, and the painting by Martin Knoller (1725–1804) on the vault of the abbatial church of Sts. Ulrich and Afra in Neresheim (Baden-Württemberg) from the first half of the 1770s.

17. de Leturia, "La 'Devotio moderna' en el Montserrat de S. Ignacio," 73–88; Swartley, "The Imitation," 81–103; Melloni, *The Exercises*; Sluhovsky, "Loyola's Spiritual Exercises," 216–231 (219); Conrod, "The Spiritual Exercises," 266–281 (271); Sluhovsky, "A Biography of the Spiritual Exercises."

18. *"En, ó, Rex supreme ac Domine universorum, tua, ego, licet indignissimus, fretus tamen gratia et ope, me tibi penitus offero, measque omnia tuae subiicio voluntati, Attestans coram infinite bonitate tua, necnon in conspectu gloriosae Virginis Matris tuae, totiusque Curiae coelestis, hunc esse animum meum, hoc desiderium, hoc certissimum decretum: ut ut (dummodo in majorem laudis tuae, et obsequii mei proventum cedat) quam possim proxime te sequar, et imiter in ferendis injuriis et adversis omnibus, cum vera, tum spiritus, tum etiam rerum paupertate: Si (inquam) sanctissimae tuae majestati placeat ad tale me vitae institutum eligere, atque recipere."* [Ignatius de Loyola], *Exercitia spiritualia, paragraph 98.*

19. Bailey, *Between Renaissance and Baroque*, 7–8; idem, "Italian Renaissance and Baroque Painting," 126; Smith, *Sensuous Worship*, 40–41; Mádl 2019c, passim.

20. Ignác z Loyoly, *Souborné dílo*, 120. See also Doran, "Lonergan on Imitating the Divine Relations," 199–219 (215); Rosenberg, *The Givenness of Desire*, 152.

21. de Palma, *Praxis et Brevis Declaratio Viae Spiritualis.*

22. Gerken, *Entstehung und Funktion von Heiligenbildern.*

23. Quote from Jacobus Gretser, *Libri quinque Apologetici*, 172, 173.

24. Levy, *Propaganda*, 118–127; Gerken, *Entstehung und Funktion von heiligenbildern*, 66–67.

25. This develops the Jesuit grasp of the originally Aristotelian concept of *mimesis*. The Jesuit Joannes David sees it as the contemplation of the invisible through the visible (*"Invisibilium per visibilia contemplatio"*), David, *Duodecim specula* (Antwerp 1610).

26. Ignatius de Loyola, *Exercitia spiritualia Sancti Patris Ignatii* (1674); Voit, *Encyklopedie knihy*, 227–229.

27. Sucquet, *Via vitae aeternae.*

28. Oulíková, "Der Bibliothekssaal des Clementinum zu Prag," 155–163; Fronek, *Johann Hiebel (1679–1755)*, 222, 237, Cat. No. VIII.B; Oulíková, *Klementinum*, 123, 125.

29. Mádl, "'Picturae elegantes' in der Prager St.-Ignatius-Kirche," 1387–1408 (1393).

30. Tietze, "Programme und Entwürfe," 24; Vondráčková, "Felix Anton Scheffler," 1425.

31. David and Stengelius, *Paradeys des Breutigams und der Braut*; Stengelius, *Weeg deß ewigen Leben.* Compare also Appuhn-Radtke, "Spirituelle Trendsetter," 1201–1215.

32. Hugo, *Pia desideria*; Idem, *Schola cordis*; Haeften, *Regia via crucis*. Compare also Saunders, *The Seventeenth-Century French Emblem*, 195–200; Guiderdoni, "The Heart and the Law in the Scales," 118–134; Mádl, "Praha – Břevnov," 125–131; Idem, "*Sanctus Benedictus Christiformis*, 34–45, 131–134.

33. Kozieł, *Angelus Sileusius*, 106–112.

34. Mádl, "Praha – Břevnov," 221–222, Cat. No. Ib.1/4.b5.

35. Caietanus, *Venerabilis Viri, Ioannis Gessen*; Quatremaires, *Ioannes Gersen*; [Jean Fronteau and Gabriel de Boissy], *La Contestation*; Lavnoy, *Remarques sommaires*; Mabillon, "Histoire de la contestation," 1–47; Ziegelbauer, *Historia Rei Literariae*, 616–617; Malou, *Recherches historiques*; Ruland, *Der Streit*; de Backer, *Essai bibliographique*; von Habsburg, *Catholic and Protestant Translations of the* Imitatio Christi, *1425–1650*, 196–198; Benz, *Zwischen Tradition und Kritik.*, 539–549.

36. Caietanus, *De Religiosa S. Ignatii*; Rho, *Achates ad D. Constantinum Caietanum*. Compare also Mariani, *Della Vita di S. Ignazio*, 40–41; Malou, "Recherches historiques," 6–7.

37. Melloni, *The Exercises*; Fitzsimmons, "A Pilgrim's Staff versus a Ladder of Contemplation," 88–101.

38. "*Invictus igitur Athleta, morbo, & morte fortior, illo non superatus, hanc stans excepit. Ita nimirum Flaviorum ille primus dicere solebat, Imperatorem stantem mori oportere. Ita quoque Rex Regum & Dominus Dominantium Christus Iesus stans expiravit . . . At gloriosus noster Patriarcha non iacens, non sedens, non genuflectens, sed erectus steti, tamquam succinctus viator caelestem intraturus Ierusalem.*" Quote from Haeften, *S. Benedictus Illustratus*, 178. Compare Stengelius, *Laudes S. P. N. Benedicti*, 93.

39. There are three known specimens of the album *Sanctus Benedictus Christiformis*. An edition from 1652 is in the holdings of Österreichische Nationalbibliothek, sign. 42 A 12, a reissue from 1680 is in the collection of the Universidad Complutense Madrid Library, sign. BH FLL 37494 (GF). A variant is preserved in the holdings of the library of the Trappist Monastery in Belgian Westmalle (see also The Belgian Art Links and Tools database, art. No. 87276, http://balat.kikirpa.be/object/87276). The copy from 1648 is mentioned in the list of Caramuel's works and also in *Memoires pour servir a l'histoire des hommes illustres*, 271; *Memoires pour servir a l'histoire litteraire*, 274; Alvarez y Baena, *Hijos de Madrid*, 254. Caramuel's collection was first studied thoroughly by Zelenková, *Barokní grafika 17. století v zemích Koruny české*, 30–33, Cat. No. 7. See also Telesko, "Die Deckenmalereien der Stiftskirche Melk," 189; Idem, *Kosmos Barock*, 61–64; Mádl, "Praha – Břevnov," 125–131; Mádl, *Sanctus Benedictus Christiformis*.

40. On the life and work of Juan Caramuel of Lobkowitz see Tadisi, *Memorie della Vita di Monsignore Giovanni Caramuel di Lobkowitz*; Sousedík, *Filosofie v českých zemích*, 183–215; Dvořák and Schmutz, eds, *Juan Caramuel Lobkowitz* (see other bibliography here). On the cooperation with Archbishop Harrach see also Catalano, *Boemia e la riconquista delle coscienze*.

41. Sartorius, *Ciestercium Bis-tertium*. See also Preiss, "Heraldická alegorie na habsburský rod," 173; Royt, "Ve znamení krve a mléka," 70–71; Stehlíková, "Alegorie Habsburské říše pod ochranou cisterciáckého řádu," 72, Cat. No. 83.

42. David, *Veridicus Christianus*, 351. See also Dobalová, *Pašijový cyklus*, 56–57.

43. Sucquet, *Via vitae aeternae*. On Sucquet's book see Smith, "Sensuous Worship," 48–49; Melion, "*Ad contemplationis aciem* ('Toward Keen-Sighted Contemplation')," 153–187; Malý and Suchánek, *Obrazy očistce*, 209–215; Malý, "The Logic of Jesuit Meditations," 151–186 (other bibliography here).

44. Compare, e.g., Guiderdoni Bruslé, "La Polysémie des figures dans l'emblématique sacrée," 97–114; Konečný, "Karel Škréta a François Le Roy," 27–35, 87–92; Smith, *Sensuous Worship*, 11–55; Dobalová, "Pašijový cyklus," 49–60; Dekoninck, *Ad Imaginem*, 273–328; Raybould, *The Symbolic Literature of the Renaissance*, 281–286; Levy, "Early Modern Jesuit Arts and Jesuit Visual Culture," 66–87; Melion, "Introduction," 1–49.

45. Compare Kircher, *Ars Magna Lucis et Umbrae*, 840–914 and the frontispiece; Traber, *Nervus Opticus sive Tractatus Theoricus*.

46. Rene Bornert, "Ein Thesenblatt von 1701 aus der Salzburgischen Benediktiner-Universität," 233–244; Neuhardt, ed., 167–168, tab. IX; Karner, *Faciamus hic tria tabernacula*.

47. Hermann Bauer, *Barocke Deckenmalerei in Süddeutschland*, 94–95; Hans Neueder, *Die barocken Fresken von Oberalteich*.

48. Karner, "*Faciamus hic tria tabernacula*," 209; Mádl, "Nástěnné malby a projekty benediktinů," 74–86 (84–85); Šeferisová Loudová, "Rajhrad. Klášter s kostelem sv. Petra a Pavla," 606–690 (646–649, Cat. No. XVIa/2.c1–4).

49. On the St. Francis Xavier sculptural group on the Charles Bridge, compare Blažíček, *Ferdinand Brokof*, 51–54, 98, Cat. No. 11.

50. On respect for Jesus' name and the "IHS" monogram, see Molanus, *De Picturis et Imaginibus Sacris*, 105–110; Lyraeus, *De Imitatione Jesu Patientis*, 518–521; [Vettori], *De Vetustate et Forma Monogrammatis Sanctissimi Nominis Jesu Dissertatio*; [Allegranza], *De Monogrammate D. N. Jesu Christi*; van Hecke, Bossue, de Buck, Carpentier, *Acta Sanctorum* X/10, 318–323; Dombart, "Der Name Jesus," 257–269; Feldbusch, "Christusmonogramm," col. 707–720; Jaeger, "Name Jesu," col. 783; Ott, "IHS," col. 337; Kemp, "Name Jesu," col. 311–313; Hlobil, "Bernardinské symboly Jména Ježíš," 223–234; Sibylle Appuhn-Radtke, "Innovation durch Tradition," 243–259; Pfeiffer, "IHS. The Monogram of the Society of Jesus," 12–15; Beneš, "Bernardinské slunce neboli symbol Jména Ježíš," 31, Cat. No. 26; Oulíková, "Reflexe úcty Jména Ježíšova," 99–105; Dal Tio, "Il trigramma IHS di San Bernardino," 207–246; Chlíbec, *Bernardinské slunce nad českými zeměmi*, 65–83; Worcester, ed., *The Cambridge Encyclopedia of the Jesuits*, 377.

51. Sartorius, *Ciestercium Bis-Tertium*, 229–247. Compare also Mádl, "Between Meditation and Propaganda," 22–23.

52. Gallner, *Regula Emblematica Sancti Benedicti*. Emblems from this collection were selected to decorate the jambs in the library halls of the Břevnov Benedictine Monastery. Compare also Vondráčková, "Die Bibliothek des Benediktinerklossters St. Margarethe," 127–169; Mádl, "Praha – Břevnov," 259–263, 267–270, Cat. No. Ib.2/2.b1–12, Ib.2/3.b1–12.

53. Menzel, *Abt Othmar Daniel Zinke*, 76–93; Hamacher, "Wahlstatt," 258–260, Cat. No. F XXII; Vilímková and Preiss, *Ve znamení břevna a růží*, 74, 119–122, 241–244; Mádl, "Between Meditation and Propaganda," 23–24; Rupprecht, "'*In hoc signo vinces*.' Die schlesische Benediktinerpropstei Wahlstatt," 218–233; Mádl, "Lehnické Pole," 866–894.

54. Telesko, "Die Deckenmalereien der Stiftskirche Melk," 169–191; Idem, *Kosmos Barock*, 39–83; Mádl, Praha – Břevnov, 120–140.

55. Mádl, Praha – Břevnov, 120–140, 150–154, Cat. No. Ia/2.a1–3.

56. "*Primo modo si spectetur, extra dubium est, quod primitiva & praecipua ejus institutio, ad ipsiusmet Sacrosanctae Crucis & Crucifixi Salvatoris D. N. J. C. cultum pertineat . . . Finem etiam quendam particularem esse cultum ac honorem S. P. BENEDICTI, qui in sacro Numismate cum Cruce ob oculos nobis constituitur, ut eum Tutelarem Patronum adoptemus, certa spe pleni, quod sub ejus praesidio ac tutela nihil a maleficis, sit nobis metuendum.*"

Quoted from Magnoaldus Ziegelbauer, *Disquisitio Sacra Numismatica de Origine, Quidditate, Virtute, Pioque Usu Numismatum, seu Crucularum S. Benedicti Abbatis . . .*, 55.

57. The manuscript is deposited in Bayerische Staatsbibliothek München, ms. sign. Clm. 8201, fol. 95r.

58. Pezius, *Thesaurus Anecdotorum Novissimus*, dis. L–LI.

59. As to the Benedict's Cross, see Ziegelbauer *Disquisitio Sacra*; Zelli-Jacobuzi, *Origine e mirabili effetti della croce*; Guéranger, *The Medal or Cross of St. Benedict*; Tumpach and Podlaha, eds. *Český slovník bohovědný*, Vol. 2, 108–109; Cornell, "Neuc Forschungen zur Geschichte des St. Benediktuskruezes," 1–9; Zoepfl, "Benediktusmedaille," col. 266–269; Vilímková and Preiss, *Ve znamení břevna a růží*, 62–165; Tomaschek, "Benediktus-Medaille, Benediktus-Kreuz und Benediktus-Segen," 299–326; Mádl, "Praha – Břevnov," 135–140.

60. On the various aspects of the Jesuit theory of the image, compare de Boer, Enenkel, and Melion, eds., *Jesuit Image Theory*.

61. On the life and works of Martin Antonín Lublinský compare Togner, *Antonín Martin Lublinský*; Zelenková, *Martin Antonín Lublinský*.

62. On the decoration of the church at Holy Hill near Olomouc, see Mádl, "Svatý Kopeček" 241–371; Mádl, "'Iconomysticism' of Jacob Masen," 4–15; Mádl, "Biskup Karel a premonstráti," 495–503; English version, idem, "Bishop Karl and the Premonstratensians," 483–491.

63. On the decoration of church in Stará Voda near Libavá see also. Zapletalová, "Malíř Giovanni Carlone na Moravě," 289–306; Zapletalová and Švácha, "The Pilgrimage Church of St. James the Greater," 393–417.

64. On this painting see also Mádl, "Emblém 'SINE MACULA' v kostele Navštívení P. Marie na Svatém Kopečku," 298–319 (291–299, Cat. No. VI/4.c8); Martin Mádl, "Svatý Kopeček," 241–371.

65. Masen, *Speculum Imaginum*, 480.

BIBLIOGRAPHY

Primary Sources

Allegranza, Giuseppe. *De Monogrammate D. N. Jesu Christi et usitatis ejus effingendi modis.* Milan: Josephus Marellus, 1773.

Acta Processus, seu Litis in Causa Praetensae Exemptionis ab Ordinaria Celsissimi et Revrendissimi Archi-Episcopi Pragensis Jurisdictione inter Curiam Archi-Episcopalem Pragensem ex una, et Quinque Abbates Ordinis S. Benedicti Brzevnoviensem, Cladrubiensem, S. Joannis sub Rupe, S. Procopii ad Sazavam, et S. Nicolai Vetero-Pragae, per dimidium et amplius seculum ex altera Partibus vertente. Anno MDCCLVIII, die I. Decembris in Curia Romana feliciter absoluta et terminata. Prague: [Jacobus Schweiger], 1759.

Alvarez y Baena, Joseph Antonio. *Hijos de Madrid, ilustres en santidad, dignidades, armas, ciencias y artes. Diccionario histórico,* vol. 3. Madrid: Benito Cano,1790.

Caietanus, Constantinus. *De Religiosa S. Ignatii, sive S. Enneconis Fundatoris Societatis Iesu, Per Patres Benedictino Institutione. Deque Libello Exercitiorum eiusdem, ab Exercitatorio Venerabilis servi dei, Garciae Cisnerii, Abbatis Benedictini, magna ex parte desumpto.* Venice: Christophorus Tomasinus, 1641.

Caietanus, Constantinus. *Venerabilis Viri, Ioannis Gessen, Abbatis, Ord. S. Benedicti, De Imitatione Christi Libri quatuor.* Romae: Jacobus Mascardus, 1616.

David, Joannes, and Carolus Stengelius. *Paradeys des Breutigams und der Braut* Augsburg: Christoff Mang, 1617.

David, Joannes. *Duodecim Specula.* Antwerp: Joannes Moretus, 1610.

David, Joannes. *Veridicus Christianus.* Antverp: Officina Plantiniana, 1601.

de Palma, Ludovicus. *Praxis et Brevis Declaratio Viae Spiritualis, prout eam nos docet S. P. Ignatius in quatuor Septimanis Libelli sui Exercitiorum Spiritualium.* Antverp: Officina Plantiniana – Balthasarus Moretus, 1634.

Fronteau, Jean, and Gabriel de Boissy. *La Contestation touchant l'autheur de l'Imitation de Iesus-Christ* Paris: Sebastien Cramoisy and Gabriel Cramoisy, 1652.

Gallner, Bonifacius. *Regula Emblematica Sancti Benedicti.* Vienna: Joannes Thomas de Trattnern, 1780.

Gretser, Jacobus. *Libri quinque Apologetici pro Vita B. P. Ignatii Societatis Jesu Fundatoris* Ingolstadt: Adam Sartorius, 1601.

Haeften, Benedictus. *Regia via crucis.* Antwerp: Officina Plantiniana-Balthasarus Moretus, 1635.

Haeften, Benedictus. *S. Benedictus Illustratus sive Disquisitionum Monasticarum libri XII* Antwerp: Petrus Bellerus, 1644.

Hermanus, Hugo. *Schola cordis, sive Aversi a Deo cordis.* Antwerp: Joannes Meursius – Hieroniumus Verdussius, 1635.

Hevenesi, Gabriel. *Cura Salutis, Sive De Statu Vitae Maturae ac prudenter Deliberandi Methodus* Vienna: Joannes Georgius Schlegel, 1712.

Hugo, Hermanus. *Pia desideria.* Antwerp: Henricus Aertsenius, 1624.

Ignác z Loyoly. *Souborné dílo. Duchovní cvičení. Vlastní životopis. Duchovní deník.* Olomouc: Refugium Velehrad-Roma, 2005.

Ignatius de Loyola, *Exercitia spiritualia Sancti Patris Ignatii* Prague, 1674.

Ignatius de Loyola. *Exercitia spiritualia*. Rome, 1648.

Kircher, Athanasius. *Ars Magna Lucis et Umbrae* Rome: Hermannus Scheus, 1646.

Kundmann, Johann Christian. *Promptuarium Rerum Naturalium et Artificialium Vratislaviense*. Wroclaw: Michael Hubertus, 1726.

Lavnoy, Jean de. *Remarques sommaires sur un livre intitulé La Contestation touchant l'autheur de l'Imitation de Iesus-Christ* . . . Paris: Edme Martin, 1663.

Lyraeus, Hadrianus. *De Imitatione Jesu Patientis sive De Morte et Vita in Christo Jesu Patiente Abscondita*. Antverp: Hieronymus Wellaeus, 1655.

Mabillon, Jean, and Thierri Ruinart. *Ouvrages Posthumes*, vol. 1. Paris: Fracois Babuty, Jean Francois Josse, and Jombert le Jeune, 1724.

Mabillon, Jean. "Histoire de la contestation sur l'auteur du livre De l'imitation de J. C." In *Posthumes*, vol. 1, edited by Jean. Mabillon and Thierri Ruinart, 1–47. Paris, 1724.

Mariani, Francesco. *Della Vita di S. Ignazio, Fondatore della Compagnia di Gesu Libri cinque*. Bologna: Lelio dalla Volpe, 1741.

Memoires pour servir a l'histoire des hommes illustres dans la republique des lettres. Avec un catalogue raisonne de leurs Ouvrages, vol. 29. Paris: Briasson, 1734.

Memoires pour servir a l'histoire litteraire des dix-sept provinces de Pays-Bas, de la principauté de Liege, vol. 8. Louvain: L'imprimerie academique, 1766.

Molanus, Joannes. *De Picturis et Imaginibus Sacris*. Louvain: Hieronymus Vellaeus, 1570.

Pezius, Bernardus *Thesaurus Anecdotorum Novissimus: seu Veterum Monumentorum, praecipue Ecclesiasticorum, ex Gemanicis potissimum Bibliothecis adornata Collectio recentissima*, vol. 1. Augsburg: Philippus, Joannes & Martinus Veith, 1721.

Pezius, Bernardus. *Epistolae Apologeticae pro Ordine Sancti Benedicti Adversus Libellum: Cura salutis* Kempten: Mayr, 1715.

Quatremaires, Robertus. *Ioannes Gersen Abbas Vercel. Ord. S. Benedicti, auctor Libb. de Imit. Christi iterum assertus*. Parisiis: Joannes Billaine, 1650.

Rho, Joannes. *Achates ad D. Constantinum Caietanum, Monachum Casinatem, & S. Baronti Abbatem V. C. Adversus Ineptias, et Malignitatem Libelli Pseudo-Constantiniani, de Sancti Ignatii Institutione, atque Exercitiis*. Lugduni: Philippus Borde, 1644.

Sartorius, Augustinus. *Ciestercium Bis-tertium seu Historia Elogialis, Sacerrimi Ordinis Cisterciensis* Prague: Wolffgangus Wickmart, 1700.

Stengelius, Carolus. *Weeg deß ewigen Leben durch R.P.F. Carolvm Stengelivm*. Augsburg, 1625.

Stengelius, Carolus. *Laudes S. P. N. Benedicti Abbatis Monachorum in Occidente Patriarchae, Eiusque sanctissimae Regulae, & Ordinis*. Augustae Vindelicorum Augsburg: Andreas Apergerius, 1647.

Sucquet, Antonius. *Via vitae aeternae*. Antverpiae: Martinus Nutius, 1620.

Tadisi, Jacopo-Antonio. *Memorie della Vita di Monsignore Giovanni Caramuel di Lobkowitz Vescovo di Vigevano.* Venice: Giovanni Tevernin, 1760.

Traber, Zacharias. *Nervus Opticus sive Tractatus Theoricus in tres libros Opticam, Catoptricam, Dioptricam distributus.* Vienna: Joannes Christophorus Cosmerovius, 1675.

Vettori, Antonio Francesco. *De Vetustate et Forma Monogrammatis Sanctissimi Nominis Jesu Dissertatio* . . . Rome: Zempelianus, 1747.

Ziegelbauer, Magnoaldus. *Disquisitio Sacra Numismatica de Origine, Quidditate, Virtute, Pioque Usu Numismatum, seu Crucularum S. Benedicti Abbatis* Vienna: Leopoldus Kaliwoda, 1743.

Ziegelbauer, Magnoaldus. *Historia Rei Literariae Ordinis S. Benedicti* . . ., vol. 4. Augsburg: Martinus Veith, 1754.

Secondary Studies

Adams, Alison. ed. *Emblems and Art History,* Glasgow: University of Glasgow, 1996.

Appuhn-Radtke, Sibylle. "Innovation durch Tradition. Zur Aktualisierung mittelalterlicher Bildmotive in der Ikonographie der Jesuiten." In *Die Jesuiten in Wien. Zur Kunst- und Kulturgeschichte der österreichischen Ordensprovinz der „Gesellschaft Jesu" im 17. und 18. Jahrhundert,* edited by Herbert Karner and Werner Telesko, 243–259. Vienna: Österreichischen Akademie der Wissenschaften, 2003.

Appuhn-Radtke, Sibylle. "Spirituelle Trendsetter. Jesuitische Andachtsbücher des Barock und ihre Wirkungen außerhalb der Societas." In *Bohemia Jesuitica 1556–2006,* 2 vols, edited by Petronilla Cemus, vol. 2, 1201–1215. Prague: Karolinum, 2010.

Bailey, Gauvin Alexander. *Between Renaissance and Baroque; Jesuit Art in Rome, 1565–1610.* Toronto: University of Toronto Press, 2003.

Bailey, Gauvin Alexander. "Italian Renaissance and Baroque Painting. Under the Jesuits and its Legacy Throughout Catholic Europe, 1565–1773." In *The Jesuits and the Arts, 1540–1773,* edited by John W. O'Malley, S.J., Gauvin Alexander Bailey, and Giovanni Sale, S.J., 123–198. Philadelphia: Saint Joseph's University Press, 2005.

Bauer, Hermann. *Barocke Deckenmalerei in Süddeutschland.* Munich: Deutscher Kunstverlag, 2000.

Beneš, Petr Regalát. "Bernardinské slunce neboli symbol Jména Ježíš." In *Historia franciscana. Katalog výstavy pořádané k 400. výročí příchodu bratří františkánů do kláštera Panny Marie Sněžné v Praze (1604–2004),* edited by Petr Regalát Beneš, Jan Kašpar, and Jitka Křečková, 31, cat. no. 26. Prague: Provincie Bratří Františkánů, 2004.

Benz, Stefan. *Zwischen Tradition und Kritik. Katholische Geschichtsschreibung im barocken Heiligen Römischen Reich.* Husum: Matthiesen Verlag, 2003.

Blažíček, Oldřich J. *Ferdinand Brokof.* Prague: Odeon, 1976.

Bornert, Rene. "Ein Thesenblatt von 1701 aus der Salzburgischen Benediktiner-Universität als Vorlage einer Deckenmalerei von 1727 in der Abteikirche zu Ebersmünster im Elsass." *Studien und Mitteilungen zur Geschichte des Benediktiner-Ordens und seiner Zweige* 95 (1984): 233–244.

Bushart, Bruno, and Bernhard Rupprecht, eds. *Cosmas Damian Asam 1686–1739. Leben und Werk.* Munich: Prestel, 1986.

Catalano, Alessandro. *Boemia e la riconquista delle coscienze. Ernst Adalbert von Harrach e la Controriforma in Europa centrale (1620¬1667).* Rome: Edizioni di storia e letteratura, 2005.

Cemus, Petronilla, ed. *Bohemia Jesuitica 1556–2006*, 2 vols. Prague: Karolinum, 2010.

Conrod, Fréderic. "The Spiritual Exercises. From Ignatian Imagination to Secular Literature." In *A Companion to Ignatius of Loyola. Life, Writings, Spirituality, Influence,* edited by Robert Aleksander Maryks, 266–281. Leiden: Brill, 2014.

Cornell, Henrik. "Neue Forschungen zur Geschichte des St. Benediktuskruezes." *Studien und Mitteilungen zur Geschichte des Benediktinerordens* 42, no. 11 (1924): 1–9.

Čornejová, Ivana, Hedvika Kuchařová, and Kateřina Valentová, eds., *Locus pietatis et vitae. Sborník příspěvků z konference konané v Hejnicích ve dnech 13.–15. září 2007.* Prague: Scriptorium, 2008.

Čornejová. Ivana, ed. *Dějiny univerzity Karlovy, vol. 2, 1622–1802.* Prague: Karolinum, 1996.

Dal Tio, Raul. "Il trigramma IHS di San Bernardino da Siena negli edifici storici di Aosta tra il XVI e il XVII secolo." *Bulletin de l'Académie Saint'Anselme* 11 (2010): 207–246.

de Backer, Augustin. *Essai bibliographique sur le livre De Imitatione Christi.* Liège: Grandmont-Donders, 1864.

de Boer, Wietse, Karl A. E. Enenkel, and Walter S. Melion, eds. *Jesuit Image Theory.* Leiden: Brill, 2016.

de Leturia, Pedro. "La 'Devotio moderna' en el Montserrat de S. Ignacio." In *Estudios Ignacianos* II, edited by Pedro de Leturia, 73–88. Rome: Institutum Historicum S. I., 1957,

Dekoninck, Ralph. *Ad Imaginem. Statuts, fonctions et usages de l'image dans la littérature spirituelle jésuite du XVIIe siècle.* Geneva: Droz, 2005.

Dobalová, Sylva. *Pašijový cyklus Karla Škréty. Mezi výtvarnou tradicí a jezuitskou spiritualitou.* Prague: Lidové noviny, 2004.

Doktorová, Jana. "Reading the Prague Lesser Town Square." In *Faces of the Community in Central European Towns. Images, Symbols and Performances, 1400–1700,* edited by Kateřina Horníčková, 229–250. Lanham: Lexington Books, 2018.

Dombart, Theodor. "Der Name Jesus." *Die christliche Kunst* 11 (1914–1915): 257–269.

Doran, Robert M. "Lonergan on Imitating the Divine Relations." In *René Girard and Creative Mimesis,* edited by Vern Neufeld Redekop and Thomas Ryba, 199–219. Lanham: Lexington Books, 2014.

Dvořák, Petr, and Jacob Schmutz, eds. *Juan Caramuel Lobkowitz: The Last Scholastic Polymath*. Prague: Filosofia, 2008.

Feldbusch, Hans. "Christusmonogramm." *Reallexikon zur Deutschen Kunstgeschichte*, vol. 3, 707–720. Stuttgart: Druckenmüller: 1953.

Fitzsimmons, Maureen A. J. "A Pilgrim's Staff versus a Ladder of Contemplation: The Rhetoric of Agency and Emotional Eloquence in St Ignatius's Spiritual Exercises." In *Traditions of Eloquence. The Jesuits & Modern Rhetorical Studies*, edited by Cinthia Gannett and John C. Brereton, 88–101. New York: Fordham University Press, 2016.

Fronek, Jiří. *Johann Hiebel (1679–1755). Malíř fresek evropského baroka*. Prague: Lidové noviny, 2013.

Gannett, Cinthia, and John C. Brereton, eds. *Traditions of Eloquence. The Jesuits & Modern Rhetorical Studies*. New York: Fordham University Press, 2016.

Garberson, Eric. *Eighteenth-Century Monastic Libraries in Southern Germany and Austria. Architecture and Decoration. Architecture and Decoration*. Baden-Baden: Valentin Koerner, 1998.

Gerken, Claudia. *Entstehung und Funktion von Heiligenbildern im nachtridentinischen Italien (1588–1622)*. Petersberg: Michael Imhof Verlag, 2015.

Goodrich, Peter, and Valérie Hayaert, eds. *Genealogies of Legal Vision*. Abingdon: Routledge, 2015.

Guéranger, Prosper. *The Medal or Cross of St. Benedict. Its Origin, Meaning, and Privileges*. London: Burns and Oates, 1880.

Guiderdoni, Agnès. "The Heart and the Law in the Scales. Allegorical Discourse and Modes of Subjectivization in Early-modern Religious Emblematics." In *Genealogies of Legal Vision*. edited by Peter Goodrich and Valérie Hayaert, 118–134. Abingdon: Routledge, 2015.

Guiderdoni-Bruslé, Agnès. "La Polysémie des figures dans l'emblématique sacrée." In *Emblems and Art History*, edited by Alison Adams, 97–114. Glasgow: University of Glasgow, 1996.

Hamacher, Bärbel, ed., *Pinxit, sculpsit, fecit. Kunsthistorische Studien. Festschrift für Bruno Bushart*. Berlin: Deutscher Kunstverlag, 1994.

Hamacher, Bärbel. "Prag. Sankt Niklas in der Altstadt." In *Cosmas Damian Asam 1686–1739. Leben und Werk*, edited by Bruno Bushart and Bernhard Rupprecht, 265–267, cat. no. F XXV. Munich: Prestel, 1986.

Hamacher, Bärbel. "Wahlstatt." In *Cosmas Damian Asam 1686–1739. Leben und Werk*, edited by Bruno Bushart and Bernhard Rupprecht, 258–260, cat. no. F XXII. Munich: Prestel, 1986.

Herain, Jan. *Stará Praha. 100 akvarelů Vácslava Jansy*, 2 vols. Prague: Bedřich Kočí, 1902.

Heussler, Carla, and Sigrid Gensichen, eds. *Das Kreuz. Darstellung und Verehrung in der Frühen Neuzeit*. Regensburg: Schnell & Steiner, 2013.

Hlobil, Ivo. "Bernardinské symboly Jména Ježíš v českých zemích šířené Janem Kapistránem." *Umění* 44 (1996): 223–234.

Horníčková, Kateřina, ed. *Faces of Community in Central European Towns. Images, Symbols and Performances, 1400–1700*. Lanham: Lexington Books, 2018.

Horyna, Mojmír, Jaroslav Macek, Petr Macek, and Pavel Preiss. *Oktavián Broggio 1670–1742* (Katalog). Litoměřice: Galerie výtvarného umění v Litoměřicích, 1992.

Hubala, Erich. *Johann Michael Rottmayr*. Vienna: Herold, 1981.

Chlíbec, Jan. *Bernardinské slunce nad českými zeměmi*. Prague: Academia, 2016.

Jaeger, Hans. "Name Jesu." *Lexikon für Theologie und Kirche*, vol. 7, col. 783. Freiburg: Herder, 1962.

Karner, Herbert, and Werner Telesko, eds. *Die Jesuiten in Wien. Zur Kunst- und Kulturgeschichte der österreichischen Ordensprovinz* der "Gesellschaft Jesu" *im 17. und 18. Jahrhundert*. Vienna: Österreichischen Akademie der Wissenschaften, 2003.

Karner, Herbert. "Die schlesischen Jesuitenkirchen in Breslau und Brieg: Architektur und Bild im Spannungsfeld jesuitischer Modelle." In *Bohemia Jesuitica 1556–2006*, 2 vols, edited by Petronilla Cemus, vol. 2, 1347–1373. Prague: Karolinum, 2010.

Karner, Herbert. "*Faciamus hic tria tabernacula*: Architektur und Deckenmalerei in der Klosterkirche in Rajhrad." In *Baroque Ceiling Painting in Central Europe / Barocke Deckenmalerei in Mitteleuropa* (Proceedings of the International Conference, Brno – Prague, 27th of September–1st of October, 2005), edited by Martin Mádl, Michaela Šeferisová- Loudová, and Zora Wörgötter, 199–217. Prague: Artefactum, 2007.

Kemp, Wolfgang. "Name Jesu." *Lexikon der christlichen Ikonographie*, vol. 3, col. 311–313. Rome: Herder, 1971.

Konečný, Lubomír, "Karel Škréta a François Le Roy, S. J., neboli historie téměř detektivní." *Bulletin Národní galerie v Praze* 10 (2000): 27–35, 87–92.

Konečný, Lubomír, and Lubomír Slavíček, eds. *Libellus Amicorum Beket Bukovinská*. Prague: Artefactum, 2013.

Kozieł, Andrzej. *Angelus Sileusius, Bernhard Rosa i Michael Willmann, czili sztuka i mistyka na Śląsku w czasach baroku*. Wrocław: University of Wrocław, 2006.

Krásl, František. "Opat Anselm Vlach ve sporu s arcibiskupem pražským Ferdinandem hrab. z Khuenburka o exempci." *Sborník historického kroužku* 6 (1897): 12–23.

Kreissl, Eva, ed., *Kulturtechnik Aberglaube. Zwischen Aufklärung und Spiritualität. Strategien zur Rationalisierung des Zufalls*. Bielefeld: Transcript, 2013.

Levy, Evonne. "Early Modern Jesuit Arts and Jesuit Visual Culture. A View from the Twenty-First Century." *Journal of Jesuit Studies* 1 (2014): 66–87.

Levy, Evonne. *Propaganda and the Jesuit Baroque*. Berkeley: University of California Press, 2004.

Mádl, Martin, Anke Schlecht, and Marcela Vondráčková, eds.. *Detracta larva juris naturae. Studien zu einer Skizze Wenzel Lorenz Reiners und zur Dekoration der Klosterbibliothek in Břevnov*. Prague: Artefactum, 2006.

Mádl, Martin, Michaela Šeferisová Loudová, and Zora Wörgötter, eds. *Baroque Ceiling Painting in Central Europe / Barocke Deckenmalerei in Mitteleuropa*

(Proceedings of the International Conference, Brno – Prague, 27th of September–1st of October, 2005). Prague: Artefactum, 2007.

Mádl, Martin. "'Picturae elegantes' in der Prager St.-Ignatius-Kirche und der Maler Johann Ezechiel Wodniansky." In *Bohemia Jesuitica 1556–2006*, vol. 2, edited by Petronilla Cemus, 1387–1408. Prague: Karolinum, 2010.

Mádl, Martin. "Between Meditation and Propaganda. Explicit and Implicit Religious Imagery in Baroque Ceiling Painting." *Acta historiae artis slovenica* 16 (2011): 11–28.

Mádl, Martin, ed. *Tencalla*, vol. 2. Prague: Artefactum, 2013.

Mádl, Martin. "Svatý Kopeček u Olomouce. Poutní kostel Navštívení Panny Marie. Katalog nástěnných maleb." In *Tencalla*, vol. 2, edited by Martin Mádl, 241–371. Prague: Artefactum, 2013.

Mádl, Martin. "Emblém 'SINE MACULA' v kostele Navštívení P. Marie na sv. Kopečku." In *Libellus Amicorum Beket Bukovinská*, edited by Lubomír Konečný and Lubomír Slavíček, 298–319. Prague: Artefactum, 2013.

Mádl, Martin. "Iconomysticism" of Jacob Masen and Decoration of Pilgrim Church at Holy Hill near Olomouc. *Ars* 47 (2014): 4–15.

Mádl, Martin, Radka Heisslerová, Michaela Šeferisová Loudová, and Štěpán Vácha, et al. *Benediktini*, 2 vols. Prague: Academia, 2016.

Mádl, Martin. "Heřmánkovice. Kostel Všech svatých." In *Benediktini*, vol. 1, edited by Martin Mádl, Radka Heisslerová, Michaela Šeferisová Loudová, and Štěpán Vácha, 468–490. Prague: Academia, 2016.

Mádl, Martin. "Lehnické Pole. Klášter s kostelem sv. Kříže a sv. Hedviky." In *Benediktini,* vol. 2, edited by Martin Mádl, Radka Heisslerová, Michaela Šeferisová Loudová, and Štěpán Vácha, 866–895. Prague: Academia, 2016.

Mádl, Martin. "Nástěnné malby a projekty benediktinů české řádové provincie v 17. a 18. století." In *Benediktini*, vol. 1, edited by Martin Mádl, Radka Heisslerová, Michaela Šeferisová Loudová, and Štěpán Vácha, 74–86. Prague: Academia, 2016.

Mádl, Martin. "Praha – Břevnov. Klášter s kostelem sv. Markéty." In *Benediktini*, vol. 1, edited by Martin Mádl, Radka Heisslerová, Michaela Šeferisová Loudová, and Štěpán Vácha, 100–311. Prague: Academia, 2016.

Mádl, Martin. "Praha – Staré Město. Klášter s kostelem sv. Mikuláše." In *Benediktini*, vol. 2, edited by Martin Mádl, Radka Heisslerová, Michaela Šeferisová Loudová, and Štěpán Vácha, 764–801. Prague: Academia, 2016.

Mádl, Martin. "Bishop Karl and the Premonstratensians." In *Karl von Lichtenstein-Castelcorno (1624–1695)*, edited by Rostislav Švácha, Martina Potůčková, and Jiří Kroupa, vol. 2, 478–491. Olomouc: Muzeum umění Olomouc, 2019.

Mádl, Martin. "Biskup Karel a premonstráti." In *Karel z Lichtensteinu-Castelcorna (1624–1695)*, vol. 2, edited by Rostislav Švácha, Martina Potůčková, and Jiří Kroupa, 490–503. Olomouc: Muzeum umění Olomouc, 2019.

Mádl, Martin. "*Sanctus Benedictus Christiformis*. Poznámky k albu Juana Caramuela z Lobkovic / *Sanctus Benedictus Christiformis*. Notes on the Album by Juan Caramuel of Lobkowitz." *Ars linearis* 7 (2017): 34–45, 131–134.

Malou, Jean-Baptiste. *Recherches historiques et critiques sur le véritable auteur du livre de L'imitation de Jésus-Christ*. Louvain: chez Fonteyn, 1849.

Malý, Tomáš, and Pavel Suchánek. *Obrazy očistce. Studie o barokní imaginaci.* Brno: Matice moravská, 2013.

Malý, Tomáš. "The Logic of Jesuit Meditations: Antoine Sucquet's *Via vitae aeternae* (1620)." *Acta Comeniana* 30 (LIV) (2016): 151–186.

Maryks, Robert Aleksander, ed., *A Companion to Ignatius of Loyola. Life, Writings, Spirituality, Influence.* Leiden: Brill, 2014.

Melion Walter S., ed., *The Meditative Art: Studies in the Northern Devotional Print, 1550–1625.* Philadelphia: Saint Joseph's University Press, 2009.

Melion, Walter S. *"Ad contemplationis aciem"* ('Toward Keen-Sighted Contemplation'): The Image of the Picturing Soul in Antonius Sucquet's *Via vitae aeternae* of 1620." In *The Meditative Art: Studies in the Northern Devotional Print, 1550–1625,* 153–187. Philadelphia: Saint Joseph's University Press, 2009.

Melion, Walter S. "Introduction: The Jesuit Engagement with the Status and Functions of the Visual Image." In *Jesuit Image Theory,* edited by Wietse de Boer, Karl A. E. Enenkel, and Walter S. Melion, 1–49. Leiden: Brill, 2016.

Melloni, Javier. *The Exercises of St. Ignatius Loyola in the Western Tradition.* Leominster: Gracewing Publishing, 2000.

Menzel, Beda Franz, *Abt Othmar Daniel Zinke und die Ikonographie seiner Kirchen in Břevnov – Braunau – Wahlstatt.* St. Ottilien: EOS-Verlag, 1986.

Menzel, Beda Franz. "Exemptionsstreit zwischen den Äbten von Břevnov-Braunau und den Prager Erzbischöfen 1705–1758." *Bohemia. Jahrbuch des Collegium Carolinum* 17 (1976): 53–136.

Mikulec, Jiří. "Klášter a barokní společnost. K vlivu řeholního prostředí na spiritualitu laiků." In *Locus pietatis et vitae. Sborník příspěvků z konference konané v Hejnicích ve dnech 13.–15. září 2007,* edited by Ivana Čornejová, Ivana, Hedvika Kuchařová, and Kateřina Valentová, 281–300. Prague: Scriptorium, 2008.

Neueder, Hans. *Die barocken Fresken von Oberalteich. Beschreibung und Deutung einzigartiger Bilder in der ehemaligen Benediktiner-Abteikirche.* Regensburg: Schnell & Steiner, 2010.

Neuhardt Johannes, ed. *1500 Jahre St. Benedikt Patron Europas.* Graz: Styria, 1980.

Ott, Brigitte. "IHS." *Lexikon der christlichen Ikonographie,* vol. 2, col. 337. Rome: Herder,1970.

Oulíková, Petra. "Der Bibliothekssaal des Clementinum zu Prag." In *Baroque Ceiling Painting in Central Europe / Barocke Deckenmalerei in Mitteleuropa* (Proceedings of the International Conference, Brno – Prague, 27 September – 1 October, 2005), edited by Martin Mádl, Michaela Šeferisová-Loudová, and Zora Wörgötter, 155–163. Prague: Artefactum, 2007.

Oulíková, Petra. "Reflexe úcty Jména Ježíšova v umění jezuitského řádu." *Acta Universitatis Carolinae – Historia Universitatis Carolinae Pragensis* 50, no. 1 (2010): 99–105.

Oulíková, Petra. *Klementinum.* Prague: Národní knihovna ČR, 2019.

Pfeiffer, Heinrich. "IHS. The Monogram of the Society of Jesus." In *Jesuits. Yearbook for the Society of Jesus,* [n.e.], 12–15. Rome: General Curia of the Society of Jesus, 2003.

Preiss, Pavel. *Václav Vavřinec Reiner.* Prague: Odeon, 1971.

Preiss, Pavel. "Der Wandel des ikonographischen Programms der Jesuitenkirche St. Niklas auf der Prager Kleinseite." *Wiener Jahrbuch für Kunstgeschichte* 40 (1987): 269–287, 339–402.

Preiss, Pavel. "Heraldická alegorie na habsburský rod a rakouský (babenberský) znak." In *Oktavián Broggio 1670–1742* (catalog), edited by Mojmír Horyna, Jaroslav Macek, Petr Macek, and Pavel Preiss, 173. Litoměřice: Galerie výtvarného umění v Litoměřicích, 1992.

Preiss, Pavel. *"Thomismus contra Molinismus.* Ein theloligischer Streit um die Fresken von Wenzel Lorenz Reiner in der Prager Dominikanerkirche." In *Pinxit, sculpsit, fecit. Kunsthistorische Studien. Festschrift für Bruno Bushart*, edited by Bärbel Hamacher, 187–195. Berlin: Deutscher Kunstverlag, 1994.

Preiss, Pavel. "Zum Prager Bilderstreit über das Problem des Thomismus und Molinismus. Addenda et corrigenda im Lichte der Dokumente." In *Rodrigo de Arriaga (†1667), Philosoph und Theologe* (Prag 25.–28. Juni 1996), edited by Tereza Saxlová and Stanislav Sousedík, 219–224. Prague: Karolinum, 1998.

Preiss, Pavel. *František Karel Palko. Život a dílo malíře sklonku středoevropského baroka a jeho bratra Františka Antonína Palka.* Prague: Národní galerie,1999.

Preiss, Pavel. *Václav Vavřinec Reiner. Dílo, život a doba malíře českého baroka*, [extended edition]. Prague: Academia, 2013.

Raková [Čornejová], Ivana. "Cesta ke vzniku Karlo-Ferdinandovy univerzity. Spory o pražské vysoké učení v letech 1622–1654." *Acta Universitatis Carolinae. Historia Universitatis Carolinae Pragensis* 24 (1984): 7–40.

Raybould, Robin. *An Introduction to The Symbolic Literature of the Renaissance.* Victoria: Trafford Publishing, 2005.

Redekop, Vern Neufeld, and Thomas Ryba, eds. *René Girard and Creative Mimesis.* Lanham: Lexington Books, 2014.

Rosenberg, Randall S. *The Givenness of Desire. Human Subjectivity and the Natural Desire to See God.* Toronto: University of Toronto Press, 2017.

Rosenberg, Randall S. *The Givenness of Desire. Human Subjectivity and the Natural Desire to See God.* Toronto: University of Toronto Press, 2017.

Royt, Jan. Ve znamení krve a mléka. Poznámky k ikonografii uměleckých děl a ke kultům v oseckém klášteře v 17. a 18. století, in *800 let kláštera v Oseku (1196–1996)* (catalog), edited by Dana Stehlíková, 67–72. Prague: Unicornis, 1996.

Ruland, Anton. *Der Streit über den Verfasser des Büchleins „De Imitatione Christi", wie solcher im XVIII. Jahrhundert in Deutschland geführt wurde.* Leipzig: T. O. Weigel, 1861.

Rupprecht, Bernhard. "'*In hoc signo vinces.*' Die schlesische Benediktinerpropstei Wahlstatt zum Heiligen Kreuz im Brennpunkt kofessioneller Spannungen. In *Das Kreuz. Darstellung und Verehrung in der Frühen Neuzeit*, edited by Carla Heussler and Sigrid Gensichen, 218–233. Regensburg: Schnell & Steiner, 2013.

Saunders, Alison. *The Seventeenth-century French Emblem. A Study in Diversity.* Geneva: Librarie Droz, 2000.

Saxlová, Tereza, and Stanislav Sousedík, eds. *Rodrigo de Arriaga (†1667), Philosoph und Theologe* (Proceedings of the conference Prag 25.–28. Juni 1996). Prague: Karolinum, 1998.

Sluhovsky, Moshe. "A Biography of the Spiritual Exercises." *Jesuit Historiography Online*, 2016. Internet access at http://dx.doi.org/10.1163/2468-7723_jho_COM_192590 (last access 19.2.2020).

Sluhovsky, Moshe. "Loyola's Spiritual Exercises and the Modern Self." In *A Companion to Ignatius of Loyola. Life, Writings, Spirituality, Influence*, edited by Robert Aleksander Maryks, 216–231. Leiden: Brill, 2014.

Smith, Jeffrey Chipps. *Sensuous Worship. Jesuits and the Art of the Early Catholic Reformation in Germany.* Princeton: Princeton University Press, 2002.

Sousedík, Stanislav. *Valerián Magni (1586–1661). Kapitola z kulturních dějin Čech 17. století.* Prague: Vyšehrad, 1983.

Sousedík, Stanislav. "Některé projevy antijesuiitismu v pobělohorském období a jejich společenské pozadí." *Studia Comeniana et historica* 16 (1977): 21–28.

Sousedík, Stanislav. *Filosofie v českých zemích mezi středověkem a osvícenstvím.* Prague: Vyšehrad, 1997.

Stehlíková, Dana, ed. *800 let kláštera v Oseku (1196–1996)* (catalog). Prague: Unicornis, 1996.

Stehlíková, Dana. "Alegorie Habsburské říše pod ochranou cisterciáckého řádu." In *800 let kláštera v Oseku (1196–1996)*, edited by Dana Stehlíková, 72, cat. no. 83. Prague: Unicornis, 1996.

Svoboda, David. "Boží předurčení a svoboda rozhodování." *Filosofický časopis* 52 (2004): 559–568.

Swartley, Willard M. "The Imitation Christi in the Ignatian Letters." *Vigiliae Christianae* 27 (1973): 81–103.

Šeferisová-Loudová, Michaela."Rajhrad. Klášter s kostelem sv. Petra a Pavla." In *Benediktini*, vol. 2, edited by Martin Mádl, Radka Heisslerová, Michaela Šeferisová-Loudová, and Štěpán Vácha. Prague: Academia, 2016.

Švácha, Rostislav, Martina Potůčková, and Jiří Kroupa, eds. *Karel z Lichtensteinu-Castelcorna (1624–1695)*, vol. 2. Olomouc: Muzeum umění Olomouc, 2019.

Švácha, Rostislav, Martina Potůčková, and Jiří Kroupa, eds. *Karl von Lichtenstein-Castelcorno (1624–1695)*, vol. 2. Olomouc: Muzeum umění Olomouc, 2019.

Telesko, Werner. "Die Deckenmalereien der Stiftskirche Melk oder die Visualisierung von Ordensgeschichte als Manifestation kirchenpolitischer Ansprüche." In *Europäische Geschichtskulturen um 1700 zwischen Gelehrsamkeit, Politik und Konfession*, edited by Thomas Wallnig, Thomas Stockinger, Ines Peper, and Patrick Fiska, 169–191. Berlin: DeGruyter, 2012

Telesko, Werner. *Kosmos Barock. Die Stiftskirche Melk.* Vienna:Böhlau, 2013.

Tietze, Hans. "Programme und Entwürfe zu den grossen österreichischen Barockfresken." *Jahrbuch der Kunsthistorischen Sammlungen des allerhöchsten Kaiserhauses* 30 (1911): 1–28.

Togner, Milan. *Antonín Martin Lublinský 1636–1690.* Olomouc: Univerzita Palackého, 2004.

Tomaschek, Johann, Benediktus-Medaille, Benediktus-Kreuz and Benediktus-Segen. "Frömmigkeitsgeschichtliche und theologische Bemerkungen zum 'Benediktinischen Kreuzamulett.'" In *Kulturtechnik Aberglaube. Zwischen*

Aufklärung und Spiritualität. Strategien zur Rationalisierung des Zufalls, edited by Eva Kreissl, 299–326. Bielefeld: Transcript, 2013.

Tumpach, Josef, and Antonín Podlaha, eds. *Český slovník bohovědný*, vol. 2. Prague: Václav Kotrba, 1916.

van Hecke, Josephus, Benjamin Bossue, Victor de Buck, and Eduard Carpentier. *Acta Sanctorum* 10. Brussels: Henricus Goemaere, 1861.

Vilímková, Milada, and Pavel Preiss. *Ve znamení břevna a růží. Historický, kulturní a umělecký odkaz benediktinského opatství v Břevnově.* Prague: Vyšehrad, 1989.

Voit, Petr. *Encyklopedie knihy. Starší knihtisk a příbuzné obory mezi polovinou 15. a počátkem 19. století* Prague: Libri, 2006.

von Habsburg, Maximilian. *Catholic and Protestant Translations of the Imitatio Christi, 1425–1650. From Late Medieval Classic to Early Modern Bestseller.* Farnham: Ashgate, 2011.

Vondráčková, Marcela. "Die Bibliothek des Benediktinerklossters St. Margarethe im 18. Jahrhundert." In *Detracta larva juris naturae. Studien zu einer Skizze Wenzel Lorenz Reiners und zur Dekoration der Klosterbibliothek in Břevnov*, edited by Martin Mádl, Anke Schlecht, and Marcela Vondráčková, 127–169. Prague: Artefactum, 2006.

Vondráčková, Marcela. "Felix Anton Scheffler a malířská výzdoba jezuitského kostela Nanebevzetí P. Marie v Brně." In *Bohemia Jesuitica 1556–2006*, vol. 2, edited by Petronilla Cemus, 1409–1429. Prague: Karolinum, 2010.

Wallnig, Thomas, Thomas Stockinger, Ines Peper, and Patrick Fiska, eds. *Europäische Geschichtskulturen um 1700 zwischen Gelehrsamkeit, Politik und Konfession.* Berlin: De Gruyter. 2012.

Wallnig, Thomas. *Critical Monks. The German Benedictines, 1680–1740.* Leiden: Brill, 2019.

Wojtyła, Arkadiusz. "Od wschodu słońca aż po zachód jego niech Imię Pańskie będzie pochwalone. Uwagi o programie ideowym wrocławskiego Il Gesu." *Biuletyn Historii Sztuki* 72 (2010): 113–148.

Worcester, Thomas, ed. *The Cambridge Encyclopedia of the Jesuits.*Cambridge: Cambridge University Press, 2017.

Zapletalová, Jana, and Rostislav Švácha. "Poutní kostel sv. Jakuba Většího a sv. Anny ve Staré Vodě, 1680–1690." In *Karel z Lichtensteinu-Castelcorna (1624–1695)*, vol. 2, edited by Rostislav Švácha, Martina Potůčková, and Jiří Kroupa, 393–417. Olomouc: Muzeum umění Olomouc, 2019.

Zapletalová, Jana, and Rostislav Švácha. "The Pilgrimage Church of St. James the Greater and St. Anne at Stará Voda, 1680–1690." In *Karel z Lichtensteinu-Castelcorna (1624–1695)*, vol. 2, edited by Rostislav Švácha, Martina Potůčková, and Jiří Kroupa, 393–417. Olomouc: Muzeum umění Olomouc, 2019.

Zapletalová, Jana. "Malíř Giovanni Carlone na Moravě. Stará Voda." *Umění* 63 (2015): 289–306.

Zelenková, Petra. *Barokní grafika 17. století v zemích Koruny české / Seventeeth-Century Baroque Prints in the Lands of the Bohemian Crown.* Prague: Národní galerie, 2009.

Zelenková, Petra. *Martin Antonín Lublinský jako inventor grafických listů. Pohled do středoevropské barokní grafiky druhé poloviny 17. století.* Prague: Národní galerie: 2011.

Zelli-Jacobuzi, Francesco-Leopoldo. *Origine e mirabili effetti della croce o medaglia di S. Benedetto.* Rome: Marini e Morini, 1849.

Zoepfl, Friedrich. "Benediktusmedaille." *Reallexikon zur deutschen Kunstgeschichte,* vol. 2, 266–269. Stuttgart: Druckenmüller, 1948.

Index

Page references for figures are italicized

About the Editors and Contributors

Martin Deutsch is currently finishing his doctoral degree in the Department of Art History of Masaryk University in Brno. His dissertation focuses on the role of visual arts in the formation of Jesuit novices during the seventeenth and eighteenth centuries.

Kateřina Horníčková is an assistant professor of art history and a senior researcher at Palacký University in Olomouc, and the University of South Bohemia in České Budějovice, Czech Republic. She has published on medieval and early modern art, religious cultures, and communication through images. Her interests include methodology of art history.

Ondřej Jakubec is an associate professor in the Department of Art History, Faculty of the Arts, Masaryk University in Brno, and in the Department of Art History, Faculty of the Arts, Palacký University in Olomouc. His research interests are architecture and the visual culture of the early modern period, art patronage, religious communication through visual media, sepulchral culture in the early modern period, historiography, theory, and methodology of art history.

Martin Mádl is a senior researcher at the Institute of Art History, Czech Academy of Sciences, Prague. He focuses on early modern art, especially seventeenth- and eighteenth-century mural painting and visual culture, in the context of monastic orders in Central Europe.

Michal Šroněk is a professor and deputy director of the Institute of Art and Culture Studies and head of the Department of Art History at the Faculty of the Arts, University of South Bohemia in České Budějovice. His research

interests are the visual arts, especially painting in Bohemia from the sixteenth through eighteenth century, the relationship between art and piety, art and the Reformation, and Early Modern painters' associations.

Katrin Sterba studied art history at the University of Freiburg/Breisgau. At the University of Innsbruck, she defended her doctoral dissertation "From the Visible to the Invisible. Studies on the visualization of Catholic dogmas in the Jesuit Church and the Corpus Christi Chapel in the city of Olomouc in today's Czech Republic." She was a participant in the project "Research Database Continent Allegories in the Baroque Age" at the University of Vienna.

Štěpán Vácha is a senior researcher at the Institute of Art History, Czech Academy of Sciences, Prague. He focuses on the painting of the seventeenth century in Bohemia, the art at the court of Emperor Rudolf II, the art and iconography of religious orders, and the iconography and representation of the Habsburgs in the visual arts. He is the editor-in-chief of bulletin *Studia Rudolphina* of the Research Centre for Art and Culture in the Age of Rudolf II at the Institute of Art History, Prague.